PAINTING WITH

WATERCOLORS OILS, ACRYLICS AND GOUACHE

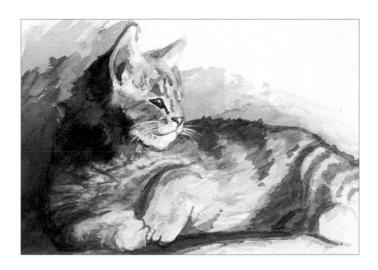

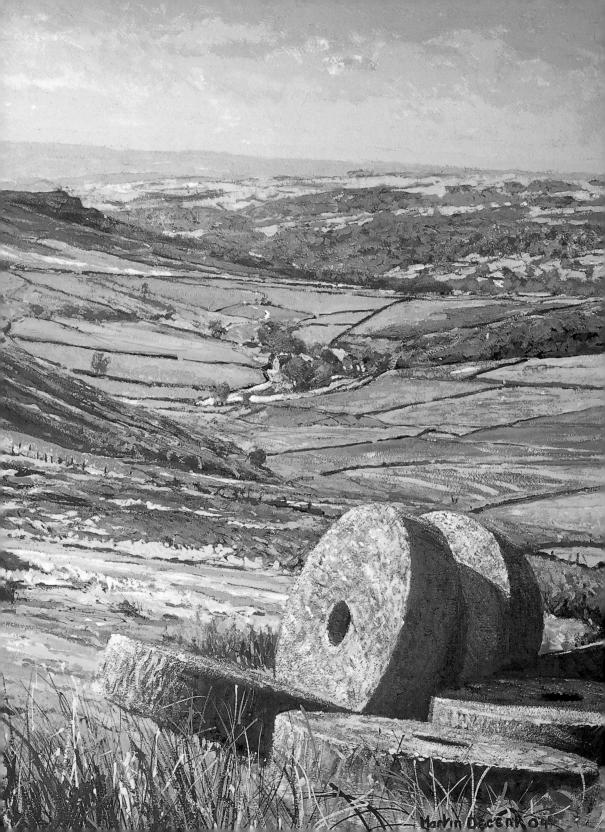

PAINTING WITH

WATERCOLORS OILS, ACRYLICS AND GOUACHE

A complete step-by-step course in painting techniques from getting started to achieving excellence, with over 1600 color photographs

WENDY JELBERT & IAN SIDAWAY

Contents

WATERCOLOURS	6
Introduction	8
Watercolour techniques	10
Paints	12
Papers	16
Brushes	18
Pencils and pens	20
Additional equipment	22
From light to dark	24
Making marks	26
Washes	28
Understanding tone	32
Understanding colour	38
Wet into wet	44
Masking	48
Resists	52
Spattering	56
Stippling	58
Drybrush	60
Sponging	62
Additives	64
Line and wash	68
Water-soluble pencils	72
Using a toned ground	76
Working into wet paint	78
Sgraffito	82
Body colour	84
Scale and perspective	88
Composition	90

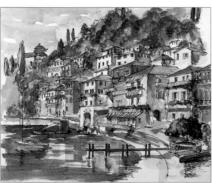

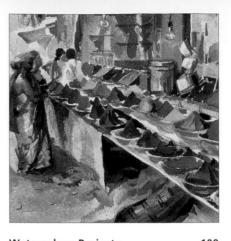

Watercolour Projects	100
PAINTING SKIES	102
Clouds at sunset	104
Storm clouds and rainbow	108
PAINTING WATER	112
Woodland waterfall	116
Crashing waves	120
Lake with reflections	126
Harbour moorings	132
PAINTING TREES	138
Woodland in spring	140
Autumn tree	144
Poppy field	148
Painting Flowers	152
Sunflower	154
Summer flower garden	158
French vineyard	164
Craggy mountains	168
PAINTING STILL LIFES	174
Strawberries and cherries in a bowl	176
Still life with stainless steel	182
Eye of the tiger	188
Tabby cat	190
Otter	196
Flamingo	202
PAINTING BUILDINGS	208
Hillside town in line and wash	210
Moroccan kasbah	216
Arched window	222
PAINTING PEOPLE	228
Head-and-shoulders portrait	230
The swimmer	236
Seated figure in interior	242
Indian market scene	2/18

OILS, ACRYLIC AND GOUACHE	254
Introduction	256
Oil, Acrylic and Gouache Techniques	258
Oil paint	260
Acrylic paint	264
Gouache paint	267
Paintbrushes	270
Alternative paint applicators	272
Palettes	274
Oil additives	276
Acrylic additives	278
Supports	280
Varnishes	285
Auxiliary equipment	288
Applying paint	290
Tone	294
Scaling up	298
Underdrawing	300
Underpainting	302
Toned grounds	304
Washes	308
Wet into wet and blending	312
Painting alla prima in oils	316
Glazing	320
Scumbling	324
Impasto	328
Removing paint	334
Drybrush	338
Gouache techniques	340

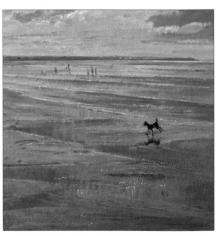

Oil, Acrylic and Gouache Projects	340
PAINTING FLOWERS AND LEAVES	350
Irises	352
Floating leaf	358
Tulips in glass vase	362
Woodland path	368
Painting Animals and Birds	374
Sleeping cat	376
Farmyard chickens	382
Tropical butterfly	388
PAINTING LANDSCAPES	392
Stormy sky	394
Rocky landscape	398
Sunlit beach	404
Rolling hills	410
PAINTING STILL LIFES	416
Still life with gourds	418
Still life with pebbles	424
Lemons in glass dish	430
Still life with glass and ceramics	436
PAINTING BUILDINGS	442
Church in snow	444
Arch and balcony	450
Moorish palace	456
Wisteria-covered archway	462
Domestic interior	468
PAINTING PEOPLE	222
Portrait of a young child	476
Head-and-shoulders portrait	482
Café scene	488
Reclining nude	494
Cupped hands	500
Glossary	502
Suppliers	504
Index	506
Acknowledgements	512

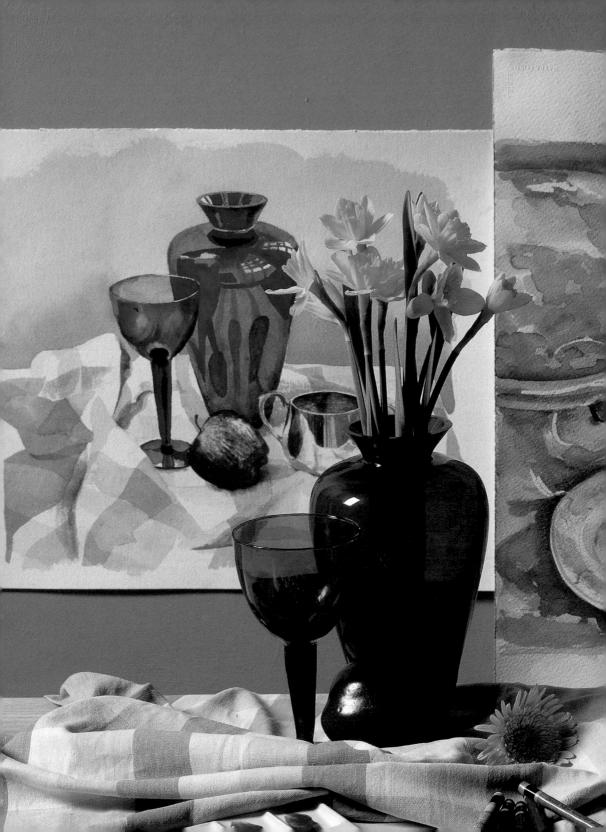

Introduction

Mention the word 'watercolour' and what do most people think of? Luminous, glowing works of art in which the paint appears to float as if by magic on the surface of the paper; transparent, wet-into-wet washes that capture the effects of light and shade to perfection; and subtle transitions of colour that are hard – if not impossible – to emulate in any other medium.

Add to this the fact that watercolour paint is relatively inexpensive, easily portable, quick drying and odour free, and it's hardly surprising that it is by far the most popular painting medium among amateur artists. Indeed, it is estimated that around 80 per cent of all amateurs produce some, if not all, of their work in watercolour.

Despite its popularity, however, watercolour is not the easiest of mediums to master – which is precisely where this book comes in. A carefully structured course that takes you step by step from buying your first paints and brushes to producing

Harbour moorings ▼

This project brings together a range of classic watercolour techniques to create a lively painting that captures the atmosphere of the scene beautifully.

works that you can be proud to hang on your wall, it not only covers all the techniques that you will ever need to know but also provides you with an inspiring selection of watercolour paintings by leading professional artists.

When considering what equipment to buy, it is all too easy to be seduced by the manufacturers' catalogues and the dazzling arrays of materials on display in art stores into buying far more than you can ever hope to use. In fact a basic palette of 12 to 20 colours, a small handful of brushes, and a pad of watercolour paper are more than enough for most people's needs to begin with.

Once you have bought your basic equipment, the next step is to become thoroughly familiar with the materials that you're using and to learn how they behave. The demonstrations and short practice exercises in the first part of this section are specially designed to allow you to practise one technique at a time and still produce a finished painting that you can enjoy showing to others. Use this section to build up both your skills and your confidence: start by copying the demonstrations and in no time you will be producing paintings of your own.

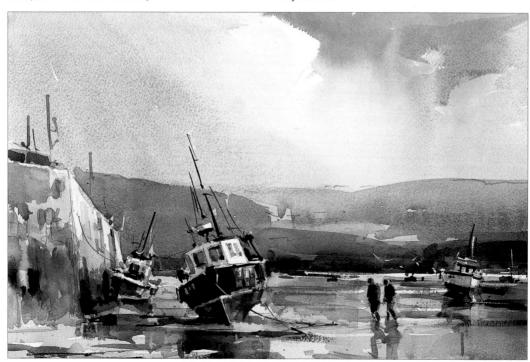

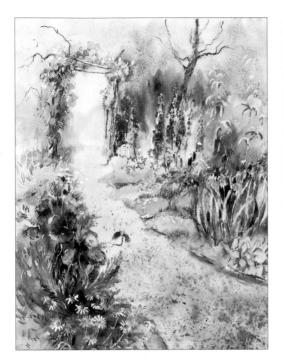

Summer flower garden A

Softly coloured poppies, irises, daisies and delphiniums line a winding path, which leads to the rose-clad arch. The intrigue is in wondering what lies beyond.

Do not worry if your first attempts do not look exactly like the ones reproduced here. The most scary thing for every novice painter is simply getting over initial inhibitions about making marks on a blank sheet of paper, and every brush stroke that you make will teach you something new about how the paint behaves or about your own hand–eye co-ordination. None of the exercises should take you more than an hour or two. Set aside a little time for painting each day, if you can – and after a couple of weeks, look back and assess your progress. You will be amazed at how far you have come.

Following the practice technique exercises are 25 step-by-step projects on a wide range of subjects, specially commissioned from leading professional artists. From a simple but dramatic study of clouds at sunset to a detailed painting of fishing boats moored in a harbour, from a single sunflower on a white background to an atmospheric contrejour study of a girl seated next to a window, you will find something here to suit all tastes.

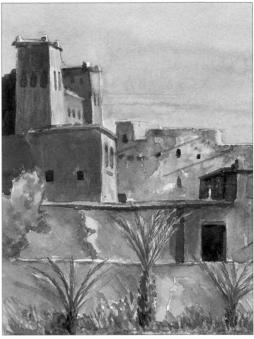

Moroccan kasbah A

Here the artist has used complementary colours – the orangey ochres and terracottas of the buildings against the rich blue sky – to create a rich, warm atmosphere.

These are longer projects to be done over the course of an afternoon – or you may even decide to spread them out over several painting sessions. You can either copy the projects step by step, exactly as shown here, or use them as a starting point for your own artistic explorations. All the projects are packed with useful tips and general principles that you can apply to subjects of your own choosing – so take the time to study them carefully, even if you do not reproduce them all.

You will find many different approaches here – some finely detailed, with delicate brushwork and careful build-ups of washes; others much looser and more impressionistic. All approaches are valid and you will almost certainly have your own preferences. The most important thing is to realize just how much you can learn from looking at other artists' work. All the artists featured here have built up a wealth of experience over many years of study, which they share here with you in the hope that you will gain as much pleasure and enjoyment from painting in watercolour as they have done.

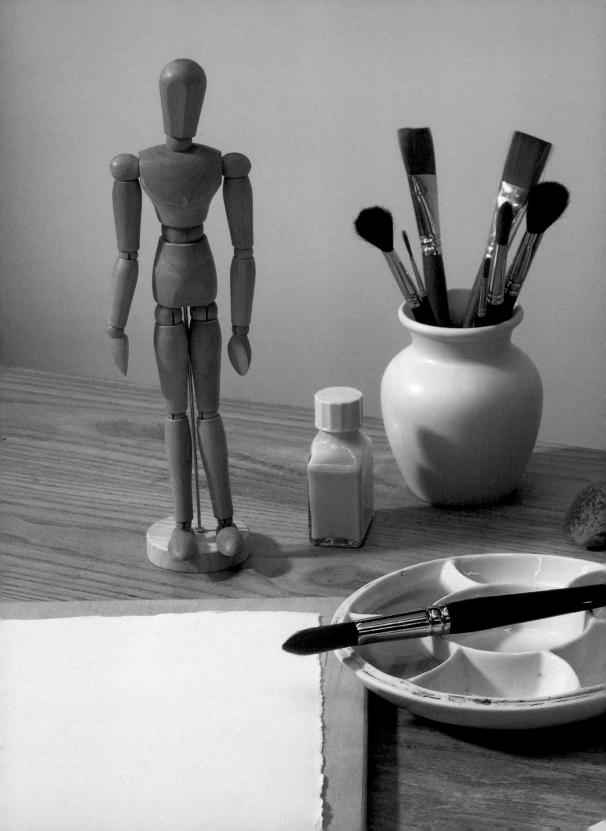

Watercolour Techniques

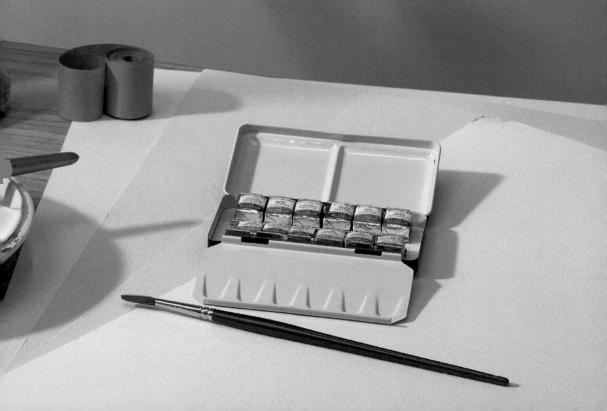

Paints

Watercolour paints are available in two main forms: pans, which are compressed blocks of colour that need to be brushed with water in order to release the colour, and tubes of moist paint. The same finely powdered pigments bound with gum-arabic solution are used to make both types. The pigments provide the colour, while the gum arabic allows the paint to adhere to the paper surface, even when highly diluted with water.

Both pans and tubes can be bought in sets or singly. Pans are available as full pans and half pans, the only difference is size. If there are certain colours that you use only infrequently, buy half pans. Tubes range in size from 5–20ml (0.17–0.66 fl oz).

It is a matter of personal preference whether you use pans or tubes. The advantage of pans is that they can be slotted into a paintbox, making them easily portable, and this is something to consider if you often paint on location. Tubes, on the other hand, are often better if you need to make a large amount of colour for a wash, although it is easy to squeeze out more paint than you need, which is wasteful. You also need to remember to replace the caps of tube colours immediately, otherwise the paint will harden and become unuseable.

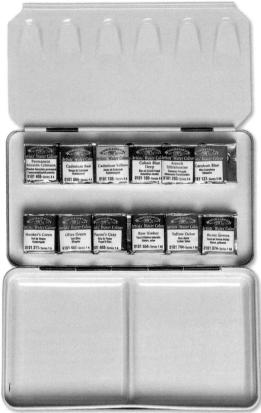

■ Paintbox

You can buy paintboxes that are already filled with a selection of colours, or empty boxes that you then fill with colours of your own choice. The model shown here is for pans of paint, but you can also buy ones with spaces for tube colours.

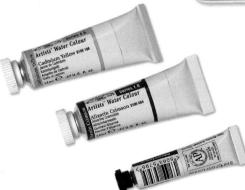

Tubes A

Tubes of watercolour paint are available in different sizes. It is worth buying the larger sizes for colours that you think you will use frequently.

Gouache paint A

This is a kind of water-based paint. Unlike pure watercolour, it is opaque, although the techniques and equipment used for gouache are similar to those used for watercolour. White gouache, in particular, is often used in conjunction with pure watercolour, both to add small highlights and to mix with watercolour to make pale, opaque colours.

Palettes

Even if you usually mix colours in the lid of your paintbox, it is useful to have one or two separate palettes as well, particularly when you want to mix a large quantity of a wash. There are several shapes and sizes available, but two of the most common are the segmented round palette and the slanted-well tile.

Palettes are made from white ceramic or plastic. Although plastic is lightweight, which is an advantage when you need to carry your materials for painting on location, it is also slightly porous and will become stained over time.

For an inexpensive alternative, look out for white china saucers and plates in charity shops or jumble (rummage) sales. They must be white, as you would be able to see any other colour through the transparent paint, which would make it difficult to judge the colour or tone being mixed. Old teacups and bowls are good if you need to mix large quantities.

Pigment does settle, so remember to stir the wash in your palette from time to time to ensure that it is evenly dispersed. Always wash your palette thoroughly after use to prevent dried paint residue from muddying subsequent mixes.

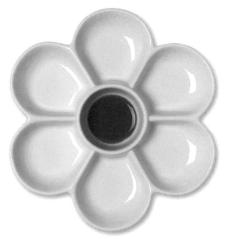

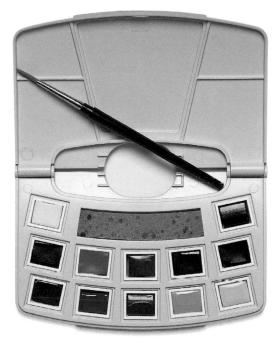

Field box ▲

Most of the major manufacturers sell field boxes specifically for use on location, which include a small brush and perhaps a sponge as well as a selection of paints.

■ Segmented round palette

This kind of palette, which is sometimes referred to as a chrysanthemum palette because of its flower-like shape, has deep wells that are perfect for mixing large washes.

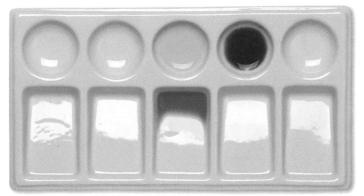

■ Slanted-well tile palette

This type of palette is useful for mixing two or more colours together: place each colour in one of the round wells at one end of the palette and transfer a little on your brush to one of the flat, slightly sloping sections.

Grades of paint

There are two grades of watercolour paint: artists' and students' quality. Artists' quality paints are the more expensive, because they contain a high proportion of good-quality pigments. Students' quality paints contain less pure pigment and more fillers, and are usually available in a smaller range of colours than artists' quality paints.

If you come across the word "hue" in a paint name, it indicates that the paint contains cheaper alternatives to the real pigment. Generally speaking, you get what you pay for: artists' quality paints tend to produce more subtle mixtures of colours.

The other thing that you need to think about when buying paints is their permanence. The label or the manufacturer's catalogue should give you the permanency rating. In the United Kingdom, the permanency ratings are class AA (extremely permanent), class A (durable), class B (moderate) and class C (fugitive). The ASTM (American Society for Testing and Materials) codes for lightfastness are ASTM I (excellent), ASTM II (very good), and ASTM III (not sufficiently lightfast).

Some pigments, such as alizarin crimson and viridian, stain more than others: they penetrate the fibres of the paper and cannot be removed.

Finally, although we always think of watercolour as being transparent, you should be aware that some pigments are actually slightly opaque and will impart a degree of opacity to any colours with which they are mixed. These so-called opaque pigments include all the cadmium colours and cerulean blue.

Judging colours

It is not always possible to judge the colour of paints simply by looking at the pans in your palette, as they often look dark. In fact, it is very easy to dip your brush into the wrong pan by mistake, so always check before you apply the brush to the paper.

Even when you have mixed a wash in your palette, appearances can be deceptive, as watercolour paint always looks lighter when it is dry. The only way to be sure what colour or tone you have mixed is to apply it to paper and let it dry. It is always best to build up tones gradually until you get the effect you want. The more you practise, the better you will get at anticipating results.

Appearances can be deceptive ▼

These two pans look very dark, almost black. In fact, one is Payne's grey and the other a bright ultramarine blue.

Test your colours ▼

Keep a piece of scrap paper next to you as you work so that you can test your colour mixes before you apply them to your painting.

Characteristics of paint ▼

Different pigments have different characteristics. The only way to learn about them is to use them and see how they behave, both singly and in combination with other colours. The chart below shows the characteristics of some of the most popular watercolour paints.

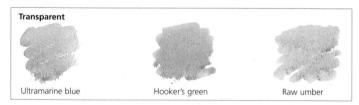

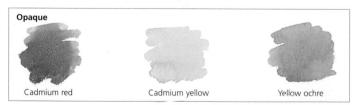

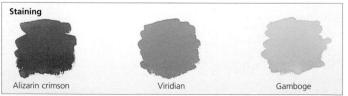

What colours to choose?

With so many colours to choose from (some manufacturers offer as many as 100 artists' quality paints and up to 50 students' quality), how do you decide which ones to buy?

Although art supply stores and catalogues contain rainbow-like selections of every colour imaginable, the most important thing to realize is that you don't need to buy a huge range. You might choose to produce a painting entirely from ready-made colours, but learning how to mix your own will give you far more scope and is far more economical.

Some artists choose to work with a very limited palette of as few as five or six colours, creating astonishingly subtle variations in hue and tone in the process. Start with a few colours and learn as much as you can about them before you add to your range. In practice, most people find that a

range of 12–20 colours enables them to mix pretty much anything that they could wish for.

As you gain more experience, you will probably find that you discard certain colours in favour of others: this is all part of the learning process. Set aside some time to experiment and see how many colours and tones you can create by mixing two, or even three, colours together.

Above all, keep a note of any mixes that you particularly like, or find useful for certain subjects (such as trees, skies or water) so that you can recreate them in the future. Remember, however, that the more colours you combine, the more risk there is that the resultant mixes will look muddy and dull: one of the received wisdoms in pure watercolour painting is that you should not mix more than three colours together at any one time.

As always, your exact choice of colours is largely a matter of personal preference, but a good "starter palette" should contain at least one of each of the three primary colours (red, yellow and blue); in fact, it's helpful to have one blue with a warm bias, such as ultramarine blue, and one that is slightly cooler, such as cerulean. Earth pigments such as raw and burnt umber and raw and burnt sienna are useful for mixing neutral browns and greys. Although you can mix your own greens, versatile ready-mixed greens include viridian, Hooker's green and sap green. Payne's grey is a good colour to mix with other colours for cast shadows.

Suggested starter palette ▼

The palette shown below is a versatile selection of colours that will enable you to create a wide range of mixes.

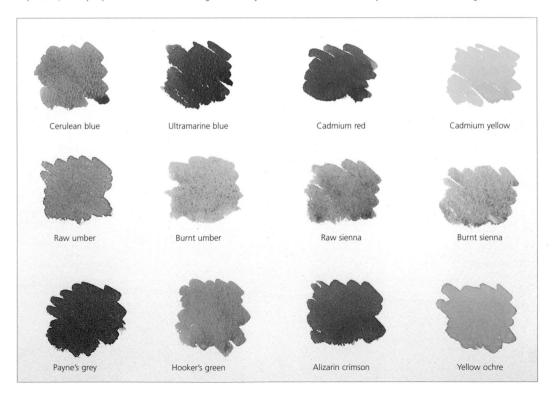

Papers

There are three main types of watercolour paper: hot-pressed (HP), NOT, and rough. Hot-pressed paper is best for drawing and detailed work; it is very smooth to the touch. NOT surface, meaning not hot-pressed (cold-pressed), has a slight texture. Rough paper has a prominent "tooth"; when a wash is laid over it, some of the deep cavities are left unfilled, giving a sparkle to the painting. The best papers are handmade from pure linen rag and the quality is reflected in the price.

Good-quality paper has a right and a wrong side. The right side is coated with size, which is receptive to watercolour applications. To find out which side to use, hold the paper up to the light and look for the water mark on the right side.

Watercolour paper is available in rolls, sheets, and pads and blocks of various sizes. Pads are either spiral bound or glued; blocks are glued on all sides to keep the paper flat until you need to remove a sheet. Pads and blocks are more practical for location work and guick sketches.

Types of paper ▼

From left to right: hot-pressed (HP), NOT and rough watercolour papers. Hot-pressed paper has a very smooth surface, while the other two are progressively more textured.

Tinted papers ▼

Tinted papers are sometimes frowned upon by purists, but there are times when you want to establish an overall colour key; these ready-made tinted papers are a good alternative to laying an initial flat wash.

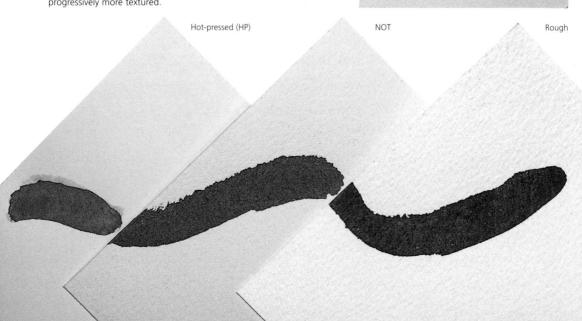

Stretching paper

Papers come in different weights. The weight refers to the weight of a ream (500 sheets) and can vary from 90lb (185 grams per square metre or gsm) for lightweight papers to 300lb (640gsm) or more. The heavier the paper, the more readily it will take the water. Papers that are less than

140lb (300gsm) in weight need to be stretched before use, otherwise they will cockle when water is applied. First, the paper is soaked in water so that it expands; it is then taped or stapled to a board. As it dries it contracts, giving a taut surface that will not buckle when subsequent washes are applied.

Dip a sponge in clean water and wipe it over the paper, making sure you leave no part untouched.

 $2^{\text{ Make sure a generous amount of water has been applied}} \\ \text{over the whole surface and that the paper is perfectly flat.}$

3 Moisten four lengths of gum strip and place one along each long side of the paper. (Only gummed brown-paper tape is suitable; masking tape will not adhere to damp paper.)

4 Repeat for the short edge of the paper. Leave to dry. (In order to be certain that the paper will not lift, some artists also staple it to the board.)

Brushes

A quick glance through any art supplier's catalogue will reveal a bewildering range of brushes, from outrageously expensive sable brushes to budget-range synthetics. Although you might be tempted to invest heavily and stock up on a vast selection, in all shapes and sizes, in practice you can get away with a small number: a large brush for laying a wash, a medium-sized brush for moderate washes and larger details, and a smaller brush for fine detail should be enough to begin with.

The two main shapes of brush are flat and round. Round brushes are perhaps the most useful general-purpose brushes. They hold a lot of paint, allowing you to lay down broad strokes of colour and washes, but they also come to a fine point for more precise marks. Flat brushes have a square, chisel-shaped end. These, too, can be used for broad washes, while the flat end is used for making clean-edged, linear marks.

Many artists use Chinese-style brushes similar to those used by calligraphers: like good-quality round brushes, they hold a lot of paint but also come to a fine point. You may also come across rigger brushes (round brushes with long hairs and a fine point), which are useful for fine lines and details, and spotter brushes (less common, with very short hairs), which tend to be used by miniaturists and other artists whose work involves painting fine, very precise details.

Brushes can be made from natural hair. Sable, which is obtained from the tail of the sable marten, a relative of the mink. is the best, and the best sables come from the Kolinsky region of northern Siberia. Camel, ox and squirrel hair are common, as are synthetic materials. Buy the best quality you can afford. Cheaper brushes may shed hairs or wear out more quickly. and they may not hold as much colour or come to a point. Look for seamless, corrosion-resistant ferrules: they hold the hairs tightly and will not tarnish. Also check whether they hold their shape well. Unfortunately, you can't always tell this when you buy brushes as they are often "dressed" with some kind of adhesive. which needs to be washed out before you use them, so that they hold their points.

Round brushes ▼

Most art stores stock round brushes ranging in size from the ultra-fine 000 right up to the rather fat size 12, although you will also find brushes that lie outside this range. To begin with, however, three brushes – one small, one medium and one large – will provide you with a versatile selection that should cover most eventualities. It is good practice to use the largest brush that you can for any given painting situation, so that you get into the habit of making broad, sweeping marks rather than tight, fussy ones.

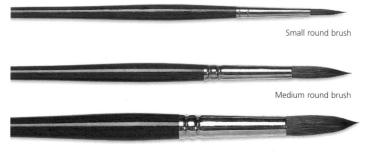

Large round brush

Large brushes ▼

Both flat brushes and mop brushes can be used to lay a wash over the paper ground. Flat brushes are wide and straight-edged, while mop brushes have large, round heads.

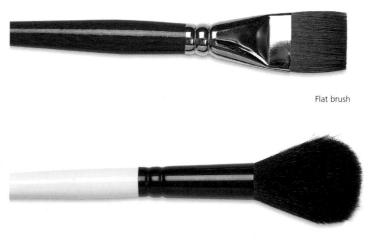

Mop brush

Other types of brush ▶

Your choice of brush is very much a matter of personal taste, so experiment to find out which ones you enjoy using. You will find that some suit your style of painting better than others. Shown here are some of the other types of brush that you might come across.

A rigger brush has long hairs and a very fine point, and is good for painting fine lines and details. A Chinese-style brush is good for flowing, calligraphic marks; it holds a lot of paint and keeps its shape well, making it a versatile brush. The flat edge of a chisel brush makes it a good choice for painting straight-edged shapes – when painting up to the edge of a building, for example. In a fan brush, the bristles are splayed out, and this makes it useful for drybrush work.

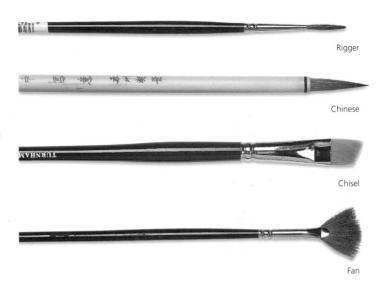

Caring for brushes

Given the cost of good-quality brushes, it is worth taking the time and trouble to look after them properly in order to prolong their life.

You should always clean your brushes immediately after use. Gently rub a little liquid detergent into the hairs, working it in with your fingertips and working right up to the ferrule. Rinse in clean running water until all the paint has been removed.

Cleaning brushes ▼

No matter how carefully you rinse your brushes, liquid detergent is the only way to be sure that you have got rid of all paint residue.

Storing brushes ▶

After cleaning your brushes, squeeze the hairs to remove any excess water and then gently reshape the brush with your fingertips. Leave to dry. Store brushes upright in a jar to prevent the hairs from becoming bent as they dry.

- Tips: When you are painting, try not to leave brushes standing in water as this can ruin both the hairs and the wooden handles.
- When cleaning brushes, keep rinsing the brush under running water until the water runs clear. Make sure that any paint near the metal ferrule has been completely removed.
- Do not be tempted to store newly cleaned and still-wet brushes in an airtight container as mildew can develop.
- Moths are very keen on sable brushes, so if you need to store your brushes for any length of time, it is a good idea to use mothballs to act as a deterrent.

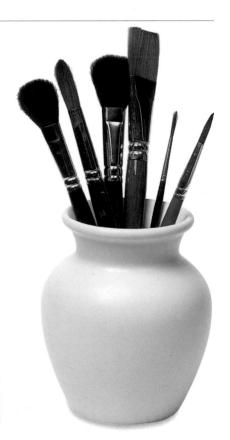

Pencils and pens

While there is no need to have more than a small selection, pencils and pens are valuable accessories in the artist's tool kit.

Pencils

The most common use of pencils in watercolour paintings is to make an initial underdrawing to map out the composition and put in the main lines of your subject as a guideline for when you come to apply the paint. It is very useful to keep a small selection of pencils to hand for this purpose.

Although graphite pencils range from 9B (very soft) to 9H (very hard), the more extreme choices are actually less useful: very soft pencils can smear while very hard ones make light, unimpressive marks. A more average HB and a 2B or 4B should be adequate for most underdrawings, depending on how strong you want the marks to be. It is also worth having a few very soft pencils in your collection to make quick tonal studies. Charcoal pencils and sticks are ideal.

Coloured pencils, too, are useful, and are particularly good for making colour notes when you are sketching on location. They are available in many colours but, unlike graphite pencils, only one degree of hardness.

You can also buy water-soluble pencils and crayons, both of which allow you to combine linear marks with the fluidity of watercolour washes. Easily portable, they are useful for location work. The range of colours is extensive, but many artists feel that they lack the subtlety of watercolour paints. Some brands seem to blend better than others, so experiment to find out which kinds you enjoy using.

Tip: If you wish to use water soluble pencils on location but do not want to carry the pencils, make heavy scribbles on paper in a range of colours: when you brush the scribbles with clean water you can pick up enough colour on the brush to use them as watercolour paints.

Pencils ▼

It is useful to keep a small range of pencils to hand for making tonal studies and underdrawings. For general usage, choose a medium hard pencil such as HB or 2B.

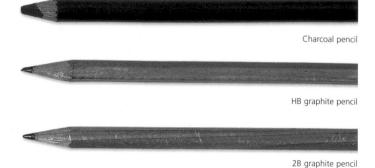

Water-soluble pencils ▼

Water-soluble pencils can be used dry, to make clearly defined marks, or wet to create soft blends and colour mixes. To use a water-soluble pencil wet, either dip the tip in clean water or apply the pencil to the paper in the normal way and brush over the marks with a wet brush.

■ Crayons

These colour sticks are similar in consistency to hard pastels. Crayons are capable of much bolder effects than pencil, and are excellent for crisp, decisive lines and for areas of solid dark tone, as they can be sharpened to a point or broken into short lengths and used sideways. Bear in mind that crayons cannot be erased easily.

Pens

Pens are most frequently used in watercolour in the line-and-wash technique, in which linear detail is put in in ink on top of (or under) loose watercolour washes.

There are various kinds of pen suitable for this technique. Fountain pens have the advantage of having a reservoir to hold the ink (or are loaded with a cartridge of ink), which means that you don't have to keep stopping to reload, but many artists prefer the spontaneity and rougher lines of dip pens. Both have interchangeable nibs, allowing you to vary the width and character of the lines you make. You can also create different widths of line by turning the pen over and using the back of the nib. Technical drawing pens of the type used by architects and graphic designers deliver a line of uniform width. These are available in a range of sizes.

As far as inks are concerned, your choice is between waterproof and water-soluble. Once dry, waterproof ink marks will remain permanent even when watercolour paint is applied over the top. Water-soluble inks, on the other hand, will blur and spread.

Inks can be used at full strength or diluted with water to create different tones; you may want to use several

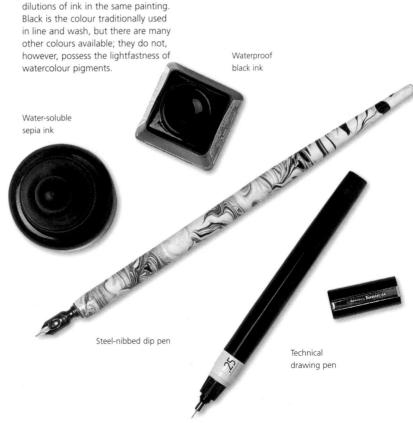

Additional equipment

There are a few other pieces of equipment that you will probably find useful in your watercolour painting, ranging from things to secure your work to the drawing board and easels to support your painting to aids to specific painting techniques.

The most important thing is that the surface on which you are working must be completely flat and unable to wobble around as you work. If you use blocks of watercolour paper, then the block itself will provide enough support; you can simply rest it on a table or your knee. If you use sheets of watercolour paper, then they need to be firmly secured to a board. Buy firm boards that will not warp and buckle (45 x 60cm/18 x 24in is a useful size), and attach the paper to the board by means of gum strip or staples.

It is entirely a matter of personal preference as to whether or not you use an easel. There are several types on the market, but remember that watercolour paint is a very fluid liquid and can easily flow down the paper into areas that you don't want it to touch. Choose an easel that can be used flat and propped at only a slight angle. The upright easels used by oil painters are not really suitable for watercolour painting.

Other useful pieces of equipment include a scalpel or craft (utility) knife: the fine tip allows you to prise up pieces of masking tape that have become stuck down too firmly without damaging the paper. You can also use a scalpel to scratch off fine lines of paint – a technique known as sgrafitto. Absorbent kitchen paper is invaluable for cleaning out paint palettes and lifting off or

softening the colour before it dries

As you develop your painting style and techniques, you may want to add other equipment to the basic items shown here. You will probably assemble a selection of props, from bowls, vases and other objects for still lifes, to pieces of fabric and papers to use as backgrounds. Similarly, you may want to set aside pictures or photographs that appeal to you for use as reference material. The only real limit to what you can use is your imagination.

Box easel ▼

This easel includes a handy side drawer in which you can store brushes and other paraphernalia, as well as adjustable bars so that it can hold various sizes of drawing board firmly in place. Some easels can only be set at very steep angles, which is unsuitable for watercolour, so do check before you buy.

Table easel ▼

This inexpensive table easel is more than adequate for most watercolourists' needs. Like the box easel it can be adjusted to a number of different angles, allowing you to alter the angle to suit the technique you are using. It can also be folded flat so that it can be stored neatly when it is not in use.

Gum strip A

Gummed brown-paper strip is essential for taping stretched lightweight watercolour paper to a board, to ensure that it does not buckle when the water is applied. Leave the paper stretched on the drawing board until you have finished your painting and the paint has dried, then simply cut it off, using a scalpel or craft (utility) knife and a metal ruler, and discard. Masking tape cannot be used in place of gum strip for the purpose of taping stretched watercolour paper.

Gum arabic A

Adding gum arabic to watercolour paint increases the viscosity of the paint and slows down the drying time. This gives you longer to work, which is often what you need when painting detail or referring to a reference photo while you are painting. Add a few drops of the gum arabic to your paint and stir to blend. Gum arabic also imparts a slight sheen on the paper, which can be useful for certain subjects, and it increases the intensity of the paint colour.

Masking fluid and masking tape A

Masking is one of the most basic techniques in watercolour. It is used to protect white areas of the paper so that they do not get splashed with paint, or when you want the white of the paper to represent the lighter areas of your subject. Depending on the size and shape of the area you want to protect, masking fluid and masking tape are the most commonly used materials. Masking tape can also be used to secure heavy watercolour paper, which doesn't need to be stretched, to the drawing board.

Eraser A

A kneaded eraser is useful for correcting the pencil lines of your underdrawing, and for removing the lines so that they do not show through the paint on the finished painting.

Sponge A

Natural or synthetic sponges are useful for mopping up excess water. Small pieces of sponge can be used to lift off colour from wet paint. Sponges are also commonly used to apply paint, with the pitted surface of the sponge creating interesting textures on the paper.

- Tips: Store small painting accessories such as sponges and rolls of tape in lidded boxes to keep things neat and tidy; plastic food storage boxes are ideal.
- Store bottles upright and always put the lids back on immediately after use to prevent spillage.
- Wash sponges immediately after use.

From light to dark

One of the things that attracts people to watercolour painting, and the one characteristic for which watercolour is most renowned, is its translucency. Good watercolours glow with a light that seems to come from within the painting itself. The reason for this is that pure watercolour paints are transparent: when a wash of watercolour paint is applied to paper, the white of the paper shines through. This is what makes watercolour the perfect choice for capturing subtle nuances of light and shade and creating a feeling of airiness that is unrivalled by any other painting medium.

However, the transparency of the paint imposes a technical constraint that you need to be aware of. When one colour is laid on top of another, particles of the first colour will still show through.

In opaque media such as oils, you can obliterate a dark colour by placing a light one on top of it. In pure watercolour, however, if you try to paint a pale yellow on top of a dark blue, some of the blue will remain visible – so instead of yellow, the two colours will appear to merge to form a green.

In practical terms, this means that you have to work from light to dark, putting down the lightest tones first and working around them as you develop the painting. You have plan ahead and work out where the light tones and colours are going to be before you pick up a brush and begin the actual painting.

One other important consideration is that in pure (transparent) watercolour there is no such thing as white paint. If you want certain areas of your painting to be white, the only white available to you is the white of the paper, and so you leave those areas free of paint, protecting them if necessary by applying some kind of mask. Alternatively, you can use white gouache, but gouache is opaque, and so you have to be very careful not to lose the feeling of luminosity.

Osprey ▼

The artist has combined watercolour with white gouache to great effect. The billowing clouds were created by leaving areas of the sky free of paint and by blotting off paint with a paper towel to soften the colour around the edges of the clouds. The ripples and spray in the water were painted using very dilute white gouache so as not to lose the wonderful feeling of light.

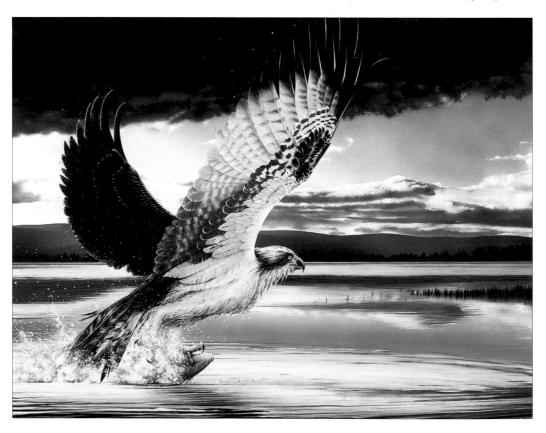

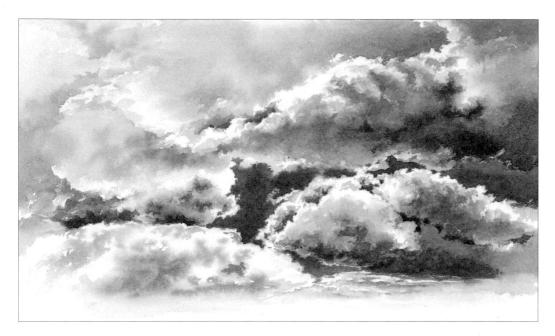

Stormy sky A

The artist began this study of a stormy sky by dampening the paper with clean water and dropping in a very pale grey colour, allowing it to spread of its own accord. She then blotted off paint in some areas with a paper towel to reveal the white of the paper before adding the mid- and dark greys and the deep blue of the sky, wet into wet.

Poppies ▶

Watercolour is a wonderful medium for painting translucent subjects such as flower petals. Following the light to dark rule, the artist began by putting down the very pale yellowy green colour that is visible in the background and around the edges of the flowers. She then gradually applied more layers of colour to build up the density of tone on the petals and make the flowers look three-dimensional, taking care to allow some of the first very pale washes to show through in places. Note how paint has been scraped off to create the striations in the petals and delineate the petal edges: using the white of the paper in this way adds "sparkle" to the image. Tiny touches of opaque yellow gouache give the flower centres and stems solidity, without destroying the translucency of the painting as a whole or the balance between the two media. Careful planning and observation of the light and dark tones have resulted in a fresh and spontaneous-looking study of a perennially popular subject.

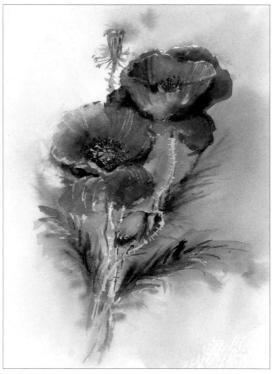

Making marks

Although artists are, by definition, inventive and apply watercolour paint with a variety of tools in order to create as wide a range of marks as possible, a brush is still the most basic and the best tool for the job. There are so many different brushes on the market that it seems as if there is a shape and a size to cover every eventuality, and it is easy to get carried away and buy a lot of brushes that you will rarely, if ever, use. With a little practice, however, you will find that you can get a remarkable range and variety of marks from a single, carefully chosen brush simply by altering the way you hold it and apply it to the paper.

A good first brush is a round, soft-haired (preferably sable) watercolour brush. This is probably the most widely used and versatile type. A medium round brush (say, no.8 or no.10) is a good, general-purpose brush, as it holds sufficient paint to make washes but also comes to a good point for fine detail work.

The conventional, and perhaps the most obvious, way to hold a brush is to hold it in the same way as you would a pen or a pencil, but that is by no means the only option.

Holding the brush with four fingers on one side of the barrel and your thumb on the other and pushing or pulling it quickly sideways will leave a broken smear of paint that is perfect for depicting texture and is totally unlike the mark made when using the point of the brush. These marks can be long or short; the density and spread of paint depends on the speed of the stroke.

Holding the brush vertically allows you to make a stabbing action, which results in a series of individual marks. You can vary the size of the marks by altering the amount of pressure you apply and the speed at which you apply it. The amount of pressure that you apply also has a marked effect. Increasing the amount of pressure that you apply, so that more of the sable hair comes into contact with the support, increases the width of the stroke.

A flat or a mop-shaped brush will result in a completely different range of marks. Experiment with different brushes to find out what you can achieve.

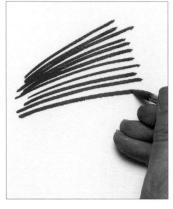

Strokes of an even width

To create strokes of an even width, use the tip of the brush and apply a steady pressure. Apply more pressure to increase the width of the line. For short strokes, you may find it helpful to rest your little finger on the paper surface as a balance, but take care not to smudge any wet paint if you do this.

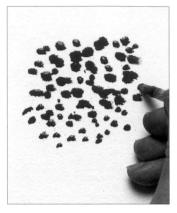

Dots

A stabbing or stippling creates a series of dots or blob-shaped marks. Holding the brush in an upright position helps to speed up the process and make it more controllable.

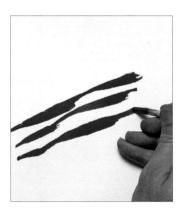

Strokes of varying widths

Varying the amount of pressure you apply also varies the width of the brushstroke, resulting in expressive calligraphic marks.

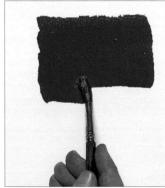

Broad washes

To make a wash that covers a wide area, use the side of the brush, rather than the point, and apply even pressure as you make the stroke.

Tip: Load your brush with plenty of paint. Using too little paint will mean that you run out quickly, often in mid mark. The amount of paint delivered to the support should come as much from the pressure applied as from the amount of liquid held within the brush fibres.

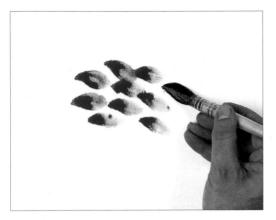

Brush shape

Pressing the brush to the paper surface without moving it results in marks that reflect the shapes of the brush.

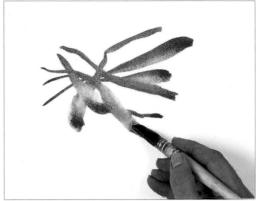

Thick and thin

Provided your brush holds a point well, you can create marks that vary greatly in thickness by applying more or less pressure.

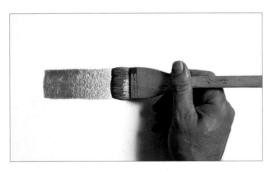

Quick washes

A Japanese-style hake brush holds a large amount of paint, and this makes it easy to lay flat washes. This is a good choice of brush if you need to cover a large area with paint.

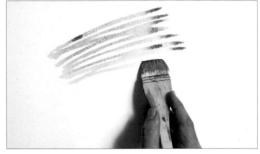

Thin lines

Used on its edge and with a light touch, even a large flat brush can be made to make delicate brush marks. Practise until you get a feel for the amount of pressure needed.

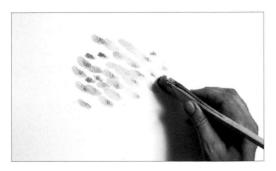

Uniform pattern

Using even pressure and the corner of the brush to dab or stipple paint on to the support will result in a series of uniformly shaped marks.

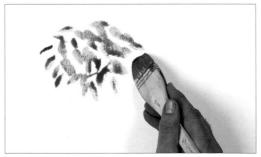

Varying the texture

Using a similar stippling action while varying the pressure and the angle at which the brush is held will create a loosely textured area, made up of marks of different shapes.

Washes

A wash is the term used to describe the process of applying watercolour paint in a single layer. There are three kinds of washes – flat, gradated and variegated (which is really a variation on a gradated wash). Although the technique is broadly the same way in all three cases, the results look very different.

Washes are among the most fundamental of all watercolour techniques. Sometimes washes are applied over the whole of the paper, and sometimes they are used over only selected areas. It is very rare for a painting to be composed entirely of washes, but as a wash of one kind or another is very often the first stage in producing a watercolour, it is well worth taking the time and trouble to master the technique. It will stand you in good stead for all your subsequent work and is an essential first step in getting used to manipulating paint on paper.

A flat wash is, as the name implies, a wash that is completely even in tone. All pictures need some blank and uncluttered areas, so flat washes are necessary on occasions, either to provide a base for the rest of the painting or as "breathing spaces" that allow the viewer's eye to rest. Flat washes can be particularly useful in abstract, or semi-abstract, work. In representational work, however, too many flat washes will lead to a dull and uninteresting painting. A flat wash contrasts well with many of the techniques used to introduce texture into watercolour paintings, such as spattering and stippling, as well as with other media, such as pastels, inks and coloured pencils.

Gradated and variegated washes are both designed to give some variety of tone. Like the flat wash, both are normally used in conjunction with other techniques. Both gradated and variegated washes are particularly useful in landscape painting.

Tip: It is difficult to mix two washes that are identical in tone, so always mix more wash than you think you will need, so that you don't have to stop halfway through a painting to mix more, then find that you cannot match the tone.

Flat wash

A well laid flat wash should show no variation in tone. Having said that, however, the kind of paper you use does have an effect and it is worth experimenting so that you know what results you can expect.

Work smoothly and confidently, without hesitation. Never go back over an area that you have already painted or the tones will be uneven. Work with your drawing board flat, or angle it slightly to help the paint flow down the paper. Use a large round-headed brush that holds a lot of paint, so that you can work quickly without having to re-load the brush.

1 Using a large wash brush, mix a generous amount of wash (here, sap green was used). Working from left to right, lay a smooth stroke of colour across the paper.

2 Quickly re-load your brush with more paint. Pick up the pool of paint at the base of the first stroke with your brush and continue across the paper, again working from left to right.

3 If you find you've got too much paint at the base of the wash, dry your brush on tissue paper and run it along the base of the wash to pick up the uneven streaks.

The finished flat wash

The wash has dried to a flat, even tone with no variation or visible brushstrokes.

The fewer strokes you use, the flatter the wash will be – so use a large brush if you want to cover the whole paper.

Gradated wash

A gradated wash is painted in a similar way to a flat wash, using a large brush and brushstrokes that dry evenly without leaving any streaks, but it shows a variation in tone. More water is added to the wash as you work down the paper so that the colour gradually gets lighter. Alternatively, you can add more pigment to the wash so that it gradually becomes darker in tone.

A gradated wash is often used to paint skies which, because of the effects of aerial perspective, are usually darkest at the top of the painting and paler towards the horizon.

You can also use a gradated wash to make one side of your subject darker in tone than another; the dark side looks as if it is in shadow, and this helps to make your subject look three-dimensional. Transitional gradations such as this are excellent for painting curved surfaces, such as glass bottles, oranges and domed roofs.

1 Lay the first stroke of colour as for a flat wash, working from left to right with smooth, even strokes.

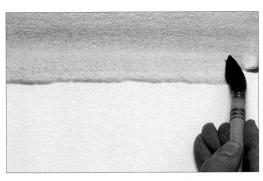

2 Add more water to the wash to make a paler tone and continue to work across the page from left to right.

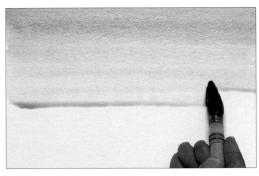

3 Continue as before, adding more water to the wash with each stroke so that it gets lighter as you move down.

As more water is added to the paint mixture, the colour virtually disappears.

The finished gradated wash

In the final wash, the colour has paled from a strong tone at the top to almost nothing at the base.

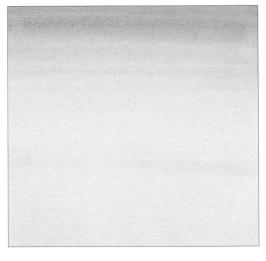

Practice exercise: Landscape using flat and gradated washes

Although washes are among the most fundamental of watercolour techniques, they can be used as the basis for simple little studies that you can be proud to hang on your wall.

This exercise is based around using flat and gradated washes to establish the planes of an imaginary landscape scene. The simple detailing that is added on top of the washes – the trees and the distant farmhouse – create texture and add visual interest to the painting.

You could easily adapt this exercise to create an imaginary landscape of your own. Choose colours for the underlying washes that are appropriate to the main subject of the painting – perhaps warm yellows and greens for a woodland scene, or blues for a seascape.

Using a 2B pencil, sketch the main shapes of the subject – in this case, the foreground path, the house and trees in the middle distance, and the tree-covered hills in the background.

2 Using a large mop brush, dampen the whole of the sky area with clean water. As soon as you have finished, lay a gradated wash of cerulean blue across the top of the sky.

Materials

• 2B pencil

Reference sketch

- 140lb (300gsm) rough watercolour paper, pre-stretched
- Watercolour paints: cerulean blue, yellow ochre, cadmium lemon, cobalt blue, viridian, raw sienna, Payne's grey, ultramarine violet, neutral tint, light red, cadmium red, burnt umber
- Brushes: large mop, medium round, fine round

A quick sketch made in situ outdoors,

when standing in front of your chosen

compositions and colour combinations

reference material to produce a more

detailed painting when you get home.

scene, is a useful way of trying out

to see what works best. Use it as

At the bottom of the gradated wash, where the colour has paled to almost nothing, put down a broad stroke of very pale yellow ochre. You may need to tilt the drawing board backwards slightly to prevent paint from flowing into the dry part of the paper, below the sky area.

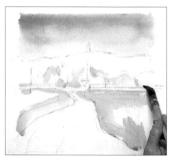

4 While the first wash is still damp, lay a stroke of cerulean blue across the top of the sky to intensify the colour. Leave to dry. Mix a pale green from cadmium lemon and cerulean blue and wash it over the foreground grass on either side of the road and the trees in the middle distance. Leave to dry.

5 Mix a bluish green from cobalt blue and a little viridian. Using a large mop brush, wash the paint over the tree-covered hill in the distance, taking care to leave the house untouched. You may need to use a finer brush to go around the outline of the house. Dot in the shapes of trees along the horizon and leave to dry.

6 Mix an olive green from raw sienna, cobalt blue and a little cadmium lemon. Brush the mixture over the trees and the foreground. Mix a pale mauve from Payne's grey and ultramarine violet and paint the road. Leave to dry.

Mix a dark green from neutral tint and viridian. Using a medium round brush, paint in the dark shapes of the trees. Don't worry too much about making the shapes accurate, just go for the overall effect. Leave to dry.

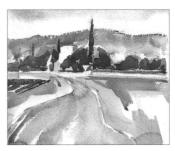

A Mix a strong wash of ultramarine violet and paint a broad stroke of colour below the trees, to the right of the farmhouse. Paint another to the left of the road to indicate the brightly coloured fields of layender.

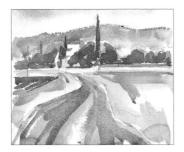

Paint the roofs in light red and the outline of the road sign in cadmium red. Note how these small touches of hot colour stand out against the cool blues and greens used elsewhere in the painting. Mix a wash of ultramarine violet and burnt umber, and paint over the foreground road.

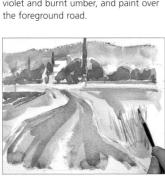

10 Mix a warm brown from cadmium lemon, raw sienna and a little cobalt blue. Paint in the fine foreground grasses, using a fine round brush.

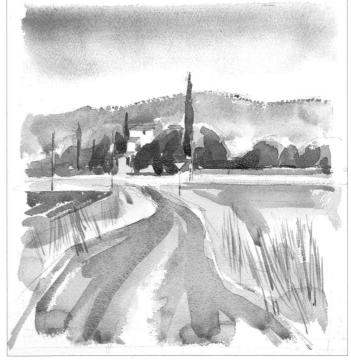

The finished painting

This painting effectively combines flat and gradated washes in a charming landscape that is full of character. Flat washes of colour on the hillside and winding foreground road, and a gradated wash of cerulean blue on the sky, establish the basis of the scene, while a few simple details — the broad strokes of colour for the trees in the distance, the sharp lines of the foreground grasses and the small touches of red on the roof in the middle distance — help to bring the scene to life.

Variegated wash on damp paper

A variegated wash is a variation on the gradated wash, but instead of adding more water, you gradually introduce another colour. When properly done, the transition from one colour to the next should be almost impercentible.

Some artists find it easier to dampen the paper first, using either a sponge or a Imop brush dipped in clean water. This allows the colours to blend and merge in a much more subtle way, without any risk of hard lines appearing between one colour and the next. You may need to allow the paper to dry slightly before you apply any paint: this is something you will learn with practice. However, if you prefer, you can work on dry paper.

Dampen the paper with a sponge dipped in clean water. Use plenty of water: you can let the paper dry a little before applying the paint, if necessary.

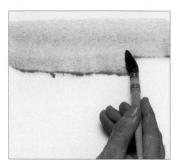

2 Using a large wash brush, lay a stroke of colour over the paper, working from left to right. The paint spreads more evenly on damp paper.

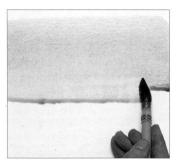

3 Clean your brush thoroughly and load it with a second colour.

Start laying this colour over the first.

Continue until the wash is complete.

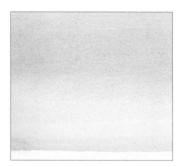

Variegated wash on damp paper In the finished wash, the colours merge together almost imperceptibly, with no obvious division between the two.

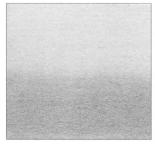

Practice exercise: Sunset using a variegated wash

A variegated wash is one of the most useful techniques for painting a sunset in watercolour. This simple exercise also shows you how to create a silhouette to turn the variegated wash into an attractive landscape painting.

Materials

- 2B pencil
- 140lb (300gsm) rough watercolour paper, pre-stretched
- Watercolour paints: ultramarine blue, cadmium orange, cadmium red, ultramarine violet, alizarin crimson, sepia
- Brushes: large round, small round

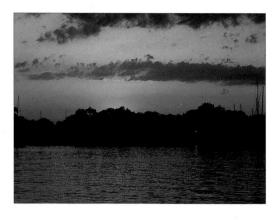

The original scene Striking colours, shimmering reflections and a bold silhouette – all the ingredients for a sunset with impact.

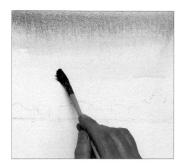

Using a 2B pencil, lightly sketch the outline of the silhouetted trees on the skyline. Using a large round brush, dampen the paper with clean water. Mix a wash of ultramarine blue and, again using the large round brush, lay a gradated wash over the top half of the paper, adding more water with each brushstroke so that the blue colour pales to almost nothing just above the horizon.

2 Mix an orangey red from cadmium orange and cadmium red. While the paper is still damp lay this colour over the lower half of the paper, allowing it to merge wet into wet into the very pale blue around the horizon line. Leave to dry. Dampen the paper again very slightly. Brush a broad stroke of the same orangey red mix across the middle of the painting (this will form the basis of the slihouetted land area) and dot it into the sky. Leave to dry.

Mix a warm purple from ultramarine violet and a little alizarin crimson. Using a large round brush, brush this mixture on to the sky to represent the dark cloud shapes. Add a little more pigment to the mixture to make a darker tone and paint the outline of the silhouetted trees. Using the same mixture, paint a few broken brushstrokes on the water for the dark reflections of both the trees and the land area.

A Mix a dark violet from ultramarine violet and sepia and darken the silhouetted area, adding a few fine vertical lines for the boat masts that stick up into the sky.

The finished painting

A two-colour variegated wash forms the basis of this colourful sunset, while a bold silhouette gives the viewer a strong shape on which to focus. Although the painting itself is very simple, the choice of rich colours and the careful placing of both the silhouetted land form and the reflections in the water combine to make an atmospheric little study.

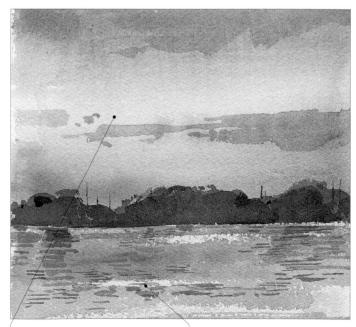

The initial blue wash merges almost imperceptibly with the rich, warm colours of the sunset.

The white of the paper shows through in places – a simple but effective way of implying water sparkling in the last rays of the setting sun.

Understanding tone

"Tone" is a word that you will often come across in art books: it simply means the relative lightness or darkness of a colour. The exact tone depends on the degree and quality of light falling on a particular object: if one side of an object is in shadow, it will be darker in tone than a side that is in direct sunlight. You can often see this clearly by looking at two adjacent sides of a building, where the front of the building is illuminated by the sun and the other forms one side of a narrow, shaded alleyway. Both sides of the building are made from the same materials, and we know they are the same colour, but the side that is in shade looks considerably darker.

But why is tone important in painting? The answer is that it enables you to create a convincing impression of light and shade, and this is one of the things that helps to make your subjects look three-dimensional.

This means that you have to analyse your subject and decide at the outset where the lightest areas of your painting are going to be. Because watercolour paint is transparent and you cannot lay a light colour on top of a dark one without the underlying colour showing through, you usually start with the lightest tones and build up to the darkest. Before you begin painting, therefore, it is often helpful to make a quick tonal sketch to work out where the light, medium and dark tones should be placed. Get the tonal structure right and much of the rest of your work will fall into place.

Tonal sketch ▼

When you sketch a single-colour subject, you need to show some differences in tone in order for it to look convincing. However, most images will still read convincingly when broken into only a handful of tones, as here. The side of the orange

Single-colour subject ▼

Even a single-colour subject, such as this strongly lit orange, consists of hundreds of slightly different tones. The human eye, however, can only make out the difference between a fraction of this number.

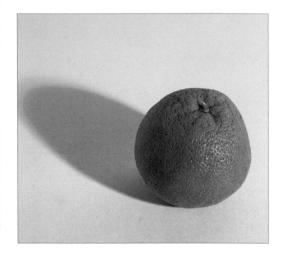

that faces away from the light, looks dark. The side that is directly illuminated by the light is a much lighter tone. In very strong light, the best way to convey this may be to leave highlight areas completely white and untouched by paint.

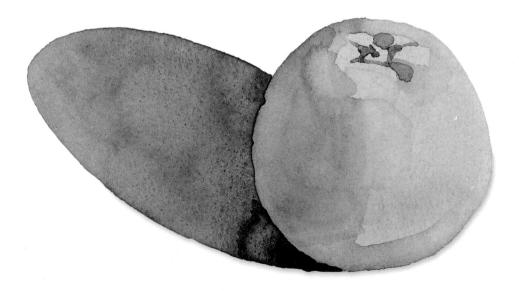

Translating colours to tones

But just how do you analyse the tones in your subject? We're used to describing things by their colour – red, blue, green and so on – but assessing tones is a different matter. One of the best ways to grasp the concept is try to imagine what a black-and-white photograph of your subject would look like.

Confusingly, colours that look very different (say, red and green) may turn out to be very similar in tone, while colours that you might expect to be light in tone (such as yellow) may actually be fairly dark, depending on how the light hits them. In addition, of course, you will find infinitely subtle gradations of tone across an object.

To make it simple, break down what you see into a few tones only - say, four or five - varying from white to black in stages. To get yourself more attuned to tones, set up some contrasting objects and, using numbers, place them in the correct order from light to dark. Time yourself. You will gradually train yourself to recognize tones more quickly. Start with objects that are strongly lit from one side, as this makes it easier to discern different tones, and gradually move on to more evenly lit objects as you develop your ability to assess tonal values. Another useful exercise is to make black-andwhite photocopies of colour photographs.

Multi-coloured subject A

When you're dealing with a subject that contains many colours, it can be difficult to work out which tones are light and which ones are dark. Try to imagine your subject as if it was a black-and-white photograph.

Colour converted to tone A

Note that different colours – for example, the oranges and the foreground lemon – are very similar in tone. The shaded sides of the bananas, which we know to be a lighter vellow than the lemon, look darker than one might expect.

Mixing tones

Once you've trained yourself to analyse tones, you need to apply this knowledge in your paintings. In pure watercolour, you make tones darker by adding more pigment (or black) and

lighter by adding more water. Practise doing this with a range of different colours so that you get better at judging how much more pigment or water to add.

Tonal strip ▼

Here, alizarin crimson watercolour paint (shown in the centre of the strip) has been progressively darkened by adding black and lightened by adding water.

Practice exercise: Tonal study in monochrome

This exercise trains you to assess tone by using five tones of the same colour to create a three-dimensional impression of blue and green children's play bricks. The image is painted in layers, working from light to dark, with each layer being allowed to dry before the next one is applied.

Note that the tone of the mixed washes always looks darker when it is wet than it does when it is dry. With practice you will learn to compensate for this by mixing your tones so that, when you first apply them, they appear to be a little darker or more intense than necessary.

Once you have done this exercise, try your own versions of it using other objects that you might have lying around the home. Books and plastic food containers are good choices as they are straight sided, so you can concentrate on the tones without having to worry too much about getting the shapes right.

Materials

- 200lb (425gsm) NOT watercolour paper, pre-stretched
- · 2B pencil
- · Watercolour pigment: burnt umber
- · Brush: medium round

The set-up

Set up your subject on a plain white background (a large sheet of paper will do), with a table lamp in front and slightly to the left of it. Spend some time looking at it in order to decide which tone each area is going to be. If it helps, make a quick pencil sketch and number each area from one to five, with one being the lightest tone and five the darkest

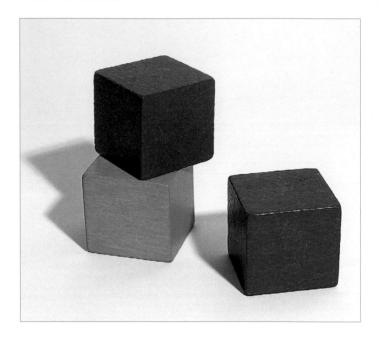

Using a 2B pencil, lightly sketch the bricks, taking careful note of where they overlap. Mix a thin wash of burnt umber (tone 1) and, using a medium round brush, paint all the brick shapes in this tone. This is the lightest tone.

2 Strengthen the wash slightly by adding a little more burnt umber pigment (tone 2). Leaving the lightest area (the side of the green brick) untouched, apply tone 2 over all the remaining areas. Even though only two tones have been used so far, the image instantly begins to have form.

Add a little more pigment to the wash to darken it further and brush it over those areas that are in deeper shadow (tone 3). The shape of the three bricks is becoming ever more apparent. The tone is deepened both by adding more pigment and by overlaying successive layers of colour.

4 Now mix up tone 4. As before, do not by make a new mix, but instead, add more burnt umber pigment to the previous one to make it darker. Carefully apply this tone along the lower edge of, and below, the topmost blue brick, where a small shadow is cast across the green brick.

5 Tone 5, the darkest tone (created by the deep shadow reflected in the slightly shiny surface), is evident on the left-hand side of the topmost brick. A similar dark tone can be seen on the right-hand side of the brick below. This is created by the reflection of the shadow from the right-hand brick.

 $6^{\,\mathrm{Put}}$ the finishing touches to the study by adding the cast shadow of all three bricks. Leave to dry.

The finished painting

Although this is nothing more than a technical exercise, the bricks look convincingly three-dimensional. This is entirely due to the fact that the artist paid very careful attention to the

relative tones and built up the density by overlaying several layers where necessary, even though he used only five tones of the same colour to make the painting.

The darker tones are created by adding more pigment to the wash and also by applying several layers so that the tone is darkened gradually. The lightest tone is created by means of a single wash of tone 1.

Understanding colour

Colour is an important element in most artistic endeavours, but in order to capture the subtle and elusive qualities of light seen in the best watercolours, a basic knowledge of colour theory is especially valuable. It will help you to understand why some colour mixes work better than others, and how to use the emotional effect of colours in your paintings.

Primary, secondary and tertiary colours

It was the Englishman Isaac Newton who first proved that white light is made by the mixing together of the seven spectrum colours of red, orange, yellow, green, blue, indigo (or blue/violet), and violet. This is known as additive colour mixing, because the "adding" together of the seven spectrum colours results in white light.

Pigment colours, however, behave in a different way. Mix together a similar range of pigment colours and the result is an almost black, mud-coloured mess. This is because every time you mix one pigment colour with another, the resulting colour is always duller and less pure than the parent colours. The more colours that are mixed together, the less pure the resulting colour will be, and the darker the resulting mix. If the three primary colours are mixed together, all the light waves are absorbed from white light, ultimately resulting in black. In other words, you subtract light and so this is known as subtractive colour mixing.

The classic diagram for explaining colour theory is the colour wheel, which illustrates the relationships between the different colours. Red, yellow and blue are the three primary

pigment colours. These can only be manufactured: they cannot be mixed by combining any other colours. They are also sometimes known as the "first" or "principal" colours.

Mixing equal amounts of red with yellow creates a midorange; mixing yellow with blue creates a mid-green; and mixing blue with red creates a mid-violet. These are known as the secondary colours.

Mixing a primary colour with an equal amount of the secondary colour next to it results in six more colours, which are known as tertiary colours. These are red-orange, orange-yellow, yellow-green, green-blue, blue-violet, and violet-red. The quality and intensity of these tertiary colours can be extended almost indefinitely, not only by varying the proportion of the primary and secondary colours used in the mix, but also by varying the amount of water added to lighten them.

However, it is important to remember that there are many different versions of the three primary colours, and your choice of primaries therefore dictates the kind of secondary and tertiary colours that you can mix.

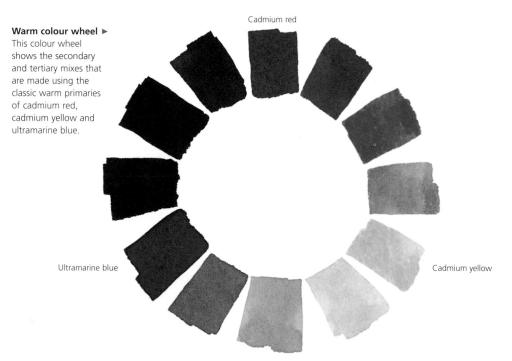

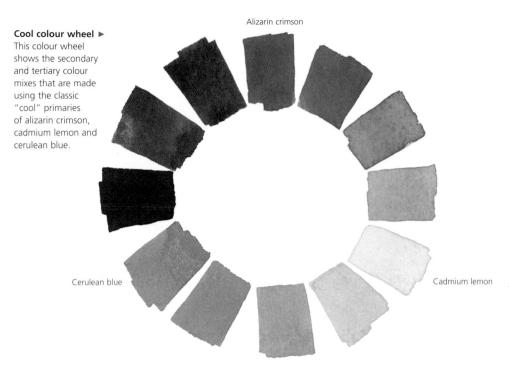

The language of colour

There are several terms relating to colour that you may come across in art books and magazines. It is important to be clear about the meaning of each.

A hue is simply another name for a colour. Red, purple and yellow are all hues. Two different reds might be described as being close in hue, while yellow and blue are different hues. There are many different versions (or hues) of the primary reds, yellows and blues, and the quality of the secondary and tertiary colour mixes depends very much on which of the primary versions you use.

A tint is made when white is added to a colour, or, in the case of pure watercolour, clean water. The opposite of a tint is a shade. This is made by making the colour darker, either by adding black or a little of its complementary colour. When you make a shade, the colour should not change dramatically in hue.

Mixing from different primaries ▶

The primary phthalocyanine blue is mixed with two versions of primary red, cadmium red (left) and alizarin crimson (right), to create two different violets.

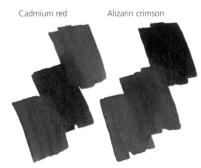

Phthalocyanine blue Phthalocyanine blue

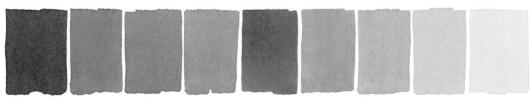

Shades Hue Tints

Colour temperature

All colours are described as being either warm or cool. We think of red, orange and yellow as being warm colours; these are found on one side of the colour wheel, opposite the so-called cool colours of violet, blue and green. However all colours, regardless of their position on the colour wheel, have either a warm or a cool bias. For example, blue is a cool

colour and red is a warm colour, but you can have a warm blue or a cool red. If a red has a blue bias, it is described as cool; if a red has a yellow bias, it is described as warm.

In order to be able to mix a full range of colours, you need to include both warm and cool variants of at least the three primaries in your chosen palette.

Warm and cool primaries ▶

This illustration shows the classic warm primaries (top row) and the classic cool primaries (bottom row).

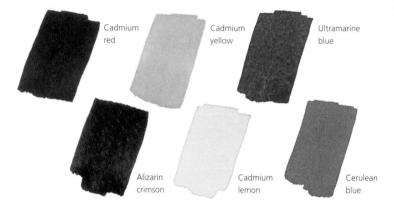

Modern paint technology, however, has meant that paint manufacturers now have primary reds, blues, and yellows that display very little or no warm or cool bias. These are the perfect primaries which, in theory, make it possible to mix a full range of colours from just three.

Colour temperature is an important part of colour mixing. Those primary colours that have a bias towards one another

on the colour wheel invariably make more intense secondaries when mixed. Primaries that lean away from each other result in muted secondaries.

Colour temperature is especially important when you are trying to create the illusion of depth. Warm colours are perceived to advance while cool ones recede, so objects painted in a warm colour seem to be closer to the viewer.

Intense and subdued secondary mixes ▶

Secondary and tertiary mixes are either intense or subdued, depending on the primary hues used to create them.

Here, ultramarine blue, which has a red bias, is mixed with cadmium yellow, which also has a red bias. This places them further apart on the colour wheel and results in a subdued secondary.

Phthalocyanine blue, on the other hand, has a yellow bias, and this results in an intense secondary when mixed with cadmium lemon.

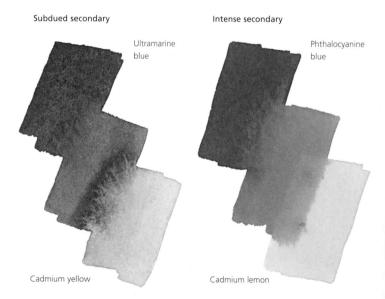

Colour contrast

Colours that fall opposite each other across the colour wheel – such as orange/blue, yellow/violet and red/green – have a special relationship and are known as complementary pairs. When they are placed next to each other in a painting, complementary colours create vibrant colour contrasts and have the effect of making each other appear more intense than they really are.

This is due to an effect known as "simultaneous contrast". If you stare at an area of green and then look away to a white surface, you will see a red after-image – red being the complementary of green. If red is placed next to a green area, it will be visually intensified by this red after-image. Likewise, the green would be intensified by the green after-image from the red. This effect can be used to add intensity to your work.

Complementary pairs ▶

These special colour pairings seem more intense when placed next to each other, but they neutralize each other when the paints are physically mixed together.

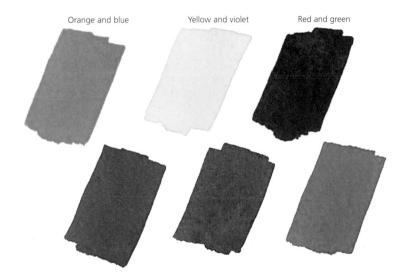

Mixing complementaries

If a little of one complementary colour is added to another, it subdues the recipient colour, knocking it back but without dulling it in the way that adding black would. If more of the colour's complementary is added, the result (depending on which complementaries are used) is a range of browns and greys, known as neutral colours. The advantage of mixing neutral colours in this way, rather than by adding black, is that the mixes look much fresher.

If you look at a colour wheel, you will see that regardless of their position all complementary pairs are, to a greater or lesser extent, composed of all three primary colours. When you mix equal amounts of all three primaries together, the result is a dark grey – almost black. However, by carefully managing the relative amounts of the three primaries that enter the mix, you can create a wonderful range of subtle, neutral mixes that echo those found in the natural world.

Mixing neutral greys ▼

Neutral greys and browns are made by mixing together two complementary colours. Here, progressively larger amounts of viridian green are added to alizarin crimson, resulting in a dark grey. A range of grey tints is then made by adding increasing amounts of water.

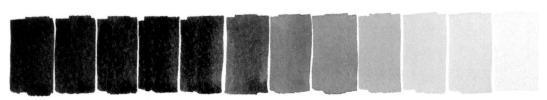

Colour harmony

Using harmonious colours that work well together creates a distinct feel or mood, and this adds immeasurably to the success of a work. This is especially true if you are trying to depict a specific season of the year or time of day, or if you are trying to show how a subject has been lit, for example, a still life bathed in candlelight or a figure lit with harsh mid-day light.

As the colour wheel below shows, there are many different ways of achieving colour harmony. With practice you will find that your instinct is the best guide: if something looks right, then it is right. However, a little basic theory about colour harmony will set you on the right path.

Different types of colour harmony ▼

Complementary harmony is created by using those colours that fall opposite each other on the colour wheel. Triad harmony is achieved by using the colours found at the angles of an equilateral triangle, superimposed at any position over the colour wheel. Using an isosceles triangle will point to the colours to form a split complementary, while using a square or a rectangle will produce tetrad harmonies. Alternatively, you can create harmony by using those colours that have one primary in common or are close to each other on the colour wheel. These are known as analogous colours.

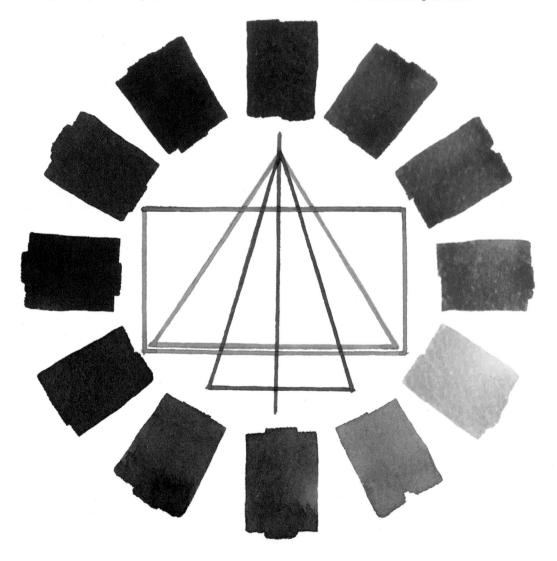

Tone and optical mixing

Traditional watercolour technique relies on one transparent wash being laid over another in such a way as to modify or consolidate the initial wash without necessarily obliterating it. It is, however, easy to overdo these wash layers so that the image and the colours look dull, lacking the sparkle and elusive inner light for which good watercolour is renowned.

Try to think ahead when planning your work, and aim to use no more than three layers of wash at the most. Working on the light to dark principle, the first washes would include the lightest tones and colours, the second layer the mid-tones and colours, and the final layer the darkest ones. As with all best laid plans, of course, this is not always possible, but it is a useful discipline to keep in mind. This is one of the reasons why the ability to assess tonal values is such an important part of watercolour painting.

Building up colour density ▼

Colour density can be built up by overlaying washes. This illustration shows three layers of the same colour, though the same principle holds true when you apply different colours on top of each other.

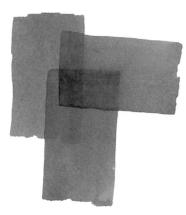

This lavering technique can also create colour mixes that are impossible when certain colours are mixed together physically. Physically mixing any two complementary colours together will result in the chosen colours being neutralized and, depending on the amounts used, being turned into a brown or a grey. However, you can mix these colours optically by applying a transparent wash of one colour over a dry wash of the other. This retains the integrity of both washes; a certain amount of the lower wash colour will show through the upper wash, modifying it. Another name for this type of colour application is broken colour. It can provide both texture and interest to those areas of a work where the colour is intrinsically flat and featureless, as well as being used to depict difficult subjects consisting of complex colour variations, such as foliage, water or extreme weather conditions.

Optical mixes ▼

When one wash is applied over another, wet on dry, the two colours mix optically to produce a third colour. These optical mixes look crisp and clean, as the colours retain their integrity.

Physical mixes ▼

When colours are mixed physically, the resulting colours look duller than their optical counterparts. This is true regardless of whether the colours are mixed wet into wet (left) or wet on dry.

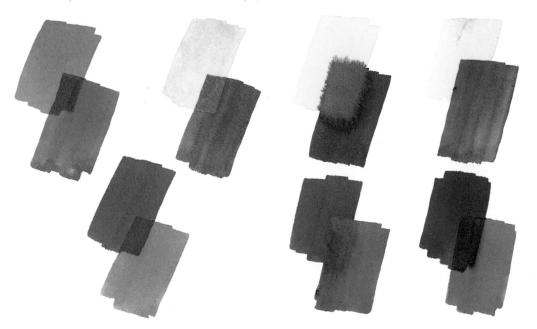

Practice exercise: Overlaying colours

In this exercise, colours are overlaid both to build up density of tone and to optically "mix" colours on the paper. Because watercolour paint is transparent, some of the colour of your initial wash will show through any subsequent washes, modifying their appearance. The only way you can be sure of the effect is to practise on a piece of scrap paper in advance. Remember that watercolour always looks lighter when it is dry, so you must wait until your practice piece is completely dry before deciding whether you've got the colour you want.

Materials

- 140lb (300gsm) NOT watercolour paper, pre-stretched
- 2B pencil
- Watercolour paints: cerulean blue, lemon yellow, yellow ochre, burnt umber, mauve, alizarin crimson, cadmium yellow
- Brushes: large round, fine round, mop
- Sponge

The set-up

When setting up a still life, choose objects of different shapes and sizes. The elongated shape of the pear and the rounded swede (rutabaga) used here give interesting visual contrasts. In terms of their colour, the same underlying green occurs on both, giving unity to the still life, while the red coloration on the swede complements the green, making it more exciting.

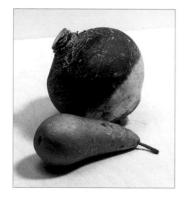

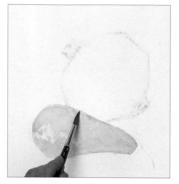

Lightly sketch the pear and swede.

Mix a bright green from cerulean blue and lemon yellow, and brush over the pear, leaving highlights untouched. Dot paint on to give an uneven texture.

Tip: When drawing fruit, work out the position of the stem and the base and draw a line between them to help get the angle of the fruit right.

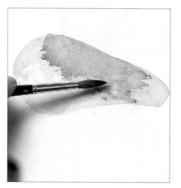

3 Mix a dark brown from yellow ochre, a little burnt umber and a touch of mauve. Using the side of the brush, brush this mixture unevenly over the pear, leaving gaps in places so that some of the first green wash is visible. The brown mixture is transparent, hence its appearance is modified by the underlying bright green. The two colours on top of each other look like a dull, mottled green.

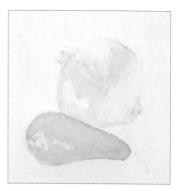

2 Add more cerulean blue to the mixture and more water to make it very dilute, and brush it unevenly over the top half of the swede, again leaving some gaps. You have now established the underlying colours of both the pear and the swede. These colours will be allowed to show through in parts of the finished painting, but they will also influence any colours that are laid down on top of them, creating mixes that could not be achieved in the palette.

A Mix a dull purple from mauve with a little burnt umber and brush it over the swede, making the top lighter than the bottom by adding more water. As on the pear, keep the texture and density of tone uneven by dotting more paint on in places. While the paint is still wet, build up the colour by touching more paint into selected areas so that it spreads wet into wet and you do not get any hard-edged shapes.

5 Mix a dilute wash of yellow ochre and brush it over the lower half of the swede, adding more pigment as you work down so that the base is darker. While the paint is still wet, brush a line of the green used in Step 1 between the two halves of the swede.

Gusing the same mixture as before, continue building up tone and depth on the purple half of the swede, applying the paint unevenly to create interesting textures. Using the same dark brown mixture as in Step 3, put a few spots and blemishes on the pear.

Mix up a very dilute wash of alizarin crimson. Using a small sponge, dab it on to the purple half of the swede. Crimson and green are complementary colours, so using the two together in the picture immediately gives it a lift. Leave to dry.

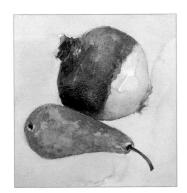

Mix a warm orange from alizarin crimson and cadmium yellow. Using a large mop brush, brush this mixture carefully on to the background; you may need to tilt the board to prevent paint from running over the pear or swede. Mix a dark brown from burnt umber and mauve and, using a fine round brush, paint the pear stem.

The initial green washes have modified the colour of subsequent layers, creating subtle optical mixes that are more effective than a single, solid wash could ever be. Applying several layers of the same colour (as on the swede) allows you to build up the tone gradually.

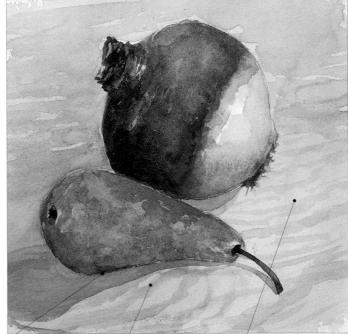

The shadows under the pear and swede anchor them to the surface and make the still life look more three-dimensional.

The "woodgrain" is painted using a more pigmented version of the background colour plus a little mauve.

The background colour harmonizes with the pear and swede but is sufficiently different to allow them to stand out.

Wet into wet

Working wet into wet means exactly what it says — applying wet paint to wetted paper. When you do this, the paint spreads outwards in soft-edged blurs, and the wetter the paper, the further the paint spreads. You can apply paint either to paper that has been dampened with clean water or on top of a wash that has not yet dried, creating interesting colour mixes. Paint will not spread into any areas that are completely dry.

Dropping gorgeous, rich colours on to wetted paper is an exhilarating experience, as you can never predict exactly what will happen or how far the paint will spread on the paper. For many people, that unpredictability is part of the charm of watercolour painting.

Colours that have been applied wet into wet always look lighter when they dry than they do when they are first put on. With experience you will learn to compensate for this by using stronger, more pigmented washes.

The wet-into-wet technique is excellent for cloudy skies, distant trees and woods, and atmospheric effects, such as fogs or storms. However, a picture painted entirely

wet into wet would look very blurred and indistinct. Try to keep a balance between wet-into-wet areas and sharper, more clearly defined sections. It is particularly important not to make the foreground too blurred. The soft-focus effect of wet into wet is normally best reserved for distant parts of a scene where you do not want a lot of sharp detail. When you apply paint on top of wet-into-wet washes that have dried, make sure you allow the underlying, diffuse effect of wet into wet to be seen in places, otherwise you will lose the character of the technique.

On very damp paper ▲
The paint spreads far beyond the line of the brushstroke.

On moderately damp paper ▲ The paint still blurs but it does not spread so far.

On almost dry paper ▲
The paint barely spreads beyond the brushstroke.

Practice exercise: Still life painted wet into wet

With their wonderful markings and silvery undersides, mackerel are beautiful fish to paint. This exercise allows you to practise controlling the degree of wetness on the paper. On the background and undersides of the fish, paint is applied to very damp paper so that it spreads freely. For the markings, the paint is applied to paper that is only very slightly damp. The paint blurs a little but the markings remain distinct.

Materials

- 2B pencil
- 140lb (300gsm) rough watercolour paper, pre-stretched
- Watercolour paints: Payne's grey, Delft blue, alizarin crimson, aureolin, viridian, raw sienna, light red, sap green, cadmium lemon
- · Brushes: large round

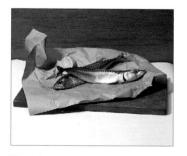

The set-up

Crumpled brown parcel paper provides a textured but simple background to this still life. Arrange the fish so that you can see both the markings and the silvery belly, and add a lemon for a touch of extra colour. Position a lamp to one side of your subject, so that it casts definite shadows.

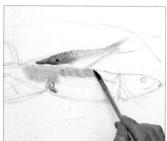

1 Using a 2B pencil, lightly sketch the still life. Using a large round brush, dampen the fish with clean water, leaving the highlights around the eyes and on the belly untouched and keeping within the outline of the fish. Mix a greyish blue from Payne's grey and Delft blue. Brush this mixture on to the damp areas so that it spreads.

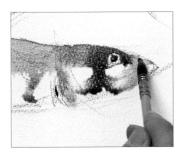

2 Add a little more Delft blue to the mixture and, using the tip of the brush, touch in the dark details around the head, again working carefully around the highlight areas.

While the first wash is still damp, brush alizarin crimson on to the belly of the foreground fish and the head of the background fish. It will merge with the underlying wash. Leave to dry.

Dampen the lemon and brush on a pale mix of aureolin. Mix a pale green and brush on to the shaded side of the lemon. Leave to dry. Dampen the background and brush on raw sienna.

5 While the background wash is still damp, add a little light red to the raw sienna and touch it into those areas of the background that you want to appear darkest in order to build up the tone and imply the creases in the paper. Leave to dry.

6 Mix a dark blue-grey from Delft blue, Payne's grey and a little alizarin crimson. Dampen the backs of the fish with clean water and brush the paint on to the darkest areas. Add more Delft blue to the mixture and, when the paper is nearly dry, paint the markings.

Dampen the darkest areas of the background and touch in more of the mixture used in Step 5. Paint the lemon segments in aureolin. Dampen the rest of the lemon and brush a mixture of sap green and cadmium lemon on to the right-hand side.

The subtle transitions of colour on the bellies of the fish and the background paper could only be achieved using the wet-into-wet technique. These areas contrast well with the dry applications of colour on the lemon and around the fish head.

Several layers of colour are applied to the background while the paper is still very damp. The paint spreads, creating soft-edged blocks of colour.

For the markings, the paint is applied to paper that is only slightly damp. It spreads enough to soften the markings, but not so far that they become blurred and indistinct.

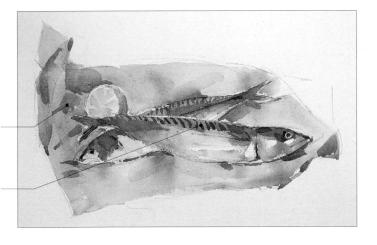

Masking

Often in watercolour, you want the white of the paper to represent the lightest areas of your subject. Sometimes you will need to protect the white areas so that they don't get splashed with paint accidentally. Masking is the way to do this. The masking technique can also be applied over a coloured wash. When a

second wash is applied over the mask, the mask can then be removed to reveal the underlying base colour. This technique is used to give an aged and weathered look to paths, walls and painted timber.

There are many subjects that might benefit from masking, from whitewashed buildings and structural objects, such as ladders, to water foam splashing against a rock, tiny flowers, and even the delicate tracery of lace and spiders' webs.

There are three methods of applying masking. The one you choose will depend largely on whether you need to mask straight lines, delicate lines or curved shapes, or larger areas.

Masking tape

Masking tape is useful for masking straight-edged shapes, such as buildings, although it can also be cut or even torn to create more random effects. Make sure you use the low-tack

variety of masking tape, otherwise you may find that you damage the surface of your watercolour paper when you attempt to remove it.

Place the masking tape on the watercolour paper, smoothing it down at the edges so that no paint can get underneath.

Apply a wash over the top of the masking tape and then leave it to dry completely.

3 Carefully peel off the tape (you may need to use the tip of a scalpel or craft or utility knife to lift the edge). The area underneath remains white.

Masking fluid

Masking fluid is useful when you want to mask out thin lines, such as grasses in the foreground of a landscape. You can also spatter it on to the paper for subjects such as white daisies in a meadow or the white foam of a waterfall. Always

wash the brush thoroughly with liquid detergent immediately after use, as it is almost impossible to remove the fluid from the bristles once it has dried; better still, keep old brushes specifically for use with masking fluid.

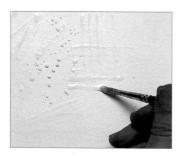

1 Using an old brush, paint masking fluid over the areas you want to protect. Leave it to dry completely.

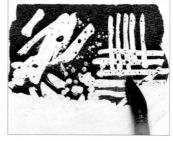

2 Apply a wash over the paper and leave it to dry completely.

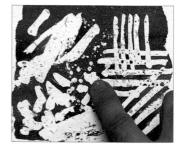

3 Using your fingertips, gently rub off the fluid. (You will find that it can be rubbed off quite easily.)

Masking film

Masking film (frisket paper) is used by draughtsmen and is available from most good art supply stores. It works best with large, clearly defined areas that you can easily cut around, such as hills or a pale-coloured building.

You need to use a very smooth watercolour paper or board so that the film has a perfectly flat surface to adhere to, otherwise paint may seep under the edges and ruin the effect. Alternatively, you could cut a paper mask and either hold it in position with one hand while you paint with the other, or fix it to your painting surface with low-tack masking tape. This is not advisable for fiddly, intricate details where you need the mask to be stuck down firmly, but if you need to protect, say, the sky area of a landscape while you spatter paint on to the land, then a paper mask is a good, low-cost option.

1 Cut a piece of masking film (frisket paper) to roughly the same size as your painting. Peel the film from its backing paper, position it on your underdrawing, and smooth it down with a soft cloth or piece of tissue paper to make sure it is stuck down firmly and smoothly.

 $2 \ \, \text{Using a scalpel or craft (utility)} \\ \text{knife, carefully cut around the outer} \\ \text{line of your subject, taking care not to} \\ \text{cut into the paper or board.}$

3 Slowly peel back the masking film from the area that you do not want to protect from paint (i.e. the area that you want to paint with colour).

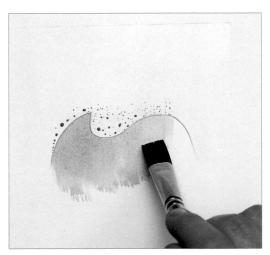

4 Apply a colour wash to the exposed paper, using a large round brush. Leave the wash to dry completely before you attempt to remove the masking film.

5 Check that the wash is dry, then slowly peel back the masking film from the unpainted area. Remove it in a smooth movement, so as not to tear the paper.

Practice exercise: Masking a white-patterned jar

This short exercise allows you to experiment with using both masking fluid (to mask out the sweeping curved lines and fine detail of the decorative jar) and low-tack masking tape (to mask out the straight-edged rectangle of paper on which the jar is placed). Painting around the pattern on the jar in order to leave the paper white would be a painstakingly slow and laborious process, and it would be very difficult to create such fine lines. Protecting the pattern with masking fluid allows you to work in a much more free and spontaneous manner.

Materials

- 2B pencil
- 200lb (425gsm) NOT watercolour paper, pre-stretched
- Watercolour paints: cobalt blue, ultramarine blue, Payne's grey, raw umber, dioxazine purple
- Brushes: old brush for masking, medium round, fine round
- Masking fluid
- · Low-tack masking tape

The set-up

Arrange your subject on a piece of coloured paper that harmonizes with it, and position a table lamp in front of and slightly to the right of the subject so that you get an interesting shadow.

1 Using a 2B pencil, lightly sketch the jar and its decorative pattern. Using an old brush and liquid rubber masking fluid, mask out any areas that you want to keep white and clear of paint. Rinse the brush thoroughly and allow the masking fluid to dry completely before moving on to the next stage.

2 With the design protected by the masking fluid, there is no risk of accidentally painting over the white areas. Mix a vivid blue from cobalt blue, ultramarine blue and a little Payne's grey. Using a medium round brush, wash this mixture evenly over the jar. Leave to dry.

3 Using the same blue paint mixture, work over the jar once again to strengthen the tone. Add more Payne's grey to the mixture when you paint the right-hand side of the jar, which is slightly in shadow. This darker tone helps to make the jar look realistically three-dimensional. Leave to dry.

4 Using your fingertip, gently rub off the masking fluid. It should come off easily, but if any of the masking fluid is hard to remove, use a soft kneaded eraser. Blow or brush any bits of loose masking fluid off the paper before continuing.

5 Using the same blue mixture used in Step 2, carefully paint in the detailing on the pattern – the outline of the flowers, the flower centres, and tiny brushmarks to indicate the bark of the branches. Leave to dry. Mix a mid-toned Payne's grey and brush over those parts of the white patterns that are in shadow. This helps to integrate the stark design into the painting and reinforces the three-dimensional feel.

Gusing low-tack masking tape, mask out the square of dark grey paper on which the jar is standing. Mix a warm grey from Payne's grey and raw umber and, using a medium round brush, paint in the rectangular shape. Do not flood on too much paint, as there is always a risk that some may seep under the tape and ruin the clean edge. Leave to dry.

Once the tape has been removed, complete the painting by adding the dark shadow cast by the jar using a pale mauve mixed from Payne's grey and dioxazine purple. The result is an

attractive little study that preserves the flowing lines and brilliant white pattern on the jar, without looking tight or laboured in its execution.

The brilliant white of the paper is preserved to the last.

The shadow anchors the jar on the surface.

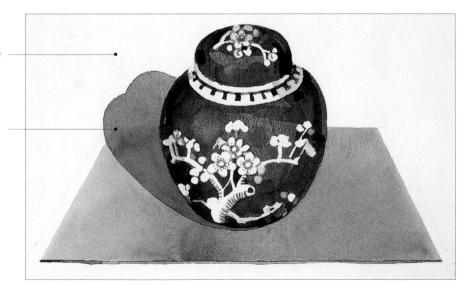

Resists

Resist techniques are based on the principle that wax and water do not mix. Wax repels water, so if there is wax on your watercolour paper, any watercolour paint that is subsequently applied to those areas will not adhere to the surface.

Wax can be applied in several ways. You can use a clear wax candle, coloured wax crayons or oil pastels to draw on to the support. Interesting results can also be obtained by brushing on furniture wax using a stiff bristle brush. The technique is similar to using masking fluid but, unlike masking fluid, a resist cannot be removed.

Since the wax remains on the support and will continue to repel any subsequent washes, you need to plan where and at what point you introduce the resist. It does not have to be applied to the paper at the beginning of the work; you can introduce it at any point by working over existing dry washes.

The technique is difficult to use in confined, detailed areas and is more commonly used to create broader areas of texture. The success of the technique depends on how much pressure you apply and on the type of surface on which you are working. On a smooth, hot-pressed paper, the wax takes to the surface in a uniform way, resulting in a more subtle, flatter effect. On a rough paper, the wax is picked up only on the "peaks" of the paper surface, resulting in the wash lying in the "troughs", producing a highly textured, speckled effect.

An interesting variation can be made by combining it with frottage. Frottage allows you to incorporate textures other than that of the watercolour paper into your painting. Place smooth, lightweight paper on a textured surface, such as a plank of wood, and rub on the wax. The wax will pick up the texture of the underlying surface and, once a wash has been applied, the pattern will be revealed.

Resist techniques are ideal for light sea waves and for broken textural effects for sand and shingle. These patterns can be applied as a drawing or as a fragmented layer of light colour. Try drawing the white petals of a daisy with a wax resist and then covering them with deep blue – the contrasting tones are quite startling.

Household candle

Using an uncoloured household candle as a resist is an effective and inexpensive way of creating large areas of texture on a painting. Be aware that you cannot remove the wax once it has been applied, so don't get too carried away!

1 Rub a household candle over the paper, presssing quite hard to ensure that enough wax is deposited on the surface of the paper.

Apply a watercolour wash. Note how the wax repels the water in the paint. Here a rough paper was used, creating a broken texture.

On smooth, hot-pressed paper

On smooth, hot-pressed paper, the wax can be applied more smoothly. As a result, when the watercolour wash has been applied, the effect is much more subtle.

Coloured wax crayon or oil pastel

With a coloured wax crayon or oil pastel, not only can you make finer, more linear marks which will remain visible in the finished painting, but it is also easier to see exactly where the

wax has been applied. This makes it less likely that you will apply too much of the resist that cannot then be removed, and it is a useful way to practise the resist technique.

1 Use the tip of the coloured wax crayon or oil pastel to draw in the areas where you want to apply the resist. Work slowly and in one smooth, continuous movement.

 $2 \ \mbox{Apply a watercolour wash over the top of the resist.} \\ \mbox{The fine coloured lines of the wax remain visible, even though the wash was applied over the whole surface.} \\$

Practice exercise: Using resists to create texture

In this exercise, a combination of oil pastels and watercolour is used to give tiny variations in tone across the surface of the fruits, revealing the dimpled texture. Resists are used both to add colour and to reserve the white of the paper. The colour of the oil pastels is rich and vibrant, and it shows through the lighter watercolour washes because the oil in the pastels acts as a resist and repels the watercolour paint. Candle wax is used to reserve the white of the paper for the brightest highlights.

Materials

- 200lb (425gsm) NOT watercolour paper, pre-stretched
- 2B pencil
- Watercolour paints: cadmium lemon, cadmium orange, burnt umber, sap green, Payne's grey, dioxazine purple
- Oil pastels: cadmium yellow, yellow ochre, deep orange
- Brushes: medium round
- Household candle

The set-up

Odd numbers of objects always seem to work better in a still-life composition than even numbers. Arrange the fruit to form a composition that is roughly triangular in shape, with the lemon angled to "point" towards the oranges.

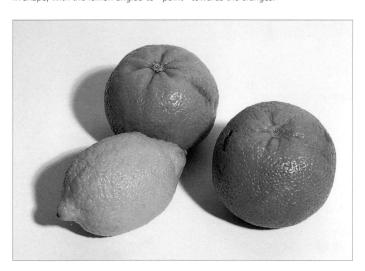

1 Using a 2B pencil, lightly sketch the outline of the fruits, looking carefully at their positions in relation to one another and at where they overlap. Scribble in the lighter yellow areas using a cadmium yellow oil pastel. Take care not to press too heavily, or the pastel will build up in the tooth of the paper to such an extent that there will be nowhere for the watercolour wash to adhere to the paper.

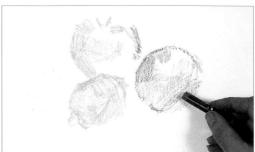

Using a clear wax candle, draw the white highlight on each orange and on the lemon; the wax will repel the watercolour paint, with the result that these areas will remain white in the finished painting. Develop the colours on the oranges and lemon using yellow ochre and deep orange oil pastels. As before, keep the pastel marks light and open so that they help describe and follow the contours of the fruit.

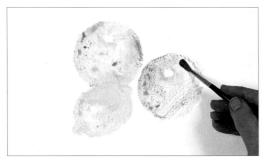

3 Brush on the lightest washes – cadmium lemon on the lemon and cadmium orange on the oranges. The paint gathers and puddles on those areas of the paper that are free of oil pastel and candle wax. Leave to dry.

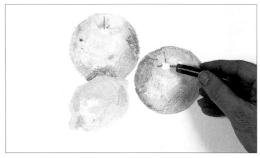

4 When dry, go back to the oil pastels to redraw areas and add colour and detail. Now that some paint has been applied, you can make this subsequent pastel work heavier, as it will not affect the washes that have been put down.

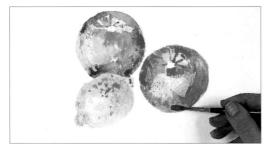

5 Using concentrated mixes of cadmium orange, cadmium lemon and burnt umber, paint the shaded sides of the fruits, and the areas where the stalks are attached, in order to make them look more rounded and three-dimensional. Allow the paint to puddle as before and leave to dry.

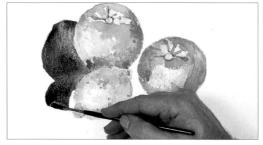

6 Mix a brownish green from sap green, cadmium orange and burnt umber and paint the point where the stalk is attached. Paint the shadow in Payne's grey and drop cadmium orange and dioxazine purple into the grey to hint at the colours reflected from the underside of the fruit.

This is a lively and spontaneous painting of a very simple still life. The oil pastel resists add both depth of colour and texture to the image, while the watercolour washes provide

smoother, calmer areas that act as an effective contrast. Even the white highlight areas have gained some texture from the candlewax resist.

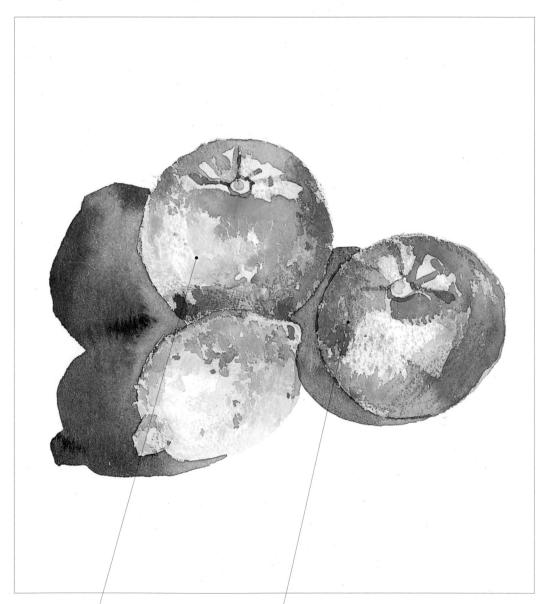

The bright highlighted areas of the fruits are reserved by using clear candle wax.

Yellow ochre and deep orange oil pastels convey the colours of the oranges and also repel the paint to create interesting textures.

Spattering

Spattering is an effective technique for creating texture in paintings. It consists of flicking paint on to the paper to create a random series of dots or flecks. It is done either by tapping a brush loaded with paint, so that drops of paint fall on the paper beneath, or by pulling back the bristles of a loaded brush with your fingers, so that paint droplets fly off.

You can apply spatter to either dry or wet paper, or even combine the two approaches in a single painting. They give very different effects. On a dry ground, the spatter doesn't blur, so this is a good technique for subjects such as old stone walls and pebbly garden paths, where you want the dots and flecks of paint to be crisp and sharp. On a wet surface, the spatter blurs and spreads, which can be useful for snow or foam-crested waves lapping against the shore.

The amount of water in the paint mixture affects the size of the spatter marks: the wetter the mixture, the larger the marks. Distance also plays a part: the further away you hold the brush, the smaller the marks and the wider the area that will be covered. Practise on scrap paper to find out how much pressure you need to apply and how far away from the paper you need to hold the brush in order to create the effect you want.

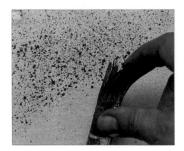

Pulling back the bristles
Load a stiff-bristled brush with paint
and gently pull the bristles back
towards you.

Spatter on a damp washApplied to a wet surface, the paint droplets blur and spread.

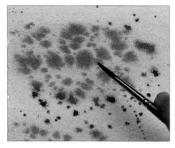

Tapping the brush
Load the brush with paint, hold it
horizontally over the area that you want
to spatter, and gently tap the handle.

Spatter on a dry washApplied to a dry surface, the paint droplets remain crisp and well defined.

Practice exercise: Beach with spattered pebbles

Spattering is the perfect technique for this pebbly beach scene. Make the foreground spatters slightly larger than those in the distance. The foreground pebbles appear larger because they are closer to the viewer, so this will help to create an impression of distance.

Materials

- 2B pencil
- 140lb (300gsm) rough watercolour paper, pre-stretched
- Watercolour paints: cobalt blue, raw sienna, light red, sepia, ultramarine violet, cadmium red, cadmium orange, Payne's grey
- Brushes: old brush for masking, large round, fine round
- Masking fluid

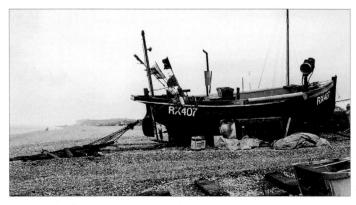

The original scene

You can almost feel the hard, crunchy texture of this shingle beach. Spattering the paint on to dry paper will create crisp dots of texture.

1 Using a 2B pencil, lightly sketch the outline of the boat and flags and the planks of wood that lie in the foreground of the beach scene.

2 Hold a piece of scrap paper over the boat to protect it and, using an old brush, spatter masking fluid over the beach. Leave to dry

3 Dampen everything except the boat with water. Brush pale cobalt blue over the sky. Brush a mixture of raw sienna and light red over the beach.

When the previous stage is dry, mix a dark brown from sepia, ultramarine violet and a little light red and paint the boat, adding more ultramarine violet for the stern. Use a pale version of the mixture for the planks and brush broad strokes of the same colour across the beach. Paint the flags in cobalt blue and the floats in a mixture of cadmium red and cadmium orange. Using a fine brush, paint around the lettering in Payne's grey.

Complete the picture by rubbing off the masking fluid. This is a delightful little scene of a beach at low tide. The spattering is subtle and does not detract from the painting of the boat, but it captures the texture of the hard, shingly beach very effectively.

These stripes of colour help to imply the ripples in the sand.

The spattering in the foreground contrasts well with the flat colour of the sky.

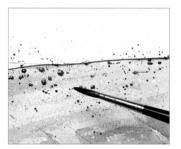

5 Mix a warm brown from raw sienna and sepia. Hold a piece of scrap paper over the boat to protect it and, using a fine brush, spatter the paint mixture over the foreground.

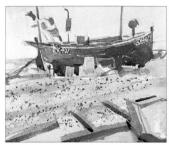

6 Add ultramarine violet to the mixture to darken it and continue spattering as before. Using the same mixture, darken the ropes tethering the boat and the planks. Leave to dry.

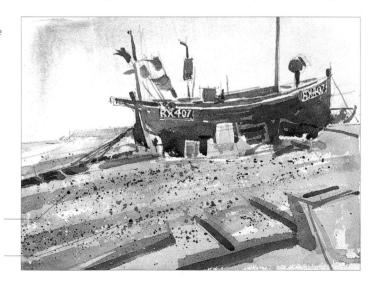

Stippling

Stippling consists of placing dots or blobs of colour on the paper. The technique is often used to create texture in a painting, but it can also be used to optically mix colours on the paper, as it was by the French Pointillist School, whose most famous exponent was Georges Seurat (1859–91).

The dots can be placed close together or further apart, depending on the effect you want to create. You can use either a specialist stippling brush, which is a short, stubby brush with hard bristles, or the tip of your normal painting brush. To create even stipples, dip an almost dry brush into a thick mix of watercolour paint. A wetter mix of paint will produce dots that are less sharply defined.

The technique

Load a stippling brush with paint and, holding the brush almost vertically, dab it on to the paper with short, sharp movements. Vary the amount of pressure to create dots of different weights.

The effect

A stippling brush creates areas of random texture that are perfect for subjects such as lichen-covered pebbles and stones.

Practice exercise: Fruits with stippled texture

Stippling is a great way of painting fruits with dimpled surfaces, such as the citrus fruits and avocado shown here. Use a fine brush and stipple darker tones on to the base colours of the fruits to convey the pitted hollows in the skin.

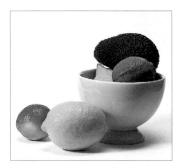

The set-up

When you set up a still-life exercise like this, position a table or anglepoise lamp to one side. The raking light will pick out the dimples on the fruit, making it easier for you to see where to apply the stippling, and will cast interesting shadows that make the subject look three-dimensional.

Materials

- 2B pencil
- 140lb (300gsm) rough watercolour paper, pre-stretched
- Watercolour paints: aureolin, yellow ochre, raw sienna, sap green, Payne's grey, ultramarine blue, burnt umber, ultramarine violet
- Brushes: fine-pointed old brush for masking, medium round, fine round
- Masking fluid

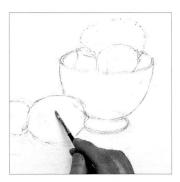

Using a 2B pencil, lightly sketch the outline of your subject. Using an old, fine brush, stipple masking fluid on any highlight areas on the left-hand side, where light hits the fruit. Leave to dry completely.

Tip: As you make your initial drawing, turn it upside down every now and then to check that you've drawn the ellipses of the bowl and the fruits correctly. Looking at the drawing upside down makes it much easier for you to see what you've drawn as simple geometric shapes, without being distracted by the subject matter.

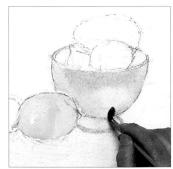

2 Mix two washes, one from aureolin with a little yellow ochre and the other from yellow ochre alone. Dampen the foreground lemon and bowl with clean water. Paint the lemon with the aureolin and yellow ochre mixture and the bowl in the plain yellow ochre.

Mix raw sienna with a little yellow or hre and, while the paper is still damp, touch this mixture on to the right-hand side of the bowl, which is in shadow. Add a little sap green to the mixture and brush it on to the shadowed side of the foreground lemon. Paint the lemon in the bowl with the aureolin and yellow ochre mixture used in Step 2. Leave to dry.

6 Strengthen the tone on the bowl by applying another wash of yellow ochre, leaving a white edge on the rim. Add a touch of burnt umber to the inside of the bowl. Leave to dry. Stipple a mixture of aureolin and yellow ochre on to the foreground lemon, adding burnt umber for the side that is in shadow. Stipple a mixture of sap green and Payne's grey on to the dark side of the avocado and the foreground lime. Leave to dry.

A Mix a pale green colour from sap green and aureolin. Wet the limes and the avacrado with clean water. While the paper is still damp, using a medium round brush, brush this mixture over the limes, leaving some white areas untouched where the light hits the fruits. Add some Payne's grey to the mixture and stipple it over the avocado. Leave to dry.

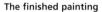

To complete the painting, rub off the masking fluid to reveal the brightest highlights. Next, paint the shadows by dropping a very pale wash of ultramarine violet and burnt umber

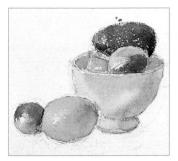

5 Mix a dark green from ultramarine blue and sap green. Using a fine round brush, stipple the mixture over the darker areas of the limes and leave to dry. Mix sap green with a little Payne's grey and wash this mixture over the right-hand side of the avocado and the shadowed underside of the lime in the bowl. Leave to dry.

wet into wet on to dampened paper. Random stippling conveys the texture of the fruits and contrasts well with the wet-into-wet washes used on the smooth china bowl

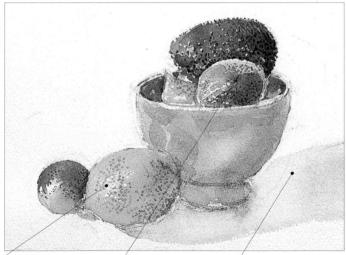

The brightest highlights are left unpainted, protected by masking fluid until the final stages.

Random stippling conveys the pitted surface of the fruits perfectly. The shadows help to anchor the painting and show that the subject is not floating in mid-air.

Drybrush

In the drybrush technique, paint is put on with a brush that is quickly skimmed over the paper, leaving the colour on the ridges of the surface but not in the troughs. As you might expect, the brush should be fairly dry. If either the paper or the brush is too wet, the indentations of the paper will quickly fill with colour. Keep a piece of kitchen paper close to hand so that you can dab off any paint that is too wet.

The drybrush technique is useful for subjects such as wood bark or ageing stonework, and for foreground grasses. Because drybrush work is often used in the final stages of a painting, to add texture and visual interest, it is a good idea to test your loaded brush on a piece of scrap paper before you use the technique in your almost completed work.

Using a round brush

Dip the brush in your chosen paint colour and, using your fingertips, squeeze out any excess paint so that the brush is almost dry and splay out the bristles. Drag the brush over the surface of the paper. It will make broken, textured marks.

Using a fan brush

A fan brush, in which the bristles are naturally splayed, allows you to cover a wider area of the paper.

Practice exercise: Lily with drybrushed leaves and buds

The drybrush technique is perfect for subjects with slightly broken textures, such as leaf forms. On rough paper, dragging an almost dry brush across these areas will give an immediacy and freshness to the painting.

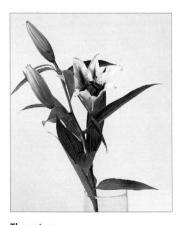

The set-up

Position your subject on a large sheet of white paper: this is a good way of practising the technique, without having to worry about painting a complicated background. Turn the lily around until you find an angle that allows you to see the inside of the half-opened flower.

Materials

- 2B pencil
- 140lb (300gsm) rough watercolour paper, pre-stretched
- Watercolour paints: aureolin, sap green, yellow ochre, rose madder deep, ultramarine blue, cadmium orange
- Brushes: medium round, fine round
- Kneaded eraser
- · Kitchen paper

Tip: If you find it hard to get the shape of the half-open lily flower right, try to think of it as a simple geometric shape – such as an inverted cone – on top of which you superimpose an ellipse and the triangular shapes of the individual petals. Taking an objective approach to your subject can be helpful when dealing with irregular shapes.

Using a 2B pencil, make a light sketch of the lily. It is important to count the number of petals and leaves beforehand, and to work out the position of each one carefully.

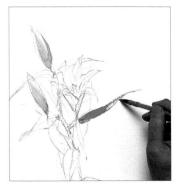

2 Mix a yellowish green from aureolin, sap green and a little yellow ochre. Holding an almost dry brush vertically, paint the buds. Add more sap green and paint the leaves in the same way.

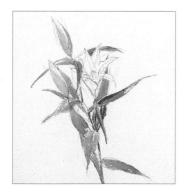

Continue putting in the leaves in the same way. Use a slightly darker version of the same mixture for the stalks and one edge of some of the main leaves, so that the painting starts to take on a three-dimensional quality.

4 Mix a dark pink colour from rose madder deep and drybrush it on to the petals of the open lily flower.

5 Mix a very pale ultramarine blue and paint the shadow on the underside of the petals. Paint the stamens in cadmium orange. Using a fine round brush, stipple tiny dots of the dark pink colour inside the petals.

6 Mix a dark green from ultramarine blue and sap green and, using a fine round brush, drybrush this mixture over the leaves to paint the veins. Paint the same colour on the unopened buds to delineate the individual petals.

Rub out some of the superfluous pencil markings with a kneaded eraser and the painting is complete. Working on dry paper, with an almost dry brush, is the perfect way to delineate the fine leaf forms and the lines that separate the petals of this lily. The technique has also allowed the texture of the paper to show through, creating a painting that is full of visual interest.

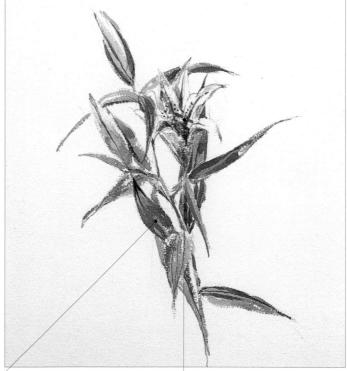

The drybrush work on the leaves has created an interesting texture.

Warm and cool colours help to make the lily look three-dimensional: the warm rose advances, while the cooler purple recedes.

Sponging

Sponges can be used to lift off unwanted colour while the paper is still damp (for example, to wipe out clouds in a dark sky) and instead of a brush to dampen paper. However, the main purpose of sponging is to produce texture.

Natural sponges are more randomly textured than synthetic ones, which have a very regular pattern. Experiment with different kinds to find out what kind of marks they make. You can sponge on to dry or damp paper. On damp paper, the marks will merge together, while on dry paper they will be more crisply defined.

Sponging is a useful technique for painting stone walls and pebbled paths and beaches. It is also excellent for misty trees and anything that needs a soft edging, and for creating the effect of lichen on walls and wooden gates.

The technique

Wet the sponge so that it is soft and pliable and squeeze out any excess water. Dip the sponge in your chosen paint (you will need to mix a large wash, as the sponge is very absorbent). Gently dab it on to the paper.

The effect

The sponge leaves a series of pitted marks that are ideal for conveying texture. This technique is particularly useful for painting clumps of foliage.

Practice exercise: Removing and adding colour with a sponge

In this exercise, sponging is used both to remove paint, softening colours applied with a brush, and to add it, creating small areas of soft texture.

Materials

- 300lb (640gsm) rough watercolour paper
- Watercolour paints: alizarin crimson, Prussian blue, cadmium lemon, ultramarine blue, cadmium yellow
- Brushes: medium round
- Small sponge

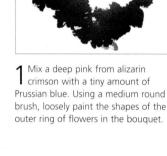

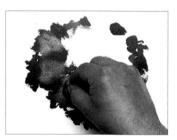

While this paint is still wet, dampen a small sponge in clean water and squeeze out any excess moisture. Wipe the sponge over the paint around the inner edge of the ring of flowers, removing colour and softening the brush marks. This creates the basis for a ring of lighter-coloured flowers.

3 Dilute the pink mixture used in Step 1 by adding more water. Dip the sponge into the mixture and gently dab it into the empty centre of the bouquet to reduce the starkness of the white.

The original scene

This array of bouquets on a market stall is almost overpoweringly colourful. The artist decided to paint a single bouquet in order to concentrate on the effects created from the sponging technique.

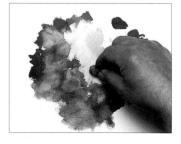

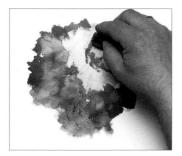

You may find that the centre now looks too dark. If so, rinse the sponge in clear water and squeeze out any excess moisture. Gently wipe the sponge over the centre of the bouquet to remove some of the colour you have just applied and soften any hard edges.

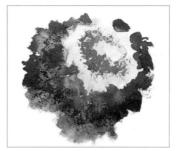

5 Load the sponge with a more highly pigmented version of the mixture used in Step 3 and gently dab it into the centre of the bouquet, to create an inner ring of flowers, and around the outer ring to create some texture and more depth of colour in this area.

6 Using a slightly bluer version of the mixture and a medium round brush, loosely delineate the edges of individual flowers within the houquel and around the outer rim.

The finished painting

Complete the painting by lightly brushing in the foliage around the outside of the bouquet, using a light green mixed from cadmium lemon and a little ultramarine blue and a darker green mixed from cadmium yellow and ultramarine

blue and paint the darkest outer leaves in the same way. This is a loose, but lively, interpretation which owes much of its success to the random sponging technique, used here both to add colour and to remove it.

Light, calligraphic brushstrokes for the leaves complement the loose textures created with the sponge.

Sponging on the outer ring of flowers has created tonal variety and a sense of depth.

Additives

There are all kinds of materials that can be added to the brush or mixed into watercolour paint. Some materials alter the characteristics of the paint, while others create textures that could not be achieved using a brush alone. These additives should be used in moderation and only in carefully selected areas of the painting, as they can easily become too dominant and detract from the effect of the work as a whole, but they are useful additional tools in your armoury.

Additives that alter the characteristics of the paint

One of the most useful additives in this category is gum arabic. Adding a few drops to your paint mixture has two effects. First, it slows down the drying time, giving you more time to work. Second, it gives the paint a slight sheen, which is particularly useful when you are painting shiny or varnished surfaces such as a wooden table in a still life. Gum arabic also makes colours appear stronger and more saturated. Glycerin will also slow down the drying time and makes the paint slightly sticky and easier to control on the paper.

Another additive that changes the characteristics of the paint is granulation medium. Some colours, such as French ultramarine, granulate naturally, but this medium allows you to exploit that characteristic with any colour, although it works better with darker colours and ones that have a natural tendency to granulate.

Gum arabic

Pour a few drops of gum arabic into pre-mixed watercolour paint and mix thoroughly. Apply the paint to the paper with a brush. Because the gum arabic retards the paint's drying time, you can then work into it with a palette knife or the tip of a brush handle.

Granulation medium

Add a few drops of granulation medium to pre-mixed watercolour paint and mix thoroughly. Apply the paint to the paper as normal. When the paint dries, it will have a slightly speckled, granular appearance. This is an effective way of painting old, worn stonework.

Additives for texture

Texture pastes and gels can be applied directly to the paper with a palette knife or mixed with watercolour paint first and brushed on. When they dry, the surface is slightly raised. Paint applied on top of the raised surface will settle in intriguing ways.

Sand, grit, tissue paper and other textured materials can be added to glue. Apply the glue to your painting, stir or press the required material into the glue, and allow to dry thoroughly before painting on top.

Finally, common household salt can create some exciting effects. Drop salt into a wet watercolour wash and leave to dry before brushing off the crystals. The salt leaches the colour out of the watercolour. The result depends on how wet the wash is: if it is too wet, the effect will not be so pronounced, and if it is too dry the salt will have no effect.

Texture medium

This is a viscous, white-coloured fluid. Mix it thoroughly into the pre-mixed watercolour paint, or apply it directly to the paper, and stipple it on to the painting surface with a palette knife. When the paint dries, the surface will be slightly raised.

Salt

Sprinkle common household salt on to a wet wash. When it is completely dry, gently brush off the salt crystals. The salt will leach the colour out of the paint, leaving mottled marks. This is a useful technique for painting snow or textured subjects, such as lichen.

Practice exercise: Textured stone and iron

In this study of a rusty chain on a worn, lichen-encrusted harbour wall, the artist has indulged in a little lateral thinking: if salt can create interesting textures, why not see what you can achieve with other items from the kitchen? Here, olive oil and plain white flour have been used as inexpensive alternatives to oil-pastel or candlewax resists and texture medium. Don't feel constrained by convention: painting should be all about experimenting and having fun.

Materials

- HB pencil
- 220lb (450gsm) rough watercolour paper, unstretched
- Watercolour paints: yellow ochre, burnt umber, cadmium red, alizarin crimson, ultramarine blue, Naples yellow, burnt sienna
- · Gouache paints: Chinese white
- Brushes: medium flat, medium round, fine round, large wash
- Olive oil
- Salt: fine-grained, coarse-grained
- Flour

2 Mix three very pale washes for the background colours: yellow ochre, burnt umber, and a pinkish mixture of yellow ochre, cadmium red and alizarin crimson. Using a medium flat brush, dab yellow ochre on at the top of the paper, burnt umber at the base, and the pink mixture on the left-hand side. Dampen any unpainted areas with clean water so that the whole paper is wet.

The original scene

The lovely, subtle colours on this old stone wall give you the opportunity to work wet into wet, allowing the colours to merge on the paper. The speckled textures in the wall provide additional visual interest, while the chain forms a diagonal line across the frame, giving a dynamic composition.

1 Using an HB pencil, sketch the subject, indicating the position of the chain and rope and the main bands of colour on the wall behind. Look at how the links of the chain are joined and at how the rope loops twist and fall over each other: the composition is very simple, but elements such as this are key to making it look realistic.

While the first washes are still wet, dip a medium round brush in olive oil and dab large and small marks into the washes. The oil acts as a resist and repels watercolour paint, and will give a mottled appearance when dry – although, because the oil is applied on top of the watercolour, rather than the other way round, the effect is subtle and understated.

A Mix a dark brown from burnt umber and ultramarine blue and dab it on to the darker areas at the base of the picture. While it is still wet, dab on more olive oil. Leave to dry. Mix a pale, rusty brown colour from burnt umber, alizarin crimson, Naples yellow and ultramarine blue. Using a fine round brush, paint the iron chain and ring.

5 Add a little ultramarine blue to the pinkish mixture used in Step 2 to make an orangey brown. Using a large wash brush, dab the mixture over the left-hand side of the wall. While this is still wet, sprinkle a little fine-grained salt over it.

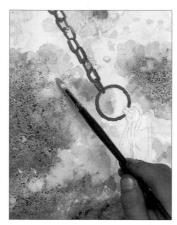

6 Mix an opaque, creamy yellow from yellow ochre and Chinese white gouache. Using a medium round brush, dot it on to the chain and the salted area on the left of the picture. This area is still damp, so the paint spreads a little and looks like small patches of lichen.

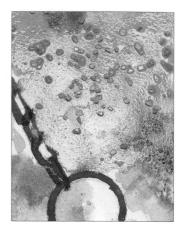

Add burnt sienna and ultramarine blue to the opaque yellow mixture used in Step 6 to make a pale, bluish grey. Using a medium round brush, dab the mixture over the light area at the top of the wall. Sprinkle on some coarse-grained salt.

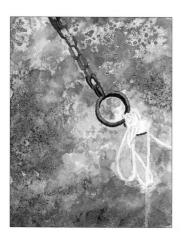

Mix an opaque pinkish grey from yellow ochre, alizarin crimson, Naples yellow, a little ultramarine blue and Chinese white gouache. Brush it over the shaded parts of the chain and ring; suddenly they look three-dimensional. Add more ultramarine blue to the mixture and paint inside the rope loops and around the chain. Mix a dark brown from burnt umber, ultramarine blue and a little alizarin crimson and paint inside the ring.

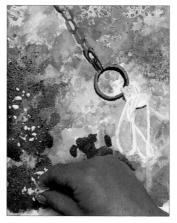

9 Using a medium round brush, dab the same dark brown mixture on to the left-hand side of the wall. Sprinkle flour into the wet areas; it will sink into the wet paint in clumps, leaving a slightly raised surface when it dries.

10 Outline the links of the chain in pure burnt sienna, taking care to break the line where the links overlap to give a three-dimensional effect.

Tip: Take plenty of time over this stage and study your reference photo carefully: these dark lines indicate how the links of the chain are joined together, so it's important to get them right.

1 1 Mix a pale blue from ultramarine blue, burnt sienna and Chinese white gouache. Paint the rope strands and the shadows underneath the rope.

 $12^{\,\,}$ MIx Chinese white gouache with a tiny amount of ultramarine blue and paint the mortar lines in the brickwork of the wall.

13 Gently brush off the dry salt crystals to reveal mottled, bleached-out marks that look like lichen growing on the harbour wall.

Often, insignificant details can make intriguing paintings: there is nothing exceptional about this subject, but the soft colours and contrasts of texture make it very appealing. The artist has applied a number of additives – some more unusual and unorthodox than others – to the wet watercolour washes, thereby creating interesting textures that could not have been achieved by brushwork alone.

Salt leaches colour out of the paint, creating a mottled effect like lichen.

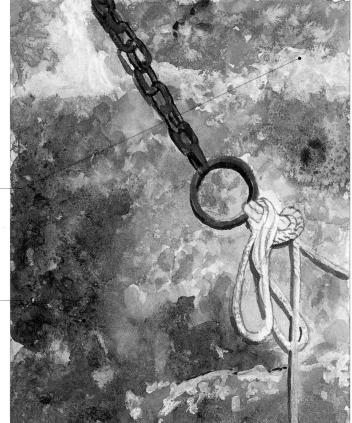

Line and wash

Combining inks with watercolours – a technique that is commonly known as line and wash – is one of the most challenging and exciting of all watercolour techniques. It enables you to combine the precise detail of pen-and-ink work with the fluidity and transparency of watercolour washes.

It doesn't matter whether you do the ink drawing or the watercolour washes first; that really depends on what you want to say about your subject. The real danger, especially for beginners, is putting in too much linear detail and consequently overworking the picture. Make a conscious effort to simplify your subject and put down only the essentials.

The key to a successful line-and-wash painting is to maintain a balance between the two media. Although there are no hard-and-fast rules, a useful quideline is that if your subject contains relatively little colour you can afford to do a lot of pen work, while a very colourful subject will probably require less. (Lots of pen work in a painting of a colourful flower border, for example, would detract from the colours of the subject; with an action subject such as a dancer or sporting scene, you might choose to make the pen work tell most of the story, applying just a little colour for atmosphere.) It takes a certain amount of practice and skill to get the balance right.

Experiment with different inks, as there are both waterproof and water-soluble kinds. If you want the pen marks to be permanent, use waterproof inks. Water-soluble ink marks will blur and run when you apply watercolour washes on top of them, but you can create some exciting effects in this way.

Try different kinds of pen, too, to find out which ones you like using, and use the back of the nib, as well as the tip, to create different widths of line. Steel-nibbed dip pens make lovely lines, but they hold relatively little ink and you may find it frustrating to have to keep stopping to re-load the pen. Fountain pens and technical drawing pens have an ink reservoir, but the quality of line that they make may be a little too neat and regular for some people's tastes.

Watercolour wash over ink

Provided you use waterproof ink, as here, and allow it to dry completely, the lines will remain permanent and unsmudged even when you apply a watercolour wash over the top.

Semi-opaque paint over ink

The top half of the image shows a mixture of watercolour paint and permanent gouache applied over ink: the semi-opaque paint partially covers the ink, making the lines more muted. Compare this with the deep lines of the ink covered by pure watercolour in the bottom half of the image.

Practice exercise: Church spire in line and wash

Line and wash is the perfect technique for architectural subjects such as this picturesque church steeple and spire. Details can be held sharply in ink while watercolour washes provide colour and tonal variety. The dip pen used here provides a less regular and mechanical quality of line than a technical drawing pen, which helps to make the study of the building more lively.

Materials

- 2B pencil
- 300lb (640gsm) rough watercolour paper
- Watercolour paints: yellow ochre, raw umber, ultramarine blue, cadmium red, burnt sienna, ultramarine blue, cadmium yellow
- ultramarine blue, cadmium yello
 Brushes: medium round
- Medium-nibbed steel dip pen
- Black waterproof ink

The original scene

There is a lot of interesting detail in this scene. The arched bell-tower windows and a rounded turret cry out to be depicted in a crisp, linear way, while the soft transitions from light to dark tones in the stonework require soft-edged wet-into-wet washes.

Using a 2B pencil, sketch the building. (If you are confident, start working in pen and ink straight away – but you cannot erase mistakes.) Using a medium dip pen and waterproof black ink, ink over the pencil lines.

2 Continue with the pen-and-ink work until you have put in all the main lines of the spire, steeple and rounded turret. Leave to dry completely before going on to the next stage of the painting.

3 Mix a pale wash of yellow ochre. Using a medium round brush put in the lightest tone, which is on the left-hand side of the steeple and spire. This establishes the underlying colour of the honey-coloured stonework.

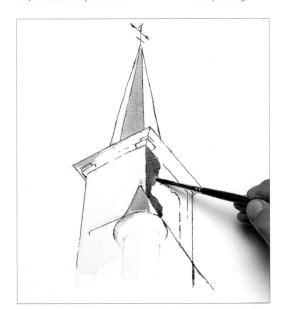

4 Mix a mid-toned grey from raw umber with a little ultramarine blue. Put in the second facet of the spire, the shadow under the eave on the left, and the roof of the rounded turret. Add a little cadmium red and paint the right-hand side of the steeple, painting around the arched window.

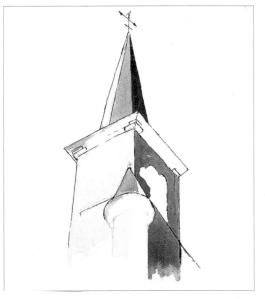

 $5\,$ Mix a dark brown from burnt sienna and ultramarine blue and put in the darkest facet of the steeple, the side that is in shade. The building is now starting to look three-dimensional, and this will be reinforced in the later stages of the painting.

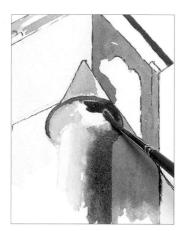

6 Mix a rich, orangey-brown from cadmium yellow, cadmium red and a little ultramarine blue and paint the rounded turret. Use the dark brown mixture from Step 5 to paint the shaded right-hand side of the turret and the eaves under the right-hand side of both the steeple and turret.

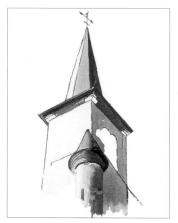

Tusing the orangey-brown mixture from Step 6, "draw" concentric lines underneath the conical roof of the turret so that you begin to establish the form of this structure. Paint the window in the turret in the same colour. Darken the mixture and paint under the eave on the right-hand side of the steeple.

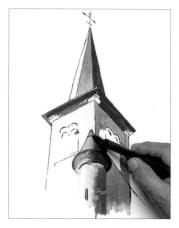

Darken the middle facet of the spire using the dark brown mixture from Step 5. Using the steel-nibbed dip pen and waterproof black ink, reinforce some of the structural lines of the building and put in the curves of the arched window on the left-hand side of the steeple.

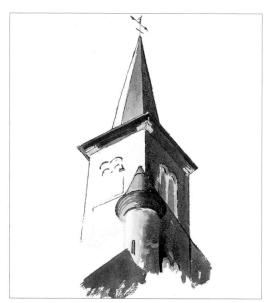

9 The right-hand side of the steeple looks too light, so mix a warm brown from ultramarine blue and cadmium red and darken it. Mix a neutral mauve from yellow ochre and ultramarine blue and paint the window on the right-hand side of the steeple.

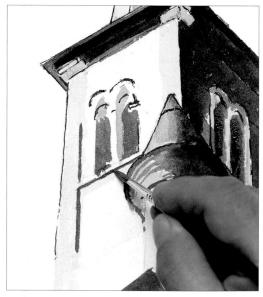

 $10^{\,}$ Brush pale yellow ochre over the left-hand side to warm up the colour of the stone. Use the dark brown mixture from Step 5 to paint the recessed window on the left. Paint horizontal and vertical lines to the left of and below the window, indicating that the façade is not completely flush.

The artist has achieved a good balance between linear pen work and watercolour washes, with the ink establishing the structure and some of the fine detail of the building and the watercolour the subtle tonal transitions from light to dark.

On its own the pen work could have looked rather tight and mechanical, but successive layers of watercolour washes have helped to enliven the study and provide it with some depth and colour.

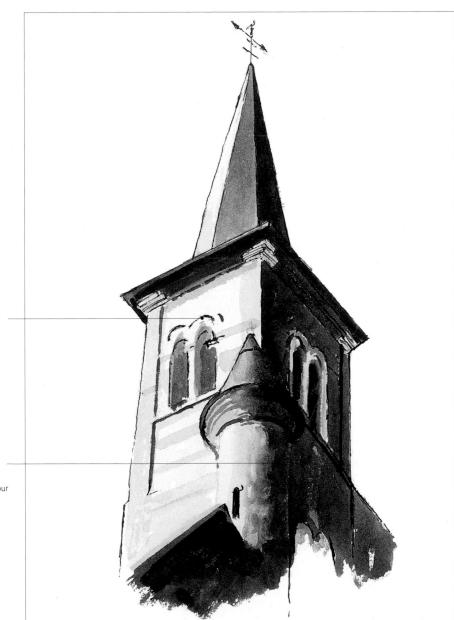

Pen lines establish the structure of the building.

Wet-into-wet washes convey the variety of colour in the stonework and the form of the building.

Water-soluble pencils

The advantage of water-soluble pencils is that they combine the linear appeal of pencil work with the fluidity of transparent watercolour washes. They are incredibly versatile: you can use them wet or dry, on their own or in conjunction with other media, and the colours do not

go muddy. Easily portable, water-soluble pencils are a real boon when it comes to making sketches on location, but they are equally useful in the studio.

Water-soluble pencils are available in a breathtaking range of colours – there are far more shades available than you will find in any range of paints. You can also blend several colours together on the paper to produce subtler shades. However, some brands of water-soluble pencil seem to blend better than others, so it is worth experimenting with different brands in order to find one that you like.

Dry on dry

Applied dry on top of dry paper or watercolour washes, water-soluble pencils can be used to draw fine lines and details, such as veins in flower petals and leaves, feathers, mortar lines in brickwork, wood-grain effects, and highlighting on objects such as bottles.

Wet on dry

Dipping the tip of the pencil in water before you apply it to the dry paper has two effects: it intensifies the colour and it also fixes the pencil marks, so that they do not blur (or do not blur as much) when a watercolour wash is applied on top.

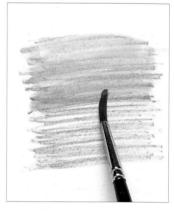

Dry marks brushed with water

If water or a watercolour wash is brushed over dry water-soluble pencil marks, they will blur and spread a little – a useful technique for implying that objects are far away, such as a distant woodland. (Foreground details should always be crisp and sharp.)

Brushing clean water over water-soluble pencil marks will allow you to blend colours together easily.

Tip: Make heavy scribbles in a range of colours and use them as easily portable "palettes": when you brush the scribbles with clean water, you can pick up enough colour on the brush to work with them in the same way as watercolour paints. However, the "paints" thus produced are generally less intense in colour than real watercolour paints.

Practice exercise: Peacock feathers

This exercise demonstrates the linear characteristics of using water-soluble pencils dry, and it gives you the chance to practise mixing colours optically by overlaying one colour on top of another. It also shows how the colour intensifies into a smooth, velvety finish when the tips of the pencils are dipped in water and used wet. For the best effect, use a smooth, HP paper.

Materials

- HP paper, unstretched
- Water-soluble pencils: yellow-green, jade green, orange, light violet, light green, dark green, emerald green, turquoise, light blue, ultramarine blue, ivory black

The display

When a male peacock displays, his tail feathers fan out into a shimmering mass of iridescent colours. Although you won't find true iridescent colours in your range of water-soluble pencils, you can come close to recreating the effect by carefully overlaying colours on the paper, so that they mix optically.

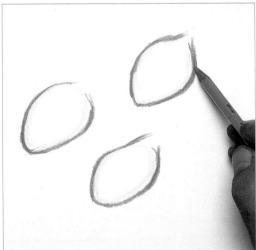

1 Outline the "eyes" of the peacock feathers with a pale, yellow-green line. Draw around the outside of the yellow lines with a jade green pencil.

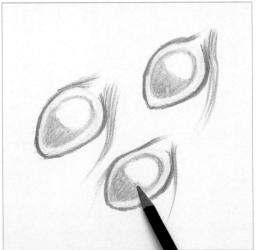

2 Using the jade green pencil again, draw long, feathery strokes on the outer edges of the eyes. Draw an orange line inside the first yellow-green lines and fill in the lower half of the eyes in orange.

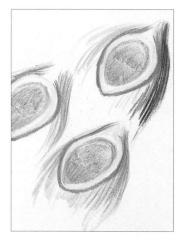

3 Fill in the upper half of the eyes with light violet. Following the direction of the peacock feathers, draw light green marks over the straggly jade green feathers, so that the two greens blend optically. Then repeat the process using a dark green pencil.

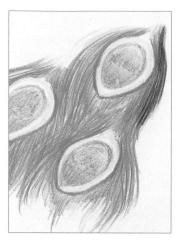

Go over the other greens again, and the large spaces between the eyes, with an emerald green pencil – again, making sure that your pencil marks follow the direction in which the feathers grow. Take care not to block in the colour too heavily.

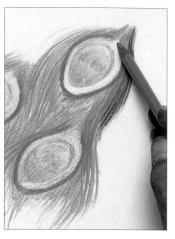

5 Draw around the outside of the eyes with a turquoise pencil and draw over the initial yellow-green lines with jade green. Note how you are beginning to build up the depth of colour while still maintaining the linear quality of the pencil work.

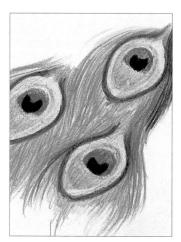

Go over the light violet of the eyes with a light blue pencil. Although you can't really see the underlying violet any more, the colours merge on the paper to create a purplish blue that you could not have created by using just one pencil on its own. Draw the "pupils" of the eyes in ivory black. (Note the irregular shape: they are not a neat circle or semi-circle.).

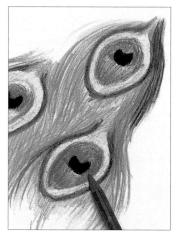

Dip the tip of an orange pencil in water and go over the orange colour again. Note how using the pencil wet intensifies the colour and creates a smooth, velvety block of colour in which the individual pencil strokes can no longer be clearly differentiated.

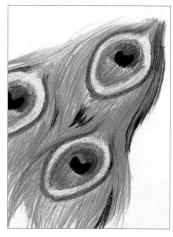

Strengthen the green feathers further by applying layers of emerald green and light green pencil. As before, follow the direction of the feathers and take care not to block in the colours completely, otherwise the feathers will look like a solid mass rather than individual strands. Draw in small touches of ivory black between the feathers: this adds drama.

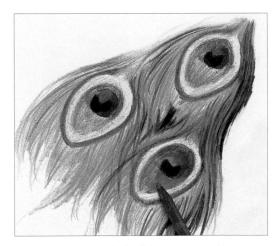

The green markings look a little too green at this stage; you need to relieve the intensity and also hint at the iridescence of the feathers. Go over the green markings in places with an ultramarine blue pencil. Dip the ultramarine blue pencil in water and intensify the blue of the eye. Strengthen the orange of the eye in the same way.

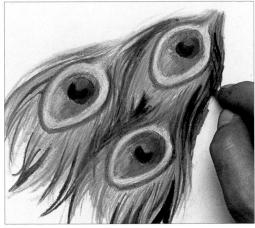

10 Dip a dark green pencil in water and go over any areas that you want to be very dark. Because the pencil is used wet, the resulting marks are very smooth and intense in colour. Dip an ivory black pencil in water and build up more of the base feathers. This provides a background against which the colours will stand out more strongly.

The finished work

More a drawing than a painting, this little detail sketch nonetheless shows the range of marks and intensity of colour that can be produced with water-soluble pencils. It is also a lovely example of optical colour mixing.

Greens and blues intermingle to create subtle optical mixes that hint at the iridescence of the feathers.

The individual pencil strokes can clearly be seen.

More solid blocks of colour are achieved by dipping the tip of the pencil in water.

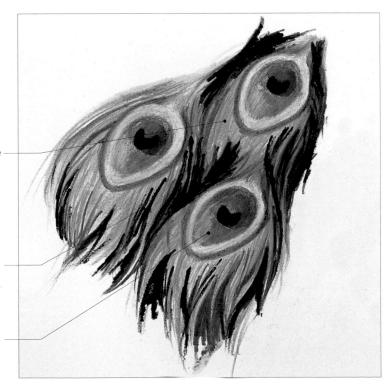

Using a toned ground

Although it is more usual for traditional transparent watercolour to be painted on white paper, it is possible – and, in some cases, even preferable – to work on a coloured or toned ground or paper.

Using a toned ground can create a colour harmony as, to a greater or lesser extent, the colour of the ground influences the colour of the washes that are applied over the top. It establishes a colour key that can help create a mood. A toned ground can also simplify and cut down considerably on the amount of time it takes to paint the picture: applying a wash over the whole paper in order to establish a colour key is often the first stage in making a watercolour painting.

Ready-prepared watercolour papers are available from art stores in shades of cream, oatmeal, grey, light blue and light green. If you require another colour, you will need to prepare the paper yourself by applying a wash of the desired hue in either watercolour or acrylic paint. Acrylic paint has the additional advantage of being permanent: there is no risk of the colour being disturbed by subsequent layers of watercolour washes. However, it does leave a slight residue and seals the surface, and this can affect the way the watercolour lies on the paper.

The toned ground need not be flat and uniform. If appropriate to the subject, you could create a textured ground using sponges or rough brush work.

The colour you choose for the ground should reflect the mood and atmosphere of the piece and complement the colours to be used. This is particularly important when using transparent watercolour. If you are using opaque watercolour (that is, watercolour to which body colour has been added), the opacity and covering power of the paint make the colour of the ground less noticeable.

If you are using opaque watercolour, the colour of the toned ground can lean towards the complementary colour of the main colours in the painting – for example, a predominantly green landscape on a pale red ground. Because of the effect of simultaneous contrast, a ground in a contrasting colour can make the colours used in the painting seem brighter.

Practice exercise: Log and axe on toned ground

This exercise shows how to create an overall colour harmony by using a toned ground. When you first start experimenting with toned grounds, keep the subject very simple, with a limited colour range, and think carefully about what colour will work best. Here, the overall colour of the wooden log and axe is a warm brown and so a pale, warm ground is the obvious choice.

Materials

- 2B pencil
- · Soft graphite pencil
- 200lb (425gsm) NOT watercolour paper, pre-stretched
- Watercolour paints: yellow ochre, burnt umber, Payne's grey, raw umber, ivory black, burnt sienna
- · Brushes: large wash, medium round

The set-up

The plain cream paper on which the log is set is helpful in some ways, because it allows you to see the cast shadow very clearly, but it is also very stark and bright and detracts from the subject.

Tone the paper with a pale wash of yellow ochre. Leave to dry. Using a 2B pencil, sketch the outline of the axe and log. Paint the axe handle in a dilute wash of raw umber. Mix a light brown from burnt umber and Payne's grey and paint the axe head. Leave to dry.

2 Mix a dark brown from burnt umber and ivory black and paint the dark on the side and bottom of the axe head. Add raw umber and burnt sienna to the mixture and paint the handle, leaving the underlying colour where the light hits the handle. Leave to dry.

Add a little Payne's grey and plenty of water to the mixture to lighten the colour, then paint the side and top of the log. Using a slightly darker version of the same mixture, begin to paint some of the growth rings on the top of the log, but leave the split in the wood unpainted as parts of it are considerably lighter in tone than the surrounding wood.

Paint a series of fine burnt umber lines along the length of the axe handle to suggest the grain and pattern in the polished wood. Mix a warm brown from burnt umber and raw umber and paint the side of the log, using the side of the brush and a slight scrubbing action in order to create a broken, uneven texture.

5 Using the same raw umber and burnt umber mixture, paint the growth rings on the top of the log. Add burnt umber and Payne's grey to the mixture and paint the shadow inside the split. Using a soft graphite pencil, indicate the grain and growth rings on the side and top of the log. Once dry, rework the dark shadows deep within the split.

The finished painting

Crisp shadows painted in a warm grey mixed from Payne's grey and a little burnt umber complete the image and make it look three-dimensional. The yellow ochre ground harmonizes well with the colours used to paint the axe and

log, whereas a white ground would have looked too stark and would have competed for the viewer's attention. It makes a subtle but important contribution to the overall warm tone of the image.

The yellow ochre ground is similar in colour to the axe and log.

The texture of the log is convincingly portrayed.

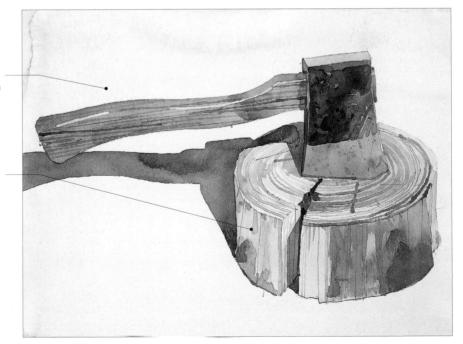

Working into wet paint

Watercolour washes can be manipulated in several ways when they are wet. They can be moved around, removed or worked into using various tools. The only restriction is the amount of time available before the paint dries to such an extent that it is no longer movable.

Certain papers facilitate working into wet paint better than others. The fibres in highly absorbent papers soak up the washes and make any manipulation impossible, even immediately after they have been applied. Even better are papers that have been sized to such a degree that washes sit on the surface and dry slowly, rather than soak in.

Some techniques work better when the paint is very wet, while others are more effective when the paint has dried a little. Adding gum arabic to your washes can facilitate certain techniques, as it thickens the paint, increasing its viscosity so that it is less fluid. Thickening the paint prevents it from flowing freely and allows you to work into it more readily.

You can work into wet paint to depict any type of textured surface. You can remove paint by using textured fabrics, absorbent paper, man-made and natural sponges, to name but a few.

You can also make marks in wet paint by using a variety of tools that you might not normally associate with painting, such as combs, palette knives, pieces of stiff card, or the wooden end of your brushes. These are all excellent for this purpose, as is the relatively new range of rubber paint-shaping tools. Pressing fabrics, paper, and even aluminium kitchen foil or clear film (plastic wrap) all create interesting textures that you could not achieve using an ordinary brush.

When a wash is partially dry, dropping water or paint into it results in an effect known as a back-run (sometimes called the cauliflower effect). This can be put to good use when painting cloudy skies or flowers, as it creates a crinkled, often highly pigmented edge as the wetter paint pushes into the drier paint. A similar effect can be seen when paint that has collected in a puddle on buckled paper dries at a much slower rate than paint on the surrounding area.

Lifting off colour

There will be many occasions during your painting when you find that you need to remove some colour from your work – either to make minor corrections or simply to soften tones and edges. The methods shown below are particularly useful for lifting out clouds from a blue sky – but remember to turn the paper or sponge around in your hand each time you use it in order to find a clean area, otherwise you run the risk of dabbing paint back on.

Absorbent paper

First, lay a wash. While it is still wet, blot off any excess paint with a scrunched-up piece of clean, absorbent tissue or a paper towel.

Sponge

You can also lift off colour from a wet wash using a sponge. This gives more texture, as the texture of the sponge is impressed into the wet wash.

Pressing materials into wet paint

You can create interesting textures by pressing things into wet paint and removing them once the paint is dry. The results are a little unpredictable, but well worth experimenting with. Two possible materials are shown below, but you can easily come up with others from readily available household items. Lace, soft absorbent fabrics, such as cotton and felt, thick wool: experiment to see how many different effects you can create with whatever you have to hand.

Clear film

Scrunch up a piece of clear film (plastic wrap) in your fingers and gently press it into a wet watercolour wash. Leave it to dry.

2 When the paint is dry, carefully remove the clear film. The lines of the scrunched-up film are clearly visible in the dry paint.

Aluminium kitchen foil

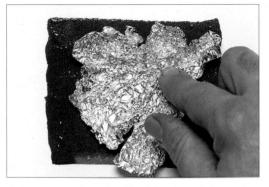

1 Scrunch up a piece of cooking foil and press it into a wet wash. Leave to dry.

2 When the paint is dry, carefully remove the foil. This creates crisper, sharper lines than the clear film.

Practice exercise: Graffiti-style abstract

Remember how much fun you had as a child, messing around with poster paints and coming home with your fingers stained with bright, primary colours? This exercise is all about recapturing that sense of fun and excitement and getting a feel for how wet watercolour paint behaves. The result is an abstract mass of colour and texture, rather like graffiti sprayed on to a wall

Feel free to experiment with materials other than the ones shown here: there are no limits to what you can use. Work quickly while the paint is still wet. Above all, don't try to plan ahead, simply react to the way the paint flows and puddles on the paper.

Materials

- 300lb (640gsm) rough watercolour paper
- Watercolour paints: alizarin crimson, cobalt blue, burnt sienna, ultramarine blue, cadmium yellow
- Watercolour pigments: alizarin crimson
- Brushes: old brush for masking, medium round
- Masking fluid and tape
- Kitchen paper
- Toothbrush
- Card
- Cotton bud (cotton swab)

1 Brush on random swirls of masking fluid and leave to dry. Cut abstract shapes from masking tape and press them on to the paper. Wash alizarin crimson and cobalt blue on to the paper, allowing the colours to merge.

3 Brush on more alizarin crimson and dab a piece of kitchen paper on to the paper to lift off and soften colour.

While the first washes are still wet, brush on burnt sienna and ultramarine blue, again allowing the colours to run together and merge on the paper in a completely random way. Tilt the board to facilitate this.

4 You have now established a mass of abstract wet colours into which you can work.

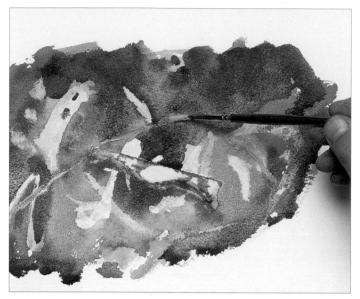

5 Using thick paint straight from the tube, brush on a few long strokes of cadmium yellow. This gives an impasto-like texture similar to oil paint.

Drag an old toothbrush over the yellow lines to spread and diffuse them. Because the bristles of the toothbrush are stiff and the paint is relatively thick, you can clearly see the marks that are left behind – an unusual way of adding texture to a watercolour.

Take a small piece of card and scrape into the wet paint, dragging it from one colour into the next. The card is flexible, so you can make curved lines, while its thin edge allows you to create lines that are clearly defined. An old, cut-up credit card would have the same effect.

Pick up a little powder pigment on a piece of card and, gently tapping it with your finger, lightly sprinkle the pigment on to the paper. Note how the pigment colour spreads and blurs in damp areas but remains on the surface, creating an impasto-like texture, in dry parts.

Dip a brush in clean water and brush over the pigment particles to blur and spread them. The more water you have on the brush, the further the powder will spread and the paler the colour will become.

10 Pull off the masking tape and rub off the fluid to reveal small areas of bright white. Brush more allzarin crimson on to selected areas of the paper and, while it is still wet, drag a toothbrush through it as before.

11 Dip a cotton bud in ultramarine blue paint and dot it on to the paper to make more clearly defined marks in selected areas.

The finished painting

This is a completely abstract, explosive riot of colour and texture. It was not pre-planned in any way, but was created by the artist responding to the way the wet paint behaved

on the paper. Exercises like this will teach you a lot about manipulating paint and free you from any hang-ups about having to paint lifelike subjects.

Clear lines and dots are created by scraping into the paint with card and dotting on colour with a cotton bud.

Allowing the paint to merge wet into wet creates soft background colour.

Using thick cadmium yellow paint straight from the tube creates an impasto-like effect.

Sgraffito

The technical name for scratching into dry paint comes from the Italian, graffiare, which means to scratch. Sgraffito can be used to reveal white paper beneath a wash, and is a good way to create highlights, such as sunlight on water. It can also be used to scratch through one layer of colour to reveal the layer beneath.

Paint can be scratched into using a variety of sharp implements. A scalpel or craft (utility) knife is useful for scratching

fine lines, as are sharpened brush handles, paper clips and even your fingernails. For larger areas, sandpaper is very effective; experiment with fine and harsh grades of sandpaper for different results.

You can also use sgraffito to remove small areas of paint to correct minor mistakes – for example, if you want to neaten an edge or the outline of an object. To do this, scrape gently, using the edge of the scalpel blade rather than

the point, so that the paper is not torn and the scraped area remains flat.

All these techniques work better if the paint sits on the paper surface, rather than soaking into it to any depth, so try to avoid using sgraffito with staining colours such as alizarin crimson, viridian or phthalocyanine blue. Needless to say, it is best to use sgraffito on heavy paper (say, 300lb/640gsm) as it is less likely to tear, and on top of dry washes.

Scalpel or craft knife

To scratch fine lines, such as highlights on water, use the tip of a scalpel or craft (utility) knife, pulling the blade sideways to avoid slicing into the paper and damaging it.

Fine sandpaper

Stroke the sandpaper over the surface of the dry paint. This is particularly effective on rough watercolour paper, as the paint remains in the troughs but is removed from the higher ridges.

Coarse sandpaper

Because the sand particles on course paper are bigger, the sgraffito lines are further apart. You can also fold the sandpaper to create a crisp edge, enabling you to scratch off sharp lines.

Practice exercise: Conch shell

This conch shell contains a number of different textures, from hard, raised ridges and points to the mottled surface of some of the flatter areas and the porcelain smoothness of the inside. The following exercise gives you the chance to practise two methods of sgraffito, using sandpaper for general areas of texture and a scalpel or craft (utility) knife for the crisp, sharp ridges on the outer side of the shell.

Materials

- 2B pencil
- 300lb (640gsm) NOT watercolour paper
- Watercolour paints: yellow ochre, Payne's grey, alizarin crimson, raw umber
- Brushes: medium round
- Medium-grade sandpaper
- Scalpel or craft (utility) knife

The set-up

Arrange the shell at an interesting angle, so that you can see both the hard, spiky outer shell and the smooth, slightly shiny interior. This provides an attractive contrast of textures and makes it easier to appreciate the form of the object.

1 Using a 2B pencil, lightly sketch the shell to establish the general outline shape and the main ridges. Using a medium round brush, establish the overall colour with pale washes of yellow ochre, Payne's grey and a little allizarin crimson, allowing the colours to blend together on the paper and create a surface with subtle variations in colour. Leave to dry.

2 Take a small piece of medium-grade sandpaper and stroke it over the paper to recreate the rough, pitted surface of the shell. (Leave the areas of smooth shell that lie deep within the interior untouched.) To scratch into small or tight areas of the image, fold the sandpaper to make a crisp, sharp edge.

Mix a cool brown from yellow ochre and Payne's grey and paint the areas in shadow and some of the linear detail. When the paint dries, it will leave a rough texture on areas of the paper that have been rubbed with sandpaper. Mix a dull pink from alizarin crimson and yellow ochre and paint the warm colours on the shell "lip". Leave to dry.

Using a sharp scalpel or craft (utility) knife, gently scratch into the dark paint until clean paper fibres are revealed, creating the ridges on the outer side of the shell.

5 Mix a mid-toned grey from Payne's grey and a little yellow ochre and paint the shadow inside the shell. Mix a darker grey from Payne's grey and raw umber and wash in the background, painting very carefully around the shell.

A scalpel or craft (utility) knife is used to scratch off these crisp lines on the outside of the conch shell.

General areas of rough texture are created using medium-grade sandpaper.

The finished painting

The dense, cast shadow is painted in a darker, more pigmented mixture, which anchors the shell to the surface on which it rests, and also has the effect of throwing it into sharp relief. When painted over, the rough texture made by the sandpaper creates a broken effect that contrasts well with the fine, crisp lines made with the point of the scalpel or craft (utility) knife blade.

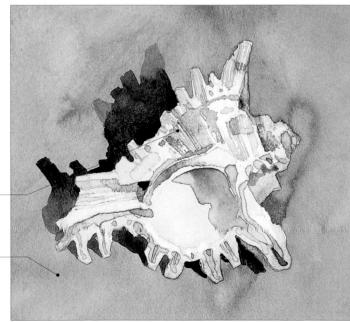

Body colour

Traditional transparent watercolour uses no white paint. Instead, you have to leave any areas of the painting that you want to be white, such as clouds or highlights sparkling on water, free of paint. Colours are made paler by adding more water.

The white of the paper also serves to reflect light back through transparent coloured washes. Depending on the depth of the colour, this can make them appear lighter or darker. Because the washes are transparent, when one colour is painted on top of another the underlying colour will always show through. This makes it impossible in pure watercolour to paint a light colour on top of a dark one.

Body colour is somewhat different. White and pale shades are obtained by adding white pigment, which adds "body" to the paint and renders it opaque. Chinese white, which is made from zinc oxide and gum arabic, was traditionally used as body colour. It is a dense white with a very high tinting strength. A good alternative, which many artists use. is white gouache.

You can use body colour straight from the tube to create highlights and details that would normally have been made by preserving the white of the paper – catchlights in people's eyes, for example, or white whiskers on a cat. You can also mix it with transparent watercolour paint to produce light, opaque pastel tints that can then be painted on top of dark colours. This is particularly useful when you want to add subtle pale details or textures – for example, by spattering white paint on to the support to represent falling snow in a snow scene.

Body colour comes into its own when you are working on a coloured or tinted ground because it enables you to use light tones and colours without them being influenced by the underlying ground colour, which can completely overpower pale, transparent washes.

Body colour can also be used to correct mistakes – perhaps highlights that you have forgotten to leave white, or even entire passages that you want to cover up and repaint. Use it cautiously, however, as too much can look heavy and deaden the lovely translucent quality for which pure watercolour is renowned.

You need a degree of competence and flair to mix the two techniques of body colour and transparent washes. It is easy for the two techniques to jar and work at odds with one another, but if used carefully, body colour can extend the creative possibilities of watercolour as a medium, and will bring another dimension to your watercolours.

Light watercolour over dark watercolour

When a paler or lighter transparent watercolour paint is applied over the top of a darker paint, the underlying dark wash will show through.

Light gouache over dark watercolour

When a paler or lighter watercolour paint is combined with Chinese white gouache, the mixture becomes opaque. It then becomes possible to apply a lighter colour on top of a darker one.

Practice exercise: Painting light on dark

A lighter blue pattern on a rich, dark blue background: in pure watercolour, the only ways to paint the pattern on this little embossed vase would be either to mask the light areas, which might look too bright when the masking is removed, or to paint the light areas first, and then carefully paint the darker blue around them, which is quite a fiddly process.

With body colour, however, things are much simpler. By mixing Chinese white gouache with transparent watercolour paints, you can create pale, opaque mixtures that can be painted on top of the dark, underlying colours. The opaque pattern also contrasts well with the translucent watercolour used to paint the blue of the vase.

The set-up

Tiny orange flowers were chosen to contrast with the rich blue of the vase – orange and blue are complementary

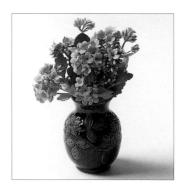

colours and they work well together. Positioning a table lamp to one side of the vase helps to pick up the texture of the embossed pattern.

Materials

- B pencil
- 140lb (300gsm) rough watercolour paper, unstretched
- Watercolour paints: ultramarine blue, burnt sienna, cadmium lemon, cadmium red, cadmium yellow
- · Gouache paints: Chinese white
- Brushes: medium round, large wash

Using a B pencil, sketch the subject. Don't attempt to draw every single leaf and flower: a light indication of the general areas is sufficient.

2 Mix a rich blue from ultramarine blue with a little burnt sienna. Using a medium round brush, paint the vase, adding a little more burnt sienna for the right-hand side of the vase, which is in shade. Dilute the mixture for the shadow cast by the vase.

Mix a dull green from cadmium lemon, ultramarine blue and a little cadmium red and brush in the broad shapes of the leaves. Add more cadmium lemon to the mixture and paint the lighter leaves. Dot the same mixture over the unopened buds.

4 Add a little cadmium yellow to the dilute shadow mixture used in Step 2 and, using a medium round brush, brush it over the background to relieve the whiteness. Mix an orangey green from cadmium lemon, ultramarine blue and cadmium red and start to put in the flower buds that are just starting to open. Mix a pale, opaque blue from ultramarine blue and Chinese white gouache and paint the pattern on the vase.

5 Add a tiny amount of burnt sienna to the opaque blue mixture and continue painting the pattern on the right-hand side of the vase. These subtle changes in tone help to establish which areas are in shade, as a result of which the vase begins to take on a more three-dimensional quality. Burnt sienna is also slightly orange in tone: shadow colours often contain a hint of a complementary colour.

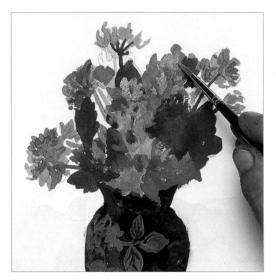

 $6\,$ Mix a bright orange from cadmium red and cadmium yellow, and paint the tiny open flowers. Note how this use of complementary colours (the orange flowers against the blue of the vase) immediately makes the painting look more lively and dynamic.

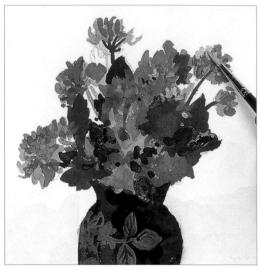

Mix a dark green from ultramarine blue, burnt sienna and cadmium yellow and paint the darkest leaves. Mix a light green from cadmium yellow and ultramarine blue and paint the unopened buds. Mix orange from cadmium lemon, cadmium red and Chinese white gouache and paint the opening buds.

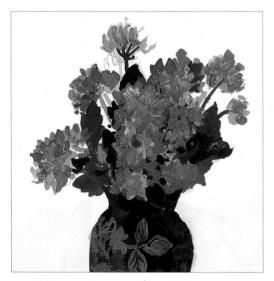

Add Chinese white gouache to the bright orange used in Step 6 to make it opaque. Use the mixture to paint the flowers that overhang the deep green leaves.

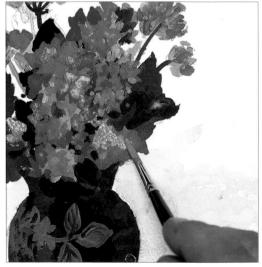

Mix a pale orange from cadmium yellow and cadmium red and brush it over the surface on which the vase sits. This will tone down the brightness and will provide a visual link to the colour of the flowers. Mix an opaque light green from cadmium lemon, ultramarine blue and Chinese white gouache and paint some light leaves over the dark ones.

The finished painting

Combining pure watercolour paint with Chinese white gouache makes it possible to paint light colours on top of dark ones. Because of its opacity, the body colour is also

very effective in suggesting the embossed texture of the vase. Note also the effective use of the complementary colours blue and orange for the flowers.

Chinese white gouache has been used to tone down the bright orange of the flowers.

Pure watercolour paint is used for most of the vase. The translucency of the paint conveys the shiny glaze very effectively.

The opaque, pale blue mixture completely covers the underlying dark blue wash.

Scale and perspective

The further away something is from you, the smaller and less distinct it seems with the naked eye. In order to convincingly depict depth and recession, and so add a sense of realism to your work, you need to depict this shift in scale accurately. This is done by using a technique known as perspective.

At first sight, perspective may seem complex and confusing, but the basics are easy to understand and even a rudimentary grasp of the fundamentals will enable you to position elements in your work so that they appear to occupy their correct "space" in the composition.

As with any endeavour, planning is the key to success. You need to consider any perspective issues from the moment you begin a work and incorporate them from the outset. If you are unsure, make a sketch or a working drawing before you begin work on the painting. This will allow you to work out any problems in advance.

Aerial perspective

Sometimes known as atmospheric perspective, aerial perspective refers to the way the atmosphere combined with distance influences and affects what you see. Being able to identify and utilize these effects will enable you to paint realistic and convincing three-dimensional landscapes.

Four things are directly influenced by distance: these are texture, colour, tone and size. The most obvious of these is size. Objects gradually become smaller the further away from you they are. You can see this most clearly by looking along a row of identically sized telegraph poles, fence posts or trees.

Second, detail and textures become less evident with distance. Close-up texture and detail are often large and in sharp focus, while texture and detail that is further away is vague and less clearly defined.

Third, colours seen in the foreground and near distance appear bright and vibrant because the warm colours – reds, oranges and yellows – are in evidence. Colours in the far distance appear much less bright. They are also cooler and contain more blue and violet.

Finally, tonal contrast is dramatically reduced with distance, and sometimes it disappears completely, so that distant hills, for example, might appear as one pale mass.

These effects on size, detail and colour are caused by our own visual limitations. They are also caused by the gases, dust and moisture present in our atmosphere, which create a veil through which light has to filter. In addition, all these effects are directly influenced not only by the time of day, but also by the season of the year, the location, and the inherent local weather conditions.

The principles of aerial perspective apply not only to terra firma but also to the sky. Clouds appear larger when they are viewed immediately overhead. The sky alters colour too, being a warmer, deeper blue immediately overhead, gradually becoming paler and often with a cool yellow tinge as it falls towards the horizon and the far distance.

The effects of aerial perspective

This simple landscape clearly illustrates the effects of aerial perspective and shows how atmosphere combined with distance influence the way we see things.

Colours in the foreground look warmer and brighter.

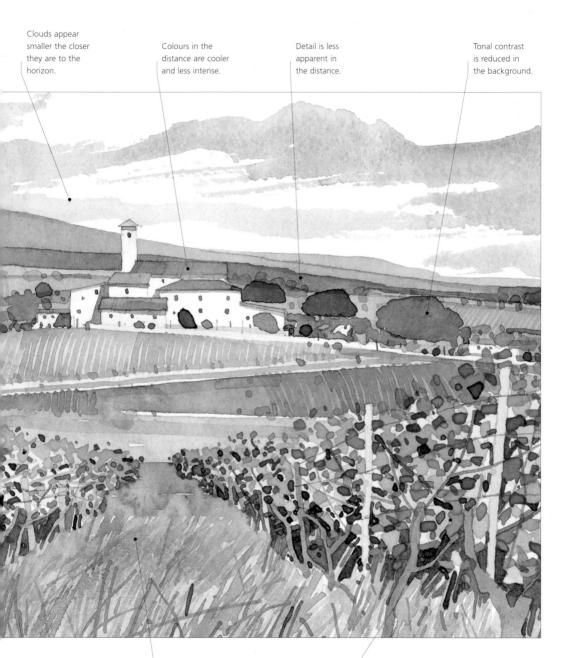

Detail is more apparent in the foreground

A full range of tones can be seen in the foreground.

Linear perspective

Linear perspective is a system or device that allows you to create the illusion of three-dimensional space on a two-dimensional flat surface. The system is based on the principle that all parallel lines, known as perspective lines, when extended from any receding surface meet at a point in space known as the vanishing point.

The vanishing point is on what is known as the horizon line, which runs horizontally across the field of vision. The horizon line is also known as the eye level, because it always runs horizontally across the field of view at eye level, regardless of whether you are sitting or standing. All perspective lines that originate above the eye level run down to meet the vanishing point and all perspective lines that originate below the eye level run up to meet it. All vertical lines remain vertical.

The simplest form of perspective is single, or one-point, perspective. This occurs when all the receding perspective lines meet at one single point. The vanishing point in single-point perspective always coincides with your centre of vision, which is directly in front of you.

You can see the effect of single-point perspective by looking along a train track that runs straight away from you into the distance. The two rails are, in reality, consistently spaced the same distance apart, but because they are resting on the ground plane, which is receding away from you, the rails appear to converge the further away they get, eventually meeting when they reach the vanishing point.

A similar effect can be seen when you are standing in a straight road and looking into the distance along a row of identical houses. Using straight perspective lines to extend the roof line, the gutters, the top and bottom of the windows and doors, you will see that they all meet at the same vanishing point.

Parallel lines receding away from the viewer ▼

In this simple illustration of one-point perspective the trees – which, in reality, are all of similar size – appear to get smaller the further away they are. All perspective lines above eye level run down to the vanishing point (VP) and all perspective lines below eye level run up to the vanishing point.

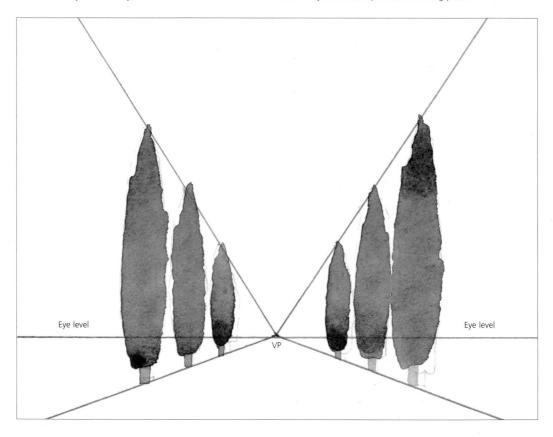

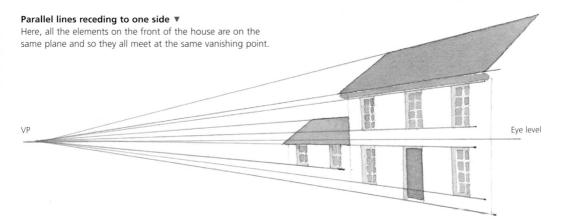

Subject below eye level ▼

As in the other examples shown on these two pages, a single vanishing point is all that is required in this view of a chess board, because the chess board is orientated with one side square to the viewer.

All the receding parallel lines on the board extend to the vanishing point. Because the board is below eye level, the

perspective lines run up to meet the vanishing point. The width of each row of squares is arrived at by measurement; the depth of the board is also measured. Drawing a diagonal line from corner to corner of the board will help you to work out the depth of each row of squares, as the corners of these squares have to fall on the diagonal line.

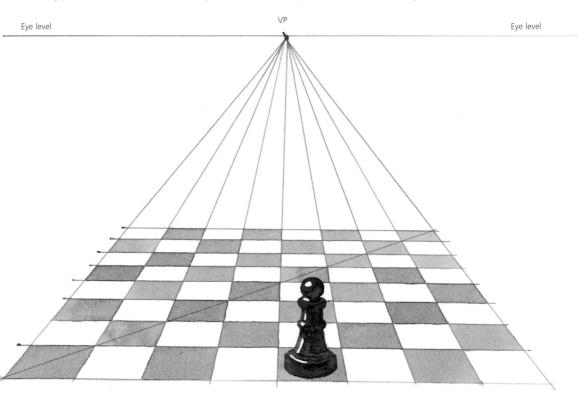

Two-point perspective

If any two sides of an object can be seen at the same time, then two-point perspective comes into play. The principle remains the same as that discussed in one-point perspective, but because two surfaces are visible and both surfaces are at different angles, any parallel lines on those surfaces will eventually meet at their own vanishing point.

In two-point perspective, neither vanishing point falls at your centre of vision. Perspective lines on the right-hand side will converge at a vanishing point off to the right and perspective lines on the left-hand side will converge at a vanishing point off to the left. Even if you move to a position that is higher than your subject, the horizon line on which any vanishing points are situated will still run across your field of

vision at eye level, so all perspective lines will run at an upwards angle to meet it. Similarly, if you move to a position below your subject, so that you are looking up at it, all perspective lines will run at a downwards angle to meet the horizon line.

Two planes visible – two-point perspective ▼

Two-point perspective needs to be taken into consideration when you can see two or three sides (planes) of a rectangular object at the same time. Here, we see two sides of a row of coloured boxes, all of which are orientated the same way. The perspective lines of each side of each box extend to the same vanishing point.

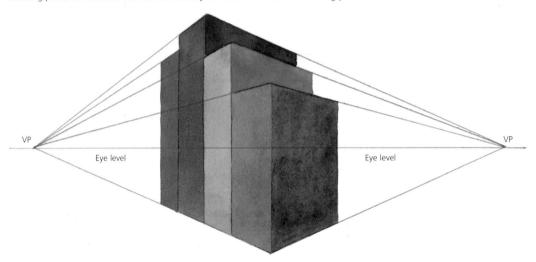

Multiple-point perspective

When several objects are arranged at different heights and angles, then multiple-point perspective comes into play. It looks a little more complicated, but the rules remain the

same. Each object needs to be treated as a separate entity and its vanishing points and perspective lines should be plotted accordingly.

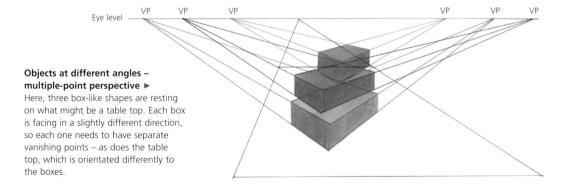

Drawing curved and circular objects in perspective

Understanding the principles of perspective enables you to represent not only simple box-like structures, as in the examples that we've looked at so far, but also highly complex-shaped objects that possess curved, as well as flat, surfaces.

Curved and circular objects become ellipses when they are seen in perspective. To draw them accurately, first work out the area they occupy using squares and rectangles, which are also in perspective.

1 First work out the area that the object (in this case, a cylinder) occupies, using simple squares or rectangles seen in perspective. Here the cylinder is viewed from directly in front and slightly above. A simple cube seen in single-point perspective indicates the position and approximate size of the cylinder.

2 Find the centre of the top of the cube by drawing lines from corner to corner. Further divide the top of the cube into quarters by drawing a line (A–B) parallel to the front of the cube through the centre point and by drawing another line (C) through the centre point to line up with the vanishing point (VP). Do the same to the base of the cube.

Prom point C on the front edge of the top of the cube, measure halfway to the corner (D). Drop a line at right angles to E, the same length as the measurement C–D. Position a compass point at C, with the radius set to E. Swing the compass from here to find points F. Draw a line from F to line up with the vanishing point (VP). Repeat on the base.

The exact curvature of the top of the cylinder is established by drawing a curved line to connect points A, B and C at point G – through the points where the line F–VP intersects the lines that run from corner to corner. Follow the same procedure to find the curvature at the bottom of the cylinder.

Composition

The way in which all the visual elements within a painting are put together is known as composition. The factors that govern composition include shape, scale, perspective, colour and texture. The purpose of composition is to manipulate and lead the eye while finding a pleasing visual balance of all these elements. Balance does not mean visual symmetry: shape can be offset with texture or colour with scale.

Composition can also be used to create mood. A composition can evoke feelings of heaviness and oppression, or be airy, light and uplifting. There are certain rules to composition, but breaking these rules often gives a work a certain edge that can lift it from the mundane and pedestrian into something much more eyecatching.

Formats

The first thing you need to consider is what shape (or format) to make your painting. The three main formats are vertical (also know as portrait), horizontal (also known as landscape) and square. Needless to say, portraits can be painted on landscape-format supports and landscapes on portrait ones. Two other formats that are often used are round (or oval) and a wider horizontal format known as panoramic.

Catching the light ▼

The roughly square format suits the subject perfectly: the neck and head curve around, balancing the bulk detail of the body.

A wide, panoramic format has been chosen for this painting of a robin on a branch. At first glance, it might seem that the subject is quite insignificant and does not warrant such an extreme format, but exaggerating the width of the painting has introduced a tension that would be lacking if the more usual landscape format had been used. The clever device of the arching branch, which runs the entire width of the image, prevents the picture from appearing one-sided: the eye wanders along it and across the picture, but always returns to the brilliant flash of red on the bird's breast.

Seaside steps ▶

The vertical format of this work again suits the subject. The eye is pulled along the length of the craft and up the steps towards the building. The golden yellow stonework pulls the eye down to the bottom of the picture and the circular journey begins again.

Etretat, Normandy ▼

The image of these cliffs in northern France sits comfortably in the horizontal format. The curve of the waterline sweeps the eye around to the cliffs and into the painting. At the base of the cliffs, the viewer's attention is caught by the dark ripples and reflection in the water; these in turn bring the eye down to the breaking waves and round again.

Dividing the picture area

The principle of good composition is that nothing should dominate to such an extent that it holds the viewer's attention completely and exclusively – although, of course, there are occasions when artists deliberately choose to do precisely that. Dividing the picture area up and deciding exactly what should go where can be difficult, but there are some general quidelines that will help you.

Over the centuries, artists have devised ways of positioning the main pictorial elements and focal points on an invisible grid around specific positions within the picture area. The classic compositional device, and the one that is considered to be the ideal division of an area and aesthetically superior to others, is based on the golden section – the term used for a mathematical formula devised by Euclid and developed by Plato. Also known as divine proportion, it states that a line or area can be divided so that the "smaller part is to the larger as the larger part is to the whole".

A simpler and less rigid grid, which is easier to follow and use, is made by splitting the picture area into thirds, regardless of the format chosen. This is done by simply dividing the image area into three, both horizontally and vertically, which

gives a grid consisting of nine sections, with lines crossing at four points. The theory is that positioning major elements of the image near these lines or at their intersections will result in a pleasing image. As with the golden section, the formula is a good starting point on which to base your compositions.

It is generally considered inadvisable to position your subject in the very centre of the picture area, as it makes for a rather static image. However, a feeling of calmness and inactivity are sometimes exactly what the subject requires. Be guided by your instincts, even if they sometimes appear to be going against the rules.

Beach, early morning ▼

This simple painting of a beach umbrella and sun loungers silhouetted in the early morning sun is firmly based on the rule of thirds. The umbrella provides a strong vertical element approximately a third of the way in from the right-hand side, while the shoreline and sun loungers provide a horizontal element approximately one third of the way up from the bottom of the picture. These dark shapes are balanced by the empty area of water.

The Tuileries, Paris A

The chairs and litter bin are the centre of interest and are loosely positioned on the intersecting grid lines to the right of the image while the top third of the painting is filled with row upon row of leafless trees. Together, they balance the empty space in the bottom left of the image.

Flamenco guitarist ▶

Although it is perhaps not immediately apparent, this portrait is also based around the rule of thirds. The head of the guitarist, the bulk of the guitar body, and the tuning head are all positioned at points where the grid lines intersect, while the figure's torso and the ornate pillar are placed a third of the way in from the left- and right-hand sides respectively.

Leading the eye

In a successful composition, the viewer's eye should be directed towards the image's centre of interest and encouraged to linger on the picture. Introducing curves and lines within the picture, either real or implied, are one way of doing this. Obvious examples of this might be a road leading up to a building, a river snaking its way through a landscape, or a line of trees receding into the distance.

All compositions are either "open" or "closed". A closed composition is one in which the eye is held within the picture area. It may be induced to move around from object to object, but essentially its focus is firmly held. An example of a closed composition might be a view from a dark interior through a window, with the window surround acting as a frame within a frame. An open gateway or tree trunks and branches might serve the same purpose. An open composition encourages the eye to move around the image, but also seems to suggest that the image continues well beyond the boundaries of the picture area. Many landscapes are perfect examples of open compositions.

Another strong compositional device, especially when painting landscapes, is the positioning of the horizon. This can have a profound effect on the mood of the image. Landscapes can be given extra impact by making the horizon very high within the picture area or even eliminating it altogether. Clouds can also be an important compositional consideration, providing large, eye-catching shapes in what might otherwise be an empty space.

Louvre Museum, Paris A

This is a good example of a closed composition. The eye is unavoidably pulled into the work past the sculpture and out the window into the centre of the image. The dark window surround acts as a visual barrier and encourages the eye to linger in the central area.

These weathered gate pillars act as a frame within a frame, drawing the eye through to the vineyard and buildings beyond. Because the pillars are placed centrally, the eye can move around within the rest of the painting. If they were placed closer to the edge of the image, the composition would seem more closed and confined.

Springs ▼

Rules are made to be broken. Placing the horizon line across the centre of an image is generally considered bad practice, but it can be made to work. Here, the strong sense of perspective leads the eye into the centre of the image.

The visual activity on the horizon line acts as a buffer, pushing the eyes out to either side. The bottom part of the image is roughly divided into thirds. The wide expanse of sky is broken by the row of telegraph poles.

Mont St Michel ▶

This is an example of both an open composition and breaking the so-called rules about where to position the horizon. The landscape and building are placed low in the picture area, with the horizon running across the image about a quarter of the way up. This has the effect of drawing attention to the sky, which is a featureless pale blue. One would not normally expect so much emphasis to be given to seemingly empty space, but in this instance the sheer size and weight of the sky provide a counterbalance to the visual activity in the lower part of the painting. The result is a powerful, atmospheric image that is possessed of a perfect spirit of place.

Watercolour Projects

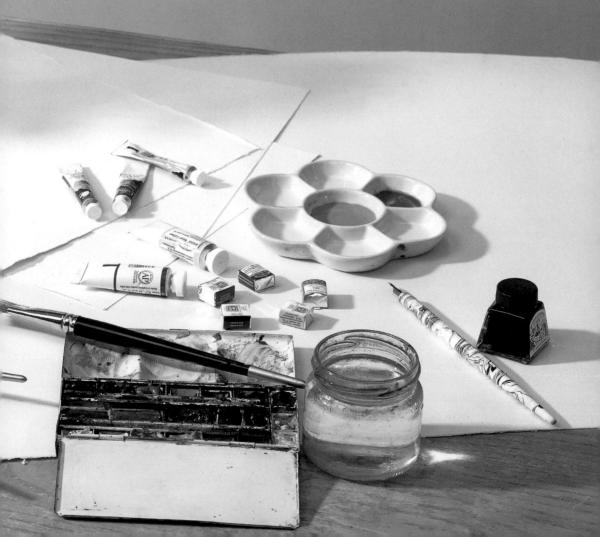

Painting Skies

Skies have always both fascinated and frustrated artists. The fascination comes from the infinite combinations of cloud formations and colours, which can change minute by minute depending on the weather conditions and the time of day, and the frustration from trying to decide on the most appropriate way in which to represent them.

Although skies can be painted as a subject in themselves, they are more commonly viewed as part of a landscape – and an important part, at that. It is from the sky that light comes to illuminate the landscape below, and the colour and mood of all landscapes are directly influenced by the sky above.

When you are painting a sky as part of a landscape, you must make sure that each looks connected and related to the other. The best way to achieve this is to make the sky an integral and important part of the overall composition. As with all things, however, you can exercise a degree of artistic licence. A dramatic and powerful sky can very easily overpower a less interesting landscape, so don't be afraid to alter the balance from what you can actually see in reality.

Although the use of colour is important, particularly when you are painting sunsets, the most critical elements in any sky scene are the cloud formations. Getting to know cloud formations is a useful step towards painting skies well. Artists who paint skies frequently tend to make practice studies of the clouds before they begin.

Beginners often make the mistake of depicting clouds as flat objects against a background of blue, but the reality is very different. Clouds have a top (which the light hits), sides, and a bottom (which is often in deep shadow). They also conform to the laws of perspective, and appear smaller with less distinct colours as they stretch to the horizon. Applying the rules of aerial perspective to clouds can throw up an anomaly, however, for while skies are usually more intense and warmer in colour immediately overhead, becoming cooler and paler nearer the horizon, the exact reverse can be seen on occasions particularly when looking out to sea, or in large cities with atmospheric pollution.

There are several techniques that you can use to paint clouds successfully. The sky colour and cloud positions might be made using wet-into-wet washes. Cloud shapes can be left as white paper or lifted out using a paper towel or a dry brush. As these washes dry, darker washes can be flooded on to create the parts of the clouds that are in shadow, with more washes being painted over the top to strengthen colour or redefine shapes when the first washes are dry.

Alternatively, you could paint the sky using only wet on dry washes, assessing the colour and tone of each so that the shape and colour of the clouds are built up in layers. Avoid hard edges, which look

out of place in a sky scene. Cloud edges can be softened periodically by using clean water and a brush or by blotting with a natural sponge or paper towel.

The Thames at Richmond ▼

In this expansive view, the landscape and the sky are of equal importance. Placing the horizon on the halfway mark is risky, but the image works because the carefully arranged cloud formations balance the intricate landscape. The clouds were created by means of carefully planned wet on dry washes. The blue colour in the sky was painted last, with the cloud shapes being "cut out" as it was applied.

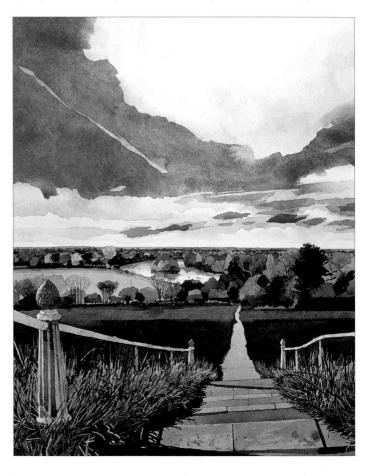

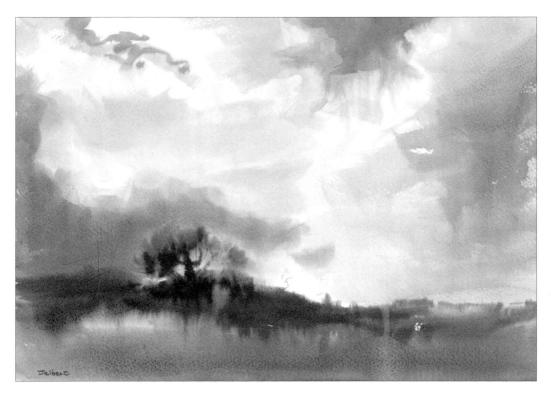

Storm clouds A

This loose impression of storm clouds gathering in a pale grey sky uses the same colours as the dark, wet landscape below. Washes were applied wet into wet in order to give a feeling of indistinct focus, which is often apparent in falling rain.

- **Tips**: Use clouds to balance dominant elements in the landscape.
- Take care not to make clear blue skies dominate your landscapes as, without clouds to add interest, such skies tend to look flat and boring.
- Remember that skies and clouds conform to the same laws of perspective as the land. As a general rule, colours get paler the nearer they are to the horizon, with clouds becoming smaller and less distinct.
- Practise painting various wash and cloud combinations. Only by knowing what your materials can do and how they behave will you be free to concentrate on creating the effects you want.

Sunset ▼

A gradated pale blue wash provided the foundation for this sunset. The pale orange strip of light on the horizon takes on an added brilliance seen against the dark landscape and the deep grey clouds above.

Clouds at sunset

The presence of a few clouds in the sky almost always adds to the drama of a sunset, as the clouds pick up reflected light and add textural interest that might otherwise be lacking.

This project is an excuse to have fun and to play around with wet-into-wet washes to see what effects you can create. Although the wet-into-wet technique is perfect for depicting the gradual transitions of colour that you find in a sunset, it is also notoriously unpredictable. Different papers give different effects, and the degree of wetness also plays an important part. Knowing how wet the paper should be to create a particular effect is something that comes with practice, so don't despair if things initially turn out very differently from what you'd expected. Instead of aiming for a photo-realistic rendition, with every cloud and subtle tonal change in exactly the "right" place, use the scene as a starting point for your explorations: let the flowing paint do the work and adapt your ideas as you go, responding to the shapes and colours that emerge.

Include a hint of the land beneath in a sunset painting, even if it's just a tiny sliver at the very base of the picture. This anchors the image and provides a context for the visual feast above.

Materials

- 140lb (300gsm) rough watercolour paper, pre-stretched
- Watercolour paints: cobalt blue, cerulean blue, cadmium yellow, cadmium red, alizarin crimson, ultramarine violet
- · Brushes: large round
- Sponge

The original scene

Pinks, oranges and violets; glowering clouds fringed with a pure and intense light: a sunset guaranteed to take away the breath of even the most hardened cynic! Clouds like these, with dramatic contrasts of light and dark, are generally much more interesting than fluffy white clouds in a brilliant blue sky.

Reflected light on these clouds provides a much-needed "lift" of colour.

These brooding clouds dominate the scene and add textural interest.

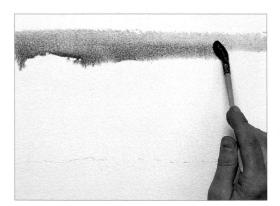

1 Using a large round brush, dampen the paper with clean water, leaving a few areas untouched. Mix a deep blue from cobalt blue and a little cerulean blue and lay a gradated wash, fading to almost nothing and stopping about halfway down the paper.

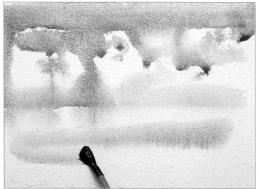

2 Mix a pale orange from cadmium yellow and a little cadmium red. Using a large round brush, wash this mixture over the lower half of the painting and dot it into the sky, where the setting sun catches the top of some of the cloud formations.

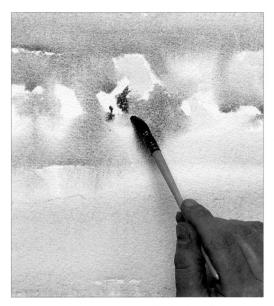

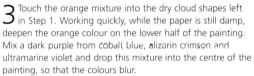

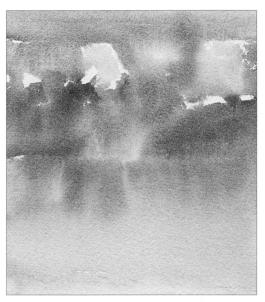

Add more purple across the middle of the painting, going into both the blue and the orange areas, to establish the dark bank of cloud that runs across the centre of the image. Leave to dry completely before moving on to the next stage.

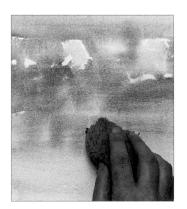

5 Dip a sponge in water, squeeze out any excess water and stroke it across the top half of the paper.

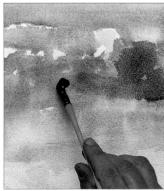

6 Using a large round brush, touch the purple mixture used in Step 3 into the dark clouds at the top.

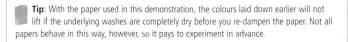

Jusing the same paint mixtures as before, continue touching colour into damp areas, allowing it to spread and find its own way. Watch what happens rather than starting out with preconceived ideas: you will find that the paint suggests shapes that you can then strengthen and make an integral part of the painting.

The finished painting

This is an expressive painting, with subtle shifts from one colour to another, which demonstrates one of the main attributes of watercolour – its translucency – to the full. Although it is not a painstaking copy of the original scene, it nonetheless captures the quality of the light and the sense of rapidly changing lighting conditions very well.

The artist has exploited the unpredictability of the wet-intowet technique by responding to changes as they occur on the paper, and so the painting has a lovely sense of freshness and spontaneity. At the same time he has paid careful attention to the light and dark areas so that the clouds really do look three-dimensional.

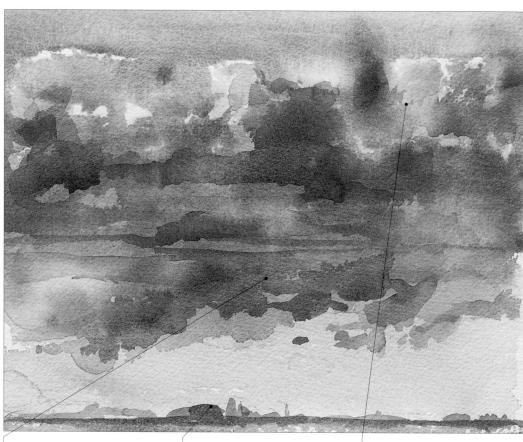

Successive wet-into-wet applications build up depth of tone.

Silhouetted shapes on the horizon anchor the scene.

The rough surface of the paper also helps to add textural interest.

Variation: Clouds at sunset painted on smooth paper

The same scene painted on smooth paper gives a rather different result. In the previous painting, the rough texture of the paper played an important role. In this painting, however, the smooth surface means that there is a more uniform band of colour across the top of the image. The paint also behaves

differently on smooth paper: although this scene was also painted by dropping colour wet into wet, there are a number of hard-edged rings. It is impossible to say that one type of surface is better than the other for this type of work: it is entirely down to personal preference.

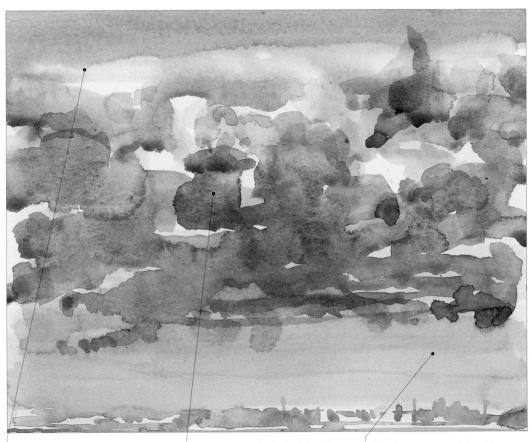

Allowing some of the initial wash to show through is an effective technique for skies.

The paint goes on smoothly, and the paper texture is less evident.

Storm clouds and rainbow

Watercolour is a wonderful medium for painting clouds. The translucency of the paint enables you to create a feeling of light and air, while wet-into-wet washes are perfect for creating subtle transitions from one colour to another.

One of the most important things to remember is that you need to make your clouds look like solid, three-dimensional forms, not just wispy trails of vapour in the sky. Clouds have a top, a bottom and a side. The top usually faces the sun and is therefore lighter than the side and the bottom. Before you start painting, work out which direction the light is coming from so that you can decide which areas of cloud are in shadow and need to be darker in tone

Make sure that any changes in tone are very gradual. You can soften colours where necessary by lifting off paint with a piece of kitchen paper or a sponge, but try to avoid hard edges at all costs.

The rules of perspective that apply to painting land also apply to painting the sky, and clouds that are further away will appear smaller than those that are immediately overhead. They will also be lighter in tone.

In this project, dramatic banks of cumulus cloud before an evening storm are the focus of interest and the land below is almost an irrelevance. Although the land is so dark that relatively little detail is visible, it is an important part of the picture, as it provides a context for the scene and an anchor for the panting as a whole. In any landscape, the sky must relate to the land beneath and so you need to continually assess the tonal balance between the two.

Materials

- 2B pencil
- 140lb (300gsm) rough watercolour paper
- Watercolour paints: yellow ochre, cadmium lemon, sap green, raw umber, ultramarine blue, cadmium yellow, Prussian blue, cadmium red, burnt sienna, alizarin crimson, viridian
- Brushes: medium round, fine round, large wash
- Kitchen paper

The original scene

This is a dramatic and unusual sky. Although the clouds and rainbow provide the main focus of interest, the low-angled early evening sunlight picks out enough detail on the land to relieve the monotony of the dark foreground.

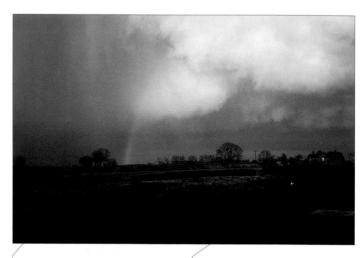

Silhouetted tree shapes provide a visual link between sky and ground.

Low-angled sunlight picks out the house and a patch of the foreground field.

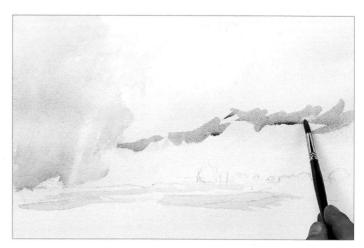

1 Using a 2B pencil, outline the tree shapes on the horizon. Mix a very pale wash of yellow ochre and, using a medium round brush, loosely brush it over the sky, leaving gaps for the lightest areas. Mix cadmium lemon and sap green and brush the mixture over the lightest areas of the fields. Mix a dilute wash of dark brown from raw umber and a touch of ultramarine blue and brush it on to the clouds in the top left of the picture. Add more ultramarine blue to the brown mixture and brush loose strokes over the base of the clouds on the right.

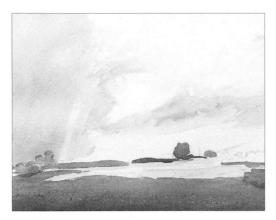

2 While the sky is still damp, add more raw umber to the mixture and brush short calligraphic strokes over the clouds to delineate the lower edges, dabbing some of the paint off with kitchen paper to soften the edges. Mix a dark olive green from cadmium yellow and ultramarine blue and block in the dark areas of the foreground and the silhouetted shapes on the horizon.

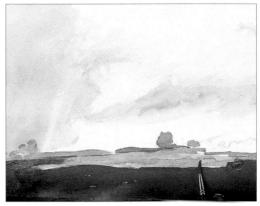

While the foreground is still damp, mix a bluish green from cadmium yellow, ultramarine blue and Prussian blue and brush it over the foreground to darken it. Mix a warm yellowish green from cadmium lemon and cadmium red with a little ultramarine and brush the mixture over the brightest areas of the fields, which are illuminated by shafts of low-angled evening sunlight.

4 Finish blocking in the silhouettes on the skyline. Mix an orangey red from cadmium red and yellow ochre and, using a medium round brush, block in the shape of the distant house.

Tip: The only details you need on the house are the roof and walls. The rules of perspective make further detail, such as windows, unneessary.

Assessment time

With the addition of a hint of blue sky and the dark hedge that marks the boundary between the house and the field, the painting is really starting to take shape. The foreground is very dark, and so the next stage is to work on the sky so that the picture has a better overall balance.

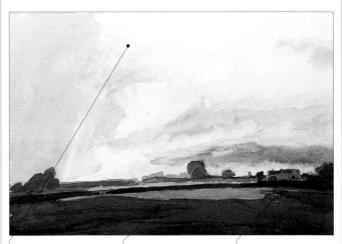

The sky is too pale to hold any interest.

The foreground is uppressively dark; the sky needs to be much stronger to balance it. Note how the red house immediately attracts the eye, even though it occupies only a small area.

5 Mix a rich, dark brown from ultramarine blue and burnt sienna. Using a large wash brush, loosely scrub it into the left-hand side of the sky, leaving a gap for the rainbow and dabbing off paint with kitchen paper to soften the edges. Note how this creates interesting streaks in the sky.

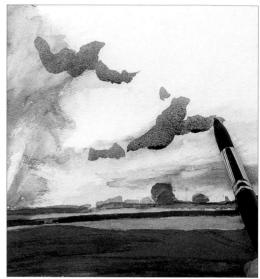

Ousing the same colour, make a series of short calligraphic strokes on the sky at the base of the clouds. The clouds are lit from above, so giving them dark bases helps to establish a sense of form. Brush yellow ochre on to the sky above the dark clouds.

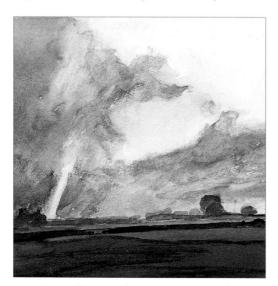

7 Again, dab off paint with kitchen paper to get rid of any obvious brushstrokes and create interesting streaks and wispy textures in the clouds. The clouds should look as if they are swirling overhead, their brooding presence dominating the entire scene.

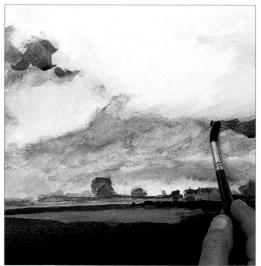

Ousing a darker version of the mixture, darken the clouds again so that the sky has more impact. You need to continually assess the tones in a painting like this, as an alteration to one area can disrupt the tonal balance of the painting as a whole.

Pinally, paint the rainbow, using a very fine round brush and long, confident strokes. There is no distinct demarcation between one colour and the next, so it doesn't matter if the colours merge. If you do want to boost any of the colours, allow the paint to dry and then strengthen the colours with a second application.

The finished painting

This is a bold and dramatic interpretation of glowering storm clouds. In the sky, the paint is applied in thin, transparent layers, softened in places by dabbing off paint with kitchen paper, and the white of the paper is allowed to show through, creating a wonderful feeling of luminosity. The land below, in contrast, is solid and dark and forms a complete counterpoint to the rapidly moving clouds above

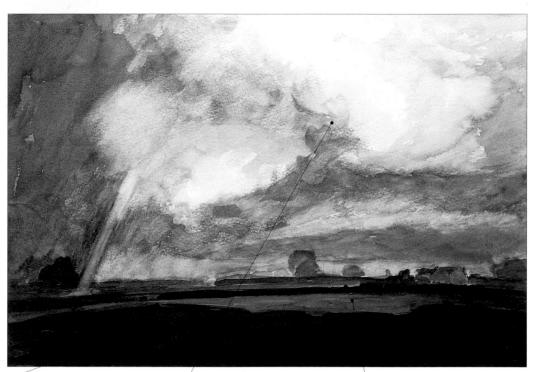

Successive layers of colour applied quite thickly in the foreground create a feeling of solidity.

The clouds have an airy texture, achieved by applying the paint wet into wet and then dabbing it off with kitchen paper.

A shaft of warm, evening sunlight leads the viewer's eye across the painting.

Painting Water

Watercolour is, by its very nature, the perfect material for painting water. Its fluidity and transparency, and its habit of puddling, pooling and generally behaving in an unpredictable way, are characteristics that can be used to great effect.

The colour and appearance of water are heavily influenced by the predominant

weather conditions, the reflected colours and shapes in the environment, and the colours of any rocks, sand or vegetation seen beneath the surface. The sea is blue because it reflects the sky, for example, while a pond deep in the woods looks deep and foreboding because it reflects the dark foliage of the surrounding trees.

Several watercolour techniques are particularly suited to painting water. Broad wash techniques, using as large a brush as possible, should be used to paint large expanses of water. Washes can be worked wet on wet to suggest subtle colour changes, or wet on dry to suggest wave or ripple shapes or reflected objects and colours.

Broken colour techniques using a dry brush dragged across rough paper give the impression of ripples or dappled sunlight. Scraping back into wet paint, using a cut-off piece of card or one of the purpose-made rubber paint shapers, is a particularly good way of representing ripples, especially on smooth, hot-pressed paper. Highlights in the water can be created by scratching back to reveal white paper or by applying masking fluid prior to making any washes.

Tips: • Always follow the rules of perspective. Waves of equal size will appear smaller the further away from you they are, while colour becomes less intense and cooler and detail is less evident.

 Note how objects in the water are slightly distorted due to the way light waves are refracted. The colours of objects reflected in water are generally less intense and more subdued than the colours of the objects themselves.

■ Waterfall

White body colour was applied using a mixture of fluid wash and drybrush techniques to capture the light catching on the falling water as it tumbles over rocks and boulders. The stones and boulders were painted using a texture paste to give them added form.

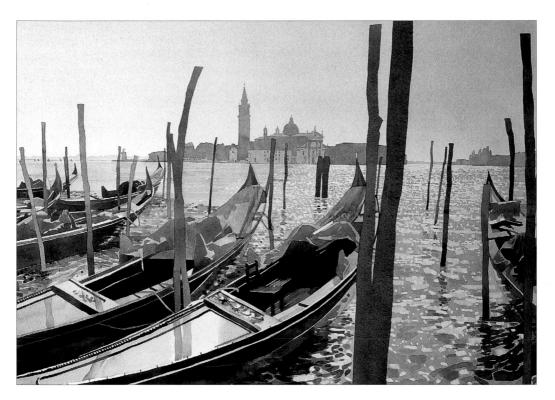

8 a.m., Venice Lagoon A

This painting, made as the early-morning light highlighted the ripples on the water, uses carefully applied wet-on-dry washes. The dappled sunlight on the water surface was created by applying masking fluid prior to making any washes. Colours were kept crisp and clean by using no more than three overlapping washes. Note how the ripples conform to the laws of perspective by getting smaller as they get closer to the horizon.

■ Willows

Wet-into-wet washes lay the foundation and general shape of the reflections of these riverside trees. Wet-on-dry washes define the shapes further, while a little linear brush and coloured pencil work hint at a slight breeze rippling the almost still surface.

Tip: Choose a surface to complement the subject. A rough sea will look rougher if painted on a rough-surface paper, while a smooth, hot-pressed paper is ideal for a painting of a tranquil, mirror-like pond.

Woodland waterfall

Waterfalls offer particular challenges to watercolour artists. Not only do you have to paint a liquid that lacks any real colour of its own but takes its colour from its surroundings, but you also need to make that liquid look wet and convey a sense of how quickly it is moving.

As always, the key is to try to convey an overall impression, rather than get caught up in attempting to recreate life, and paint every single water droplet and leaf. Before you start painting, and even before you make your first preliminary sketch, stop and think about what it is that appeals to you in the scene. Is it the intensity of the rushing water or the sunlight sparkling on the water surface? Is the waterfall itself the most important feature or are the surroundings just as interesting? This will help you to decide on the main focus of interest in your painting - and armed with this knowledge, you can decide how best to tackle the painting as a whole.

In real life, all your senses come into play: you can hear the water cascading down and feel the dappled sunlight on your face. In a painting, however, you have to convey these qualities through visual means alone. Sometimes this means you need to exaggerate certain aspects in order to get the message across—making the spray more dramatic, perhaps, or altering the composition to remove distracting features or make interesting ones more prominent.

Materials

- B pencil
- Tracing paper
- 140lb (300gsm) NOT watercolour paper, pre-stretched
- Watercolour paints: cadmium lemon, phthalocyanine green, Payne's grey, burnt sienna, phthalocyanine blue, alizarin crimson
- Brushes: large round, fine round, medium wash, old brush for masking fluid
- Masking fluid
- · Low-tack masking tape
- Drawing paper to make mask
- Household candle
- Gum arabic

The original scene

Although the scene is attractive, the lighting is flat and the colours dull. Here, the artist decided he needed to increase the contrast between light and shade. To do this, you need to carefully work out which areas will be hit by light from above and which will be in shadow. He also increased the size of the pool below the waterfall: paradoxically, the waterfall itself has more impact if it is surrounded by calmer areas.

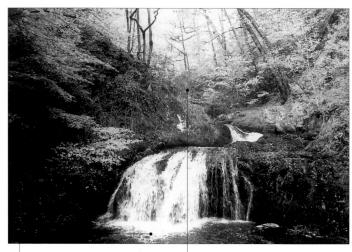

The waterfall ends too near the bottom of the frame

The colours are very subdued. Increasing the contrast between light and shade will make the painting more interesting.

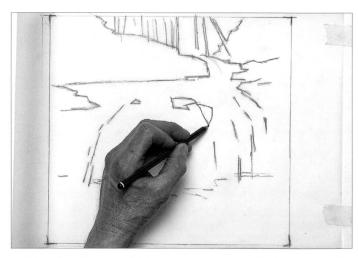

1 Using a B pencil, make a sketch on tracing paper to establish the main lines of your subject and work out the size and shape of your painting. When you are happy with the result, transfer your tracing on to pre-stretched watercolour paper.

2 Place a sheet of white drawing paper between the watercolour paper and the tracing paper and draw around the waterfall area. Cut out the shape of the waterfall and place it in position on the watercolour paper as a mask, fixing it in place with low-tack masking tape. Gently rub a household candle over the area of water below the waterfall, keeping the strokes very loose. This will preserve some of the white of the paper and add an interesting texture.

3 Using an old brush, apply masking fluid over the white lines of the waterfall. Leave to dry.

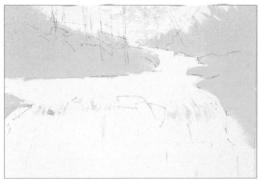

Apply masking fluid to the bright highlight area of sky at the top of the picture area and leave to dry. Using a large round brush, brush clean water over the trees. Mix a strong wash of cadmium lemon and brush it over all the damp areas. Leave to dry.

5 Mask off the water area with paper. Mix a mid-toned green from cadmium lemon and a little phthalocyanine green. Holding a fine round brush at the same angle at which the branches grow, spatter water across the top of the picture. Spatter the damp area with green paint. Leave to dry.

Continue spattering first with water and then with the green mixture of phthalocyanine green and cadmium lemon, as in Step 5, until you achieve the right density of tone in the trees. Leave each application of spattering to dry completely before you apply the next one.

Tip: Spattering clean water on to the paper first, before you spatter on the paint mixture, means that the paint will spread and blur on the wet paper. If you spatter the paint on to dry paper, you will create crisply defined blobs of colour — a very different effect.

Add Payne's grey to the phthalocyanine green and cadmium lemon mixture and, using a fine brush, put in the very dark tones along the water's edge in order to define the edge of the river bank.

O Using your fingertips, gently rub and peel the masking fluid off the sky area. The sky area is very bright in comparison with the rest of the scene, and so it is important to reserve these light areas in the early part of the painting – even though they will be toned down very slightly in the later stages.

Susing a fine brush, brush burnt sienna between the leaves adjoining the dark spattered areas. Mix a rich brown from burnt sienna and Payne's grey and paint the tree trunks and branches. Leave to dry.

Assessment time

The surrounding woodland is now almost complete. Before you go any further, make sure you've put in as much detail as you want here. The water takes its colour from what's reflected in it. Because of this it is essential that you establish the scenery around the waterfall before you begin to put in any of the water detail.

The line of the riverbank is crisply painted, establishing the course of the river.

The rocks in the waterfall have been marked in pencil, providing an underlying structure for the scene.

10 Using masking fluid, mask the long strokes of white that cascade down from the waterfall into the pool below. Leave to dry. Using a medium wash brush, brush clean water horizontally across the top of the water above the waterfall. Brush a little gum arabic on to the damp area. Keeping the brush fairly dry in order to control the colour, brush vertical strokes of phthalocyanine blue mixed with a little alizarin crimson and burnt sienna on to the damp area.

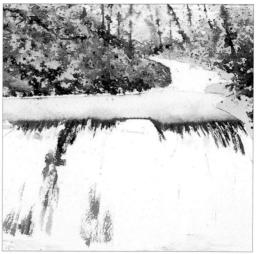

1 1 Brush straight lines of Payne's grey across the top of the waterfall to denote the edge over which the water topples. Mix Payne's grey with phthalocyanine blue and brush on to the waterfall itself, using a drybrush technique. On the lower part of the fall, make the marks longer and rougher to indicate the increased speed of the water. Leave to dry.

12 Re-wet the pool above the fall. Using a fine, round brush, touch cadmium lemon into the damp area. Dab on vertical strokes of cadmium lemon, burnt sienna, and phthalocyanine green for the tree trunk reflections. The colours will merge together and the fact that they are blurred helps to convey the wetness of the water.

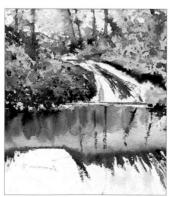

13 Brush burnt sicning mixed with Payne's grey on to the cascade of water than runs into the pool.

Tip: By applying clean water to the surface before you paint, the strokes diffuse and blur, giving soft blends rather than hard-edged streaks of colour.

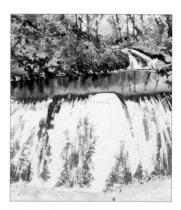

14 Working from the hottom of the waterfall upwards, brush a mixture of Payne's grey and phthalocyanine blue into the waterfall Note how the texture of the candle wax shows through. Keep the brush quite dry, dabbing off excess paint on kitchen paper, if necessary. Add a little alizarin crimson to the mixture for the darker water at the base of the fall.

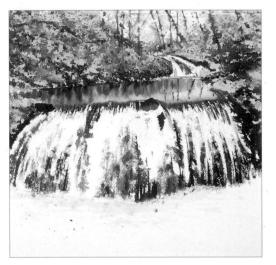

 $15\,$ Paint the rocks under the waterfall in a mixture of Payne's grey, phthalocyanine blue and a little alizarin crimson. Use the same mixture to paint more rocks poking up through the foam of the water. Drybrush water along the left and right edges of the painting and apply the rock colour – again with an almost dry brush. The paint will spread down into the damp area.

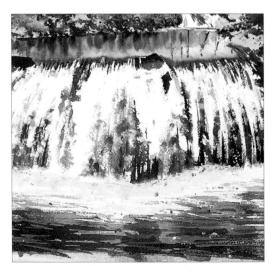

17 Using a large brush and a darker version of the phthalocyanine blue and Payne's grey mixture, paint the dark area at the base of the pool with bold, zigzag-shaped brushstrokes. Leave to dry.

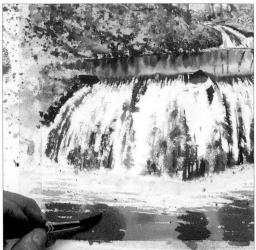

16 Stipple little dots of masking fluid on to the base of the pool below the waterfall for the white bubbles of foam. Leave to dry. Apply a light wash of phthalocyanine blue mixed with a little Payne's grey over the pool below the waterfall, brushing the paint on with loose, horizontal strokes. While the paint is still damp, run in a few darker vertical lines of the same mixture. Leave to dry.

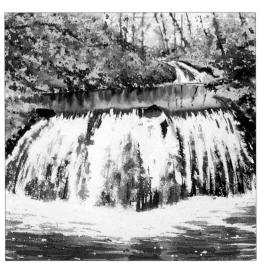

18 Using your fingertips, gently rub off the masking fluid on the lower half of the painting. Stand back and assess the tonal values of the painting as a whole. If the exposed area looks too white and stark, you may need to touch in some colour in the water areas to redress the overall balance of the scene.

The finished painting

This is a very lively rendition of a waterfall in full spate, which conveys the mood and atmosphere of the scene rather than capturing every leaf and twig in painstaking detail. Much of

the paper is left white, in order to convey the full force of the rushing water. The painting has a stronger feeling of light and shade than the original photo, and hence more impact.

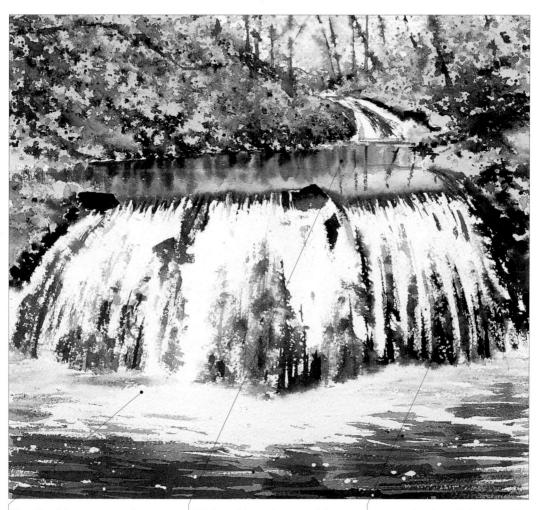

The white of the paper conveys the cascading, foaming water.

\$k||ful use of the wet into wot technique has allowed colours to merge on the paper, creating realistic-looking reflections.

Longer brushstrokes in the lower part of the Waterfall Help to create an impression of movement in the water.

Crashing waves

This project depicts a massive sea wave just as it is about to break over craggy rocks. Your challenge is to capture the energy and power of the scene.

Few people would go as far in their search for realism as the great landscape artist J.M.W. Turner, who is reputed to have tied himself to a ship's mast in order to experience the full force of a storm at sea. Fortunately, there are easier and less perilous ways of adding drama to your seascapes.

The first thing to think about is your viewpoint. Construct your painting as if you are viewing the scene from a low viewpoint, so that the waves seem to tower above you.

For maximum drama, capture the waves while they are building or when they are at their peak, just before they break and come crashing down. You can gauge the height of the waves by comparing them with nearby rocks or clifftops, while including such features in your painting will provide you with both a focal point and a sense of scale.

Try to attune yourself to the sea's natural rhythms. Watch the ebb and flow of the waves and concentrate on holding the memory of this rhythm in your mind as you are painting. This will help you to capture the energy of the scene.

Finally, remember that water takes its colour from objects in and around it. You may be surprised at how many different colours there are in a scene like this.

Materials

- 4B pencil
- 140lb (300gsm) NOT watercolour paper, pre-stretched
- Watercolour paints: Payne's grey, phthalocyanine blue, cadmium yellow, lemon yellow, Hooker's green, cerulean blue, yellow ochre, raw sienna, sepia, violet, burnt sienna, cobalt blue
- Gouache paints: permanent white
- Brushes: medium round, fine round
- · Mixing or palette knife
- Fine texture paste
- · Ruling drawing pen
- Masking fluid
- Sponge

The original scene

It is notoriously difficult to photograph a breaking wave at exactly the right moment, and so the artist used this photograph merely to remind herself of the energy of the scene and the shapes and colours.

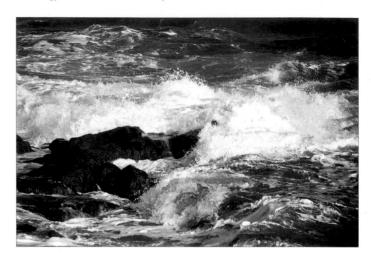

Reference sketches

Tonal sketches are a very good way of working out the light and dark areas of the scene. You will find that it helps to think of the waves as solid, three-dimensional objects, with a light and a shaded side. Try several versions so that you get used to the way the waves break over the rocks.

1 Using a 4B pencil, lightly sketch the scene, putting in the foreground rocks and the main waves. Take time to get the angles of the waves right: it is vital that they look as if they are travelling at speed and are just about to come crashing down.

2 Using a palette knife, apply fine texture paste over the rocks. Leave to dry. (Texture paste is available in several grades; the coarser it is, the more pronounced the effect. Here, the wave is more important than the rocks, so fine texture paste is sufficient).

Using a ruling drawing pen, apply masking fluid over the crest of the main wave and dot in flecks and swirls of foam in the water. Using a small sponge, dab masking fluid on to selected areas of the sea to create softer foamy areas. Leave to dry.

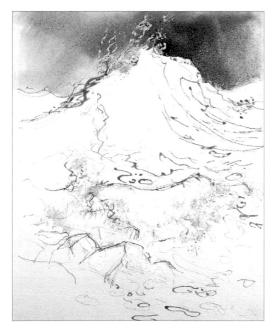

A Mix a mid-toned wash of Payne's grey and another of phthalocyanine blue. Dampen the sky area with clean water and brush Payne's grey on to the right-hand side and phthalocyanine blue on to the left-hand side. Leave to dry.

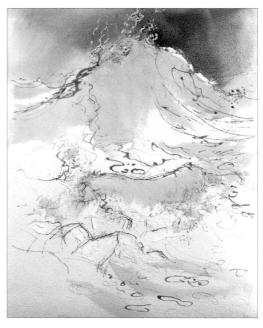

 $5\,$ Mix a strong wash of cadmium yellow with a touch of lemon yellow. Dampen the waves with clean water and lightly brush the bright yellow paint mixture over the tops of the waves.

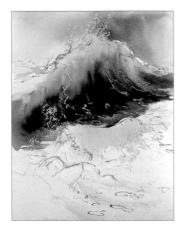

6 While the first wash is still wet, brush Hooker's green into the yellow so that the colours merge together. Mix a darker green from Hooker's green, phthalocyanine blue and a little cadmium yellow and brush this mixture into the lower part of the waves, feathering the mixture up into the yellow so that the colours blend imperceptibly on the paper. Brush over this darker green several times to build up the necessary density of tone.

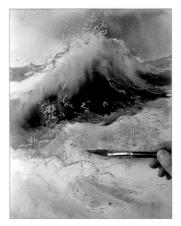

Mix a dark blue from phthalocyanine blue and cerulean blue and brush this mixture into the lower part of the large wave, feathering the colour upwards. Because the previous washes are still wet the colours spread and merge together on the paper, building up darker tones without completely blocking out the underlying colours. Use loose, swift brushstrokes and try to capture the energy and power of the sea.

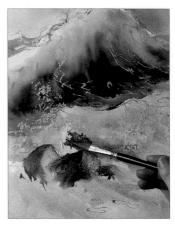

8 Mix a mid-toned wash of yellow ochre and brush it over the texture paste on the rocks, adding raw sienna and sepia for the dark foreground.

Tip: Allow the colour to "drift" into the sea so that it looks as if the sea is washing over the rocks. Unless you do this the rocks will simply look as if they are floating on the water.

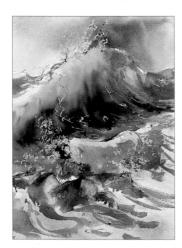

Mix a greyish blue from violet and Hooker's green. Brush little touches of this colour into the waves and into the pools at the base of the rocks, making swirling brushstrokes to help convey the movement of the water.

10 Using the dark green mixture from Step 6 and the brown used on the rocks, put a few dark accents into the waves. Soften the brushstrokes by brushing them with clean water to blend them into the other wave colours.

11 When you are sure that the paint is completely dry, gently rub off the masking fluid with your fingertips to reveal the foaming crests of the waves and the spattered highlights on the water.

Assessment time

Now that all the masking fluid has been removed, you can see how effectively the white of the paper has been reserved for the swirls and flecks of foam in the sea. However, these areas now look glaringly white and stark: they need to be toned down so that they become an integral part of the scene. However, you will need to take great care not to lose the very free, spontaneous nature of the swirling lines or the water will start to look too static and overworked. The contrast between the light and the very dark areas also needs to be strengthened a little in order to give a better feeling of the volume of the waves.

The exposed areas are much too bright.

The colours work well in this area, but there is not enough of a sense of the direction in which the water is moving.

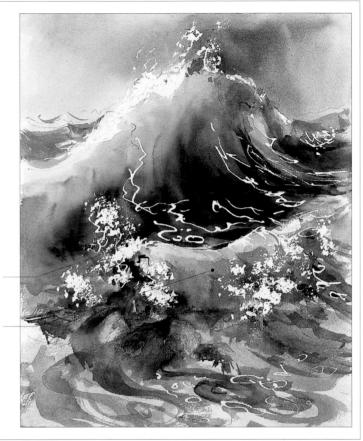

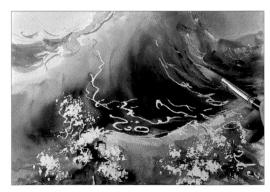

 $12\,$ Mix an opaque mauve from permanent white gouache, violet and a tiny touch of burnt sienna. Brush this mixture under the crest of the main wave, so that it looks like shadows under the very bright, white foam.

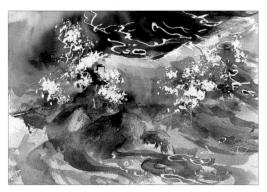

13 The exposed white areas look too stark against the dark colours of the water and rocks. Mix a very pale opaque blue from cobalt blue and permanent white gouache and cover up the exposed swirls of white in the water.

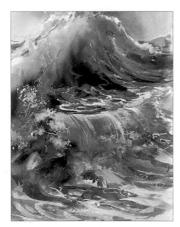

14 Soften the harsh markings by brushing over more of the cobalt blue and gouache mixture. Paint some swirls of white gouache at the base of the main wave. Putting a little opaque colour into the water helps to give it some solidity.

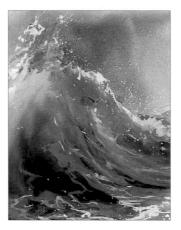

15 Spatter a few specks of white gouache above the crest of the wave for the flecks of foam that fly into the air. Don't overdo it: too much gouache could easily overpower the light, translucent watercolour washes that you've worked so hard to create.

16 Spatter a few specks of the cobalt blue and white gouache mixture above the rocks. (This area is very dark and pure white gouache would look too stark.)

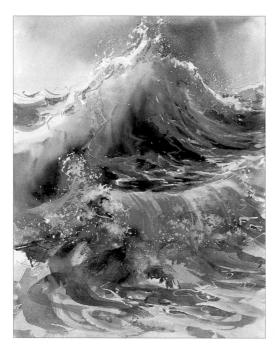

17 Stand back from the painting and assess the tonal values. You may find that you need to darken some of the colours in the centre of the painting.

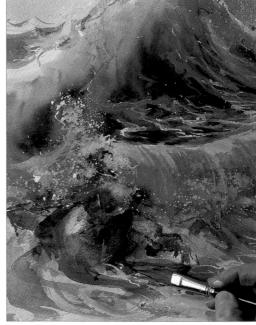

 18° Using the same dark brown mixture as before, build up the tones on the rocks. They need to stand out from the water that surrounds them.

The finished painting

This is a dramatic and carefully observed painting that captures the energy of the scene to perfection. Note the many different tones in the water and the way the

brushstrokes echo the motion of the waves. The rocks provide solidity and a sense of scale, but do not detract from the large wave that is hurtling forwards.

Spattering is the perfect technique for depicting foam-flecked waves.

Dark tones in this area contrast with the light edge of the breaking wave and help to give it volume.

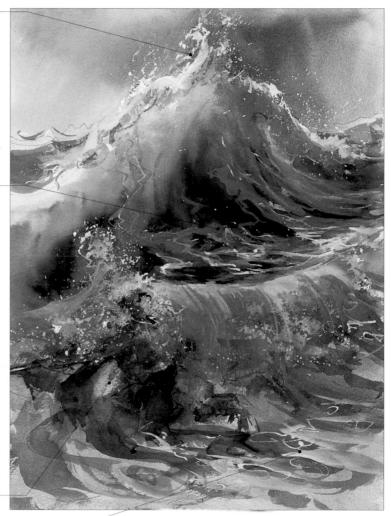

The rocks provide a necessary point of solidity in the scene.

Loose, swirling brushstrokes capture the motion of the sea.

Lake with reflections

Who could resist the bright, sunny colours of this lakeside scene in the heat of the summer, with its reflections of hillsides covered in trees? Any artist would be happy to while away a few hours sketching and painting in such a tranquil setting.

However, straightforward symmetrical reflections can sometimes look a little boring and predictable, so look out for other things that will add interest to your paintings. Sweeping curves, such as the foreshore on the right in this scene, help to lead the viewer's eye through the picture, while interesting textures are always a bonus.

This project also provides you with the challenge of painting partially submerged objects. Here you need to think about the rules of perspective: remember that things look paler and smaller the further away they are. As an added complication, the way that water refracts lights also distorts the shape of submerged objects. Trust your eyes and paint what you see, rather than assuming you know what shape things actually are.

Materials

- B pencil
- · Tracing paper
- 140lb (300gsm) NOT watercolour paper, pre-stretched
- Watercolour paints: alizarin crimson, Naples yellow, phthalocyanine blue, phthalocyanine green, burnt sienna, French ultramarine, Payne's grey, quinacridone magenta
- Brushes: medium round, fine round, old brush for masking fluid
- Masking fluid
- Gum arabic
- Kitchen paper

Tip: Leave the tracing paper attached to one side of the watercolour paper, so that you can flip it back over if necessary during the painting process and reaffirm any lines and shapes that have been covered by paint.

The original scene

You can almost feel the heat of the sun when you look at this photograph of a lake in southern Spain. The foreshore and hillside are dry and dusty, while the lake itself appears to be slowly evaporating, exposing rocks in the shallows. Because of the angle at which the photograph was taken, the colours are actually less intense than they were in real life. The artist decided to exaggerate the colours slightly to emphasize the feeling of heat.

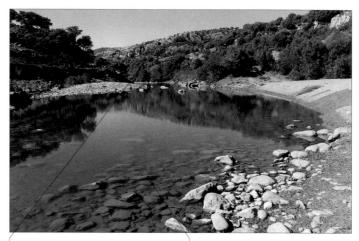

The distant mountains are muted in colour and will benefit from being made more intense in the painting.

Much of the foreground is made up of submerged stones. You could put some exposed stones in this area to add interest.

1 Using a B pencil, make an initial sketch on tracing paper to establish the main lines of your subject. When you are happy with the result, trace your sketch on to pre-stretched watercolour paper. Using an old brush, apply masking fluid to some of the large foreground stones. Leave to dry.

Mix alizarin crimson with a little Naples yellow and, using a medium round brush, brush the mixture over the mountains and up into the sky. Leave to dry. Mix a bright blue from phthalocyanine blue and a little phthalocyanine green. Dampen the sky with clear water and, while the paper is still wet, brush on the blue mixture, stopping along the ridge and drawing the colour down into the mountains. Leave to dry.

 $3^{\rm Mix}$ a mid-toned orangey brown from Naples yellow and burnt sienna, and paint the dry and dusty foreshore of the lake, dropping in more burnt sienna for the darker areas. Leave to dry.

A Mix a purplish grey from burnt sienna, French ultramarine and alizarin crimson. Using a fine round brush, brush clean water across the mountains and then brush on marks of the grey mixture. Leave to dry.

5 Make up more of the burnt sienna and Naples yellow mixture and, using a medium round brush, paint the arid, sandy background on the top right of the painting. While this area is still wet, mix an olive green from phthalocyanine green, burnt sienna and a little Naples yellow and, using a medium round brush, paint in the loose shapes of trees and bushes. Paint the shadow areas in the trees in the same purplish grey mix used in Step 4. Leave to dry.

6 Paint more trees on the left-hand side of the painting in the same way. Brush clean water across the sky. Mix Payne's grey with a little phthalocyanine green and, using the tip of the brush, dot this mixture into the damp sky area to denote the trees that stand out above the skyline. The colour will blur slightly. Leave to dry.

Zusing a B pencil, map out a few more stones on the shoreline. Mix a warm brown from burnt sienna and French ultramarine and brush in on to the foreground, working around the stones. Add more French ultramarine to the mixture and paint shadows around the edges of the stones to establish a three-dimensional effect. Leave to dry.

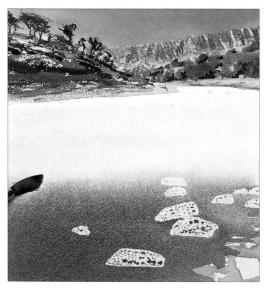

8 Brush clean water over the lake area. Mix burnt sienna with a little quinacridone magenta and, using a medium round brush, wash this mixture loosely over the shallow foreground of the lake, where partially submerged stones are clearly visible.

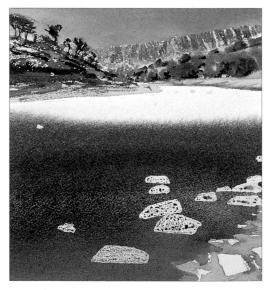

9 While the lake is still damp, brush phthalocyanine blue over the centre of the lake, adding a little quinacridone magenta as you work down over the stones in the foreground. Apply a second layer of the same colours over the same area and leave to dry.

Assessment time

Wet the blank area at the top of the lake and brush gum arabic on to the damp area. Using a fine brush, brush on vertical strokes of Naples yellow, burnt sienna, quinacridone magenta mixed with French ultramarine, and the olive green mixture used in Step 5. Leave to dry.

With the reflections in place, the painting is nearing its final stages. All that remains to be done is to put in some of the fine detail. Step back and think carefully about how you are going to do this. Far from making the painting look more realistic, too much detail would actually detract from the fresh, spontaneous quality of the overall scene.

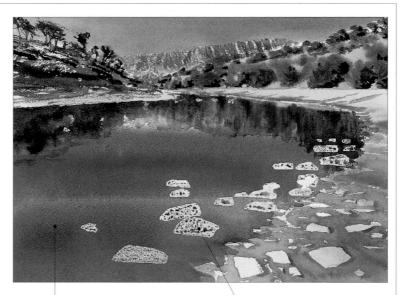

This area lacks visual interest. Adding submerged stones here will indicate both the clarity of the water and how shallow it is at this point.

These stones look as if they're floating on the surface of the water.

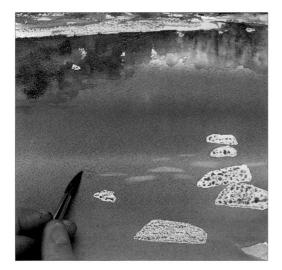

 10° Dip a medium round brush in clean water and gently lift off the flattened, elongated shapes of underwater stones, varying the sizes. You may need to stroke the brush backwards and forwards several times on the paper in order to loosen the paint.

11 As you lift off each shape, dab the area firmly with clean kitchen paper to remove any excess water. Turn and re-fold the kitchen paper each time you use it, to prevent the risk of dabbing paint back on.

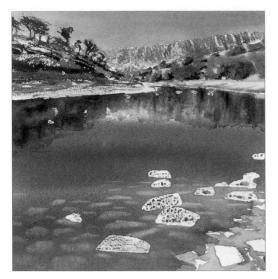

12 The submerged stones in the foreground of the lake add visual interest to what would otherwise be a dull, blank area of the scene, but as yet they do not look three-dimensional. The large stones above the surface of the water and on the shoreline also need more texture if they are to look convincing.

13 Mix a dark brown shadow colour from burnt sienna and French ultramarine and, using a medium round brush, use this mixture to loosely paint the shadows underneath the submerged stones. This makes the stones look three-dimensional and allows them to stand out more clearly from the base of the lake. It also adds texture to the base of the lake. Leave to dry.

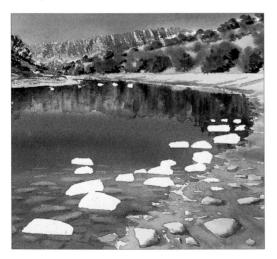

14 Using a fine brush, wet the area at the base of the reflection and touch in a mixture of French ultramarine and alizarin crimson to soften the edges. Mix burnt sienna with a little French ultramarine and use it to touch in the shadows under the largest rocks on the shoreline. Leave to dry. Using your fingertips, gently rub off the masking fluid.

15 Using a fine, almost dry brush, brush water over the exposed rocks and then drop in a very pale wash of burnt sienna. Leave to dry. Drybrush a darker mixture of burnt sienna on to the rocks in places, for dark accents. To make the rocks look more three-dimensional, stroke on a little French ultramarine for the shadow areas.

This is a truly inviting image. The lake looks so realistic that you want to dabble your toes in it, while the feeling of heat is almost tangible.

The artist's skilful use of complementary colours (the bright blue of the sky set against the rich orangey brown of the stones and earth) has helped to create a really vibrant painting. Textural details, such as the dry brushwork on the rocks and the distant trees painted wet into wet, are subtle but effective, while the careful blending of colours in the reflections conveys the stillness of the water perfectly. The composition is simple, but the foreshore leads the eye in a sweeping curve right through the painting.

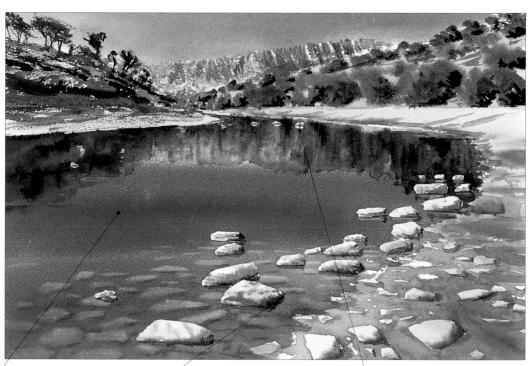

The lake is not a uniform blue throughout, but takes its colour from the objects that are reflected in it, as well as from the visible shallow areas.

The easiest way to paint the reflection of the small rocks in the distance is simply to paint a thin line of burnt sienna right through the middle.

Harbour moorings

Ports and harbours are a never-ending source of inspiration for artists. The scene is constantly moving as the tide ebbs and flows, and the changing seasons bring different weather and lighting conditions. Reflections in the water, patterns in the sand, and countless details from boat masts to barnacles: there are thousands of things to stir the imagination. It's not just a visual feast: the sound of lapping water and squawking gulls, and the smell of seaweed combine to make this one of the most satisfying of all subjects to paint.

The key is to plan ahead and think about what you want to convey. Harbours are busy places, with lots of things going on and a host of fascinating details and textures to distract the eye, and you will almost invariably need to simplify things when you're painting. Decide on your main focus of interest and construct your painting around it. You may find that you need to alter the position of certain elements within the picture space, or to subdue some details that draw attention away from the main subject and place more emphasis on others.

This particular project uses a wide range of classic watercolour techniques to create a timeless scene of a working harbour at low tide. Pay attention to the reflections and the way the light catches the water: these are what will make the painted scene come to life, and there is no better medium for these transient effects of the light than watercolour.

Materials

- 4B graphite pencil
- 140lb (300gsm) NOT watercolour paper, pre-stretched
- Watercolour paints: cadmium orange, Naples yellow, phthalocyanine blue, cerulean blue, permanent rose, raw sienna, ultramarine blue, burnt umber, cadmium red, burnt sienna, light red
- · Gouache paints: permanent white
- Brushes: old brush for masking,
 1in (2.5cm) hake, small round,
 medium filbert, fine filbert, fine rigger
- Masking fluid
- Masking tape
- Plastic ruler or straightedge

The original scene

The tilted boats, wet sand and textures on the harbour wall all have the potential to make an interesting painting, but the sky and water are a little bland and there is no real focus of interest.

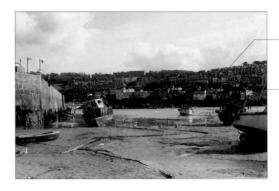

The town on the far side of the estuary is a little distracting.

The boats form a straight line across the image; it is unclear where the main focus of interest lies.

Preliminary sketch

The artist decided to make more of the water in his painting, introducing reflections that were not there in real life. He made this preliminary charcoal sketch to work out the tonal values of the scene. He then decided that the boats were too close together and that the scene was too cramped. In his final version, therefore, he widened the image so that the right-hand boat was further away; he also introduced two figures walking across the sand to provide a sense of scale.

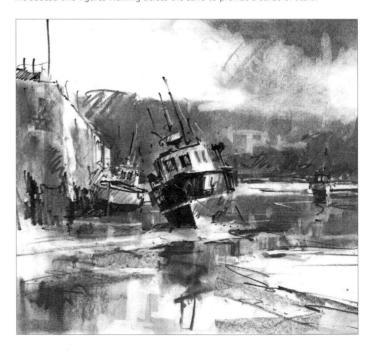

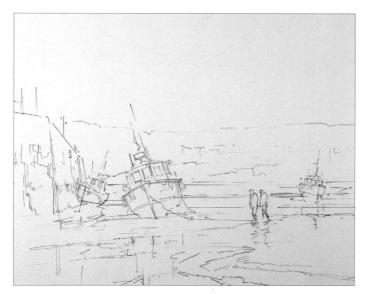

1 Using a 4B graphite pencil, sketch the scene, putting in the outlines of the harbour wall, distant hill, boats and figures and indicating the different bands of sand and water in the foreground.

2 Using an old brush, apply masking fluid over the foreground water and the brightly lit right-hand side of the main boat to protect the highlight areas that you want to remain white in the finished painting. To get fine, straight lines, place a plastic ruler or straightedge on its side, rest the ferrule of the brush on top and gently glide the brush along.

3 Spaller a little masking fluid over the foreground of the scene to suggest some random texture and highlights in the sand and water. Be careful not to overdo it as you need no more than a hint of the sun glinting on these areas.

A Mix a pale orange from cadmium orange and Naples yellow. Wet the sky in places with clean water. Using a hake brush, wash the orange mixture over the left-hand side of the sky and phthalocyanine blue over the right-hand side, leaving some gaps for clouds.

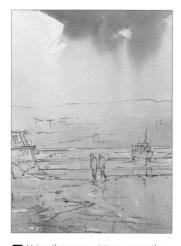

5 Using the same mixtures, carry the sky colours down into the water and sand, paying careful attention to the colours of the reflections in these areas. The warm colours used in the sky and sand set the mood for the rest of the painting.

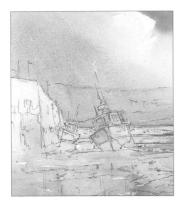

6 Mix a dilute wash of pale greyish purple from cerulean blue and a little permanent rose. Wet selected areas of the sky with clean water so that the colours will merge on the paper. Using the hake brush, wash the mixture over the darkest areas of cloud on the left-hand side of the sky and bring the colour down into the background hills and water. Darken this greyish purple mixture by adding more pigment to it and start putting a little colour on the shaded side of the largest boat in the scene.

7 Using the same mixture of cerulean blue and permanent rose, continue building up washes on the sides of the largest boat.

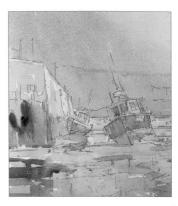

Barken the harbour wall with a wash of cadmium orange mixed with Naples yellow. While still wet, drop in a mixture of phthalocyanine blue and a little raw sienna. Paint the reflections of the harbour wall in the wet sand. Apply a little cerulean blue to the main boat and the one behind it.

Tip: Do not make the wall too dark at this stage: assess how strong it should be in relation to the background.

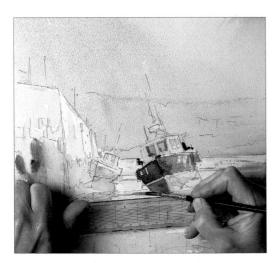

Outramarine blue, burnt umber and a little cadmium red to the main boat. Mix a purplish grey from cerulean blue and permanent rose and, using a ruler or straightedge as in Step 2, paint the shadow under the main boat. Leave to dry.

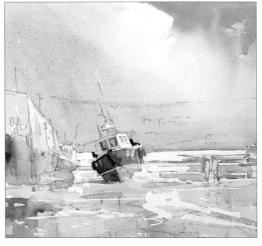

10 Using your fingertips, gently rub off the masking fluid to reveal the highlights on the water and sand.

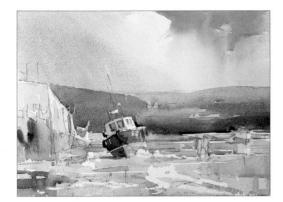

1 1 Apply further washes, wet into wet, over the hill in the background of the scene so that the colours fuse together on the paper, using ultramarine blue and light red, with a touch of raw sienna for the dark areas in the middle distance. Continue building up the tones of the reflections and intensify the colour of the water by adding a little cerulean blue with a touch of Naples yellow.

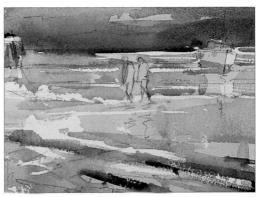

12 To add more texture to the ridges of sand in the foreground, apply strokes of burnt sienna straight from the tube, lightly stroking an almost dry medium filbert brush over the dry painting surface. This allows the paint to catch on the raised tooth of the paper, creating expressive broken marks that are equally suitable for depicting the sparkle of light on the water.

Assessment time

The basic structure of the painting is now in place. There are four principal planes – the sky, the landscape on the far side of the river which has put some solidity into the centre of the picture, the boat and harbour wall (the principal

centre of interest in the painting), and the immediate foreground, which is structured to lead the eye up to the boat. Now you need to tie everything together in terms of tones and colours.

All the boats need to be strengthened, as they are the main interest in the painting.

The land is not sufficiently well separated from the estuary area.

More texture and depth of tone are needed on the harbour wall to hold the viewer's eye within the picture area.

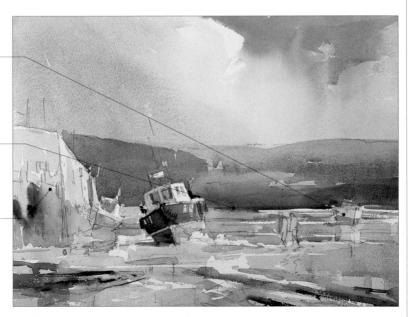

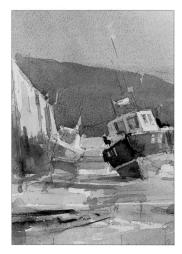

13 Now you can begin gradually to build up the washes to achieve the correct tonal values. Darken the harbour wall, using the original mixture of cadmium orange and a touch of raw sienna and build up the sandy area immediately in front of the main boat with the same mixture.

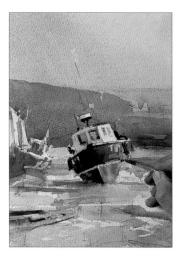

14 Using a small round brush and a dark mixture of ultramarine blue and light red, put in some of the detail on the boats.

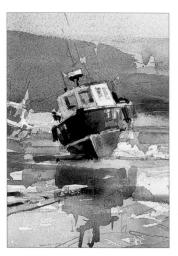

15 Now concentrate on the reflections of the boats, using colours similar to those used in the original washes. Do not to make the reflections too opaque. Keep these washes watery and as simple as possible. Use vertical brushstrokes so that they look more like reflections.

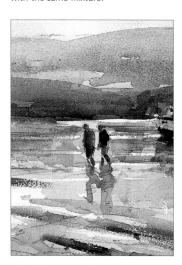

16 Mix a warm blue from cerulean blue, permanent rose and a touch of burnt umber and put in the two figures and their reflections.

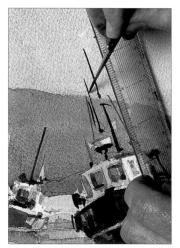

17 Using a fine rigger brush and resting the ferrule on a plastic ruler or straightedge, as in Step 2, put in the masts on the main boat in a mixture of ultramarine blue and light red and the rigging in a paler mixture of cerulean blue and permanent rose.

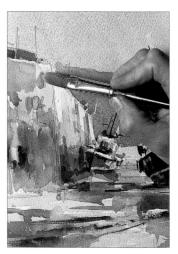

18 Using a filbert brush and the original mixture of cadmium orange and a little permanent rose, darken the stonework on the harbour wall. These uneven applications of colour give the wall texture and make it look more realistic.

The finished painting

This project brings together a range of classic watercolour techniques – wet into wet, building up layers of colour, using masking fluid to preserve the highlights, drybrush work – to create a lively painting that captures the atmosphere of the scene beautifully. The background is deliberately subdued in

order to focus attention on the moorings. The main subject (the largest boat) is positioned at the intersection of the thirds, with the diagonal line of the sand directing the viewer's eye towards it. The different elements of the scene are perfectly balanced in terms of tone and composition.

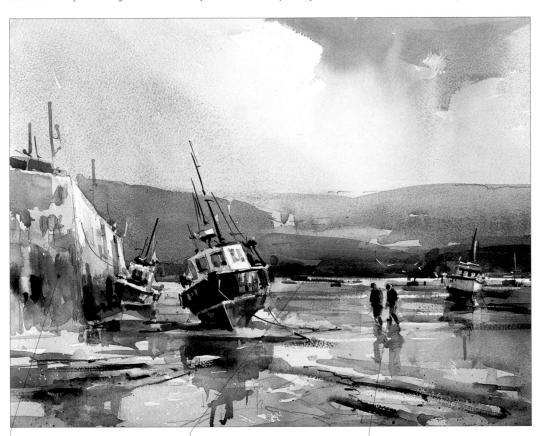

The harbour wall is painted wet into wet to create muted but interesting colours and textures.

The town in the original scene has been replaced by an atmospheric blend of colours that suggests wooded hills.

The two walking figures introduce human interest to the scene and provide a sense of scale.

Painting Trees

It is virtually impossible to paint landscapes without painting trees as they feature heavily, even in many urban views. Trees add texture, colour and pattern, and they provide an important vertical element that often cuts startlingly across or through a work, dividing the picture area and drastically affecting the composition.

The most common mistake when painting trees is to make them all look the same. Even trees of the same species can look surprisingly different to each other, with no two trees growing in exactly the same way.

Trees are complex objects and not the easiest of things to draw or paint well. The best way to approach the subject is to simplify it, so that you paint the underlying structure and general shape of the tree before adding any detail. All trees can be seen as simple shapes which are either rounded, rectangular, columnar or pointed

in their overall shape. The underlying structure is best seen in winter, when trees are devoid of leaves. The skeletal network of limbs, branches and twigs shows how the trees grow upwards and outwards from the roots and central trunk.

Although you can paint foliage as blocks of colour, you should remember that trees are composed of thousands upon thousands of delicately shaped individul leaves. Do not attempt to paint every leaf, but pay attention to the broken edge quality of the tree shape and carefully depict any spaces that you see between the leaves and branches, where the sky becomes visible.

Colour is another very important consideration. Foliage is not always green, nor are tree trunks always brown. Silver, yellow, orange, red and even purple foliage can be found, and the colour of trunks and stems can vary just as much.

A number of watercolour techniques are especially useful when painting trees. Drybrush is perfect for painting the texture on bark, as are sgraffito and linear marks made using a pencil or a fine brush. Broken colour techniques are particularly successful for foliage: try using natural sponges to gently dab a second colour over dry washes.

Winter trees ▼

The initial scene was established using wet-into-wet washes. Once these had dried, further washes were applied to bring out the intricate forms and pattern of the crossing jumble of gnarled branches and the shadows they cast across the trunk. The shadow of the tree seen coming in from the bottom of the picture is a compositional device, indicating that things do not end at the picture edge.

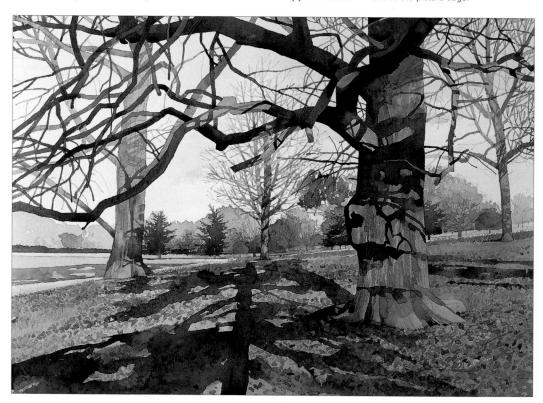

Autumn beech tree ▼

The fine linear textures on the trunk of this beech tree were made by applying masking fluid with a pen. The same technique was used for some of the fine branches.

The foliage colour was flooded on using orange, yellows and browns applied wet into wet, while the foliage texture was achieved by sprinkling rock salt onto the wet paint.

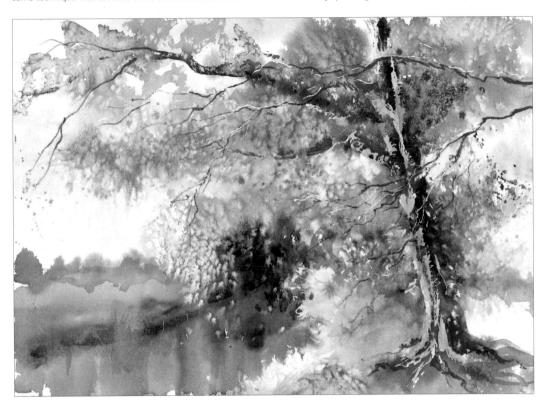

Cedar tree ▶

This delicate painting carefully observes the way the branches spread and fall in layers around the thick central trunk. Painted using a fine brush and wet-on-dry washes, the foliage colours consist of only three tones of the same silver-green colour.

- **Tips:** Study the tree's growth habit and break it down into a simple basic shape. Establish the overall shape of the tree before adding surface detail.
- Use drying marks where paint has puddled and dried at different speeds to suggest clumps of foliage.
- Experiment with textural techniques like wax resists, sponging, and using rock salt.
- Instead of using colours straight from the paint box, mix greens and other tree colours: the results will look far more natural and subtle.

Woodland in spring

Green is, without any doubt, the most important colour in the landscape artist's paint palette. Once you start to look, it is astonishing how many different shades there are, from the bright, almost acidic greens of fresh spring growth through to muted tones of olive and sage.

Although a quick glance through any paint manufacturer's catalogue will reveal a wide range of ready-made greens, it is quite unusual to find one that suits your needs exactly, and you almost always have to modify commercial colours or mix your own. This project, of a spring woodland in the late-afternoon sunlight, gives you the opportunity to do precisely that.

So that you build on what you learn here, make a point of painting different types of woodland: a coniferous forest, for example, tends to contain darker greens than the deciduous woodland shown here. It is a good idea to keep a note of the paint colours used in successful colour mixes so that you can easily recreate them at a later date.

The time of year makes a difference, too. At the height of summer, you will find that leaves are larger and darker than they are in spring, and the tree canopy is more dense, making it harder for light to penetrate through to the woodland floor. In a deciduous woodland in winter, on the other hand, the trees will have lost their leaves and so it will be much easier to see the underlying shapes and structure of different tree types.

The direction and angle of the light also affects the shade of green: the same leaves can look completely different in colour depending on whether the sun is to one side or behind. A single back-lit leaf, with the veins clearly visible, can make an interesting watercolour study in its own right.

Materials

- 2B pencil
- 90lb (185gsm) rough watercolour paper, pre-stretched
- Watercolour paints: cadmium red, yellow ochre, lemon yellow, alizarin crimson, phthalocyanine blue, cobalt blue, raw umber
- · Brushes: Chinese

The original scene

This photograph captures the essence of the scene – the slender trees and dappled light – but there is no real focus of interest. The artist decided to make one tree more prominent by bringing it forwards. This breaks the straight line across the centre of the image and allows the viewer's eye to weave in and out of the trees.

The trees form a straight line across the picture and appear to merge together.

Bright, wide shafts of sunlight indicate that the tree canopy is not very dense.

1 Using a 2B pencil, lightly sketch the scene, putting in the trunks of the main trees and indicating some of the clumps of grass alongside the track.

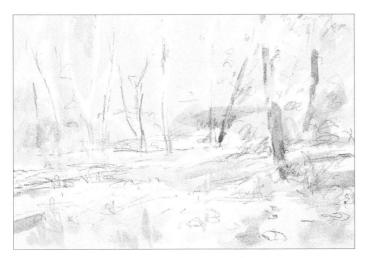

 $2\,$ Mix a pale golden brown from cadmium red and yellow ochre. Using a Chinese brush, loosely brush the mixture on to the trunks of the main foreground trees and the pebbly track to establish the warm undertones of the painting. Mix a pale wash of lemon yellow and brush it over the foliage area as a base colour, leaving some gaps for where the brightest patches of sky show through. Add a little more pigment to the wash as you get closer to ground level, as not as much light reaches this area. Brush the same lemon yellow wash loosely over the clumps of grasses in the foreground. Leave to dry.

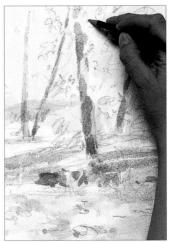

3 Mix a warm purplish grey from alizarin crimson and phthalocyanine blue and brush it over the shaded areas of the track. Paint the tree trunks with the same mixture. Mix a warm brown from yellow ochre and cadmium red and paint the larger stones on the track. Using a 2B pencil, lightly sketch in the leaf masses on the trees.

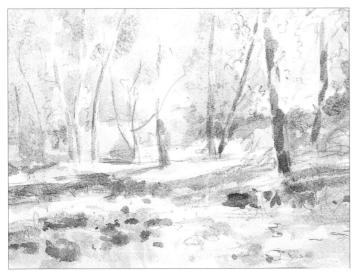

4 Mix a cool green from lemon yellow and cobalt blue and brush in the mid-tone foliage areas. Take care not to obliterate all the very lightest foliage areas that you applied in Step 2, otherwise you will lose the feeling of dappled light and fresh spring growth in the image.

5 Mix a dark green from lemon yellow and phthalocyanine blue and paint the grasses growing under the trees, using short vertical strokes.

Tip: When painting foliage and grasses, try to make your strokes follow the direction of growth.

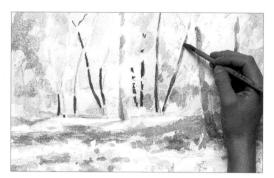

6 Add more phthalocyanine blue to the mixture and dab it over the foliage for the darkest greens. Strengthen the tree trunks, using the same grey mixture as in Step 3. Mix a dark brown from phthalocyanine blue, alizarin crimson and raw umber, and paint the shaded sides of the tree trunks, cutting in and out of the foliage masses.

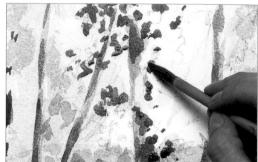

Put in the darker tones of the main foreground tree, using the same mixture. Mix a bright, dark green from phthalocyanine blue and raw umber and dot in the darker foliage tones on the foreground trees. It is important to have more detail in the foreground, as it is closer to the viewer, while impressionistic blurs will suffice in the background.

Assessment time

The woodland scene is beginning to take shape but the details are still relatively indistinct and much more needs to be done to separate the foreground elements from the background. When you move on to the next stage, make sure you don't concentrate on one area at the expense of the rest. Work across the painting as a whole, standing back every now and then to assess the tonal values and compositional balance.

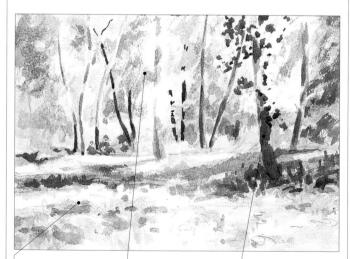

The foreground shadows need to be strengthened to enhance the feeling of dappled light coming through the trees.

The background is all of a similar tone. As a result, there is not a strong enough sense of depth in the image.

The main tree is beginning to stand out from the background, but more detail is still needed here.

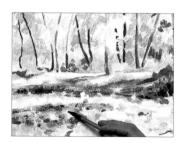

Strengthen the shadow colour on the track, using the same alizarin crimson and phthalocyanine blue mixture as before. Add more alizarin crimson and put in some thin trunks on the left of the painting. Using a blue-biased mixture of alizarin crimson and phthalocyanine blue, start dotting in some dark pebbles on the track.

9 Some of the foliage areas look very light. Dot in a mid-toned green to tone down the brightness a little.

The finished painting

With its bright, fresh greens and dappled light, this painting is suffused with a wonderful feeling of spring sunlight. The painter has used a little artistic licence to make the composition more dynamic than it was in real life: one tree

has been placed at the intersection of the thirds to provide a focus of interest, and the straight line of trees has been staggered in order to encourage the viewer's eye to move around the whole picture.

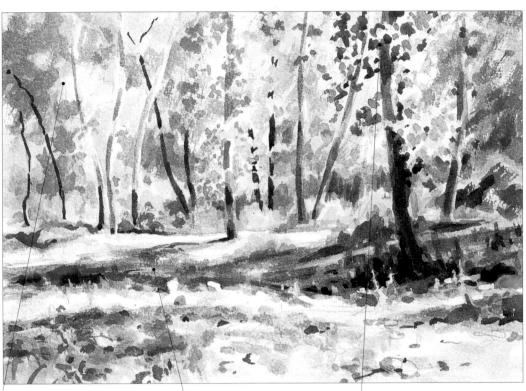

Soft, pale colours and a lack of detail imply that this area of the scene is further away from the viewer.

Long shadows lead the viewer's eye through the scene and indicate low-angled afternoon sunlight.

Crisp leaf detail helps to separate this tree from those in the background, where the foliage is much less distinct.

Autumn tree

Many trees are at their most dramatic in the autumn, when the leaves change from green to dazzling displays of reds, russets and golds. Combine those colours with early-morning mists, as in this scene, and you will have the makings of a very atmospheric painting.

When you are painting trees, always start by establishing the overall shape. The oak tree in this project has a spreading habit: the branches radiate outwards from the main trunk, while the crown is rounded and reasonably symmetrical. When trees are in leaf the underlying "skeleton" can sometimes be hidden from view, but you need to be aware of it. The leaves do not simply sit on top of the branches in clumps; they are attached to branches and twigs, and you must convey a sense of the shapes underneath and the directions in which the branches and twigs grow, even if you cannot see them clearly, in order for your painting to look convincing.

Because the sunlight in this scene is coming from behind the tree, the tree itself is in semi-silhouette. However, the light does catch the edge of the tree branches in places, creating warm wisps of colour against the dark branches and trunk. Pay careful attention to these highlights and look for areas where shafts of sunlight break through.

Textures, too, are important. Although you cannot see much detail because the tree is in semi-silhouette, the gnarled trunk is an essential part of the tree's character. Here, water-soluble pencils were used to establish a base texture that was then overlaid with watercolour washes.

Materials

- 4B pencil
- 140lb (300gsm) NOT watercolour paper, pre-stretched
- · Water-soluble pencils: sepia
- Watercolour paints: cadmium yellow, burnt sienna, alizarin crimson, cobalt blue, sepia, violet
- Gouache paints: neutral grey, permanent white
- Brushes: medium round, small round
- Ruling drawing pen
- Masking fluid

Preliminary sketch

The artist made a quick colour sketch in situ to work out the overall shape of the tree and which colours to use for the vibrant autumn leaves.

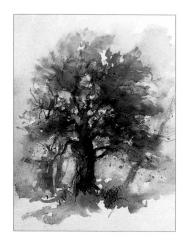

1 Using a 4B pencil, lightly sketch the scene, putting in the main branches of the tree. Look carefully at how they twist and overlap.

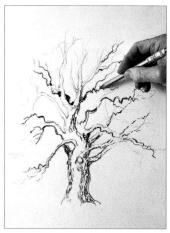

2 Dip the tip of a sepia water-soluble pencil in water and put in the dark textural markings of the gnarled trunk and the main branches. (Dipping the pencil in water intensifies the colour and makes the marks more permanent, so that this linear pencil work is still visible when the watercolour washes are applied to the tree in the later stages of the painting.)

3 Using a ruling drawing pen, apply masking fluid to the highlighted edges of the branches and the foreground grasses. Leave to dry completely. The masking is subtle, but it plays an important role in establishing a sense of light and shade.

A Mix a pale wash of cadmium yellow and wash it over the background behind the tree and the foreground grasses. Dot some of the same cadmium yellow mixture into the branches to establish the lightest-coloured foliage areas.

5 Wet the tree with clean water and touch in burnt sienna, dabbing it on with the side of the brush. The colour will spread over the damp paper and merge with the yellow applied in Step 4. Apply several layers wet into wet, in some places, to deepen the tones.

6 While the burnt sienna washes are still wet, drop alizarin crimson into the lower branches, angling your brushstrokes in the direction in which the branches and leaves naturally grow. The richness of the autumnal colours is now starting to develop. Leave to dry.

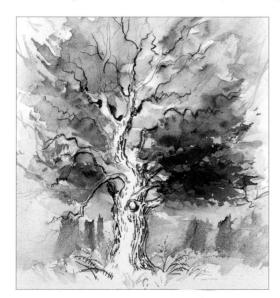

Wash around the edges of the tree and into the negative spaces with clean water. Mix a very pale, dilute grey from neutral grey gouache and cobalt blue watercolour and touch this mixture on to the damp paper. Add a tiny amount of burnt sienna to the mixture and paint the misty tree trunks in the background, wet into wet.

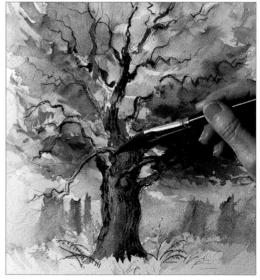

Mix a greyish brown from burnt sienna, sepia and a tiny amount of cobalt blue. Paint the branches of the main tree, looking carefully to see which branches go behind others. Even though you are brushing over the water-soluble pencil marks made in Step 2, they will show through again once the watercolour wash is dry.

There needs to be more tonal contrast on the trunk, in particular, to make the tree look natural

and rounded.

Foreground detail is

essential in order to

make the tree look

as if it is standing

on solid earth.

The main colours have been established but it is hard to tell which direction the light is coming from, and without any strong indication of light and shade, the tree looks rather flat and one-dimensional. For the remainder of the painting, concentrate on improving the tonal contrast and creating a feeling of sunlight streaming through the tree branches.

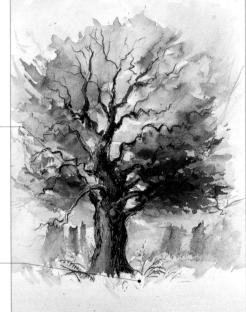

9 Brush loose strokes of burnt sienna into the foreground, bringing some of your strokes up over the yellow grasses. The warm colour and foreground texture help to bring this area of the painting forward. Leave to dry completely. Using your fingertips, gently rub off the masking fluid to reveal the highlighted edges of the branches and the foreground grasses. The feeling of light and shade in the painting is now much stronger.

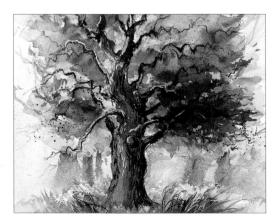

Mix a pale grey from white gouache, cobalt blue and Violet and paint the exposed areas of the branches and trunk. Spatter alizarin crimson on to the leaves. Leave to dry.

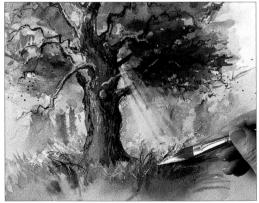

Mix a very pale yellow from permanent white gouache with a little cadmium yellow. Brush in very thin shafts of misty early-morning sunlight.

Painted in a free and spontaneous manner, this little study exploits the richness of autumn colours to the full. In any subject that is viewed against the light, the detail is subdued: here, the dense browns of the trunk and branches provide the necessary structure for the painting, while virtually everything else is reduced to an impressionistic mass of colour. The semi-opaque yellow mixture used to create the shafts of sunlight mutes the underlying colours but does not obscure them completely. This is a very effective way of creating the effect of early morning mist.

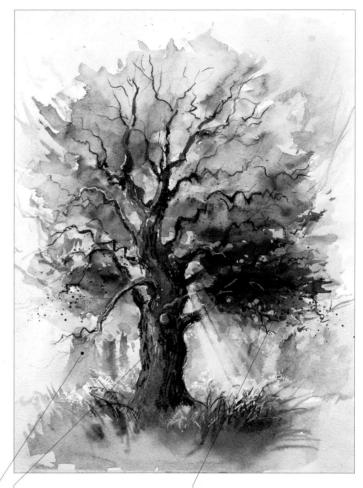

The misty trees in the background provide a hint of the landscape beyond.

Water-soluble pencil marks convey the texture of the tree bark beautifully.

Spattering provides the merest hint of leaf texture: too much would be distracting.

Poppy field

Lush expanses of wild flowers are always attractive, and when those flowers are a rich and vibrant red, like this stunning array of poppies, the subject simply cries out to be painted.

This project presents you with several challenges. First and foremost, it is an exercise in painting spontaneously and in creating an impression of the scene, rather than trying to capture each individual flower. Work quickly and freely, and concentrate more on the overall tones than on specific details. Make sure you don't make the poppies look as if they have been planted in neat, straight rows. It is surprisingly difficult to position dots of colour randomly, but unpredictable techniques, such as spattering, can help.

Second, remember that this is not a botanical study: what you are trying to create is an overall impression of the scene, not an accurate record of how the flowers are constructed. You really don't want a lot of crisp detail in a scene like this, otherwise it will look stilted and lifeless. This is where watercolour really comes into its own. Wet-into-wet washes that merge on the paper create a natural-looking blur that is perfect for depicting a mass of flowers and trees gently blowing in the breeze.

Finally, take some time considering the tonal balance of the painting. Red and green are complementary colours and they almost always work well together, but if the greens are too dark they could easily overpower the rest of the painting. On the other hand, if they are too light they will not provide a strong enough backdrop for the flowers.

Materials

- 2B pencil
- 140lb (300gsm) rough watercolour paper, pre-stretched
- Watercolour paints: cobalt blue, alizarin crimson, gamboge, raw sienna, sap green, Delft or Prussian blue, burnt umber, viridian, cadmium orange, cadmium red, Payne's grey
- Brushes: large mop, medium mop, fine rigger, old brush for masking fluid, medium round, fine round
- Masking fluid

The original scene

This field is a blaze of red poppies as far as the eye can see, counter-balanced by a dark green background of trees. Although the horizon is very near the middle of the picture, which can sometimes makes an image look static, this is offset by the fact that the top half of the image is divided more or less equally into trees and sky. However, the sky is very bright, and this detracts from the poppies; adding colour here will improve the overall effect.

The sky lacks colour and needs to be made less dominant.

The dark trees provide a neutral background that makes the red of the poppies all the more vibrant.

1 Using a 2B pencil, lightly sketch the outline of the trees and some of the larger foreground poppies. Don't attempt to put in every single flower – a few of the more prominent ones are all you need as a guide at this stage. Using an old brush, apply masking fluid over the poppies in the foreground. In the middle ground and distance, dot and spatter masking fluid to create a more random, spontaneous effect. Draw some thin lines of masking fluid for the long grasses in the foreground. Clean your brush thoroughly and leave the painting to dry.

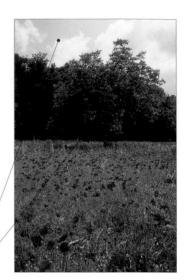

2 Using a medium round brush, dampen the sky area with clean water, leaving a few strategically placed gaps for clouds. Mix up a strong wash of cobalt blue and drop this on to the damp sky area, so that it spreads up to the gaps left for the cloud shapes. The colour is more intense than it was in reality, but the sky needs to look dramatic. Leave to dry.

Apply a strong wash of gamboge to the tree tops. Add raw sienna and brush over the base of the trees and the horizon. Touch raw sienna into the clouds. While this is still damp, touch a purplish-blue mixture of cobalt blue and alizarin crimson on to the underside of the clouds. Leave to dry.

A Mix a dark green from sap green, raw sienna and a little Delft or Prussian blue. Using a medium round brush, brush this mixture over the trees to create dark foliage areas, allowing some of the underlying gamboge to show through in places.

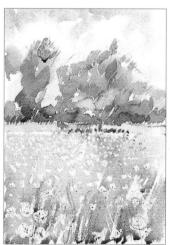

6 Mix a darker green from viridian and cobalt blue and apply this mixture to the foreground, using a large mop brush. Use the same colour to touch in some dark lines for the long shadows under the main tree. Leave to dry.

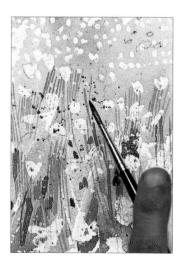

Mix a dark green from sap green, raw sienna and burnt umber and, using a fine rigger brush, brush thin lines on to the foreground. Leave to dry. Spatter the same mixture over the foreground to represent the grass seed heads and add texture. Leave to dry.

Cool greens and yellows have been put in across the whole painting, establishing the general tones of the scene. As you continue to work, you will probably find that you need to darken some of the background colours to maintain a balance between them and the foreground. This kind of tonal assessment should be an on-going part of all your paintings. Now it is almost time to start putting in the bright red poppies in the foreground, the finishing touches that will bring the scene to life. Try above all else to maintain a feeling of spontaneity in the painting as you work: the poppies must look as if they are randomly distributed over the scene.

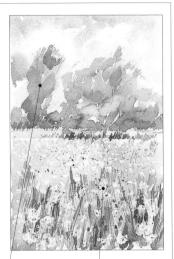

The dark tonal masses of the background have been established.

Spattering in the foreground gives interesting random texture.

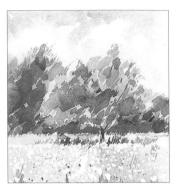

Mix a dark green from Delft or Prussian blue, viridian and burnt umber and, using a medium mop brush, darken the trees, leaving some areas untouched to create a sense of form. Add a little more burnt umber to the mixture and, using a fine rigger brush, paint the tree trunks and some fine lines for the main branches. Leave to dry. Using your fingertips, gently rub off the masking fluid.

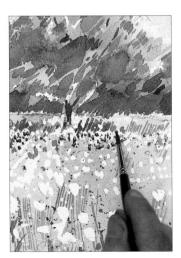

9 Mix an orangey red from cadmium orange and cadmium red. Using a fine round brush, start painting the poppies in the background.

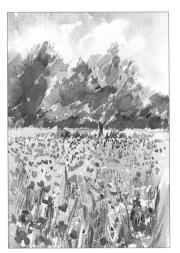

Continue painting the white spaces with the red mixture used in Step 11, leaving a few specks of white to give life and sparkle to the painting. Apply a second layer of colour to some poppies while the first layer is still wet; the paint will blur, giving the impression of poppies blowing in the wind, and the tone will deepen.

11 Using a fine, almost dry brush and the same dark green mixture used in Step 7, paint in the exposed foreground stalks and grasses. Finally, using a fine rigger brush, touch in the black centres of the poppies with a strong mixture of Payne's grey.

This is a loose and impressionistic painting that nonetheless captures the mood of the scene very well. It exploits the strong effect of using complementary colours (red and green),

but the density of colour has been carefully controlled so that the whole painting looks balanced, with no one part dominating the rest.

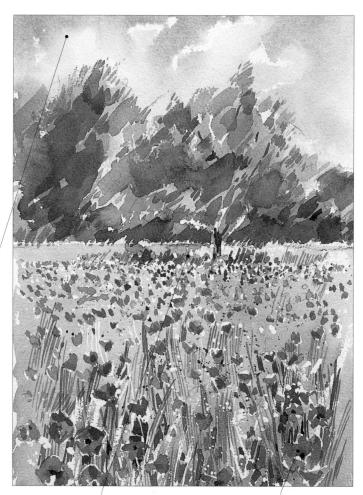

The sky is darker than in the original photograph, which helps to maintain the transfer of the sky is the sky is darker than in the original photograph.

The shadow under the tree is painted with short brushstrokes that echo the direction have the direction for the shadow of the sh

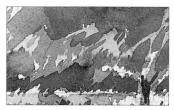

Only the foreground poppies have painted centres. Those in the background are so far

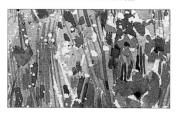

Painting Flowers

The aim of botanical artists is to record for scientific purposes. They need to create as faithful a representation of the flower or plant as possible, with every detail in evidence. The so-called fine artists usually

paint flowers for decorative and symbolic reasons, and, of course, because flowers and plants make such terrific subjects.

Like other subjects, you should start by looking at and understanding the basic

shape of the flowers you are painting. Look at how they grow and at how the leaves are attached to the stem and radiate out from it. Remember that the flower or flowers are an extension of the stem and not simply something that is stuck on the end of it. The flower head is made up of several different parts: note how each is connected to the others.

Analysing and reducing these often complex elements into simple geometric shapes is a good way to start. Look closely and you will see that flower heads can resemble saucer-like discs, simple spheres, upright or inverted cones, bell or goblet shapes, to name but a few. Learning to look at flowers in this way will not only allow you to draw and paint them well, but it will also let you approach the subject in a looser, more impressionistic or expressionistic way, secure in the knowledge that you are capturing the character of your subject correctly.

You can use every watercolour technique in your repertoire when painting flowers, but planning the sequence in which you are going to work is essential. Unless you are using body colour, you will be working from light to dark, and this often raises the question of how to paint small, complex-shaped flowers against a dark background without painstakingly painting around each flower. (The answer is, of course, masking fluid.)

The colour of certain flowers can seem particularly elusive, as can the way in which colours often bleed into each other, or are distributed on the petals. Make your colour mixes a little stronger and more intense that you think they should be, as watercolour always looks paler when it is dry. Use wet-into-wet techniques, as these will allow the colours to run and mix together by themselves.

■ Pansies

This colourful painting uses several watercolour techniques. The image was blocked in using wet-into-wet washes of transparent watercolour. Body colour was then added, some of which was removed by carefully blotting with a paper towel. Detail was added using more body colour and soft pastel.

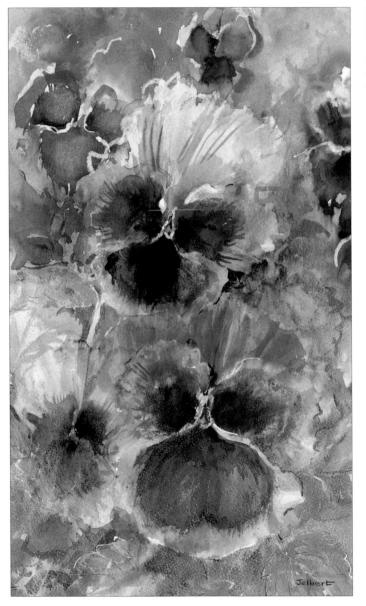

Parrot tulips ▼

Wet-into-wet and wet-on-dry wash techniques were used to paint these parrot tulips. Chance back-runs and drying marks add to the pattern and interest on the leaves and flower heads, while the characteristic curve of the stems under the weight of the flower heads has been perfectly captured.

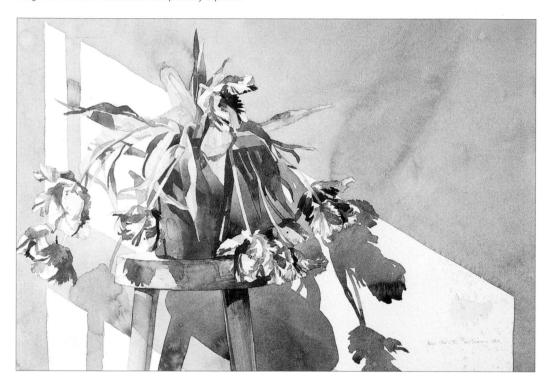

Spring bouquet ▶

Here, irises, tulips, anemones and small yellow narcissi have been painted in their wrapping paper. Although the arrangement looks casual, it was very carefully arranged. Wet-on-dry washes were used exclusively. The colours were kept bright by using no more than three layers of wash in any one place.

- **Tips:** Look at the underlying structure and simplify what you see into hasic geometric shapes.
- Make several studies of your subject before you begin painting, to increase not only your technical skills, but also your familiarity with the subject.

Sunflower

Bold and bright, their faces turning to follow the sun as it travels through the sky, sunflowers are an artist's dream.

Although the aim of this project is not to produce a botanical illustration, with every last detail precisely rendered, a good flower "portrait" should show something of how the flower is constructed. Is the stem straight or twisted? Are the leaves grouped together at the base of the stem or spread out evenly? Does the flower consist of a single large bloom or lots of little florets? A side view will often tell you more than a face-on viewpoint and can make it easier to make the flower look three-dimensional, particularly when you are painting a relatively flat, symmetrical flower, such as a sunflower.

Materials

- · 4B pencil
- 140lb (300gsm) NOT watercolour paper, pre-stretched
- Oil pastels: orange, lemon yellow, bright yellow, sage green, light green, burnt sienna
- Watercolour paints: burnt sienna, violet, cadmium yellow, yellow ochre, Hooker's green, cobalt blue, cerulean blue
- · Gouache paints: permanent white
- Brushes: medium round

The set-up

Because sunflowers were not in bloom when this painting was done, an artificial sunflower was used for the composition. The stem and flowerhead have been twisted slightly to make the image more interesting.

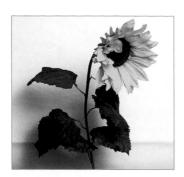

Reference photograph

The artist used a photograph as reference for the colours and the texture in the flower centre. However, the head-on viewpoint and frontal lighting do not make a very interesting composition as there are virtually no shadows or changes of tone in the petals.

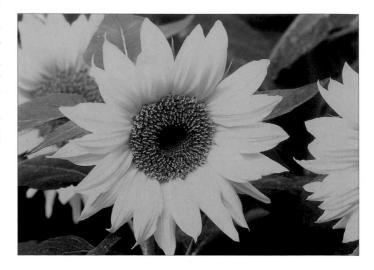

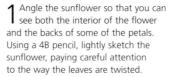

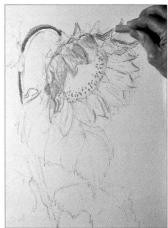

2 Begin putting in some detail with oil pastels, which will act as a resist and allow you to make short, textural marks that would be difficult to achieve using a brush alone. Use orange in the flower centre, lemon yellow and bright yellow on the lightest parts of the petals, and sage and light green on the stalk.

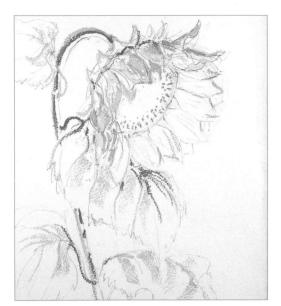

3 Continue using the oil pastels on the stalk and leaves, using sage for the shadowed side of the stalk and the deepest creases in the leaves and light green for the other leaf markings and highlights.

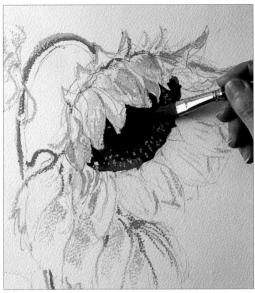

A Mix a mid-toned wash of burnt sienna watercolour paint and brush it over the centre of the flower. Mix a dark brown from burnt sienna and violet and paint the darkest part of the flower centre.

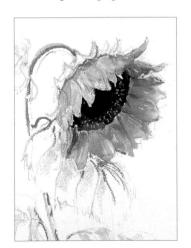

5 Mix a mid-toned wash of cadmlurn yellow and brush it all over the flower. While this first wash is still wet, mix a light brown from yellow ochre and burnt sienna and drop it wet into wet on to the inner petals, allowing some of the underlying yellow to show through as striations in the petals.

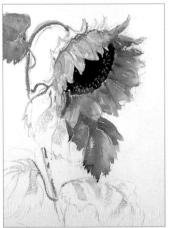

6 Mix a mid-toned green from Hooker's green with a little yellow ochre and begin brushing in the colour for the leaves. Add more yellow ochre to the mixture for the top leaf, which is slightly withered. Note how the oil pastel markings show through from beneath the watercolour.

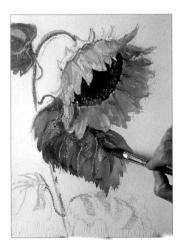

While this first green wash is still wet, continue painting the leaves. Sunflower leaves are very textured, so paint the deep crinkles in the main leaf, wet into wet, in cobalt blue, using the tip of the brush. This foreground texture helps to imply that the leaf is closer to the viewer than the others.

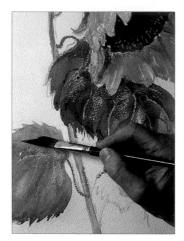

Paint the base petals around the outer edge of the flower in a light green mixture of Hooker's green and cadmium yellow. Paint the lowest leaf on the left in the same green mixture used in Step 6, adding cerulean blue to the mixture for the top edge. This cool colour helps to make the leaf recede. Brush yellow ochre, wet into wet, on to the outer edge of this leaf.

Assessment time

The use of warm and cool tones in the leaves is beginning to make the spatial relationships clearer. The cool blue-green of the leaf to the left of the stalk makes it recede, while the warmer greens and yellow ochre of the leaf immediately below the flower make it advance, implying that it is closer to the viewer. Although the painting is nearing completion, some subtle adjustments need to be made in order to create more texture and build up the tones.

The two lowest leaves are too similar in tone: the one at the base needs to be very slightly darker, so that it comes forward more.

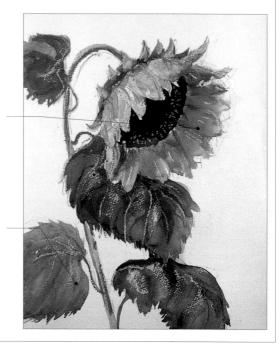

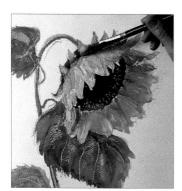

9 Enhance the feeling of light and shade by painting the shadowed side of the stalk in cobalt blue. Dot more blue in behind the base petals.

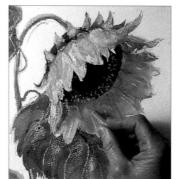

10 Darken the petals and add texture to the inside of the flower, which is shaded from the light, by dotting in orange oil pastel.

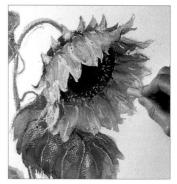

1 1 Dash short strokes of burnt sienna and yellow oil pastel on to the inner petals in order to darken the tones still further.

This is a colourful and lively flower study that captures the essence of the plant. Note how wet-into-wet washes create subtle variations in tone on both the flower and the leaves, while the use of oil resists provides interesting textures and highlights. Angling the head of the sunflower and positioning the stalk on a slight diagonal have also helped to create a dynamic composition.

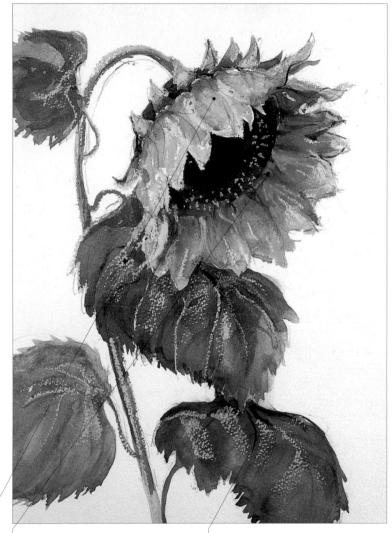

Using pale tones and leaving some of the white paper still visible indicate that this area receives the

Oil pastel markings create important tonal and textural contrasts in the centre of the flower.

The shadow cast by the leaf above helps to define the spatial relationships of the leaves.

Summer flower garden

This scene was invented entirely from the artist's imagination, using quick sketches of flowers in her own garden and photographs from a garden centre catalogue as reference. When you are combining material from several sources, take the trouble to check a few basic facts. Make sure that the flowers you've selected really do bloom at the same time, and check the relative sizes, so that you don't make a ground-hugging plant appear taller than a small tree.

The project gives you the chance to combine classic watercolour techniques with the relatively modern medium of water-soluble pencils. The characteristics of water-soluble pencils are exploited to the full here. The pencil marks are used dry, to create fine linear detail, particularly in the foreground. They are also covered with watercolour washes, so that the colours merge. You can control the amount of blur to a certain extent: if you wet the tip of the pencil before you apply it, the pencil marks will blur less, allowing you to hold some of the detail and texture in these areas.

Materials

- 140lb (300gsm) NOT watercolour paper, pre-stretched
- Water-soluble pencils: dark blue, light brown, cerulean blue, light violet, dark violet, blue-green, olive green, red, yellow, orange, deep red, green
- Watercolour paints: cerulean blue, rose doré, Linden green, dark olive, olive green, cobalt blue, cadmium yellow, Naples yellow, burnt sienna, vermilion, alizarin crimson, Payne's grey
- Brushes: medium round, fine round
- · Ruling drawing pen
- Masking fluid

Tip: Changing from a horizontal to a vertical format may alter other elements as well. In the final composition, the path still runs from the bottom right to the top left but the artist made the foreground flower border more prominent.

Reference sketches

Look closely at detailed sketches, illustrations or photographs of individual flowers before you embark on your full-scale painting. Although a massed clump of foliage and flowers may look like an indistinct jumble, knowing the shape and colour of an individual bloom will help you capture the essential features of the plant.

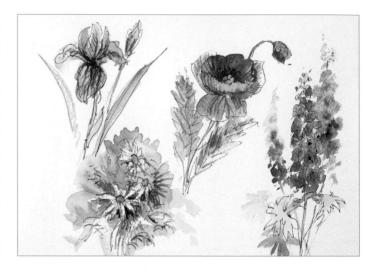

Preliminary sketch

The artist invented a garden scene and made a small sketch to try out the colours and the composition. To begin with, she opted for a horizontal format. Then she decided that this placed too much emphasis on the pathway and that a vertical format, with the rose arch as the main feature, would have more impact.

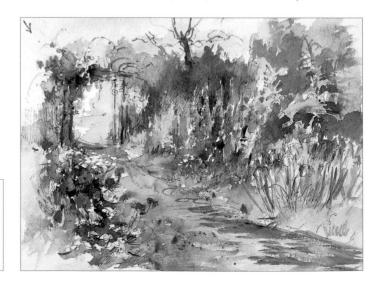

1 Using a dark blue water-soluble pencil, sketch the main shapes of your subject. Dip a ruling drawing pen in masking fluid and mask the lightest parts of the flowers.

2 One of the advantages of using a ruling drawing pen is that it holds the masking fluid in a reservoir. A range of marks is used to convey the different textures of each of the massed clumps – flowing lines for the poppy heads and little dashes for the daisy petal in the foreground. It would be more difficult to achieve this with a dip pen as the nib would block up, leaving blobs and blots on the paper.

3 Shade in the trunk of the tree with loose pencil strokes, using a light brown water-soluble pencil. (This makes the marks more permanent.) Dip the tip of the pencil in clean water and draw the branches. Draw the wooden rose arch Iff Iffe same culuum Caltum in the individual delphinium blooms with small dots of cerulean blue, changing to light and dark violet for the stems that are in deeper shade. Dip the pencil the imwater to make some of the marks

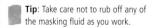

Continue with these dots and dashes of pencil work until you have established the general colour scheme of the garden. Don't be tempted to do too much or the pencil work might begin to overpower the picture: this is a painting, not a drawing, and it is the watercolour paint applied in the subsequent stages that will give the work its character.

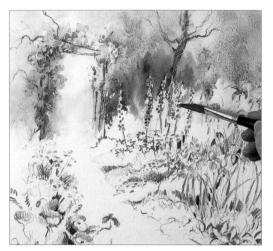

Dampen the background with water. Wash a pale mix of cerulean blue watercolour paint over the sky, brushing around the branches. Dot rose doré over the rose arch: the paint will blur, suggesting full-blown blooms. Brush Linden green under the arch and dot a mixture of dark olive and cerulean blue into the background and between the delphiniums. While the paint is still damp, add bright olive green with cerulean blue and brush over the first blue wash.

Dampen the middle distance with clean water. Dot cerulean blue, rose doré and cobalt blue on to the delphiniums. Both the paint and the initial water-soluble pencil marks will blur and spread, causing the flowers to look slightly out of focus. Mix a neutral brown from olive green and rose doré and brush it into the negative spaces between the iris stems. The flowers will begin to stand out more against this dark background.

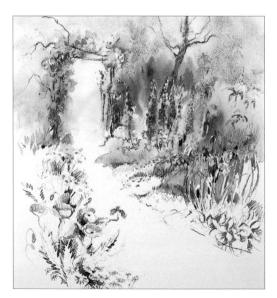

6 The distance and middle ground have now been established. Note how the soft tones and lack of clear detail help to imply that these areas are further away from the viewer.

7 Mix a bright green from cerulean blue and cadmium yellow and dot it loosely into the pathside area for the hummocks of low-growing ground-cover plants that spill over on to the path.

Dampen the path. Starting near the arch, brush pale Naples yellow over the path, adding burnt sienna towards the foreground. Brush clean water over the tip of a brown water-soluble pencil and spatter colour on to the path, using the brush. Start spattering in the foreground and work towards the rose arch. As the brush dries, the drops of water – and the dots of colour – get smaller, and this will help to create a sense of recession.

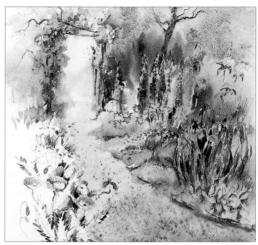

9 Note how effectively the curved path leads the eye to the focal point of the painting – the rose-covered arch. The spattered drops of colour provide important texture in what would otherwise be a large expanse of flat brown.

10 Brush cadmium yellow and then vermilion over the red poppy heads, allowing the colours to blend on the paper, and brush a tiny bit of alizarin crimson over parts of the foreground poppies to give added depth of tone.

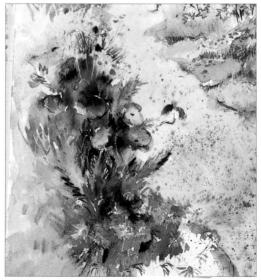

1 1 Mix Payne's grey with olive green for some of the background poppy leaves and stems. Add a little cobalt blue to the mixture for the foreground poppy leaves. Dot cadmium yellow in the centre of the daisy flowers.

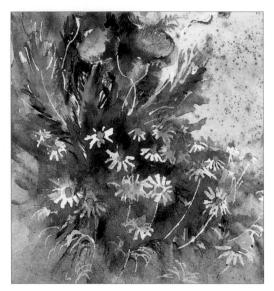

 12^{Finish} the bottom left-hand corner, using the same green mixture as before.

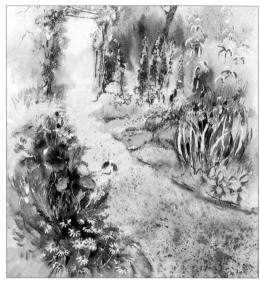

 $13^{\,}$ Using your fingertips, gently rub off the masking fluid to reveal the white parts of the flowers.

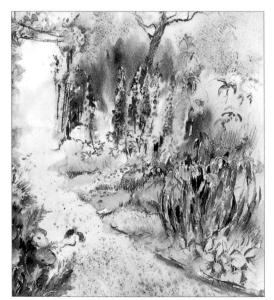

 14° Some of the exposed white areas now look too stark – particularly in the background. Mix a very pale wash of cerulean blue and brush it over some of the iris stems to tone down the brightness – otherwise the viewer's eye will be drawn to these areas, which are not the most important parts of the scene.

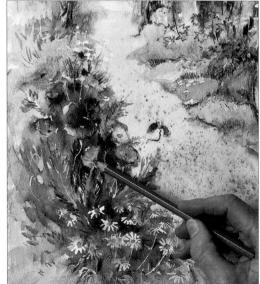

15 Now go back to the water-soluble pencils to add sharper details in the foreground. Use a deep red pencil to delineate the petals and frilly edges of some of the larger poppies, and draw a green pencil circle around the yellow centres of the poppies. Darken the spaces between the daisy petals with a dark blue pencil.

This painting is a romantic, impressionistic portrayal of a traditional flower garden. Softly coloured poppies, irises, daisies and delphiniums line the winding path, which leads to the focal point of the image – the rose arch. There is a hint of mystery in the painting, too: what lies on the other side of the archway?

Flowers in the background are more blurred than those in the foreground, but some Ilriear detail is still visible

The poppies are painted with a number of different techniques – masking for the twisting stems, wet-into-wet washes for subtle colour blends, and fine pencil detail.

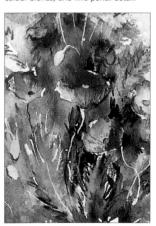

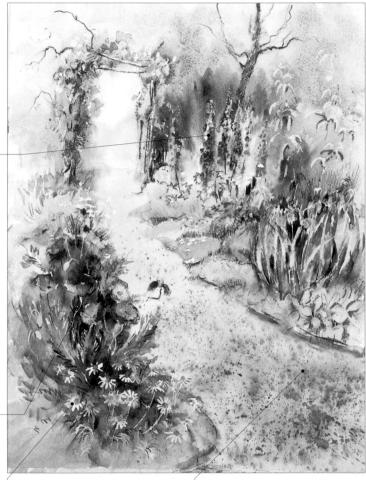

Reserving the white of the paper for the daisy petals adds sparkle to the image.

The textured path provides subtly coloured but necessary foreground interest.

French vineyard

This deceptively simple-looking scene is a useful exercise in both linear and aerial perspective. Take care over your underdrawing, as it underpins all the rest of the painting: if the rows of vines appear to be going in the wrong direction it will look very strange. It is worth taking plenty of time over this stage.

You also need to mix tones carefully. Note how the dark green vine leaves in the foreground give way to a much paler, yellower green in the distance – and then see how these pale greens gradually darken again above the horizon line, shifting from a mid green to a very bluish

green on the distant hills. Remember to test out each tone on a scrap piece of paper before you apply it to the painting.

Materials

- · 2B pencil
- 140lb (300gsm) rough watercolour paper, pre-stretched
- Watercolour paints: cerulean blue, Naples yellow, gamboge, light red, sap green, ultramarine violet, cobalt blue, viridian, Payne's grey, burnt umber
- Brushes: large mop, medium mop, fine round

Sometimes one reference image simply doesn't give you enough information to create the painting you want. Don't be afraid to combine elements from several photos or sketches to create the desired effect. Here, the artist referred to the long panoramic-format photograph for the close-up detail of the vine leaves and the farm buildings, but based his composition on the larger photograph, in which the rows of vines are angled in a more interesting way.

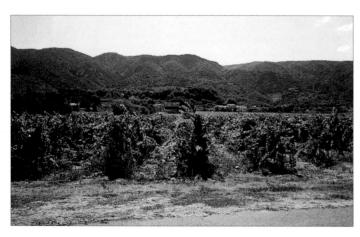

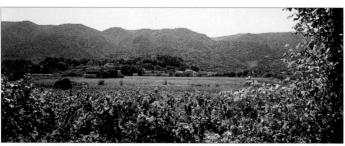

Sketch the outline of the hills and vines, then dampen the sky with clean water, leaving some gaps. Mix a wash of cerulean blue and drop it on to the damp areas. Leave to dry.

Mix a pale wash of Naples yellow and touch it into the dry cloud shapes and along the horizon line. Leave to dry.

Barken the top of the sky with cerulean blue and leave to dry. Mix gamboge with light red and brush over the vines. Paint light red on the foreground and in between the vines.

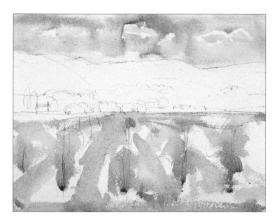

4 Using a medium mop brush, loosely paint sap green into the foreground to indicate the rows of vines. Leave to dry.

5 Mix a deep blue from ultramarine violet, cobalt blue and viridian and wash it over the hills. Put a few dots along the top edge to break up the harsh outline and imply trees.

Mix a mid-toned green from viridian with a little cobalt blue. Using a medium mop brush, brush this mixture over the lower part of the hills. Mix a dark blue from cobalt blue, ultramarine violet and viridian. Using a large mop brush, darken the shadows on the distant hills. Use the same colour to stipply a four dotr on the green hills to imply trees on the horizon.

Tip: It is often easier to assess colours if you turn your reference photo upside down. This allows you to concentrate on the tones without being distracted by the actual subject matter.

Once you are happy with the general lines and colours of the scene, you can start thinking about adding those all-important touches of detail and texture. Don't be tempted to do this too early: once you have painted the detail, it will be much harder to go back and make any tonal corrections to the background or the spaces between the rows of vines.

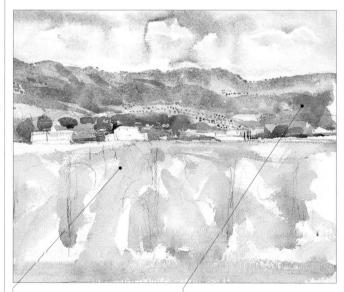

The perspective of the foregound has been established, leaving you free to add detail and texture.

The background is virtually complete, with darker shadows on the hills providing a sense of light and shade.

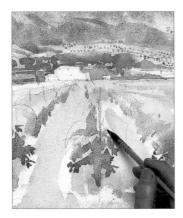

Mix a dark green from sap green, Payne's grey, and a little burnt umber. Using a large mop brush, wet the foreground with clean water, leaving gaps for the vines. Using a medium mop brush, brush the dark green mixture on to the damp areas and let it flow on the paper to define the general green masses of the vines and their leaves. Paint the dark shapes of the foreground vine leaves.

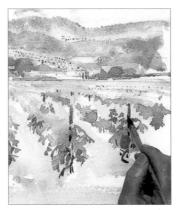

Continue painting the vine leaves, as in Step 7. Don't try to be too precise or the painting may easily start to look overworked: generalized shapes will suffice. Mix a warm but neutral grey from ultramarine violet and burnt umber and, using a fine round brush, paint in the stems of the vines and the posts that support them, taking care to make the posts smaller as they recede into the distance

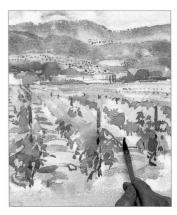

Mix a dark shadow colour from ultramarine violet and a little burnt umber and brush this mixture across the ground in between the rows of vines. Again, take care over the perspective and make the shadows narrower as the vines recede into the distance.

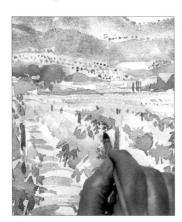

10 Mix a warm, reddish brown from light red and a touch of Naples yellow and use this to paint the buildings in the background. This warm colour causes the buildings to advance, even though they occupy only a small part of the picture area. Using a fine brush and the same dark green mixture that you used in Step 7, touch in some of the detail on the vines.

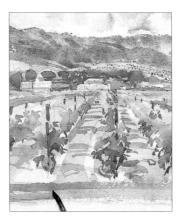

1 1 Using an almost dry brush held on its side, brush strokes of light red in between the rows of vines. This strengthens the foreground colour but still allows the texture of the paper to show through, implying the pebbly, dusty texture of the earth in which the vines are planted.

12 Using a fine brush, brush a little light red on the top of the roofs. This helps the roofs to stand out and also provides a visual link with the colour of the earth in the foreground. Add a little burnt umber to the light red mixture to darken it, and paint the window recesses and the shaded side of the buildings to make them look three-dimensional.

Fresh and airy, this painting is full of rich greens and warm earth colours, providing a welcome dose of Mediterranean sunshine. Note how most of the detail and texture are in the foreground, while the background consists largely of loose washes with a few little dots and stipples to imply the tree-covered mountains beyond. This contrast is a useful device in landscape painting when you want to establish a sense of scale and distance.

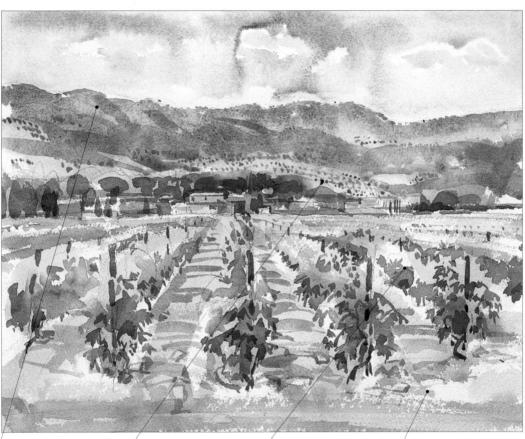

Cool colours in the background recede.

Simple dots and stipples are enough to give the impression of distant trees.

Note how the rows of vines slant inwards and converge towards the vanishing point.

Warm colours in the foreground advance.

Craggy mountains

This project is a good exercise in aerial perspective. Although the scene itself is very simple, you must convey a sense of the distances involved in order for it to look convincing. Tonal contrast is one way of achieving this: remember that colours are generally paler towards the horizon, and so the mountains in the far distance look paler than those in the immediate foreground. Textural contrast is another way to give a sense of distance: details such as jagged rocks and clumps of snow need to be more pronounced in the foreground than in the background.

The use of warm and cool colours to convey a sense of light and shade is important, too. Cool colours, such as blue, appear to recede and so painting crevices in the rocks in a cool shade makes them look deeper and further away from the viewer. Warm colours, on the other hand,

appear to advance and seem closer to the viewer. These should be used for the areas of rock that jut upwards into the sunlight.

Although you want the painting to look realistic, don't worry too much about capturing the exact shapes of individual rocks: it is more important to convey an overall impression. Use short, jagged strokes that follow the general direction of the rock formations. This will help to convey the mountains' craqqy texture.

The original scene

These craggy peaks, stretching far into the distance, make a dramatic image in their own right. In the late spring, when this photograph was taken, the drama is enhanced by the billowing white clouds, set against a brilliant blue sky, and the last vestiges of snow clinging to the rocks.

Materials

- 2B pencil
- Rough watercolour board
- Watercolour paints: ultramarine blue, burnt sienna, cobalt blue, phthalocyanine blue, alizarin crimson, raw umber
- Brushes: large round, old brush for masking
- Sponge
- Tissue paper
- Masking fluid
- Scalpel or craft (utility) knife

Tip: The sponge is used in this project to lift off paint colour applied to the sky area, and to apply paint. The surface of the sponge leaves a soft, textured effect.

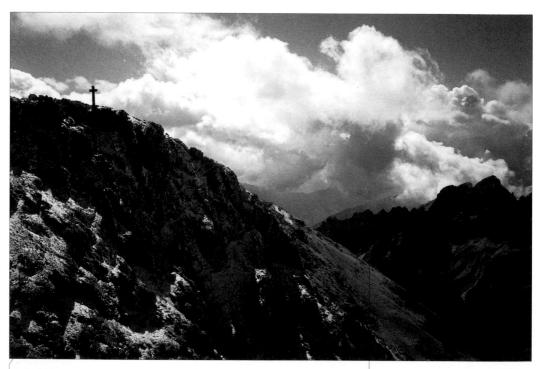

Textural detail is most evident in the foreground; this also helps to create a sense of distance.

Note how the colours look paler in the distance, due to the effect of aerial perspective.

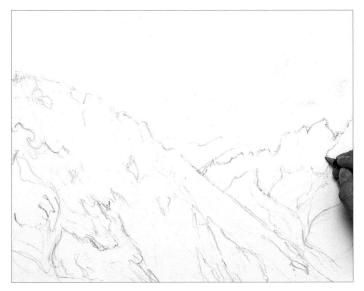

f 1 Using a 2B pencil, lightly sketch the scene, indicating the main gulleys and crevices and the bulk of the clouds in the sky. Keep your pencil lines loose and fluid: try to capture the essence of the scene and to feel the "rhythm" of the jagged rock formations.

A Marine Marine

2 Mix a pale, neutral grey from ultramarine blue and burnt sienna. Using a large round brush, wash this mixture over the foreground mountain.

Mix a bright blue from cobalt blue and a little phthalocyanine blue. Using a large round brush, wash it over the top of the sky. While this is still wet, dampen a small sponge in clean water, squeeze out the excess moisture, and dab it on the sky area to lift off some of the colour. This reveals white cloud shapes with softer edges than you could achieve using any other technique.

ilp. Each thine you apply the sponge, turn it around in your hand to find a clean area, and rinse it regularly in clean water so that you don't accidentally dab colour back on to the paper.

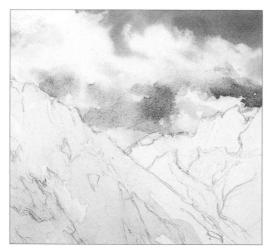

4 Mix a neutral purple from alizarin crimson, ultramarine blue and a little raw umber. Using a large round brush, dampen the dark undersides of the clouds and touch in the neutral purple mixture. While this is still damp, touch in a second application of the same mixture in places to build up the tone. If necessary, soften the edges and adjust the shapes of the dark areas by dabbing them with a piece of sponge or clean kitchen paper to lift off colour.

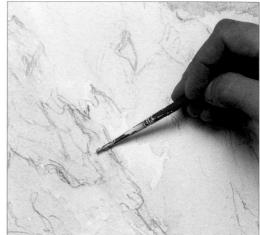

5 Study your reference photograph to see exactly where the little patches of snow lie on the foreground mountain. Using an old brush, apply masking fluid to these areas to protect them from subsequent applications of paint. Use thin lines of fluid for snow that clings to the ridges and block in larger areas with the side of the brush. Wash the brush in liquid detergent and warm water. Leave the masking fluid to dry completely before moving on to the next stage.

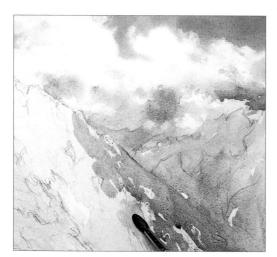

6 Mix a dark blue from cobalt blue and phthalocyanine blue and paint the distant hills between the two mountains. Dilute the mixture and brush it over the background mountain. Leave to dry. Mix a dark brown from burnt sienna with a little alizarin crimson and ultramarine blue, and wash this mixture over the background mountain. Add a little alizarin crimson and begin painting the foreground mountain.

Z Using a large round brush, continue to paint the foreground mountain. Use the same dark brown mixture that you used in Step 6 for the areas that catch the sun, and phthalocyanine blue for the areas that are in the shade. Paint with relatively short and slightly jagged vertical brushstrokes that echo the direction of the rock formations. This helps to convey the texture of the rocks.

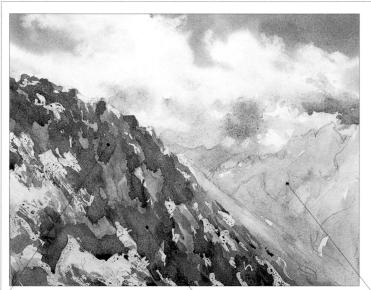

The rocks that jut out into the sunlight are painted in a warm brown so that they appear to advance.

The crevices are in deep shade and are painted in a cool blue so that they appear to recede.

Because of the careful use of warm and cool colours, the painting is already beginning to take on some form. Much of the rest of the painting will consist of building up the tones you have already applied to enhance the three-dimensional effect and the texture of the rocks. At this stage. it is important that you take the time to assess whether or not the areas of light and shade are correctly placed. Note, too, the contrast between the foreground and the background: the foreground is more textured and is darker in tone, and this helps to convey an impression of distance.

The background mountain is painted in a flat colour, which helps to convey the impression that it is further away.

Mix a deep, purplish blue from alizarin crimson, phthalocyanine blue and raw umber. Brush this mixture along the top of the background peak, leaving some gaps so that the underlying brown colour shows through. Using the dark brown mixture used in Step 6, build up tone on the rest of the background mountain, applying several brushstrokes wet into wet to the darker areas.

Ontinue building up the tones on both mountains, using the same paint mixtures as before. Leave to dry. Using your fingertips, gently rub off the masking fluid to reveal the patches of white snow. (It is sometimes hard to see if you've rubbed off all the fluid, so run your fingers over the whole painting to check that you haven't missed any.) Dust or blow all dried fluid off the surface of the painting.

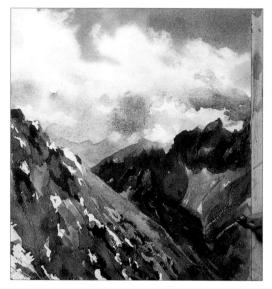

10 Using the tip of a scalpel or craft (utility) knife and pulling the blade sideways, so as not to cut through the paper, scratch off thin lines of paint to reveal snow in gulleys on the background mountain.

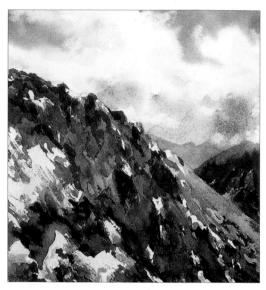

1 1 Apply tiny dots of colour around the edges of some of the unmasked areas to tone down the brightness a little. Continue the tonal build-up, making sure your brushstrokes follow the contours of the rocks.

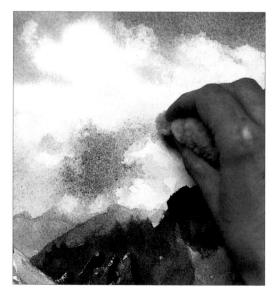

 $12^{\rm Dip}$ a sponge in clean water, squeeze out any excess moisture and dampen the dark clouds. Dip the sponge in the neutral purple mixture used in Step 4 and dab it lightly on to the clouds to darken them and make them look a little more dramatic.

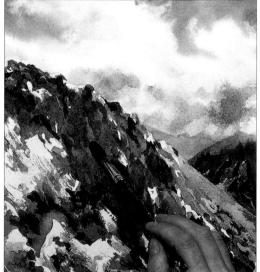

13 The final stage of the painting is to assess the tonal values once more to make sure that the contrast between the light and dark areas is strong enough. If necessary, brush on more of the purplish blue mixture used in Step 8 to deepen the shadows.

This is a beautiful and dramatic example of how contrasting warm colours with cool colours can create a sense of three dimensions. Although the colour palette is restricted, the artist has managed to create an impressively wide range of tones.

Jagged brushstrokes that follow the direction of the rock formations create realistic-looking textures on the foreground mountain and the white of the paper shines through in places, giving life and sparkle to the image.

The white of the paper is used to good effect to imply patches of snow clinging to the rocks

The soft-edged clouds and brilliant blue sky provide a perfect counter-balance to the harshness of the rocks below.

The background mountain is painted in flat washes, with far less textural detail than the foreground.

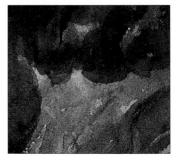

Painting Still Lifes

Of all the subjects to draw and paint, still lifes are unique as all the elements are under your control – not only the objects being used, but also their position and the quality and direction of the light used to illuminate them. This gives you the chance to work at your leisure, with no pressure, and to experiment with composition, colour and technique.

Still-life subjects are found everywhere. The obvious ones include the numerous and ever-increasing varieties of fruit, vegetables and flowers available all year round. Kitchen and gardening equipment, children's toys, ceramics and glassware, patterned fabrics, found natural objects and the numerous objets d'art that litter most homes: the list is endless.

Traditionally, the objects used in a still life have some kind of association with each other, but you can also make interesting images by grouping together a range of objects that have little, or no, common ground.

There are also what are known as "found" still lifes, which are arrangements that you simply come across by chance. By definition, these are usually less contrived and more natural-looking than an arranged grouping. Found groupings might include fruit and vegetables falling out of a shopping basket, or a group of terracotta flower pots and garden tools in the corner of a shed or outbuilding.

Perhaps the most important point to consider with still lifes is the quality or type of light that you use to illuminate your subject. Although natural light is ideal, it can prove problematic. Arranging still-life groups directly in the sun can make for dramatic, strong images, but the sun will move and the light will constantly change. You can use lamps of various kinds to light your subject. It is important to remember that low-voltage bulbs can give an orange cast, so it is better to invest in a few daylight bulbs, as these will make colours look cleaner and brighter.

- **Tips:** Invest in a couple of anglepoise lamps and daylight bulbs, so that you can control the direction and quality of the light.
- Make a series of thumbnail sketches of the composition before you begin.
 Often, you will find that a better composition suggests itself.
- Take risks with your groupings and compositions in order to give your images an edge.
- Look out for "found" groupings that may give rise to an image. If you do not have painting materials to hand, capture the moment with a photograph.

Tulips ▼

Natural sunlight pours through a window and falls on a bunch of tulips. The intensity of the light is exaggerated by making the shadow on the wall much darker than it was in reality.

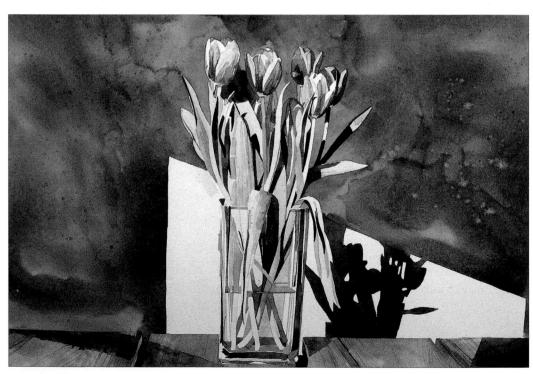

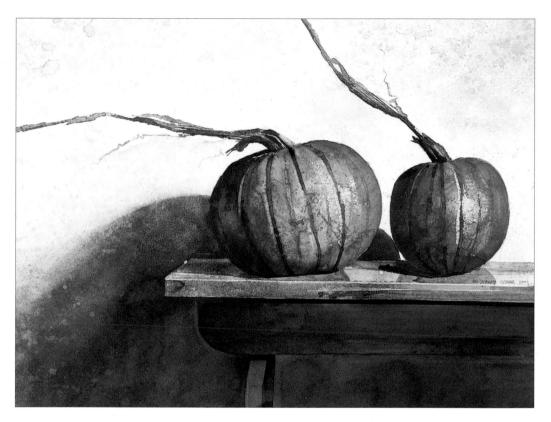

Pumpkins A

This painting was made on a heavy, rough paper that did not require stretching. Gum arabic was used in the mixes to increase the intensity and transparency of the paint. The paint was applied wet into wet and wet on dry, with areas of paint removed and distressed using sandpaper.

Leeks ▶

This is a contrived and carefully arranged still life. The leeks and knife are viewed from above, and an illusion of depth is achieved by painting the linear pattern on the cloth at a slight angle.

Strawberries and cherries in a bowl

Still lifes don't have to be complicated, and with a few colourful fruit and a china bowl, you can set up a simple but very attractive study on a corner of your kitchen table. However, you do need to spend time thinking about your composition: with relatively few elements, the position of each one is critical.

When you have chosen your subject, move the fruit and bowl around until you get an arrangement that you are happy with. Look at the shadows and the spaces between the objects, as well as at the objects themselves: they are just as important in the overall composition.

Above all, this is an exercise in colour. Choose fruit that have some variation in colour, to provide visual interest. Also look for complementary colours – ones that are opposite each other on the colour wheel – such as red and green, or yellow and violet. Here, touches of green on the leaves and stems offset the vibrant reds of the fruit, while shadows on the yellow ochre background are painted in a complementary shade of violet.

Remember that even things that you know are a brilliant white, such as the doily on which the bowl stands, should rarely (if ever) be painted as such. Shadows and reflected light imbue them with a subtle but definite hue of another colour. Half close your eyes to help you assess what colours and tones to use, and keep any washes in these areas very pale to begin with. You can build them up later if necessary, but if you make them too strong there's no going back.

Materials

- 2B pencil
- 140lb (300gsm) NOT watercolour paper, pre-stretched
- Watercolour paints: yellow ochre, dioxazine violet, cobalt blue, Hooker's green, vermilion, cadmium orange, cadmium yellow, Naples yellow, calizarin crimson, leaf green, olive green, phthalocyanine blue
- · Brushes: medium chisel
- · Ruling drawing pen
- Masking fluid

The set-up

Set up your still life on a plain white piece of paper, so that you can concentrate on the subject, and position a table lamp to one side to cast interesting shadows. Experiment by placing the fruit in different positions and at different angles: you need to create a balanced composition so that you don't end up with too large an area of empty background.

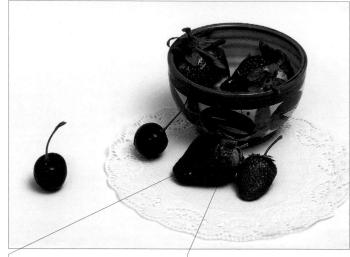

The strawberries shade gradually from deep red to a pale yellow.

The bowl is painted in strong colours that detract from the fruits.

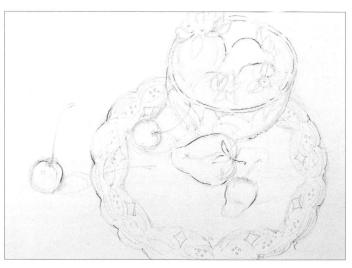

1 Using a 2B pencil, lightly sketch the fruit and the bowl and roughly indicate the cut-paper pattern on the doily.

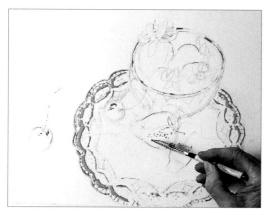

 $2^{\rm Dip}$ a ruling drawing pen in masking fluid and mask out the areas that will be left white in the final painting – the bright highlights on the fruit and the rim of the bowl and the pattern on the doily.

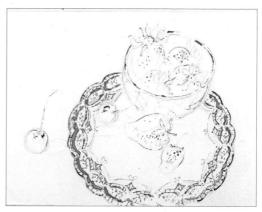

3 Finish off the masking. You must leave it to dry completely before you start to apply any paint, otherwise you run the risk of smudging it and destroying the crisp, clean lines that you want to keep.

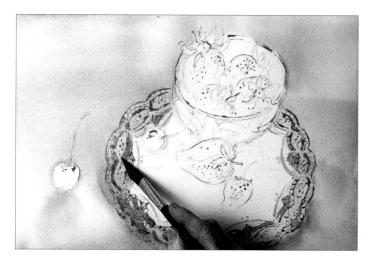

The white background is very stark, so start by mixing yellow ochre with a little dioxazine violet to make a dull yellow as a background colour. Dampen the background and the patterned edge of the doily with clean water, taking care to brush around the cherry, and brush the mixture over this area, adding a little more violet to the mixture on the left-hand side. Brush a slightly darker violet under the edge of the doily to create a slight shadow. The background and shadow colours are virtually complementary colours, which work well together.

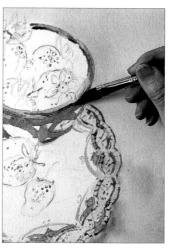

5 Mix a dull blue from cobalt blue and a little dioxazine violet. Using the tip of the brush, start to paint the blue of the pattern on the bowl. Continue to build up the pattern using Hooker's green and a pale mixture of vermilion and a little dioxazine violet.

Tip: Make the colours on the bowl more subdued than they are in real life, so that they do not detract from the vibrant reds of the fruit.

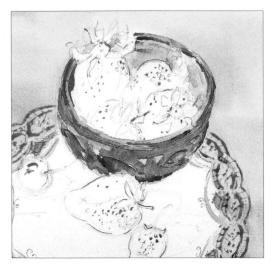

6 Mix a rich orange from cadmium orange and cadmium red and finish painting the pattern on the bowl. Mix a very pale blue from cobalt blue and cerulean blue and paint the inside of the bowl, taking care not to touch any of the fruit. Brush a little dioxazine violet into the most deeply shaded part of the inside of the bowl. Leave to dry.

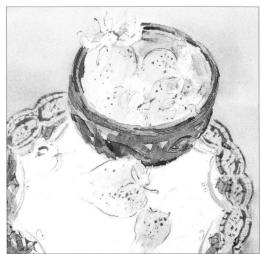

You need to work quickly for the next two stages, which are painted wet into wet so that the colours merge on the paper. Mix a very pale yellow from cadmium yellow and a hint of Naples yellow. Wet the strawberries with clean water and carefully brush this yellow mixture on to the palest areas, taking care not to allow any paint to spill over on to the doily.

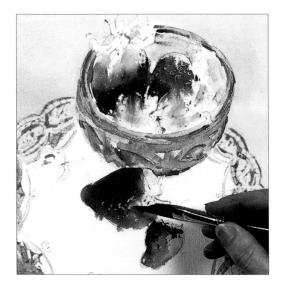

While this is still damp, mix cadmium red with a little cadmium orange and brush this mixture over the red parts of the strawberries. Mix vermilion with alizarin crimson and drop this mixture wet into wet on to the very darkest parts of the strawberries. (You may need several applications to build up the necessary density of tone.)

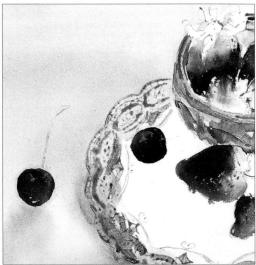

Paint the cherry on the background in vermilion. Apply another layer of vermilion while the first one is still wet, brushing a little cadmium yellow on to the right-hand side to give some variety of tone. Mix alizarin crimson with a hint of dioxazine violet and paint the cherry on the doily, which is a darker tone than the one on the background. Leave to dry.

10 Brush clean water over the strawberry leaves. Paint the lightest leaf areas in cadmium yellow, the mid tones in leaf green, and the darkest tones in olive green, adding a little phthalocyanine blue to the olive green for the very shaded parts.

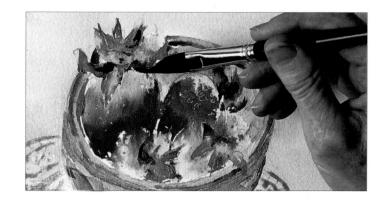

Assessment time

Paint the cherry stalks in olive green and darken the tone of the leaves overall, if necessary. The painting is very nearly complete, but you need to build up the shadows to make

the still life look more realistic. Study your subject carefully to work out where the shadows fall and how dark they need to be in relation to the rest of the painting.

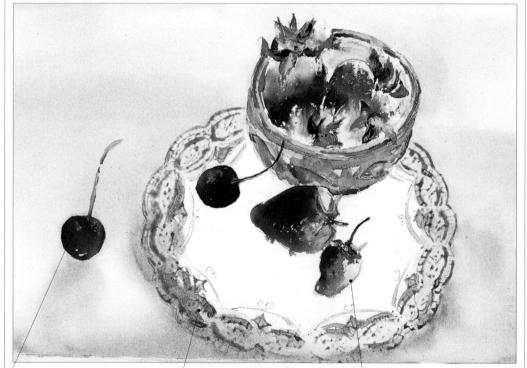

Subtle variations in tone across the surface of the fruit help to make them look lifelike.

Even though the doily is very thin, the lighting is so strong that it should cast a definite shadow.

With no shadows to anchor them, the cherries and strawberries look as if they are suspended in mid-air.

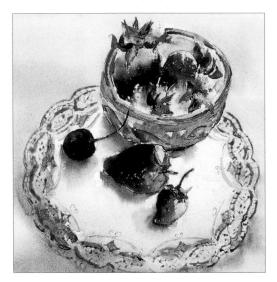

1 Brush clean water over the doily, carefully brushing around the fruit and bowl. Mix a very pale wash of cerulean blue and brush it over the doily; the paint will blur and spread softly, without leaving any harsh edges. While this wash is still damp, mix a very pale purple from dioxazine violet with a tiny amount of Hooker's green and paint the shadows under the fruit and bowl, wet into wet. Use the same paint mixture to brush in the shadow under the background cherry, this time wet on dry.

12 Although one is painted wet into wet and one wet on dry with harsher edges, the shadows under the two cherries look equally effective.

13 Deepen the shadow under the doily, using the same purple mixture of dioxazine violet and Hooker's green as used in Step 11. Leave to dry.

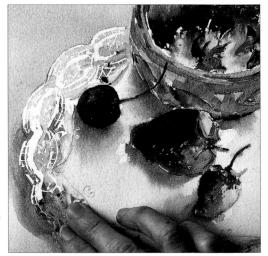

14 Using your fingertips, gently rub off the masking fluid, revealing the brilliant white of the doily and the highlights on the fruit and bowl.

This is a simple, yet carefully thought out, still life in which rich colours and textures abound. Note, in particular, the effective use of complementary colours. The artist has put

together an attractive arrangement in which the shadows and the spaces between the objects play as important a role in the overall composition as the objects themselves.

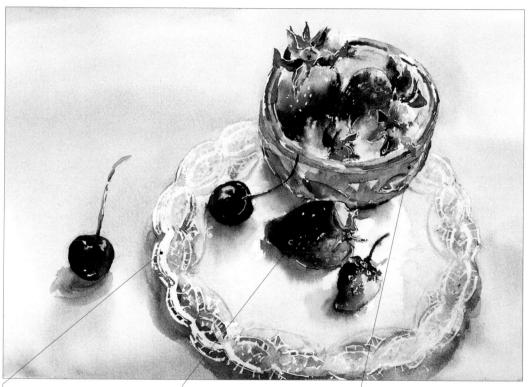

The intricate pattern and brilliant white of the doily are preserved through the careful application of masking fluid.

The reds are achieved by carefully building up a number of different tones – cadmium red, vermilion and alizarin crimson.

The colours of the bowl are deliberately subdued, so as not to detract from the richly coloured fruit.

Still life with stainless steel

This kind of still life project is easy to set up at home. The trick is not to make the composition too complicated: a few colourful objects, strategically placed to exploit the way they are reflected in the metallic surfaces, will suffice.

Although this looks, at first glance, like a relatively simple still life, it requires very careful assessment of tone. Metal objects and other reflective surfaces take a lot of their colour from the objects that are reflected in them, so in this project you will need to look carefully at the reflections in order to assess what colours and tones you need to apply. However, the reflections tend to be a little more subdued in tone and less crisply defined than the objects being reflected. Bear this in mind while you are working and adjust your paint mixtures accordingly.

It is a common mistake to paint reflective surfaces too light, with the result that they lack substance. Remember to assess the tones of your painting at regular intervals and build up the tones gradually until the density is right.

Another aspect of tone that you need to consider here is how to make your subject look three-dimensional. To give form to a subject, you need to put darker tones on the shadowed side, but when you are dealing with curved or spherical shapes, like the stainless steel olive oil pourers in this project, the curves are so smooth that it can be hard to decide where the darker colours should begin. Work wet into wet for these areas, so that the colours merge naturally on the paper without any hard edges.

Materials

- 2B pencil
- 200lb (425gsm) NOT watercolour paper, pre-stretched
- Watercolour paints: cerulean blue, Payne's grey, cadmium lemon, ivory black, raw umber, burnt umber, lamp black, yellow ochre, burnt sienna, dioxazine purple, cadmium orange, alizarin crimson
- Brushes: fine round, medium round
- 2B graphite stick

The set-up

When you are setting up a still-life that contains shiny, reflective surfaces, make sure that the light source (which, indoors, is invariably some kind of lamp) does not reflect too prominently in the subject. The best way to do this is to place the light source to one side and at a reasonable distance from your subject.

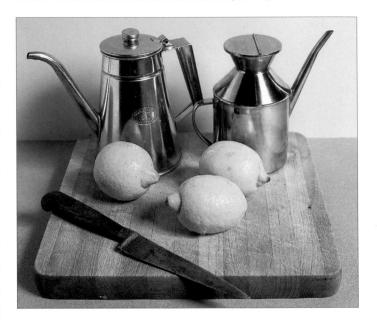

1 Using a 2B pencil, lightly sketch the outline of your subject, making sure the shapes are accurate. You may find it easier to assess the shapes objectively if you turn your drawing upside down.

2 Mix pale washes of cerulean blue, Payne's grey, cadmium lemon and ivory black. Using a fine round brush, start to paint the lightest tones on the stainless-steel olive oil pourers, leaving any highlights as white paper. Judge which colour to use where by looking carefully at the reflections.

3 Paint the left-hand lemon and the reflected yellow highlights in the right-hand olive oil pourer in the same cadmium lemon wash used in Step 2. Leave some white highlights on both the lemon and the olive oil pourer. Note that the reflected yellows are duller in tone than those used to paint the actual lemon.

Paint the two right-hand lemons in the same pale cadmium lemon wash. Mix a mid-toned brown from raw umber with a touch of burnt umber and paint the handle of the knife. Paint the blade of the knife in a very dilute wash of lamp black, leaving a highlight near the handle. Leave to dry. Mix a pale brown from yellow ochre and a little burnt sienna and, using a medium round brush, paint the wooden chopping board.

The initial, lightest washes have now been laid down and the base colours of the whole still life established. You can now begin to elaborate on this, building up tones to the correct density and putting in the details. Work slowly, building up the tones gradually to avoid the risk of laying down a tone that is too dark.

The very brightest highlights have been left as white paper.

The reflections are muted in colour and worked wet into wet so that the colours blur a little.

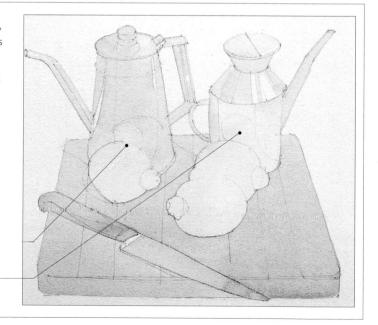

5 Mix slightly darker versions of the greys and blues used in Step 2, adding a touch of dioxazine purple to the cerulean blue, and start to paint in the mid tones on the olive oil pourers, gradually defining the individual facets more clearly. Leave to dry.

Mix a mid-toned grey from Payne's grey and ivory black and darken the blade of the knife, leaving an area of lighter tone near the handle. Make sure you don't go outside the pencil lines: the outline of the knife must be crisply defined. Leave to dry.

Add cadmium lemon to the mixture used to paint the chopping board in Step 4 and paint the reflections of the lemon in the pots. Begin to intensify the colour on the lemons themselves with a wash of cadmium lemon, working around the highlights. As you work down the lemons, gradually add cadmium lemon and then a hint of cerulean blue to the mixture, so that the colour is darker on the shadowed underside and the rounded shape of the fruit is clearer.

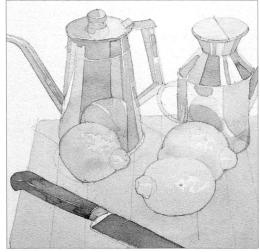

Prouch a little more greenish yellow into the reflections of the lemons. Paint the handle of the knife again with the same mixture of raw umber and burnt umber used in Step 4, leaving a slight gap in the middle, where light hits the edge, to indicate the change of plane between the side and top of the handle. Leave to dry. All the mid tones of the painting have now been established.

Mix slightly darker versions of the greys and blues used in Step 5 and continue reinforcing the tones on the olive oil pourers. As you darken these tones, the reflections (which are considerably lighter in colour) will begin to stand out even more clearly.

10 Strengthen the tones of the right-hand olive oil pourer in the same way, paying careful attention to the different facets of the two pourers. Add a touch of cadmium orange to paint the reflection of the chopping board.

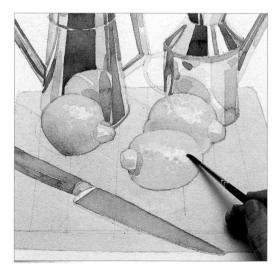

1 Using the same yellow mixtures as used in Step 7, build up the density of tone on the lemons. Again, remember to work carefully around the highlights that you left white in Step 3. Leave to dry.

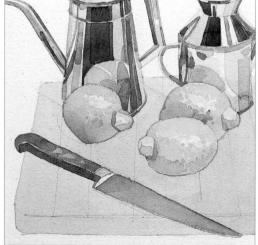

 $12\,$ Mix a dark brown from burnt umber and burnt sienna and, using a fine round brush, carefully paint the shaded side of the knife handle under the highlight line, making sure you retain the crisp, sharp lines. The knife immediately looks much more three-dimensional. Leave to dry. Using the same fine round brush, stipple a little of the greenish yellow mixture on to the dark undersides of the lemons to create the pitted surface texture of the fruit.

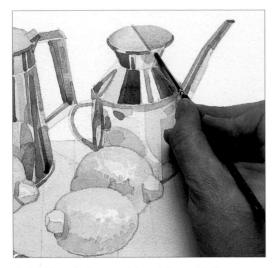

 13° in these final stages of the painting, put in the very darkest tones. Work across the painting as a whole, assessing the tones in relation to each other rather than concentrating on one specific area.

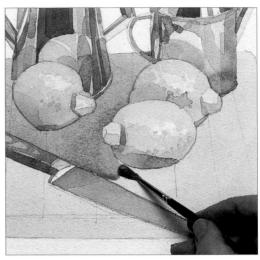

14 Brush a little more of the greenish yellow mixture on to the underside of the foreground lemon. Leave to dry. Using the dark brown mixture of burnt umber and burnt sienna, and a medium round brush, paint the top of the chopping board. Leave to dry.

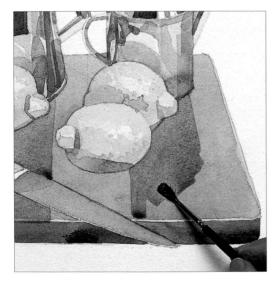

15 Darken the burnt umber and burnt sienna mixture by adding a little more burnt sienna and a hint of alizarin crimson. Paint the front of the chopping board, which is in shadow, leaving a tiny highlight along the edge between the top and front of the board. Leave to dry. Paint alternate panels on the top of the board in a mixture of burnt umber and burnt sienna. Leave to dry.

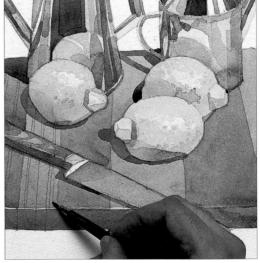

16 Add a little dioxazine purple to the dark brown mixture that you used to paint the front of the chopping board and paint the shadows behind the olive oil pourers and under the lemons and the knife. Leave to dry. Using a 2B graphite stick, draw vertical lines on the chopping board to indicate the grain of the wood.

This is a contemporary-looking still life with bold shapes and shadows. All the elements are contained within a triangle formed between the tip of the knife and the spouts of the

olive oil pourers. Placing the knife on the diagonal also makes the composition more dynamic. Several layers of colour are applied to build up the tones to the right density.

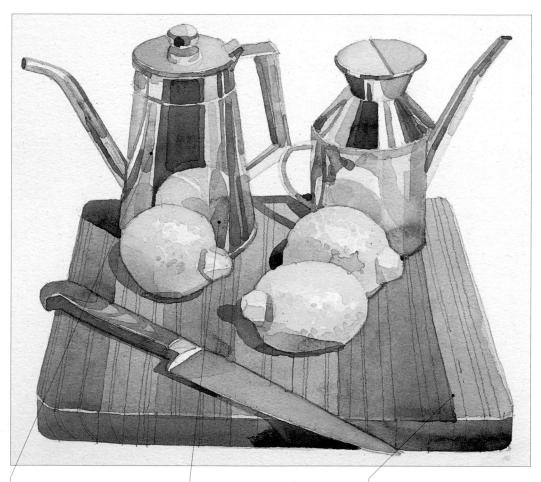

Variations in tone convey the shape of the olive oil pourers.

The reflections are slightly blurred and more subdued in tone that the objects being reflected.

Simple pencil lines effectively convey the grain of the wooden board without detracting from the main subjects.

Eye of the tiger

People sometimes say that the eyes are the windows of the soul and, regardless of whether you are painting humans or animals, they certainly tell you a lot about the character and mood of your subject. All too often, eyes are drawn and painted as circles or ovals, which looks very unnatural. The eyeball is spherical even though, of course, only a small part of it is visible. This spherical shape is particularly obvious if you look at an eye from the side, but regardless of your viewpoint it helps to think of the eye as a three-dimensional form.

Subtle blends of colour are essential when it comes to painting the iris of the eye, while the "white" of the eye is often shadowed and not white at all. Finally, you must capture that all-important sparkle, which makes your subject look alive. Look at the position and shape of bright highlights in the eyes.

The artist chose a tiger's eye for this demonstration, because he also wanted to explore the markings on the surrounding fur, but the same principles apply to all subjects. An original painting of a tiger was used as reference material.

Materials

- · HB pencil
- Hot-pressed watercolour board or paper
- Watercolour paints: cadmium yellow, cadmium red, burnt sienna, Payne's grey, viridian, French ultramarine, Vandyke brown, ivory black
- · Gouache paints: permanent white
- Brushes: fine round, ultra-fine round

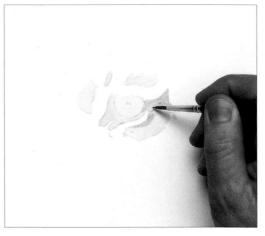

Using an HB pencil, lightly sketch the tiger's eye on smooth watercolour board or paper. Mix cadmium yellow with cadmium red for the gold of the eye and apply it carefully, using a fine round brush. Leave to dry. Mix burnt sienna with a little cadmium yellow and brush it over the tiger's fur, leaving the highlight area under the eye untouched. Paint the black facial markings around the eye in a dark mixture of Payne's grey. Leave to dry.

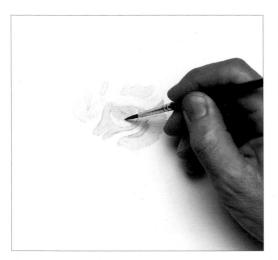

 $2\,$ Mix a cool green from viridian and a little French ultramarine and, using a fine round brush, brush it over the top half of the iris, covering the pupil. Leave to dry. The basic colours and shapes have now been established. The next stage is to make the eye look three-dimensional by showing how the lids curve over the eyeball.

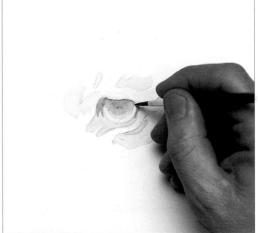

3 Using an ultra-fine round brush, paint the upper part of the iris in Payne's grey, gently feathering the colour down on to the green. This softens the transition in colour from one part of the eye to the next and looks much more natural than hard-edged, concentric circles of colour. Darken the upper rim of the eye with Payne's grey. Leave to dry.

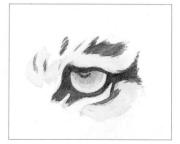

Darken the markings around the eye with a mixture of Vandyke brown and Payne's grey. Paint the pupil in the same colour.

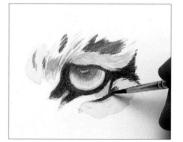

5 While the pupil is still damp, feather the colour down on to the iris, so that there is a very subtle transition of colour. Mix French ultramarine with a touch of permanent white gouache and, using a fine round brush, brush in the shaded areas of the fur, making sure your brushstrokes follow the direction of the fur growth. Build up the dark markings around the eye with ivory black. Leave to dry.

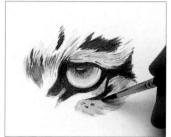

6 Continue to build up the dark markings around the eye with ivory black. Darken the brown fur colour with burnt sienna and Vandyke hrown, alternating between the two. Add tiny strokes of permanent white gouache on the eyeball and the lower eyelid to create highlights.

The dramatic colouring and fine detail make this a very attractive study. Subtle feathering of colour and the careful positioning of the highlights on both the eyeball and the

lower lid combine to depict a rounded and very life-like eye. Tiny details like this can have as much impact as a full-scale painting and are a good way of practising difficult subjects.

Tiny touches of permanent — white gouache on the pupil reflect the light, while subtle feathering softens the transition from one colour to the next.

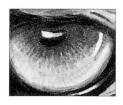

Although the fur is white, it is in shade here and is painted in pale French ultramarine.

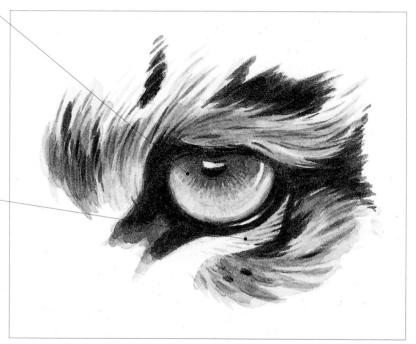

Tabby cat

Cat fur is fascinating to paint and you will find a huge variety of markings, from tortoiseshell and tabby cats with their bold stripes to sleek, chocolate-point Siamese and long-haired Maine Coons. One of the keys to painting fur is being able to blend colours in a very subtle way, without harsh edges. Even pure white or black cats, with no obvious markings, have their own "patterns": because of reflected light and shadows, the fur of a pure white cat will exhibit clear differences in tone which you need to convey in your paintings.

Fur markings also reveal a lot about the shape of the animal. You need to look at an animal's fur in much the same way as a portrait painter looks at how fabrics drape over the body of a model: changes in tone and in the direction of the fur markings indicate the shape and contours of the body underneath. Always think about the basic anatomy of your subject, otherwise the painting will not look convincing. If you concentrate on the outline shape when you are painting a long-haired cat, for example, you could end up with something that looks like a ball of fluff with eyes, rather than a living animal. The cat in this project has relatively short hair, which makes it easier to see the underlying shape.

Cats seem to spend a lot of their time sleeping or simply sprawled out, soaking up the sunlight and, if you are lucky, you might have time to make a quick watercolour sketch. For "action" pictures – kittens batting their paws at a favourite toy or adult cats jumping from a wall or stalking a bird in the garden – you will almost certainly have to work from a photographic reference. You will be amazed at the number of ways cats can contort their bodies.

Materials

- · HB pencil
- 140lb (300gsm) rough watercolour paper, pre-stretched
- Watercolour paints: yellow ochre, raw umber, alizarin crimson, ultramarine blue, cadmium red, Prussian blue, burnt sienna
- · Gouache paints: Chinese white
- Brushes: medium round, fine round

Reference photograph

This is a typical cat pose – the animal is relaxed and sprawled out, but at the same time very alert to whatever is happening around it. The markings on the fur are subtly coloured but attractive. The face is full of character, and this is what you need to concentrate on in your painting. If you can get the facial features to look right, you are well on the way to creating a successful portrait.

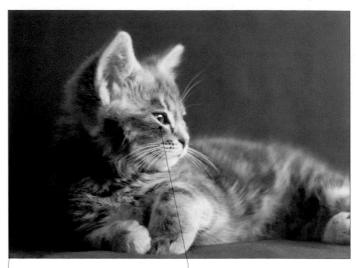

A plain background allows you to concentrate on the subject.

The eyes, the most important part of the portrait, are wide open and alert.

1 Using an HB pencil sketch the cat, making sure you get the angle of the head right in relation to the rest of the body. Start with the facial features, sketching the triangle formed by the eyes and nose, then work outwards. This makes it easier to position the features in relation to each other. If you draw the outline of the head first, and then try to fit in the facial features, the chances are that you will make the head too small.

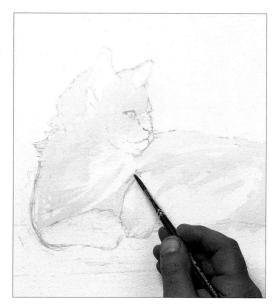

2 Mix a pale wash of a warm brown from yellow ochre and raw umber. Using a medium round brush, wash the mixture over the cat leaving the palest areas, such as the insides of the ears and the very light markings, untouched.

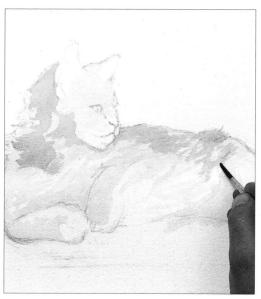

3 Add a little more raw umber to the mixture to make a darker brown and paint the darker areas on the back of the head and back.

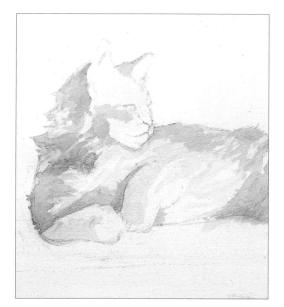

4 Continue applying the darker brown mixture, which gives the second tone. You are now beginning to establish a sense of form in the portrait.

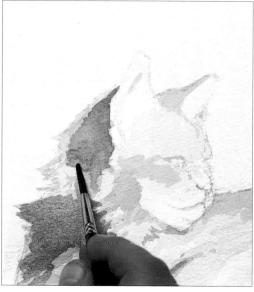

5 Add a little alizarin crimson and ultramarine blue to the mixture to make a dark, neutral grey. Begin brushing in some of the darker areas around the head.

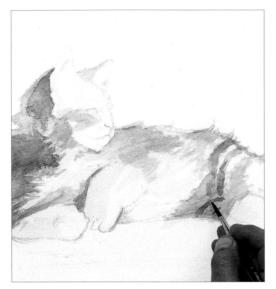

6 Add more water to the mixture and paint the cat's back, which is less shaded. Start painting some of the markings on the hind quarters, using short, spiky brushstrokes along the top of the cat's back. This indicates that the fur does not lie completely flat.

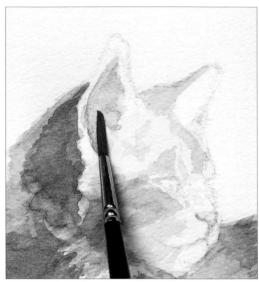

Mix a warm brown from yellow ochre and raw umber and brush it loosely over the mid-toned areas. Mix a warm pink from alizarin crimson and a little yellow ochre and, using a fine round brush, paint the insides of the ears, the pads of the paws, and the tip of the nose.

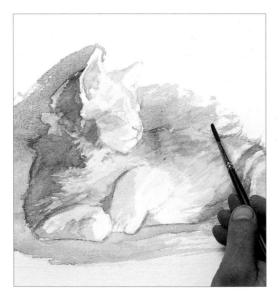

A Mix a warm maroon colour from cadmium red, yellow ochre and alizarin crimson and paint the surface on which the cat is lying. Add ultramarine blue to darken the mixture and paint the background, carefully brushing around the cat.

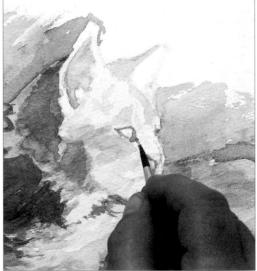

9 Mix a purplish blue from ultramarine blue and cadmium red. Using a fine round brush, paint the dark fur on the side of the cat's head, the nostril, the area under the chin and the outline of the eye.

Although the broad outline of the cat is there, along with some indication of the markings on the fur, the painting does not yet look convincing because the body looks flat rather than rounded. In addition, the cat's head is merging into the warm colour of the background, when it needs to stand out much more clearly.

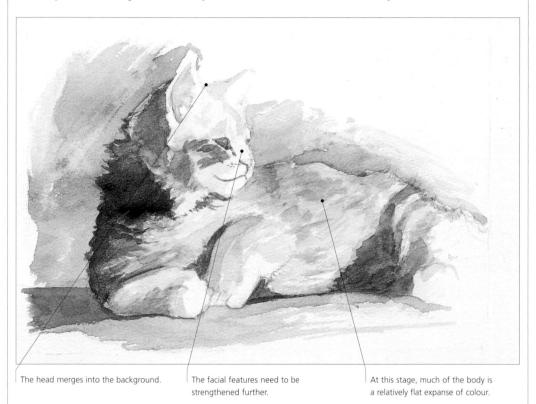

Mix a greenish black from Prussian blue, burnt sienna and cadmium red and paint the pupil of the eye, leaving a white highlight. Brush more of the purplish-blue mixture used in Step 9 on to the shaded left-hand side of the cat and strengthen the shadow under the chin and on the back of the cat's head.

Tip: Pay careful attention to the highlight in the cat's eye. The shape and size of the white area must be accurate in order to look lifelike.

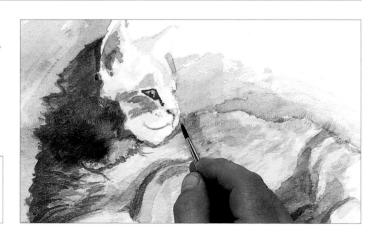

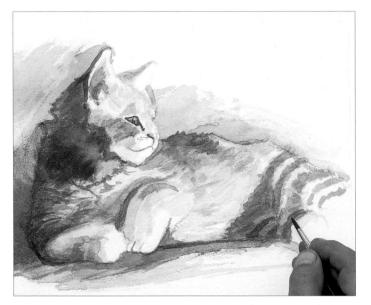

 $1\,1\,$ Using the same purplish-blue mixture, put in some of the stripes on the hind quarters and darken the tones on the back, paying careful attention to the direction of the brushstrokes so that the markings follow the contours of the body.

12 Using the same mixture, continue darkening the tones on the back to give a better sense of form.

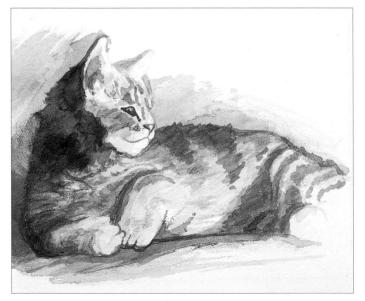

13 Adjust the tones where necessary. Now that you have put in lots of darks, you may need to tone down some of the bright areas that have been left unpainted by applying a very dilute wash of the first pale brown tone.

14 Darken the insides of the ears with alizarin crimson. Using a very fine brush and Chinese white gouache, paint the whiskers.

This is a lively and engaging study of a favourite family pet. All portraits, whether they are of humans or animals, need to convey the character of the subject. The artist has achieved this here by placing the main focus of interest on the cat's face and its alert expression. The fur is softly painted, with careful blends of colour, but the markings are clearly depicted.

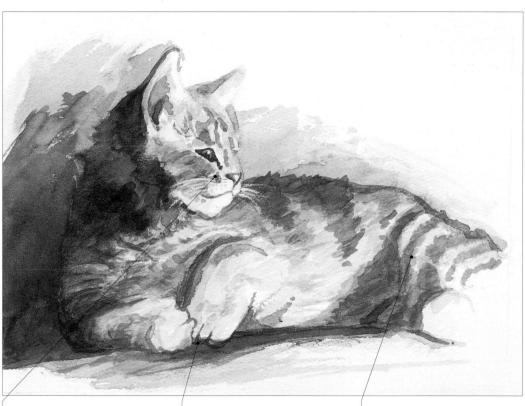

The facial features are crisply painted.

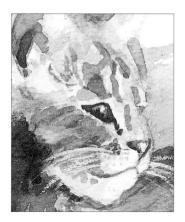

Deep shadow between the paws helps to create a sense of depth in the painting.

The markings change direction, following the contours of the body beneath.

Otter

This delightful study of an otter, peering inquisitively out to sea, is an exercise in building up textures. You can put in as much or as little detail as you wish, but don't try to finish one small area completely before you move on to the next. Go over the whole painting once, putting in the first detailed brushmarks, and then repeat the process as necessary.

Remember to work on a smooth, hot-pressed watercolour paper or board when using masking film (frisket paper). If you use masking film on a rough-surfaced paper there is a risk that the film will not adhere to the surface properly, allowing paint to slip underneath and on to the area that you want to protect. Smooth paper also enables you to make the fine, crisp lines that are essential in a detailed study such as this.

Materials

- HB pencil
- Hot-pressed watercolour board or smooth paper
- Watercolour paints: ultramarine blue, cadmium yellow, burnt sienna, Vandyke brown, Payne's grey, cadmium red
- Gouache paints: permanent white
 Prushes: madium flat, madium faut.
- Brushes: medium flat, medium round, fine round, very fine round
- Masking film (frisket paper)
- · Scalpel or craft (utility) knife
- Tracing paper

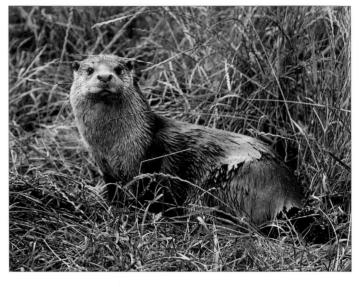

Reference photographs

Here the artist worked from two reference photographs – one for the otter's pose and fur detail, and one for the seaweed-covered rocks in the foreground. When you do this, you need to think carefully about the direction of the light. If you follow your references slavishly, you may find that sunlight appears to hit different areas of the picture at different angles, which will look very unnatural.

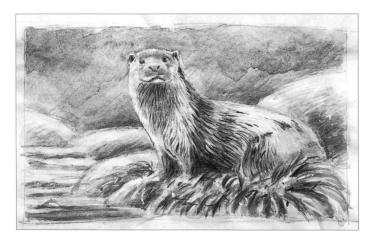

Preliminary sketches

Quick pencil sketches will help you to select the best composition, while a watercolour sketch is a good way of working out which colours to use.

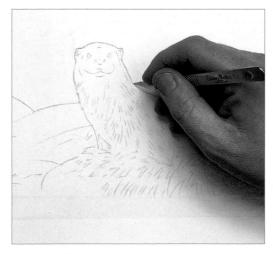

Using an HB pencil, copy your reference sketch on to watercolour board or smooth paper. Place masking film over the picture area. Using a sharp scalpel or craft (utility) knife, cut around the otter and rocks. To avoid damaging your painting surface, trace your pencil sketch, then place the masking film over the tracing paper, cut it out, and reposition the film on the painting surface.

2 Carefully peel back the masking film from the top half of the painting. You may need use a scalpel or craft knife to lift up the edge. You can now work freely on the sky and background area, without worrying about paint accidentally spilling over on to the otter or foreground rocks – though it is worth rubbing over the stuck-down film with a soft cloth or piece of tissue paper to make sure it adheres firmly to the surface and that no paint can seep underneath.

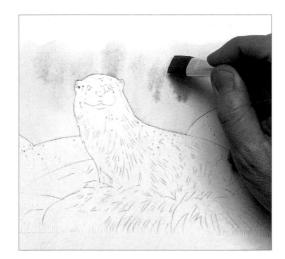

3 Mix a pale blue wash from ultramarine blue with a hint of cadmium yellow. Using a medium flat brush, dampen the board above the masking film with clean water and then brush in vertical strokes of the pale blue mixture. While the first wash is still damp, brush more vertical blue strokes along the top of the paint and allow the paint to drift down, forming a kind of gradated wash. Leave to dry.

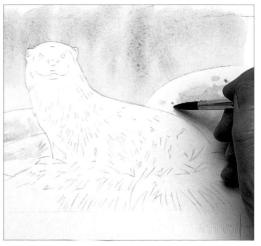

4 Carefully peel back the masking film from the bottom half of the painting, revealing the otter and rocks. Using a medium round brush, dampen the rocks with clean water and dot on the pale blue mixture used in Step 3.

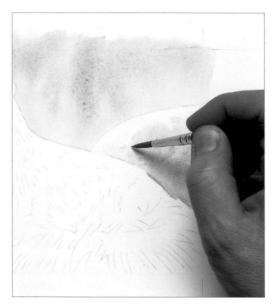

5 While the paint is still damp, use a fine round brush to dot in a darker mix of ultramarine blue and start building up tone on the rocks. Because you are working wet into wet, the colours will start to blur. Stipple a very pale cadmium yellow onto the rocks in places and leave to dry.

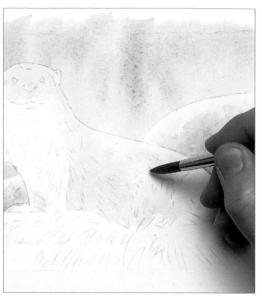

6 Mix a pale wash of burnt sienna and brush it over the otter's head and body. Brush over the chest area with the pale blue wash used in step 3. Leave to dry. Mix a darker brown wash from Vandyke brown and Payne's grey, and brush from shoulder to abdomen. Add a line around the back legs.

The base colours have now been established across the whole scene. Using the same colour (here, ultramarine blue) on both the background and the main subject creates a colour harmony that provides a visual link between the background and the foreground. You can now start to put in detail and build up the fur. In the later stages of this painting, you will want lots of crisp detail, so it's important to let each stage dry completely before you move on to the next otherwise the paint will blur and spread.

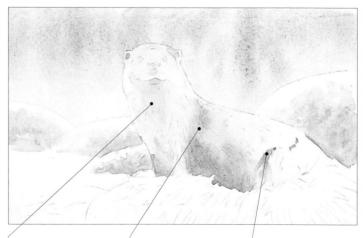

The chest, which is in shadow, is painted in a cool, pale mixture of ultramarine blue.

This darker brown helps to show the direction in which the fur is growing.

This dark line around the otter's back legs starts to establish the rounded form of the body.

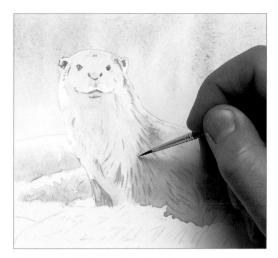

Mix a very dark brown from Vandyke brown and Payne's grey and, using a very fine round brush, put in the dark detail on the head – the inside of the ears, the eyes and the nose. Using the same colour, start to put in short brush marks that indicate the different directions in which the fur grows.

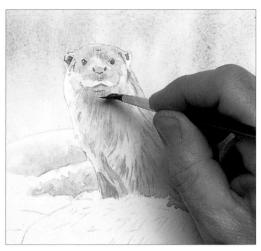

Mix a warm grey from Payne's grey and a little Vandyke brown. Using a fine round brush with the bristles splayed out in a fan shape, drybrush this mixture on to the otter's chest, taking care to follow the direction of the fur.

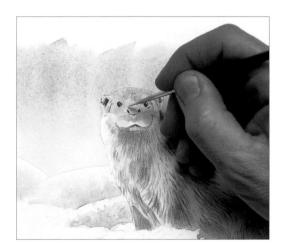

Ocontinue building up tones and textures on the otter's chest and body. Paint the lightest areas on the otter's face with permanent white qouache. Mix a light, warm brown from burnt sienna and Vandyke brown and build up tones and textures on the otter's body. Darken the facial features.

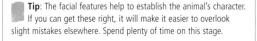

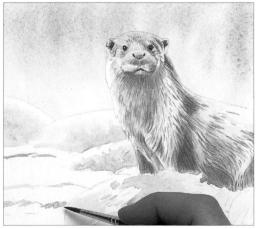

 $10\,$ Mix a bright but pale blue from ultramarine blue with a hint of cadmium yellow and, using a fine round brush, brush thin horizontal lines on to the rocks on the left-hand side of the painting. This blue shadow colour Tielps to establish some of the crevices and the uneven surface of the rocks

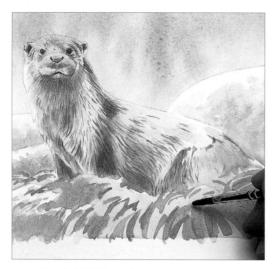

11 Mix a dark, bluish grey from Payne's grey and Vandyke brown and, using a medium round brush, paint the strands of seaweed on the rocks on the right of painting with loose, broad brushstrokes of this mixture. Leave to dry.

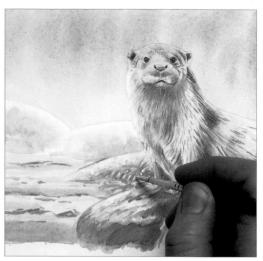

12 Brush a little ultramarine blue into the bottom left corner. Mix a warm brown from cadmium yellow and cadmium red and brush this mixture on to the rocks. Leave to dry. Paint lines of sea foam in permanent white gouache.

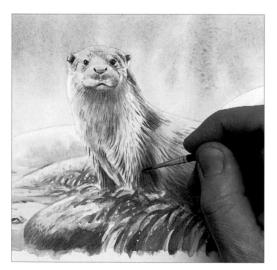

13 Now add more texture to the rock on the right, behind the otter, by stippling on a dark mixture of ultramarine blue. Note that the top of the rock, which is hit by the sunlight, is very light while the base is much darker. Using the drybrush technique, continue to add tone and form to the body of the otter, using a warm mixture of burnt sienna and ultramarine blue. Build up tone and texture on the otter's chest in the same way, using a mid-toned mixture of ultramarine blue.

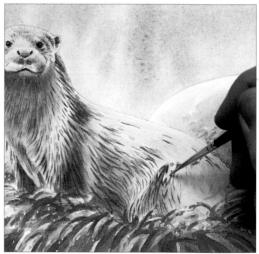

14 Using a fine round brush and very short brushstrokes, paint white gouache to form the highlights along the top of the otter's back and on the body, where water is glistening on the fur. Use white gouache to paint the otter's whiskers on either side of the muzzle.

This is a fresh and lively painting that captures the animal's pose and character beautifully. The background colours of blues and greys are echoed in the shadow areas on the otter's fur, creating a colour harmony that gives the picture unity.

By including a lot of crisp detail on the otter itself and allowing the background colours of the sky and rocks to blur and merge on the paper, the artist has made the main subject stand out in sharp relief.

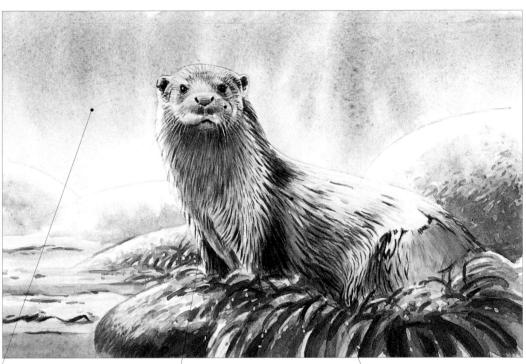

The background is painted in translucent, wet-into-wet washes that blur into indistinct shapes.

The crisp fur detail on the otter is made up of several layers of tiny brushstrokes, worked wet on dry – a painstaking technique but one that is well worth the effort.

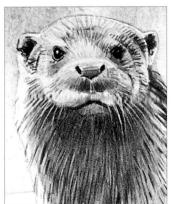

Flamingo

This project offers you the opportunity to practise building up layers of colour and to use your brush in a very controlled way. You need to assess the tones quite carefully when you are painting a subject that is mostly just one colour. You may find that it helps to half close your eyes, as this makes it easier to work out where the lightest and darkest areas are.

It is often a good idea to keep the background soft and blurred by using wet-into-wet washes when you are painting a textured subject like this, as the details stand out more clearly and the subject is separated from its surroundings.

Materials

- HB pencil
- Hot-pressed watercolour board or smooth paper
- Watercolour paints: viridian, Payne's grey, cadmium red, ultramarine blue, ivory black, cadmium yellow
- Gouache paints: permanent white
- Brushes: large round, medium round, fine round, small flat, very fine
- Masking film (frisket paper)
- Scalpel or craft (utility) knife

Preliminary sketches

Try out several compositions to decide which one works best before you make your initial underdrawing.

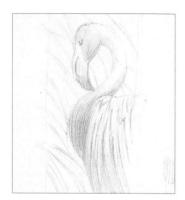

Reference photograph

This shot was taken in a nature reserve as reference for the feather colours. Wildlife parks and nature reserves are good places to take photos of animals and birds that you might not be able to get close to in the wild.

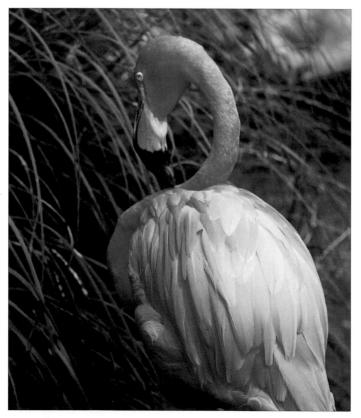

Using an HB pencil, trace your reference sketch on to hot-pressed watercolour board or smooth paper. Place masking film (frisket paper) over the whole picture area. Using a sharp scalpel or craft (utility) knife, carefully cut around the outline of the flamingo and the oval shape formed by the curve of the bird's neck. Peel back the masking film from the background, leaving the flamingo covered.

 $2^{\text{Take a piece of tissue paper and gently rub it over the film} to make sure it is stuck down firmly and smoothly. It is essential that the background wash can't slip under the mask and on to the flamingo's body.}$

3 Mix a pale, watery wash of viridian. Using a large round brush, brush it over the background in long diagonal strokes, stopping about halfway down the paper.

A Mix a pale wash of Payne's grey. While the first wash is still damp, working from the bottom of the painting upwards, brush the Payne's grey over the background, stopping at the point where it overlaps the viridian a little.

 $5\,$ Using a medium round brush and holding the brush almost vertically, brush long strokes of Payne's grey over the damp wash to imply the foreground grasses. The paint will blur slightly, creating the effect of an out-of-focus background. Leave to dry.

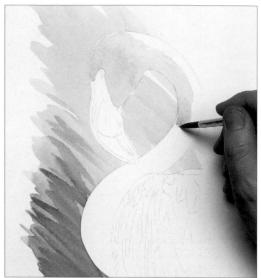

Remove the masking film from the flamingo. Mix a pale, watery wash of cadmium red. Using a medium round brush with a fine point, carefully brush the mixture over the flamingo's head and neck, leaving the bill and a small highlight area on the top of the head unpainted. Make sure none of the paint spills over on to the background.

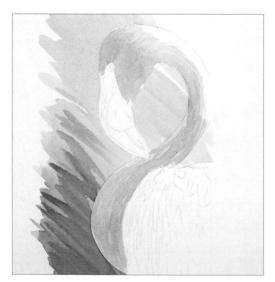

7 Strengthen the colour on the bird's head and neck by applying a second layer of cadmium red. Paint the pale pink wash on to the central part of the face.

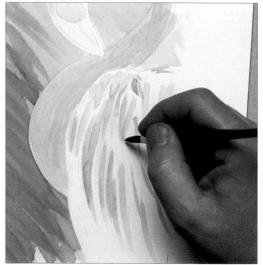

Susing the first wash of pale cadmium red, move on to the body, making broad strokes that follow the direction of the wing feathers. Leave the highlight areas unpainted. Add a wash of Payne's grey to the bill. Leave to dry.

The overall base colours of the painting have been established and we are beginning to see a contrast between the blurred, wet-into-wet background and the sharper, wet-on-dry brushstrokes used on the bird, which will be reinforced as the painting progresses. Much of the rest of the painting will be devoted to building up tones and feather texture on the flamingo.

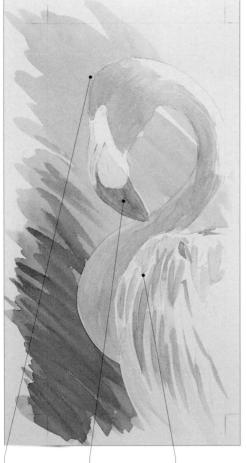

Note the use of complementary colours – red on the bird and green on the background.

The bill has been given a pale wash of Payne's grey.

The strokes follow the direction of the feathers.

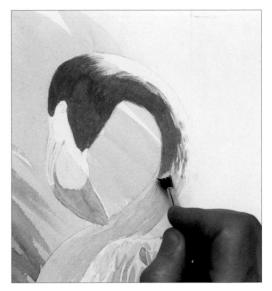

Mix a stronger wash of cadmium red and, using a very small, almost dry, round brush, start building up the colour on the head, making tiny, evenly spaced brushstrokes to create the feeling of individual feathers. Using a small flat brush with the bristles splayed out, start working down the neck, again making tiny brushstrokes.

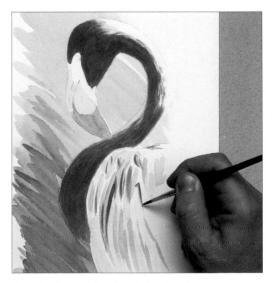

10 Continue painting the flamingo's neck, making sure that your strokes follow the direction in which the feathers grow. Using a fine round brush, paint over the main wing feathers again. Leave to dry.

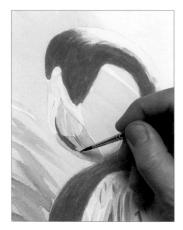

1 1 Mix a very pale pink from pale cadmium red with a little permanent white gouache and, using a fine round brush, carefully paint the area around the eye. Mix a mid-toned wash of Payne's grey and, using a fine round brush, paint the detailing on the bird's bill. Leave to dry.

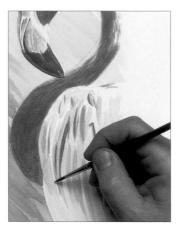

12 Continue building up detail on the bill. Add a little ultramarine blue to the Payne's grey mixture and paint the shadow cast by the beak and the shadowed area on the outer edge of the bird's body. Leave to dry.

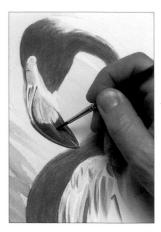

13 Mix a wash of ivory black and paint the bill, leaving spaces between your brushstrokes in order to give some texture and show how light reflects off the shiny bill. Add a dot of pale cadmium yellow for the eye.

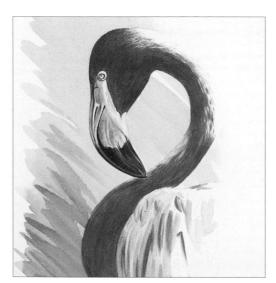

14 Mix cadmium red with a little cadmium yellow and, using a very fine round brush, dot this mixture on to the bird's neck, just beyond the point where the initial cadmium red washes end, so that there isn't such a sharp transition from red to white. Use a fine round brush to add detail in ivory black to the eye.

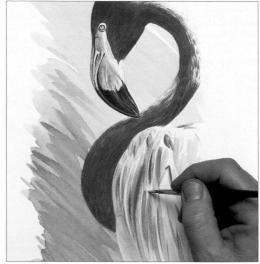

15 The body looks very pale compared to the head and neck so, using a fine round brush and cadmium red, continue to build up tone on the body with tiny brushstrokes that follow the direction of the feathers. Touch permanent white gouache into the white spaces on the bird's body, leaving white paper on the right-hand side so that the image appears to fade out on the lightest side.

This is a beautiful example of the effectiveness of building up layers of the same colour to achieve the desired density of tone. The lovely soft texture is achieved through countless tiny brushstrokes that follow the direction of the feathers.

The composition is very effective, too. The tall, thin shape of the painting echoes the shape of the flamingo, and the viewer's eye is led in a sweeping curve from the bottom right-hand corner to the focal point – the bird's head.

Softly feathered brushstrokes soften the transition from red to white.

Paying careful attention to where the highlights fall has helped to make the bill look three-dimensional.

Note how gouache gives you much more control over the exact placement and size of highlights than simply leaving the paper unpainted, as you can paint over underlying colour with a very fine brush.

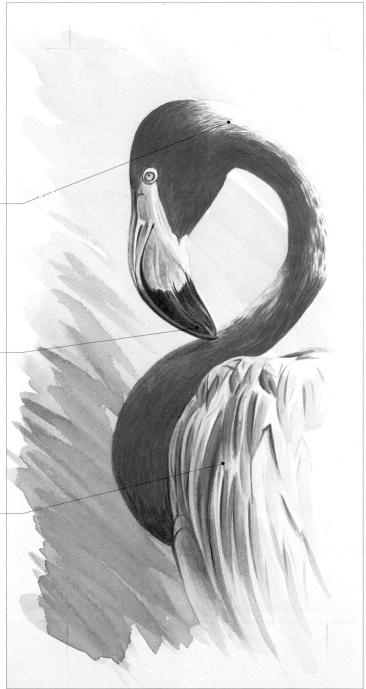

Painting Buildings

We spend our lives living and working inside buildings, but often pay them scant regard for, as long as they serve the purpose for which they were constructed, our attentions are focused elsewhere.

Buildings not only reflect function and purpose, but also the people for whom they were built. Styles can vary greatly, depending on location and the prevailing weather conditions and climate. Often, buildings can be immediately identified as belonging to a certain place – think of the palazzos of Venice or the art deco skyscrapers of New York or Chicago. They also reflect the age in which they were built and may also often give clues to the surrounding landscape and geology, as many buildings are constructed using materials that are obtained locally.

Building materials vary enormously in colour and texture. Honey-coloured dressed stone, red brick, grey concrete, flint, weathered and painted wood, steel and glass, terracotta tiles, blue-grey slate, mud and straw: the wide range makes demands on any artist and will require the use of several different techniques to successfully represent them.

Inevitably, when you are drawing and painting buildings, you will need to use both aerial and linear perspective. The idea of having to use perspective alarms some people, but once you have mastered the basic principles, the rest is relatively straightforward. Simplicity is the key, and even highly complex buildings consist, when all the intricate architectural and decorative detail has been stripped away, of a few simple geometric shapes. Try to analyse your subject in these terms before you set pencil to paper.

Draw your building in the same way and sequence in which it was constructed. First, the basic structure, then the doors and windows. Only in the very final stages should you attempt to add any decorative embellishment.

Although you do not need to become an architectural authority, it does help if you have some knowledge, no matter how rudimentary, of how buildings are constructed. It is all too easy to draw or paint a building that does not appear solid and looks as if it will fall over at any minute. This is a common mistake, particularly for novice painters.

Broadway, New York ▼

This complex painting used both aerial and linear perspective. Linear perspective creates a sense of depth, leading the eye along the avenue and into the distance. Aerial perspective enhances the effect of distance, as the colour and the detail become less pronounced the further away they are.

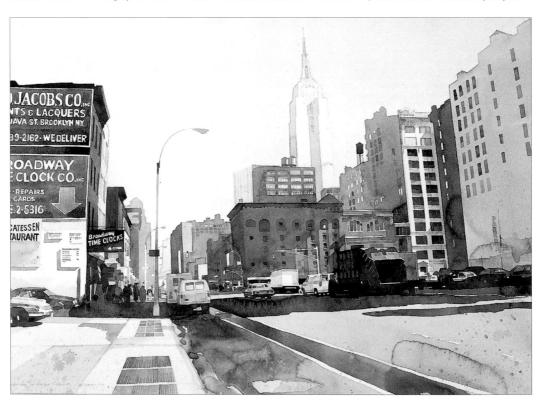

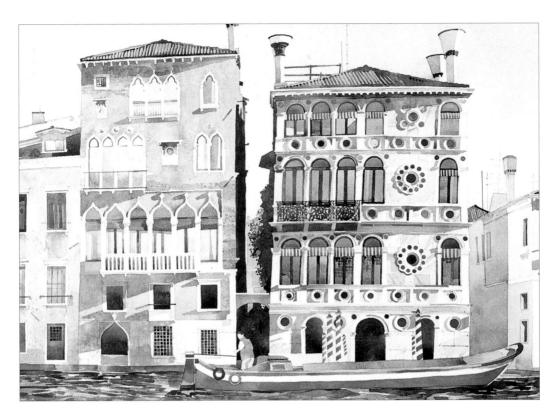

Grand Canal, Venice

This painting of canalside buildings in Venice was made using wet-on-dry washes after a careful and detailed preliminary drawing.

- Tips: Unless you are particularly confident, begin by making a light underdrawing to work out any problems regarding perspective and proportion.
- Use both linear and aerial perspective. Both will help to create an illusion of depth, and the correct use of linear perspective will ensure that your building does not look as if it is about to fall over.
- Pay attention to shadows: they contribute to the composition and will help to establish a sense of depth.
- Use a range of watercolour techniques to capture the texture and character of the building and the materials used in its construction.

Le Garde Freinet A

This painting of a house in a small French village uses wet-on-dry and wet-into-wet techniques, along with careful spattering and drybrush work, to show the crumbling plaster and weathered paint on the pale blue shutters.

Hillside town in line and wash

Line and wash is the perfect technique for this brightly coloured lakeside town, where you need fine detailing in the buildings and soft wet-into-wet washes in the surrounding landscape.

This project uses both waterproof and soluble inks, as they bring very different qualities to the image. Waterproof ink must be used in areas where you want the pen lines to remain permanent, such as the skyline and the wrought-iron balconies. Soluble ink, on the other hand, blurs and runs in unpredictable and exciting ways when you brush water or watercolour paint over it. Before you embark on any pen work, therefore, you need to think carefully about what kind of ink to use where

In this scene, the tree-covered background is darker than the foreground. (Often in landscape paintings, you find that things in the background appear paler because of the effect of aerial perspective.) This helps to hold the image together, as it provides a natural frame around the focal point – the colourful buildings and their reflections.

Materials

- HB pencil
- 120lb (220gsm) good-quality drawing paper
- Art pen loaded with waterproof sepia ink
- Art pen loaded with water-soluble sepia ink
- Watercolour paints: ultramarine blue, cobalt blue, sap green, yellow ochre, phthalocyanine green, cadmium orange, cadmium red, burnt sienna, cadmium yellow, alizarin crimson, deep violet
- · Brushes: medium round

Tip: If you are working from a reference photograph in which the light is very flat and bland, imagine how the light would fall on the scene on a bright sunny day. Where and how long would the shadows be? Make sure you keep your imaginary lighting consistent over the whole scene.

The original scene

This photograph was taken on a very overcast day, simply as a reference shot for the architectural details. As a consequence of the weather, the colours are dull and the light is flat and uninteresting. In situations like this, feel free to improve on what you saw at the time by making the colours brighter in your painting.

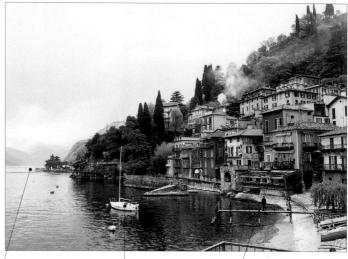

The composition pulls your eye to the edge of the picture, out into the centre of the lake.

The boat is a very stark white and detracts from the bright colours of the buildings.

The light is very flat: more contrast is needed to make the buildings look three-dimensional.

Preliminary sketch

Here the artist decided to crop in to make the composition tighter than it was in the original photograph. He also moved the boat further into the picture.

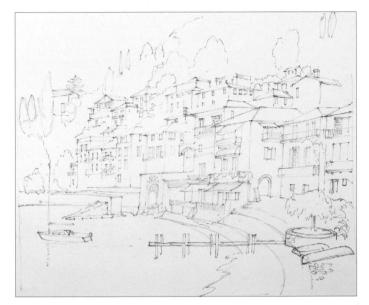

1 Using an HB pencil lightly sketch your subject, taking plenty of time to measure the relative heights and angles of the buildings carefully and making sure that you keep all the many vertical lines truly vertical. You can work much more loosely for the background hillside and trees, which will form a much softer, impressionistic backdrop to the scene.

2 Using waterproof sepia ink, put in the skyline. Using water-soluble sepia ink, put in the roofs and background trees, loosely hatching the trees to indicate the tones.

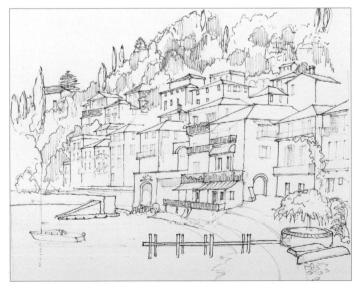

3 Continue with the line work, hatching the darkest areas of the trees in water-soluble ink, which you want to blend with paint in the later stages, and drawing the railings on the balconies in waterproof ink, so that the lines are permanent.

4 Using waterproof sepia ink, block in the windows on the shaded sides of the buildings.

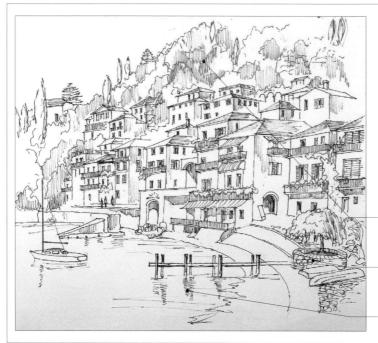

The pen work is now complete and will underpin the whole of the painting. If you have planned it properly, the lines drawn in waterproof sepia ink will be permanent, while those drawn in water-soluble ink will blur and run when washed over with watercolour paint. You cannot predict exactly how the lines will run, but this unpredictability is part of the fun and will impart great liveliness and spontaneity to the finished work.

Hatching in water-soluble ink indicates the areas of light and dark on the trees.

Waterproof ink is used for all the lines that need to be retained in the final painting.

Loose scribbles indicate the ripples in the water.

5 Mix a bright blue from ultramarine blue and cobalt blue watercolour paints. Using a medium round brush, wash this mixture over the sky, leaving some gaps for clouds. Mix a pale wash of sap green and brush it over the trees. Note how the soluble sepia ink blurs, giving the impression of the tree branches. Add a little yellow ochre to the mixture for the trees on the right-hand edge of the painting. Leave to dry.

6 Mix a dark green from ultramarine blue and phthalocyanine green and paint the tall cypress trees that stand along the skyline. The vertical lines of the trees break up the horizon and add interest to the scene. Use the same dark green mixture to loosely brush in some dark foliage tones on the trees, taking care not to allow any of the paint to spill over on to the buildings below.

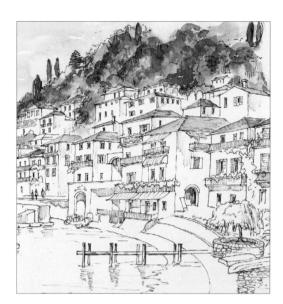

Mix a terracotta colour from cadmium orange, cadmium red and burnt sienna. Using the tip of the brush, paint the roofs, adding more burnt sienna for the shaded sides of the roofs. Note how the whole picture begins to take on more form and depth as soon as you put in some shading.

Suse a slightly paler version of the mixture used for the roofs to paint the shaded sides of some of the buildings. Work carefully so that you retain the sharp vertical lines of the buildings. This is an important aspect of making the buildings look three-dimensional.

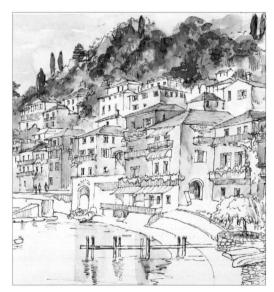

9 Mix a very pale wash of yellow ochre and brush it on to the front of some of the houses. Paint the shaded sides of the terracotta-coloured houses in a mixture of yellow ochre and burnt sienna.

10 Finish painting the façades of the buildings. Mix a light green from sap green and cadmium yellow and dot in the foliage on the balconies. While this is still damp, dot on dark phthalocyanine green to build up some tone and depth.

1 Paint the striped awnings in dilute washes of alizarin crimson and cobalt blue (but don't try to make the stripes on the awnings too precise and even, or the work will start to look stilted). Paint the window shutters in cobalt blue and phthalocyanine green.

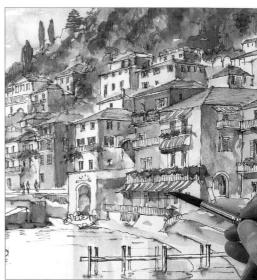

12 Mix a pale but warm purple from ultramarine blue, deep violet and burnt sienna and paint the shadowed sides of the buildings and a narrow strip under the awnings. This reinforces the three-dimensional effect and separates the houses from each other and from the background.

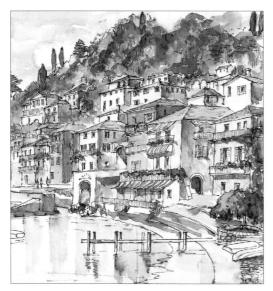

13 Using the same colour, continue putting in the shadows on the houses and on the shoreline promenade and jetty. Paint the reflections in the water, using watered-down versions of the colours used on the buildings. Leave to dry.

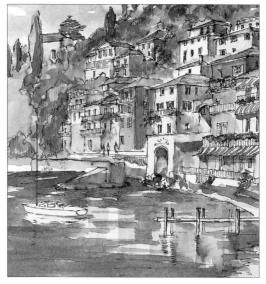

14 Mix a deep blue from ultramarine blue, cobalt blue and a little deep violet. Carefully brush this over the water area, working around the boat and the posts of the jetty and leaving some gaps for broken ripples and highlights.

With the addition of a few final details (the jetty, painted in a mixture of burnt sienna and ultramarine blue; the upturned boats in very pale washes of alizarin crimson and ultramarine blue, and the boat on the lake in alizarin crimson), the

painting is complete. Precise pen work in both water-soluble and waterproof ink has combined with loose brushstrokes and wet-into-wet washes to create a lively rendering of this charming lakeside town.

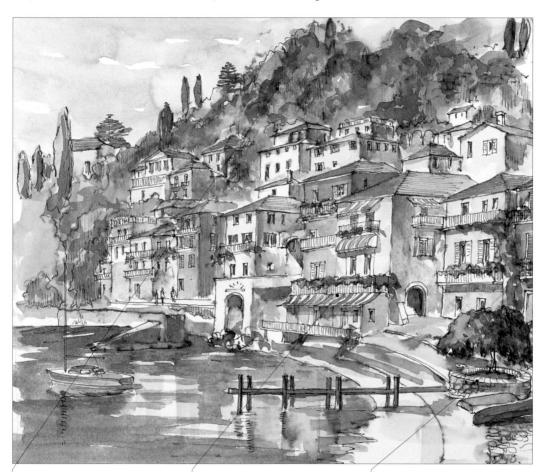

The blurred, wet-into-wet trees focus attention on the sharply defined buildings.

Loose strokes of colour are used to depict the awnings.

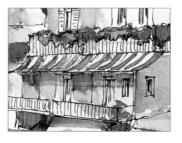

Precise pen lines set down in the very earliest stages remain in the finished work.

Moroccan kasbah

The location for this striking and unusual project is the World Heritage site of Ait-Ben-Haddhou, in southern Morocco. It is a traditional-style village made up of several earthen fortresses, each one some 10 metres (30 feet) high.

With its straight-edged buildings and clean lines, the scene looks deceptively simple, but it demonstrates well how important it is to train yourself to assess tones. The earthen buildings are all very similar in colour (predominantly ochre and terracotta), so without strong contrasts of tone you will never succeed in making them look three-dimensional.

If you are painting on location, you may find that the light and, consequently, the direction and length of any shadows changes as you work. It is a good idea to make light pencil marks on your paper, just outside the margins of your painting, indicating the angle of the sun. This makes it easier to keep the lighting consistent when you are painting over a period of several hours.

Materials

- 2B pencil
- 140lb (300gsm) NOT watercolour paper, pre-stretched
- Watercolour paints: cerulean blue, yellow ochre, light red, vermilion, mauve, white, alizarin crimson, Hooker's green, Winsor yellow, Payne's grey, ultramarine blue, burnt umber
- Brushes: large wash, medium round, medium flat, fine filbert

Tip: Use a pencil to measure the relative heights of the buildings. Hold the pencil out in front of you and align the tip with part of your subject (say, the top of the tallest building), then run your thumb down the pencil until it aligns with the base of the building. You can transfer this measurement to your watercolour paper, again holding the pencil at arm's length. It is important to keep your arm straight and the pencil vertical, so that the pencil remains a constant distance from the subject.

The original scene

The artist took this photograph around midday, when the sun was almost directly overhead. Consequently, the colours looked somewhat bleached out and there were no strong shadows to bring the scene to life. She decided to use a little artistic licence and enhance what she saw by intensifying the colours in order to make her painting more dramatic.

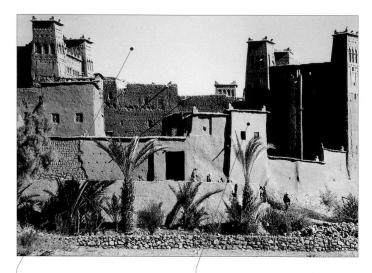

The sky looks pale and doesn't have the warmth that one associates with hot African countries.

Here, the mud-brick buildings look pale and bleached out; in the right light, however, they glow a warm orangey-red.

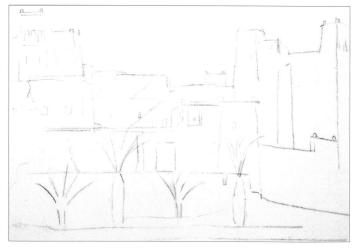

 $\mbox{\bf 1}$ Using a 2B pencil, lightly sketch the scene, taking careful note of the relative heights of the buildings and their angles in relation to one another.

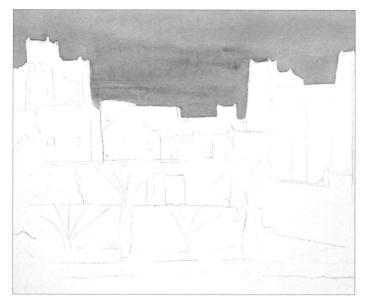

2 Using a large wash brush, dampen the sky area with clean water, brushing carefully around the outlines of the buildings to get a neat, clean edge. Mix a wash of cerulean blue. After about a minute, when the water has sunk in but the paper is still damp, quickly brush on the colour. (You may want to switch to a smaller brush to paint up to the edge of the buildings. Use the side of the brush and brush the paint upwards, to avoid accidentally getting any of the blue colour on the buildings.)

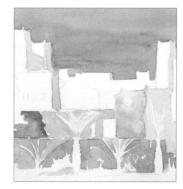

5 Continue working across the painting until you have put in all of the lightest tones of the buildings.

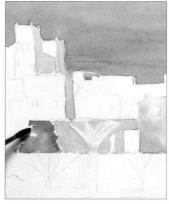

Mix a pale but warm terracotta colour from yellow ochre, light red and a tiny amount of vermilion. Using a medium round brush, wash this mixture over the buildings, working around the fronds of the foreground palm trees and adding a little more yellow ochre as you work across from right to left.

Mix a mid tone from yellow other and a tiny amount of mauve and, using a medium flat brush, stipple this mixture on to the buildings in the centre of the painting to give them some texture as well as tone. Add more mauve to the mixture for the darker left-hand side.

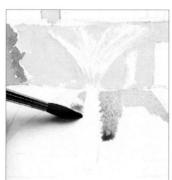

Add a little mauve to the milkture to make a deeper tone. Paint the wall at the base of the picture, painting around the trunks of the palm trees. Hold the brush at an angle as you do this and make jagged marks, as this helps to convey the texture of the trunks and shows that they are not straight-edged.

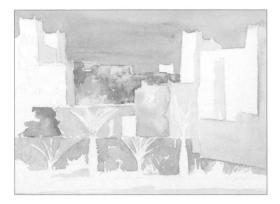

 \overline{Z} Brush white watercolour over the top edge of the building in the centre. This reduces the intensity of the yellow and makes it look as if it has been bleached by the sun.

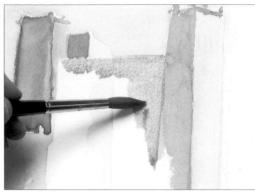

Mix a dark terracotta from light red, yellow ochre and a touch of alizarin crimson and start painting the darkest tones – the sides of the buildings that are in deepest shade.

The light, mid- and dark tones are now in place across the picture and, although the tones have not yet reached their final density, we are beginning to get a clear sense of which facets of the buildings are in bright sunlight and which are in shade. From this stage onwards, you need to continually

assess the tonal values as you work, because even slight changes in one area will affect the balance of the painting as a whole. Take regular breaks, propping your painting up against a wall and looking at it from a distance to see how it is developing.

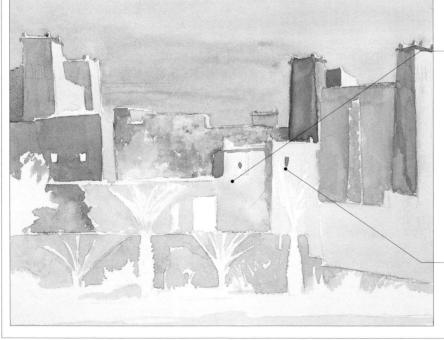

Stronger contrasts of tone are needed in order for the buildings to look truly threedimensional.

- Details such as the recessed windows and doors will help to bring the painting to life.

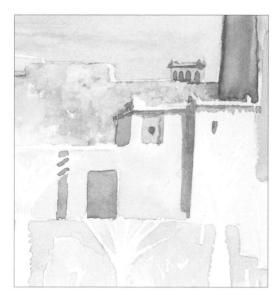

Mix a very dark terracotta colour from light red, yellow ochre and a touch of alizarin crimson, and begin putting in some of the fine details, such as the door in the exterior wall and some of the small windows. You are now beginning to establish a feeling of light and shade in the painting.

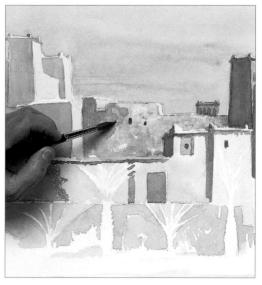

10 The right-hand buildings, which are in the deepest area of shade, look too light. Darken them as necessary by overlaying more washes of the colours used previously. Also darken the mid-toned wall in the centre of the picture and put some dark windows on the light side.

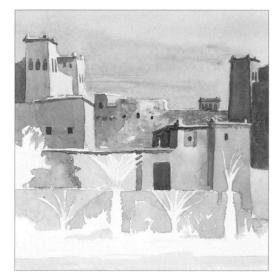

1 1 The lightest walls now look too light in relation to the rest of the painting, so darken them with another wash of the pale terracotta mixture used in Step 3. Build up the tone gradually. You can apply more washes if necessary, but if you make things too dark there is no going back.

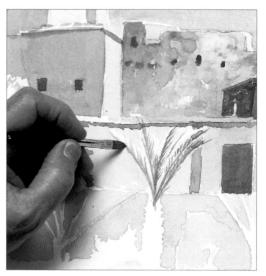

 $12\,$ Mix a yellowy green from Hooker's green and a little yellow ochre and, using a fine filbert brush, start putting in the green palm fronds in the foreground. Make short upward flicks with the brush, following the direction in which the palm fronds grow.

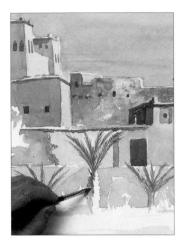

13 Continue painting the palm fronds, adding a little Winsor yellow at the point where the fronds spring out from the trunk. Paint the shaded sides of the palm trunks in Payne's grey, using short, broken strokes to indicate the knobbly surface texture of the trunks.

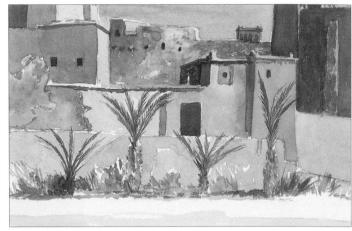

14 Lighten the grey by adding a little yellow ochre. Using the side of the brush, dab this mixture on to the left-hand side of the painting to indicate the scrubby texture of the bushes that grow in this area. Mix a very pale green from Payne's grey, yellow ochre and Hooker's green and dot in the side of the palm trunks that catches the light. Mix a grey-green from Payne's grey and Hooker's green and dot this mixture into the foreground shrubs. Mix a pale purple from alizarin crimson and ultramarine blue and paint the dry earth and the shadows around the base of the palm trees.

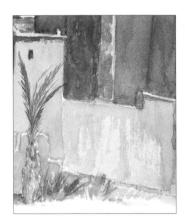

15 Mix a pale wash of alizarin crimson and darken the wall in the foreground. Feel free to use some artistic licence in your choice of colours. Although the wall is, in reality, more terracotta than pink, you are trying to put colour into a subject that doesn't have much in order to create some drama and variety in your image. Adjust the tones over the painting as a whole if you feel that it is necessary.

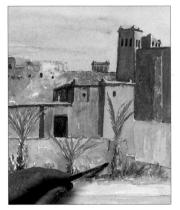

16 Mix a dark brown from light red and Payne's grey and put in the dark details, such as the windows. Drybrush a pale mixture of Hooker's green over the foreground to give it some tone. Mix a dark brown from burnt umber and Payne's grey and dab it on to the palm trunks to give them more tone and texture. Paint the shadows of the palm trees on the wall in a pale mixture of Payne's grey.

17 Mix a dilute wash of white watercolour paint and brush it over the tops of the highest buildings. Because the paint is transparent the underlying colour shows through, creating the effect of strong sunlight shining on the buildings and bleaching out the colour. Don't worry if the white looks too strong when you first apply it to the paper as it will quickly sink in and look natural.

The artist has managed to create a surprisingly wide range of tones in this painting, and this is one of the keys to its success, as the variety helps to convey not only the weathered textures of the mud bricks but also that all-important sense of

light and shade. Rich, warm colours – far warmer than in the original reference photograph – help to evoke the feeling of being in a hot country. The foreground trees and bushes contrast well with the buildings in both colour and shape.

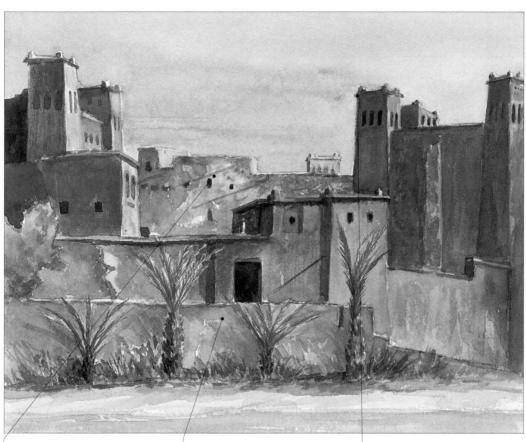

Transparent white watercolour paint allows some of the underlying colour to show through, and this creates the impression of sun-bleached brick.

In reality, this wall is the same colour as those behind. Painting it a warm pink brings it forward in the picture and helps to create an impression of distance.

Note the use of complementary colours – the orangey ochres and terracottas of the buildings against the rich cerulean blue of the sky.

Arched window

Many people would have passed by this little window in favour of something with more obvious appeal, such as brightly painted shutters or a courtyard filled with colourful blooms. The beautiful proportions of this old window, however, with its worn stonework and row of empty terracotta pots, struck an instant chord with the artist. It is proof, if proof were needed, that you can find a subject to paint wherever you go.

Why not try this approach for yourself? Instead of looking for the picturesque, deliberately set out to find a subject that most people would consider to be unsuitable for a painting — the contents of a builder's skip, perhaps, or battered tin cans in the street. Even graffiti on a brick wall or a rusting padlock on a rickety old wooden gate can be turned into intriguing, semi-abstract studies.

From a pictorial point of view, one of the most fascinating things about old, worn subjects like this is that they have wonderfully subtle colours and textures, which makes them ideal candidates for the whole spectrum of watercolour textural techniques. Spattering, sponging, stippling and a whole range of additives can all be incorporated to good effect.

This project starts by using oil pastels as resists, revealing both the texture of the paper and underlying colours. Remember to press quite hard on the oil pastels, otherwise there won't be enough oil on the paper to resist the watercolour paint applied in subsequent stages.

Materials

- 2B pencil
- 140lb (300gsm) NOT watercolour paper, pre-stretched
- Soft oil pastels: light green, dark green, pale yellow, terracotta, bright orange, pink, light grey, mid-toned grey, olive green
- Watercolour paints: cerulean blue, dioxazine violet, Payne's grey, olive green, burnt sienna, cadmium orange, leaf green, phthalocyanine blue, cobalt blue
- Brushes: medium round, fine round
- Ruling drawing pen
- Masking fluid

Preliminary sketch

This scene contains relatively few colours and lots of dense shadows. The only way to make it look realistic is to work out in advance where the darkest and lightest tones are going to be, as the artist has done in this quick tonal sketch.

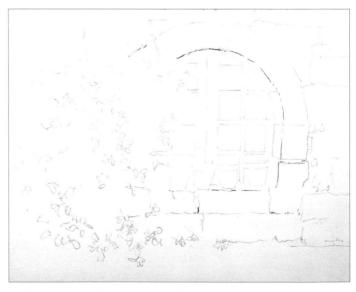

1 Using a 2B pencil, lightly sketch the outline of the window with its row of terracotta flowerpots, the main blocks of stone that surround it, and the mass of plants growing on the left-hand side.

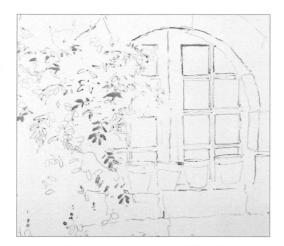

 $2^{\rm Dip}$ a ruling drawing pen in masking fluid and mask the glazing bars on the window frame, the highlights on the rims of the terracotta flowerpots and the little yellow flowers on the bush on the left. Note the differing types of marks: thin straight lines for the highlights and short dots and dashes for the individual flower petals. Leave to dry.

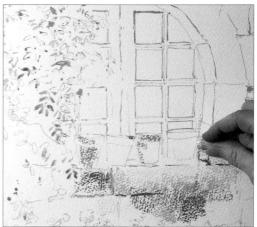

Now start to put in colour and texture with soft oil pastels, pressing quite hard to ensure that enough oil is deposited on the paper to act as a resist when the watercolour paint is applied. Roughly dash in the leaf shapes, using light green for the tallest bush and a darker green for the one in the foreground. Drag pale yellow streaks across the stonework under the window. Put in some terracotta pastel on some of the bricks and the flowerpots. Draw the orange and pink flowers on the bush. Put in some light- and midtoned grey on the worn stonework under the window.

With the addition of a few more pastel marks – more green on the leaves, orange on the terracotta pots, and a dark olive green in the spaces between the pots the oil pastel stage is now complete. Oil resists water, so these colours will show through any subsequent watercolour washes. Because you are using a rough paper, some of the oil pastel lines will be broken and the texture of the paper will also be visible. Take time to check that you have included all the areas where you want texture.

Short dots and dashes convey the shapes of the leaves and flowers.

Long, broken strokes are used for the worn stonework.

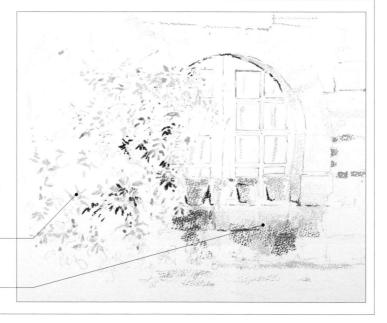

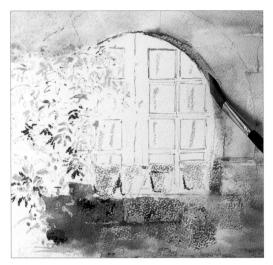

A Now for the watercolour stages. Dampen the stonework with clean water. Mix a very pale greyish blue from cerulean blue and a little dioxazine violet watercolour paints and brush this mixture over the stonework, adding a little Payne's grey for the shadowed areas and a little more violet for the foreground. Brush very pale olive green over the shadowed stonework beneath the window ledge. Applied wet into wet, the colour blurs and looks like soft lichen.

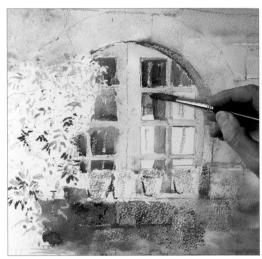

5 Mix a very pale wash of cerulean blue and paint the white woodwork of the right-hand window frame. (Leaving the frame as white paper would look too stark in relation to the rest of the image.) Mix a warm brown from burnt sienna and dioxazine violet and carefully paint the window panes, leaving some gaps for highlights reflected in the glass.

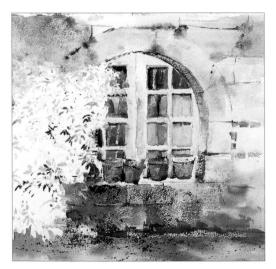

 $6\,$ Mix an orangey brown from cadmium orange and dioxazine violet and paint the first terracotta flowerpot. Add Payne's grey to the mixture for the second pot in the row, which is in shadow, and burnt sienna for the third and fourth pots.

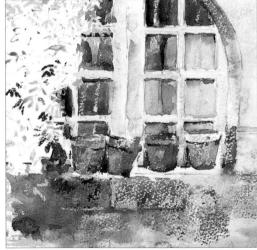

Note how the oil pastel marks that you applied in the early stages resist the watercolour paint, creating very realistic-looking but subtle texture in the stonework under the window and the flowerpots. The texture of the paper plays a part in this, too.

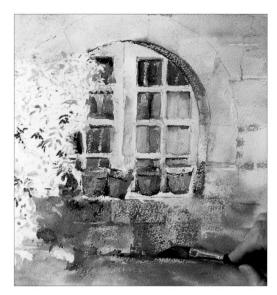

A Mix a pale but warm grey from cerulean blue and a little dioxazine violet and wash this mixture over the stonework under the window. While the wash is still damp, brush burnt sienna over the terracotta pastel of the bricks. Allow the paper to dry slightly, add dioxazine violet to the burnt sienna wash and paint the cracks in the stonework.

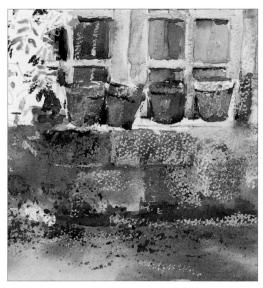

Mix dioxazine violet with a little olive green and spatter this mixture lightly over the foreground to create some texture on the path and wall. These spatters of dark colour look like clumps of moss or small pebbles – both of which are in keeping with the somewhat derelict and dilapidated nature of the subject.

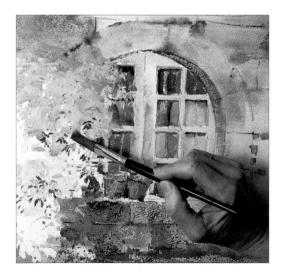

10 Mix a fairly strong wash of leaf green (which is a bright, yellowy green) and brush it over the lightest areas on the tops of the bushes. Add cerulean blue to the mixture and use this colour to paint the mid-toned leaves, taking care not to obliterate all of the light green.

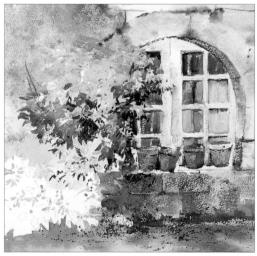

1 1 Mix a dark green from olive green and phthalocyanine blue and dot in the darkest tones of the leaves on the background bush, making sure your brushstrokes follow the direction in which the leaves grow. You are now beginning to establish the form of the bushes.

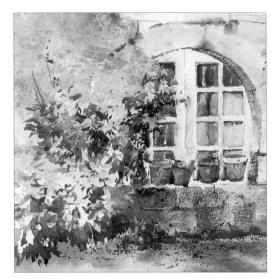

12 Add cobalt blue to the dark green used in Step 11. Paint the spaces between the leaves of the foreground bush.

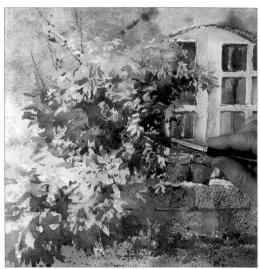

13 Mix a very pale wash of cerulean blue and brush it over the white spaces to the left of the bushes, which look very stark in relation to the rest of the image. Mix a very dark green from burnt sienna, olive green and a little phthalocyanine blue. Stroke this mixture on to the very darkest leaves on the foreground bush, taking the colour across the front of the window to imply overhanging leaves and branches. Leave to dry.

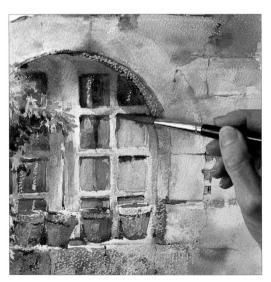

14 Gently rub off the masking fluid. Mix a dark purple from cobalt blue, violet and a little burnt sienna and darken some of the shadows around the window.

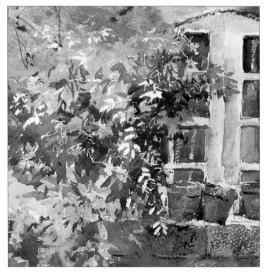

 $15\,$ Mix a very pale wash of cerulean blue and tone down the starkness of some of the revealed whites.

This is a beautifully controlled study in texture, painted using a relatively subdued and limited palette – proof that simplicity is often the most effective option. The empty flowerpots are

what really make the picture: they provide visual interest in the foreground to hold the viewer's attention and also imply a human presence in the scene.

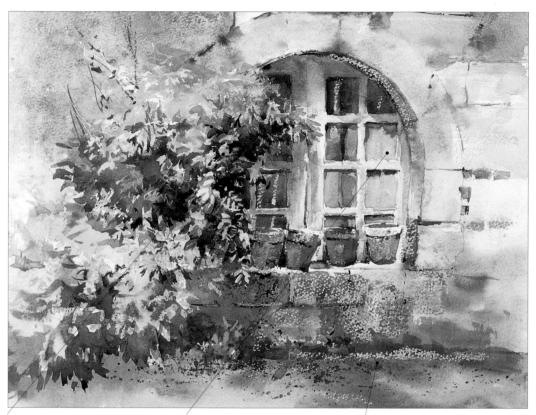

Using a range of greens both gives depth and indicates that there is more than one type of plant in this area.

Leaving tiny areas of window pane unpainted conveys the impression of light being reflected in the glass.

Two textural techniques, spattering and the use of resists, have been combined to good effect here.

Painting People

Portraits are often considered difficult to paint, although in reality they are no more complicated than any other subject. Part of the perceived difficulty in painting portraits comes from the need to capture a true likeness of the sitter, as somehow we expect portraits to be more lifelike. and less subject to the artist's personal interpretation, than other subjects. If you approach the subject and construct your image in the same way as any other, taking measurements and observing proportions, then that likeness should and will - follow. Take time over your underdrawing as this is important, and observe where each facial feature is positioned in relation to the others.

A little knowledge of what the human skull is like will make it easier to position the facial features correctly. Although facial features will differ, certain measurements and proportions are approximately the same on most people.

However, a really good portrait should achieve far more than a physical likeness of the subject, it should also reveal something of the sitter's character. Hair, make-up and clothes are all important in capturing an individual's personality, and should be subject to the same scrutiny as the sitter's features.

The main watercolour techniques that you will find yourself using are wet into wet and wet on dry. Techniques that are

Tips: • Spend time plotting the facial features. If your measurements and assessment of proportion are correct, a good likeness should follow.

- Limit yourself to one or two techniques. Use wet-into-wet washes initially, and then create sharper focus by using weton-dry washes as the work progresses.
- Use gum arabic in your washes, or work on a support that has been heavily sized: this makes it easier to make corrections by washing off paint.
- If you are painting someone in their environment, work on the background and setting at the same time as the figure per se to avoid the portrait looking as if it has simply been pasted in.

usually associated with making texture will, for obvious reasons, be used less often in portraiture, if at all, although drybrush can prove useful when painting hair. Watercolour is a good medium for portraits, but it requires a little forethought and planning. The traditional transparent watercolour technique of working light to dark is perfect for building up skin colours and tones, as new washes are applied over dry ones. Alternatively, flood paint colour into a wet area to create soft transitions, with one colour blending

seamlessly into another. Wet-on-dry work, which creates a sharp, hard-edged focus, should be restricted to painting the features on the sitter's face.

The red shirt ▼

The boy's mischievous and adventurous character is self-evident as he hangs from a tree branch with a considerable drop beneath. Carefully placed wet-ondry washes were used over a drawing using very light wet-into-wet watercolour paints.

Lydia and Alice A

The initial work was made using wetinto-wet washes and the features were then sharpened using wet on dry. Gum arabic was used in many of the mixes. This has the effect not only of intensifying the colour but also of making the washes more transparent. Gum arabic also makes dry paint soluble if it is re-wet, so you can wash off dry paint and make any necessary corrections – this is a very useful facility when painting portraits.

Sisters ▶

Working over a careful pencil drawing using wet-on-dry washes, an overall colour harmony was achieved by using a limited range of colours. Interestingly, the two girls were painted at different times. The poses were carefully chosen so that the figures could be combined on the support.

Head-and-shoulders portrait

Painting a portrait from life for the first time can be a daunting prospect. Not only do you have the technical aspects to deal with, but you are working with a live model, who will almost certainly fidget and demand to see what you are doing. Before you embark on your first portrait session, practise drawing and painting from photographs to build up your skills and confidence.

You also have to consider your model's well-being. Make sure they are warm and comfortable and have adopted a pose that feels natural: they may have to hold the same pose for a long time. Ask them to fix their gaze on an object behind you

(a picture on the wall, perhaps) so that, if they do move, they can easily regain their original position.

Put a lot of care into your underdrawing. If you can get the facial features in the right place and know where the main areas of light and shade are going to be, then you are well on the way to success

Finally, don't try to do too much. Details like clothing are relatively unimportant in a head-and-shoulders portrait. Instead, try to capture your subject's mood and personality by concentrating on the eyes and expression.

Positioning the features

The sketches below are intended to provide some general guidelines to help position the facial features correctly. They are not infallible rules, however: everyone is different and you should train yourself to take objective measurements rather than relying on your preconceptions. Your viewpoint also makes a difference.

Resist the temptation to start by drawing an outline of the face. If you do this, the chances are that you will find you haven't allowed yourself enough space for the features. Start by working out the relative sizes and positions of the features and then worry about the overall outline.

It is always a good idea to put in faint pencil guidelines – a line down through the central axis of the face and lines across to mark the positions of the eyes, nose and mouth.

A large mass of hair can make things more complicated, as it is hard to work out exactly where the cranium ends and the hair begins. To begin with, try to work with a model whose hair sits close to the scalp or can be scraped back tight – or even a model with no hair at all.

Head tilted forwards

When the head is titled forward, you can see more of the cranium and less of the facial features.

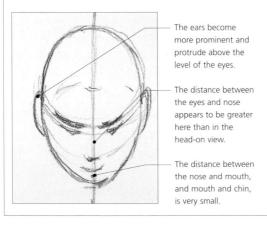

Head-on view

The left and right sides of the face are not totally symmetrical, but drawing a central guideline is a good starting point.

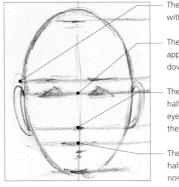

The eyes are level with the ear tips.

The eyes are approximately halfway down the facial area.

The nose is roughly halfway between the eyes and the base of the chin.

 The mouth is less than halfway between the nose and chin.

Head tilted backwards

When the head is tilted backwards, you can see very little of the cranium.

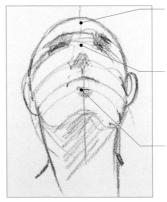

The distance between the eyes and the top of the cranium is very small from here.

The distance between the eyes and nose appears to be less here than in the head-on view.

 The distance between the nose and mouth, and mouth and chin, is greater than in the head-on view.

Materials

- HB pencil
- 140lb (300gsm) HP watercolour paper, pre-stretched
- Watercolour paints: light red, yellow ochre, alizarin crimson, sap green, sepia tone, neutral tint, ultramarine blue, ultramarine violet, cobalt blue, burnt umber, cadmium orange, cadmium red
- Brushes: large round, medium round, fine round

The pose

If you are new to portraiture, a simple pose, with the model looking directly at you, is probably the best way to begin. Place a strong light to one side of the model, as it will cast an obvious shadow and make it easier for you to assess areas of light and shade.

Select a plain background that does not draw attention away from your subject.

The eyes are the key to any portrait.

Using an HB pencil lightly sketch your subject, putting in faint construction lines as a guide to help you check that the features are accurately positioned.

 $2^{\,\text{Begin}}$ to put in some indication of the pattern in the model's blouse. You do not need to make it detailed.

Tip: From time to time, look at your drawing in a mirror. This often makes it easier to assess if you have got the proportions and position of the features right. Also hold your drawing board at arm's length, with the drawing vertical, to check the perspective. When you work with the drawing board flat, the perspective sometimes becomes distorted.

3 Mix light red and yellow ochre to make the first warm but pale flesh tone. Using a medium round brush, wash this mixture over the face, neck and forearms, avoiding the eyes and leaving a few gaps for highlights. This is just the base colour for the flesh. It will look a little strange at this stage, but you will add more tones and colours later on.

4 You have to work quickly at this stage to avoid the wash drying and forming hard edges. While the first wash is still damp, add more pigment and a little alizarin crimson to the first skin tone and paint the shadowed side of the face to give some modelling. Add more alizarin crimson to the mixture and paint the lips. Leave to dry.

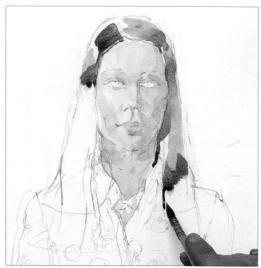

5 Touch a little very dilute alizarin crimson on to the cheeks and some very pale sap green into the dark, shaded side of the face. Mix a warm, rich brown from sepia tone and neutral tint and start to paint the hair, leaving some highlight areas and the parting line on the top of the head completely free of paint.

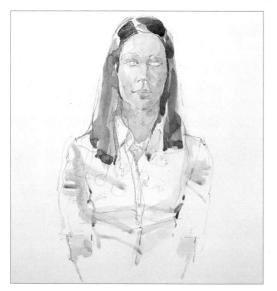

6 Mix a very pale blue from ultramarine blue and a hint of ultramarine violet. See where the fabric in the blouse creases, causing shadows. Using a fine round brush, paint these creases in the pale blue mixture.

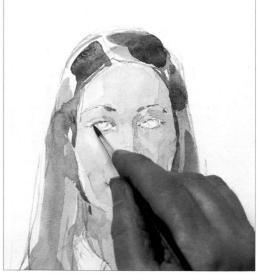

7 Go back to the hair colour mixture used in Step 5 and put a second layer of colour on the darker areas of hair. Paint the eyebrows and carefully outline the eyes in the same dark brown mixture.

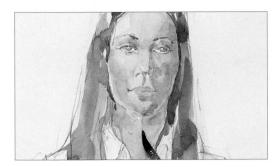

Mix a very light green from yellow ochre with a little sap green and, using a fine round brush, paint the irises, leaving a white space for the highlight where light is reflected in the eye. Strengthen the shadows on the side of the face and neck with a pale mixture of light red and a little sap green.

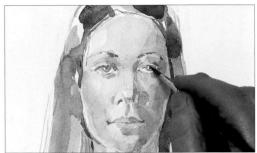

9 Use the same shadow colour to paint along the edge of the nose. This helps to separate the nose from the cheeks and make it look three-dimensional. Mix ultramarine violet with sepia tone and paint the pupils of the eyes, taking care not to go over on to the whites.

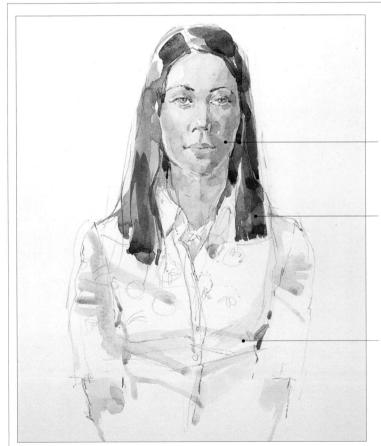

The portrait is nearing completion and it is time to stand back and decide what adjustments to make and what final details to add.

Beware of overworking a portrait like this. The key to its success is its directness.

The model does not stand out clearly from the stark white background.

Successive washes of colour give the hair depth and sheen.

The creases and shadows in the blouse imply the contours of the body underneath the fabric.

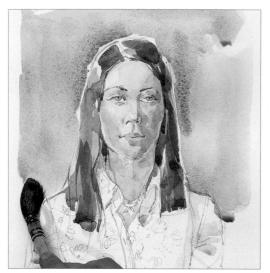

10 Mix a dark green from sap green, cobalt blue and burnt umber. Using a large round brush, carefully wash this mixture over the background, taking care not to allow any of the paint to spill over on to the figure. (You may find it easier to switch to a smaller brush to cut in around the figure.)

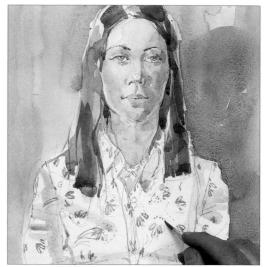

11 While the background wash is still damp, add a little more pigment to the green mixture and brush in the shadow of the girl's head. Mix an orangey-red from cadmium orange and cadmium red and, using a fine round brush, start putting in some of the detail on the girl's blouse.

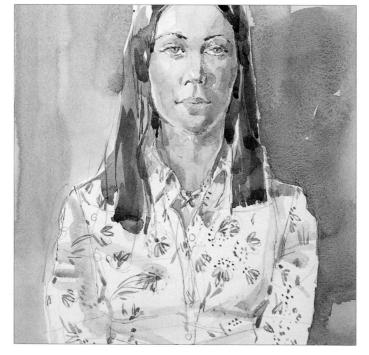

12 Continue building up some indication of the pattern on the girl's blouse, using the orangey red mixture from Step 11, along with ultramarine blue and sap green.

Tip: Don't try to replicate the pattern exactly: it will take far too long and will change the emphasis of the painting from the girl's face to her clothing.

This is a sensitive, yet loosely painted portrait that captures the model's features and mood perfectly. It succeeds largely because its main focus, and the most detailed brushwork, is on the girl's eyes and pensive expression. Careful attention to the shadow areas has helped to give shape to the face and separate the model from the

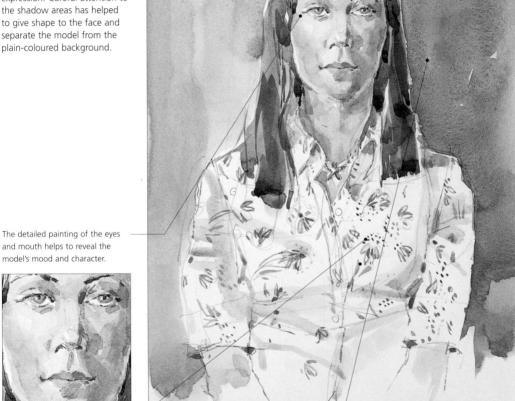

The detailed painting of the eyes and mouth helps to reveal the

In reality, the pattern on the blouse is much more detailed than this, but a more accurate rendition would have drawn attention away from the girl's face.

The shadow on the wall helps to separate the model from the background and gives the image more depth.

The swimmer

Although the subject of this project looks simple enough — a solitary figure swimming underwater, with relatively little discernible detail — the real interest lies in the play of light on the water and the way that shapes are slightly distorted, producing an image that tends towards abstraction. Your task is not only to capture the sleek form of the swimmer and to freeze a moment in time, but also to convey a sense of the dappled sunlight and the movement of the water.

As so often happens in painting, it helps to exaggerate certain elements in order to get across the mood that you want. Distorting the figure of the swimmer slightly in order to make it look more streamlined is one way to do this; making more of the dappled patches of sunlight on the water is another.

Adding a few drops of gum arabic to your paint mixes is a very useful technique when painting water, as it increases the gloss and transparency of watercolour paint. This, combined with the careful build-up of layers of colour, helps to make the water look as if it is shimmering in the sunlight.

Materials

- 2B pencil
- 200lb (425gsm) NOT watercolour paper, pre-stretched
- Watercolour paints: cadmium lemon, alizarin crimson, cerulean blue, cobalt turquoise, cadmium red, cadmium yellow, Payne's grey, ivory black, burnt sienna, burnt umber
- Brushes: large round, medium round, small round
- Gum arabic
- 3B graphite stick

Reference photograph

Fascinated by the way the sunlight played on the water, the artist asked his daughter to dive repeatedly into this brightly tiled swimming pool, so that he could take reference photographs to work on at his leisure. When you are shooting a moving subject, it is hard to predict what you will actually capture on the film, so always take a lot more shots than you think you will need.

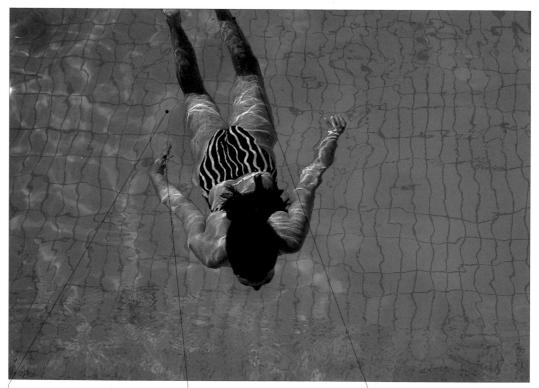

There is some dappled light on both the girl and the water, but this can be exaggerated in the painting to increase the feeling of sunlight.

Elongating the legs, arms and hands will increase the sense of movement.

Cutting off the legs at the top of the frame gives a more dynamic composition and allows the figure space into which to move.

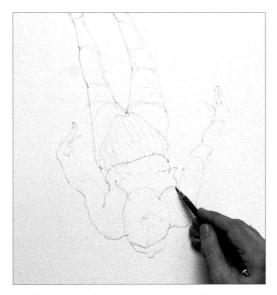

Using a 2B pencil, lightly sketch the figure. Note that it is slightly distorted because of the way the light is refracted through the water. In addition, the fingers and legs have been deliberately elongated a little to create a sense of the figure moving through the water at speed.

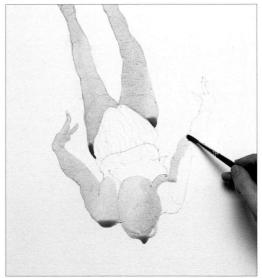

2 Mix a light pink wash from cadmium lemon and alizarin crimson, and a slightly redder version of the same mixture. Using a medium round brush, wash these colours over the whole of the body, alternating between the two mixtures to give some tonal variety. Leave to dry.

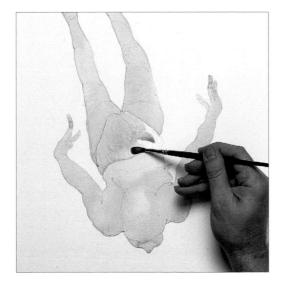

 $3^{\rm Mix\ a\ strong\ wash\ of\ cadmium\ lemon\ and\ add\ a\ little} of\ the\ lighter\ pink\ wash\ used\ in\ Step\ 2.\ Using\ a\ medium\ round\ brush,\ paint\ the\ girl's\ bikini\ bottoms\ in\ this\ colour.$ Leave to dry.

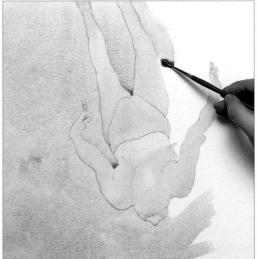

A Mix a large quantity of a pale blue wash from cerulean blue and a little cobalt turquoise. Wash this mixture over the whole of the background, taking care not to allow any of the paint to go over the figure. (You may need to switch to a smaller brush to "cut in" around the edges of the figure.)

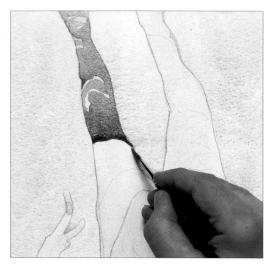

5 Mix three flesh tones from the following colours: alizarin crimson and cadmium lemon; alizarin crimson and a little cerulean blue; cadmium red and cadmium yellow. Dot a small amount of gum arabic into each mixture. Using a medium round brush and alternating between the three mixtures, start to paint over the girl's legs, leaving the base colour showing through in highlight areas. It doesn't matter too much which colour you use where, but try to reserve the darker mixtures for shadow areas.

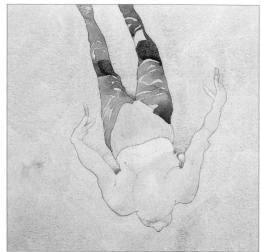

 $6\,{\rm Continue}$ in this way until you have finished painting the legs. Leave to dry.

Tip: Some of the washes may look very dark when you first apply them, but watercolour always dries to a slightly lighter tone. To be on the safe side, test your mixtures on a piece of scrap paper and leave to dry before applying them to the painting.

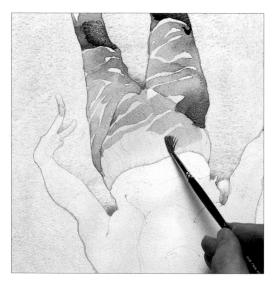

Mix a greenish yellow from cadmium lemon with a little Payne's grey. Using a small round brush, paint the ripples of light that run across the bikini bottoms.

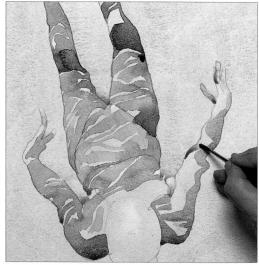

Susing a small round brush and the same flesh tones that you mixed in Step 5, paint the girl's arms and back, leaving some of the underlying wash showing through.

The underpainting is almost complete. The figure stands out well against the pale blue background of the water and is starting to take on a three-dimensional quality. The next stage is to redefine the form by using slightly darker mixtures and to start to put in some of the details.

Varying the flesh tones gives the figure form.

The base colour alone is visible in the most strongly lit areas.

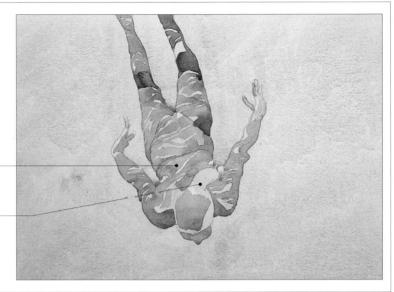

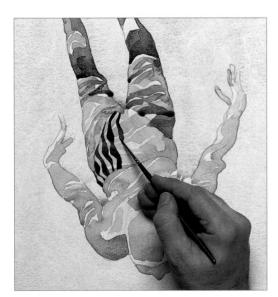

Mix slightly darker versions of the flesh tones used in Step 5 and work over the body again, in the same way as before. Mix a warm black from ivory black with a little Payne's grey and paint the stripes on the bikini bottoms. Note that the stripes are not straight lines. This is partly because the pattern is distorted by the way the light refracts from the water and partly because the fabric clings to the girl, helping to indicate the contours of her body.

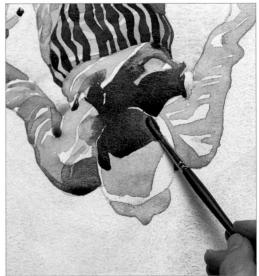

10 Mix a rich, dark brown from burnt sienna and burnt umber and, using a medium round brush, paint the girl's hair. Leave some areas unpainted and apply a second layer of colour in others so that the hair is not a solid mass of the same tone of brown.

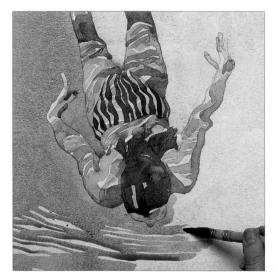

1 1 Mix a bright blue from cerulean blue and cobalt turquoise and, using a large round brush, begin to wash this mixture over the background. Leave some areas untouched in the top left-hand side, where sunlight dapples the water, and paint ripples in front of the girl's head to show how the water is displaced as she moves through it.

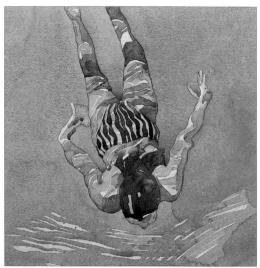

12 Continue working around the figure with the same blue mixture until you have been over the whole of the background. As in Step 4, you may find that you need to switch to a smaller brush in order to paint right up to the edge of the figure, as you must take care not to allow any of the blue mixture to spill over on to the figure. Leave to dry.

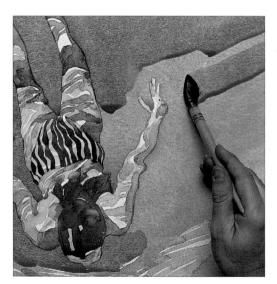

13 Mix a stronger version of the cerulean blue and cobalt turquoise mixture used in Step 11 and add a few drops of gum arabic. Paint over the background again, leaving a few spaces here and there to give the effect of dappled light. Leave to dry.

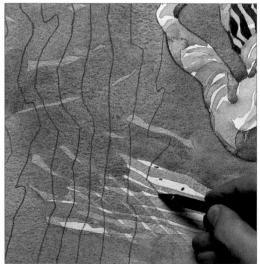

14 Using a 3B graphite stick, draw the lines of the tiles on the base of the pool. Note that, because of the way the light is refracted and the effects of perspective, the lines are not straight. The lines in the distance slope inwards because this area of the painting is further away from the viewer.

This is a graphic depiction of a swimmer slicing through water, the impression of speed reinforced by a deliberate distortion of her figure and the energetic ripples in front of her head. There is a wonderful feeling of light and warmth in this painting, achieved through the careful build-up of layers of colour.

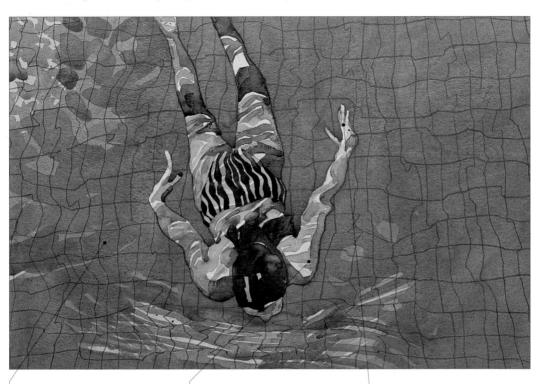

Because of the effects of perspective, the lines of the tiles slope inwards.

The swimmer's hands, arms and legs are slightly elongated, which helps to give the impression of movement.

Seated figure in interior

Painting someone in a setting gives you the opportunity to say much more about them than you can in a straightforward head-and-shoulders portrait. For example, you might choose to include things that reveal something about your subject's interests – a keen musician with a guitar, perhaps, or an antiques collector surrounded by some of his or her most treasured possessions – or their work. In a domestic setting, the décor of the room itself is very often a reflection of your subject's tastes and personality.

The most important thing is not to allow the surroundings to dominate. The focus of the painting must remain on the person. This usually means that you have to deliberately subdue some of the detail around your subject, either by using muted or cool colours for the surroundings, so that your subject becomes more prominent, or, if the setting is very cluttered, by leaving some things out of your painting altogether.

Materials

- 3B pencil
- · Rough watercolour board
- Watercolour paints: raw umber, alizarin crimson, cobalt blue, lemon yellow, phthalocyanine blue
- Brushes: medium flat, Chinese, fine round, old brush for masking
- Masking fluid
- Craft (utility) knife or scalpel
- Sponge

Reference photographs

Here the artist used two photographs as reference – one for the seated, semi-silhouetted figure and one for the shaft of light that falls on the table top. Both photographs are dark and it is difficult to see much detail, but they show enough to set the general scene and give you scope to use your imagination. Instead of slavishly copying every last detail, you are free to invent certain aspects of the scene, or to embellish existing ones.

The highlight on the figure's hair is very atmospheric.

The shaft of bright sunlight illuminates part of the table top while almost everything else is in deep shade.

Using a 3B pencil, lightly sketch your subject, making sure you get the tilt of her head and the angles of the table, papers and books right.

2 Mix a warm, pinky orange from raw umber and alizarin crimson. Using a medium flat brush, wash it over the background, avoiding the highlight areas on the window. Add more alizarin crimson to the mixture for the warmest areas, such as the girl's shirt and the left-hand side of the curtain, and more raw umber for the cooler areas, such as the wall behind the girl and the glazing bars on the window. Leave to dry.

3 Mix a very pale green from cobalt blue and lemon yellow and, using a Chinese brush, paint the lightest foliage shades outside the window, remembering to leave some white areas for the very bright sky beyond.

Tip: To enhance the impression of light coming through the window, take care not to paint foliage right up to the edge of the window frame.

Assessment time

Mix a very pale blue from cobalt blue and a touch of raw umber and put in the cooler tones inside the room – the left-hand side, which the shaft of sunlight coming through the window doesn't reach, and the shadows under the table. Leave to dry.

You have now established the warm and cool areas of the painting, which you will build on in all the subsequent stages. Because of her position within the frame (roughly in the first third), the girl is the main focus of interest in the painting, even though she is largely in shadow. Keep this at the forefront of your mind as you begin to put in the detail and as you continually assess the compositional balance while painting.

This area is left unpainted, as it receives the most direct sunlight.

The warm colour of the girl's shirt helps to bring her forwards in the painting.

The shadow areas are the coolest in tone. They recede.

A Mix a warm brown from alizarin crimson and raw umber and paint the girl's hair. Mix a rich red from alizarin crimson, cobalt blue and a little raw umber and, using a Chinese brush, paint the curtain. Apply several vertical brushstrokes to the curtain, wet into wet, to build up the tone and give the impression that it hangs in folds.

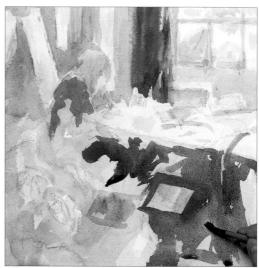

5 Using the same red mixture, paint the shoulders and back of the girl's shirt. Add more raw umber to the mixture and paint the shadow area between the wall and the mirror, immediately behind the girl. Mix a warm blue from phthalocyanine blue and a little alizarin crimson, and paint the dark area beneath the table using loose brushstrokes.

6 Using an old brush, "draw" the shapes of leaves in the bottom left-hand corner in masking fluid. Leave to dry. Mix a rich, dark brown from raw umber and a little alizarin crimson and, using a fine round brush, paint the darkest areas of the girl's hair.

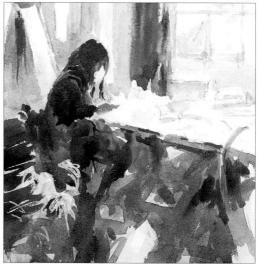

Add a little raw umber to the mixture for the lighter areas of hair around the face. Build up the shadow areas in the foreground of the scene, overlaying colours as before. Darken the girl's shirt in selected areas with the alizarin crimson, cobalt blue and raw umber mixture.

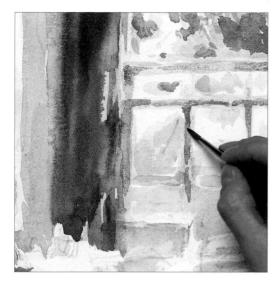

A Mix a mid-toned green from phthalocyanine blue and lemon yellow and, using a fine round brush, dot this mixture into the foliage that can be seen through the right-hand side of the window. Mix a very pale purplish blue from pthalocyanine blue and a little alizarin crimson and darken the glazing bars of the window.

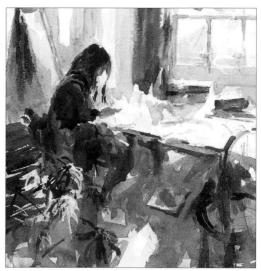

Paint the area under the window in a warm mixture of alizarin crimson and phthalocyanine blue. Mix a dark, olive green from raw umber and phthalocyanine blue and, making loose calligraphic strokes, paint the fronds of the foreground plant. Brush a very dilute version of the same mixture on to the lower part of the mirror. Build up the background tones.

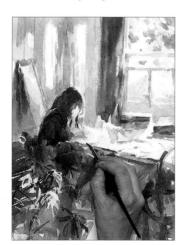

10 Mix a muted green from phthalocyanine blue and lemon yellow. Brush it over the background behind the girl. Because the green is relatively cool, it helps to separate the girl from the background. It also provides a visual link between this area and the foliage on the right.

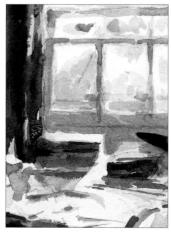

1 1 Paint a few vertical strokes on the curtain in a dark mixture of alizarin crimson and phthalocyanine blue. This helps to make the highlight on top of the pile of books stand out more clearly. Mix a warm brown from raw umber and phthalocyanine blue and paint under the window.

12 Rub off the masking fluid from the bottom left-hand corner.

Continue building up the tones overall, using the same paint mixtures as before and loose, random brushstrokes to maintain a feeling of spontaneity.

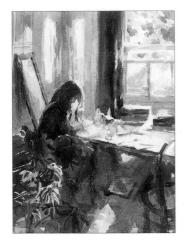

13 Mix a very pale wash of raw umber and lightly brush it on to some of the exposed areas in the bottom left-hand corner. Build up more dark tones in the foreground, using the same mixtures as before.

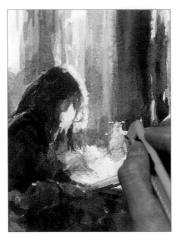

14 Using a craft (utility) knife or scalpel, carefully scratch off some of the highlights on the bottle on the table. Paint the wall behind the girl in a pale, olivey green mixture of raw umber and phthalocyanine blue.

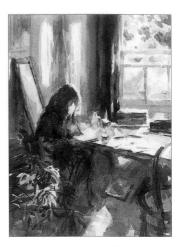

15 Brush a little very pale cobalt blue into the sky area so that this area does not look too stark and draw attention away from the main subject.

16 Continue building up tones by overlaying colours. Use very loose brushstrokes and change direction continually, as this helps to convey a feeling of the dappled light that comes through the window.

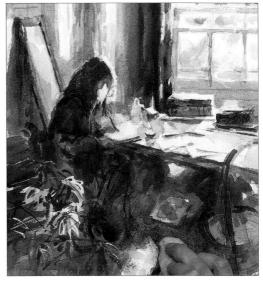

17 Using a 3B pencil, define the edges of the papers on the table. Mix a very pale wash of phthalocyanine blue and, using a fine round brush, carefully brush in shadows under the papers on the table to give them more definition. Dip a sponge in a blue-biased mixture of phthalocyanine blue and alizarin crimson and gently press it around the highlight area on the floor to suggest the texture of the carpet.

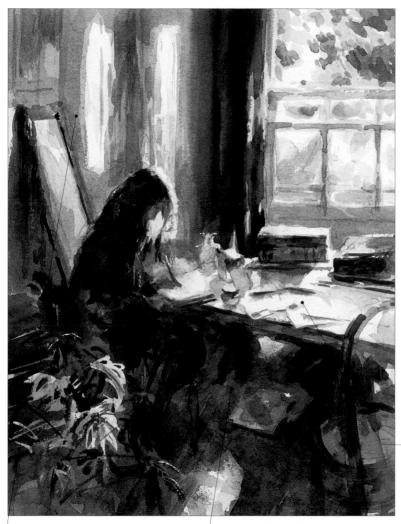

There is a wonderful sense of light and shade in this painting, and the loose brushstrokes give a feeling of great freshness and spontaneity. The scene is beautifully balanced, both in terms of its distribution of colours and in the way that dark and light areas are counterposed.

Pale, cool colours on the wall help to differentiate the girl from the background.

The foreground is loosely painted with overlayed colours, creating a feeling of spontaneity.

Sunlight pours through the window, illuminating the books and papers. Much of this area is left unpainted.

Indian market scene

Full of hustle and bustle, often packed with colourful displays of fruit, vegetables and other goods, street markets are a wonderful source of inspiration for artists — but with so much going on, it is often very difficult to work in situ. And even if you do manage to find a quiet spot to set up your easel, the chances are that you will soon find yourself surrounded by a crowd of curious onlookers, which can be somewhat intimidating.

This is one situation where it is useful to take reference photos, as you can work quickly and unobtrusively, and gather a whole wealth of material to paint from at a later date. Start with distant views and gradually move in closer to your chosen subject – and don't forget about things like advertisements, hand-written signs and unusual produce, all of which can add a lot of atmospheric local detail to your paintings.

If you want to take photographs of people, it is always best to ask their permission, although this does bring with it the risk that your subjects will start playing up to the camera. If this happens, take a few "posed" shots first and then, when they have turned back to their business, take a few more. Another good tip is to set your camera on its widest setting and point it slightly to one side of the person you are photographing. You will appear to be looking somewhere else, but the camera's field of view will be wide enough to include them in the frame, too. Above all, don't stint on the number of shots you take: film is inexpensive and if you've got a digital camera, there are no processing costs at all.

Materials

- 4B pencil
- 90lb (185gsm) rough watercolour paper, pre-stretched
- Watercolour paints: indigo, alizarin crimson, raw umber, cobalt turquoise, cadmium red, Hooker's green, cadmium yellow, burnt umber, cobalt blue
- Gouache paints: Bengal rose, permanent white
- · Brushes: Chinese, fine round
- Household candle

Reference photographs

Here the artist used two photographs. The one on the right shows the corner of the stall and the stallholder selling his wares, and the one below shows the two ladies shopping and rows of colourful bowls of powdered dyes. In her compositional sketch, the artist angled the bowls to provide a more gentle lead-in to the picture.

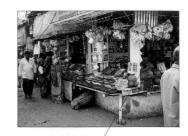

The stallholder is just visible. He will be more prominent in the painting.

 There is nothing of interest in this area.

A more gentle leadin will be provided if the bowls start in the bottom right corner of the image.

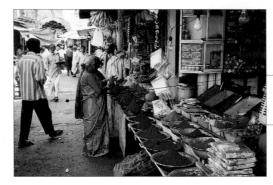

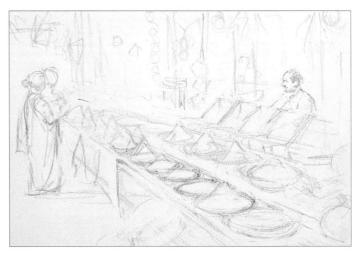

1 Using a 4B pencil, sketch the subject, taking care to get the perspective right. Note how the bowls of powder get smaller and closer together as they recede into the distance.

Tip: To make it easier to get the shapes of the bowls of powder right, think of them as simple geometric shapes — ovals with rough triangular shapes on top.

Mix a warm, greyish blue from indigo, alizarin crimson and a little raw umber and start putting in the cool background colours. Paint the area of deepest shade under the table, adding more raw umber to the mixture for the pavement area. This neutral background will help to unify the painting. With so many vibrant colours in the scene, the overall impact could easily be overwhelming.

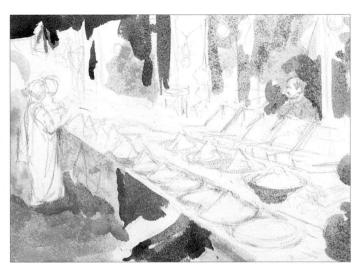

Add more alizarin crimson to the mixture to make a darker, brown colour and brush in the shadows under the bowls and the wooden vertical supports of the shelves in the background. Use a paler version of the mixture to paint the stallholder's shirt and a darker one to paint the background of the more distant stall and the area immediately behind the stallholder's head. Filling in the negative spaces in this way makes it easier to see what it is happening in such a complicated scene.

 $4^{\rm Mix}$ a warm shadow colour from indigo with a tiny amount of alizarin crimson and paint the shadows under the steel bowls, taking care to leave highlights on the rims. Use the same mixture to paint lines in between the oblong dishes of powder in the background.

5 Using an ordinary household candle, stroke candle wax over the lightbulbs. Press firmly so that enough of the wax adheres to the paper. The wax will act as a resist. The white paper will show through in places, while other areas will take on the surrounding colour, as if that colour is reflected in the glass of the bulb.

Using the same basic mixtures as before, continue putting in some background colours and the shadows under the

bowls. The basis of the background is now complete, both tonally and compositionally.

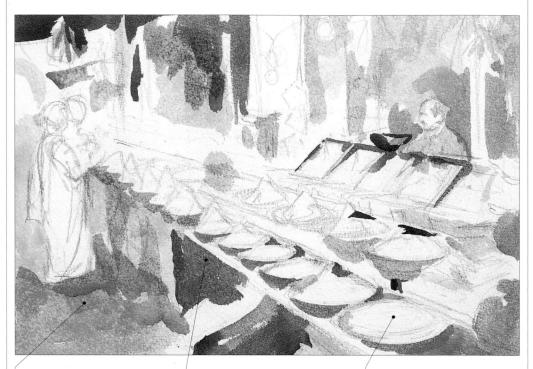

Blocking in the negative spaces makes it easier to see what is happening in the rest of the scene.

We "read" this shaded area as being on a different plane to the stall top, which is in bright sunlight.

Although the bowls are empty at this stage, their shapes and shadows are clearly established.

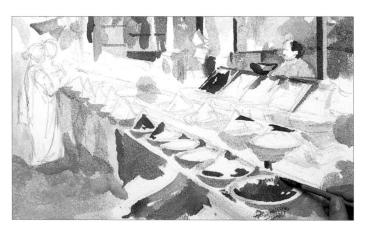

6 Mix a warm, purplish black from alizarin crimson and indigo and paint the stallholder's hair. Mix cadmium red with alizarin crimson and paint the wooden support on the right-hand edge of the foreground stall. Drybrush a little of the same colour on to the stall top, where powder has been spilt, and start putting the same colour into the bowls of powder. Paint cobalt turquoise on the walls at the far end.

Tip: While you have one colour mix on your palette, see where else you can use it in the painting.

Mix a wash of Hooker's green and paint the green plastic that covers the basket on the ground and the mounds of green powder. Mix a warm orange from cadmium red and cadmium yellow and dot the mixture into the background immediately behind the stallholder to indicate the packages on sale. (A hint of the basic shape and colour is sufficient.) Add a little burnt umber to the orange mixture and paint the stallholder's face.

Paint the women's skin tones in the same orangey-brown mixture. Mix a strong purple from Bengal rose gouache and cobalt blue watercolour and paint the sari worn by the woman in the foreground, leaving a few highlight areas untouched.

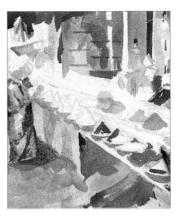

O Using the same mixture and a fine round brush, paint the creases in the sari, adding more cobalt blue to the mixture for the very darkest creases. By darkening the tones in this way, you will begin to imply the folds in the fabric. Mix a dark purple from Bengal rose, alizarin crimson and a little indigo and dot in the pattern on the sari. Mix Bengal rose with a tiny amount of cobalt blue and paint the mounds of very bright pink powder.

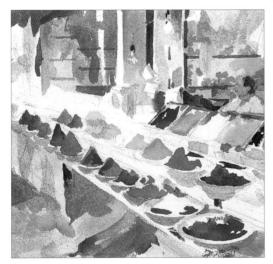

10 Continue painting the powders, mixing cadmium red with Bengal rose for the red powders and using cobalt blue for the blue ones. Don't worry too much about the shapes of the mounds at this stage. This will become clearer as you build up the tones later on.

1 1 Build up the tones on the powders, using the same mixtures as before. Using a 4B pencil, draw the lines of the plastic-wrapped packages on the corner of the stall. Mix a pale wash of cobalt turquoise and brush over the lines, using a fine round brush.

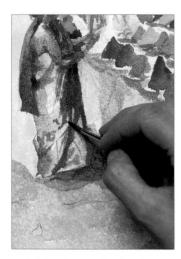

 $12\,$ Mix a dark purple colour from Bengal rose, alizarin crimson and a little indigo. Using a fine round brush, accentuate the creases in the sari fabric in the same colour.

13 Using a mixture of alizarin crimson and indigo, paint around the stallholder. Darkening the background in this way helps to make him stand out from his surroundings. Use the same alizarin crimson and indigo mixture to strengthen the shadows on the right-hand side of the stall.

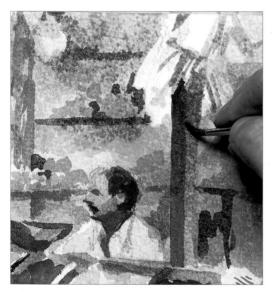

14 By this stage, all you need to do is refine some of the details. Mix a rich, brownish black from alizarin crimson, indigo and cadmium red and darken the stallholder's hair. Darken his skin tones with a more dilute version of the same mixture. Paint the stripes on the colourful woven basket in Bengal rose gouache and darken the tones on the wooden posts of the stall.

15 Tone down the brightness of the paper, where necessary, with very pale washes of the background colours. Paint the highlights on the lightbulbs in permanent white gouache.

The finished painting

Here, the artist has created a lively interpretation of a busy market, packed with colourful sights and people going about their daily business. The composition is much more satisfactory than that of the original reference photographs. The line of bowls leads diagonally through the image to the two women, while the stallholder is positioned near enough to the intersection of the thirds to provide a secondary focus of interest for the painting.

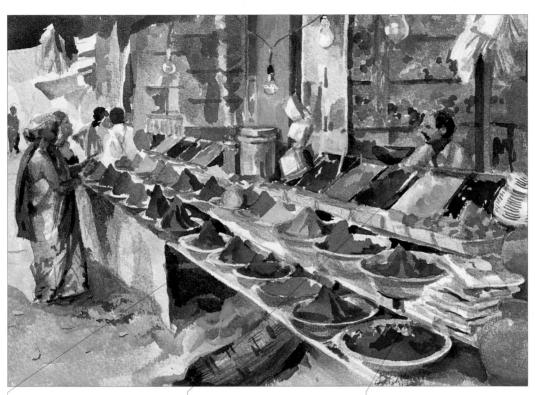

The contrast between light and dark areas establishes the different planes of the image.

The stallholder's direct gaze encourages us to follow his line of sight across the scene to the two women.

The indentations in the mounds of powder are skilfully conveyed by applying more layers of colour to the darker, shaded areas.

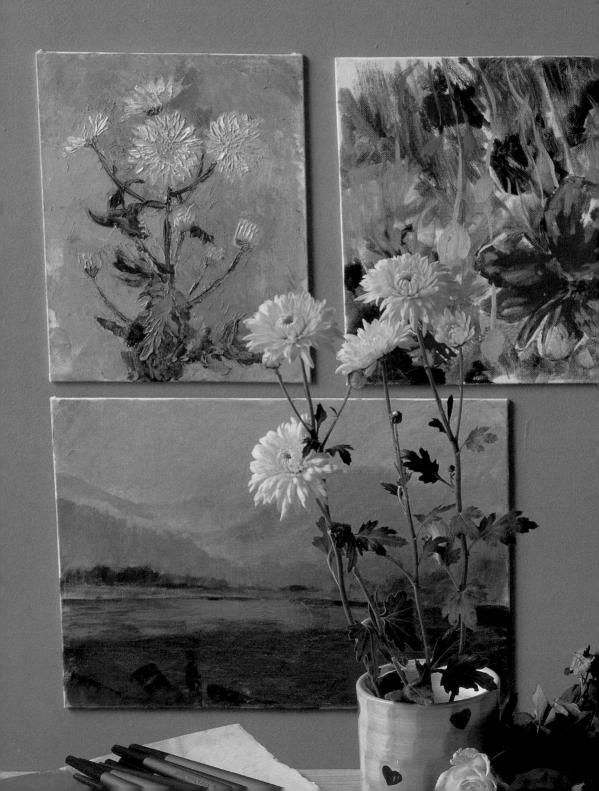

Introduction

Oil paints have an unjustified reputation for being difficult to use. One reason for this may be that we tend to think of oils as being a medium for 'real' artists – for people who have been professionally trained and know what they're doing. Oil painting is something that many of us feel we might aspire to at some stage in the future, when we have cut our teeth on something easier and technically less demanding.

Once you know how the paint handles, however, and have mastered a few basic techniques, you will quickly discover what a joy it is to work with. There is nothing quite like the tactile feeling of smoothing thick, buttery oil paint on to canvas – but you can also use it in a dilute form to create thin, transparent washes of almost infinite subtlety. Unlike watercolour, which has an unnerving tendency to dribble and pool and run into areas where you don't want it to go, oil paint stays where you put it.

Farmyard chickens ▼

This farmyard scene shows the versatility of acrylic paint to the full. Paint on the wheelbarrow has been applied in thin layers so that the colour and the subtle tone variations are built up gradually.

It also looks exactly the same colour when it is dry, so there is no need to make any allowance for colour shifts when painting. And, most importantly, the long drying time means that you can manipulate the paint on the canvas, or even rework areas of your painting, far more readily than you can with a quick-drying medium such as watercolour.

Acrylics, on the other hand, are often perceived as being at the other end of the scale from oils. First introduced in the 1950s they were, for many years, derided by 'serious' artists as second-rate materials suitable only for illustrators and graphic designers. But instead of turning up our noses, we should learn to celebrate the unique characteristics of acrylics. They really are incredibly versatile: like watercolour and gouache, you can dilute them and apply them as thin washes; like oil paints, you can use them straight from the tube to create thick, impasto applications in which every stroke of the brush or painting knife can be seen. With acrylics, it seems, you really do get the best of both worlds.

Gouache is sometimes seen as little more than the 'poor relation' of watercolour, as both are water-based and the techniques are virtually identical. Some purists lament the fact that, because

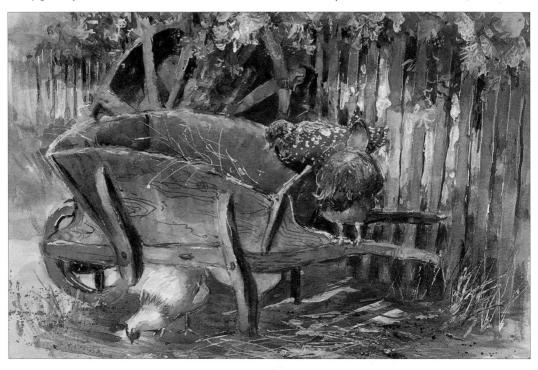

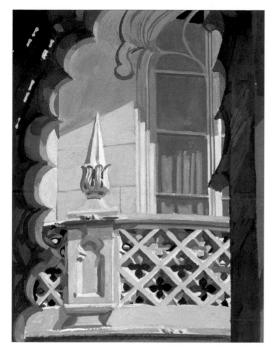

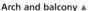

In this painting the use of gouache paint enables the artist to paint highlights over dark paint with stunning effects.

the paint is opaque, a painting in gouache can never achieve the translucency and transparency of a watercolour painting. But this belies the fact that gouache is a medium in its own right, with its own special qualities. The inclusion of precipitated chalk in the manufacturing process is what gives gouache its opaque, slightly chalky, matt (flat) finish.

The aim of this section of the book is to demonstrate the unique qualities of each medium and show you how to exploit them to the full. First of all it sets out all the equipment available in these media, including the wide range of oil and acrylic additives and varnishes, and explains what each one is best used for. A suggested basic starter palette for each medium will set you on the right track. Then there are a host of demonstrations and practice exercises, from underdrawings and simple washes to glazing, scumbling and the thick impasto work that gives oils and acrylics such a rich, tactile texture. With clear step-by-step photographs and detailed instructions, these demonstrations and exercises will enable you to master all the painting techniques that you are ever likely to need.

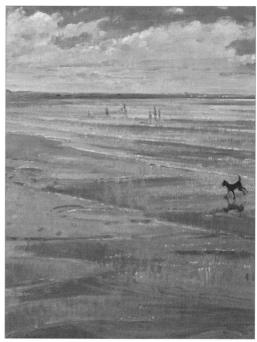

Sunlit beach A

An almost deserted beach, painted in oils, is alive with colour and texture creating an attractive, lively scene.

After the practice technique exercises, there are 25 full-length step-by-step projects on all the most popular painting subjects – landscapes, flowers and leaves, still lifes, animals and birds, buildings and people. Here you will find something to suit all tastes and abilities, from a beautiful study of irises growing in the wild to a charming painting of a sleeping cat, from an almost deserted beach with sunlight sparkling on the sea to a busy café scene full of people and life. The projects have been specially commissioned from leading professional artists in order to show you a range of styles and approaches. Study them carefully, and learn from the tips and techniques suggested.

This is not a fool-proof set of recipes. As with any creative endeavour, there are no short-cuts: If you want to learn new skills or improve existing ones, the only way to do it is to practise – and then carry on practising until you feel you are getting somewhere. But here is an invaluable source of oil, acrylic and gouache techniques and approaches that will stand you in good stead for many years to come.

Oil paint

There are two types of traditional oil paint – professional, or artists', quality and the less expensive students' quality. The essential difference is that artists' quality paint uses finely ground, high-quality pigments, which are bound in the best oils and contain very little filler, while students' paints use less expensive pigments and contain greater quantities of filler to bulk out the paint and give it more body. The filler usually consists of blanc fixe or aluminium hydrate, both of which are white pigments with a very low tinting strength.

Students' quality paint is often very good and is, in fact, used by students, amateur painters and professionals alike. The range of colours is more limited but still comprehensive, and each tube of paint in the range, irrespective of its colour, costs the same. Artists' quality paint is sold according to the quality and cost of the pigment used to make it. Each colour in the range is given a series number or letter: the higher the number or letter, the more expensive the paint. Various oils are used to bind the paint and make it workable; linseed, poppy and safflower oil are the most common. The choice of oil depends on the characteristics and drying properties of the pigment being mixed.

Oil bars

Like "tube" paint, oil bars can be used to draw on to the support and the paint can be thinned and manipulated in exactly the same way as one would use traditional paint. They can be used in conjunction with traditional oil paint but, because of the added wax content, they are not recommended for heavy or extensive underpainting use.

Drawing with oils ▼

Oil bars consist of paint with added wax and drying agents. The wax stiffens the paint, enabling it to be rolled into what resembles a giant pastel.

Tubes or tubs? ►

Oil paint is sold in tubes containing anything from 15 to 275ml (1 tbsp to 9fl oz). If you tend to use a large quantity of a particular colour – for toning grounds, for example – you can buy paint in cans containing up to 5 litres (8¾ pints).

Alkyd oil paints

A synthetic resin, which is made by combining acid and alcohol, is used in the manufacture of alkyd oil paints. The paints are used in exactly the same way as traditional oil paints and can be mixed with all the traditional mediums and thinners.

The range of colours is not as extensive as that for traditional oil paint, but it is wide enough for most purposes. The largest tube size available is 200ml (7fl oz).

Alkyd-based paint dries much faster than oil-based paint. This makes it very useful for underpainting prior to using traditional oils and for work incorporating glazes or thin layers.

However, you should not use alkyd paint over traditional oil paint, as its fast drying time can cause problems with the stability of the oil paint.

Water-mixable oil paint

One of the most recent developments in paint technology is water-mixable oil paint. Although it sounds like a contradiction in terms, it was conceived so that people who are allergic to mineral and vegetable solvents could still have access to paint with the handling characteristics of traditional oil paint.

Water-mixable oil paint is made using linseed and safflower oils that have been modified to be soluble in water. Once the paint has dried and the oils have oxidized, it is as permanent and stable as conventional oil paint. Some water-mixable paint can also be used with conventional oil paint, although its mixability is gradually compromised the more traditional paint is added. Water-mixable oil paint is available in tube sizes up to 275ml (9fl oz).

Oil starter palette

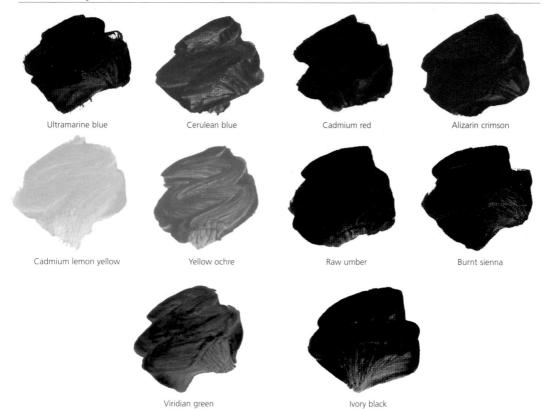

The starter palette shown here is based on readily available colours and should cover most eventualities.

Ultramarine blue: originally made from lapis lazuli, it is now more commonly made from an artificial and less expensive pigment that is stable in mixes, although it is relatively slow to dry. The synthetic colour is often sold as French ultramarine. Ultramarine blue is a transparent blue. It has good tinting strength and is the classic "warm" blue. Cerulean blue, a "cool", semi transparent blue. The artificial pigment is mixed with either linseed or poppy oil and dries relatively fast. Phthalocyanine blue is often used in place of cerulean. Cadmium red: made from an artificial mineral pigment, this is the classic "warm" red. Slow to dry but stable, it is opaque and has good tinting strength.

Alizarin crimson: a transparent colour with a high tinting strength. Once made from madder root but now produced synthetically, alizarin is a "cool", slow-drying red. The colour can fade when used in light mixes. Quinacridone red is often used as an alternative.

Cadmium lemon yellow: made from an artificial mineral, the colour has a relatively high tinting strength and opacity and is slow to dry. Mixed with cadmium red, it makes a deep cadmium yellow or cadmium orange.

Yellow ochre: a natural, relatively opaque earth colour with medium tinting strength, yellow ochre dries moderately slowly and mixes well with most colours.

Raw umber: a natural pigment with good tinting strength, raw umber is relatively transparent. It mixes well to create a range of browns. It dries quickly, which makes it ideal for underpainting. Burnt sienna: a fast-drying, bright redbrown with good tinting strength, burnt sienna is relatively transparent. Viridian green: a strong, bright, transparent green with high tinting strength. Viridian mixes well with other colours to create a range of greens. It dries relatively slowly.

Ivory black: a natural pigment with a slight brown bias. It has good tinting strength but is slow to dry. It creates a range of interesting greens when mixed with yellow.

You will also need a good white.

Titanium white (not shown here): a very bright, opaque white that is not prone to yellowing. The pigment is usually bound in safflower oil and so is slow drying.

Characteristics of oil paint

Oil paint has been the favoured painting medium of artists for many centuries since its development during the early Renaissance. It is a tried and tested material that, given its relatively long drying time, is astonishingly adaptable and versatile. Works created using oil paint possess a depth and richness of colour that is difficult to achieve with any other type of paint.

Oil paint has a reputation for being difficult to use, but nothing could be further from the truth. The secret lies in efficient preparation and good working practice. Because oil paint takes a long time to dry, you can easily rectify mistakes by simply wiping or scraping off the wet paint and repainting. Alternatively, you can paint over the area in question once the first layer of paint is dry. The long drying time,

together with the smooth, creamy consistency of the paint, also allows you to blend colours and tones seamlessly. It also means that expressive brush work and vibrant colour combinations can be achieved by working paint wet into wet. However, this same drying characteristic can lead to areas being overworked, and without discipline can result in jumbled and muddy colours. Unlike fast-drying acrylics, unused paint can be left for a limited time on the palette between painting sessions without the danger of it drying out.

Oil paint can be used thick or thin and mixed with various oils and additives to increase and improve its handling. Paint used straight from the tube is the consistency of toothpaste and unless it is brushed smooth it will hold the brush mark. The paint can

easily be thickened further by mixing in an additive that increases the volume or amount of paint without altering the depth of colour. These types of additives also contain drying agents, without which thick impasto applications of paint might take months, if not years, to harden and dry.

The paint is thinned using thinners or diluents. These can be used alone or mixed with various oils to create painting mediums. Many ready-prepared mediums can be purchased from art stores, including mediums that enable the paint to be thinned and used as transparent glazes. If the smell of white spirit and turpentine is unpleasant, low-odour thinners are available that do the same job as traditional thinners without their associated smell.

Good working practice

However you use and apply oil paint and whatever techniques you elect to use, the most important rules are to work on correctly prepared supports and always to work "fat over lean".

"Fat" paint, or paint that contains oils, is flexible and slow to dry, while

"lean" paint contains little or no oil, is inflexible and dries quickly. Oil paintings are often painted in layers and can be unstable and prone to cracking if lean (inflexible, quick to dry) paint is placed over fat (flexible, slow to dry) paint. For this reason, any

underpainting and initial blocking in of colour should always be done using paint that has been thinned with a solvent and to which no extra oil has been added. Oil can be added to the paint in increasing amounts in subsequent layers.

Working "fat over lean" A

The golden rule when using oil paint is to work "fat" (or oily, flexible paint) over "lean", inflexible paint that contains little or no oil.

Glazing with oils A

Oils are perfect for glazes (transparent applications of paint over another colour). The process is slow, but quick-drying glazing mediums can speed things up.

Thick and thin paint ▶

Oil paint can be used straight from the tube (left) or thinned using a medium or solvent (right).

Working wet into wet ▼

The slow drying time of oil paint gives you the chance to work at your leisure and blend colours and tones together on the canvas.

Paint applied straight from the tube holds its shape and the mark of the brush. For heavy impasto work, the paint can be thickened further by using an additive.

Mixing colours with oils

Colour mixing with oils is relatively straightforward, as there is no colour shift as the paint dries: the colour that you apply wet to the canvas will look exactly the same in intensity when it has dried, so (unlike acrylics, gouache or watercolour) you do not need to make allowances for colour changes as you paint. However, colour that looks bright when it is applied sometimes begins to look dull as it dries. This is due to the oil in the paint sinking into a previously applied absorbent layer of paint below. You can revive the colour in sunken patches by "oiling out" that is, by brushing an oil-and-spirit mixture or applying a little retouching varnish over the affected area.

No change in colour when dry ▼

Unlike acrylic and watercolour paints, the depth and intensity of oil colours remains the same even when the paint has dried.

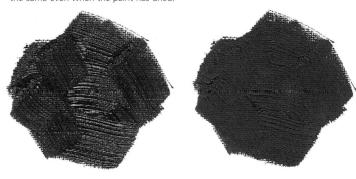

Wet oil paint

Dry oil paint

Acrylic paint

Perhaps the most important and far-reaching advance in artists' materials in the last 100 years has been the formulation of water-mixable acrylic paint. Acrylic resins were formulated in the 1920s and 1930s, although it took several years before a liquid acrylic emulsion that dried to a clear film was used to carry and bind together pigment. The first commercially available paint based on these emulsions was made available in the 1950s.

Acrylic paint can be mixed with a wide range of acrylic mediums and additives and is thinned with water. Unlike oil paint, it dries quickly and the paint film remains extremely flexible and will not crack. The paint can be used with a wide range of techniques, from thick impasto, as with oil paint, to thin, semi-transparent washes, as with watercolour. Indeed, most if not all of the techniques used in both oil and watercolour painting can be used with acrylic paint. Acrylic paint should not be thought of as an alternative to either, however, but as a very adaptable and unique painting material in its own right.

Acrylic paint is made by suspending pigment in an acrylic emulsion; in some paint formulations, several slightly different emulsions are combined. The paint may also contain various dispersants to ensure the uniform distribution of the pigments, defoamers, preservatives and thickeners.

Both students' and artists' quality acrylic paint is made. As with oil paint, artists' quality paint is available in a wide range of colours, with the cost depending on the pigments used. A less extensive range of colours is available in the students' range and the cost is the same across the whole range.

Acrylic paints come in three different consistencies. Tube paint tends to be of a buttery consistency and holds its shape when squeezed from the tube. Tub paint is thinner and more creamy in consistency, which makes it easier to brush out and cover large areas. There are also liquid acrylic colours that are the consistency of ink and are often sold as acrylic inks.

It has been

suggested that, because they are made using slightly different formulations, you should not use or mix together paint from different manufacturers. You may experience no problems in mixing different brands or consistencies of paint, but it is always good practice to follow the manufacturers' instructions.

▲ Tubes and jars

Acrylic paint is available in tubes and jars of various sizes.

Characteristics of acrylic paint

The pigments in acrylic paints are bound with an acrylic resin that is water soluble and virtually odour free. Because it is water soluble, the paint is very easy to use, requiring only the addition of clean water. Water is also all

that is needed to clean up wet paint after a work session. Once it has dried, however, acrylic paint creates a permanent hard but flexible film that will not fade or crack and is impervious to further applications of acrylic or oil paint and any of their associated mediums or solvents.

Acrylic paint dries relatively quickly: a thin film will be touch dry in a few minutes and even thicker applications dry in a matter of hours. Unlike oil

Texture gels A

Various gels can be mixed into acrylic paint to give a range of textural effects. These can be worked into while the paint is still wet.

Mediums and additives A

A wide range of mediums and additives can be mixed into acrylic paint to alter and enhance its handling characteristics.

Adhesive qualities A

Many acrylic mediums have very good adhesive qualities, making them ideal for collage work.

paints all acrylic colours, depending on the thickness of paint used, dry at the same rate

Athough hardened paint can be removed with strong paint strippers, this will quickly ruin your brushes. Wet paint, however, can easily be removed by rinsing in water. Try to get into the habit of rinsing your brushes regularly as you work.

Paint can also quickly dry on the palette, although you can avoid this by

Extending drying time A

The drying time of acrylic paint can be extended by using a retarding medium, which gives you longer to work into the paint and blend colours.

Covering power A

Acrylic paint that is applied straight from the tube has good covering power, even when you apply a light colour over a dark one. laying out and mixing only small quantities of paint and by spraying your palette periodically with clean water or using a special "stay-wet" palette.

The unique qualities of acrylic paint mean that many of the techniques that are commonly used with both oil paint and watercolour can be used. Acrylic paint is also excellent when used for underpainting prior to completing a work in oils, but it should not be used over oil paint.

Glazing with acrylics A

Acrylic colours can be glazed by thinning the paint with water, although a better result is achieved by adding an acrylic medium.

Shape-holding ability A

Like oil paint, acrylic paint that is applied thickly, straight from the tube, holds its shape and the mark of the brush as it dries.

However, it would be a mistake to see acrylic paint as a substitute for any of these traditional materials. It is, in fact, very different from other media and needs to be treated as such. Thinned with water and used on paper, acrylic paint behaves like watercolour paint – the big difference being that once it is dry, acrylic paint is no longer re-soluble. It also behaves like oil paint and can be used thickly, straight from the tube, to build up heavily textured areas of paint. Unlike oil paint, it dries in a matter of minutes – and this can make blending colours together, even over a small area, somewhat difficult.

Manufacturers have thought of many of these problems, and over the years since acrylics were first invented, they have steadily introduced a long list of mediums and additives. Perhaps one of the main advantages of acrylic paint. especially for abstract painters or for artists who like to work on a large scale, is the use of additives that extend or bulk out the amount of paint without altering its handling characteristics or depth of colour. Needless to say, using these extenders in large works makes economic sense. as you can make a relatively small amount of paint go much further.

Acrylic paint and acrylic painting mediums also have good adhesive qualities, which are useful if you are making mixed-media works that include collaged materials.

Lightening acrylic colours ▼

Acrylic colours can be made lighter by adding white paint, which maintains opacity (below top), or by adding water, which increases transparency (bottom).

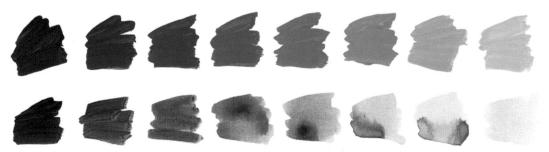

Acrylics starter palette

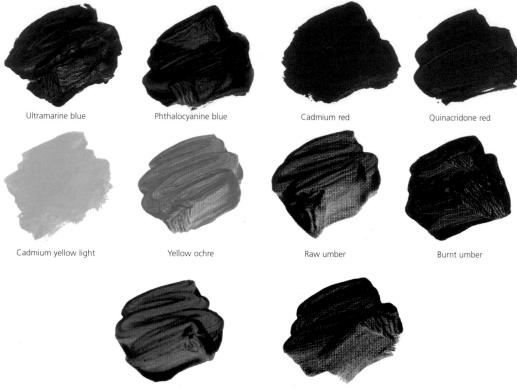

Phthalocyanine green

Payne's grey

As always, this range is only a suggestion and can be extended if a particular subject demands it.

Titanium white (not shown): this is the only white available in acrylic. It is a bright, opaque white with a high tinting strength.

Ultramarine blue: a deep, warm, transparent blue that is permanent and has a high tinting strength.

Phthalocyanine blue: a strong, deep, vivid blue available with either a red or a green undertone. Use sparingly, as it has an incredibly high tinting strength. Cadmium red: a warm, opaque red with good tinting strength.

Quinacridone red: a very bright red with high tinting strength. Cooler than cadmium red, it makes very good purples when mixed with phthalocyanine blue.

Cadmium yellow light: a relatively opaque yellow that mixes well with red to create a range of orange hues and with blue to create a range of intense greens.

Yellow ochre: a semi-opaque earth colour with relatively low tinting strength. It is good for modifying other colours.

Raw umber: a useful transparent earth colour with low tinting strength.

Burnt umber: a rich, deep, warm brown, which is a good starting point for mixing a range of other browns.

Phthalocyanine green: a brilliant strong green with a high tinting strength. This is a good "base" from which to mix a wide range of greens.

Payne's grey: a transparent blue-grey with relatively low tinting strength that is useful for modifying other colours.

Change in colour when dry ▼

One of the fundamental differences between oil and acrylic paint is the slight darkening of colour as acrylic paint dries. This is due to the milky appearance of the wet acrylic emulsion binder: as the emulsion dries it becomes clear and transparent, allowing the pigment it is carrying to be seen more clearly. It can be difficult to judge the exact tone or intensity of your mixes.

Wet acrylic paint

Dry acrylic paint

Gouache paint

Made using the same pigments and binders found in transparent watercolour, gouache is a water-soluble paint. The addition of blanc fixe – a precipitated chalk – gives the paint its opacity. Because gouache is opaque you can paint light colours over darker ones – unlike traditional watercolour, where the paint's inherent transparency means that light colours will not cover any darker shades that lie underneath.

Recently some manufacturers have begun to introduce paint made from acrylic emulsions and starch. The best-quality gouache contains a high proportion of coloured pigment. Artists' gouache tends to be made using permanent pigments that are light fast. The so-called "designers" range of colours uses less permanent pigments, as the work produced by designers is intended to last for only a short time.

Gouache paint is available in tubes and jars. Some brands are sold in series, with

the price reflecting the varying cost of the raw materials, while other brands cost the same across the range. Different brands can be mixed, and the range of colours available is relatively wide. Tube and jar colours have much the same consistency.

What to purchase

Tubes of gouache are large enough for most purposes, although you might like to consider buying a larger jar for colours that you use a lot of, such as permanent white (good for highlights) or zinc white (good for mixling with other colours to lighten them).

All of the equipment and techniques used with watercolour can be used with gouache. Like watercolour, gouache can be painted on white paper or board; due to its opacity and covering power, it can also be used on a coloured or toned ground and over gesso-primed board or canvas. Gouache is typically used on smoother surfaces that might be advised

for traditional watercolour, as the texture of the support is less of a creative or aesthetic consideration.

If they are not used, certain gouache colours are prone to drying up over time. Gouache does remain soluble when dry, but dried-up tubes can be a problem to use

Certain dye-based colours are very strong and, if used beneath other layers of paint, can have a tendency to bleed through. These colours

Characteristics of gouache

Gouache paint is water based and remains water-soluble when dry. This allows you to remove paint easily – but it also means that you need to take care when working over previously applied paint layers. If the brushwork is anything but direct and sure, it can pick

up previously applied paint, resulting in muddy and confused colour.

Gouache can be used as thin, dilute, semi-transparent washes like watercolour or, due to its innate density, applied to form a thicker, opaque film. As with traditional watercolour, you can

Work confidently A

Gouache remains soluble when it is dry, so if you are applying one colour over another, your brushwork needs to be confident and direct: a clean, single stroke, as here, will not pick up paint from the first layer.

Muddied colours A

If you scrub paint over an underlying colour, you will pick up paint from the first layer and muddy the colour of the second layer, as here.

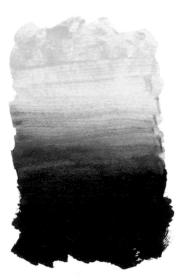

Blending colours A

Gouache colours can be blended together wet into wet on the support, so that colours merge together almost imperceptibly.

lighten the colour simply by thinning it with water: this increases its transparency and allows more of the support of a previously applied layer of paint to show through. Alternatively, you can add white paint, which increases the opacity and enables you to paint light colours over darker ones.

The paint film shrinks as it dries: if you apply gouache too thickly, therefore, you run the risk of the paint cracking. You can overcome this simply by re-wetting a cracked area: this makes the paint soluble again, allowing you to brush or clean off some paint. Once it is dry, the area can be repainted if required.

Due to the high chalk content of the paint, there is a slight colour shift as the paint dries: gouache generally looks a little lighter when it is dry than it does when it is wet. As with acrylics, it will not take you long to get used to this and to compensate by making your wet mixes slightly stronger or more intense. Always test any mixes on a piece of scrap paper and wait for them to dry before you apply them to your actual painting.

It can sometimes be difficult to obtain dark, deep rich colour with gouache so, although it is often necessary to add white paint to mixtures, this should be done with care.

wet (as here) or wet on dry.

Removing dry paint ▲
Dry paint can be re-wetted and removed by blotting with an absorbent paper towel.

Change in colour when dry ▼

Gouache paint looks slightly darker when dry than it does when wet, so it is good practice to test your mixes on a piece of scrap paper – although, with practice, you will quickly learn to make allowances for this.

Lightening gouache colours ▲
Gouache colours can be made lighter either by adding water, which increases transparency (above left), or by adding white paint, which maintains opacity (above right).

Gouache starter palette

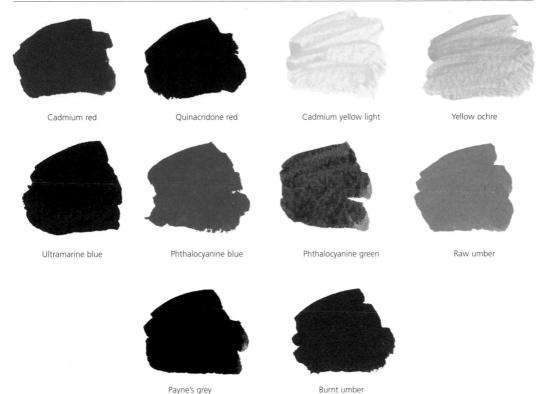

The colours suggested here will provide you with a good, multi-purpose palette of gouache paints from which you will be able to mix virtually any colour that you need. However, you may want to adapt or extend the list if you tend to paint a particular type of subject frequently — portraits or figures, for example, or landscapes. The benefit of using a limited palette such as this is that it will force you to mix your colours carefully, learning as you go.

Experiment to see what colours you

Experiment to see what colours you can create—and get into the habit of making a note of any particularly useful mixes, so that you can recreate them easily the next time you need to use them. You will soon begin to see how different colours can be combined to make new ones.

Cadmium red: a warm, opaque red with good tinting strength.

Quinacridone red: a very bright red with high tinting strength. Cooler than cadmium red, it makes very good purples when mixed with phthalocyanine blue.

Cadmium yellow light: a relatively opaque yellow that mixes well with red to create a range of orange hues and with blue to create a range of intense greens.

Yellow ochre: a semi-opaque earth colour with relatively low tinting strength. It is good for modifying other colours.

Ultramarine blue: a deep, warm, transparent blue that is permanent and has a high tinting strength.

Phthalocyanine blue: a strong, deep, vivid blue available with either a red or green undertone. Use it sparingly, as it has an incredibly high tinting strength.

Phthalocyanine green: a brilliant strong green with a high tinting strength. This is a good "base" green from which to mix a wide range of other greens.

Raw umber: a useful transparent earth colour with low tinting strength.

Payne's grey: a transparent blue-grey, with relatively low tinting strength that is useful for modifying other colours.

Burnt umber: a rich, deep, warm brown, which is a good starting point

brown, which is a good starting point for mixing a range of other browns. As with other media, you will also need a white paint in your palette.

Titanium white (not shown) is a bright, opaque white with a high tinting strength and Is particularly good for painting bright highlights such as sunlight sparkling on water. Zinc white tends to be better for mixing with other colours in order to lighten them.

Paintbrushes

Brushes are available in a wide range of shapes and sizes, from tiny brushes that consist of just a few hairs or fibres that are used to paint very fine detail to large, flat brushes several inches (centimetres) across. Most brushes are sold in series, with each brush being given a number depending on its size: the higher the number, the larger the brush.

The cost of a brush depends on the quality of the materials from which it is made and on its size. Good-quality brushes are worth their initial high cost as, provided you look after them, they will last longer than cheaper alternatives. Having said that, however, certain types of paint application and painting techniques can be very rough and this, coupled with the corrosive nature of some solvents, means that the bristles or fibres used to make a brush do wear out. In these cases, it can be more economical to use a cheaper alternative.

Regardless of cost, when you are buying brushes discard any that do not hold their shape, lack spring, or have loose fibres or bristles.

Brush materials

The materials used to make brush fibres may be either natural or synthetic, hard or soft. The type you choose depends on the medium in which you are working.

Oil-painting brushes are traditionally made from bristle from the back of a hog. Today, most bristle is obtained from China, with the best coming from an area known as Chungking. The bristles hold their shape well and the fibres are thick, which means they can hold a substantial amount of paint. In the very best bristle brushes, the end of each bristle is split; this is known as "flagging", and it allows the bristle to hold more paint and distribute it evenly.

Synthetic brushes are good quality and hard wearing. They are also less expensive than either bristle or natural-hair brushes. However, they can quickly lose their shape if they are not looked after and cleaned well. Synthetic brushes can be used with oil, acrylic and gouache.

Natural hair brushes can be made from sable, goat, squirrel, ox and even mongoose hair. Traditionally, natural hair brushes are more often associated with watercolour painting, and so they are ideal for using with gouache. They can also be used with acrylics; in fact, as painting in acrylics draws on techniques that are used in both watercolour and oil painting, it is best to have a selection of hard and soft brushes for acrylics.

There is also a tradition of using sable- and mongoose-hair brushes with oils; the fine-tipped hairs are good for fine detail, although it is not easy to move oil paint around on the canvas with natural-hair brushes. If you do use natural hair brushes with oils or acrylics, however, you must clean them scrupulously after use. Given the availability of good-quality synthetic brushes, it is perhaps better to reserve natural-hair brushes for working in water-soluble media.

Cleaning brushes

Cleaning your brushes thoroughly will make them last longer. Wipe off any excess wet paint on a rag or a piece of newspaper. Take a palette knife and place it as close to the metal ferrule as possible. Working away from the ferrule towards the bristles, scrape off as much paint as you can.

Pour a small amount of household white spirit (paint thinner) (or water, if you are using a water-based paint such as acrylic or gouache) into a jar; you will need enough to cover the bristles of the brush. Agitate the brush in the jar, pressing it against the sides to dislodge any dried-on paint.

3 Rub household detergent into the bristles of the brush with your fingers. Rinse the brush thoroughly in clean water until the water runs clear. Reshape the bristles or fibres with your fingertips and store the brush in a jar with the bristles pointing upwards, so that they hold their shape.

Brush shapes

Several brush shapes are available in bristle, synthetic fibres and natural hair. Although the choice might seem bewildering at first glance, some of the more "specialist" brushes are of limited use, and you would probably do better to experiment with a small range and find out what kind of marks you can make with each one. Finally, do not overlook the range of brushes available from home improvement stores: decorators' brushes can be very useful for laying in large areas of colour when toning a ground, for example. These are often of a very high quality and cost far less than similar brushes sold in art supply stores.

Regardless of the medium in which you are working, you will need a range of different brush sizes. The shapes that you select are often very much a matter of personal preference, but the following are all useful.

Flat brushes **▼**

These brushes have square ends. They hold a lot of paint, which can be applied as short impasto strokes or brushed out flat. Large flat brushes are useful for blocking in and covering large areas quickly. Short flats, known as "brights", hold less paint and are stiffer. They make precise, short strokes, ideal for impasto work and detail.

Brushes for fine detail ▶

A rigger brush (top right) is very long and thin. It was originally invented for painting the straight lines of the ropes and rigging on ships in marine painting – hence the rather odd-sounding name. A liner (bottom right) is a flat brush which has the end cut away at an angle. Both of these brushes may be made from natural or synthetic fibres.

Wash brushes ▶

The wash brush has a wide body, which holds a large quantity of paint. It is used for covering large areas with a uniform or flat wash of paint. There are two types of wash brush: rounded or "mop" brushes (top right), which are commonly used with watercolour and gouache, and flat wash brushes (bottom right), which are more suited for use with oils and acrylics.

Round brushes ▼

These are round-headed brushes that are used for detail and for single-stroke marks. Larger round brushes hold a lot of paint and are useful for the initial blocking-in. The point on round brushes can quickly disappear, as it becomes worn down by the abrasive action of the rough support. The brushes shown here are made of natural hair.

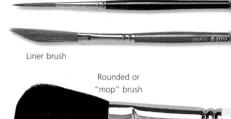

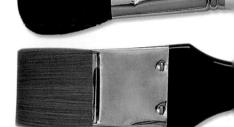

Flat wash brush

Rigger brush

Unusually shaped brushes ▼

Fan blenders (below left) are intended for blending together colours on the support. They are also useful for special effects such as drybrush work. A filbert (below right) combines some of the qualities of a flat and a round brush.

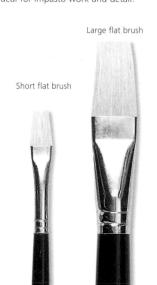

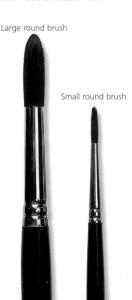

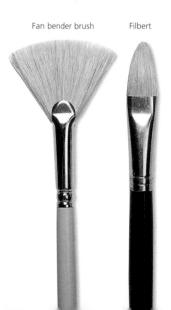

Alternative paint applicators

Although brushes are the most usual means of applying paint to the support, there are a number of other tools that you can use. Some, such as palette and painting knives, are intended specifically for painting, but you can also improvise using virtually anything that comes to hand, including old rags, cardboard and even your fingertips.

Artist's palette and painting knives

Palette knives are intended for mixing paint with additives on the palette, scraping up unwanted paint from the palette or support, and general cleaning. Palette knives are available with either plastic or stainless steel blades. The steel blades are more durable and can be found in several different shapes. With plastic blades, there is a more limited range of shapes. The blade of most palette knives extends straight out from the wooden handle, although some have a cranked handle. This raises the hand holding the knife clear of the surface being worked on.

Strong knives can also be found in DIY or home improvement stores. Although they are intended for

stripping wallpaper or applying quickdrying filler to cracks and holes, they made very good palette knives.

All painting knives have cranked handles. Made from flexible stainless steel, the knives – like brushes – come in different shapes and sizes. You can create a wide range of marks using painting knives. In general, the body of the blade is used to spread paint, the point for detail, and the edge for making crisp linear marks. The knife is not as adaptable as the brush and you will need a range of painting knives in order to create a range of different marks and effects.

Plastic painting knives are also available, but they are not recommended for use with oils or acrylics. They can, however, be used with the more liquid gouache; the gouache seems to be "held" more by the blade, while it is difficult to pick up thin paint using knives with steel blades.

Regardless of the type of knife you use, it is important to clean it thoroughly after use. Paint that has dried on the blade will prevent fresh paint from flowing evenly off the blade. If paint dries on to a steel blade, remove it using paint stripper, the caustic action of which will not damage the blade. Do not use caustic paint strippers on plastic blades, as they will dissolve; instead, peel the paint away. Ideally, you should clean the paint from plastic knives while it is still wet.

Steel knives

Painting and palette knives made of steel are available in a range of shapes and sizes. In order to work successfully with this method of paint application, you will require several.

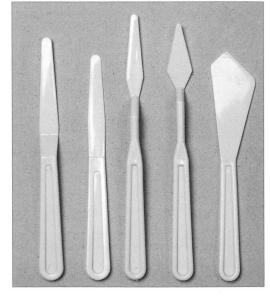

Plastic knives

Less expensive and less durable than steel knives, plastic knives manipulate watercolour and gouache paints better than their steel counterparts.

Paint shapers

A relatively new addition to the artist's range of tools are paint shapers. They closely resemble brushes, but are used to move paint around in a way similar to that used when painting with a knife. Instead of bristle, fibre or hair, the shaper is made of a non-absorbent silicone rubber. Various tip shapes are

available in several different sizes and degrees of firmness. They are used in a number of ways to apply and push paint around the support, as well as to remove paint and blend different-coloured areas together. Although they are not as versatile as the brush, they bring a different quality to the work.

Shapers can be used with all types of paint, mediums and adhesives. They are easy to clean, as wet paint can be washed off and dry paint can be peeled off the rubber tip without the use of solvents. Another advantage is that the rubber tip will not harden or wear with use

Foam and sponge applicators

Nylon foam is used to make both foam brushes and foam rollers. Both of these are available in a range of sizes and, while they are not intended as substitutes for the brush, they are used to bring a different quality to the marks they make.

Natural sponges have always found a place in the watercolourist's work box and, together with man-made sponges, can be used to good effect with acrylics and gouache. They are invaluable for spreading thin paint over large areas

Sponge applicators and paint shapers ▼

Shapers (below left) can be used to apply paint and create textures, and to remove wet paint. Foam rollers (below centre) are useful for covering large areas quickly. Sponge applicators (below right) are useful for initial blocking in.

and for making textural marks. They are also useful for mopping up spilt paint and for wiping paint from the support in order to make corrections.

Foam and sponge applicators are better used with water-based mediums than with oil-based ones, as cleaning the applicators first in solvent and then in soap and water can be a long and messy process. With water-based mediums, however, all you need to do is rinse the paint from the applicator by holding it under a running tap.

Natural and man-made sponges ▼

With their pleasing irregular texture, natural sponges (below top) are used to apply washes and textures. They are especially useful to landscape artists. Man-made sponges (below bottom) can be cut to the desired shape and size and used in a similar fashion.

Alternative applicators

Paint can be applied and manipulated using almost anything. Artists are, by and large, thoughtful and inventive people, and the only limitations are set by practicality and imagination. The cutlery drawer and tool box are perhaps a good starting point, but you will no doubt discover plenty of other items around the home that you can use. Cardboard, pieces of rag, wood, wire wool and many other seemingly unlikely objects can all be – quite literally – pressed into service.

Everyday household items ▼

Although they might not seem like the obvious choice, everyday household items, such as an old rag, wire wool and piece of cardboard shown here, can also be used to apply paint to a support.

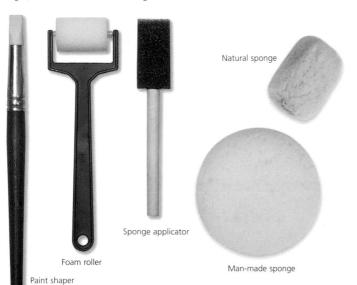

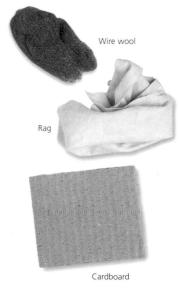

Palettes

The surface on which an artist arranges colours prior to mixing them and applying them to the support is known as the palette. Somewhat confusingly, the same word is also used to describe the range of colours used by a particular artist, or the range of colours found in a particular painting. The type of palette that you use depends on the medium in which you are working, but

you will undoubtedly find that you need more space for mixing colours than you might imagine. A small palette gets filled with colour mixes very quickly and it is a false economy to clean the mixing area too often: you may be cleaning away not only usable paint, but also mixed colours that you might want to use again. Always buy the largest palette practical.

Wooden palettes

Flat wooden palettes in the traditional kidney or rectangular shapes with a thumb hole are intended for use with oil paints. They are made from hardwood, or from the more economical plywood.

Before you use a wooden palette with oil paint for the first time, rub linseed oil into the surface of both sides. Allow it to permeate the surface. This will prevent oil from the paint from being absorbed into the surface of the palette and will make it easier to clean. Reapply linseed oil periodically and a good wooden palette will last for ever.

Wooden palettes are not recommended for acrylic paint, as hardened acrylic paint can be difficult to remove from the surface.

Holding and using the palette ▼

Place your thumb through the thumb hole and balance the palette on your arm. Arrange pure colour around the edge. Position the dipper(s) at a convenient point, leaving the centre of the palette free for mixing colours.

White palettes

Plastic palettes are uniformly white. They are made in both the traditional flat kidney and rectangular shapes. The surface is impervious, which makes them ideal for use with either oil or acrylic paint. They are easy to clean, but the surface can become stained after using very strong colours such as viridian or phthalocyanine blue.

There are also plastic palettes with wells and recesses, intended for use with watercolour and gouache. The choice of shape is entirely subjective, but it should be of a reasonable size.

White porcelain palettes offer limited space for mixing. Intended for use with watercolour and gouache, they are aesthetically pleasing but can easily be chipped and broken.

Wooden palette A

These wooden palettes are generally used for oils. Always buy one that is large enough to hold all the paint and mixes that you intend to use.

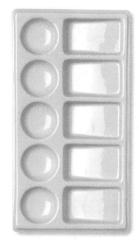

Slanted-well palette A

This type of porcelain palette is used for mixing gouache or watercolour. The individual colours are placed in the round wells and mixed in the rectangular sections.

Disposable palettes

A relatively recent innovation is the disposable paper palette, which can be used with both oils and acrylics. These come in a block and are made from an impervious parchment-like paper. A thumb hole punched through the block enables it to be held in the same way as a traditional palette; alternatively, it can be placed flat on a surface. Once the work is finished, the used sheet is torn off and thrown away.

Paper palette A Disposable palettes are convenient and make cleaning up after a painting session an easy task.

Stay-wet palette

Intended for use with acrylic paints, the stay-wet palette will stop paints from drying out and becoming unworkable if left exposed to the air for any length of time. The palette consists of a shallow. recessed tray into which a waterimpregnated membrane is placed. The paint is placed and mixed on this membrane, which prevents the paint from drying out. If you want to leave a painting halfway through and come back to it later, you can place a plastic cover over the tray, sealing the moist paint in the palette. This prevents the water from evaporating and the paint from becoming hard and unusable. The entire palette can be stored in a cool place or even in the refrigerator. If the membrane does dry out, simply re-wet it.

Stay-wet palette ▶

This type of palette, in which the paint is mixed on a waterimpregnated membrane, prevents acrylic paint from drying out. If you like, you can simply spray acrylic paint with water to keep it moist while you work.

For work in the studio, any number of impermeable surfaces and containers can be used as palettes. Perhaps the most adaptable is a sheet of thick counter glass, which you can buy from a glazier; the glass should be at least ¼ in (5 mm) thick and the edges should be polished smooth. Glass is easy to clean and any type of paint can be mixed on it. To see if your colours will work on the support you have chosen to use, slip a sheet of paper the same colour as the support beneath the glass.

Aluminium-foil food containers, tin cans, glass jars, paper and polystyrene cups also make useful and inexpensive containers for mixing large quantities of paint and for holding water or solvents. Take care not to put oil solvents in plastic or polystyrene containers, as the containers may dissolve.

Containers for water, solvents and oil

Although a regular supply of containers such as empty jam jars, can be recycled from household waste, several types of specially designed containers are available from art supply stores.

Among the most useful are dippers small, open containers for oil and solvent that clip on to the edge of the traditional palette. Some have screw or clip-on lids to prevent the solvent from evaporating when it is not in use. You can buy both single and double dippers, like the one shown on the right

Used in oil painting, dippers are clipped on to the side of the palette and contain small amounts of oil or medium and thinner.

Oil additives

Although oil paint can be used straight from the tube, it is usual to alter the paint's consistency by adding a mixture of oil or thinner (solvent). Simply transfer the oil or thinner to the palette a little at a time and mix it with the paint. Most oil painters attach

dippers to the edge of the palette so that the oil and thinner are readily at hand, but any small container will do. There are a great many oils and thinners on the market. Some of the more common ones are shown below.

Oils and mediums

Oils and mediums are used to alter the consistency of the paint, allowing it to be brushed out smoothly to increase its transparency or to make it dry more quickly. Once exposed to air, the oils dry by oxidization, leaving behind a tough, leathery film that contains the pigment. Different oils dry at a different rate. Because some oils (linseed, for example, which dries relatively quickly) tend to yellow slightly with age, they are used only in the manufacture of darker colours. Delicate colours and white are often manufactured using safflower or poppy oil, both of which dry more slowly. Many oils are made from plant extracts, but more recent additions are made from synthetic resins that also speed up drying.

A painting medium is simply a ready-mixed painting solution that may contain various oils, waxes and drying

agents. The oils available are simply used as a self-mixed medium. Your choice of oil or medium will depend on several factors, including cost, the type of finish required, the thickness of the paint being used, and the range of colours.

All oils take several days to dry. The exact drying time, however, depends on the amount used and on atmospheric temperature and humidity.

There are several alkyd-based mediums on the market. They all accelerate the drying time of the paint. Some alkyd mediums are thixotropic; this means that they are initially stiff and gel-like but, once worked, they become clear and loose. Other alkyd mediums contain inert silica and add body to the paint, which is useful for impasto techniques where a thicker mix of paint is required.

Oils and thinners

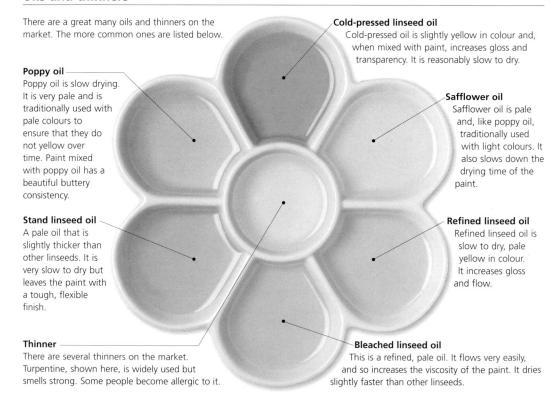

Thinners

If you dilute oil paints using only oil, the paint may wrinkle or take too long too dry. As the name suggests, a thinner (also known as a diluent) thins the paint, making it easier to brush out. It does not remain in the paint, but evaporates from the surface.

The amount of thinner that you use depends on how loose or fluid you want the paint to be. Do not use too much, however, or you may find that the paint film becomes weak and prone to cracking.

Ideally, any thinner that you use should be clear and should evaporate easily from the surface of the painting without leaving any residue. There are several thinners suitable for use with oil paints. There is very little, if any, difference in appearance between them – but they do have different characteristics.

Turpentine

Distilled from the thick, resinous sap or oleoresin of several different species of pine tree, turpentine is colourless, with a distinct odour. Many people develop an allergy to it, so use it with care and make sure that the room in which you are working is well ventilated.

Turpentine is the strongest and best of all the various thinners used in oil painting. Use only fresh turpentine, as old turpentine can become discoloured with a gummy residue if it is exposed to air and light. To minimize the risk of this happening, store your turpentine in closed metal cans or dark glass bottles.

Good-quality turpentine is expensive, so use it only for painting; for cleaning your brushes, use cheaper white spirit.

White spirit

Paint thinner or white spirit, which is also known as mineral spirit, is a petroleum by-product. It is clear, has a less

Warning

- Always follow any instructions and warning advice carried on containers.
- All solvents are flammable and should be used in a well-ventilated environment, away from naked flames.
- Avoid contact with the skin and eyes and avoid breathing the fumes.
- Do not use solvents when handling food and drink.
- If you experience any adverse effects when using solvents, switch to a low-odour variety.
- All oil-painting mediums and varnishes can be an irritant and should be used following the same procedures as for solvents.
- Keep a suitable empty container available into which you can pour used solvent. When the container is full, dispose of it at your local refuse or waste disposal centre.

pronounced smell than turpentine, does not deteriorate over time and dries faster than turpentine. It is inexpensive and can therefore be used both for painting and for cleaning brushes, although ideally it is best used for cleaning brushes. However, it is not as strong a solvent as turpentine and can leave the paint surface matt.

Oil of spike lavender

This exotic-sounding solvent is made from lavender oil and smells wonderful. Unlike other solvents, which speed up the drying time of oil paint, oil of spike lavender slows the drying time. It is very expensive. Like turpentine and white spirit, it is colourless.

Low-odour thinners

For those who dislike the smell of traditional thinners, are allergic to them, or are simply concerned about the health implications of breathing in the fumes, various low-odour thinners such as sansador have come on to the market in recent years and are now a popular choice. However, the drawback of low-odour thinners is that they are relatively expensive and dry slowly.

Citrus solvents

You may be able to find citrus thinners. They are thicker than turpentine or white spirit but, like spike lavender oil, smell wonderful. They are more expensive than traditional thinners and slow to evaporate.

Liquin ▼

Liquin is just one of a number of alkyd painting mediums that speed up drying time considerably – often to just a few hours. It also improves flow and increases the flexibility of the paint film. It is excellent for use in glazes.

Acrylic additives

Although acrylic paint can be used straight from the tube or jar, or thinned with water, manufacturers have steadily introduced a wide range of mediums and additives that enable the real potential of the paint to be exploited to its maximum. Scour the shelves of any good art supply store and you will find additives that make the paint finish gloss or matt, thick or thin, textured or smooth.

There are additives that slow down the drying time of the paint, giving you longer to work into it. There are even additives that make colours glow in the dark or turn acrylic into a fabric paint that can withstand being put through a washing machine. The chances are that if you want to do something creative with acrylic paint, there is an additive to enable you to do it.

Types of finish

Acrylic paints dry to leave a matt or slightly glossy surface. The finish depends entirely on the brand being used. Gloss or matt mediums can be added to leave the surface with the desired finish. Gloss and matt mediums can also be mixed together to give the dry paint varying degrees of sheen. The choice is a personal one. As a general rule, colours on a gloss surface tend to look brighter. It is also preferable to use gloss mediums when glazing colours.

Gloss and matt mediums ▼

It is impossible to tell simply by looking at it whether a medium will give a matt or a gloss finish. Both gloss (below) and matt (bottom) mediums are relatively thin white liquids that dry clear if applied to a support without being mixed with paint.

The effect of gloss medium A

Adding gloss medium to the paint increases its transparency. This allows you to build up several thin glazes relatively quickly, leaving the dry paint with a slight gloss sheen. Gloss medium also enhances the depth of colour, improves adhesion to the support and increases the flexibility of the paint. It can be used as an adhesive for collage work. Some manufacturers also advise using gloss medium as a varnish.

The effect of matt medium A

Matt medium also increases transparency and can be used to make matt glazes. Matt medium has good adhesive properties. It can be thinned with water and used to size canvas, or diluted 50:50 with water and used as a fixative for drawings. Matt mediums are not generally used as varnish, as they can deaden colour and look slightly cloudy.

Adding flow-improving mediums

Flow-improving mediums reduce the water tension, increasing the flow of the paint and its absorption into the surface of the support.

One of the most useful applications for flow-improving medium is to add a few drops to very thin paint, which can tend to puddle rather than brush out evenly across the surface of the support. This is ideal when you want to tone the ground with a thin layer of acrylic before you begin painting.

When flow-improving medium is used with slightly thicker paint, a level surface will result, with little or no evidence of brushstrokes.

The medium can also be mixed with paint that is to be sprayed, as it assists the flow of paint and helps to prevent blockages within the spraying mechanism.

Flow-improving medium ▲
This medium is a colourless liquid and therefore does not affect the colour of the paint.

Adding retarding mediums

Acrylic paints dry quickly. Although this is generally considered to be an advantage, there are occasions when you might want to take your time over a particular technique or a specific area of a painting – when you are blending colours together or working wet paint into wet, for example. Adding a little retarding medium slows down the drying time of the paint considerably, keeping it workable for longer.

Without flow-improving medium ▲
Very thin acrylic paint tends to puddle rather than brush out evenly.

With flow-improving medium ▲
Adding flow-improving medium to thicker paint results in a level surface in which no brushstrokes can be seen.

Always follow the manufacturer's instructions regarding how much medium to add to your mixes. Beware of adding too much medium as this can recult in the paint becoming sticky

and leaving a soft, easily damaged

paint film.

Retarding medium ►
Retarding mediums are available as gels (shown here) and as fluids.

Adding gel mediums

Gel mediums are the same consistency as tube colour. Available as matt or gloss finishes, they are added to the paint in the same way as fluid mediums. They increase the brilliance and transparency of the paint, while maintaining its thicker consistency. Gel medium is an excellent adhesive and extends drying time. Gel mediums can be mixed with various textural substances such as sand or sawdust to create textural effects.

There are also thicker versions of gel mediums, which (not surprisingly) are known as heavy gel mediums. They hold brush or knife marks well, making them ideal for impasto work. Another effect of heavy gel mediums is to extend the working time of the paint. Some brands dry to a translucent finish and others to an opaque one.

Heavy gel mediums have very good adhesive properties and can be mixed with sand or sawdust. It is better to

build up very thick applications in several thin layers than in one thick one, as this reduces the chance of any splitting in the paint film due to water evaporation and shrinkage. Very thick applications can be heavy and are best made on non-flexible surfaces such as board, rather than on canvas, which may sag.

Heavy gel medium ▲ Heavy gel medium is a thick paste.

■ The effect of heavy gel medium Mixed with acrylic paint, heavy gel medium forms a thick paint that is used for impasto work.

Adding modelling paste

Modelling pastes can be mixed with acrylic paint and dry to give a hard finish, which can be sanded or carved into using a sharp knife. They are best used on non-flexible substrates, as thick applications can be heavy, although there is a modelling paste with a lighter structure, which is ideal for use on canvas. If you are using modelling pastes on flexible supports, add a gel medium to maximize flexibility.

In order to aid drying, it is better to build up several thin coats, allowing each layer to dry before adding the next, rather than apply one thick layer. Although heavy applications may crack, they do not affect the structural strength of the application and any cracks can be filled using more paste once the area is dry.

Modelling paste ▼

White or light grey in colour, modelling pastes are either smooth to the touch or very slightly granular in texture. As with other acrylic mediums, there are several reputable brands on the market.

The effect of modelling paste ▲ Modelling pastes dry to give a hard finish, which can be sanded or carved into using a sharp knife.

Adding texture pastes and gels

While sand, gravel, sawdust and various other materials can be added to texture paste and other acrylic gel mediums, there are several proprietary texture gels with different textural characteristics. These pastes have fine, medium or coarse textures and resemble sand, stucco, plaster, lava, flakes or fibres. Paint can be mixed into the paste, or the paste can be applied and painted over when dry. To avoid damaging your brushes, it is best to apply texture paste with a knife.

Natural sand texture gel ▲
The natural sand texture gel shown here is fine in texture.

Glass beads texture gel ▲
Glass beads are embedded in the gel. It
looks grainy, like medium-textured sand.

Black lava texture gel ▲
Black lava texture gel is speckled grey
in appearance.

Natural sand texture gel ▲
This gel creates the texture of sand. The colour is more even than real sand.

Glass beads texture gel ▲
Glass beads texture gel creates an effect
like medium-textured sand.

Black lava texture gel ▲
Mixed with a pale colour, as here, the colour of the gel remains visible.

Pearlescent, iridescent and phosphorescent mediums

These mediums are intended primarily for decorative works. Pearlescent mediums create a shimmering effect. Iridescent mediums contain tiny flakes of mica that, when mixed with paint, appear to change colour depending on the direction of the light. The mediums are particularly effective with transparent colours. Phosphorescent medium is green and glows in the dark. It can be mixed with other colours but the glow effect is gradually redured.

The effect of iridescent medium ► Tiny flakes of mica in the medium appear to change colour.

Iridescent medium ▲
Iridescent medium looks very similar to some of the other acrylic additives.

Supports

A "support" is the name for the surface on which a painting is made. It needs to be physically stable and resistant to deterioration from both the corrosive nature of any of the materials being used and the surrounding atmosphere. It needs to be light enough

to be transported from one place to another. It also needs to have a sympathetic surface texture, as this will have a direct effect on the marks and techniques that you use. Your choice of support depends on the medium in which you are working.

Canvas

Without doubt, canvas is the most widely used support for both oil and acrylic work. Several types of canvas are available, made from different fibres. The most common are made from either cotton or linen, both of which can be purchased ready stretched and primed to a range of standard sizes (although there are suppliers who will prepare supports to any size) or on the roll by the yard (metre) either primed or unprimed. Unprimed canvas is easier to stretch.

Linen canvas is made from the fibres of the flax plant, Linum usitatissimum. The seeds of this plant are also pressed to make linseed oil, used by artists. Linen is the finest type of canvas available. It is light brown in colour, very strong, and gives a pleasingly receptive surface on which to work. Depending on the gauge or weight of the thread used, linen canvas can be found in a wide variety of weave textures and weights. Linen canvas is often described as being fine, medium or coarse. As a general rule, lighter weights (200-225g/ 7-8oz) with a fine tooth are used for smaller works, while heavier grades (375-450g/12-15oz) are best for larger works. Because of the way linen is woven, the surface texture never looks too even or mechanical.

Cotton canvas is known as cotton duck. It is light cream in colour and has a more regular or mechanical weave than linen. Stretched cotton duck is more stable than linen and is less prone to becoming slack on its stretcher if the air becomes damp. Seen as inferior to linen, it is nonetheless a popular and widely used support. It is substantially cheaper than linen and is also easier to stretch. Cotton duck is available in a range of weights from 200–450g/7–15oz; for larger works, use weights over 250q/10oz.

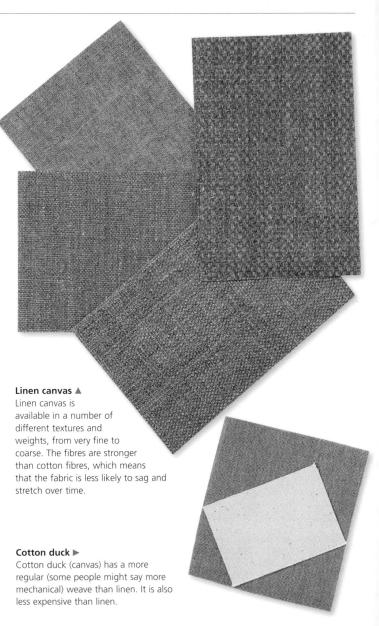

Stretching canvas

Canvas must be stretched taut over a rectangular wooden frame before use. For this you will need stretcher bars and wooden wedges.

Stretcher bars are usually made of pine and are sold in pairs of various standard lengths. They are pre-mitred and each end has a slot-in tenon joint. Longer bars are morticed to receive a cross bar (recommended for large supports of 75 x 100cm/30 x 40in or more).

The wonden wedges are tapped lightly into the inside of each corner and can be hammered in further to allow you to increase the tension of the stretched canvas a little if necessary.

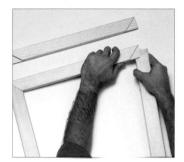

Press or tap the stretcher bars together to make a frame. They should slot together easily, without you having to exert much pressure.

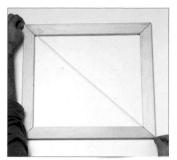

2 Using a tape measure or piece of string, measure diagonally from corner to corner in both directions to check that the corners are square.

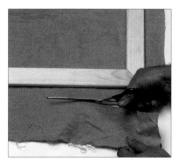

3 Arrange the canvas flat on a work surface. Place the frame on top, bevelled side down. Cut out allowing an overlap of approximately the width of the stretcher bars on all sides.

4 Fold the excess canvas over the stretcher bars, ensuring the canvas threads run parallel to the bars. Drive a staple into the centre of opposite sides. Repeat on the other sides.

5 Insert one staple to each side of the centre staple on opposite sides, half way between the centre staple and the edge. Repeat on the other sides. Fold in the canvas corner and hold in position.

6 Fold over the flap of canvas on one side of the corner, pull it taut and hold it firmly in position with your fingertip.

7 Fold over the remaining flap of canvas and secure with a staple to make a neat mitre, keeping your finger well away from the staple qun.

In each corner, push two wedges into the slots in the stretcher bars. If the canvas sags, the wedges can be pushed in further to keep the canvas taut.

Priming canvas

Canvas is usually sized and primed (or, increasingly, just primed) prior to being worked on. This serves two purposes. The process not only tensions the fabric over the stretcher bars but also (and more importantly in the case of supports used for oil) seals and protects the fabric from the corrosive agents present in the paint and solvents. Priming also provides a smooth, clean surface on which to work.

In traditional preparation, the canvas is given a coat of glue size. The most widely used size is made from animal skin and bones and is known as rabbit-skin glue. It is available as dried granules or small slabs. When mixed with hot water the dried glue melts; the resulting liquid is brushed over the canvas to seal it.

Increasingly, acrylic emulsions are used to size canvas. Unlike rabbit-skin glue, the emulsions do not have to be heated but are used diluted with water.

The traditional partner to glue size is an oil-based primer. Lead white, which is toxic, together with titanium white and flake white, are all used in oil-based primers. In order to penetrate the fibres of the canvas, it should be the consistency of single cream; dilute it with white spirit if necessary.

Traditional primer can take several days to dry, however; a modern alternative is an alkyd primer, which dries in a couple of hours.

Primers based on acrylic emulsion are easier to use. These are often known as acrylic gesso, although they are unlike traditional gesso. Acrylic primer should not be used over glue size, but it can be brushed directly on to the canvas. Acrylic primers can be used with both oil and acrylic paint, but oil primers should not be used with acrylic paints.

Primer can be applied with either a brush or a large palette knife. If a brush is used the weave of the canvas tends to be more apparent.

If you want to work on a toned ground, add a small amount of colour to the primer before you apply it. Add oil colour to oil primer and acrylic colour to acrylic primer.

Boards

Several types of wooden board make good supports for both oil and acrylic work. The boards can simply be primed with an acrylic gesso, or canvas can be glued to the surface; a technique known as marouflaging. There are three types of board in common use: plywood, hardboard (masonite) and medium-density fibreboard (MDF).

Plywood is made from several thin layers of wood or veneers glued together to form a rigid sheet. The surface veneers are usually made from hardwood and are smooth.

Hardboard is made from exploded wood fibre and is available both tempered and untempered. Tempering

with oils or resins makes it harder and more water resistant. Use the softer-surfaced, untempered board, as the hard and somewhat oily surface of tempered board can resist paint. Some hardboards have a rough and a smooth side; you can paint on either side, depending on the effect you want.

MDF, made from compacted wood fibres, is perhaps the best board to use as it is stable and warp resistant. Both sides of MDF are hard and smooth.

All these boards can be found in a range of sizes. If used at a size where they begin to bend, mount rigid wooden battens on the reverse to reinforce them.

Priming board

Wood was traditionally sized with rabbit-skin glue and then primed with a thixotropic primer in the same way as canvas; nowadays, most artists use ready-made acrylic primer or acrylic gesso primer, which obviates the need for sizing. Acrylic primer also dries much more quickly.

Before you prime your boards, make sure they are smooth and free of dust. You should also wipe over them with methylated spirits to remove all traces of grease.

Using a wide, flat brush or a decorator's brush, apply primer over the board with smooth, vertical strokes. For a very large surface, apply the primer with a paint roller. Allow to dry.

 $2 \\ \begin{array}{l} \text{Rub the surface of the board with} \\ \text{fine-grade sandpaper to smooth out} \\ \text{any ridges in the paint. Blow or dust} \\ \text{off any powder.} \end{array}$

Apply another coat of primer, making smooth horizontal strokes. Allow to dry. Repeat as many times as you wish, sanding between coats.

Covering board with canvas

Canvas-covered board is a lightweight painting surface that is particularly useful when you are painting on location. Covering board with canvas gives you a support that combines the strength and low cost of board with the texture of canvas. You can use linen or cotton duck, which makes it a good way of using up remnants of canvas; calico, which is a

cheap material, is also suitable. Acrylic primer is used to stick the canvas to the board. It looks white when it is first applied, but dries clear. When you have stuck the canvas on to the board, you should leave it to dry for an hour or two in a warm room. Prime the canvas with an acrylic primer before use.

Arrange the canvas on a flat surface. Place the board on the canvas. Allowing a 5cm/2in overlap all around, cut out the canvas with a pair of sharp scissors.

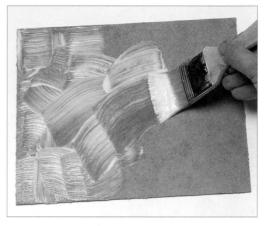

 $2^{\,\text{Remove}}$ the canvas from the work surface. Using a wide, flat brush or a household decorator's brush, liberally brush matt acrylic medium over the surface of the board.

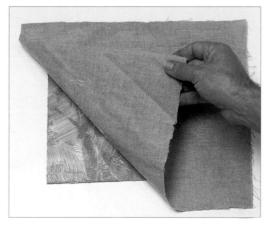

3 Place the canvas on the sticky side of the board and smooth it out with your fingertips, working from the centre outwards.

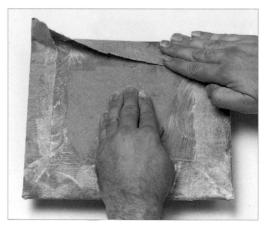

Brush acrylic medium over the canvas to make sure that it is firmly stuck down. Place the board canvas-side down on an upturned plate or bowl so that it does not stick to your work surface. Brush acrylic medium around the edges of the board. Fold over the excess canvas, mitring the corners, and brush more medium over the corners to stick them down firmly

Canvas paper and board

Artists' canvas boards are made by laminating canvas – or paper textured to look like canvas – on to cardboard. They are made in several sizes and textures and are ideal for use when painting on location. However, take care not to get them wet, as the cardboard backing will disintegrate. They can also be easily damaged if you drop them on their corners. They are ready sized and can be used for both oils and acrylics.

Oil and acrylic papers are also available. Both have a texture similar to canvas and can be bought as loose sheets or as sheets bound together in blocks. Although they are perhaps not suitable for work that is intended to last, they are perfect for sketching and making colour notes.

Oil and acrylic papers have a texture similar to canvas.

Paper and illustration board

Although best suited to works using water-based materials, paper and illustration board, provided they are primed with acrylic primer, can also be used for painting in oils.

Watercolour papers provide ideal surfaces for gouache work. The papers are found in various thicknesses and with three distinct surfaces – rough, hot pressed (which is smooth) and NOT or cold pressed, which has a slight texture. Watercolour boards tend to have either a rough or a hot-pressed surface. Illustration board tends to be very smooth and is intended for use with gouache and linework.

Illustration board ▶

Used with gouache, illustration board is very smooth and good for finely detailed work.

Varnishes

Traditionally, varnish was applied to oil paintings to protect them from atmospheric pollution and dirt. Varnish also had an aesthetic purpose: oil painting techniques often result in a paint surface that looks uneven, with dull and shiny areas depending on the amount or type of painting media used. A varnish unifies and enhances the colour, bringing the whole painted surface together beneath a uniform gloss or semi-matt sheen.

The painting must be completely dry before it is varnished, otherwise the dry ing paint will contract beneath the less flexible varnish and cause the varnish to crack. Oil paintings can take months or even years to dry, depending on the thickness of the paint. Acrylic paintings can be safely varnished with acrylic varnish after a few hours. Watercolours and gouache paintings are normally framed behind glass, so they are protected and there is no need to varnish them.

All varnishes should be flexible. They should remain clear and non-yellowing and be easily removable. Varnishes are made from both natural and synthetic

materials. The two traditional natural varnishes are damar and mastic. However, mastic varnish has a reputation for going dark and yellowing with age. It also tends to become cloudy, if it is prepared in damp air, leaving behind a surface bloom.

Varnishes made from natural resins are being replaced by synthetic varnishes made from Ketone and acrylic resins. Synthetic-resin varnishes have several advantages, as they do not yellow with age or become brittle. They can be used on both oil and acrylic paintings. They are also very tough. However, you cannot mix synthetic resin varnishes with oil mediums or turpentine. Several manufacturers market a range of these resins. They are manufactured to dry to a gloss or a matt finish and can be mixed together to provide varnish with varying degrees of sheen.

There are also spray varnishes, both removable and non-removable, which dry to give gloss, satin or matt finishes. They can be used on both oil and acrylic paintings. They are quick drying, but need to be used with care in order to achieve uniform coverage.

Applying varnish

Make sure the painting is completely dry before you varnish it. Always use a clean varnish brush and work in a dustfree environment

The technique ▼

Place your painting flat on a surface. Dip a large, flat brush in your chosen varnish and apply it in smooth, even strokes in one direction. Do not scrub the surface or you will create alr bubbles. If you go over any area more than once the finish will be uneven.

Different types of varnish

Varnishes are pale or colourless and it is difficult to tell the difference between the types by their appearance. Here are some of the most widely used.

Acrylic matt varnish

Synthetic varnishes can be used on oil and acrylic paintings. The one shown here dries to a matt finish.

Wax varnish

Wax varnish is used on oil paintings. It is made from beeswax mixed with a solvent. The wax is brushed over the work and allowed to stand for a short time. The excess is then removed with a rag and the surface buffed. The more the surface is buffed, the higher the resulting sheen.

Acrylic gloss varnish

This synthetic varnish dries to a gloss finish.

Retouching varnish

Retouching varnish is used on oil paintings and can be used at any time while the work is in progress. It is used to revive sunken areas where the paint looks dull. Both damar and mastic thinned with solvent can be used as retouching varnish.

Damar varnish

Damar varnish is used on oil paintings. It is made from the resin of the damar tree, which is found throughout Indonesia and Malaysia. The resin is mixed with turpentine to create a slightly cloudy liquid. The cloudiness is caused by natural waxes in the resin, and clears as the varnish dries. Damar does yellow

the varnish dries. Damar does yellow with age, but it is easy to remove it and replace it with a fresh coat. The varnish dries very quickly.

Auxiliary equipment

Art stores are like candy stores, with shelves full of handsomelooking, colourful materials and equipment. Despite what the manufacturers' catalogues would have you believe, by no means all are essential – but there are several articles, such as the ones shown on these two pages, that are virtually indispensable and will make it easier for you to work.

Easels

Buying a good easel will make working on even a modest-sized support easier. It will also give you a psychological boost, inspiring you to greater things. There are several questions that you need to ask yourself when buying an easel. What size of work do you intend to produce? Are you going to use the easel on location or in the studio? If it is going to be used in your home or studio, is the room large enough?

The medium in which you like to work is also an important consideration. Oils are invariably painted with the support vertical, as are acrylics if used at the consistency of oil paint. However, if you are using fluid washes, then you will be working with the support horizontal, or nearly so, in order to prevent the paint from running. The same is invariably the case with gouache.

With any upright easel, stability is a primary consideration. Always test the stability of your chosen easel by placing on it the largest support that you intend to use.

Portable easels need to be lightweight, so that they can be easily transported, easy to erect and stable. They are usually made of wood, although a limited range is available in metal. Portable easels usually have three telescopically adjustable legs, so that you can set up the easel on uneven ground. The support is held between adjustable clamps and can be angled at any position from the horizontal to the vertical. Large portable easels can double as studio easels but they are generally not as stable.

A variation on this type of easel is the portable box easel, which incorporates a box that will hold all the equipment needed for a day's painting. Everything folds and packs away

The simplest table easels can be adjusted to hold a support horizontally or at varying angles up to about 45 degrees. They are perfect for working on gouache and acrylic paintings using thin, fluid paint.

Portable box easel Everything you need for a day's painting on location can be stored in the box beneath the easel.

neatly, while a carrying handle makes transportation easy. Some box easels even come with carrying straps, so that you can transport the easel on your back, like a rucksack – perfect for location work.

There is a comprehensive range of studio easels, with a model available to suit all styles and sizes of work. They are expensive, but a good studio easel will last a lifetime. Made of wood, studio easels are based around two distinct shapes – the A shape and the H shape. Both hold the support vertically.

H-shaped easels can handle larger canvases, with larger

models being raised and lowered by means of a ratchet system. Some lighterweight easels fold and convert into an casel that can hold a drawing board horizontally.

A-shaped easels are invariably smaller than H-shaped easels. They also fold flat easily, which makes them more suitable for use when space is at a premium. The height is adjusted by means of a series of catches that lock the support into position.

A less expensive alternative is the radial easel. These easels can hold a reasonably sized support. They have three short legs that give reasonable stability and can be adjusted in height.

⋖ Studio easel

This is just one of many kinds of studio easel available. Buy one that is sturdy enough to hold a large canvas.

Drawing boards

Unless you are working on a rigid board or stretched canvas, you will need a drawing board on to which you can secure or stretch your paper or watercolour board. Art stores stock boards made from thick, smooth plywood in a range of sizes. It is sometimes possible to find boards made from jointed timber with screwed cross-pieces in second-hand stores, and these are worth buying as they will last a lifetime.

There are also boards intended for location work, which have a long strap running diagonally across the board and can be placed over the shoulder and neck, allowing you to hold the board in position while you are standing, without using your hands.

Mahl stick

Another useful piece of equipment when oil painting at an easel is a mahl stick, which consists of a light rod of wood (bamboo) with a soft leather ball secured on one end. This simple piece of equipment can be held in one hand and rested on the edge of the work. You can then rest your painting hand on the rod, which is positioned over the area being worked on. This steadies the hand, making it easier to do fine detailed work, and also keeps your painting hand clear of any wet paint so that you do not run the risk of smudging the paint.

If you do not want to go to the expense of buying a readymade mahl stick, it is very easy to improvise and construct one yourself. Simply buy a length of dowelling or similar lightweight wood, wrap old rags around one end, and tape them in position with masking tape.

Mahl stick ▼

The mahl stick shown here comes in two parts, which can be screwed together to make one long stick so that it can be used when working on large canvases.

Applying paint

Brushes are the obvious means of applying paint to the support, and a wide range is available. The marks they make depend on both the shape of the brush (round or flat) and the material from which it is made. Hogshair bristle, which is often used for oil and acrylics brushes, is stiff and relatively unbending, and creates definite-shaped marks, while the sable or synthetic/sable mixes used for gouache and watercolour brushes are more pliable and create a softer mark. Of course, you can also use watercolour and gouache brushes for acrylic paints if you are using the paint thinly.

There are also many other things that you can use to make marks. Some are designed specifically for painting, while others are everyday household items. Experiment to see what effects you can achieve. Dip fabrics, from coarse but evenly textured linen to pretty, delicate lace, into paint to transfer their patterns to the support; press twigs, pieces of cardboard, or even out-of-date credit cards into paint and scrape them over your painting surface to make straight lines; dip scrunched-up aluminium foil or clear film (plastic wrap) in paint and press it on to the support to make random textures; even apply paint with your fingers, just as you did when you were a child.

Foam brush A

This consists of a wedge of synthetic foam attached to a handle. It can be dragged across the support to make broad marks in which the texture of the foam is evident. You can also dip the tip in the paint to make straight lines.

Unusual paint applicators

There is a huge range of paint applicators on the market – some of which are useful, while others are little more than manufacturers' gimmicks. Each type makes a different kind of mark

Paint shaper A

Available in a range of sizes and forms paint shapers consist of a shaped rubber tip fitted into a metal ferrule, which in turn is fitted into a wooden handle, just like a brush. The type of mark you can make depends on the size and shape of the tip. Paint shapers are best used with reasonably thick acrylic or oil paint; you can also use them with thin acrylic paint, gouache or watercolour.

Foam roller A

Foam paint rollers, like those used in household decoration, are a great way of covering a large area quickly – when you want to prepare a toned ground, for example. They can also be used to achieve textural effects. They are available in various sizes and are inexpensive enough to be discarded when they are too dirty to use.

Sponge A

Sponges are a great way of creating texture for things like lichen on stone or random clouds and are particularly useful for landscape work. Synthetic sponges give a more even texture than the natural sponge shown here.

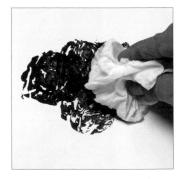

Rag or paper A

Rags and scrunched-up absorbent paper are used in the same way as sponges to create textured marks for particular subjects, although the textures that they create tend to be more irregular.

Brushes for oils and acrylics

Brushes for oils and acrylics tend to be made from bristle, which is relatively hard and unvielding. This means that the

Round brushes

Short strokes A With the brush handle more or less parallel to the

support, you can quickly build up an area of paint by making short strokes.

Dots A Holding the brush almost

perpendicular to the support and dabbing it on to the support creates small dots and stipples.

Rounded marks A

Holding the brush at 45 degrees to the support means that you are using the tip of the brush. This creates more rounded marks.

Long strokes A

Stroking the brush over the support as if you were drawing with a pencil allows you to make long, flowing marks.

Rough, uneven texture A

Scrubbing on paint using the side of the brush creates a rough, uneven texture that is ideal when you want to cover a large area but do not want a flat wash of colour.

marks tend to have a distinctive shape. Synthetic nylon brushes are much softer.

Flat brushes

Long strokes A

Making long strokes with a flat brush held parallel to the support, the wedge-like shape of the brush head is evident.

Short strokes A

Short, wedge-shaped strokes can be used to deliver thick paint to the support – a technique used to create heavy impasto.

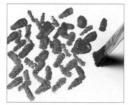

Holding the brush almost perpendicular to the support and dabbing it on to the support creates short lines and wedge-shaped marks.

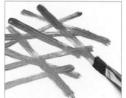

Thin strokes A

Use the edge of the brush to make thin marks, applying light pressure so as not to splay the bristles. The marks can be straight or curved.

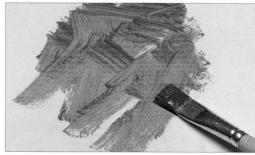

Rough, uneven texture A

Scrubbing on paint using the side of the brush creates a rough, uneven texture in the same way as with a round brush and is useful for scumbling one colour over another.

Brushes for gouache

The brushes used for gouache tend to be the same as those used for pure watercolour – soft sable and sable/synthetic mixes. For control and fine mark making, make sure that you

Round brushes

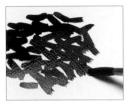

Short strokes ▲

Made using the point of the brush and, depending on the amount of pressure applied, short strokes are reasonably even in width.

Rounded marks A

Dabbing the end of the brush on to the support produces blob-like dots, the size of which depend on the consistency of the paint.

Applying pressure A Holding the brush almost perpendicular to the support and applying pressure splays out the bristles, creating broad marks.

Long strokes A

As with oil and acrylic brushes, stroking the brush over the support and applying

Rough, uneven texture A

Scrubbing on paint using the side of the brush creates a rough, uneven texture that allows some of the support or underlying paint layer to be seen.

buy brushes that hold their shape well. Although sable brushes are more expensive than synthetics, they will last longer if you look after them.

Flat brushes

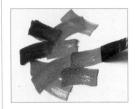

Long strokes A

Dragging the whole width of the brush over the support while applying even pressure results in a mark of an even width.

Short strokes ▲

Made using only the top half of the brush, short strokes create even and relatively broad rectangularshaped marks.

Fine marks A

Holding the brush upright and dabbing it lightly on to the support results in a thin, often slightly curved mark the width of the brush tip.

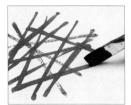

Long strokes using one edge of the brush A

For fine lines, use only one edge of the brush rather than the whole width and apply steady pressure.

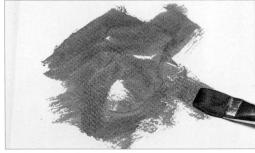

Uneven texture A

As with the other brushes, scrubbing on paint using the side of the brush rather than the tip creates a random, uneven texture in which individual brushmarks cannot be discerned.

Painting knives

Painting knives are available in several shapes and sizes, in both metal and plastic. They are ideal for thick, impasto-like applications. Painting knives are generally used for oils and

Painting knives using oils and acrylics

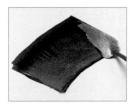

Broad marks A

Spreading paint on to the canvas with the flat of the knife, as one would when icing a cake, creates a flat, even application of paint.

Dotting the tip of the knife

short, sharp marks that are

useful for detail and adding

highlights.

on to the support creates

Press on and lift off

Pressing the knife on to the support and then lifting it off, without dragging it. makes marks that echo the shape of the knife.

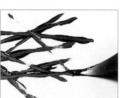

Because the paint is thick and does not spread evenly, dragging the tip of the knife across the support creates

Uneven lines A

lines that vary in width.

Thin strokes using the knife edge A

Turning the knife on its edge and pressing it on to the support, or dragging it across the surface, creates thinner lines that are even in width - a good technique for straight edges.

acrylics, although it is also possible to use gouache straight from the tube; however, the texture will not be as pronounced as when using oils or acrylics.

Painting knives for gouache

Broad marks A

For broad marks, smear the paint over the paper using the flat of the knife. The technique is exactly the same as for oils and acrylics.

Short marks A

Pressing one flat edge of the knife on to the paper and smearing the mark a little creates short marks the width of the knife.

Dotting the tip of the knife on to the paper creates fine points that could be used to depict pollen inside a flower, leaves on trees, or highlights.

Long, uneven marks A

Using the edge of the knife and angling it at about 45 degrees to the paper creates long, uneven marks that are good for loose, linear work.

Press on and lift off

Pressing one sharp edge of the knife at an angle of 90 degrees creates a crisp, clean line of even width on the paper. To make longer lines pull the knife across the support.

Tone

If you want to show that an object is three-dimensional, you need to master the art of depicting tone. Tone is simply the relative lightness or darkness of a colour. Another term that you may come across in art books is "value" – but the meaning is exactly the same.

The apparent lightness or darkness of a subject depends on several things. First, it depends on the quality, intensity and direction of the light source: if one side of an object is brightly lit (for example, a still life illuminated by sunlight streaming in through a window to the side of the setup), it will be lighter in value than the side that is in shadow or shielded from the light. Second, the tone depends on the relative lightness or darkness of the colours present within that subject.

In order to create the illusion of threedimensional form on a flat, two-dimensional surface, more than one tone needs to be in evidence. If you draw a circle and paint it a uniform mid-tone red, all you will see is a flat red disc. If, however, you paint one side of your circle red and then gradually darken that red colour as you paint across the circle to the other side, the circle appears to become a sphere, one side apparently hit by the light and the other side in shadow.

In general, strong light makes colours appear brighter and more intense. It also increases the tonal gap, or the range of tones evident between the lightest tone and the darkest. This is known as contrast. An image with a strong tonal contrast will look more three-dimensional and appear to have greater depth than an image that lacks contrast. Used well, tone can also play an important part in conveying mood and atmosphere.

Colour also has an important part to play when you are assessing tonal values. When you are painting an image, a black object in bright light still needs to look black, just as a white object in shadow still needs to look white. A light-coloured object in bright light or deep shadow will look lighter than a dark colour in light or shade. In reality, however, very different colours can have the same tonal value, with even comparatively light colours looking surprisingly dark in the right lighting

conditions. Perhaps the best way to appreciate this is to look at a black-and-white photograph, where colours that are very different can look tonally the same or very similar.

Pure hues have distinct tonal values. Prussian blue is very dark in value, while lemon yellow is very light. This is best seen when positioning a hue against its matching tonal value on a value scale. However, similar hues can have very different tonal values, while different hues can be very similar in tone.

A pure hue straight from the tube is usually made darker by adding black or a mixture of other colours. A colour is lightened by adding white.

Colours and tonal equivalents ▼

Although there are hundreds of tonal values between black and white, the brain can only distinguish the differences between a few – as shown in the tonal scale, below. The second row shows the tonal equivalent – the relative lightness or darkness – of a number of different hues.

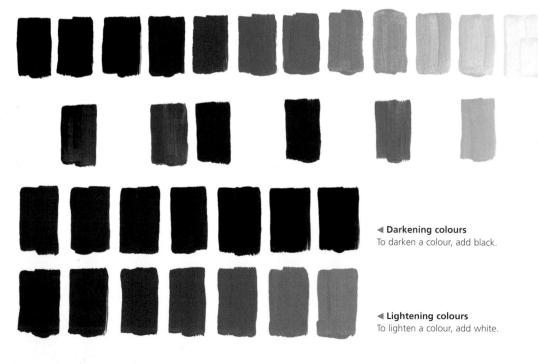

Practice exercise: Seeing in tones

This exercise, painted in shades of grey, provides the opportunity to translate colours into tone. You may be surprised to discover that colours that you think of as being very different – the red of the pepper and chillies and the green of the broccoli, for example, or the red and dark blue of the cloth – are very similar in tone. Note, too, how many variations in tone there are within one colour – for example, in the white areas of the cloths and on the white plate. These differences are essential in conveying a feeling of light and shade.

In this exercise, the very brightest areas are left unpainted. Start by working out where these are, and then where the next lightest tone occurs. Working from light to dark in this way allows you to build up the tones very gradually. Remember that acrylic paint looks slightly darker when it is dry than it does when it is wet. Test all your mixtures first by applying them to a piece of scrap paper or board and waiting for them to dry.

It's often hard to be sure in the early stages that you've got things right, so be prepared to re-assess matters once you've put down several tones then make adjustments if necessary.

Materials

- B pencil
- Canvas board
- Acrylic paints: Mars black, titanium white
- · Brushes: small flat

The set-up

This still life contains all three primary colours – red, yellow and blue – as well as black and white. The tablecloths and the lemons may turn out to be much darker than you might imagine, while even the darkest object (the aubergine [eggplant]) contains areas of bright highlight that help to define its form.

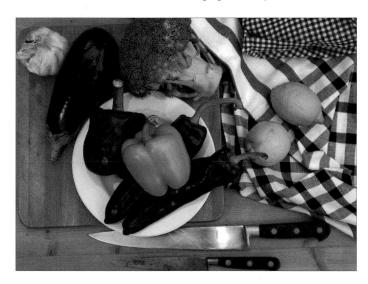

1 Using a B pencil, lightly sketch the subject. Put in as much detail as you need: although it's quite time-consuming to draw the checks of the cloths, for example, they will enable you to place the shifts in tone accurately. Similarly, the highlights on the vegetables will help you to define their form.

2 Mix the lightest tone from Mars black and titanium white. Using a small flat brush, paint the highlights on the aubergine, broccoli stalk, peppers and cloths. Use the same tone for the garlic, lemons and the blade of the topmost knife, except for the very brightest highlights.

3 Look carefully to see where apparently uniform colours change tone. Add a little black to the mixture to darken it slightly and paint the cast shadows on the plate, the shaded edges of the lemons and the broccoli florets. Go over the first tone where necessary to darken it.

Tip: When assessing tones, halfclose your eyes: you will be able to see the differences more clearly.

A Now add more black to the paint mixture for your third tone. Darken the individual segments and the papery top of the garlic. Brush tone 3 over the wooden table and chopping board and around the main subject, taking care to cut around any light areas.

5 The chopping board is darker than the table on which it rests, so add still more black to the paint to make tone 4 and go over the chopping board again. Use the same tone to deepen the shadows on the peppers and chillies. Also use it to paint the rivets on the knife handles and the blade of the lower knife, which is somewhat tarnished and darker in tone.

 $6\$ lf you think the highlights that you put down in the early stages look too pale – as here on the yellow pepper, for example – darken them a little. Add more black to make tone 5. Using short brushstrokes, dab the paint over the broccoli florets, leaving some of the underlying tone showing through in places. Use the same tone on the large red pepper and chillies, leaving the highlights untouched, and on the blue-and-white cloth in the background.

7 Still using tone 5, continue working on the cloths. Note how the direction of the stripes changes with the folds in the cloth. Paint a thin shadow under the edge of the chopping board; this helps to separate it from the table and defines its form. Painting around the rivets, paint the dark wooden handle of the topmost knife.

Tip: You may find it helps to switch to a smaller brush, as you're working on very small, crisply defined areas at this stage in the painting.

Add more black to make tone 6 and paint the darkest parts of the blue-and-white cloth – the squares where two blue bands overlap. Paint the aubergine, brushing around the light areas, and the handle of the lower knife.

9 Using tone 6, darken the left-hand side of the red pepper. Add more black to make the darkest tone. Paint a thin strip along the top of the topmost knife. Use the same tone for the darkest parts of the aubergine and chilli peppers.

The finished painting

In this painting, seven tones plus the white of the support have been used to create a convincingly three-dimensional portrayal of a multi-coloured still life. It is interesting that colours that appear to be very different from one another (the red of the peppers and the green of the broccoli florets, for example) turn out to be very similar in tone. When you've done this exercise, you might like to try setting up another multicoloured still life. Although it might seem difficult at first, you will quickly become adept at interpreting colours as tones; it is a vital part of making your paintings look rounded and three-dimensional.

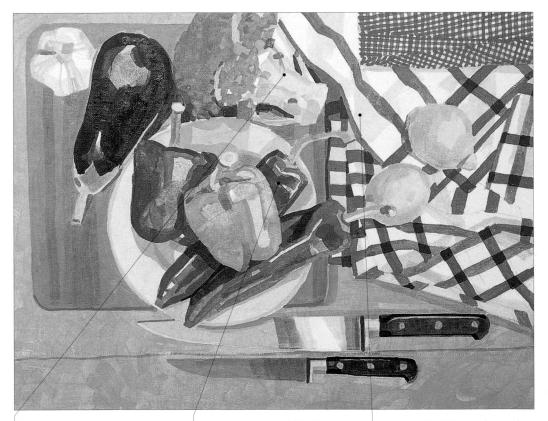

The pale green of the broccoli stalk is almost the same tone as the yellow pepper, although you might expect it to be considerably darker.

The darkest part of the chilli is almost as dark as the aubergine, although you might expect it to be lighter in tone. Don't assume that things you know to be white will actually appear pure white: as you can see, some tone is evident in the white of the cloth.

Scaling up

People often paint from photographs. Some artists argue that this kills spontaneity, as there's a risk that you end up slavishly copying rather than interpreting what's in front of your eyes, but it's a perfectly valid way of painting. It isn't always practical to paint a scene from life, and photographs give you the opportunity to collect reference material when you're on your travels, or simply going about your daily business, and then work them up into a painting at your own convenience.

Some artists also make a small-scale sketch before they start on the painting itself. There are several reasons for doing this. First, it is a good way of deciding on the best composition: a quick sketch establishes the work's centre of interest and shows how the different elements of the scene relate to one another. Second, it enables you to work out the tonal values of the scene. This is just as important in colour work as it is in a monochrome drawing or pen-and-ink work, as an accurate assessment of tones is one of the things that will make your painting look three-dimensional.

But whether you're painting from a photo or from life, once you've got your reference material how do you transfer it on to a larger canvas or support?

It takes a certain amount of confidence to do this purely by eye, without any guidelines to help you - although, like anything else, you'll get better with practice. Luckily, there is a tried-and-tested means of scaling up. It involves superimposing a grid on your preliminary sketch or photo and marking a larger grid on your canvas. You can then copy the scene, one square at a time, and the lines of the grid will give you a good guide to where to position things. You can see, for example, that your subject's eye or the edge of a vase coincides with the edge of the second square down - so all you have to do is make sure that you draw it in the same position in your larger grid.

In a complicated scene such as a building or an elaborate still life, you might want to subdivide some of the squares. Any method that enables you to keep track of where you are in the sketch is fine.

Acetate grid over photograph A

Draw a grid on acetate (available from craft and art supply stores) and place it over your photograph. Then draw a grid on your paper or canvas, keeping the same proportions. If, for example, the grid on your photo is five squares across and four squares down, the grid on your canvas should be the same – although the squares will be larger. You can then transfer the contents of each square in turn to make your underdrawing or sketch.

Different-sized squares within the same grid A

In areas where you need more guidelines, simply divide the squares of the grid into smaller squares.

Practice exercise: Scaling up a small sketch

The method for scaling up a small composition sketch is exactly the same as for scaling up a photograph. If, for example, the grid on your sketch is five squares across and four squares down, the grid on your canvas should contain

the same number of squares – although they will be larger than the squares on the sketch. The grid system can also be used to make a drawing or sketch smaller, simply by reducing the size at which the grid is drawn on the support.

1 First make your initial sketch freehand and divide it up with a grid of evenly sized squares. The number of squares is up to you, but they should all be the same size.

Then lightly mark a grid on the canvas on which you're going to make your painting, keeping the same proportions. Lightly mark the main intersections – the points where the edges of your subject touch on the lines of the grid.

Start joining up the intersections, working square by square and referring continually to your initial sketch to check that each shape is occupying the same area on your canvas as it did on the sketch. Already, your subject is beginning to take shape.

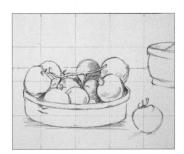

4 Continue transferring information until your underdrawing is complete. At this point, if you wish, you can also put in some shading to act as a tonal guide.

The finished underdrawing

When you have put down as much information as you need, you can begin the process of painting. The amount of detail that you put into your underdrawing depends at least in part on the complexity of your subject and is entirely up to you. Remember that an underdrawing is merely a guide to help you place elements correctly and work out the tones.

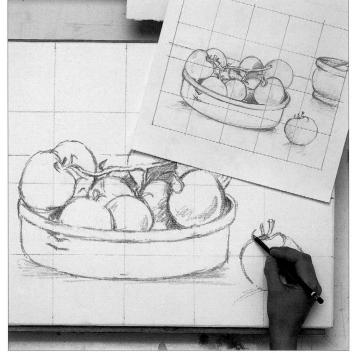

Underdrawing

An underdrawing is exactly what it says – a preliminary sketch on the canvas or paper, over which you paint your picture. Although some artists launch straight into a painting, most people – particularly if they are new to painting – like the reassurance that an underdrawing provides. It allows you to set down the lines of your subject, and erase and change them if necessary, before you commit yourself irrevocably to paint.

Your approach to the underdrawing will depend partly on the medium in which you're working. If you're painting in a transparent or relatively transparent medium such as watercolour or thin acrylic paint, you need to make sure that your underdrawing is light enough to be covered by the subsequent layers of paint. With thicker and opaque mediums, such as oils or impasto acrylics, the underdrawing can be heavier.

The style of your underdrawing also depends on the subject. If you're painting buildings, for example, it's important to get the angles of the roofs and windows right — so you might want to make a fairly detailed underdrawing that gives you plenty of guidelines to follow when you start to apply the paint. The same might apply to a complicated still life, in which lots of different elements overlap each other. For a loose, impressionistic land-scape, on the other hand, a few sweeping lines might suffice.

But providing linear guidelines to follow is only one function of an underdrawing. It should also give you information about the tonal range of the scene, so that you know where the light and dark areas are. This can be in the form of loose scribbles and cross-hatching that roughly define the different areas.

For most purposes, an ordinary pencil is all you need, but it is not your only option. The underdrawings on these two pages are all made in different mediums, chosen for a specific reason.

Underdrawing in charcoal ▼

The lovely sweeping lines of the ground and foliage, counterbalanced by the strong upright lines of the tree trunks, are what attracted the artist to this subject. The intention is to produce an atmospheric landscape, in which an overall impression of the scene is more important than precisely rendered detail. Charcoal is perfect for this, as you can make broad sweeping strokes across the support using the side of the charcoal. It is also superb for blocking in areas of dark tone. To prevent the charcoal from mixing with the paint and muddying the colours, always brush off any excess, and spray fixative (available from all art supply stores) over the underdrawing.

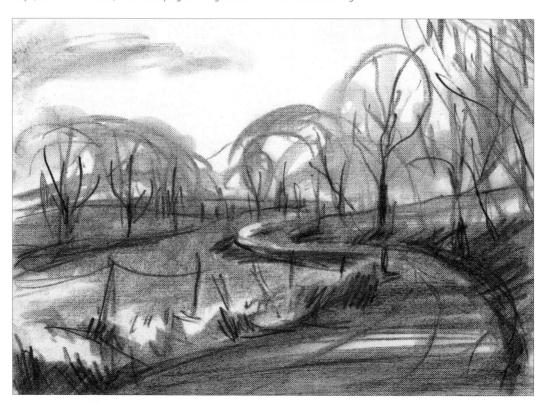

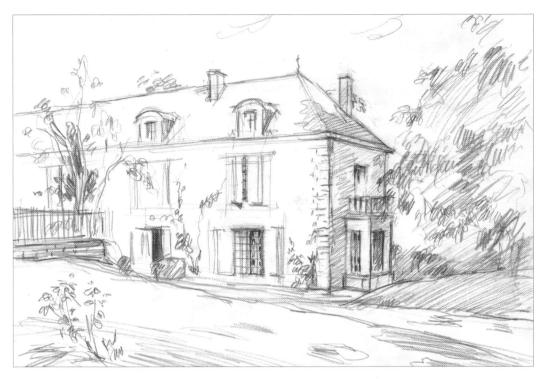

Underdrawing in pencil A

Architectural subjects generally require quite a detailed underdrawing: whenever you are painting buildings in two-point perspective, as here, it's vital that you get all the angles right and position all the different elements (windows, chimneys and so on) correctly in relation to one another. A complicated still life is another subject where the relations between one object and its neighbours are critical. A sharp pencil allows you to do this and cross-hatch small, more densely shaded areas such as the window recesses and foliage. It also produces a relatively light underdrawing that will easily be covered by subsequent layers of paint.

Underdrawing in acrylic paint ▶

The boundary between an underdrawing and an underpainting is sometimes blurred, but if we define an underdrawing as a linear approach, then this certainly qualifies. The brush has been used in the same way as a pencil or pen to indicate the tilt of the head and body and the position of the facial features. There is also some indication of tone within the subject. The choice of burnt sienna is an appropriate one, as it hints at the warm flesh tones of the subject.

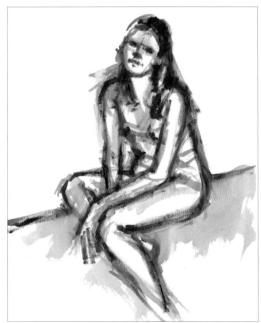

Underpainting

The main difference between an underdrawing and an underpainting is that the former is primarily linear in approach while the latter provides more tonal information by roughly blocking in the main shapes and tones before applying colour. Whether you choose to make an underdrawing or an underpainting is entirely a matter of personal choice. Both, however, enable you to work out your composition and the tonal structure of the scene before you begin to apply colour and refine the detail of your subject.

Underpaintings are used in both oil and acrylic paintings. In both mediums, the colour is diluted to a thin consistency – oils with turpentine or other thinner, acrylics with water to which matt medium has been added – to prevent any shine on the underpainting. Because the paint

is so thin, alterations can be made by wiping a turpentine- or water-soaked rag, depending on the medium, over the paint – something that is much more difficult to do in the later stages of a painting, when the paint has been applied more thickly.

Underpaintings for works in acrylic must always be made in acrylic paint. Under-paintings for works in oils can be made either in acrylics (provided the support has previously been primed with an acrylic primer) or oils. The benefit of using acrylics for the underpainting, of course, is that they are fast drying. Even fast-drying oil colours, such as flake white and diluted earth colours, need to be left to dry for a couple of days, while a thin acrylic underpainting will dry in a matter of minutes.

Colours for underpaintings

Many artists favour the traditional method of making a monochrome underpainting in neutral colours, generally greys or browns.

Others block in the light and dark tones in a rough approximation of the final colours. This allows you to check the overall colour balance of the work at a very early stage.

A third approach is to use a contrasting or complementary colour for the underpainting. The great Flemish artist Peter Paul Rubens (1577–1640), for example, often used terre verte (a muted green) as the underpainting colour in his nudes, as it complements the pink flesh tones and cools the shadows

Practice exercise: Monochrome underpainting

The advantage of a monochrome underpainting is that it enables you to concentrate on tone rather than colour. It also provides a tonal base for any subsequent glazing technique. Work boldly without putting in textural detail.

Materials

- Acrylic paper
- Acrylic paints: ivory black, titanium white
- · Brushes: small flat

The set-up

The tones in this still life need to be carefully assessed if the objects are to be made to look convincingly three-dimensional. Set up a table lamp to one side of the still life, so that the objects cast strong and clearly defined shadows, as this will make it easier for you to assess both the direction and the intensity of the light – and hence to work out the relative tones of the various objects.

1 Mix a light grey and loosely draw in the outline of the lemons and the pot. Darken the tone slightly and block in the pot.

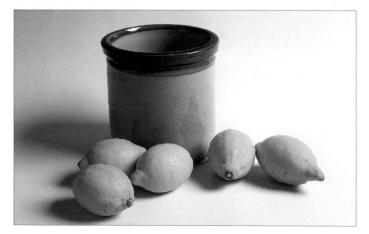

2 Apply the same tone to the inside of the pot, which is in shadow, and to the shaded sides of the lemons, again roughly blocking in the colour.

Add a little more black to the mixture to darken it further, and indicate the shadows cast by the lemons. Use the same mixture to paint in the outer rim of the shaded side of the pot.

Darken the inside lip of the pot and paint in the darker reflections and the shadows cast on its outer surface. Use the same mixture to apply a tone over the area of shadow on the left of the image.

5 Add white to the mixture to make a very light grey and paint the lightest area of the image – the brightly lit backdrop on the right of the still life. Complete the blocking in by using white on the highlights.

The completed underpainting

The underpainting has deliberately been kept loose and sketchy in style, but it has allowed the artist to work out his composition and it provides all the tonal information needed

to make a more detailed and resolved painting. Once you have worked out the tonal structure of the still life, you can think about putting in the colour and textural detail.

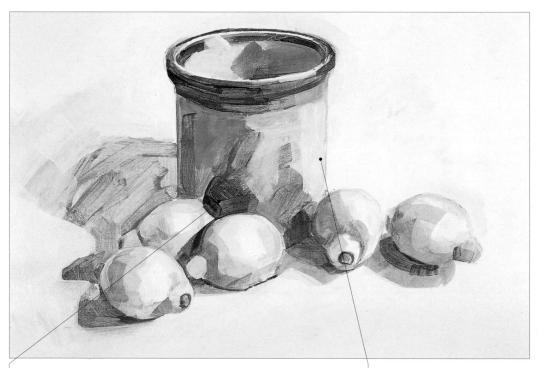

The darkest areas are only roughly blocked in: this is simply a preliminary to making the painting, so do not attempt to smooth out brushstrokes or put in any kind of detailing.

The very brightest areas can be painted as pure white.

Toned grounds

Some artists like to paint on a coloured, or toned, ground rather than on white canvas or paper. There are two main reasons for doing this. First, it can be difficult to judge colours against a white ground, particularly in the early stages of a painting when there are few, if any, other colours on the support to which you can relate them. In this situation, most colours tend to look darker than they really are—and so you may overcompensate by making your mixes lighter than they should be. If you start on a mid-toned, neutral-coloured ground, however, it is much easier to assess tones correctly.

Second, working on a toned ground establishes an overall colour "key" or mood for your painting. If you allow the colour of the ground to show through in places, it helps to unify the painting.

A toned ground may be either transparent or opaque. On a transparent ground, some of the colour of the support is reflected back up through the paint, giving a more luminous, vibrant feel to the painting. For this method, the paint should be heavily diluted (with water for acrylic or gouache paints, or with a thinner such as turpentine or household white spirit for oil paints), and spread over the support in a thin layer, using a brush or a lint-free rag. An opaque ground is used with opaque painting methods such as impasto, where the influence of the white ground is not so important. For an opaque ground, mix your chosen colour with either white paint or primer.

Acrylic paints dry quickly, whereas an oil ground may take a whole day or even longer to dry. To speed things up, many oil painters tone the ground with acrylic paint. (It is possible to paint oils on top of acrylics, but not the opposite way around, as this is likely to make the paint crack.)

What colour should you use to tone the ground? Some artists use a colour that is in keeping with the subject – a warm pink or orange for a nude study, or earth colours for a landscape. Others prefer a contrast, such as a hint of yellow beneath a brilliant blue sky or a reddish brown to warm up a landscape. Opt for a neutral tone that is mid-way between the lightest and darkest values in your painting.

How to tone a ground

Whether you apply paint with a rag or with a brush is largely a matter of personal preference. The important thing is to use a thin layer of paint. It doesn't matter if some brushes strokes are visible or if the paint is slightly streaked; in fact, this gives a more lively, spontaneous effect.

Applying paint with a rag

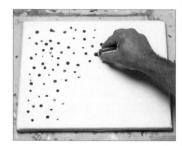

1 Dab your chosen colour (which can be oil or acrylic) over the canvas.

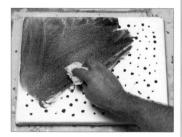

2 Dip a rag in the appropriate thinner (white spirit, turpentine or low-odour thinner for oil paint; water for acrylics), and rub the rag over the canvas to spread the paint over the surface. It is a good idea to wear rubber gloves. Leave to dry.

The prepared ground A

Applying paint with a brush

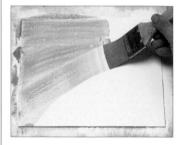

This method can be used with oils, acrylics or gouache. Mix a thin wash of your chosen colour and, using a large, flat brush, apply the paint to the surface, varying the direction of the brushstrokes.

The prepared ground ▲
Always allow the prepared, toned ground to dry completely before you begin your painting.

Tip: When choosing a colour for your toned ground, whether you decide to go for a neutral grey or a toning or a contrasting colour, opt for a neutral tone that is midway between the lightest and darkest values in your painting. Soft colours – earth colours such as raw sienna or burnt umber, or soft blues, bluegreys and greens – tend to work well.

Practice exercise: Teapot on a warm ground

For your first attempts at using a toned ground, try painting a simple subject on different colours of ground to see what difference it makes. You will probably find that the differences are quite subtle; nonetheless, the colour of the ground will have an impact on the overall mood and colour temperature of the painting.

In this exercise, the artist decided to work on a warm ground that would complement the colour of the copper lustre teapot. The warm underpainting also serves to accentuate the coolness of the blues used to paint the background and table cloth. She then went on to paint the same subject on a white and a blue ground; the results can be seen overleaf.

Materials

- Acrylic paper
- HB pencil
- Acrylic paints: burnt sienna, cerulean blue, titanium white, phthalocyanine green, ultramarine blue, cadmium red, cadmium yellow, alizarin crimson
- Brushes: medium flat, small round, fine round or rigger

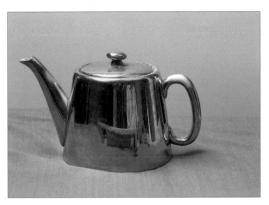

The set-up

Choose a simple subject on a plain background – but look for an interesting interplay of colours and tones.

First, tone the support with burnt sienna acrylic paint. It doesn't matter if the coverage is slightly uneven. Leave to dry, then sketch your subject using an HB pencil.

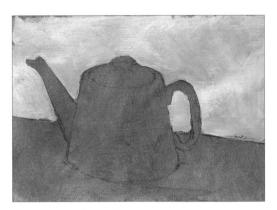

2 Mix a very pale blue from cerulean blue and titanium white. Using a medium flat brush, block in the background above the table. The pale blue serves as a complementary colour to the burnt sienna ground and the contrast between the two gives the painting more impact.

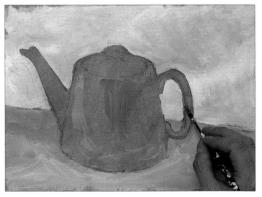

3 Mix a bluish green from phthalocyanine green, ultramarine blue and titanium white and paint the cloth on which the pot is resting, darkening the mixture by adding more green for the shadow cast by the teapot's spout. Use the same colour for the inner edge of the handle and a very dilute version of the mixture for the cooler areas within the teapot, where the colour of the cloth is reflected up into the metallic glaze.

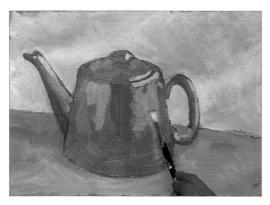

4 Mix a pale, yellowish gold from cadmium red, cadmium yellow and titanium white. Using a small round brush, put in the very brightest, irregularly shaped highlights, where light is hitting the glazed surface of the teapot. Note that the colour of the highlights is applied as a very thin layer of paint; consequently, it is slightly modified by the underlying burnt sienna of the ground.

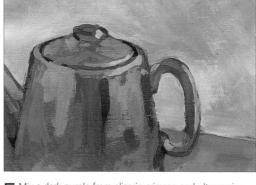

 $5\,$ Mix a dark purple from alizarin crimson and ultramarine blue. Using a fine round or rigger brush, "draw" a very fine line around the lid to imply the shaded recess in which the lid sits. Use the same colour to paint the thin line of shadow under the pot. Add more phthalocyanine green to the bluish green mixture from Step 3 and paint the reflections of the cloth at the base of the pot.

The finished painting

The burnt sienna ground gives an overall warmth and richness to the painting, as can be seen in the background, where hints of it remain visible through the thin blue-white paint.

It also serves as the deepest copper colour within the pot; the ground colour has not been painted over in these sections and this helps to unify the painting.

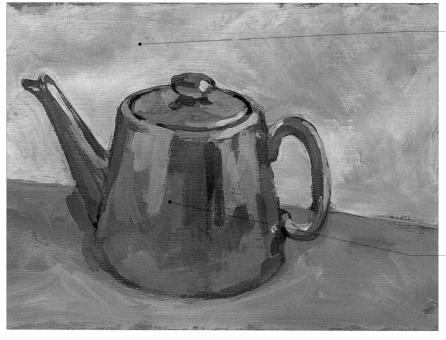

 Hints of the toned ground remain visible through the thin blue-white mixture used to paint the background.

- The burnt sienna ground is not completely covered over; here, it serves as the deepest copper colour within the pot.

White ground ▶

The artist also painted the same scene on a white ground. A white ground tends to reflect a certain amount of light, even through a relatively opaque colour, which has the effect of making the overall key lighter. There is less interplay of colours within the metallic glaze of the pot and the highlights have been left as white, rather than painted on later.

Blue ground ▼

The version painted on a blue ground is cooler in mood. However, the blue ground is a good complementary colour for the coppery pot. Even small areas of blue underpainting, if allowed to show through, will have an effect on any adjacent colours.

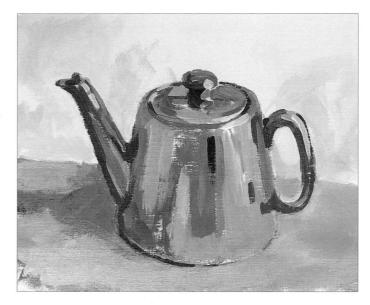

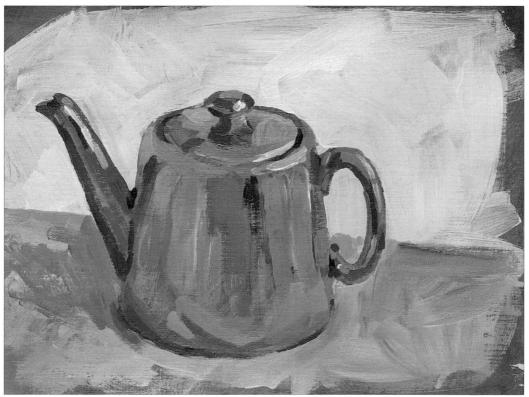

Washes

Laying a wash - a thin layer of transparent colour - is common practice in both gouache and acrylic painting, just as it is in watercolour painting. (The nearest equivalent in oil painting is glazing.) The idea is to apply fluid, thinned paint over areas that are too large to be covered by a single brushstroke. Washes are often used to form a base colour over which the image is then developed. As this tends to involve working over a large area, or even covering the whole of the support, always mix far more paint than you think you'll need: it's surprising how quickly you use it up, and if you run out, it can be very difficult to re-mix exactly the same shade. Before you apply the paint, prop your drawing board up on the easel at a slight angle, so that the paint can flow easily down the paper.

When using gouache paint or acrylic thinned with water and applied in the same way as watercolour, there are various types of wash. A flat wash is a smooth, even layer of colour with no discernible differences in tone or visible brushmarks. In a gradated wash, the colour shades from dark to light (or vice versa). A variegated wash, as the name suggests, consists of more than one colour. All washes are applied in a similar way, with the paint either merging wet into wet into another colour or spreading naturally over a damp support.

The main difference between gouache (or watercolour) and acrylic washes stems from the way in which the paints are manufactured. In gouache and watercolour paints the pigments are bound with gum, which holds them together even when they are diluted with water to the point where the paint appears to be virtually colourless. In acrylic paints the pigments are bound with an acrylic resin, which gives the paint body and substance; but if the paint is diluted too much, it begins to break down and any wash will look thin and lifeless. Because the paint has body, acrylic washes are easier to control than watercolour and gouache. When using acrylic paint as a thin wash on canvas or board, add either a flow-improving medium or a retarding medium so that the thin paint brushes out evenly.

Laying a wash

This sequence demonstrates the technique of laying a flat wash and is the same for acrylics, gouache and watercolour. When you are working in acrylics, however, it is a good idea to add a little flow-improving medium, as this increases the flow of the paint; very thin paint tends to puddle rather than brush out evenly across a surface. For a gradated wash, add more water to the paint as you work down the paper. For a variegated wash, change to a different colour part way through.

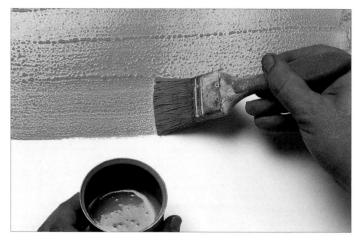

1 Using a large wash brush and working from left to right, lay a smooth stroke of colour across the paper. Quickly re-load your brush with more paint. Pick up the pool of paint at the base of the first stroke with your brush and continue across the paper, again working from left to right.

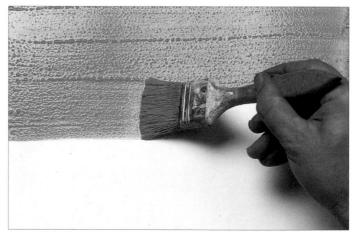

 $\ 2^{\,\,}{\rm Continue\ until\ you\ have\ covered\ the\ paper.\ The\ paint\ should\ dry\ to\ a\ flat,\ even\ tone\ with\ no\ variation\ or\ visible\ brushmarks.}$

Practice exercise: Italian landscape

In any landscape, open spaces are essential: the viewer's eye needs somewhere to rest after taking in the detail of trees, hills and other features. In this exercise, such spaces are provided by the series of flat washes laid over the paper, which also help to lead our eye through the scene.

Note how the tone deepens and becomes warmer with each successive wash: this is a classic device in land-scape painting and a very simple way of creating a feeling of recession, as colours generally look paler and slightly cooler the further away things are.

Materials

- Watercolour board
- B pencil
- Acrylic paints: cadmium red, cerulean blue, ultramarine blue, olive green, cadmium yellow
- Flow-improving medium
- Brushes: large round, medium round, small round

The scene

Here we are looking into the sun and so the scene appears somewhat hazy. This makes it easier to paint: relatively little detail is discernible, so you can get away with painting generalized shapes and concentrate on assessing the tones correctly.

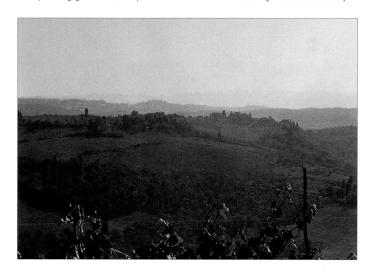

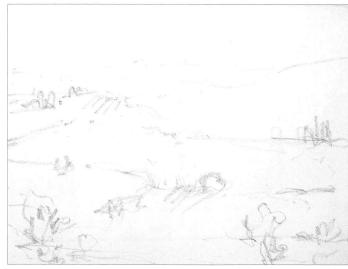

1 Using a B pencil, sketch the scene so that you have some guides for placing the main features. You don't need to include a lot of detail, but put in the outlines of the hills and the main trees and clumps of vegetation.

Tip: Successively darker washes will create a sense of recession in the landscape, so you don't need to include a lot of tonal information in the drawing.

Using a large round brush, wash very pale, dilute cadmium red over the sky. The colour is so pale that is it barely perceptible, but it adds warmth to the image. Wash very pale cerulean blue mixed with a few drops of flowimproving medium loosely over the sky. Add more paint to the mixture to darken it and paint the most distant range of hills. Darken it still further by adding ultramarine blue and a tiny amount of cadmium red and brush in the next line of hills. Mix a dark green from cerulean blue and olive green and paint the next range. With just four simple washes, the landscape is already beginning to take on a sense of depth.

3 Wash olive green over the foreground, darkening the colour by adding cadmium red as you move down the paper. The warmer colour brings this area of the painting forwards and suggests the earth showing through the vegetation.

4 While the foreground is still slightly damp, mix dark and mid-toned greens from varying proportions of olive green and cerulean blue, and using a small round brush, put in the main areas of vegetation. Use vertical brushstrokes for the cypress trees along the horizon and dab the paint on using a circular motion of the brush for the main wooded area on the left.

5 Mix a mid-green from olive green and ultramarine blue and, using a small brush, block in the shapes of the cypress trees in the middle distance, just below the nearest range of hills. Because the underlying paper has dried out quite considerably by this stage, the paint you add now does not spread over the surface and the trees retain their neat, crisp shapes.

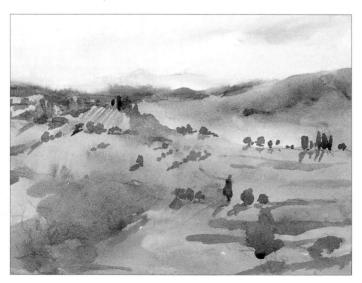

Continue putting in the mid-green detail in the middle distance, using the same colours as before and alternating between the different greens on your palette as appropriate. Paint the shadows cast by the trees in a neutral grey created by mixing cadmium red and ultramarine blue. With just a few washes and simple strokes, the scene is already turning into a delightful little landscape.

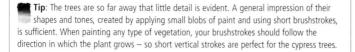

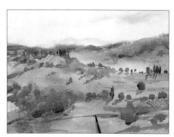

Mix a warm brown from olive green and cadmium red and, using a medium round brush, dot this mixture into the foliage areas. Use the same mixture to paint furrows and shadows on the land.

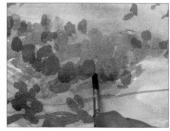

Mix a very dark green from ultramarine blue and olive green and dab it into the wooded area on the left. Again, generalized shapes are sufficient.

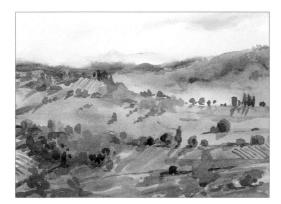

9 Wash the brown mixture from Step 7 over the foreground, adding some cadmium yellow to the mixture when you come to paint the immediate foreground. The warmth of the yellow has the effect of bringing this area forwards in the painting and makes it seem closer to the viewer.

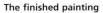

Washes form the basis of this charming and atmospheric Italian landscape, and the detail of the trees and other vegetation is developed over the top once the washes are dry.

10 Mix a dark brownish green from olive green and cadmium red. Using a small round brush and loose strokes, put in the trees in the foreground. You can use thicker, more textured, paint here: along with the darker colour, this is another means of making the area appear closer to the viewer.

The tones of the washes have been carefully chosen to create a feeling of recession, while the earth colours in the foreground give a sense of warmth.

Areas of flat colour provide a resting space for the eye of the viewer.

Note how the washes become darker and warmer in tone as we move towards the foreground.

Wet into wet and blending

Allowing one wet paint colour to merge into another on the support is a very exciting way of painting and it can create some extremely atmospheric effects. The thinner the paint, be it oil, acrylic or gouache, the more the different colours will bleed into one another.

With gouache and acrylic paints mixed with lots of water, the technique is akin to that used in watercolour painting and the result depends on how wet the first colour is. If the first colour is still very wet, any subsequent colour will spread and blur, and the result will be soft and somewhat hazy – perfect for subjects such as skies or reflections in water. If the first colour or the support has dried a little, however, the paint will not spread so far – and the brush marks will have a harder edge.

Working wet into wet in this way will always be slightly unpredictable – but that is one of the charms of the technique and, with practice, you will get better at judging how far the paint is likely to spread.

Oil paints, even when mixed with relatively large amounts of thinner, tend to have a certain amount of body and they do not spread on the support in the same way. However, because oil paints take such a long time to dry, you can blend wet colours together on the canvas with the brush to create both optical and physical colour mixes.

In landscapes, this is a useful technique for certain atmospheric effects, such as clouds and fog. It is also invaluable when you are painting subjects with subtle transitions from one tone to another – skin tones, for example, or soft fabrics in a still life. The amount of blending that you do is up to you. It is possible to blend colours so smoothly that the brushstrokes and the transition from one tone to another are virtually imperceptible; alternatively, you can loosely brush one wet colour over

another, so that the two retain their own identity but appear to be mixed when the painting is viewed from a distance. Such optical mixes often create a more lively effect than physical mixes.

Very thin oil paints mixed with thinner but no added oil are often used to block in a painting. As the thinner evaporates, the paint dries sufficiently to allow further work, using progressively thicker paint, after a relatively short period of time.

On a wet base colour ▼

If the first colour is still very wet, any subsequent colour will spread, blurring at the edges. The extent of the spread depends on how wet the underlying colour is; this is something that you will learn to judge with practice.

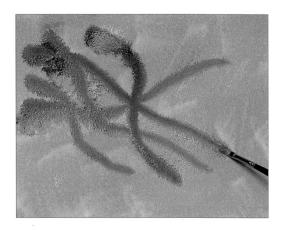

Blending paint with a fan brush

Thick oil and acrylic paints can be blended on the support, rather than in the palette, to create another colour. This

technique is very effective where subtle gradations of colour are required.

1 Put the two colours down separately on the support. Here, we used cadmium red and cadmium yellow.

2 Using a fan brush, gently stroke one colour into the other so that the two blend together.

3 The two colours merge physically on the support to create a third colour – here, orange.

Blending wet acrylic paint with water

When acrylic paint touches an area that is already wet, it will spread and blur within the wet area. If you do not want this

to happen, make sure you allow colours to dry throughly before applying an adjacent one!

1 Put the first colour down on the support and leave it to dry. Brush clean water over part of the first colour.

 $\label{eq:polyanting} 2 \text{ apply the second colour, painting} \\ \text{up to the edge of the area that you} \\ \text{wetted with clean water.}$

3 The second colour spreads into the wet area and mixes optically to create orange.

Practice exercise: Autumn leaves

In this exercise, red and green paints are allowed to merge into each other, blending together on the support to create subtle, soft-edged shifts from one colour to the next. Painting autumn leaves is a great way of practising the wet-into-wet technique, as you don't need to be terribly precise about where one colour ends and the next one begins.

Materials

- Watercolour board
- 2B pencil
- Acrylic paints: alizarin crimson, cadmium yellow, phthalocyanine green, titanium white
- Brushes: large round, fine round

The scene

These vine leaves are just beginning to turn from a glossy green to a rich red.

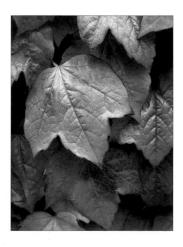

1 Using a 2B pencil, lightly sketch the outline of the leaves and the main veins.

2 Mix a warm, dilute red from alizarin crimson and a little cadmium yellow. Using a large, round brush, loosely brush the mixture over the red parts of the leaves. You don't need to be very precise about where you place the red, but try not to allow paint to spill outside the leaves.

3 Mix a bright green from cadmium yellow and phthalocyanine green. While the red paint is wet, brush the mixture over the brightest green leaves, allowing it to merge into the red. Add more phthalocyanine green to darken the mixture, and paint the leaves on the bottom right of the image.

A Mix a very dark green from phthalocyanine green and alizarin crimson. Using a fine round brush, put in the most prominent veins. Hold the brush by the end of the handle, almost vertically to the support, and lightly touch it on to the support to get some variation in the line.

5 Mix a dark red from alizarin crimson and a little phthalocyanine green and outline the edges of some of the redder leaves.

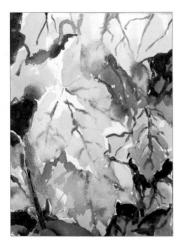

6 Using the dark green from Step 4, block in the spaces between the leaves. While the paint is still wet, mix some alizarin crimson into the dark green and drop it into the spaces, wet into wet. This looks much more interesting than a flat wash of a single colour as dark shadow areas are rarely, if ever, uniform in colour.

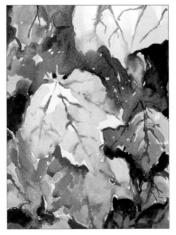

Continue working on the dark, shadowy spaces between the leaves. Defining these spaces will make the shapes of the leaves stand out more clearly from the background.

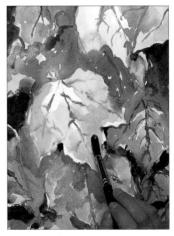

Now build up colour on the leaves. Darken the red leaves by brushing on a very dilute mix of alizarin crimson, dropping in some green in places so that the two colours merge wet into wet. Add more cadmium yellow to the bright green mixture from Step 3 and brush it on to the central leaf, which is catching the light.

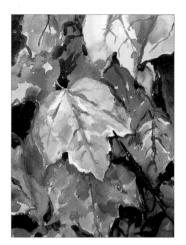

Ombine your basic red and green mixtures to make a very dark, almost black colour. Using a fine round brush held almost vertically, put in the very dark veins on the shaded red parts of the leaves. Mix a soft pink from titanium white and alizarin crimson and paint the pink leaf tips.

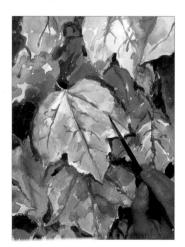

10 Continue to huild un the tenner on the central leaf, which is in the most prominent position, adding more of the yellowish-green mixture from Step 8. Finally, use the dark green mixture from Step 4 to put in the veining on the central leaf, holding the brush loosely by the end of the handle to make flowing calligraphic marks.

The finished painting

By working wet into wet, the artist has achieved some lovely, subtle colour shifts in the leaves, with pink merging into red and red into varying shades of green. The joy of painting in this way is that you can allow the paint to flow of its own accord and do a lot of the work for you. The detail of the leaf veins was added when the first washes had almost dried, so these lines are crisper without overpowering the initial washes. By holding the brush near the end of the handle, however, the artist has been able to make lovely flowing lines like those used in Chinese brush painting or calligraphy. The result is an atmospheric, spontaneous-looking study.

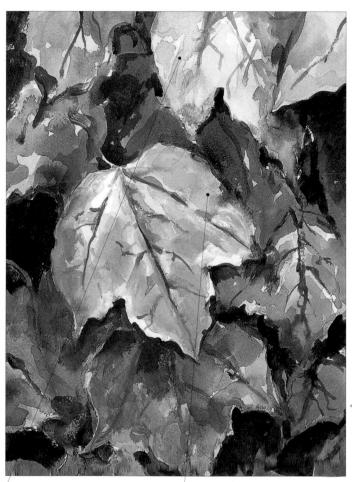

When one colour is applied on top of a colour that is almost dry, the second colour has a clearly discernible edge.

When two colours are allowed to merge wet into wet, the transition between the two is virtually imperceptible.

Painting alla prima in oils

The term *alla prima* comes from the Italian for "at the first" and is used to describe a work (traditionally an oil painting) that is completed in a single session. No underpainting is made, and often there is no preliminary drawing. Reasonably thick, creamy paint is applied using direct and expressive brushstrokes.

Even though they are made using a relatively thick layer of paint, alla prima paintings are invariably technically accurate, as the paint dries at a similar rate over the whole image. There is no problem of an underpainting of a different consistency dry-

ing at a different rate and possibly causing the paint to crack at some point in the future.

The alla prima technique is well suited to portrait work and to landscape work done on location, as well as to preliminary studies. Size is an issue, as the work must be no larger than can be comfortably completed in a single session. To help facilitate the uniform drying of the paint, the same painting medium (preferably one that does not accelerate drying time) should be used throughout.

Practice exercise: anemones painted alla prima

Fresh spring flowers require a fresh, spontaneous approach, and painting them alla prima is a great way of capturing the delicate texture of the petals. Although the arrangement of leaves and stems looks complex, look for generalized shapes rather than trying to capture every single element. Look at the spaces between leaves, as defining these "negative shapes" will make the shapes of the leaves stand out more clearly.

Materials

- Canvas board
- B pencil
- Oil paints: phthalocyanine green, yellow ochre, burnt umber, cadmium yellow, titanium white, quinacridone red, ivory black, phthalocyanine blue, purple lake
- White spirit (paint thinner) or lowodour thinner
- Brushes: small flat

1 Using a B pencil, make a careful drawing of the flowers on the canvas. Establishing the shapes of the individual elements at this stage will make it easier later on: without an underdrawing, the mass of different greens in the bottom half of the image is potentially very confusing.

The set-up

Although this vase of flowers looks so informal that you might imagine the flowers have simply been placed there, with no thought as to their arrangement, the artist has carefully positioned them so that some flower heads are fully open while others are seen from the side. This gives the artist the opportunity to explore the structure of the blooms and makes for a more interesting picture. The colour distribution, too, is important: the reds and purples balance each other well.

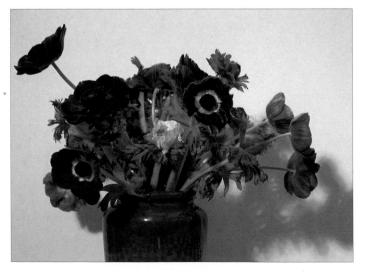

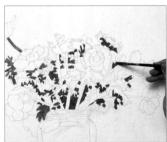

2 Mix a dark green from phthalocyanine green, yellow ochre and burnt umber, thinning the mixture with just enough solvent for the paint to come off the brush easily: too much solvent will make the paint too fluid and hard to control. Using a small flat brush, begin painting the darkest leaves and the spaces between the stems.

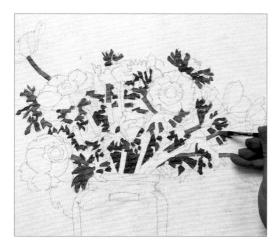

Ontinue adding the green leaves, using short single brush strokes to build up the forms. Lighten the mixture by adding cadmium yellow, a tiny amount of yellow ochre, and titanium white. Alternate between the two greens as you work, so that you begin to establish a sense of light and shade, and make a conscious effort to vary the angle at which you hold the brush, as this will result in marks of different thicknesses.

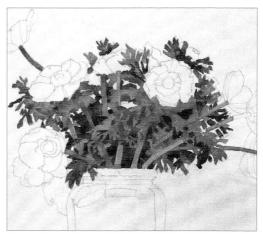

A Still using various green mixtures, gradually build up the mosaic of colour and form. Note that some of the greens are very light (achieved by adding more white to the mixture), while some are very dark (achieved by adding a little quinacridone red): work slowly and methodically, so that you do not lose track of where you are in the painting, and refer continually to your still-life set-up. Use the underdrawing only as a guide.

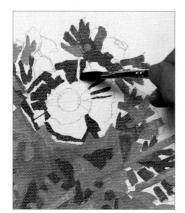

5 Mix a dark red from minarridone red, a little ivory black, cadmium vellow and vellow orbre and start putting in the darkest reds of the anemone flowers. There are several tones of red within the same flower, so you will need to look closely to establish where the darkest reds occur. Use the same mixture for the delicate veining on the petals, using the edge of the brush to create very fine lines.

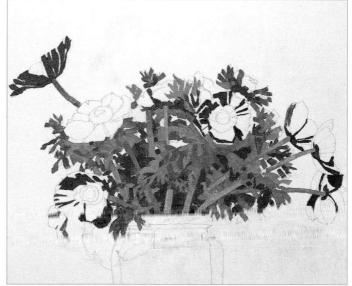

6 While the dark red mixture is on the palette, use it to paint all the dark reds that you can see on the other flower heads. This is not only an economic use of paint, but it also forces you to work across the whole painting, rather than concentrating on one area and running the risk of overworking it.

Z Lighten the red mixture by adding titanium white and a little cadmium yellow, and begin putting in the mid tones on the anemone flowers, working around the deep reds that you have already established in the previous two steps. Use just the tip or the thin edge of the brush and apply only light pressure, as this allows you to place your strokes very precisely and paint small, delicate areas with ease.

Mix a bluish-black colour from phthalocyanine blue and burnt umber and, with a few short and carefully controlled strokes, paint the dark mass that lies at the centre of each flower.

Mix a yellowish green from white, a little of the original green mixture and yellow ochre and touch this colour around the dark flower centres. Mix a dark purple from purple lake and a little phthalocyanine blue and paint the darkest parts of the purple flowers, delineating the individual petals. Mix a lighter purple from quinacridone red, phthalocyanine blue and titanium white and paint the lighter purple areas.

10 Add white to the light purple mixture from the previous step and paint over the lightest areas around the centre of the purple flower. Use some of the light green mixture that you used to paint the stalks to put in the light colour on the ceramic vase, leaving the brightest highlights untouched.

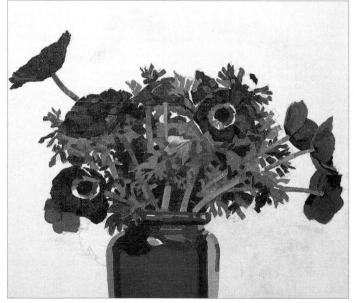

1 Add purple lake and a little burnt umber to the original dark green mixture that you used in Step 2 and paint the darker reflected colours that can be seen on both sides of the vase, taking care to paint around the highlights that you painted in Step 10. The vase is now beginning to look much more rounded and three-dimensional: the use of different tones of green helps to give it form, while the highlight shows us which direction the light is coming from and helps to enliven the composition.

Tip: Look carefully at the shapes of the shadows cast on the wall: although the flowers are soft, rounded shapes, some of the shadows are quite angular. Using a flat brush allows you to make precise marks: use a corner of the wedge shape to fill in detail, the end of the wedge for thin straight lines, and the full width to cover larger areas.

12 Now paint the shadow that the flowers cast on the wall behind. Mix a purplish grey from the purple flower colour, the red mixture used in Step 7, and phthalocyanine blue. Loosely brush in the shadow, remembering to leave gaps to indicate where the light shines through the flowers on to the wall.

The finished painting

Add lots of titanium white and a little yellow orbre to the shadow colour and put in the background. Working alla prima allows you to blend the colours on the support and

capture the delicacy of the papery pelals to perfection. The finished painting is a lively and realistic-looking interpretation of a loose arrangement of spring flowers.

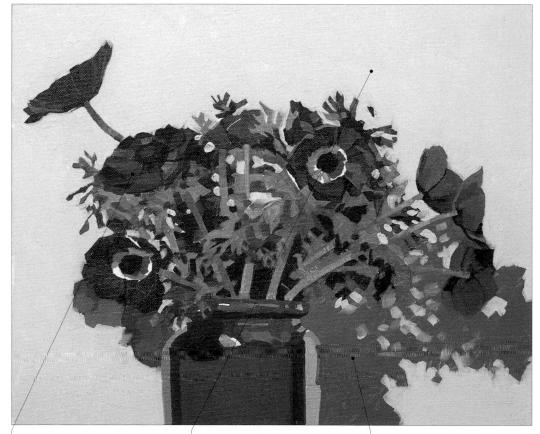

Thin layers of paint, blended wet into wet on the support, create the delicate veining and subtle coloration of the anemone petals.

The background is painted in a single, thin layer of a pale purplish grey, using short brushstrokes of lighter paint to soften the shadow edges.

The cast shadow has the effect of throwing the vase of flowers forward.

Glazing

A glaze is a transparent layer of paint that is applied over a layer of paint. As with traditional watercolour, light passes through the transparent glaze and is reflected back by the support or any underpainting. Glazing is a form of optical mixing as each glaze colour is separate from the next, with the mixing taking place within the eye. Each glaze needs to be dry before the next layer is applied, otherwise the colours will simply mix together as they would on the palette. Glazing techniques can be used with both oils and acrylics.

Glazed colours reflect light more readily than opaque colours, which tend to absorb light. This gives glazed works a richness and luminosity that can be lacking in paintings done using conventional mixing techniques.

Traditionally, the work began with an involved tonal underpainting in monochrome over which the colours were carefully glazed. Depending on the subject, the underpainting can be made using a warm brown, black, or even green. However, glazing techniques can also be used in conjunction with more opaque painting techniques. Glazes made over opaque layers of paint can liven up dull areas of colour, or make warm areas of colour appear cooler or cool areas warmer. This is particularly useful when painting portraits. A single colour glaze is often used over the entire picture area once it is finished and dry, which has the effect of bringing an overall harmony to the colours.

Lightness or darkness of the glazed colour ▼

Traditionally, glazed colours were applied over a tonal underpainting. It is the tones in the monochrome underpainting that determine the lightness or darkness of the colours glazed on top.

Physical colour mixing ▼

Physically mixing cadmium yellow (below left) and dioxazine purple (below right) creates a dull brown (bottom left). When the same two colours are glazed one over the other, the integrity of both remains intact and the result is a brighter mix in which the two colours combine optically (bottom right).

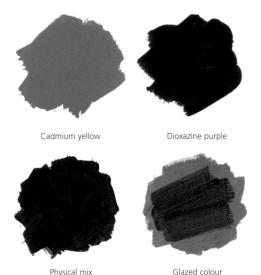

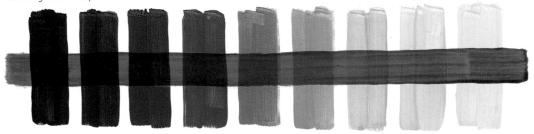

Mediums for glazes ▶

When using oil paint, which is less opaque than acrylic, use a glazing medium. With acrylic paints use a gloss painting medium; this not only thins the paint but also increases its transparency. Acrylic paints are ideal for glazing, as they dry very quickly. Certain colours, which are by their nature more transparent, are more suitable for glazing techniques than others, but even opaque colour can be used.

Oil paint straight from the tube

Oil paint plus glazing medium

Acrylic paint straight from the tube

Acrylic paint plus gloss medium

Practice exercise: Glass jar and chiffon

Glazing is the ideal technique for painting transparent and semi-transparent subjects such as this tiny glass jar and chiffon scarf, as it allows colour to be built up gradually until the right density is achieved. The final effect of both transparent glass and transparent fabric is skilfully achieved Careful observation is the key, as there are many subtle shifts of tone within

the scene, even though the number of colours in this particular exercise is relatively small.

Remember that you need to allow each glaze to dry completely before you apply the next one, otherwise the colours will combine in a muddy mess.

Materials

- Oil paper
- B pencil
- Oil paints: phthalocyanine green, raw sienna, alizarin crimson, ultramarine blue: zinc white
- Thinner
- Drying linseed oil
- Brushes: medium flat, small round

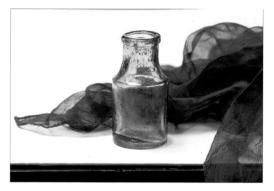

The set-up

Although the chiffon scarf is casually draped, it naturally falls into folds, some of which are several layers thick, and you have to assess the depth of colour very carefully. The scarf can also be seen through the glass jar, although its colour here is modified by the green of the glass.

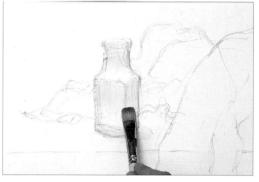

Using a B pencil, make a light underdrawing, putting in the lines of the main folds in the chiffon scarf as a guide. Mix a bluish green from phthalocyanine green and a tiny amount of raw sienna. Using a medium flat brush block in the jar, leaving some areas untouched for the highlights in the glass. Indicate the cast shadow to the right of the jar.

 $2^{\,}$ Mix a pale pinkish red from alizarin crimson with a little raw sienna. Paint the scarf. Your brushstrokes should run in the same direction as the folds in the fabric; you will find that the flat brush makes it easier to paint the edges of the folds.

3 Mix a neutral grey from alizarin crimson and a little phthalocyanine green, and paint the shadow under the scarf. Mix an orangey brown from raw sienna and alizarin crimson and paint the shelf edge. Add a little phthalocyanine green and glaze it over the shelf to get some variation in colour. Use this mixture for areas where the wood can be seen through the chiffon.

A Mix a cooler version of the scarf colour used in Step 2 by adding a tiny amount of phthalocyanine green and paint the scarf that can be seen through the jar. At this stage, simply block in the area of colour without making any attempt to work out the tones.

5 Glaze this cooler colour over the most deeply shaded parts of the scarf. Already the scarf is beginning to take on some depth.

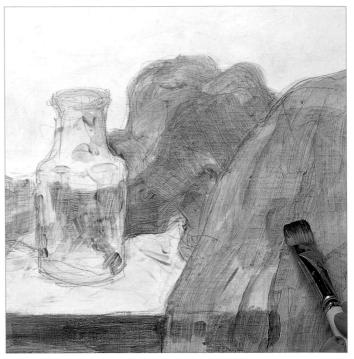

6 Mix a very pale, dilute raw sienna and brush it lightly over the white background to warm up this area and make the contrast between it and the still life less stark. Using the medium flat brush, glaze alizarin crimson over the deepest-coloured parts of the scarf, where several layers of fabric overlap each other.

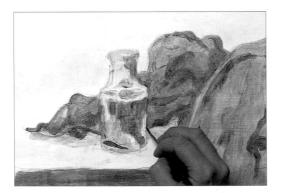

7 Glaze the cool pink colour from Step 5 over the deepest folds in the fabric. Mix a dark blue-green from phthalocyanine green and ultramarine blue and, using a small round brush, darken the colour of the jar where necessary. Glaze this blue-green colour over some of the dark reds in the jar. Note how the two glazes modify each other: the red is cooled by the green.

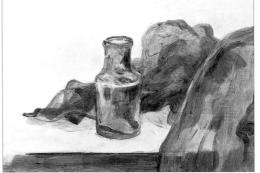

Continue building up the dark green colour of the jar, remembering to work around the highlights. Glaze more of the pink mixture over the most deeply coloured parts of the scarf, where several layers of fabric fall in soft folds on top of one another. Use a cooler (bluer) mix inside the jar, as the colour of the scarf in this area is affected by the green of the glass.

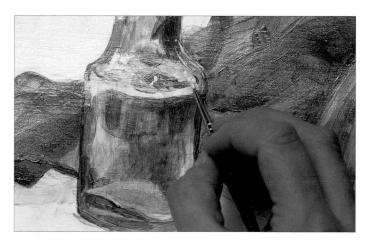

Glaze more dark green over the jar to make a stronger contrast, so that the jar comes forwards in the scene. Reinforce the highlights in the jar with zinc white (or zinc white mixed with a tiny amount of bluegreen, as appropriate).

Tip: Even in clear glass, highlights are rarely, if ever, pure white. Instead they are tinged with a hint of the colour of any nearby objects that are reflected in the glass. Here, the highlights are created by using a paler version of the green used for the glass jar.

The finished painting

Thin layers of paint have been skilfully applied to build up the colours and tones. Where several layers of sheer fabric overlap one another, glazes are the perfect means of building up the colour to the right density. Each glaze modifes the preceding colour, creating optical mixes that are more lively than could be achieved by mixing colours in the palette.

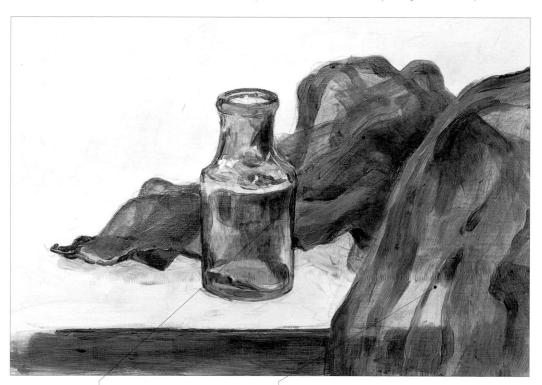

Several glazes of different colours are used for the deepest-coloured areas.

One layer of thin paint is enough to portray the delicate wispy nature of the fabric.

Scumbling

Scumbling is the technique that involves applying dry, semi-opaque paint loosely and roughly over a dry underlayer, leaving some of the underlayer visible to create optical colour mixes on the support. The technique also produces interesting surface textures in which the marks of the brush or other paint applicator may still be seen. The technique can be used with oils, acrylics, gouache, watercolour and pastels. The texture of the support plays an important part in scumbling techniques, which tend to be more successful on rough surfaces than on smooth. Having said that, however, subtle scumbling is useful for adding variation and relief to large areas of flat, uninteresting colour on smooth supports.

Scumbling is a great way of modifying colour while keeping the painted surface looking lively. For example, if an area looks too hot, you could scumble a cool colour over the top - and vice versa. Or you might choose to use the technique to paint an area of deep shadow, which is rarely if ever a uniform, flat colour; the colours thus applied will create an optical mix that looks much more lively and interesting than a physical mix of the same hues. There are lots of subjects for which scumbling is appropriate. Masses of foliage seen from a distance, clouds racing across a stormy sky, torrents of water, worn stone or distressed wood: all consist of intermingling colours and can benefit from the fresh, spontaneous look that scumbling can achieve.

Whatever medium you are using, when applying a scumble you should always work loosely and freely. If you're using a brush, scrub the paint on to the support with the brushstrokes going in different directions or even in a circular motion. A bristle or synthetic brush is best, as the fibres are hard and separate from one another; with a soft-haired watercolour brush, the fibres would stick together and detract from the irregular effect of the technique. It is best to save old, worn brushes for this technique as the scrubbing action will quickly damage the bristles of good brushes. You can also scumble paint on using a rag or sponge, or even your fingers.

Broad scumble A

Here, a stiff mix of paint is scumbled over the dry, slightly impasto paint applied previously. The paint catches on some of the brushstrokes, but in other areas the underlying layer still shows through.

Scumbling to add interest A

An area of dry, flat colour can be made more interesting by scumbling a slightly different colour over it.

Transparent scumble using acrylics A

For a more transparent scumble and delicate optical colour mixes, add acrylic medium to the paint. This increases the transparency of the paint.

Heavily textured scumbling A

For a more textured look, dot the paint on to the support straight from the tube. You can use this technique with both oils and acrylics.

Light scumbling with a rag A

To allow more of the first layer to show through, dip a rag or absorbent kitchen paper into your chosen colour and lightly touch it on to the support, so that the paint adheres only to the peaks of the brushstrokes of the first layer.

Light colour scumbled over dark A

Use a stiff, dryish mix of paint and remove some of it from the brush prior to making the mark, in the same way as you would with drybrush techniques. This allows more of the first layer to show through.

Practice exercise: Distressed wood and metal

Scumbling is the perfect technique for painting weathered wood and metal, as it allows underlying colours to show through and creates interesting textures. Keep your paints fairly thick and dry, and apply the paint unevenly, so that the colour is not uniform.

Build up the scumbles gradually. If you apply too much heavy paint all at once, the subtlety of the effect will be lost. A few drops of acrylic medium improves the paint flow. In this exercise, which is painted on cardboard, the medium also acts as a size; even though the cardboard has been primed, it is still porous, and the medium prevents the paint from sinking into the surface.

Materials

- Cardboard primed with acrylic gesso
- HB pencil
- Acrylic paints: alizarin crimson, phthalocyanine green, raw sienna, titanium white
- Matt acrylic medium
- Brushes: large round, small round, small flat

The artist came across this magnificent but rather scary-looking door knocker on a trip to Venice; small details such as this are often as evocative as views of an entire building.

Using an HB pencil, sketch the scene. Although the subject is small in scale, the changes in tone from one plane to another need to be carefully rendered, so make sure you put in all the detail you need. Your pencil marks will be fully covered by the paint.

2 Mix a dark, almost black, green from alizarin crimson and phthalocyanine green and add a few drops of matt acrylic medium. Using a large round brush, start painting the background.

3 Lighten the mixture for the top left of the painting, which is catching more of the light. Add some raw sienna to the mixture and brush it wet into wet into the background to get some variation in colour.

A Mix a warm brown from raw sienna and alizarin crimson and dab it loosely over the darkest parts of the metal door knocker. This will serve as a warm base for subsequent applications of paint.

5 Mix an opaque, pale metal colour from titanium white, raw sienna and a little phthalocyanine green. Using a small round brush, brush it over the lightest areas, adding more green to the mixture for those areas that are slightly cooler in tone.

Continue to paint the door knocker, alternating between the warm and cool mixtures used in the previous step as necessary in order to build up the form. Leave to dry.

Mix an opaque white from titanium white and the cool green mixture. Using a medium flat brush, loosely scumble it over the wood of the door, allowing some of the underlying colour to remain visible, creating the effect of worn, distressed paintwork.

Continue to scumble paint over the door, varying your mixtures by adding more green for some parts and more raw sienna for others. Remember that the light in the scene is coming from the top left, which means that the bottom right is darker and more deeply shaded.

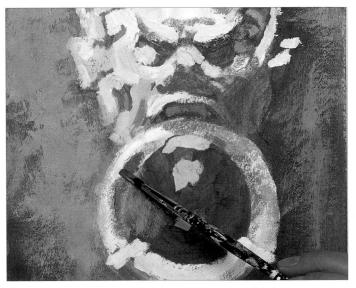

9 The scumbling on the door establishes the mid tones of the painting, which makes it easier to assess how dark the very shaded parts need to be. Mix a dark, brownish green from raw sienna, alizarin crimson and phthalocyanine green. Using a small brush, put in the dark recesses on the face, adding more raw sienna on the right-hand side. Scumble the same colour over the round knocker.

10 Build up the form by continuing to add shaded recesses on the face.

1 1 Refine the wotails, using apagin mixtures of all the colours on your palette. Use a small flat brush to sharpen the outline of the door knocker with dark greens and blue-green mixes.

Tip: The shape of the flat brush makes it easier to give objects a crisp, sharp outline.

The finished painting

This painting shows just how effective scumbling can be when painting worn and weathered surfaces. Although only a limited number of colours were used, the various layers of paint imply not only the way the wooden door has been bleached by years of exposure to the sun and rain, but also create rough textures. The use of warm and cool tones of the same colours creates a convincing sense of light and shade, even though the light source itself (the sun) is not visible. This helps to build up the form of the door knocker and make it look three dimensional.

Rough scumbling adds texture to the image.

Here, the scumbling hints at the rustiness of the metal.

Impasto

Impasto techniques involve applying and building the paint into a thick layer and are not unlike icing a cake. The word impasto is Italian for "dough" and describes the consistency of the paint used. In reality, the paint is usually more like butter; it is easy to spread and manipulate, but retains the mark of any brush or implement used to apply it. The consistency of paint straight from the tube is usually about right.

Given the amount of paint that can be used in even a modestsized work, it can be economical to mix the paint with a medium specifically designed for impasto work. In the case of oil paint, these mediums contain drying agents that speed up the paint's drying time and cause the paint to dry at a uniform rate regardless of thickness. The medium also adds bulk to the paint without affecting its colour, so you use less paint – an important consideration given the cost of many oil paints. Acrylic paints can be bulked out using heavy gel medium and texture pastes.

By its nature, working with impasto techniques precludes the inclusion of fine detail. The work should be well planned, but painted as freely and intuitively as possible to keep it fresh. One solution is to use impasto work over an underpainting. If you are using oil paint (following the important oil-painting rule, painting "fat over lean"), use thin paint to which you have added plenty of thinner. Alternatively make the underpainting in thin acrylic paint and do the impasto work in oils.

Using paint straight from the tube A

With both oils and acrylics, you can squeeze paint straight from the tube on to the support. More often than not, artists will apply paint to the support in this way and then work into it using a painting knife or other implement.

Using a brush A

You can also squeeze the paint on to your palette and apply it with a brush. Paint from the tube is invariably of the right consistency for impasto work. Provided you do not overbrush, the brushmarks will stand proud and evident.

Using a painting knife A

You can drag and press a painting knife into thick paint and also blend colours together on the support. The marks you make will depend on the size and shape of the knife. The knife can also be used to scrape into wet paint to create textures and to remove paint that has been incorrectly positioned.

Adding impasto medium to paint A

There are a number of so-called impasto mediums, for both oils and acrylics, that can be mixed into the paint on the palette. The one shown here is a quick-drying impasto medium designed specifically for use with oils. If you are using acrylic paints, use a heavy gel medium.

Blotting up excess oil A

If your paint is too oily when you squeeze it out of the tube, it will tend to spread and flow too easily. To overcome this, simply squeeze it on to absorbent paper (kitchen paper or blotting paper); the paper will absorb the oil, leaving behind a blob of thick paint.

Practice exercise: Pumpkins painted impasto using acrylics

Pumpkins are highly textured vegetables: there are clear indentations on the outer surfaces delineating the different segments, while a tangled mass of fibres and hard seeds on the inside provides you with the perfect opportunity to practise impasto work. The coloration, too, gives you the chance to apply the paint thickly, dabbing on different colours to achieve the necesary variations in tone. Adding acrylic gel medium to the paint thickens it and makes it irleal for impasto work, as it holds the marks of the knife or brush. It also makes the paint go further.

Materials

- Primed canvas
- 2B pencil
- Acrylic paints: burnt umber, cadmium red, cadmium yellow deep, phthalocyanine blue, alizarin crimson, cadmium yellow medium, yellow ochre, titanium white, sap green, cadmium orange
- · Acrylic gel medium
- Brushes: small flat, medium flat
- · Medium trowel-shaped painting knife

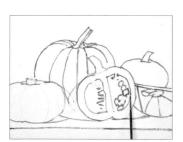

1 Using a 2B pencil, lightly sketch your composition. You do not need to put in all the detail, but indicate the striations on the largest pumpkin (these curved llines will make it easier for you to get the overall shapes right). Add the angles of the stalks, and the main internal divisions in the cut pumpkin so that you have some guidelines for when you begin to paint. When you are happy with the sketch, go over the lines in burnt umber acrylic paint, using a small flat brush. If you wish, you could underpaint the picture at this point, using watered-down acrylic paint.

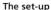

Arrange the pumpkins on a table or shelf, aiming for good contrasts of size: it looks more interesting if at least one vegetable is laid on its side, so that you can see the cut-off stalk. Look at the angle of the stalks, too: here, the artist has positioned the largest and the cut pumpkins with their stalks pointing towards each other, which helps to direct the viewer's eye through the picture. Cut at least one of the pumpkins open to reveal the seeds and fibres inside.

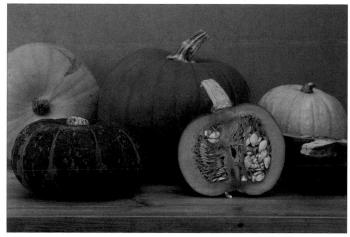

2 Mix a warm dark orange from cadmium red, cadmium yellow deep, and a little burnt umber, adding acrylic gel medium to the mix to thicken it. Using the edge of the brush, paint the segments on the surface of the largest pumpkin. Mix a dark brown by adding phthalocyanine blue and alizarin crimson to the orange mixture and paint the deep shadow at the base of the pumpkin. Add cadmium yellow medium to the orange mixture to lighten it, and block in the sections, carefully painting around the stalk of the cut pumpkin.

B Using the same dark orange mixture, outline the cut pumpkin and block in the dark area around the seeds in the middle, delineating the largest of the individual seeds in the same colour. Add yellow ochre and titanium white to the mixture and paint the fibrous area with loose, horizontal brushstrokes, varying the proportions of the mixture to create tonal variety. Add more cadmium yellow and white to the mixture and paint the pumpkin flesh around the outside of the seeded area, using a full range of brushstrokes to work around the shapes.

4 Using the same mixture as in Step 2, paint the shadow between the cut pumpkin and the pumpkin on the far right. Paint the individual segments of the pumpkin on the right, then paint the cut surface in a mixture of cadmium yellow medium and titanium white. Add cadmium red to the basic warm orange mixture and block in the segments of the pumpkin.

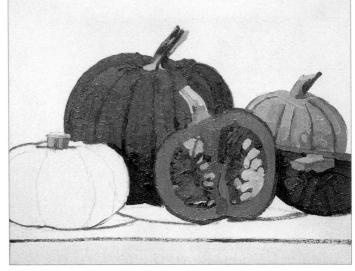

Tip: Use a hairdryer to speed up the drying time of thick acrylic paint.

Once you are sure that the first layer is completely dry, you can apply further layers to build up the impasto effect without disturbing the underlying paint.

5 Mix a pale, greyish-green from titanium white, phthalocyanine blue, yellow ochre and the basic orange mix and outline the segments of the small green pumpkin on the right. Add more white to the mixture and block in the segments. Mix a pale beige for the seeds of the cut pumpkin from titanium white, yellow ochre and the pale green mixture. Use the pale beige for the top of the stalk and the pale grey-green mixture for the base of the stalk. Mix a darker green, using the grey-green mix plus orange, and paint the stalks of the two pumpkins on the far right, using the dark green for the shaded sides to create a sense of light and shade.

6 Mix a mid-tone green from sap green, yellow ochre, a little phthalocyanine blue and titanium white, and outline the segments of the green pumpkin on the bottom left of the picture. Dab the same mixture over other parts of the pumpkin too. Mix a darker green from sap green, phthalocyanine blue and alizarin crimson and paint around the first green. Brush the paint on thickly, using the side of the brush, to build up interesting textures.

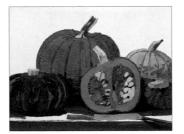

7 Use the same greens to reinforce the dark lines and shadow areas on the green pumpkin on the right, which are too light in relation to the rest of the image. This also helps to create a visual link across the painting. Mix a dull brown from the dark green mixture, cadmium red, yellow ochre and white and paint the table edge, using horizontal brushstrokes to echo the direction of the wood grain. Add yellow ochre and cadmium orange to lighten the mixture, and paint the table top.

Add yellow ochre and titanium white to the pale brown mixture. Using a medium flat brush, paint the background, constantly varying the direction of the brushstrokes and allowing the brushstrokes to remain visible in order to enhance the impasto effect. Using the edge of a trowel-shaped painting knife, press some of the dark brown mixture on to the stalks to create a fibrous, woody texture.

Dip the tip of the painting knife into the basic orange mixture and drag it over the fibrous area in the middle of the cut pumpkin to make a series of uneven lines. Add titanium white to the background colour and, using the painting knife, shape the seeds in the cut pumpkin.

The finished painting

Using the paint thickly has allowed the artist to create a range of interesting textures that are perfectly suited to the subject – fine lines for the fibres inside the cut pumpkin, achieved

through both brushwork and the use of a painting knife; splotches of thick colour on the bumpy exterior surface of the vegetables.

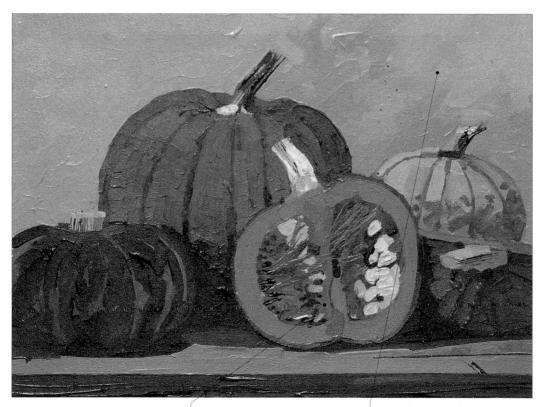

The fibres and seeds are created by dragging and dabbing the edge and the end of the painting knife on to the support.

Allowing the brushstrokes to remain visible creates texture and offers visual relief in an otherwise flat area.

Practice exercise: Impasto landscape in oils

With its scrubby vegetation and pebbly path, this Mediterranean cliffside scene provides many opportunities for working impasto. In a landscape such as this, however, it is generally helpful to include some quieter, flatter areas, such as the sea and sky, for the viewer's eye to rest on. This exercise is painted entirely with a painting knife.

Materials

- Canvas-covered board primed with acrylic gesso
- HB pencil
- Oil paints: phthalocyanine blue, titanium white, ultramarine blue, alizarin crimson, cadmium lemon, sap green, burnt sienna, raw sienna
- Rag
- Small painting knife

This is a classically composed scene, with the main cliff falling at the intersection of the thirds and the path leading our eye through the picture. The contrasting textures – the relative smoothness of the sea and sky versus the pebbly path and dense vegetation – make a picture that is full of interest.

1 Using an HB pencil, lightly sketch the scene so that you have a rough guide to where to place the different elements.

2 Mix a pale blue from phthalocyanine blue and titanium white. Using a rag, smear it across the sky. Add more phthalocyanine blue and, using a small painting knife, put in the sky, smoothing the paint out so that the coverage is fairly even.

3 There are some deep shadows on the sea; paint these in using ultramarine blue. Still using the painting knife, apply strokes of thick titanium white for the clouds. The rough impasto work helps to give a sense of volume to the clouds.

A Mix a dark purplish blue from alizarin crimson and ultramarine blue and smear it over the rocky, exposed area of cliff on the right, adding some sap green to the mixture as you work down towards the path. To capture the jagged feel of the rocks, pull the paint up with the tip of the knife to form small peaks. Mix a bright green from cadmium lemon, sap green and a little burnt sienna and begin putting in the lightest parts of the foreground vegetation on the left, dabbing in a more yellow version of the mixture in parts.

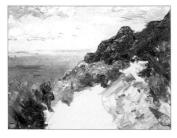

 $5^{\,\,\text{Mix}} \text{ a pale brown from raw sienna} \\ \text{and white and paint the roughtextured ground to the right of the path.}$

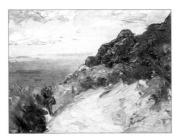

Tip: When painting the vegetation, angle the painting knife so that it follows the direction in which the plants naturally grow.

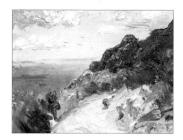

Mix a pale purple from ultramarine blue, titanium white and a little alizarin crimson and use this mixture to put in the shaded sides of the foreground rocks that lie to the right of the path. Paint the bright highlights where the sun hits the tops of the rocks in titanium white.

A Mix a very dark green from ultramarine blue and sap green and put in the very darkest areas of the plants that are growing on the cliff side, dabbing the paint on with the tip of the painting knife. Add some alizarin crimson to the mixture and put in some slightly curved strokes, using the side of the knife, for the taller stems and branches.

Ontinue to build up textures in the vegetation and rocks, using the same colours as before. Vary the way that you apply the paint, sometimes using long thin strokes of the side of the knife and sometimes dabbing the paint on with the tip of the knife. Paint the tall, thin grass strokes on the right-hand side of the painting using a mixture of raw sienna and white.

The finished painting

Impasto work adds great vitality to this image: you can almost reach out and feel the texture of the rocks and plants. The artist has also made full use of the range of marks that can be made with a knife, from smoothing out the sky and sea

areas with the flat of the knife to dabbing on small blobs of paint with the tip, and even dragging the side of the knife over the canvas to create long, flowing marks for the thinnest stems and branches.

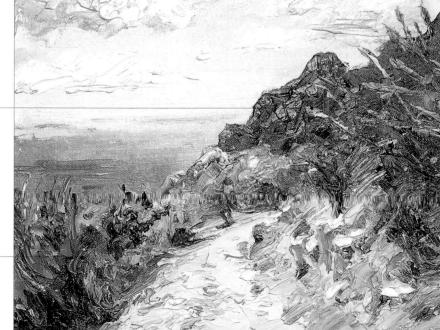

Thick oil and acrylic paint can be pulled up with the tip of the knife to form small peaks, as here.

Note how the knife marks echo the direction in which the plants grow.

Removing paint

There are three main reasons for removing paint from your canvas or support: to get back to the original support, either so that you can reveal the underlying colour or so that you can paint

over the area again and correct a mistake; to remove excess paint from an area that is too heavily impastoed or has become clogged with paint; and to work into paint to create textured marks.

Removing paint to get back to the original support

If the underlying colour is very strong, it's best to try and remove it so that it doesn't affect any subsequent glazes. The method that you select depends on the medium you are using and on whether the paint is wet or dry.

To remove wet acrylic paint ▼

Dip a rag in water and wipe it through the paint.

To remove dried gouache paint ▼

You can remove gouache paint that has dried by brushing clean water over the paint to soften it. You can then lift off the colour with your brush or a rag and paint over the affected area again. Note that this technique cannot be used with acrylic paint as once it has dried, the paint is no longer water soluble.

Removing excess paint

When you're doing very heavy impasto work in oils or acrylics, the canvas can become clogged with paint. If the effect is as you desire, then allow the paint to dry before applying more paint. If the effect is not what you intended, scrape off the

paint and start again. Thick oil paint remains wet for weeks, so it can be scraped off the support at leisure. Thick acrylic dries in hours, so it needs to be scraped off immediately. To remove excess paint, use one of the following methods.

Scraping off paint with a knife ▼

Hold the edge of the knife. perpendicular to the support, press down firmly, and drag the knife through the wet paint to remove any surplus. This leaves a flat area of colour, in which no brush marks can be seen.

Tonking

An alternative method is a technique known as tonking - named after the British artist Henry Tonks (1862–1937).

1 Place a sheet of newspaper over the affected area and smooth it down with your hands.

2 Peel away the paper, removing any excess paint in the process. The result is more textured than using a knife.

Working into paint to create texture

Thick paint has a pleasing texture that comes from the marks left by the bristles of the brush. This, combined with the texture of the support, is often all that is needed. However,

Sgrafitto - wet paint ▲

You can make textured marks in paint by scraping into the paint with the end of a brush. Alternatively, use a twig, the tip of a craft knife or the edge of a piece of cardboard.

greater verisimilitude can often be achieved when replicating the textures present on whatever is being painted by working into the paint.

Sandpaper – dried acrylic or gouache paint A

To create texture on dried acrylic and gouache paint, lightly rub sandpaper or another abrasive material over the area. Do not rub so hard that you damage the support.

Practice exercise: Watermelons

Two methods of lifting off paint are used in this exercise – tonking and scraping off paint with a knife. Tonking creates some texture, whereas scraping off paint leaves a much flatter, smoother surface.

Acrylic paints are used here, although the subject and techniques that the artist employed would work equally well in oils. As acrylics dry quickly, it is a good idea to add a little retarding medium to your mixes as this gives you longer to work into the paint. Even so, it is best to work on relatively small areas – one melon at a time – finishing one off before the next.

Materials

- · Acent/) minimic minimic acipine graces
- B pencil
- Acrylic paints: cadmium yellow, litarium white, phthalocyanine green, olive green, alizarin crimson, cadmium red
- Retarding medium
- Small painting knife
- Newspaper
- Brushes: flat wash, medium flat, small flat

The scene

The artist came across these water-melons on a market stall. Red and green are complementary colours and almost always work well together. The jagged lines of the cut melons counterbalance the rounded forms of the whole fruits.

Mix a pale yellow from cadmium yellow and titanium white and, using a flat wash brush, cover the board. Leave to dry. Using a B pencil, draw the outlines of the fruits. At this stage, you don't need to put in the jagged outlines of the cut melons: an indication of the overall shape, which you can use as a guideline, is sufficient.

2 Mix a dark green from phthalocyanine green and olive green, adding a little retarding medium to the mixture to give yourself longer to work. Using a small painting knife, cover the first uncut watermelon with the mixture. The coverage does not have to be completely even, but try not to go outside the pencil lines.

Tear off a piece of newspaper and scrunch it up into a long, thin strip. Press it firmly into the paint and lift it off to reveal the toned ground underneath. Note the lovely random textures and markings that this creates: it would be much more difficult to achieve this effect by painting on the lighter colour with a brush.

Repeat Steps 2 and 3 until you have painted all the uncut watermelons, varying the dark greens by adding more cadmium yellow for some fruits and more olive green for others. Using a medium flat brush, fill in the spaces between the melons with a very dark green. The image immediately takes on more of a sense of depth.

5 Mix a pinkish red from alizarin crimson, cadmium red and titanium white. Paint the red flesh of the cut melons, leaving a broad band of yellow around the edge. Place the knife tip in the centre of the melon, with the knife on its side, and scrape it clockwise, lifting off wedge-shaped areas of paint.

6 Darken the pink mixture from the previous step by adding more alizarin crimson. Dip the side of the knife into the paint and press it on to the melons to create the jagged cuts in the surface. This helps to create shading and makes the surface of the melons look three-dimensional.

Mix an opaque yellow from cadmium yellow and titanium white. Using a medium flat brush, paint the zigzag-shaped cut edges of the melons.

Step 2 and a small flat brush, cut in around the edges of the melons to sharpen the shapes.

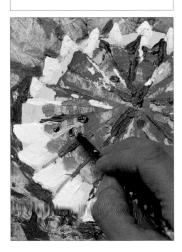

10 Mix together the dark green from Step 2 and the dark red from Step 6 to create a colour that is almost black. Paint the pips, using a small brush, and then scrape off the highlights on the pips using the end of your brush handle.

Mix pale pink from alizarin crimson and titanium white and touch in the pale pinks in the melon flesh, taking the colour to the melon rim in places. Mix a pale off-white from titanium white and a little cadmium yellow and put in some thin highlight lines on the melon flesh.

The finished painting

This is a lively and energetic painting that uses the technique of lifting off paint to great effect to create interesting textures.

Colour has been lifted off to reveal the toned ground beneath, creating the pale stripes on the outside of the watermelons.

Scraping paint off with the side of a painting knife creates flatter, less textured areas of colour.

Drybrush

The technique of drybrush work means precisely what it says: the brush is loaded with the minimum amount of paint and then skimmed gently over a dry surface so that it catches on the "peaks" or raised tooth of the paper or canvas, leaving part of the support showing.

It is important to splay out the bristles of the brush (or to use a fan brush) so that the individual bristle marks are evident on the support. Make sure your paint mix is not too wet: keep a raq or a piece of absorbent kitchen paper handy to blot off any excess paint, so that your brush is only very lightly loaded.

Drybrush work is a great way of conveying the texture of things like wood or weathered stone, which have a linear quality within them.

Using a fan brush ▶

A fan brush is ideal for drybrush work as the bristles are naturally splayed out.

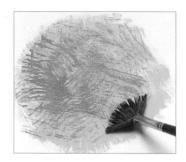

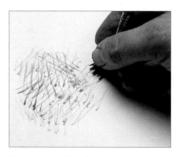

Splaying out bristles A

If you do not have a fan brush, you can splay out the bristles of an ordinary brush between your finger and thumb in order to create the same kind of drybrush marks.

Loading the brush with paint A

If you simply dip your brush into your palette, there is a risk that you will overload it. To avoid this, splay out the bristles and gently pull them over a paper towel soaked in paint.

Drybrush work over a large area

To cover a large area, dip the tip of a large bristle or household decorating brush in paint and gently drag it over the support, holding the brush at 90 degrees to the support.

Practice exercise: Seashells

The delicate, linear markings and ridges on seashells such as these make them the perfect candidates for the drybrush technique. Because the shells are very light in tone, the artist decided to start from a mid-toned ground. She used button polish, which serves both to tone and to prime the ground, although you could equally well use acrylic gesso mixed with burnt umber paint.

Materials

- · Cardboard primed with button polish
- · HB pencil
- Acrylic paints: titanium white, ultramarine blue, raw sienna, cadmium red, cadmium yellow
- · Brushes: small flat, fine round
- · Kitchen paper

The set-up

This simple still life consists of two large shells on a white background, simply lit from one side. One of the shells is placed upside down, enabling us to look inside it. Always look at your still-life subjects from different angles to find out what makes the most interesting composition.

A Sketch the shells with an HB pencil. Paint the background in a dilute wash of white and ultramarine. Paint the shadows in a purplish grey mixed from ultramarine and raw sienna. Mix a warm-toned mix of white and raw sienna and a cool-toned mix of white and ultramarine. Alternating between them, begin painting the shells.

2 Mix a purplish colour from cadmium red and ultramarine blue. Load the paintbrush, dab off any excess paint on a piece of kitchen paper, and paint the dark colour on the inside of the left-hand shell. Add white to the mixture to make it more opaque and put in the dark markings on the other shell. Using a fine round brush and the warm-toned mixture from Step 1, drybrush the grooves on the shell.

3 Mix a dark purple from cadmium red and ultramarine blue and drybrush on the markings on the interior of the left-hand shell. Add a tiny amount of raw sienna to the cool-toned mixture from Step 1 and put in the slightly shaded areas of the right-hand shell, making sure your brushstrokes follow the direction of the grooves on the shells to reinforce the three-dimensional impression.

The finished painting

spontaneity of the image.

A Mix a very pale yellow from cadmium yellow and titanium white and paint the tops of the ridges on the right-hand shell. Continue putting in the dark patterning on the shells, using the drybrush technique all the time to create texture and imitate the rough, irregular markings on the shells.

5 Mix a mid-toned grey from titanium white, cadmium yellow and raw sienna. Scumble the mixture over the background, carefully brushing around the shadows. Using the purple mixture from Step 3, reinforce the lines in the left-hand shell.

These shells have a jagged and irregular surface. Drybrush work is the perfect way to paint the small, spiny ridges. As the brushes are skimmed only lightly over the surface of the support, the technique also allows underlying colours to show through, conveying the mottled, irregular coloration of the shells very effectively. The key with any isubject like this is not to overwork it and lose the

Drybrush work captures these small ridges to perfection.

6 Reinforce the dark patterning on the shells where necessary, using the same colours as before.

Gouache techniques

The techniques that are used when painting in gouache are very similar to those used when working in watercolour, and these two pages give a brief summary of the most common methods. Like watercolour, gouache is water soluble - but unlike watercolour (which is transparent), gouache is opaque. This means that, because of its opacity, light pale colours can be painted over dark colours, just as one would when using certain oil or acrylic techniques. However, gouache paint can also be heavily diluted with water and used in semi-transparent washes, as one would use watercolour paint. It is common practice to combine the two approaches in the same work.

Wet on dry

Paint applied to a dry surface creates marks that retain their edge and shape, and the paint tends to stay where it is put. However, the underlying support or paint layer must be completely dry before you apply a second layer, or else the effect will be lost. As gouache can easily be made re-soluble when it is rewet, wet colour needs to be applied over a dry colour using quick, sure brushstrokes in order not to pick up any of the underlying colour.

Wet paint applied to dry paper ▼

Below, the first (red) wash was allowed to dry completely before strokes of yellow paint were applied on top. The yellow has not spread at all, but retained its original edges. As gouache is opaque, of course, it is possible to apply a light colour on top of a dark one without the underlying colour showing through – unlike watercolour.

Wet into wet

Paint applied to a surface that is already wet with paint or water will bleed and spread, creating a soft, seductive blend of colour. The technique takes practice to control, as the results can, to a certain extent, be unpredictable. The extent and speed of the paint spread depends on the wetness of the surface. On a damp surface, paint will spread slowly, within a contained area. On a visibly wet surface, paint will spread rapidly and not always in a predicted direction. However, you can control the direction in which the paint spreads by tilting the support.

Masking

Masking is done to prevent paint from getting on to unwanted areas or to create an edge that would be impossible using any other method. Masking fluid can be used with thin washes, although heavy, thick paint can prevent the dry fluid from being removed. Masking tape and film (frisket paper) can be used to create straight edges or cut to create curved edges. Torn paper can be used in the same way as tape, while torn fabric with frayed edges can create wonderful effects.

Different types of mask ▼

Masking fluid and thin strips of torn and untorn masking tape were applied to the unpainted paper before a wash of orange paint was brushed over the whole area. When the paint was dry the masks were removed, revealing the unpainted paper underneath.

Wet paint applied to damp paper ▼ Applied over a slightly damp first layer, the red paint has spread a little.

Resist techniques

Wax candle or wax crayon can be used to draw on to the dry support or dry paint work. When the area is painted over, the wax will repel the watery paint, which will only settle in areas where there is no wax. If the paint is too thick it will settle on the wax and the effect will be lost. The exact result depends on how much pressure you apply and on the type of surface on which you are working: the wax will leave more broken marks on a rough surface than on a smooth one. Resists are a useful technique for painting waves or turbulent water, trackways and ploughed fields.

Candle wax ▼

Here, a candle was rubbed over parts of the unpainted paper before a wash of green paint was applied. The wax repels the water in the paint, leaving a textured effect.

Spattering

Gouache paint can be spattered on to a dry or a wet surface: blobs of paint spattered on to a dry surface will retain their shape, while blobs spattered on to a wet surface will soften and spread. Very wet paint tends to make larger blobs, as more paint is picked up by the brush and leaves it easily when the brush is tapped. Thick paint clings to the brush and is reluctant to leave it when tapped, resulting in a fine spatter. The distance that you hold the brush from the support also has an effect on the spatter density and size. It is hard to control exactly where spatters will go, and you may need to mask certain areas of your painting to prevent blobs of paint accidentally falling on them. Spattering is a useful technique for painting pebbles or gravel paths.

Spatter texture ▼

Paint can be spattered by tapping your finger against the handle of a brush loaded with paint or by pulling back the bristles of the brush with your fingertips to release a fine spray. Many artists keep old toothbrushes to use for spattering.

Sgrafitto

The technique of scratching into paint is known as sgrafitto. It is used to create texture and highlights. You can scratch or scrape into dry paint to reveal previously applied paint or the surface of the support. Any sharp implement can be used, as can abrasives such as sandpaper. Once made, the scratch marks can be left as they are or worked over using more paint. Sgrafitto can also be used to remove areas of paint to correct mistakes, although the technique is less successful if so-called staining colours have been used, as they tend to soak into the support and stain the paper fibres to a greater depth than non-staining colours. Sgrafitto techniques are best used on heavy or thick supports as there is less risk of cutting through the paper.

Sandpaper and craft (utility) knife ▼

On the left, fine sandpaper was rubbed over a wash of dry paint – a useful technique for creating texture on rock faces or areas of grassland. On the right, paint was scratched off using the tip of a knife – good for highlights such as sun touching water.

Sponging

Both natural and man-made sponges can be dipped into paint and used to create textural effects and apply washes of colour. Natural sponges tend to have a more random texture than man-made sponges and leave a more pleasing mark. Various shapes and sizes are available, and sponges can be cut or pulled apart for work on small areas. Thin mixes of gouache tend to soak into the sponge, so you will need to mix up a large quantity of paint. Thick paint, however, tends to be picked up only on the sponge surface. Complex textural marks can be made by building up a sequence of sponge marks in layers, allowing each one to dry before you apply the next. You can also dip sponges in water and wipe them over the paper surface to remove paint.

Natural sponge ▼

Here you can see the effect of pressing a sponge loaded with paint several times over the same area: the paint is quite dense, but the pattern is sufficiently broken to create a textured effect that is useful for painting things like distant areas of foliage.

Drybrush

Any type of brush can be used to apply drybrush marks, but fan brushes intended for blending oil or acrylic paint are particularly effective. If you do not have a fan brush, you can create the same effect by loading a brush with paint and then splaying out the bristles with your fingers before applying the brush to the support. The technique can be slow, but if it is applied with care and patience it is possible to build

a beautiful textured surface. Paint needs to be used sparingly or the effect will be lost. Drybrush is a useful technique for painting the flow and fall of fabric, birds' feathers and animal fur.

Drybrush marks with splayed-out brush ▶

This technique creates the effect of regularly spaced lines, with areas of the support showing through the paint.

Practice exercise: Combining gouache techniques

This simple still life gives you the chance to practise different gouache techniques within the same painting: overlaying colours; wet into wet and wet on dry; various ways of creating textures, including spattering and sponging; and exploiting the natural chalky consistency and opacity of gouache paint.

The artist chose watercolour board as the support for this painting, as it has a smooth surface that is ideal for capturing fine detail.

Crabs and other shellfish, such as lobsters, langoustines and mussels, make fascinating subjects for still lifes as their shells contain many variations in colour, providing you with the ideal opportunity to practise assessing different tones.

In this project the darkest colours are put down first – unlike pure transparent watercolour, where you have to work from light to dark. Establishing the dark colours first gives you a strong guide to follow for placing the individual elements of the scene. It also keeps the colours looking fresh and lively: light gouache colours contain proportionally higher amounts of chalk, which means that any colours that are put down on top of them may pick up some of the chalk and lose their clarity. Dark gouache colours, on the other hand, contain very little chalk, so any light colours that are put down on top of them will not pick up the chalk. Nonetheless, the chalk content of the paint also makes it ideal for this particular subject as it allows you to recreate the slightly matt surface of the crab shell.

Materials

- Watercolour board
- HB pencil
- Gouache paints: cadmium red deep, lamp black, raw sienna, phthalocyanine blue, cadmium red medium, cadmium yellow lemon, yellow ochre, cadmium yellow light, zinc white
- Brushes: fine round, medium round
- Cardboard
- · Pencil: red

The set-up

In terms of both its size and its colour the crab dominates the composition. The redand-white tablecloth and napkin echo the coloration of both the crab shell and the plate on which it is set; they also offer a contrast of texture. The lemons, with their slightly pitted outer skin, provide an interesting contrast of texture and colour.

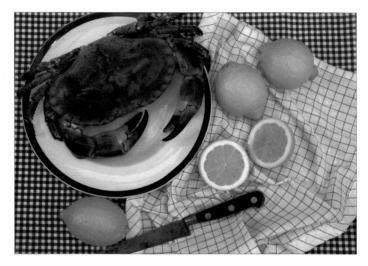

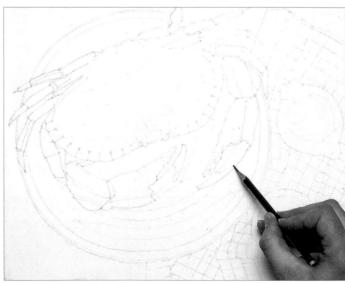

Using an HB pencil, make an underdrawing of your still-life set-up. It is easy to lose track of where you are in a painting like this, so make sure you put down all the information you are likely to need. The segments of the crab claws, the indentations on the shell, and the lines of the draped napkin are all useful guidelines.

 $2\,$ Mix a dark reddish brown from cadmium red deep, lamp black and raw sienna. Using a fine round brush, paint the darkest red of the crab shell and claws. Add a little more lamp black and some phthalocyanine blue to the mixture and paint the very dark tips of the claws. Mix lamp black and phthalocyanine blue together and paint the border of the plate. Leave to dry.

Mix a dark, brownish red from raw sienna and cadmium red medium. Using a fine round brush put in the next darkest parts of the crab claws, taking care to follow the hard-edged, angular shape of the segments. Switch to a medium round brush and begin to apply the same colour to the body of the crab, using the side of the brush to scrub on the colour.

A Spatter some of the brownish red mixture from Step 3 over the body of the crab and leave to dry. While you are waiting for the brown paint to dry, brush cadmium yellow lemon over the lemons in order to establish the base colour. Leave to dry.

5 Add more cadmium red deep and a little yellow ochre to the brownish red mixture from step 3 and paint more at the unit stell and selection. This is a slightly lighter and redder tone than the ones used to date; with the transition from dark tones to mid-tones, the three-dimensional form of the crab is becoming more evident.

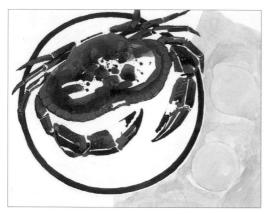

Add cadmium yellow light to the mixture to make it more orange and paint the lighter tones around the end of the shell and claws. Now start to put in some colour on the redand-white napkin on the right. Although it looks predominantly white, the white is not as bright and pure as the brightest areas on the plate, so mix a pale, yellow-tinged grey from yellow ochre, zinc white and a little lamp black. Using a medium round brush, brush the mixture over the napkin to establish the underlying colour. Leave to dry.

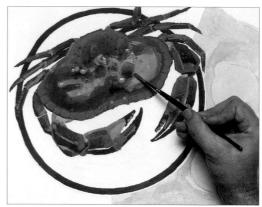

 $\begin{tabular}{ll} A dd some cadmium red deep to the orange mixture from the previous step and lightly dot it over the crab's shell. Leave to dry. \end{tabular}$

Tip: Study the crab shell carefully before you apply the paint. The indented areas are slightly darker in tone, and this helps you to convey the gently undulating nature of the hard shell.

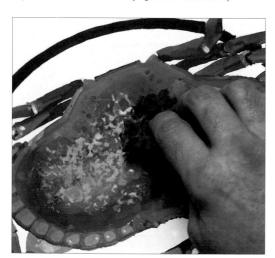

A Mix a very pale yellow from yellow ochre and white and, using a fine brush, paint the bright highlights on the shell – around the scalloped edge, for example. Mix a pale and dilute reddish orange from cadmium red medium and cadmium yellow light. Dip a clean sponge into the mixture and dab it over the shell to build up tone and texture. Leave to dry. You may want to repeat the sponging to build up more texture, but do not make any decision on this until you've seen how the first application looks.

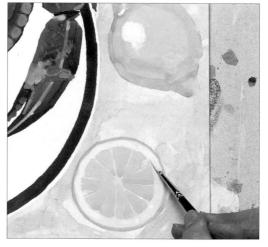

Mix a warm yellow from cadmium yellow lemon and a tiny amount of cadmium red medium and paint the lemon in mid-tones, leaving some of the underlying colour as the highlight, the outer rim of the cut lemon, and the segments of the cut lemon, with spaces between the segments. Paint the pith of the cut lemon in a mixture of cadmium yellow lemon and zinc white. Mix a greener yellow from cadmium yellow lemon with a little phthalocyanine blue and paint the shaded underside of the whole lemon.

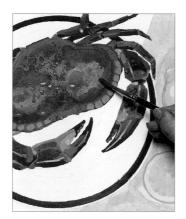

10 Continue building up texture on the shell, using the same mixtures as before. To create more tonal variation, dip a brush in clean water and scrub over any areas that you judge to be too dark, in order to soften the paint; you can then either lift off some of the paint, rinsing your brush periodically as you do so, or re-blend it.

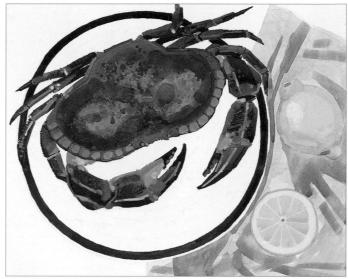

 $1\,1\,$ Using the same grey as before, block in the shadow areas on the napkin. Leave to dry. The cloth is now starting to look three-dimensional, as the folds in the cloth gradually take shape.

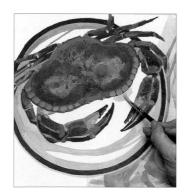

12 Mix a cool grey from phthalocyanine blue, lamp black and white and using a medium round brush, paint the shadows cast on the white plate by the crab's body. Use the same colour to paint the shadow cast by the plate itself.

Tip: Most people seem to find it easier to paint straight vertical lines than horizontal ones, so turn the painting around to paint the horizontal lines.

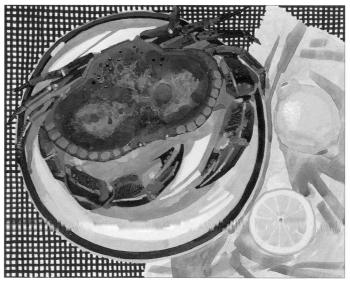

13 Add lots of zinc white to the shadow mixture to make a very pale grey and paint the remainder of the white plate, leaving a few of the very brightest highlight areas untouched. Using a fine brush, paint the vertical red lines of the redand-white cloth on which the plate sits; you may find it easiest to rest your painting hand on your other hand or on a straightedge to steady it. Leave to dry, then paint the horizontal lines.

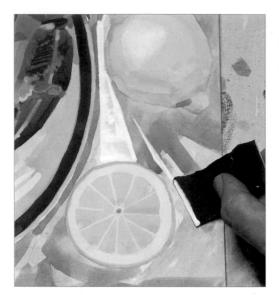

14 Dip the edge of a piece of cardboard in white paint and press it on to the support to create the highlights on the napkin, scraping and dragging it over the surface like a flat brush and "painting" around the shadows. This allows you to create sharp edges that would be harder to achieve with a brush.

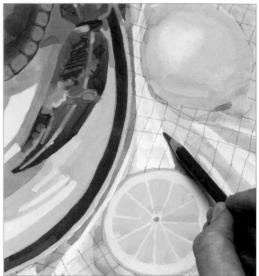

15 Draw thin red lines on the napkin with a red pencil, noting how the lines change direction with the folds in the cloth. The pencil marks are softer and thinner than you could achieve with a brush, which ensures that this area does not compete for attention with either the crab or the red-and-white cloth on the left of the image.

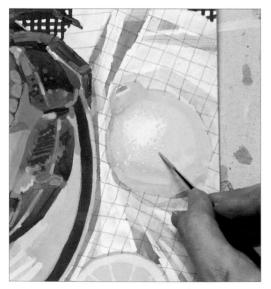

16 Using a fine round brush, stipple cadmium yellow light over the surface of the whole lemon to create the pitted texture of the skin.

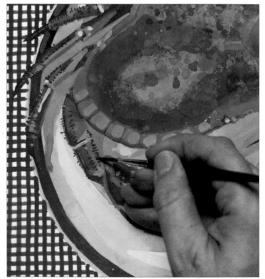

17 Mix a dark reddish brown from cadmium red, phthalocyanine blue and raw sienna and stipple it on to the crab claws for extra texture.

The finished painting

This is a richly textured still life that demonstrates the versatility of gouache. Although the composition is simple, it has been handled with skill. The colours are well balanced,

with the red of the cloths echoing the tones in the crab shell and the white of the plate and cloths and the bright yellow of the lemons offsetting the deeper tones used elsewhere.

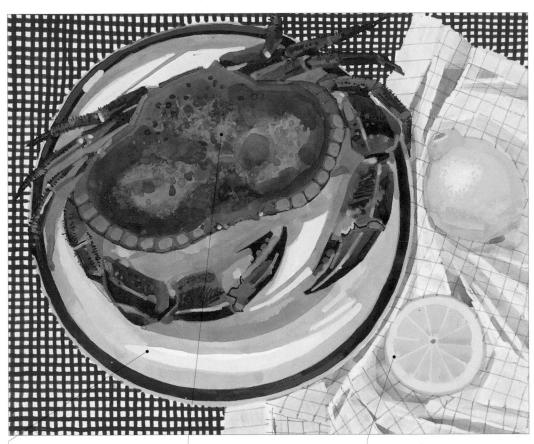

The brightest highlight areas on the plate are left unpainted.

The chalky, opaque nature of gouache paint is ideally suited to painting the pith of the lemon.

Painting Flowers and Leaves

From tiny meadow flowers growing in the wild to hot-house exotics such as orchids. flowers and leaves are an infinitely appealing subject to paint. The approaches to painting them are equally varied. If it's the subtle coloration of the blooms and foliage that appeals to you, or a particular species of flower, you might choose to concentrate on a single leaf or flower - or even to close in on one or two petals so that your work becomes semi-abstract. Bouquets of cut flowers allow you to explore a number of different blooms in the same arrangement. Alternatively, you might want to paint a floral landscape a field full of poppies or lavender, perhaps.

Whatever approach you take and whatever medium you are working in, start with the overall shape. Make studies in your sketchbook, looking at how the petals and leaves overlap, where the flower head sits in relation to the stalk, the size and shape of the leaves and so

on. The better you understand the structure, the better your painting will be.

Colour is undoubtedly one of the main reasons for painting flowers; the rich golds and russets of autumn leaves are stunning. If you are painting in oils or acrylics, thin glazes are a good way of conveying the delicacy of petals and leaves; the colours mix optically on the support, creating subtle blends that would be difficult, to achieve in the palette. The equivalent technique in gouache is to work thinly in semitransparent washes, allowing each wash to modify the wash beneath.

Working wet into wet in any medium will enable you to convey subtle shifts of tone. In gouache and thin acrylics, you can allow the colours to flow and merge on the support of their own accord; although the technique is somewhat unpredictable, with practice you will have more control. In thicker acrylics and in oils, working wet into wet allows the artist to blend the

paint on the support, feathering brushstrokes to create subtle transitions in tone.

Textures are important too. Exploit the full range of textural techniques at your disposal – drybrush work for linear details on petals or leaves, scumbling one colour over another, dabbing paint on thickly with a painting knife to convey a mass of small flowers.

If you're painting several flowers together, choose a viewpoint that allows you to see some of them from the side, rather than straight on. This makes it easier to see the structure of the bloom and make it look three-dimensional; it also makes for a more interesting painting.

Alchemilla and roses ♥

This lovely oil study effectively contrasts both colour and shape, the delicate and "frothy" stems of bright, yellowy green alchemilla providing a lovely foil to the more rounded forms of the roses.

Autumn day A

Here, the foliage makes a naturallooking frame for the church, the warm-coloured leaves enhancing the pale colour of the stonework.

Lovage, clematis and shadows ▶

In this scene, it the shadows cast by the stems, rather than the flowers that caught the artist's eye. They bring the painting to life

- Tip: Match the technique to the flower: use delicate wash or glazing LcLiniques for delicate flowers and more robust textural techniques for more substantial blooms.
- Subtle coloration, where one colour blends imperceptibly into another, is best painted using wet-into-wet techniques.
- Flowers and leaves have a strong underlying structure, which should always be shown. These structural differences are what separates one species from another.

Irises

You don't have to venture outside to create convincing nature studies: in this project, a vase of irises is painted to look like flowers growing in the wild. They have been given a background of subtle washes and brushstrokes of yellowy green that give the impression of a luxuriant flower meadow. The artist has also selected a low viewpoint, so that we feel as if we are lying down in the grass and looking through the stems. You could try the same approach with other relatively tall wild flowers, such as poppies.

This project also gives you the chance to explore an interesting means of creating subtle paint textures by pressing plastic food wrap into wet paint: who would have thought that something so mundane could be put to such creative use? The paint seeps into the crinkles in the food wrap; when it is completely dry the food wrap is removed, leaving behind linear marks that perfectly convey the delicate veining and papery texture of the flower petals.

You need to work quickly, while the paint is still wet, so tear off appropriately sized pieces of food wrap in advance. Stretch them out between your fingers and place them on the wet paint following the direction in which you want the lines to run. Tap them down gently with your fingertips – but do not rub, or you will smudge the paint. Above all, wait until you are sure that the paint is completely dry before you attempt to remove the food wrap. The technique is a little unpredictable, but that is part of its charm and the results more than repay the effort.

Materials

- 140lb (300gsm) rough watercolour paper
- · Pencils: 2B or water-soluble
- Acrylic paints: ultramarine blue, light blue violet, dioxazine violet, Hooker's green, medium yellow, Hooker's green deep, yellow ochre, titanium white
- Brushes: medium round; fine-tipped round or rigger
- Clear film (plastic wrap)
- Masking fluid
- Ruling drawing pen

The set-up

Place your flowers in a vase and experiment until you find an arrangement you are happy with. You will probably need to remove or add stems to get the effect you want, but remember to look at the spaces between the stems, as well as at the flowers, as the placement of the stems is an important part of the composition. You may also need to adjust the height of the vase in order to get the right viewpoint: the flower heads should be slightly above your eye level.

Nowadays, you can buy good-quality very convincing-looking artificial flowers. Although they do not have the same texture and subtlety of colour as real flowers, they can show you the botanical structure very clearly. If you are interested in painting flowers, it is also worth building up your own personal collection of gardening books and cuttings from magazines and seed catalogues to use as reference material for your paintings.

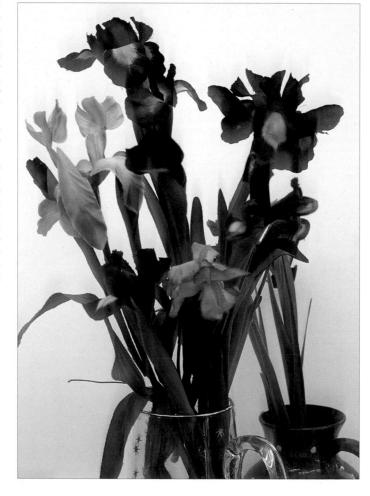

Lightly sketch the flowers in pencil. Here, the artist used a blue water-soluble pencil to delineate the flowers; the linear marks will disappear when paint is applied. However, an ordinary graphite pencil would work just as well.

2 Using a ruling drawing pen, stipple masking fluid into the flower centres and mask the edges of the leaves where they catch the light. Allow the masking fluid to dry completely. Working on one flower at a time, brush clean water over the petals. Drop a watery mixture of ultramarine blue and light blue violet into the damp area, adding a touch of dioxazine violet on the lower petals. The paint will spread within the damp area, and the colours will merge with no harsh edges.

3 Working quickly while the paint is still wet, stretch a small piece of clear film out in your fingers and press it gently but firmly on to the first petal. Make sure that you lay the film out so that it follows the direction of the striations in the petals.

Repeat the process until all the petals have been covered. Provided the wash is still wet, you can lift off the clear film two or even three times to reposition it if necessary, but remember that you will lift off paint every time you do this: take care not to get paint on to areas outside the petals.

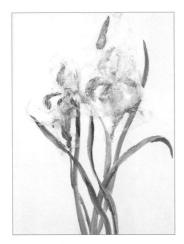

Begin painting the leaves in **)** Hooker's green, adding medium vellow for the lighter-coloured leaves. While the paint is still wet, brush a little dioxazine violet along the shaded lower edge of some leaves; this helps to show how the leaves twist and turn, and it provides a visual link with the colour of the flowers. Paint the papery sheathes at the base of the petals in a mixture of yellow ochre and Hooker's green and cover with plastic food wrap, taking care not to dislodge any of the food wrap from the petals as you do so.

When you are sure that the petals are completely dry, carefully peel off the food **O** wrap. Note how some of the paint has been blotted off, creating the delicate papery texture and veining that is so characteristic of iris petals.

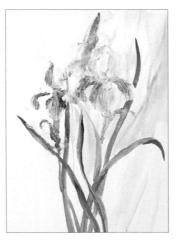

Mix a pale, watery yellow-green from medium yellow, yellow ochre, Tip: Colour is one of the ways in Hooker's green and a little light blue violet. Wet the background with clean water. Don't worry if some water goes over the painted areas; the paint will not lift off provided it is completely dry. With flowing, calligraphic strokes that imitate the shape of the leaves, brush the yellow-green mixture over the righthand side of the background. Paint a few more strokes in Hooker's green deep, which is darker, to imply that these leaves are closer to the viewer.

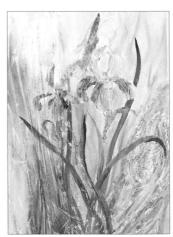

8 Add light blue violet to the previous yellow mixture and, as in the previous step, paint loose, leaf-like strokes to the left and right of the central flowers in order to create an atmospheric, but realistic-looking background. While the paint is still wet, apply plastic food wrap over these areas in exactly the same way as you did for the petals, stretching it taut from top to bottom so that it runs in the same direction as the leaves.

which you can imply distance in your paintings, as colours look paler the further away things are from the viewer. In this project, the use of different tones of green for the iris stalks and leaves makes it seem as if we are looking through a sea of waving stems and grasses, with only the flowers and leaves in the immediate foreground being in sharp focus and strong colour - a simple but effective technique.

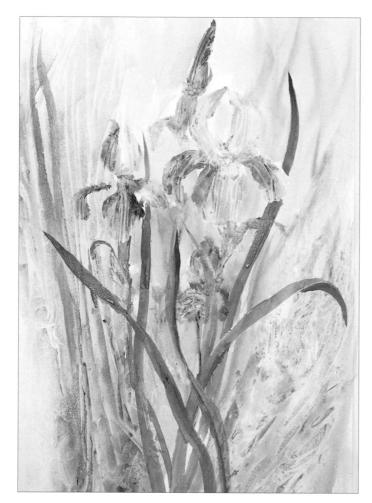

When the paint is completely dry, remove the plastic food wrap. In the space between the two main flowers, brush in the shape of another flower head, using a paler, bluer mixture of the previous flower colours. Because it is paler than the main flowers, it gives the impression of being further away. Leave to dry.

10 Using the same green mixtures as before, brush in more dark leaves in both the foreground and the background. Look carefully at the points where leaves overlap: it should be obvious which leaves are in front and which are behind.

1 1 Using the tip of the brush, paint fine lines of dioxazine violet on to the petals of the top right-hand flowers to reinforce the striations in the petals that were left when you pulled off the plastic food wrap. Your brushstrokes should be delicate squiggles rather than flat applications of colour, as this helps to create texture. Leave to dry, then rub off the masking fluid from the centres of the flowers.

Assessment time

Now it is time to assess exactly how much more work you need to do in order to complete the painting. At present, the flowers merge into the background because the colours are a little too pale: the tones need to be strengthened and darkened in order to make the flowers stand out more. In the final stages of a painting, it is often necessary to adjust the tones that you put down to begin with. The flowers are also somewhat soft and indistinct – the delicate textures created by pressing the clear film into the wet paint need to be reinforced with some careful and subtle brushwork. It would be very easy to overdo things and lose the subtlety of the painting, so mix and assess any darker tones very carefully before you apply them to the support and use a fine-tipped brush so that you can control where you place your brushstrokes.

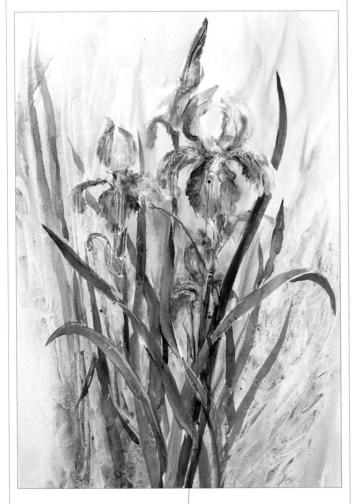

The flowers are too soft and indistinct.

12 Brush medium yellow into the flower centres. Strengthen the petal colour using the same ultramarine blue and light blue violet mixtures as before. Note that the upper petals are bluer in tone than the lower ones.

13 Mix a pale, opaque yellow from medium yellow and titanium white. Brush this into the spaces between the leaves where necessary to reinforce the shapes of the leaves.

The finished painting

This is a delicate study that captures the characteristics of the flower to perfection. The clever use of tone, with darker tones in the foreground and lighter ones further back, has created a convincing sense of depth. The papery texture of the petals is created through a combination of calligraphic brushstrokes and blotting off paint.

Soft yellows and greens provide a natural-looking background that allows us to concentrate on the flowers.

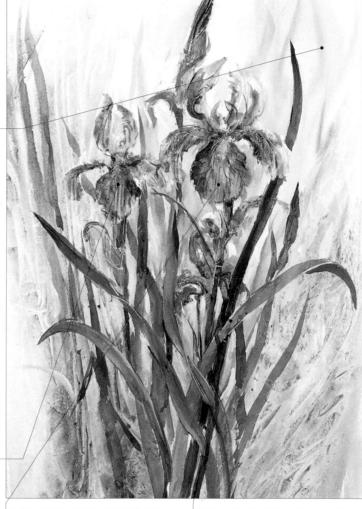

The vertical lines on the translucent petals are created by pressing plastic food wrap into wet paint and lifting it off when dry.

Calligraphic brushstrokes, made using only the tip of the brush, define the petal edges.

The leaves twist and turn over one another, enlivening the composition.

Floating leaf

A landscape doesn't have to be a grand, panoramic view that stretches far away to the distant horizon: little details, such as this brightly coloured leaf floating in a mountain stream, can be just as appealing and atmospheric.

Although this little stream and rocks might not, at first glance, appear to contain much colour, there are many subtle variations in tone, and it is essential that you take time to observe the scene closely and work out where these changes in tone occur.

This looks like a very simple scene, but in practice you would have to be very lucky to find a leaf floating exactly where you want it to be! However, one of the advantages of painting is that you can alter reality to make a better picture – so feel free to introduce a leaf where none exists in real life or to change the angle at which it lies across the stream to make a more interesting composition.

One of the advantages of using gouache for a scene such as this is that, because you can paint light colours over dark ones, you can put in the highlights on the sparkling water right at the end, when everything else is in place. If you were using pure, transparent watercolour, you would have to reserve the white of the paper for the highlights or scratch off paint using the tip of a craft (utility) knife, with the risk of damaging the surface of the support. With gouache, you can spatter on white paint for a random effect or dot it on with a fine paintbrush for a more controlled look. Use permanent white gouache for highlights: it has better covering power than zinc white, which is best reserved for mixing with other colours in order to lighten them.

Materials

- Watercolour board
- HB pencil
- Masking film (frisket paper)
- · Craft (utility) knife
- Gouache paints: cadmium yellow deep, sap green, ultramarine blue, flame red, indigo, Vandyke brown, permanent white
- Brushes: medium round, fine round, old toothbrush

The leaf ▶

Here, the artist decided to make a floating leaf the main centre of interest. It makes a bold splash of colour against the darkness of the water.

The stream ▼

When you are painting a moving subject, such as this flowing stream, a photograph can help you to capture the way the light plays on the scene.

Tonal sketch ▼

Making a tonal sketch helps you to work out the main areas of light and shade before you begin painting, although it does not have to be as detailed as the one shown here.

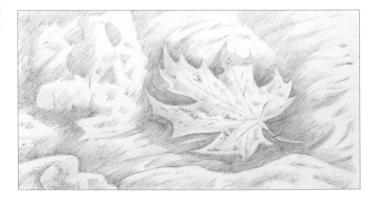

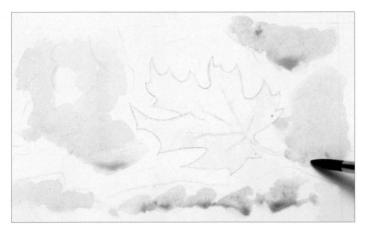

1 Lightly sketch the scene on watercolour board. Stick masking film (frisket paper) over the image and, using a craft (utility) knife, cut around the floating leaf. Peel the masking film off the rest of the image, leaving the leaf covered. Using a medium round brush and a dilute mix of cadmium yellow deep, paint the underwater rocks. Mix a dilute bluish green from sap green and ultramarine blue and dab it over the water area.

 $2^{\text{Continue dotting ultramarine blue}} \\ \text{over the water, brushing the colour} \\ \text{over the rocks and leaving the highlight} \\ \text{areas untouched. Leave to dry.} \\$

Tip: If you are worried about cutting into the board when you cut out the leaf for the mask, trace the entire underdrawing on to tracing paper and stick masking film over the trace. Put the trace on a cutting mat, cut out the mask, and position the masking film on the relevant part of the image.

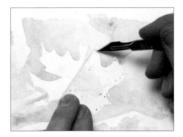

3 Using the tip of the craft knife to lift up the edge of the masking film, peel the film off the leaf.

A Mask off everything except the leaf. Brush very dilute cadmium yellow deep over the leaf. Add more pigment to the mixture and drop it into the centre of the leaf, allowing it to spread of its own accord. Brush flame red, wet into wet, around the edges.

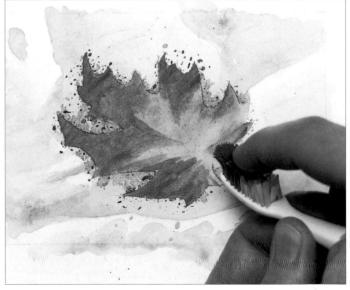

5 Brush flame red over the tips of the leaf, leaving the central portion of the leaf light yellow. Dip an old toothbrush into the flame red paint, hold it over the leaf, and gently pull back the bristles to spatter droplets of paint on to the leaf.

Tip: Practise on a scrap piece of board first until you are confident that you can make spatters the right size. Do not pull too hard: the spatters should be small.

6 Gently peel off the masking film to reveal the whole painting.

7 Mix a dark blue from indigo and Vandyke brown and, using a fine round brush, paint around the leaf and surrounding rocks. Brush small strokes of cadmium yellow deep over the rocks to deepen the tone.

Assessment time

The colours and shapes of the leaf and rocks have been established, as have the areas of water. This is a good start, but the image still looks rather flat and one-dimensional at this stage. There is little sense of depth, and it is a little hard to tell which rocks are above the water level and which ones are covered by the flowing stream. The painting is also rather static: there is also no real feeling of movement in the water.

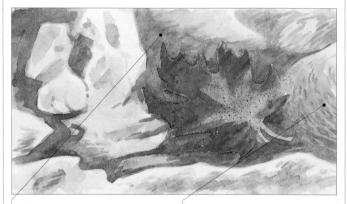

More sense of movement is needed in the water. This can be achieved with fine brush strokes

These rocks lack form. Greater definition of the rock and the water next to it will help.

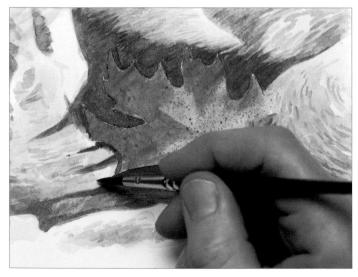

Susing a fine round brush, go over the water again with ultramarine blue paint, sharpening the outline of the leaf. With short brush strokes, brush a mixture of cadmium yellow deep and flame red over those areas of the rocks on the left that stick up above the water.

9 Using indigo, paint shadows on the rocks.

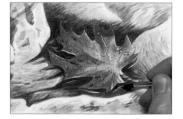

10 Brush small, curved strokes of permanent white into the water around the leaf to indicate ripples.

11 Mix together sap green and ultramarine blue and build up the texture in the strip of greenish water at the base of the image. Continue building up the tones and textures over the whole image. It is better to work across the whole painting than to concentrate on just one area, otherwise you risk overworking one part at the expense of the rest.

The finished painting

This is a simple little scene that many landscape artists might pass by in favour of a grander view. It is a study in contrasts – the softness of the water versus the solidity of the rocks, the vibrant colour of the leaf versus the muted tones of the water. The brushwork is controlled, with the brush strokes in the water following the direction of the water flow to create lifelike ripples. Note how the main centre of interest – the leaf – is positioned slightly off centre and at an angle to add interest to the composition.

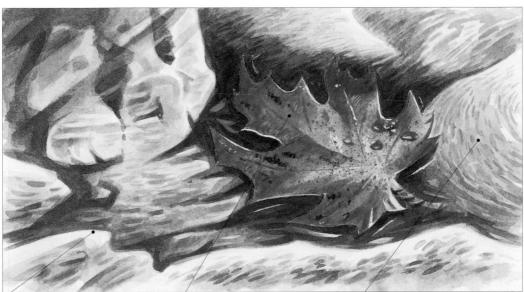

Water flows over the rocks in this area, and so the detail and texture are deliberately subdued.

Wet-into-wet spatters and wet-on-dry applications combine to create a lively texture on the leaf.

This rock stands clear of the water; more detail and texture are evident here than in the submerged rocks.

Tulips in glass vase

In this simple still life, a bunch of pink and green parrot tulips has been placed in a turquoise glass vase that complements their shape beautifully. When you paint a subject like this, with overlapping shapes and twisting stems, remember to look at the spaces between as well as at the flowers and stems themselves. Note, too, how the water in the vase distorts the shapes of the stems and how the semi-opaque glass affects the colours of anything seen through it.

In order for the form of the flowers to stand out, opt for a neutral, plain-coloured background. Here, the vase was placed on a window ledge in front of a sheer muslin curtain, which diffuses and softens the light it lets through, creating a subtle contre-jour effect. But even though the background is a plain colour, you will see that there are lots of tonal contrasts within it. Even the gentlest of folds in the

fabric will create shadows that you must render tonally. Try half-closing your eyes when you look at the scene, as this will subdue the detail and make it much easier for you to assess where the tonal changes occur.

One difficulty with painting cut flowers is that they either wilt and perish or turn upwards towards the light. You may find that your still life is not still at all: over a period of just a few hours, the flowers may droop and change position. If you're painting in oils, and creating a painting over a number of painting sessions several days apart, this can be a real problem. Work quickly in the early stages to make sure you capture the position, shape and colours while the flowers are at their best — or take photos for reference.

Another problem with this set-up is that natural light can change considerably over several sessions. As you can see from the

photographs below, in the first session the light was very overcast and uniform. During the final painting session a few days later, strong sunlight cast oblique shadows on the scene, and the artist incorporated them into the final painting to add drama and interest. This project, above all else, is an exercise in painting the effects of light.

Materials

- · Stretched and primed canvas
- Oil paints: olive green, raw sienna, viridian, yellow ochre, Indian yellow, lemon yellow, titanium white, madder lake, Caesar purple, cadmium red, cobalt blue, cerulean blue, phthalocyanine turquoise
- Turpentine
- Brushes: selection of small and medium filberts and sables
- Rag or kitchen paper

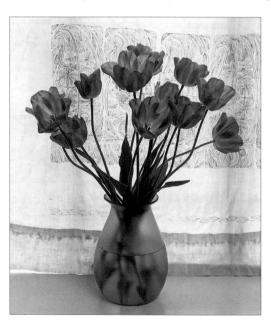

The set-up

A vase of spring tulips, loosely arranged, was placed on a window ledge. The light coming from outside, which was soft and uniform, was diffused still further by the semi-transparent muslin curtain. As a result, there are few shadows in the scene and the colours are muted.

Change in lighting

At the beginning of the final painting session, the sunlight outside was much stronger than it had been originally. The glazing bars of the window cast interesting oblique shadows on the muslin curtain, which the artist decided to exploit in the final painting.

1 Mix a dull brown from olive green and raw sienna. Using a small brush, draw the overall lines and shapes of the flowers and vase. Put in the glazing bars, which can be seen through the curtain, and the window ledge.

Tip: Put down guidelines, such as a vertical line through the centre of the vase. Turn your painting upside down to check the shapes. This makes it easier to see objects as geometric forms.

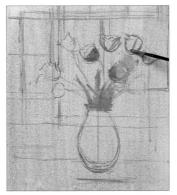

2 Mix greens for the leaves and stalks (viridian, yellow ochre and Indian yellow for the warmer dark and midtoned areas, and viridian, lemon yellow, and titanium white for the more acidic areas). Mix pinks for the flowers (madder lake and white, with a touch of blue for the cooler shades, and Caesar purple and white). Vary the proportions of the colours to give a good range of tones. Using a midtoned and a slightly bluer green, put in the stalks and leaves protruding from the vase. Start to block in the flowers.

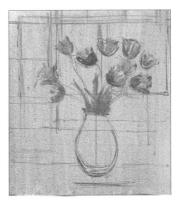

Acontinue to block in the flowers, adjusting the proportions of the colours in your mixes to get the right tone. Because of their position in relation to the light, some flowers are much warmer in tone than others: add a little cadmium red for these mixes. In others, where petals overlap, a deeper shade of purple can be seen. Work methodically and spend as much, if not more, time looking at your subject as you do looking at the canvas: you need to assess tones and colours continually as you work.

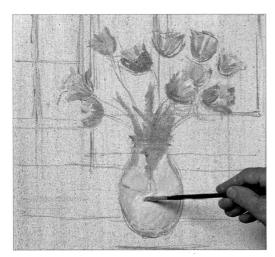

4 Using various dark greens, paint the stalks. Mix a bright blue from cobalt blue and titanium white and put in the darkest areas at the top of the vase, and the water line halfway up. Mix cerulean blue and white for the light blues in the top half of the vase, and a greener blue for the water.

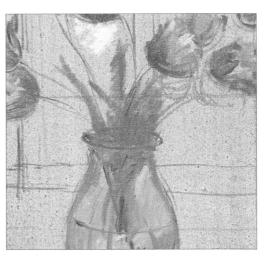

5 Paint the stems that are underwater, using a darker green. The shapes are slightly distorted by being seen through water; the colours are also softened by the opaque glass of the vase. You can create these effects by blending the green into the underlying wet paint.

6 Mix a pale, creamy brown colour by adding Indian yellow and white to the bright green that you used you used on the flower heads. Begin blocking in the dark panel in the centre of the muslin curtain behind the flowers, taking care not to obliterate the lines of the glazing bars completely.

7 Outside the central panel, the curtain is lighter in tone. Mix blue and white and scumble the colour on loosely, allowing some of the toned ground to show through to create the texture of the woven fabric. Paint more of the stems, noting how they twist and turn over one another.

At this point, the artist decided to alter some of the flowers on the left, as he felt that the painting was weighted too heavily towards the right-hand side. Because oil paint stays wet for so long, you can simply wipe it off with a rag soaked in turpentine and re-paint if necessary.

Assessment time

The basic elements and tones of the composition have been established, but more form is required. Both the vase and the flowers look rather flat at this stage and tend to merge into the background.

The flowers look flat and one-dimensional.

There is no sense of depth to the window ledge.

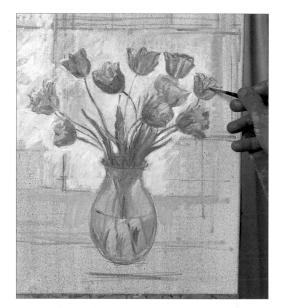

Ousing the tip of a small sable brush, sharpen the edges of the flowers to give them a crisp outline, and put in some linear detail on the petals, using a deep purplish pink and a bright, acidic green as appropriate. You can see that the flowers almost immediately begin to take on more of a sense of form and to stand out more clearly from the neutral-coloured background; they are no longer merely flat blocks of colour.

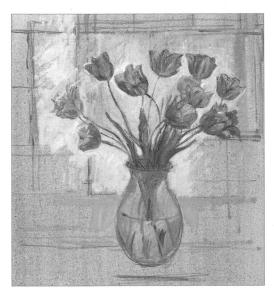

10 Continue to refine the details, working on the tonal changes within the petals to create some sense of depth and form. As before, half-close your eyes as you look at the scene, to see where the changes in tone occur.

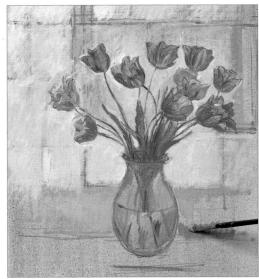

1 1 Paint the deep hem of the curtain in the same mixture that you used for the central panel. The darker colour means that the flowers have something to register against. Don't obscure the glazing bars; they will be reinforced later.

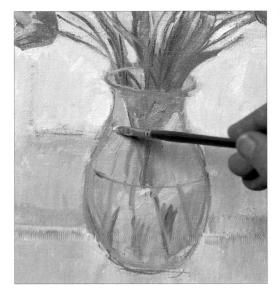

12 The vase is reflected in the window ledge. Put in this reflection, using slightly curved brushstrokes that echo the form of the vase, and leaving some gaps to create the effect of shimmering light. Work more pale blue into the vase interior, carefully painting around the flower stems.

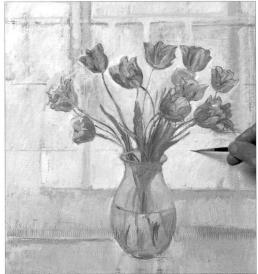

13 Using the same neutral background colours as before, work around the vase, sharpening the edges and softening any areas that are overly blue. Using a pale, neutral blue-grey, strengthen the glazing bars that can be seen through the fabric.

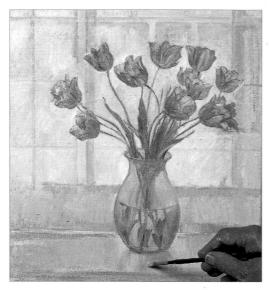

14 Strengthen the greens of the stems in the water. Look at the negative spaces between the stems as well as at the stems themselves. Reinforce the shadow cast by the vase on the window ledge.

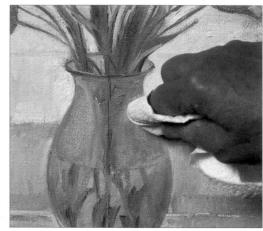

15 At this point, the artist realized that the shape of the glass vase was not quite right. He also felt that the blue he had used for the vase was not vibrant enough. Because the paint was still wet, he was able to scrape it off with a knife and repaint, using a mixture of phthalocyanine turquoise and white. He then wiped off some of the turquoise paint with a piece of absorbent paper to soften the colour and create the effect of light being diffused through the glass.

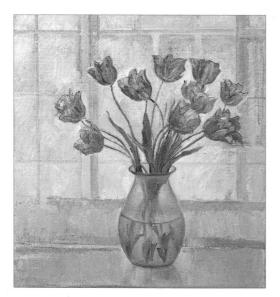

16 Gently stroke a paler version of the phthalocyanine turquoise and titanium white mixture used in Step 15 over the top half of the vase, blending the colours wet into wet, to heighten the effect of soft, diffused light coming through the glass.

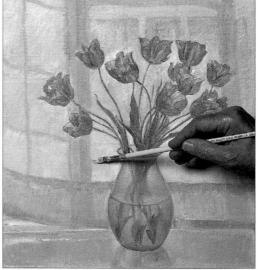

17 In the final stages, the lighting changed. Mix a range of greys from cobalt blue, white and a little Caesar purple and put in the shadows cast by the glazing bars. Warm up the neutral background mixture by adding Indian yellow, and scumble it over the background.

The finished painting

This is a charming study in the effect of diffused and reflected light. The texture of the translucent petals and the opacity of the blue vase have been beautifully captured in soft blends of colour. Loose scumbles of various warm- and cool-toned neutral mixes convey both the texture of the muslin curtain and the effect of light shining through it.

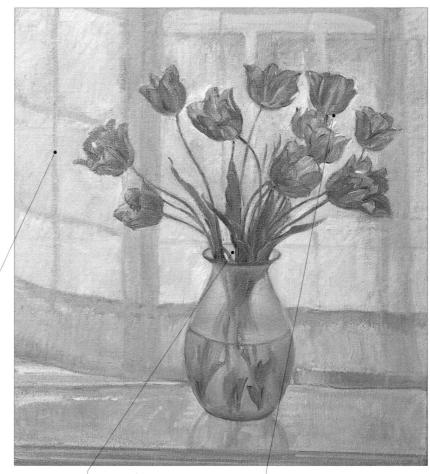

The glazing bars can still be seen through the curtain, although their shadows are more prominent.

The glass distorts the shapes and softens the colour of any objects that can be seen through it.

Linear details applied using the tip of a fine brush help to bring the flowers forwards in the scene.

Woodland path

This project is about interpreting what you see and conveying the mood of the scene, rather than making a photorealistic rendition. That does not mean that observation is not important, however. When you are painting a scene like this, look at the overall growth patterns. Are the tree trunks tall and straight or do they lean at an angle? Do the branches droop and spread on either side of the trunk, like weeping willows, or is the foliage weighted towards one side, like maples and Scots pines? Is the shape of the tree basically conical (like many conifers) or rounded (like oaks)?

Look at where the shadows fall, too – and remember that the shape made by

the shadows should match the shape of the objects that cast the shadows. Above all, make sure that the shadows are dense enough, as the contrast between the dark and the brightly lit areas is what gives the work a three-dimensional quality.

This scene also gives you the useful opportunity to explore many different textures – the tangled undergrowth and criss-crossing branches, the rough texture of the path and the peeling bark on the trees. Again, try to capture the mood rather than placing every detail precisely. Spatters of paint convey the rough texture of the ground, while the colour of the tree trunks and the patterning of the bark call for more carefully placed brush strokes.

Here the artist also added a few small pieces of collage in the final stages. This is optional, and you may think that the image does not need it; however, provided you do not overdo things it is well worth experimenting with simple techniques like this, as they can bring an added dimension to your work.

Materials

- Watercolour paper primed with acrylic gesso
- 4B pencil
- Masking fluid
- Medium-nibbed steel dip pen
- Gouache paints: phthalocyanine green, brilliant yellow, raw umber, raw sienna, zinc white, scarlet lake, jet black, phthalocyanine blue
- Brushes: large wash, small round, old toothbrush
- Newspaper
- · Gum arabic

The scene

Although there is no real focus of interest in this scene, the textures and the contrasting shapes (the sweeping curve of the path against the strong vertical lines of the tree trunks) make it very rewarding to paint. The shadows over the foreground also add interest.

1 Using a 4B pencil, sketch the scene, putting in as much detail as you feel you need. Your underdrawing will help you to keep track of where things are once you start applying the paint.

Tip: You do not need to get all the branches in exactly the right place in your underdrawing, but you should try to be faithful to the general patterns of growth and the rhythms of the scene. Although this is a fairly loose, impressionistic painting, it must look convincing — but it is also important to try to capture a sense of spring-like growth and energy in the scene.

2 Using a medium-nibbed steel dip pen and masking fluid mask the lightest trunks and branches. Also mask any branches that are lighter than their immediate surroundings, even if they are brown in colour rather than a light, silvery grey. Using an old toothbrush, spatter some masking fluid over the undergrowth. Leave to dry: this won't take long, but it is essential that the masking fluid is completely dry before you apply the first washes of colour.

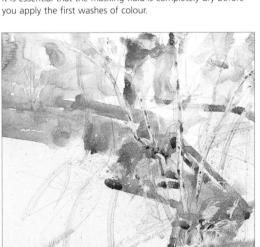

A Mix a dilute, bright green from phthalocyanine green and brilliant yellow. Using a large wash brush, put in broad horizontal strokes for the band of undergrowth that runs across the centre of the scene. Mix a duller green from phthalocyanine green and raw umber and repeat the process in the foreground. For the tree trunks in the background, put in vertical strokes of raw sienna and raw umber, occasionally adding some green to them.

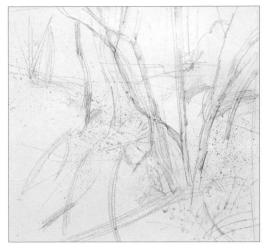

Before you begin the painting stages, take some time to make absolutely sure that you have masked all of the light-coloured areas of branches and foliage that need to be protected. Even though gouache is opaque and it is perfectly possible to paint light colours over dark ones, such corrective measures should only be used as a last resort – otherwise you run the risk of losing some of the freshness and spontaneity of the painting.

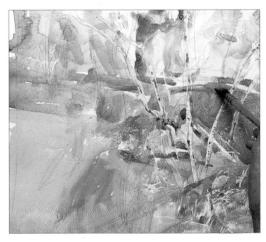

5 Mix a dilute yellowish brown from zinc white and raw umber and brush the mixture lightly over the earth in the foreground, allowing some of the support to show through to create some texture in this area. The earth on the far right, behind the band of undergrowth, is warmer in tone, so paint this in raw sienna. While the paint is still wet, touch a little scarlet lake into it so that it spreads of its own accord.

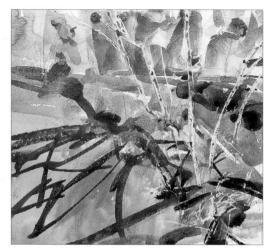

6 Mix a very dark greenish black from jet black, phthalocyanine blue and phthalocyanine green and paint the little stream in the background. Add raw umber to the mixture and paint the cast shadows on the ground.

Add more phthalocyanine green to the mixture and paint the shapes of the trunks in the background. Using the bright green mixture from Step 4, spatter colour over the foreground for the low-growing plants alongside the path.

Roughly cut masks from newspaper the same shape as the largest cast shadows on the ground and lay them in position. (There is no need to stick them down.) Mix brilliant yellow with white," load an old toothbrush with the mixture, and spatter it over the foreground, pulling the bristles back with your fingertips.

9 Repeat the spattering process with a mixture of white and raw umber to create the rough, pebbly texture of the path in the foreground. When the paint is dry, remove the newspaper masks: the scene is now beginning to take on more depth and texture.

10 There are some warm, pinkish tones on the path, so mix scarlet lake and white and lightly spatter a little of the mixture over the foreground.

Leave to dry completely, then rub off all the masking fluid.

Tip: When you have removed a little of the masking fluid, squash it together into a ball and rub it over the surface of the painting like an eraser. Any remaining fluid will stick to it — and it is a lot easier on your fingertips.

Assessment time

Now that you have removed the masking fluid, it is easier to see what must be done to complete the painting. Although the general shapes are all there, at this stage the painting lacks depth: you need to increase the density of the shadows.

The exposed areas are too stark and bright and contain no detail.

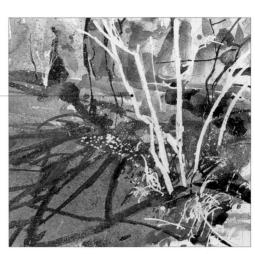

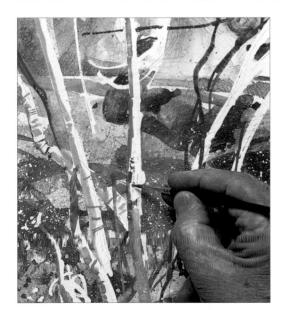

1 1 Mix a pale brown from raw sienna and white. Using a small round brush, paint the shaded sides of the exposed tree trunks. Add raw umber to the mixture and paint the shadows cast on the tree trunks by other branches.

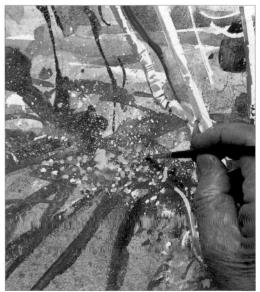

 $12\,$ Mix brilliant yellow with a little phthalocyanine green and, using a small round brush, dot in the yellow flowers in the undergrowth, making the distant dots slightly smaller than those in the foreground.

13 Using various versions of the dull green mixture from Step 4, paint the exposed grasses on the bottom right of the painting, keeping your brushstrokes loose and flowing.

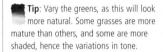

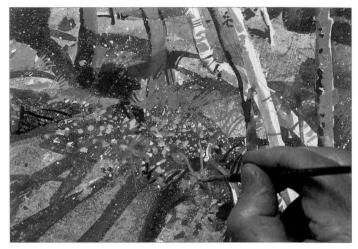

14 The yellow flowers in the centre look a little too vibrant, so tone them down by dotting some of the dull green mixture from the previous step into this area. Put in some solid areas of green, too, obliterating the exposed whites and reestablishing any shadow areas that have been lost on the grasses. Using mid-toned browns, reinforce the lines of trunks in the background.

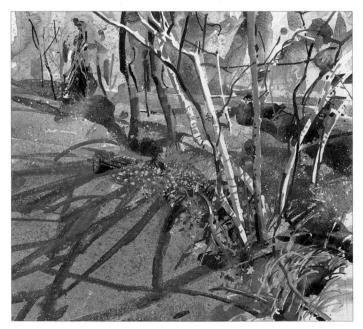

15 You might consider the painting finished at this point, but here the artist decided to enhance the three-dimensional quality of the upper part of the image by incorporating a little collage. If you do this, take care not to overdo it, or the result could end up looking messy and overworked.

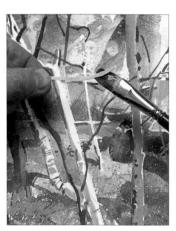

16 Paint strokes of branch-coloured paint on a piece of scrap paper and leave to dry. Cut out curving, branch-shaped pieces and brush a little gum arabic on to the reverse side. Position the pieces on the painting and brush gum arabic over the top to fix them in place. Leave to dry. (The advantage of using gum arabic is that, unlike ordinary glue, it can be painted over if necessary.) The collage element adds depth and texture to the image.

The finished painting

This is a lively and atmospheric painting of a woodland path in dappled sunlight. The strong vertical lines of the tree trunks and the diagonal lines of their shadows give the picture a feeling of energy that is echoed by the textural

details and bold applications of colour. The palette of colours chosen by the artist is muted but natural looking. Although the scene looks deceptively simple, there is much to hold the viewer's attention.

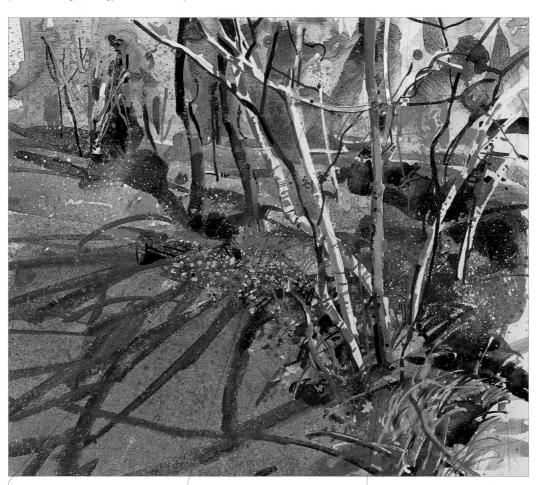

Spatters and dots of colour convey the texture of the path and the tiny flowers.

The use of collage on some of the branches is subtle but effective.

Carefully placed brushstrokes are used for the grasses and tree bark.

Painting Animals and Birds

One of the most obvious difficulties of painting animals and birds is that, unlike people, they cannot generally be persuaded to sit still. However, with relaxed subjects such as a sleeping cat or dog or a rabbit held in its owner's arms, you stand at least some chance of being able to put down the basic lines of the 'pose' before the animal moves. Sketching a family pet that you already know well is a good introduction to animal painting.

When you feel ready to paint moving animals and birds, spend time simply watching them, without even attempting to put brush to canvas. You'll soon see patterns emerging – the way a cat licks itself clean, or a dog sniffs at the ground, or a caged bird hops from one perch to another, for example. Try to fix these movements in your mind so that you can

incorporate them into your paintings. Reference photos may help, provided you don't rely on them too much – but there is no substitute for sketching from life, even though your first attempts will probably not be very successful.

A little knowledge of basic anatomy is a great help, just as it is when you're painting people. Knowing the names of all the joints and muscles won't get you very far, but having some idea of how the joints are articulated or the sequence in which an animal's legs move will. Until the early days of photography, for example, jumping horses tended to be depicted with their front legs stretched out in front and the back legs stretched out behind; think of the paintings of George Stubbs (1724–1806). Now we know that they launch themselves off their back legs with

their front legs brought close to the body and tucked in tightly.

When it comes to painting feathers and fur, aim to convey a general impression rather than capture every single hair, otherwise your painting will look fussy and overworked. Painting wet into wet is a good way to achieve this as you can work a second fur colour into or over a first to create subtle blends on the support. Drybrush is also a good technique for rendering fur and feathers, especially when used with a fan blender.

Swans ▼

The ripples in the water and the sparkling sunlight give this painting a lovely sense of movement. Note how many different tones have been used to paint the birds' white feathers.

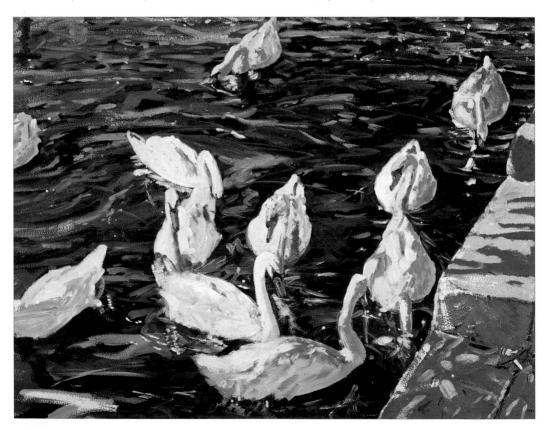

- Tip: The more time you spend observing animals, the better your paintings will be. Make quick sketches
- Animal and bird movements are often repetitive. Analyse this so that you call anticipate what the animal is likely to do, as this will make it easier to draw them.
- As with human portraits, the eyes are very important: get their position and shape right and you're well on the way to a successful portrait.

Studio window reflected A

Anyone who owns a cat will recognize this as a typical cat "pose" – legs sprawled out, head erect unit ruin pricked for the slightest sound. Quick sketches of such poses made while the animal is at rest are a good way of capturing its character and personality.

Turning fish ▶

The artist has skilfully conveyed the movement of the fish with his treatment of the light shining on the water and the ripples on the surface.

Sleeping cat

It is lovely to be able to put your painting skills to good use to paint a portrait of a cherished family pet. Because you know your animal so well, you will easily be able to find a pose that sums up its character and personality, and a painting like this would make a wonderful gift for another family member. Here, the artist combined a quick snapshot of the sleeping animal with a background of brightly coloured leaves from his garden.

There are several ways to approach painting fur. In a water-based medium such as acrylic, you might choose to apply loose, impressionistic washes of colour wet into wet, so that the the paint blends on the support to create subtle transitions from one tone to another, perhaps lifting off colour with clean water to create lighter-toned areas. In this project, we build up the colour in thin glazes, gradually darkening the shaded areas until the right density is achieved, with each layer of paint being allowed to dry before the next one is applied. Use short brushstrokes that follow the direction in which the fur grows, and an almost dry and very fine brush. This creates the impression of individual strands of hair and is a particuarly effective way of conveying the texture of the fur.

The project also gives you the chance to practise masking. Because you need to mask out large areas in the early stages of the painting, use masking film (frisket paper) rather than tape or fluid. Masking film is used by draughtsmen and is available from most good art supply stores. To ensure that the film adheres firmly to the support and that no paint can seep under the edges, choose a smooth surface, such as illustration board.

Materials

- Illustration board
- Masking film (frisket paper)
- · Craft (utility) knife
- Gouache paints: cadmium yellow deep, flame red, burnt sienna, Vandyke brown, indigo, permanent white
- · Brushes: medium round, fine round

The cat

The artist used this photograph as reference material for the cat's "pose" and the colour and texture of its fur. However, the striped wallpaper does not make a very attractive background.

The background

These leaves provided a colourful and natural-looking background against which to position the cat.

Compositional sketch

When you are combining two or more references in a painting, you must give some thought to the relative scale of the different elements. Make a quick sketch, in colour or in black and white, before you begin painting.

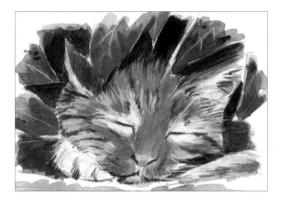

Tonal sketch

This cat is predominantly ginger in colour, but there are many different tones within the fur. Making a tonal sketch in pencil or charcoal enables you to work out not only the different tones but also the composition of your painting.

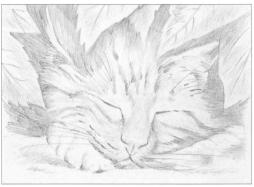

Referring to your initial sketch, lightly draw the cat using an HB pencil, indicating the main clumps of fur. Draw the veins on the leaves. Place masking film (frisket paper) over the sketch and, using a craft (utility) knife, cut around the outline of the cat. Peel away the masking film that covers the leaves.

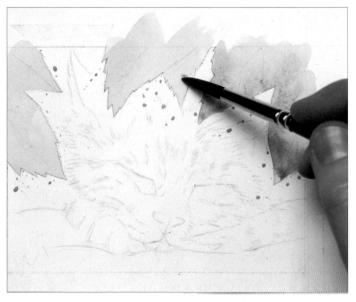

2 Using a medium round brush, brush cadmium yellow deep gouache paint over all the leaves to establish the underlying colour. While the paint is still wet, rinse your brush in clean water and drop flame red over the tips of the leaves. The two colours will combine wet into wet to make a warm orange, creating soft-edged transitions of colour. It is important that you leave the paint to dry completely before you move on to the next stage; like watercolour, gouache paint dries very quickly, so this should only take a minute or two, but if you want to speed up the drying time, you can use a hairdryer on a warm setting. Hold the dryer well away from your painting so that you do not accidentally blow the red paint away from the tips and into the centre of the leaves.

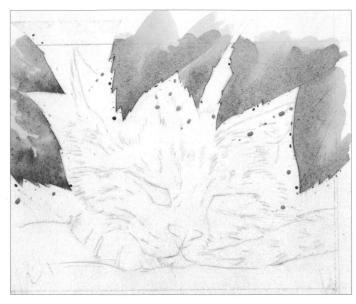

When you are sure that the paint is completely dry, carefully peel the masking film back from the cat. You can see how the leaves have crisp edges: it is easy to achieve this using a mask.

3 As you can see, the yellow and red merge together on the support in a way that looks completely natural. It does not matter if the colour is darker in some parts of the leaves than in others.

5 Mix a warm, yellowish brown from cadmium yellow deep and burnt sienna. Using the medium round brush, brush this mixture over the cat, leaving the white fur untouched. Your brushstrokes should follow the direction in which the fur grows. Leave to dry.

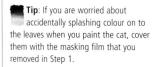

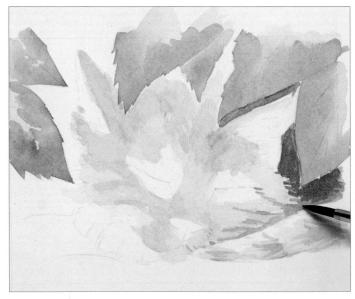

6 Mix a rich, chestnut brown from burnt sienna and Vandyke brown. Using a fine round brush, put in the dark fur on the cat's face, again using short brushstrokes that follow the direction in which the fur grows. Mix a darker brown from Vandyke brown and indigo and paint the dark fur around the edges of the ears.

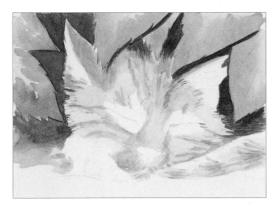

7 Use the same colour to paint the dark spaces between the leaves, so that the individual leaves stand out clearly.

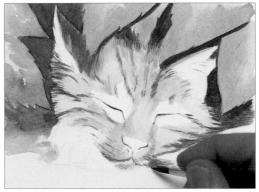

8 Using Vandyke brown and the tip of the brush, start putting in the dark brown markings on the cat's face.

Assessment time

Brush a dilute version of the cadmium yellow deep and burnt sienna mixture used in Step 5 over the non-white areas of the cat's face to warm up the tones overall. The painting is starting to take shape but more detail is needed to bring out the roundness of the face and the texture of the fur.

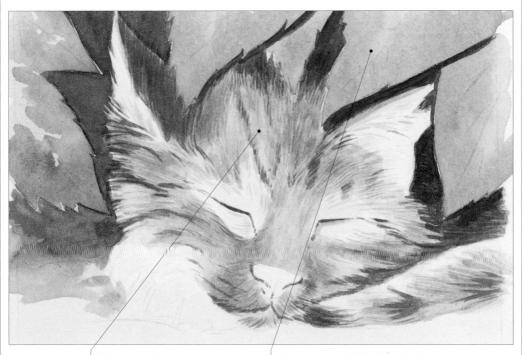

The fur contains little texture.

The cat merges with the background; the leaves do not yet look like leaves.

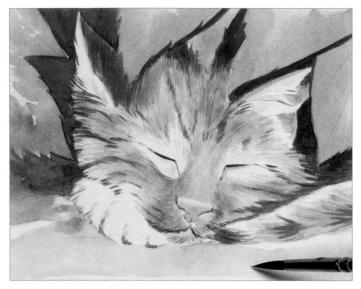

10 Mix flame red with a little cadmium yellow deep. Using a medium round brush, brush this colour over the leaves, allowing some of the original pale yellow colour to show through as the veins in the leaves.

Mix a very pale pink from flame red and permanent white and brush it on to the tips of the ears, which are slightly pink, and the tip of the nose. Using the Vandyke brown and indigo mixture from Step 6, put in the dark spaces between the claws. Add more water to the mixture. Brush clean water over the foreground and dot the indigo and Vandyke brown mixture into it.

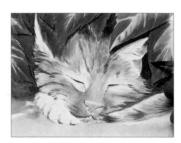

11 Using the same mixture, build up the intensity of the red, taking care not to go over the veins.

Tip: Remember that gouache looks slightly darker when it is dry than it does when it is wet, so wait until the paint is dry and assess its colour before you add another layer. It is better to build up the density of colour gradually: if you make the leaves too dark, they will overpower the cat, which is the main focus of the painting.

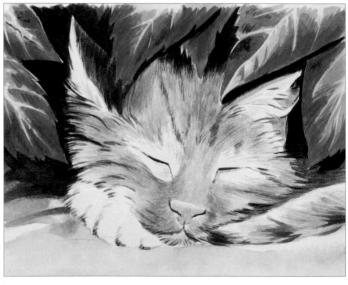

12 Using the indigo and Vandyke brown mixture, deepen the colour of the leaves. Note that the edges of the leaves are slightly serrated; use a fine brush to paint the serrations. Use the same colour to darken the very dark fur markings and the outlines of the mouth and nose.

The finished painting

This is a slightly whimsical but very appealing painting of a cherished family pet in a characteristic "pose". The leafy background provides a colourful foil for the animal and focuses attention on its face, while delicate brushwork captures the texture of the fur.

Here, the artist has used white gouache and a very fine brush to put in the whiskers and more fur texture in the final stages. It is up to you how much detail you put in: you might choose to build up the tones and textures more than has been done here.

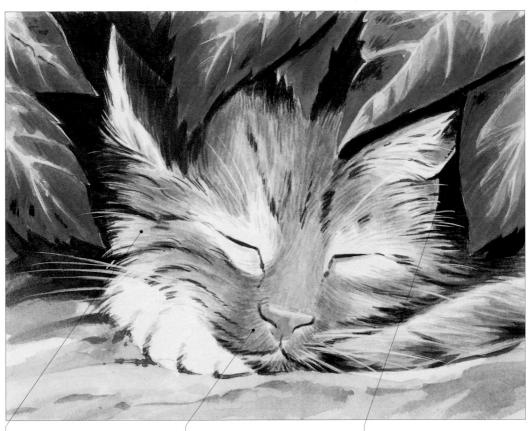

The texture of the fur has been built up gradually, using fine brushstrokes that follow the direction in which the fur grows.

Small details – the pink of the nose and the outline of the mouth – convey the character of the sleeping cat.

The richly coloured, textured autumn leaves provide a simple but dramatic backdrop to the portrait.

Farmyard chickens

Whether you are painting wild or domesticated animals, it is interesting to paint them in their environment – in this case, a corner of a farmyard, where the chickens are allowed to range freely, pecking at grain.

Before you begin painting, spend time observing how the chickens move. Although you might at first imagine their movements to be completely random, you will soon see a regular pattern emerging - a staccato rhythm of strutting and pecking, stabbing at the ground to pick up grains of wheat before throwing the head back to swallow. Try to fix this rhythm in your mind, as it will help you to anticipate what the bird is likely to do next. Look, too, at the way the movement of the head and legs affects the rest of the bird's body: when the head is tilted down, the rest of the body tilts up - and vice versa. Regardless of whether you are painting from life or from a photograph, accurately capturing the angle of the body in relation to the head will give added veracity to your work.

This project also gives you the opportunity to practise a number of different ways of capturing texture in acrylics. By applying very thin layers of paint in glazes, you can build up the slightly uneven coloration of the rusting cartwheel in the background, while the woodgrain on the wheelbarrow is painted using just the tip of the brush. Spatters of paint on the gravelled area in the foreground and thick dabs of paint applied to the chickens with a painting knife also add textural variety to the painting.

Materials

- 300gsm (140lb) NOT watercolour paper
- HB pencil
- Masking fluid
- Ruling drawing pen
- Acrylic paints: yellow ochre, raw sienna, burnt sienna, cadmium orange, cadmium yellow, Hooker's green, burnt umber, light blue violet, violet, cadmium red
- · Brushes: medium chisel or round
- Small painting knife

The scene

Although this is an attractive scene, with lots of detail, the colours are a little subdued. The artist decided to boost the colours a little and make more of the sense of light and shade in her painting, in order to make a more interesting and better balanced picture.

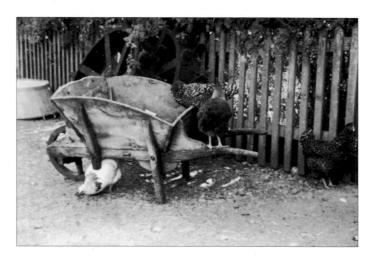

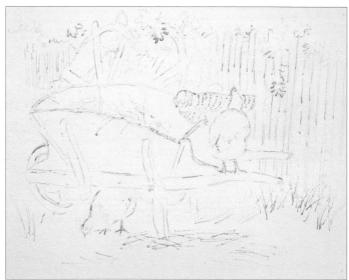

1 Using an HB pencil, make a light underdrawing of the scene to use as a guide. Dip a ruling drawing pen in masking fluid and outline the chickens. Mask out the lightest areas – the white dots on the chickens' feathers, the bright wisps of straw on the ground, and the brightest bits of foliage. Leave the masking fluid to dry completely.

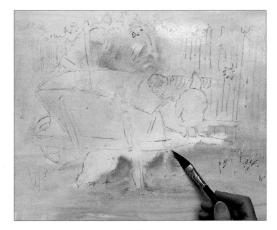

2 Mix up a dilute wash of yellow ochre and another one of raw sienna. Using a medium round brush, wash yellow ochre over the side of the wheelbarrow and the background foliage. Loosely brush raw sienna over the foreground, which is darker than the rest of the image. These two loose washes of warm colour establish the overall colour temperature of the scene.

Brush raw sienna over the fence posts. Add burnt sienna to the mixture and paint the triangular-shaped wedges inside the background cartwheel. Use the same mixture for the shaded portion of the wheelbarrow wheel and for the wooden supporting struts and handle of the barrow. In effect, what you are doing in these early stages is making a tonal underpainting of the scene.

A Brush a dilute mixture of cadmium orange over the straw lying in the wheelbarrow and on the ground, using short brushstrokes. Brush the same colour over the spokes of the cartwheel and the body of the brown hen perched on the wheelbarrow handle. Add more pigment to the mixture and paint the brown lien's liead.

5 Mix a yellowy green from cadmium yellow and a little Hooker's green and wash this mixture over the bushes behind the fence. Add a little burnt umber to the mixture in places to get some variety of tone. Leave to dry.

6 Mix a dark green from Hooker's green and burnt sienna and dab this mixture over the bushes, twisting and turning the brush to create leaf-shaped marks and allowing some of the underlying yellowy green from the previous step to show through. Note that some of the foliage pokes through the gaps and obscures part of the wooden fence posts.

Mix a purplish grey from light blue violet and burnt sienna and paint the shaded wheelbarrow interior and the shaded parts of the fence posts.

Tip: Neutral greys can be created by mixing together two complementary colours. This scene is relatively warm in temperature, and therefore two warm colours (light blue violet, which is a warm, red-biased colour, and burnt sienna, a warm reddish brown) were combined to produce the shadow colour. For a cool shadow colour (a snow scene, for example), mix cool, blue-biased complementaries.

A Mix a warm grey from violet and a little Hooker's green and paint the grey chicken on the wheelbarrow, leaving the beak untouched. Add burnt sienna to the mixture and paint the dark shadow areas inside the cartwheel and on the struts of the wheelbarrow.

Paint the dark feathers of the white chicken in light blue violet and brush the same colour loosely over the grey chicken on the wheelbarrow to create some variety of tone in its feathers. Mix a warm brown from burnt sienna and cadmium orange and paint the rim of the cartwheel. Brush burnt sienna over the body of the brown chicken on the wheelbarrow, allowing some of the underlying colour to show through. Splay out the bristles of the brush and brush thin lines of burnt sienna over the foreground.

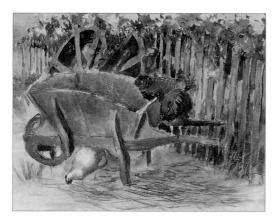

10 Paint the chicken combs in cadmium red. Mix a very dark green from violet and Hooker's green and dot this colour into the foliage, wherever there are really dark leaves or shaded areas. The different tones of green help to create a feeling of dappled light in the foliage.

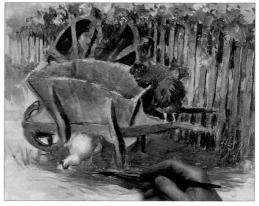

1 1 Mix a purple shadow colour from violet and light blue violet, adding lots of water so that the mixture is very dilute, and brush this colour over the shadowed area underneath the wheelbarrow. When this is dry, brush thin, straw-like strokes of yellow ochre over the foreground.

Assessment time

Rub off the masking fluid. At this stage, the painting still looks rather flat and lifeless; the wheelbarrow and chickens do not stand out sufficiently from the

background. You need to add more texture to both the foliage and the foreground areas and increase the contrast between the light and dark areas.

Stronger tonal contrast is needed in the foliage to help create a sense of light and shade.

More texture is needed – particularly on foreground elements such as the wheelbarrow.

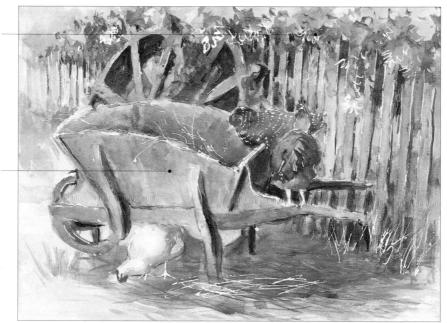

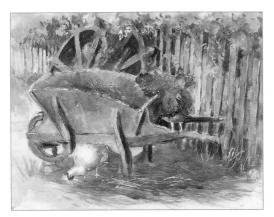

 $12\,$ Mix a very dilute yellowy green from cadmium yellow, Hooker's green and a little yellow ochre and brush the mixture over the greenery at the top of the image to warm it a little. Brush pale yellow ochre over the exposed straw in the wheelbarrow and in the foreground. Brush very pale light blue violet over the gray chicken to tint the exposed dots.

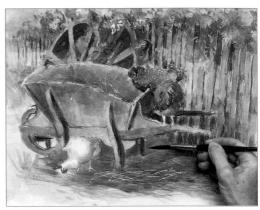

13 Brush the purple shadow colour from Step 11 over the foreground to deepen the shadows and improve the contrast between the light and dark areas.

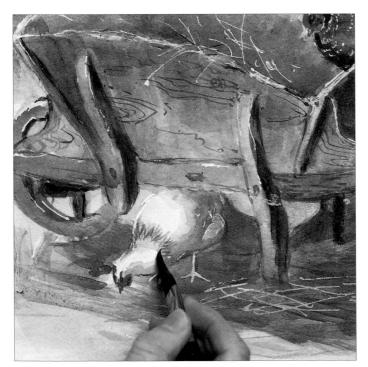

 $14\,$ Mix a dark brown from burnt sienna and violet and, using the tip of the brush, "draw" in the wood grain on the wheelbarrow. Use the same colour to paint the "ruff" of dark feathers on the white chicken in the foreground.

15 Spatter dark brown mixture over the foreground. Use the same colour to paint dark feathers on the brown chicken. Mix cadmium yellow with yellow ochre and apply light, textured strokes to the foreground.

 16° Dot thick white paint over the grey chicken's body and yellow ochre over the brown chicken's body.

The finished painting

This is a charming farmyard scene that exploits the versatility of acrylics to the full. The paint on the rusty metal cartwheel and wooden wheelbarrow is applied in a similar way to watercolour – in thin layers, so that the colour and subtle

variations in tone are built up gradually. Elsewhere – on the bodies of the chickens and the straw-strewn ground, for example – relatively thick impasto applications create interesting textures that bring the scene to life.

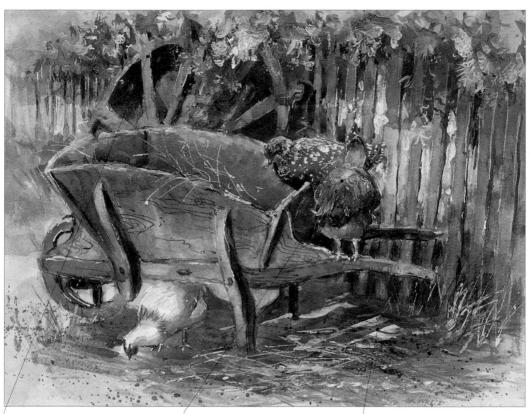

Note how the application of layers of colour, wet on dry, creates the texture of rusty metal.

Thick paint, applied using the tip of a painting knife, shows the texture of the ruffled feathers.

A range of techniques, from fine spatters to thick impasto work, is used to paint the pebble-strewn ground and loose straw.

Tropical butterfly

Both butterflies and moths belong to the scientific order Lepidoptera, which means "scale-wing" in Latin, and most butterfly wings are covered with tiny, individually coloured scales arranged in partially overlapping rows, like tiles on a roof. Butterfly houses give you the chance to see all kinds of exotic, brilliantly coloured and patterned species that you might never be able to encounter in the wild. This peacock pansy butterfly (Nymphalidae precis almana) is indigenous to Nepal and neighbouring regions and is characterized by the eyespots on the wings, which act as a deterrent to potential predators.

The artist selected a smooth-surfaced board for this study in oils, for two good reasons: first, he wanted this to be a reasonably detailed painting and a smooth surface allows you to put in small details without the paint spreading and sinking into the support; second, he did not want the texture of the support to show through in the final painting.

To speed up the drying time and enable you to complete the painting in one session, use a medium to which a drying agent has been added, such as drying linseed oil.

As each scale on the wing is differently coloured, you will find infinitely subtle gradations of tone. One way of conveying both the texture of the wings and the subtlety of the colour shifts is to stipple the paint on, using the tip of the brush, to create optical colour mixes in the same way that the Pointillist painters such as Georges Seurat (1859–91) did. However, although some inks and liquid water-colours can come close, it is difficult to match the intensity of iridescent colours with even the brightest of pigments.

Materials

- · Smooth-surfaced board
- HB pencil
- Oil paints: chrome yellow, cadmium orange, geranium lake, brilliant pink, titanium white, ultramarine blue, turquoise blue deep
- Turpentine (white spirit)
- Drying linseed oil
- Brushes: selection of fine rounds, filbert

The butterfly

With its dramatic eyespots and brilliant colouring, this peacock pansy butterfly makes an appealing subject for a painting. However, the artist decided not to include all the flowers, as he felt they detracted from the butterfly. It is perfectly permissible to leave out certain elements of a scene in order to make your painting more dramatic.

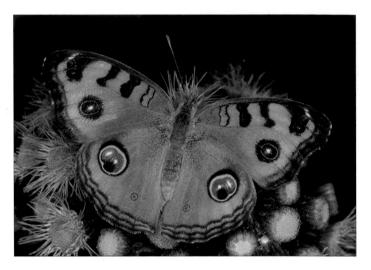

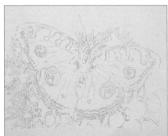

1 Lightly sketch the butterfly in HB pencil. It is entirely up to you how much detail you put into your underdrawing, but including the veins and the fringe-like pattern around the outer edge of the wings will make it easier for you to keep track of where you are in the painting.

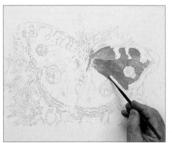

2 Using a fine round brush and alternating between chrome yellow and cadmium orange, start putting in the basic colour of the wings. Thin the paint with turpentine (white spirit) and mix it with drying linseed oil so that it is the consistency of single (light) cream.

Tip: Use a different brush for each colour, so that you do not have to keep stopping to clean brushes.

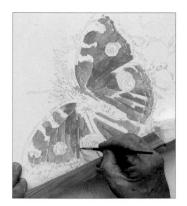

Continue until all the yellow is complete, looking closely at your subject to see the different tones. You may need to turn the support around and use a mahl stick to keep your hand clear of wet paint. If you do not have a mahl stick, you can improvize one by taping rags around one end of a thin piece of wood or dowelling, as the artist did here.

A Mix a range of bright pinks from geranium lake, brilliant pink and titanium white and start painting the flowers on which the butterfly is resting. Mix a dark, purplish blue from ultramarine blue and geranium lake and start putting in the background, taking care not to get any colour on the butterfly. Again, use a mahl stick, if necessary, to keep your hand clear of any wet paint.

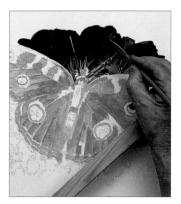

5 Continue painting the background, carefully cutting in around the flower tendrils.

Tip: When you are clear of the butterfly and flowers, switch to a larger brush to enable yourself to cover the background more quickly.

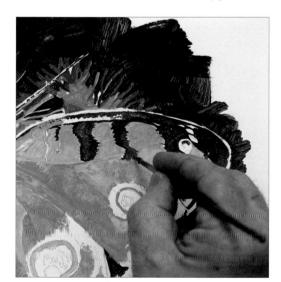

6 Using the same colours that you used for the flowers and background, start putting in some of the dark detail on the butterfly, using short brush strokes to convey the texture of the scales on the wings.

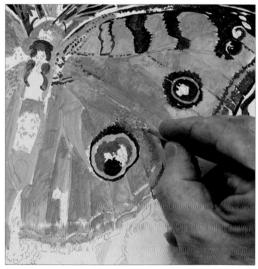

Paint the "eyes", using cadmium orange and the purple/pink mixture from the previous step and stipple the colour on with the tip of the brush to create an optical colour mix. Note that there are bluish-purple patches next to the two largest eyes: add more white and ultramarine blue to the mixture for these areas. Paint the "fringe" around the outer edge of the wings in oranges and pinks, as appropriate.

Assessment time

The main elements of the painting are in place. All that remains is to add more fine detailing to the butterfly and complete the surrounding flowers and background, working carefully and methodically. Although the artist had originally intended to include the flowers to the right of the butterfly, at this point he decided that they would detract too much from the painting of the insect.

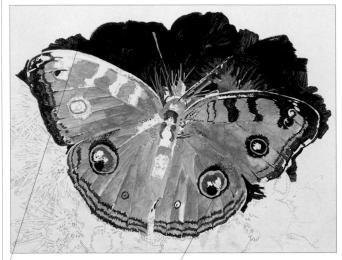

The dark background acts as a foil to the butterfly. Keeping its edges irregular adds to the informality of the study.

The detail is beginning to take shape; features like this are best put in during the final stages, when the underlying colours and shapes have been established.

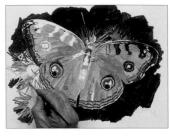

Susing a fine brush and the same pinks and purples as before, paint the flowers on the left-hand side, gradually working down the painting. Paint as much of one colour as you can while you have it on your brush. When you have finished the flowers, paint the dark background.

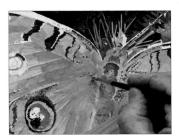

Paint the body of the butterfly, blending the colours on the support so that the brushstrokes are not visible.

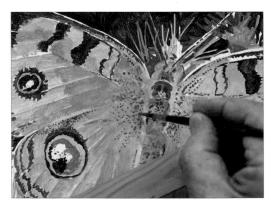

10 Continue painting the dots of colour on each side of the body. Although the dots are clustered more densely near the body, the same colours also run along some of the veins. Finish painting the "eyes" on the left-hand side of the butterfly, using the same colours as before.

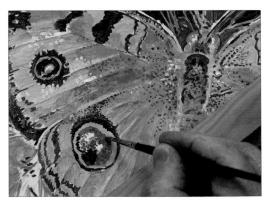

1 1 Mix a bright blue from turquoise deep blue and white and dot it into the whites of the "eyes". The patterning is now beginning to stand out strongly. Reinforce the orange areas around the two largest eyes with cadmium orange, deepening the colour with geranium lake where necessary.

The finished painting

Although this was never intended as a photorealistic painting, pointillist-style dots of colour help to capture the iridescent quality of the wings – something that cannot be achieved easily in paint. Much of the painting consists of a single layer of paint, which is appropriate for the thin, delicate structure of the insect. Note the clever use of different lengths

of brush stroke to create texture: longer, blended strokes are used for the furry body, while short strokes and tiny stipples convey the individual scales on the wings. The artist has also used some artistic license in reducing the number of flowers so that the butterfly is more clearly defined against the dramatic, dark background.

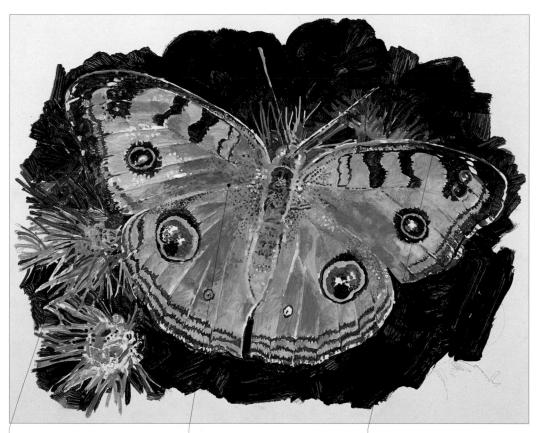

The flowers are loosely painted but echo some of the colours in the butterfly.

Different lengths of brush stroke create different textures.

The butterfly stands out clearly against the dark background.

Painting Landscapes

Landscapes are probably the most popular of all subjects to paint. Each season has its own mood and colours, each scene its own unique features.

The most important thing to decide on when painting a landscape is what constitutes your focal point. A grand panoramic view is all very well, but there must be something that holds the viewer's interest. Do not include too much, however, or your painting will look jumbled. Feel free to simplify and leave out any elements that do not contribute to the overall effect.

Once you have selected your focal point, decide where to place it within the picture area. Placing a subject in the centre of the picture is generally best avoided, as it tends to result in a static

image – although there may be times when you deliberately do this to create a calm mood. One placement that almost always works well is "on the thirds" – roughly one-third of the way into the painting from both the horizontal and the vertical edge.

Use lines or curves, either real or implied, to help lead the viewer's eye to the focal point. You might, for example, choose a viewpoint that allows a river to snake its way through the scene in an S-shape, or have a secondary point of interest on an implied diagonal line.

Another important consideration is how much sky to include. Beginners often place the horizon line right across the middle of the image, which cuts the picture in half and looks rather boring. If you have

an interesting sky, emphasize it by placing the horizon low down; conversely, a sliver of sky (or even no sky at all) places the emphasis on the land.

To convey a sense of scale and distance in landscapes, keep in mind that objects that are further away look smaller than those that are close by. Colour is another way of implying distance, as colours tend to look paler the further away they are. Texture, too, plays a part: more textural detail should be evident in the foreground than in the background.

Crooked tree against the dazzle ▼

The strong diagonal line that runs upwards through the painting from the bottom left gives a sense of energy to this very simple seaside scene.

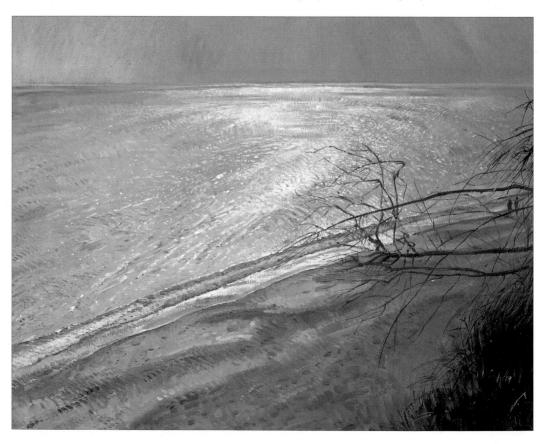

The view from here A

The lines of the fence and furrows in the snow curve inwards, leading our eye to the focal point of the image, which is placed on the third.

River Laune, Ring of Kerry ▶

The main interest is in the rolling hills and sinuous curve of the river. Note how the sky is reduced to a relatively small sliver near the top of the frame.

- When working in impacts, incorporate plenty of direction strokes to help the eyes read the shape of the thing being painted.
- Use a degree of artistic licence to improve a scene by leaving things out or even by adding elements that are not there in reality.

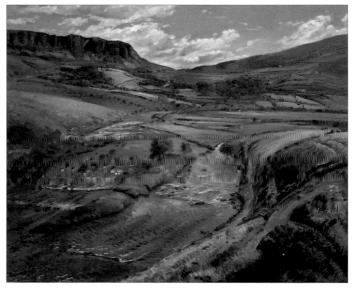

Stormy sky

Although the small strip of land and the high-rise buildings at the base of this picture provide an essential calm, static point on which the viewer's eye can rest, the main interest undoubtedly lies in the dramatic and bleak, stormy sky, with its dark, billowing clouds and the warm glow of the setting sun shining through them.

When you are painting clouds, remember that you need to make them look like solid, three-dimensional objects, not mere wisps drifting across the sky. You should also follow the rules of

perspective and make clouds that are far away smaller than those that are directly overhead.

For this project use acrylic paint thinly, flooding the paper with generous washes of dilute colour. The aim is to create an impressionistic scene, with no hard edges to the clouds and very little detail in the buildings. Let the paint do as much of the work for you as possible, such as puddling at the base of damp areas to form darker tones at the base of the clouds. Soften paint edges by dabbing off any excess with a paper towel.

Materials

- Watercolour board
- Acrylic paints: cerulean blue, alizarin crimson, burnt sienna, ultramarine blue, lemon yellow, titanium white
- Brushes: large round, medium flat
- Household plant sprayer
- Flow improver
- · Kitchen paper

The scene

The warm glow of an evening sunset contrasts dramatically with the glowering purple of the storm clouds in this scene. Note the complementary colours – purple and yellow – which almost always work well together. Although the silhouetted buildings along the skyline occupy only a small part of the picture area, they are critical in giving a sense of scale to the image.

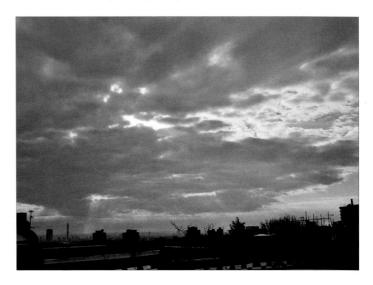

1 Using a household plant sprayer, spray clean water on to the board over the areas that you want to remain predominantly blue. (You could brush on water – but the spray gives a more random, less controlled coverage.)

2 Mix a few drops of flow improver into cerulean blue paint. Using a large round brush, drop the paint into the areas that you dampened in Step 1; it will spread and blur to give a soft spread of colour.

3 Scrunch up a piece of clean paper towel in your hand and dab it on to the blue paint to soften the edges.

A Mix a warm purplish blue from rerulean blue and alizarin crimson. and brush it over the land area at the base of the image with the large round brush. Mix a neutral purplish grey from burnt sienna and ultramarine blue. Spray clean water over the left-hand side of the painting and quickly drop in the neutral colour, allowing the paint to pool at the base of the damp area, as storm clouds are darker at their base.

5 Soften the edges of the clouds by dabbing them with a paper towel, as in Step 3. While the paint is still damp, dot in more of the dark mixture in the top right of the painting.

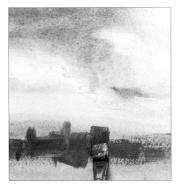

Using a watery version of the 6 neutral purplish grey mixture from Step 4, brush in a dark line above the purplish base, adding more burnt sienna nearer the horizon to warm up the tones. Allow the paint to dry. Mix a warm purple from hurnt sienna and ultramarine blue and, using a medium flat brush, make broad, rectangularshaped strokes for the high-rise buildings along the horizon line, varying the tones so that the nearer buildings are slightly darker than those that are further away. Use strokes of different thicknesses to create a natural-looking variation in the shapes and sizes of the buildings.

Assessment time

You have now established the basic framework of the image and the main areas of colour – the blue of the open patches of sky, the dark storm clouds that dominate the scene, and the thin sliver of land with its high-rise buildings at the base. However, for the painting to look convincing, the clouds should be made more three-dimensional.

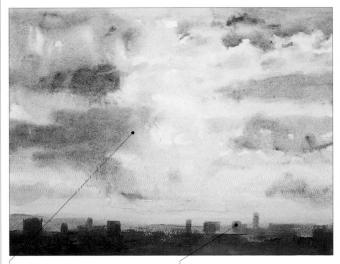

The clouds are soft-edged but do not appear to have volume

Varying the tones of the buildings helps to create a sense of recession

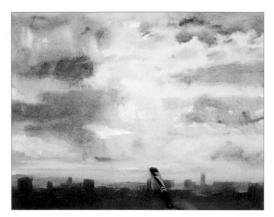

7 Mix a pale but warm, yellowy orange from lemon yellow, titanium white and a little burnt sienna. Brush this mixture into the breaks between the clouds, making horizontal brushstrokes that echo the direction in which the clouds are being blown in order to create a sense of movement in the sky. This adds warmth to the horizon and makes the dark storm clouds stand out all the more dramatically.

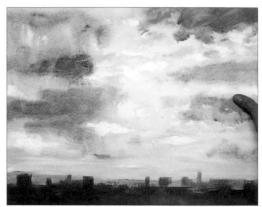

Continue adding this warm yellowy orange, adding more burnt sienna to the mixture as you get nearer the horizon; the sun is sinking, so the colours are warmer nearer the horizon. Mix an opaque blue from cerulean blue and titanium white, and brush this mixture over the top of the sky, smudging the paint with your thumb to soften the edges and get rid of any obvious brushstrokes.

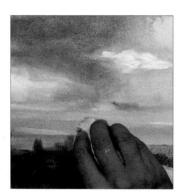

Dip a small piece of paper towel into the warm purple mixture that you used in Step 6 and squeeze out any excess moisture. Lightly stroke the paper towel over the yellow area just above the horizon to create streaks of storm cloud.

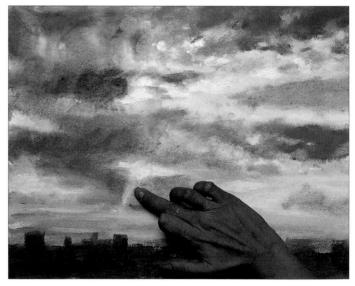

10 Dab light opaque blue into the very dark area at the top of the picture, using your fingertips. Mix a purple from cerulean blue and burnt sienna and swirl it around the light area in the centre of the paper to darken it and give the clouds more of a feeling of depth. Mix a pale, warm yellow from burnt sienna, lemon yellow and titanium white and stroke on shafts of light coming down from the clouds with your fingertips. Using a flat brush, block in the shapes of the nearest buildings on the skyline; using warmer, darker tones in this area will make these buildings look closer to the viewer.

This is a convincing representation of a stormy sky at dusk. The colours are allowed to spread on damp paper and pool naturally, creating soft-edged shapes that are darker at their base and thus appear to have volume. Although the colour

palette is limited and based mainly around the complementary colours of purple and yellow, the clever use of different tones of purple in the buildings at the base of the image creates a sense of recession.

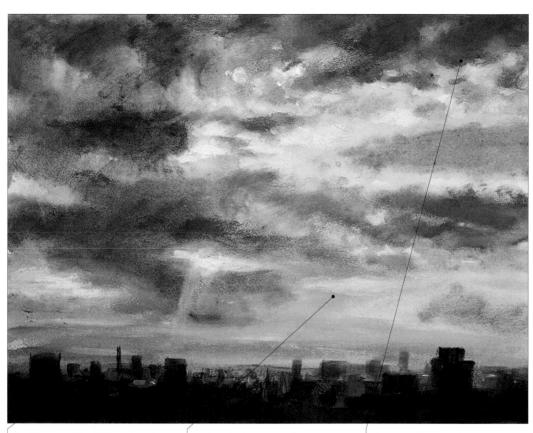

The silhouettes of the buildings along the skyline are painted as simple rectangles of colour, exploiting the natural shape of the flat brush.

Purple and yellow are complementary colours and almost always work well together. Here, they create a warm-toned yet dramatic-looking composition.

There are no harsh-edged colours in the sky – dabbing the wet paint with a paper towel helps to remove any potentially distracting brushmarks.

Rocky landscape

This is a dramatic and impressive vista of rocky outcrops surrounded by open moorland, which falls away rapidly to the sunlit landscape below.

The scene covers a wide area and there are lots of things to hold your attention – but don't allow yourself to get too caught up in the detail. Think instead about the general characteristics – hard rocks next to soft, springy vegetation, deeply shaded areas such as the side of the rock that is facing us versus brightly lit sections such as the fields

There are also lots of different colours, from the muted grey of the rocks and the purple heather to the bright blue of the sky. You may find that it helps to half-close your eyes when you look at the scene, as this will help you to see it in terms of blocks of colour rather than as a landscape that consists of many different individual elements.

There are several things to bear in mind when trying to convey a sense of scale and distance. First, the further away things are, the smaller they look. Note the crag in the middle distance, for example: it's actually about the same height as the foreground crag, but because it's quite a long way away, we perceive it as being smaller.

Colour plays a part in this, too: generally, things that are further away appear paler in tone, so remember to make your colours paler as you move towards the horizon.

Finally, foreground elements should contain more detail and texture than those in the background.

Gouache is an interesting choice of medium for a scene like this. The slightly chalky nature of the paint makes the shaded rocks look almost hazy, as if our vision is affected by the bright sunlight that is streaming in from the right. At the same time, the opacity and covering power of gouache enable you to paint very precise, crisp highlights without any of the underlying colour showing through.

Finally, toning the ground a bright yellow, as the artist has done here, means that you begin your painting from a warm mid-tone, which sets the overall colour temperature of the sunlit scene and contributes to the mood of the painting.

Materials

- Illustration board
- B pencil
- Gouache paints: cadmium yellow deep, cadmium orange, cadmium red, phthalocyanine blue, spectrum violet, cerulean blue, permanent white, Naples yellow
- Brushes: large wash, small round, large round bristle
- · Rag or kitchen paper

The scene

There are many interesting textures to paint in a scene such as this, from the springy heather that covers much of the ground, to the hard gritstone rocks. The lighting is important, too: note how the contrast between light and shaded areas helps to convey the direction of the light and makes what might otherwise seem like flat areas of vegetation appear three-dimensional.

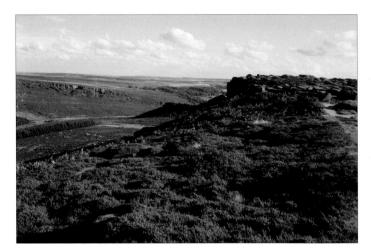

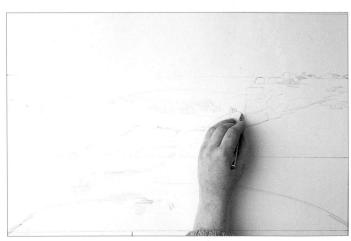

1 Using a B pencil, make a light underdrawing of the main elements of the scene, indicating the outline of the rocky outcrops. Make a series of flowing pencil strokes across the foreground to indicate shading within the moorland vegetation.

 $2\,$ Mix a generous wash of cadmium yellow deep gouache paint and another one of cadmium orange. Using a large wash brush, loosely wash cadmium yellow deep over the whole of the paper. While the first wash is still slightly damp, brush cadmium orange over the bottom right of the painting – the rocky outcrop in the foreground. Leave to dry. The colour is uneven but it provides a lovely warm, toned ground on which you can develop your painting.

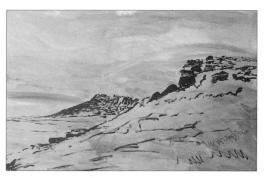

3 Mix a dark purple from cadmium red, phthalocyanine blue and spectrum violet. Using a small round brush loaded with very little paint, brush the mixture over the pencil marks made in Step 1. Holding the brush almost vertically, make short, spiky strokes for clumps of grass in the foreground and longer, calligraphic strokes on the rocky outcrop in the background. Block in the rocky outcrop in the foreground.

Tip: The use of a dark, solid colour (as an underpainted colour) on the large rocky outcrop in the foreground makes it appear closer to the viewer.

A Mix a mid-toned greyish blue from rerulean blue permanent white and cadmium orange. Using a small main again musical strokes to the left of the second outcrop of rock. You are starting to establish the undulating bands of vegetation that run across the scene. The use of a cool colour here helps to convey a sense of distance.

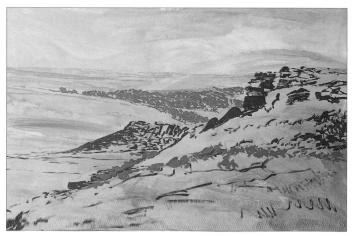

 $5\,$ Now mix a dark green from phthalocyanine blue, cadmium vellow deep and a little of the purple mixture from Step 3. Using a small round brush, dab this mixture on loosely to create a triangular wedge of green for the wooded area in the middle distance, allowing the underlying colour to show through. Dab the same colour across the foreground hill.

Tip: Whenever you are painting vegetation, make your brushstrokes follow the natural direction of growth: use short, vertical brushstrokes for the trees in this scene.

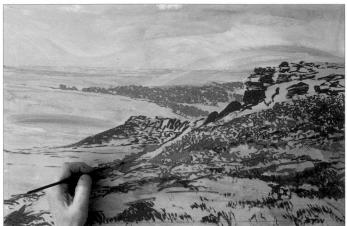

Continue dabbing on green and the Opurple mixture from Step 3, as in the previous step, in order to build up texture in the vegetation.

scrub-like plants rather than a botanically

accurate rendition.

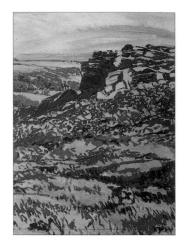

Using the purple mixture again, but varying the proportions of the colours in the mixture, block in the rocky outcrops, using vertical brushstrokes of varying lengths and widths and allowing some of the underlying rock colour to show through for the lighter-coloured rocks.

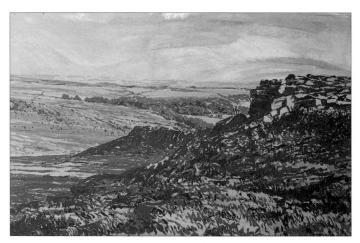

8 Continue darkening the colour of the foreground vegetation, using the same mixtures as before. Add permanent white to the purple mixture to lighten it and make it more opaque, and brush small horizontal strokes over the low-lying area beyond the second outcrop. This establishes the colour of the main vegetation in this area – the flowering heather. The area is so far away that the general colour is sufficient: there is no need to put in lots of textural detail.

9 Add more permanent white and a little phthalocyanine blue to the opaque purple mixture from step 8 and dab it over the shaded areas of the foreground rocky outcrop, allowing some of the underlying colour to show through. This helps to create the texture of the rocks, which have cracks and crevices running through them.

10 Mix a bright green from cadmium yellow deep and phthalocyanine blue. Brush small horizontal strokes of the mixture over the low-lying, sunlit fields in the background.

Assessment time

The contrast between the shaded and sunlit parts of the image is now becoming more apparent and the scene is taking on a convincing sense of depth and perspective. Note, in particular, how toning the ground yellow has imparted a warm glow to the sunlit areas.

This bright green nestles between the two rocky outcrops and draws our eye to them.

The yellow in this area looks unnatural but gives a warm glow to this sunlit area.

The rocks are beginning to take form, but will require more texture if they are to look convincing.

1 1 Mix a brownish pink from cadmium red, permanent white, Naples yellow and spectrum violet and dot and dab it over the foreground vegetation. As before, your aim is to create a general impression of the british, Scrubby Piulib.

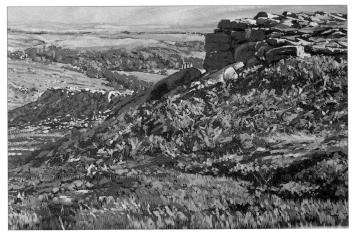

12 Using a small round brush, apply short strokes of permanent white and a little cadmium yellow deep to highlight areas of the rocks. This emphasizes the structure of the rocks, which have very distinct facets.

Tip: Permanent white gouache has good covering power, which makes it ideal for painting opaque highlights.

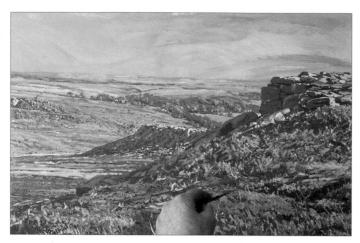

13 Continue to build up texture in the vegetation. Using a small, almost dry round brush loaded with permanent white paint, make a series of light vertical brushstrokes over the foreground to imply gently the taller grasses among the heather. Foreground texture is one of a number of ways in which the artist can imply that such areas are physically closer to the viewer.

14 Using a large round bristle brush, scumble dilute permanent white over the sky. Although gouache is opaque, the fact you are using a dilute mixture means that the white is slightly modified by the underlying yellow, which will give the impression of warm afternoon sunlight in the sky.

15 Mix a bright blue from cerulean blue and permanent white and brush it loosely over the sky, leaving some white shapes for clouds. Skies are never uniform in colour because of the effects of light, so darken the mixture by adding a tiny amount of cadmium red and put in a few strokes of this colour here and there to create some tonal variation. While the paint is still wet, gently dab a clean cloth or a piece of absorbent kitchen paper over the sky to soften the brushstrokes and blend the colours together on the support, so that the transition from one tone to the next is virtually imperceptible.

16 Reinforce the clouds with permanent white where necessary to make them stand out a little more dramatically, remembering to make them smaller as they recede towards the horizon.

Repeat the previous two steps if necessary to build up more colour in the sky. This is a strong and dramatic landscape that exploits the characteristics of gouache to the full. Wet-intowet applications of paint in the sky create soft-edged cloud formations, giving a sense of movement that is counter-

balanced by the solidity of the rocky landscape below. Texture in the vegetation is achieved through drybrush work and short brushstrokes. The natural opacity and chalky nature of gouache paint can be seen in the way the artist has painted the rocks, which look convincingly three-dimensional.

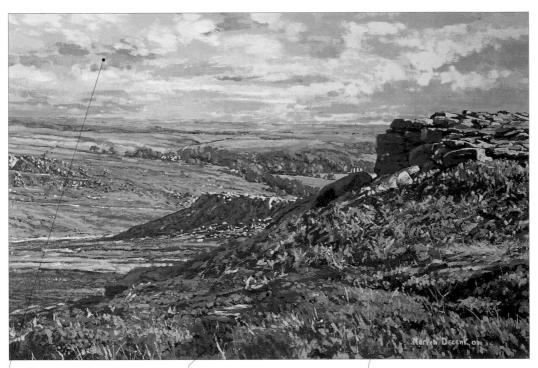

Note how darker tones are used for the undersides of the clouds, which are in shade. Clouds, just like any other feature of the landscape, are three-dimensional and it is important to give them volume.

Texture is a feature of this painting. The artist has used drybrush work and small dabs and dots of paint to create a convincing impression of the scrubby moorland vegetation.

Bright highlights are achieved with short strokes of opaque permanent white, while the shaded sides of the rocks are painted in an appropriately dull, chalky mixture of purplish grey.

Sunlit beach

This simple-looking scene of an almost deserted beach on a bright summer's day gives you the chance to paint two of nature's most fascinating subjects – moving water and sparkling sunlight.

Painting the sea is an interesting challenge: how can you capture the constant ebb and flow of the water? As always, the more time you spend observing the scene the better. Although the movement of the waves may seem random, if you stand still and watch for a while you will soon see a pattern. Look at the shapes that the waves make as they roll in towards the shore and try to fix them in your mind.

One of the risks of painting in bright sunshine is that your eyes can be dazzled by the intensity of the light, with the result that you tend to make the scene too high-key. Instead of capturing the brightness of the scene, as you expected, you will find that your painting simply looks bleached out. Look for tonal contrasts within the scene and balance bright areas with dark, cooler shadows. The dark passages will have the effect of making the light areas look even brighter.

When painting highlights, don't try to put in every single one or your work will look overly fussy. Half-close your eyes: this reduces the glare, enabling you to break down the pattern of light more easily and put in just the key highlight areas.

Finally there is the question of how to paint the sky. If you're painting en plein air and the clouds appear to be fleeting, you may want to put them down quickly to capture the effects, whereas with a relatively static scene, you might concentrate on the land first. But remember that clouds have volume: look for the lights and darks within them to make them look three-dimensional

Materials

- · Stretched and primed canvas
- Oil paints: olive green, cobalt blue, titanium white, alizarin crimson, cerulean blue, burnt umber, Indian yellow, cadmium red, black, lemon yellow
- Turpentine
- Brushes: small filbert brush, selection of small hogshair and sables

The scene

The tide has receded, leaving shallow inlets illuminated by bright sunlight and large areas of exposed sand – an interesting contrast of colours and textures.

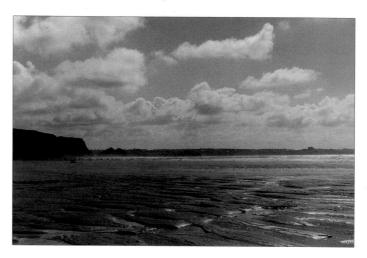

1 Using a thin mix of olive green, 'draw' the cliffs on the horizon, the lines of the waves and the little channels. At the outset the artist decided to add a small dog to the scene to focus the viewer's attention. Add its outline and shadow now.

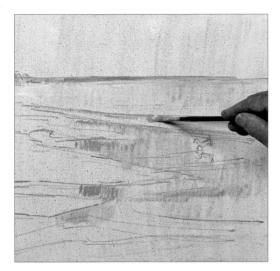

 $2\,$ Mix a bright, light blue from cobalt blue and titanium white. Using a small filbert brush, loosely scumble the mixture over the shallow areas of water in the foreground of the scene. Add a little alizarin crimson to the mixture to make it slightly more purple in tone, and brush in the line of cliffs along the horizon in the background. Mix a paler blue from cerulean blue and titanium white and use this mixture for the most distant area of sea.

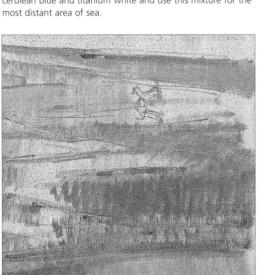

Add a little burnt umber to the bright blue mixture from Step 2, and scumble it over the deepest areas of the foreground water. Using short, vertical brushstrokes, loosely scumble various sand colours over the shallowest parts of the water, where the underlying sand is clearly visible.

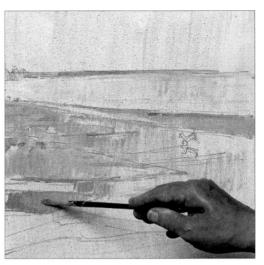

Add a tiny amount of burnt umber to the purplish blue mixture from Step 2 and blend this colour, wet into wet, into the darkest parts of the sea – the undersides of the waves that roll in towards the shore. Mix a rich, dark sand colour from burnt umber and Indian yellow and scumble this mixture over the sand, blending in a few strokes of cadmium red here and there, and adding purple for the very darkest lines along the edges of the water channels.

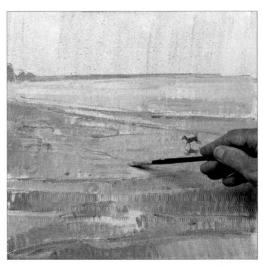

5 Continue putting in the sand areas in the middle distance. Note that some areas are pinker and warmer than others; adjust the mixtures on your palette as appropriate. Block in the dog and its reflection in a dark mixture of olive green, black and a little burnt umber.

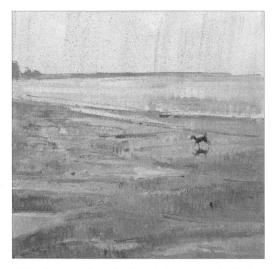

Continue to build up the tones in the water, using the same purplish blues as before to emphasize the darker areas. Overlay pale blue paint over the water-covered sand in the foreground, blending the vertical brushstrokes that you put down in the earlier stages to create the impression of sand seen hazily through shallow water.

Now start to work on the sky. Put in the clouds first, using light- and mid-toned greys mixed from burnt umber, cobalt blue and titanium white in varying proportions. Warm or cool the mixtures as necessary by adding a touch of pink or blue. Put in the bright blue of the sky using a mixture of cobalt blue and titanium white.

8 Use a darker version of the olive green, black and burnt umber mixture that you used in Step 5 to reinforce the shape of the dog and its reflection in the wet sand.

9 Now start to put in some of the reflected highlights on the crests of the waves, dotting in little specks of white tinged with yellow to give the impression of sunlight glancing off the surface of the water.

Assessment time

Now that the main elements and colours are in place, take time to assess the tonal balance of the painting as a whole. Although the orange of the sand and the blue of the sea are complementary colours and give the scene a lot of energy, they are both predominantly midtones. You need to reinforce the sense of sunlight within the scene – and, paradoxically, the way to do this is to make the dark areas darker, so that they form an effective contrast to the brightly lit parts.

You need to create a sense of sunlight sparkling on the water.

The sand is little more than a block of colour at this stage; it needs more texture.

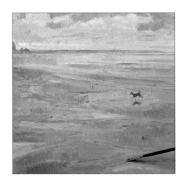

10 Darken the water channels in the four ground, using the sum purples and blues as before.

Tip: Don't add any solvent to the paint for this process: using the paint straight from the tube means that it is relatively dry, so the colours do not turn muddy even though you are overlaying paint on a layer that it still wet.

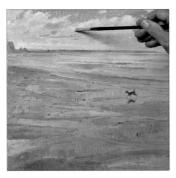

1 Touch some very pale yellow (mude by mining lemon yellom u little Indian yellow and titanium white) into the top of the clouds to create the affect of warm sunlight.

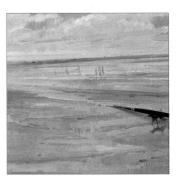

12 Look at the colours within the blue. Add a little purple to your blue miles to put in the darkest parts of the small waves as they break on the shore. Loosely block in the figures, using a purplish blue-black. As they are silhouetted, with the sun behind them, little detail is discernible. Add a hint of yellow to titanium white and put in fine lines to create highlights on the foamtipped wave crests.

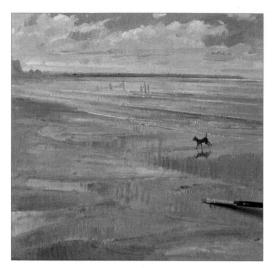

13 Continue putting lights and darks into the sea area, using small strokes and dotting in the highlights. In the deeper channels in the foreground water, use loose vertical strokes of a mid-toned blue to create the sense of light shimmering in the water. The brushstrokes will soon be blended out, but their direction is important as it helps to give the effect of sunlight glancing off the water.

14 Continue working on the foreground area, using the sand colour and blue mixes tinged with purple as appropriate. Gently and gradually blend the wet paint on the canvas and smooth out the brushstrokes.

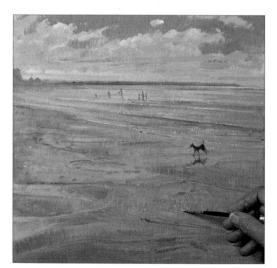

 15° Create more variety and texture in the exposed sand area by dotting in other colours – a light yellow mixed from lemon yellow and white, and burnt umber lines and dots. Dot the pale yellow mixture that you used in Step 12 over the foreground to create the effect of sunlight sparkling on the water.

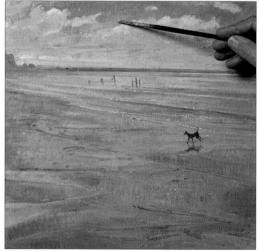

16 Mix a bright blue from cobalt blue and titanium white and scumble it over the top of the sky to darken it and allow the clouds to stand out more dramatically. The use of a dark colour at the top of the picture holds the viewer's eye within the frame, while the loose brushstrokes help to give an impression of movement in the sky.

This is an attractive painting of an almost deserted beach in summer. Lively brushstrokes convey the dark clouds scudding across the sky, and loose scumbles of colour over the water also help to convey a sense of movement. The viewpoint has been carefully chosen so that the wedge-shaped areas of sand

in the foreground balance the composition and lead our eye through the painting. Although the dog and the silhouetted figures in the middle distance occupy only a small part of the scene, their position (roughly on the thirds) means that our eye is drawn to them.

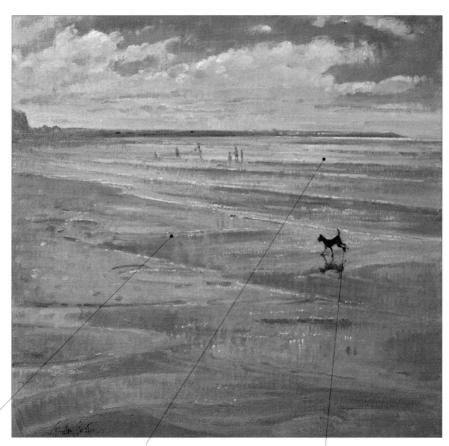

The use of complementary colours (blue and orange) imparts a sense of energy.

Specks of yellow create the effect of warm sunlight glancing off the water.

The dog occupies only a small area, but its position means that our eye is drawn to it.

Rolling hills

Sometimes when you are painting a land-scape, a single element – a lone tree, a waterfall, a farm building, for example – attracts your attention; at other times, it's the sheer scale and drama of a broad panorama that draws you. In the latter case, however, it can be hard to evoke the same feeling of awe in the viewer that you felt on beholding the scene – and more often than not, the reason for this is that you have failed to provide a focal point in your image.

In the landscape shown here, gently rolling hills sweep far away into the distance in an idyllic rural setting that gives no hint of the hustle and bustle of the modern world. But even in the most rural of settings, evidence of former industries can often be seen. Although the quarries in which they were cut have long since ceased to operate, these abandoned mill-stones provide the artist with a focal point for his painting. Without them, the scene would look like an empty stage set, with nothing to hold the viewer's interest.

This project uses acrylic paint in a similar way to traditional watercolour, with the colours being built up gradually in thin glazes, so that each layer is modified by the underlying colours. It also incorporates a wide range of textural techniques, from drybrush work to less conventional methods such as pressing bubble wrap into the paint and dabbing on paint with your fingertips. There is no "right" or "wrong" way to apply paint to the support: use whatever tools you have to hand to create the effect you want.

Materials

- Card primed with acrylic primer
- · B pencil
- Acrylic paints: cadmium yellow, cadmium red, phthalocyanine blue, burnt umber, magenta, titanium white, cobalt blue, cerulean blue
- · Brushes: medium round, small round
- Rag
- Bubble wrap

1 Using a B pencil, make a light underdrawing of the scene, taking care to get the ellipses and angles of the millstones right.

The scene

The millstones are the focal point of the painting. Note how they form a rough triangle, positioned just off centre at the base of the image, leading the viewer's eye up the line of the hill and back down again to the foreground. When you paint a scene like this, make sure you spend time selecting the best viewpoint.

2 Using a rag, spread cadmium yellow acrylic paint straight from the tube over the support, leaving a few gaps in the sky area for clouds. Drop a little cadmium red over the centre left of the image and blend it into the yellow paint with the rag so that the two colours merge on the support, creating an orange, wedge-like shape. Leave to dry.

3 Mix a dark green from cadmium yellow and phthalocyanine blue. Using a medium round brush, scumble the mixture over the wooded hillside in the middle distance to give a generalized impression of trees. While the first green is still damp, add a little more blue to the mixture and dot this in for the darkest areas of green.

4 Mix a dull but warm orange from cadmium yellow, cadmium red and a little burnt umber and brush it over the distant escarpment on the left of the image and over the fields in front of the wood. The warm colour helps to bring this area forwards in the image.

5 Using a medium round brush, apply a thin glaze of magenta in a broad stroke over the slope of the hill on the left. Add a little phthalocyanine blue to the mixture and paint the crest of the escarpment behind it. While the paint is still wet, gently press bubble wrap into it to create some texture.

6 Add a little burnt umber to the dark orange mixture from Step 4 and brush it loosely over the bottom left corner of the painting. While the paint is still wet, lift off some of the colour by "drawing" the shapes of grass stems with the tip of a paintbrush.

Parken the hillside, using the same colours as in Step 5. Press bubble wrap into burnt umber paint and then press the bubble wrap across the bands of orange and magenta on the left to create loose, textured dots that echo the growth pattern of the vegetation. Paint the fence posts using a dark, reddish brown mixed from phthalocyanine blue and burnt umber. Mix a dark purple from cadmium red and phthalocyanine blue and brush it over the shaded sides of the mill-stones. For the darkest stones, use phthalocyanine blue.

Obt in the shapes of the isolated trees in the middle distance, using the same dark orange that you used to paint the fields. Following your initial pencil marks, mark out the field boundaries in burnt umber. Roughly block in the buildings in the middle distance in magenta. Brush a broad sweep of magenta over the hill to the right of the buildings and wipe a rag over it to blur the colour.

9 Brush titanium white over the sky area, allowing a hint of the underlying yellow to show through to maintain the overall warm colour temperature of the scene. Re-establish the highlight areas on the ground by smearing on titanium white paint with your fingertips, which gives a more spontaneous-looking and random effect than applying the paint with a brush.

Assessment time

It is becoming clear which parts of the scene are in shadow and which are brightly lit, and the underlying yellows and oranges give a warm glow to the whole scene. Now you need to concentrate on putting in the greens and browns of the landscape and on building up the textures.

Note how the colours become paler in tone the further away they are.

The yellow used as a base colour on these sunlit fields will modify any glazes that are applied on top.

More texture is needed in the grasses in the immediate foreground.

10 Reduce the starkness of the white areas by brushing over them with a thin glaze of the appropriate colour – cobalt blue over the wooded area, burnt umber over the shaded parts of the hillsides, and various yellow-orange mixtures over the sunlit fields. Note how the scene becomes more unified as a result.

11 Mix a bright green from cadmium yellow and cerulean blue and, using a medium round brush, paint over the mostly brightly lit fields in the middle distance. Note that some of the fields contain crops, so leave the underlying grangey brown colour in these areas and take care not to go over the field boundaries.

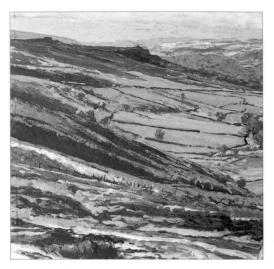

12 Add a little more titanium white to the mixture to lighten it and paint the most distant fields. Mix a neutral brown from cadmium yellow, cadmium red and phthalocyanine blue and use it to tone down the reddish areas on the hill to the left, which look too harsh.

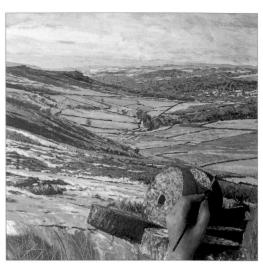

13 Mix a slightly darker green from cadmium yellow and phthalocyanine blue and paint the green grass in the immediate foreground. The use of a darker tone pulls this area forwards and makes it seem closer to the viewer. The shaded sides of the millstones look too red in tone and jump forwards too much. Mix a neutral brownish grey from cadmium yellow, cadmium red, cobalt blue and titanium white and paint over these areas, reinforcing the cast shadows with a slightly darker version of the same mixture.

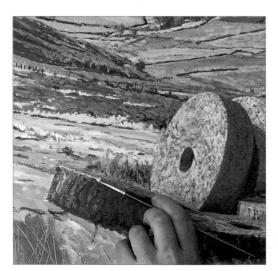

14 Using a very small round brush, paint a thin line of titanium white around the top edge of the millstone that is lying on its side, so that it appears to be rim-lit by the sun.

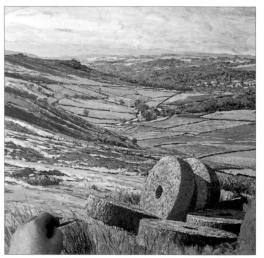

 $15\,$ Using a small round brush, drybrush thin strokes of burnt umber over the foreground to the left of the millstones to add texture and create grass stems blowing in the breeze.

Finally, put in the sky using a bright blue mixed from cerulean blue and titanium white. This tranquil landscape simply glows with sunlight and warmth. The scene covers a wide area but the millstones in the foreground, which are positioned slightly off centre, provide a strong triangular shape at the base of

the image and a much-needed focal point. Although they occupy only a small part of the frame, the buildings in the middle distance provide a secondary point of interest, to which our eye is drawn by the gently sloping diagonal lines of the hills and fields.

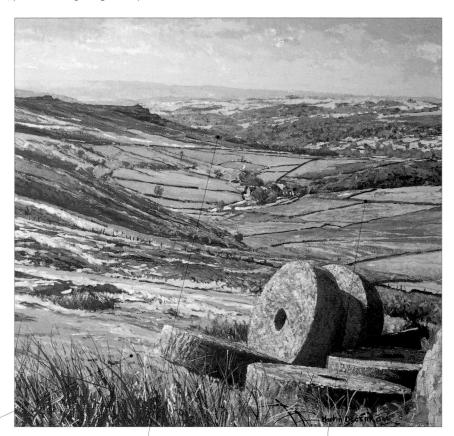

Strong textures in the foreground help to pull this area forwards and imply that it is closer to the viewer.

The sloping line of the hills leads our eye down towards the buildings, which form a secondary point of interest

The greens and browns of the fields are modified by the underlying yellow, adding Wattitit to these rather subduct colours.

Painting Still Lifes

One of the advantages of painting still lifes is that all the elements are under your control: you don't have to worry about the weather or the light, your subject won't get up and walk away, and potential subjects are all around you in the form of everyday household objects. Nonetheless, planning your composition and making preliminary sketches to check you've got the balance right are absolutely vital.

In traditional still lifes there is normally some kind of thematic link between the various objects, although this is by no means essential. But do look for interesting contrasts of shape and texture. If, for example, you are painting fruit in a bowl, all of which are rounded in shape, introduce a tall, vertical element in the form of a vase in the background. Juxtapose the rough-hewn texture of a rustic wooden table with the smooth, shiny surface of glazed pottery, or the soft texture of velvet with the faceted edges of crystal. Such contrasts will add interest to your painting. Odd numbers of objects (three, five or seven) tend to look better than arrangements of even numbers.

Whatever subject you choose, the most common mistake is not to spend enough time arranging the set-up. When you've selected your subjects, move them around until you're happy with the grouping. Even very slight adjustments can have a big impact on the overall composition. Look at how the shapes overlap and at the overall balance of colours. Triangular compositions work well, as they encourage the viewer's eye to move around the picture. Placing all the elements in a straight line is rarely, if ever, successful.

Look at the spaces between the objects, too; they play an important part in the composition. If the objects are too far apart, they will look as if they don't belong together; if they are too close, the composition may look cluttered.

Another common mistake is including too many things: sometimes, as the saying goes, 'less is more'. If your set-up isn't working, try simplifying the composition by taking items away.

Keep the background simple, too. A plain-coloured wall or piece of fabric in an appropriate colour will allow your chosen

objects to stand out – but don't leave too much space around the objects or the background will become too dominant.

Finally, remember to experiment with different viewpoints. It's interesting to note how different objects can look when viewed from above or below, rather than at normal eye level, making your paintings look much more dynamic.

Sweet Williams and cherries ▼

The colour of the flowers is echoed in the cherries that are randomly scattered over the table. The plain wood allows the flowers and fruit to stand out, while the diagonal planks lead our eye through the scene.

- Tips: Spend time moving objects around and looking at your set-up from different viewpoints before you begin making your preliminary sketches.
- Take time to sketch a number of thumbnails in order to establish the composition.
- Arrange your still lifes on a board of wood so that, once you have set it up, the entire still life can be turned in order to alter the light.
- Try creating still-life set-ups using unusual or strange-looking objects, in order to create tableaux that are exciting and fresh.

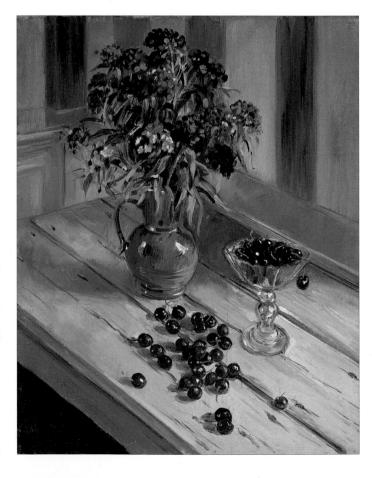

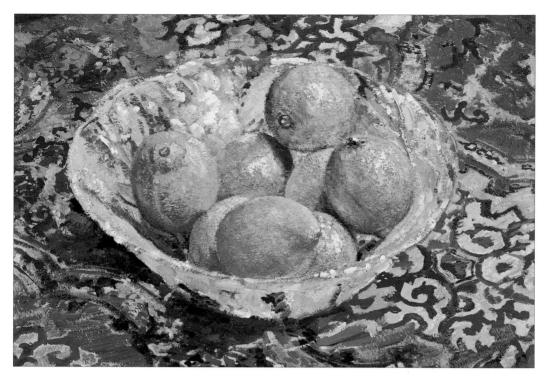

Lemons A

The simplest arrangements often work best. Here, lemons in an opaque glass bowl form the centrepiece of the image, their colours and shapes offset by the patterned tablecloth. Note that the bowl is not positioned in the centre of the image; there is slightly more space on the right-hand side, which prevents the image from looking bland and static.

The apple basket ▶

In this still life, in contrast to the painting shown above, the wicker basket in which the fruit are placed is highly textured and intricate. A brightly coloured background would distract, but the terracotta flagstones provide the perfect foil for both basket and fruit. The unusual viewpoint (from almost directly overhead) enhances the feeling that the scone has been captured en passant.

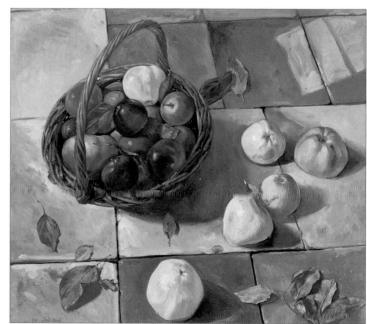

Still life with gourds

A still life does not have to be an elaborate scene in the style of the Dutch Old Masters such as Rembrandt: you can set up a scene on a corner of your table with just a few carefully chosen fruits.

Interestingly, one of the gourds in this painting is artificial – but it is virtually impossible to tell which one. Realistic-looking artificial fruits and flowers are readily obtainable from florists and craft stores and it is worth putting together a small collection of things that you can incorporate into your paintings. An added bonus is that they will not wilt or rot while you are in the process of painting them! Seashells, pieces of driftwood, pebbles and pine cones also make interesting subjects that you can pick up for free while out walking, as well as being attractive items to display around the home.

Odd numbers of objects – three, five, or seven – always seem to look more balanced in a composition than even numbers. Spend time over your arrangement: even a slight adjustment to the position of the your chosen subjects can make a substantial difference to the painting. Placing one object behind the others will give your painting more of a sense of depth: putting everything in a straight line almost always looks boring and static.

If you do not feel up to tackling a complicated background but still want to have something behind your main subject, a small piece of fabric is a good choice. Buy remnants from fabric stores in a variety of colours and patterns; they are inexpensive and don't take up much storage space.

Materials

- 2B pencil
- 300gsm (140lb) rough watercolour paper
- Acrylic paints: yellow ochre, cadmium orange, Hooker's green, ultramarine blue, cadmium red, cadmium yellow, Hooker's green deep hue, titanium white, burnt sienna
- Brushes: wash brush, medium round brush that holds a good point
- · Ruling drawing pen
- Masking fluid
- Kitchen paper
- · Plastic painting knife

The set-up

Before you start painting, spend time arranging the subjects you have selected for your still life and experiment with different arrangements and viewpoints until you find one that you are happy with: many amateur artists make the mistake of rushing this stage. Here, the gourds have been arranged to create interesting contrasts of scale, colour and texture. Not surprisingly, groups of three objects seem to work well in compositions that are roughly triangular in shape – and if you draw imaginary lines from the tip of the largest gourd down to the base of each of the two foreground gourds, you will see that this is what the artist has done here. The triangular shape of the composition is echoed in the way that she has chosen to drape the background fabric.

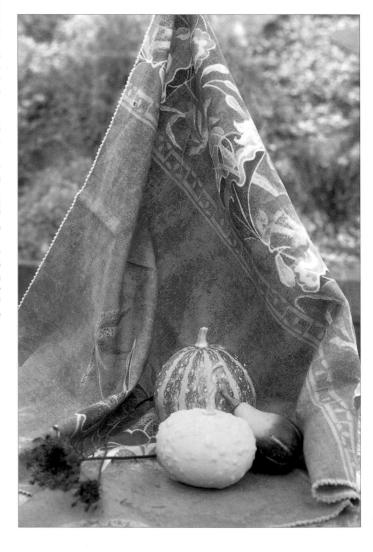

1 Using a 2B pencil, lightly sketch the still-life set-up. Put in some of the striations on the surface of the gourds, as the direction of the lines helps to show the curve of the fruits. Using a ruling drawing pen, apply masking fluid over the light-coloured patterns on the background fabric. Look at where the lines of the pattern break, as this indicates the drape of the fabric. Apply a little masking fluid over the dried cow parsley heads in the foreground, and allow it to dry completely.

2 Using a medium wash brush, wet the paper completely with clean water. Mix a pale wash of yellow ochre and brush it over the whole paper, scrubbing on cadmium orange, wet into wet, for the folds of the fabric and the gourds.

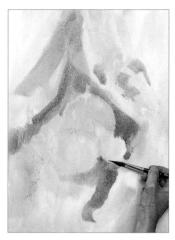

Mix a dark green from Hooker's green, yellow ochre and a little ultramarine blue. While the first wash is still slightly damp, start putting in the green of the background fabric around the gourds, using broad, confident brushstrokes.

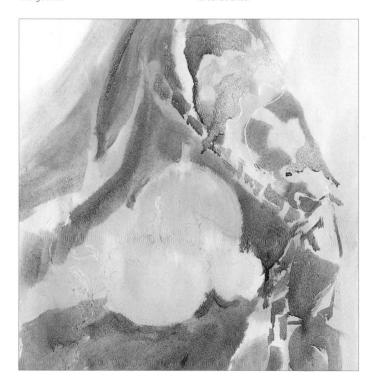

Continue painting the green of the background fabric, leaving the underlying yellowy orange wash showing through for the lighter parts of the fabric

 $5\,$ Mix a bright orangey red from cadmium red and a little cadmium orange. Using a medium round brush, start painting the red pattern on the fabric and some of the shadows in the background.

6 Mix a dark blue from ultramarine blue with a little Hooker's green and paint the blue pattern on the background fabric. Work quickly, with flowing brush strokes: getting the exact pattern is not important, but the curving lines enliven the painting and contrast with the solidity of the gourds in the foreground. Leave to dry.

Now that the background is well established, you can turn your attention to the main subject – the gourds. Mix a warm orange from cadmium orange and a little cadmium yellow and brush it over the largest gourd, making sure your brushstrokes follow the striated lines on the fruit's surface. Use the same colour on the top half of the smallest gourd, and stipple yellow ochre on to the rounded gourd, which has a bumpy surface texture.

A Mix a thick, bluey-green from Hooker's green deep and ultramarine blue and paint the base of the small gourd, working from the base upwards. As you get near the top half, brush on cadmium yellow, dragging the brush to soften the line between the two halves. Rinse the brush thoroughly. While the paint is still wet, drag the tip of the brush over the green half to lift off lines of paint and reveal the underlying yellow wash applied in Step 2.

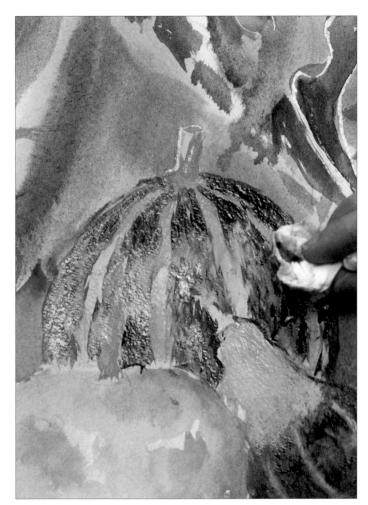

Using the side of the brush, dab Hooker's green and Hooker's green deep over the largest gourd. It is not a uniform, flat colour, and alternating between the two greens helps to show up the texture. Leave broad lines of the underlying Usually distributed the two greens helps to show up the texture. Leave broad lines of the underlying Usually distributed the two greens helps to show up the texture. Leave broad lines of the underlying Usually distributed to the texture and the color of paper towel to create more texture and visual interest.

Tip: Turn the paper towel around in your hand each time you press it on to the paper so that you are using a clean area and don't accidentally dab paint back on to the support.

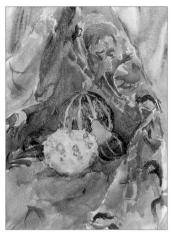

10 Mix a thick, warm yellow from cadmium yellow, titanium white and a little cadmium orange and paint the light areas on the rounded gourd in the foreground. Using the tip of the brush, dot on burnt sienna in places to indicate the bumpy surface texture. Mix ultramarine blue with titanium white and paint some of the pale, muted blues in the background fabric; loosely brush burnt sienna on to the right-hand side of the painting, outside the draped background fabric. Leave to dry.

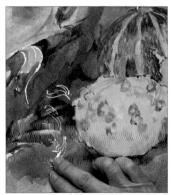

1 1 Using your fingertips, gently rub off the masking fluid from the cow parsley and the background fabric. Run your fingers over the surface of the painting to make sure you have removed all of the masking fluid.

Assessment time

Take some time to stand back and think about what still must be done. The shapes, colours and patterns are all established, but the foreground gourd, in particular, still looks a little flat and needs to stand out more from the background.

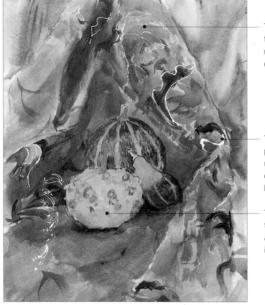

The background fabric should look more three-dimensional.

The areas protected by the masking fluid are distractingly bright.

 The texture of this gourd is not as pronounced as it should be.

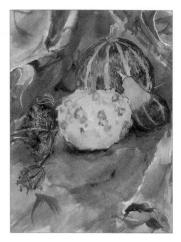

12 Mix a dark brown from burnt sienna and a tiny amount of Hooker's green deep and brush the mixture over the heads of cow parsley in the foreground. Mix cadmium orange with titanium white and, using the tip of the brush, "draw" the little florets of the dried cow parsley heads as crisscrossing, star-shaped lines. The shapes do not have to be exact; just aim to give an impression of the texture. The colour provides a visual link with the colours of the gourds and the warm orangey red of the background fabric.

 $13\,$ Mix a pale yellow from cadmium yellow and a little titanium white and brush over the exposed masking fluid lines on the background fabric. Mix a very pale blue from ultramarine blue and titanium white and paint flowing lines on the background fabric, noting how the fabric drapes.

14 Using a plastic painting knife, dot blobs of the pale yellow mixture used in Step 13 over the surface of the bumpy gourd in the foreground, where the raised surfaces catch the light. This enhances the texture of the gourd and helps to make it look more three-dimensional.

Gourds and other autumn fruit and vegetables make attractive subjects for still lifes. Instead of painting the subject in photorealistic detail, the artist has interpreted the scene loosely, creating an animated painting that is full of swirls of colour and interesting textures. Too precise a rendering of the background fabric, in particular, could have resulted in an overly tight piece of work that lacked any sense of life.

Note the contrast between wet-on-dry paint applications on the fabric and the wet-into-wet blurs of the background.

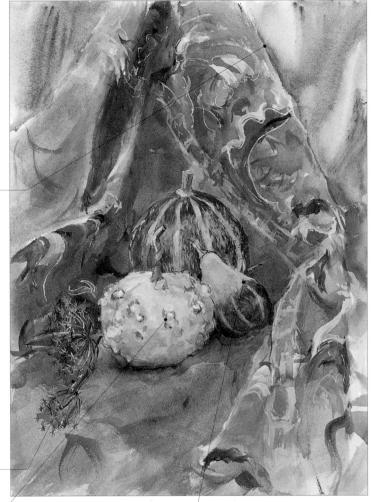

Specks of warm, bright yellow on the cow parsley help to bring it forwards in the painting.

Dots of thick burnt sienna and pale yellow applied with a painting knife create the textured surface of the gourd.

The yellow lines are created by lifting off wet paint with a damp brush or paper towel to reveal the underlying colour.

Still life with pebbles

This project is all about taking something very mundane and making a painting from it. Although we may tend to think of still lifes as being carefully controlled compositions, in which every element is deliberately placed, potential subjects are all around us. It's simply a matter of keeping your eyes open. In this project, a random arrangement of pebbles and lengths of twine in a small fishing harbour, which the artist came across quite by chance, has been transformed into a colourful painting that is full of texture and interest.

Of course, "found" still lifes still require a certain amount of input on the part of the artist. You have to decide how much of the scene to include, and where to place the edges of the painting. You may even have to move things around a little to get the effect you want, although beware of doing too much as this can destroy the spontaneous, natural look.

In this project, the pebbles are more or less life-size. Painting a smaller subject than normal is a useful exercise, as you will have to look at things in a different way. If you often paint landscapes, for example, your initial instinct might be to scan the scene rapidly to gain an impression of the key elements; you will probably then spend time working out how best to make these elements stand out. When you concentrate on a small area, as here. every element counts: you need to slow down and look at how the different parts relate to one another in terms of their size. shape and colour, and adjust your position until you are sure you have got the best viewpoint. At this scale, moving just one step to the left or right, backwards or forwards, can make a real difference.

Materials

- Illustration board
- B pencil
- Gouache paints: cadmium yellow deep, cadmium orange, burnt umber, phthalocyanine blue, ultramarine blue, zinc white, ivory black, cerulean blue, mid green, flame red, lemon yellow
- Brushes: large wash, old toothbrush, small round, fine round
- Rag or kitchen paper
- Small painting knife
- Acrylic gold size
- · Gold leaf

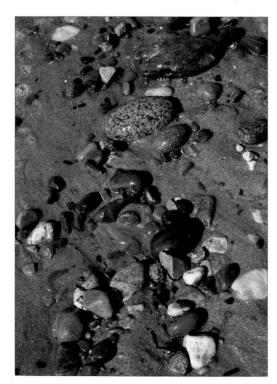

The scene

Pebbles in a harbour, glistening with water left by the retreating tide, present an interesting challenge. When painting a subject like this, look for contrasts of size and colour.

Using a B pencil, mark a grid of squares on your paper.

Many of the pebbles are similar in size and shape, so
the grid will help you to keep track of which pebble you are
painting. Again using the B pencil, make a light underdrawing.

2 Mix separate washes of cadmium yellow deep and cadmium orange. Wash cadmium yellow deep over the whole paper. While it is still wet, brush in cadmium orange, leaving some areas as pure yellow. Press a clean rag or absorbent kitchen paper over the top right of the paper, to lift off some of the orange. Leave to dry.

A Load an old toothbrush with burnt umber and any other colours that you can detect in the sand, and drag a painting knife through the bristles to spatter paint over the paper, creating a background of large-grained sand. (If you don't have a painting knife, an ordinary kitchen knife will work just as well.) Leave to dry.

A Mix various blues and greys from phthalocyanine blue, ultramarine blue, zinc white and ivory black. Using a small round brush, begin putting in the pebbles. Note that you are simply placing the pebbles at this stage; although they look like flat circles and ovals, you will begin to build up the form later.

5 Continue putting in the pebbles, varying the colours. Some have a purple undertone; others have a greenish tinge, created from a base colour of mid green plus ginc white or ivory black, as appropriate. Leave to dry.

6 Load the toothbrush with cadmium yellow deep. Drag a painting knife through the bristles, as in Step 3, to spatter both the pebbles and the sand with yellow paint. Repeat the process with flame red and lemon yellow.

Tip: To get the size of the spatters right, try practising on a piece of card, holding the toothbrush at different distances from the painting.

While the yellow spattering is still wet, drag a rag or a piece of absorbent kitchen paper over the spatters on some of the larger and darker pebbles to create streaked marks. On other pebbles, simply dab off any excess paint with a damp cloth to reveal the underlying colours, so that the spatters look like mica or other mineral crystals lodged within the stone, rather than lichen growing on top.

Assessment time

The initial blocking in of colours is complete, and the sand (which contains spatters of several different colours) looks convincingly textured, but at this stage the majority of the pebbles simply look like circles or ovals of dark colour positioned within the sand, rather than three-dimensional objects. The lighting is fairly flat and uniform, so there are no clearly defined shadows to help you, but if you look closely you will see differences in both tone and colour temperature, with the sides of the pebbles that are turned away from the light being cooler (bluer) in colour. As you complete the painting, you should concentrate on reinforcing these tonal contrasts and on giving the pebbles more texture.

Smudging wet paint over dry has created streaks of paint that provide a good basis on which to build up more texture.

The shape of the pebbles is clear, but so far they all look flat and one-dimensional.

The texture of the sand has been built up well by blending colours wet into wet and by spattering.

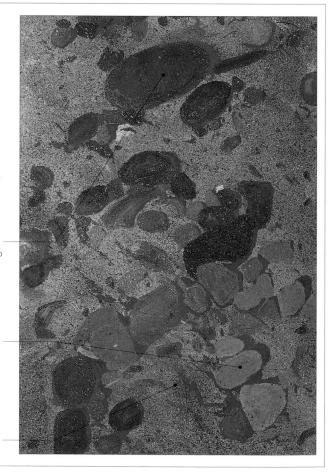

8 Mix a bright but chalky blue from cerulean blue and a little zinc white. Using a small round brush, brush this mixture over the brightest parts of any blue-grey pebbles. Mix a pale yellow from cadmium yellow deep, lemon vellow and zinc white, and a pale pink from flame red and white, and dab these mixtures over the large, pale pebble near the top of the painting, using short horizontal brushstrokes. Mix a dilute, neutral shadow colour from phthalocyanine blue and a little burnt umber. Paint the small shadows to the right of the largest pebbles; they immediately look much more threedimensional.

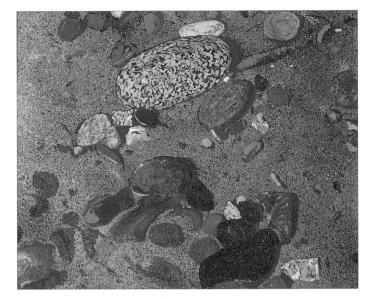

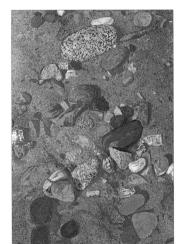

10 Vary your brushstrokes, stippling the paint in some places and using short strokes in others, but always allowing some of the underlying colours to show through.

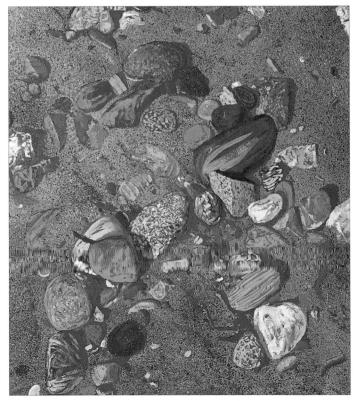

1 Using a very fine brush, stipple all the colours on your palette on to the sand to create the appearance of large grains of sand or very tiny pebbles. Stand back from your work at regular intervals in order to see how the whole painting is progressing.

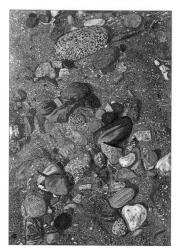

12 Many different colours have now been spattered and stippled on to the sand, creating a suitably granular-looking background for the pebbles. Take time to assess whether or not the texture of the sand is complete before you move on to the next stage.

13 If some of the stones look too dark in relation to the rest of the image, stipple or dab on some of your very pale yellow mixture. Use artistic licence where necessary in your choice of colours and keep looking at the balance of the painting as a whole.

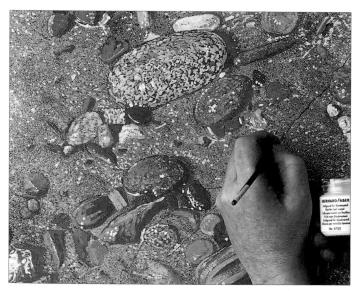

14 Now for the final touch – the twine that twists and turns its way through the pebbles, creating a dynamic diagonal line that draws our eye through the composition. Using a fine round brush, "draw" the line of the twine in acrylic gold size. Leave the size until it is tacky to the touch, following the manufacturer's instructions.

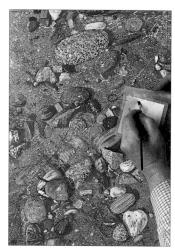

15 Lift a small piece of gold leaf by the backing paper and position it on the sized surface. Brush over the backing paper with a soft brush. Press a piece of kitchen paper over the gold leaf to ensure that it adheres firmly. Brush off any excess gold leaf with a clean, dry brush.

This is a deceptively simple-looking still life, but the gradual build-up of tones and textures makes it very convincing. A number of textural techniques have been used, and the artist has exploited the chalky consistency of gouache paint to give the pebbles solidity. The use of gold leaf for the twine is an imaginative touch that adds yet another texture to the image.

The trick with a painting like this is not to overwork it. Try to build up the image as a whole, rather than trying to finish one small area before you move on to the next. Taking time out at regular intervals, so that you can stand back and assess whether or not you've built up the textures to the degree that you want, is also important.

Just a hint of a shadow under the right-hand edge of the largest pebbles is enough to make them look three-dimensional.

The different facets of the stones have been carefully observed.

The twine, created by applying gold leaf, snakes its way through the line of the same and the sa

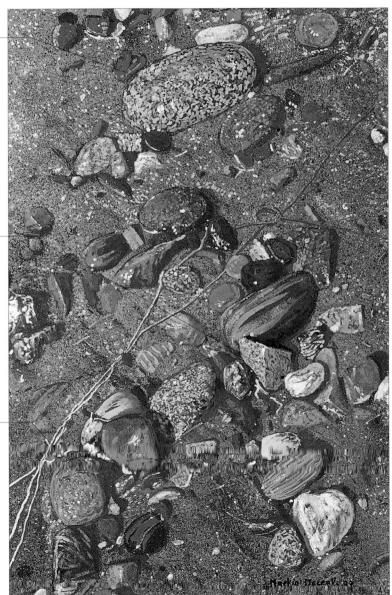

Lemons in glass dish

Less is very often more when painting still lifes; in other words, a small number of objects, carefully arranged, is often more effective than an elaborate set-up of many different elements. What could be simpler than a few lemons in a glass dish?

However, you still need to take time and care over your arrangement. Place the lemons so that they create an attractive overall shape, and look at the balance of the composition and at the spaces between the objects. Does the arrangement look too heavily weighted towards one side? Do the lemons make an interesting shape that draws our eye around the picture? Positioning the lemons at different angles and cutting one of them in half, so that we can see its internal structure, adds interest to the scene.

Because clear glass takes on the colours of the objects around it, you need to establish the background colour and the colour of any objects seen through the glass before you can turn your attention to the glass itself. The highlights on both the dish and the lemons require careful study, but you should resist the temptation to put in every single one: too many highlights can easily detract from your main subject. Half-close your eyes, as this makes it easier to assess which highlights are the most prominent and therefore the most important.

Shadows are an essential part of the composition, too, with both the lemon on the table top and the glazing bars of the window casting interesting shadows that tell us about the direction and intensity of the light. Beginners sometimes make the mistake of adding black to the local colour of an object to make its shadow colour, but shadows often contain a hint of the complementary colour, as well as colours reflected from nearby objects. Here, for example, the lemon's shadow contains some violet—the complementary of yellow. Even within the shadows there are warm and cool colours and light and dark areas: never paint a shadow as a uniform, flat colour.

Materials

- · Stretched and primed canvas
- Oil paints: olive green, lemon yellow, cadmium red, cobalt blue, raw umber, alizarin crimson, titanium white
- Turpentine
- Brushes: selection of small and medium hogshair

Always look for interesting shapes and lines when you're setting up a still life. In this arrangement, the lemons are angled in different directions, which adds interest to the scene. One lemon was also cut in half, which provides the opportunity to explore its internal structure and texture. Although the initial stages of the painting were made in flat lighting conditions, during the second painting session the sun moved round, casting diagonal shadows that form a strong contrast to the horizontal planks of the rough wooden table.

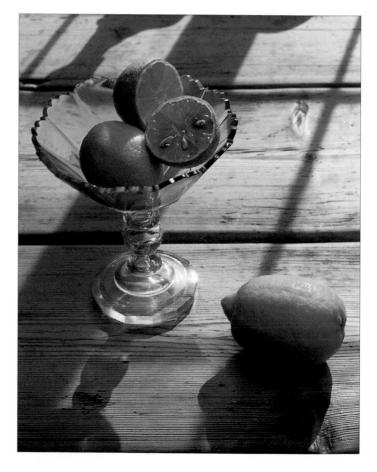

1 Using a small brush and a thin mix of olive green, draw the glass dish. Put in vertical and horizontal guidelines to help you get the shape of the ellipse right and a vertical line as the centre of the stem: these guidelines will be covered up later, but with plain glass it's very obvious if the shape is wrong.

 $2^{\,}$ Draw the lemons (including the shadow cast by the lemon on the table) and indicate the lines of the planks of wood on the table top. Try to think of the lemons as rounded geometric forms rather than simply drawing an outline, and look at where edges overlap.

Once you are happy with your underdrawing, you can start to apply some paint. Mix a dark olive colour from olive green, lemon yellow and a minute amount of cadmium red and block in the shaded sides of the lemons. Add more lemon yellow to your mixture and paint all the unshaded parts of the lemons, including the cut surfaces. Leave unpainted the ring of pith around the edges of the cut lemons.

Tip: Look carofully at the different yellows within the still life; some areas have a blue-green tinge, while others are much warmer. Look at the relative tones, too; you will probably find that the shaded areas are actually much darker than you expected.

A Block in the shadow under the lemon on the table using a neutral grey mixture of cobalt blue, raw umber and a touch of alizarin crimson. Mix a neutral grey-brown from raw umber, cobalt blue and titanium white. Scumble this mixture over the table top, using diagonal brushstrokes that echo the direction of the light. Note that the colour is not uniform: there are warm and cool areas within it, so adjust the proportions of your mix accordingly.

Tip: Although the scumbling can be fairly loose, take care not to go over the outlines of the lemons or the glass bowl. One advantage of scumbling is that it allows some of the underlying colour to show through, and this helps to create the texture of the rough wooden table top. The contrast between this texture and that of the more smoothly painted glass bowl and lemons will be important in the final painting.

Assessment time

Clear glass has no colour of its own; it takes its colour from what is around it, so you need to establish the basic tonal framework of the scene first. Once you have done this, you can concentrate on refining the lights and dark, and on making the glass really look like glass.

Spend time assessing which colours and tones are reflected in the glass before you apply any more paint.

The lemons are starting to look rounded, but require more work in order to look convincing.

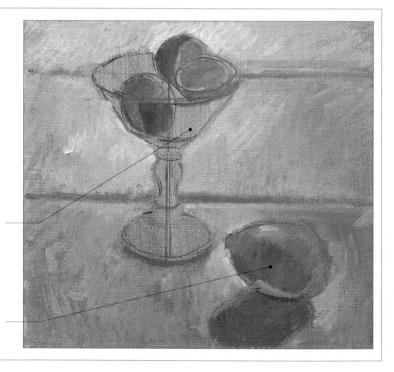

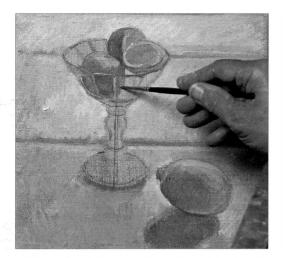

5 Now begin to indicate the different facets of the glass dish by putting in warm (pinky brown) or cool (blue-biased grey) lines as appropriate. Brush a pale blue around the rim of the cut lemons.

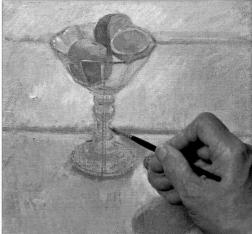

6 Continue to paint the stem and the base of the glass dish, using warm- or cool-biased mixes as appropriate. The tone can change quite dramatically within a small area, so take your time and use a small brush.

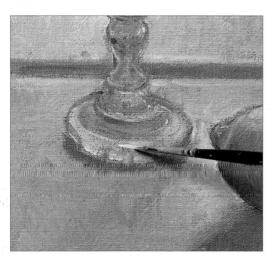

7 Using the same pale blue colour that you used around the rim, lightly touch in the segments on the surfaces of the cut lemons and put in the highlights reflected in the base of the glass dish.

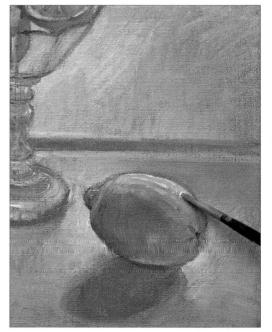

Susing a pale yellow mixed from lemon yellow and white, draw in the highlights on the foreground lemon. Use slightly uneven, broken strokes to create texture on the surface of the lemon.

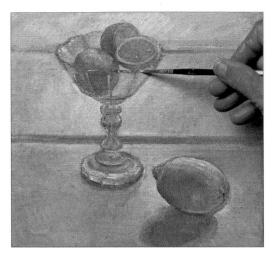

O Now put in the scalloped edge of the dish. The crisp lines of the cut glass pick up highlights, and you can use these to imply the shapes. Use a small brush and put little touches of blue-grey around the back of the dish, which is largely in shadow, and white tinged with yellow around the front.

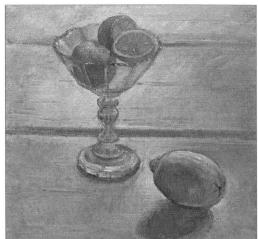

10 Using a fine sable brush and almost dry paint, gently stroke fine lines of the grey-brown mixture from Step 4 over the table top to imply the grain of the wooden table. The effect is subtle but it adds much-needed texture to the table top without detracting from the still-life arrangement.

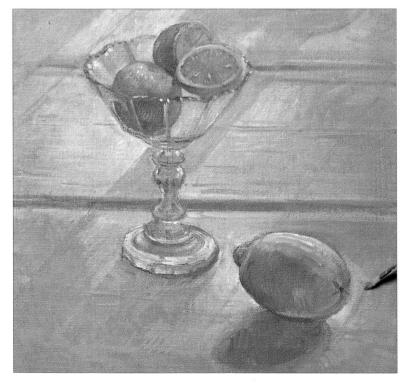

1 1 Mix a pale blue-grey from cobalt blue, titanium white and a little of the mixture used to paint the table top in Step 10. Block in the diagonal shadows cast on the table by the glazing bars in the window, scumbling the mixture on thinly so that some of the underlying colour comes through. Paint the shadow cast by the glass in the same way. This immediately brings more drama to the scene.

Tip: It's very often the contrast between light and dark areas that gives a painting its impact. If the scene doesn't look as strong as you would like, try darkening the dark areas rather than lightening the light ones. If the scene is allowed to become too high-key, the drama may be lost.

The drama of the lighting enhances this little still life immeasurably, with the strong diagonal shadows giving the scene much more drama and impact. The highlights are not

overstated but bring much-needed sparkle to the work. A mix of cool and warm tones in the glass provides information about the strength and direction of the light.

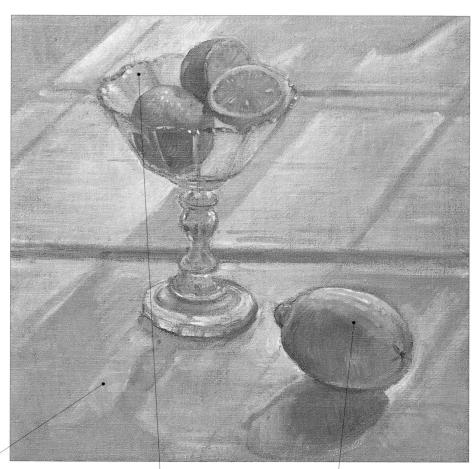

The contrast between light and dark areas is what gives the still life its impact.

Both cool and warm tones can be seen in the glass dish.

Relatively thick paint captures the texture of the lemon skin beautifully.

Still life with glass and ceramics

This project is primarily an exercise in observing and painting glass and hard-edged, solid-coloured objects. The technique chosen suits the hard, crisp quality of the objects.

The thing to remember when painting clear glass is that it has no colour of its own: any colour that you can see comes from surrounding objects that are either reflected in the glass or can be seen through it.

Although we know that solid-coloured objects such as the play bricks and pots in this scene are a uniform colour, you cannot paint them as such: their position in relation to the light source means that some areas will be darker or lighter in tone than others, and you must convey these tonal variations in order to make your picture look three-dimensional. There will also be some very bright, almost white, highlights where the lights catches one edge of the object. Although there are relatively few colours in this still life, there is a great deal of tonal variation, which you need to assess very carefully.

Shadows also play an important part in creating a three-dimensional impression. Keep the lighting simple: use just one light, positioned to one side of the objects so that they cast soft shadows both on to other objects within the group and on to the background wall. You can control the size and intensity of the shadows by altering the distance between the light and the objects. If you find that the shadowed side looks too dark, place a sheet of white cardboard or hang a piece of white fabric (a T-shirt will do) on the other side of the still life from the light in order to reflect some light back on to the collection of objects.

Materials

- MDF (medium density fibreboard) primed with acrylic gesso
- B pencil
- Acrylic paints: phthalocyanine blue, titanium white, alizarin crimson, burnt umber, yellow ochre, cadmium yellow, phthalocyanine green, purple lake, cadmium red
- Matt acrylic medium
- Brushes: medium flat

The set-up

This still life is an eclectic mix of stoneware pots and glass bottles, chosen for the contrast between transparent objects and ones that are solid, and children's play bricks and a wooden ball, selected for their contrasts in shape and colour. Light from a table lamp, positioned out of shot to the right of the set-up, casts interesting shadows on both the objects and the background wall.

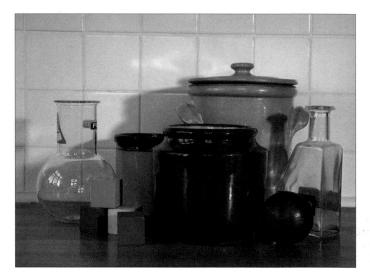

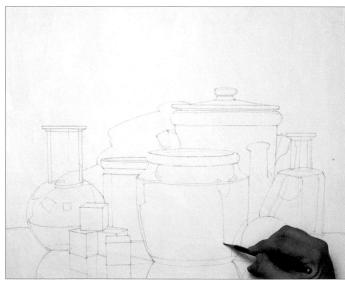

1 Using a B pencil, make a light underdrawing of the still life. Include the highlights and shadows, as these are an integral part of the composition.

2 Mix a dull grey from phthalocyanine blue, titanium white, a tiny amount of alizarin crimson, and a few drops of matt acrylic medium, which makes the paint transparent and a little smoother. Using a medium flat brush, block in the shadows of the objects on the background, and the shadow that can be seen through the glass bottle on the left, leaving some of the highlights untouched. Use the same grey to outline the glass bottles, which take their colour from surrounding objects and reflections.

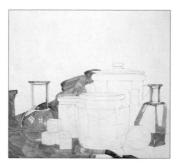

Add alizarin crimson and hurnt umber to the mixture to make a light brown and start to paint the table, working carefully around the objects but remembering to paint the table that can be seen through the glass bottles.

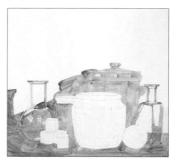

4 Continuc until you have completed the table. Use the same light brown to block in the large, lidded ceramic jar in the background and the bottom part of the stoneware jar on the left.

Tip: The brushmarks will remain evident as the paint dries. Do not try to smooth them out or obliterate them, even though the objects you are painting are smooth in texture, as the brush marks give added interest to the painting.

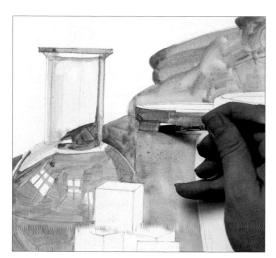

 $5\,$ Mix a deep brown from burnt umber, yellow ochre and alizarin crimson and paint the dark rim of the stoneware jar. The flat brush makes it easy to paint straight edges such as this. Use a very thin version of the blue-grey mixture from Step 2 to paint the glass bottle on the right.

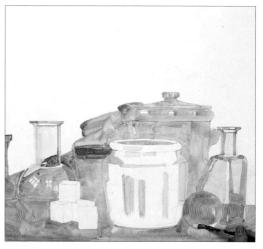

6 Mix pale brown from yellow ochre and burnt umber and paint the shaded interior of the foreground jar, leaving the highlit rim untouched. Mix a pale, greyish green from the previous pale brown mixture and a little phthalocyanine blue and paint the lightest areas on the green foreground jar with broad, vertical brushstrokes. Add a little alizarin crimson to the mixture used to paint the inside of the foreground jar and paint the ball in the foreground, leaving the highlights white

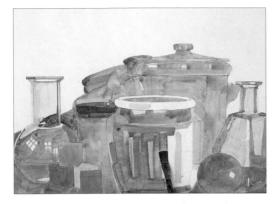

7 Now paint the children's bricks in the foreground, using phthalocyanine blue, cadmium yellow, and a bright green mixed from cadmium yellow and phthalocyanine green. Add some blue to the green mixture and start painting the green jar, working around the dull green highlights that you put down in the previous step.

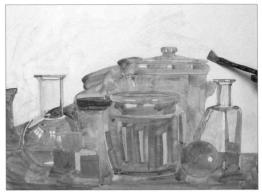

Paint the rim of the green jar, painting around the highlights. Now paint the background. Add more titanium white to the pale brown mixture used in Steps 3 and 4 and brush around the outlines of the objects, feathering the brush strokes upwards, away from the jars. The flat brush makes it easy to work right up to the edge of each object.

Assessment time

The basic shapes and reflections have been put in, and all the objects have been given one layer of colour. You can see, however, that the picture looks rather flat and one-dimensional. You need to work over the whole

painting again, increasing the tonal contrasts and adding more detail, in order to make the image look threedimensional and make the objects stand out clearly from the background.

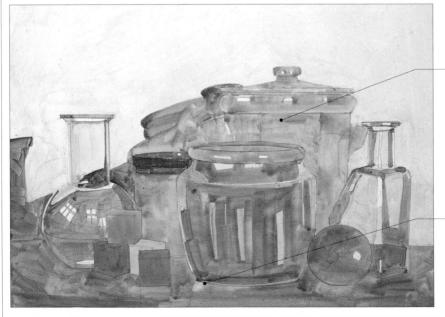

The large brown pot, in particular, lacks form and merges with both the background and the objects in front of it.

The absence of shadow makes it hard to "read" the image and work out the strength and intensity of the light.

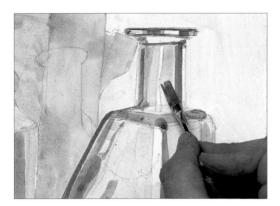

Mix a very pale, dilute blue from phthalocyanine blue and titanium white. Paint over the interior of the right-hand glass bottle, working around the highlights and using vertical brushstrokes. Although the glass is clear, it should be slightly darker in tone than the background wall that can be seen through it.

10 Mix a very pale brown from titanium white and burnt umber and fill in the colour in the lower half of the right-hand glass bottle, through which you can see the colour of the wooden table. Mix a rich brown from alizarin crimson, burnt umber and yellow ochre and paint the ball. Add a little purple lake to the mixture and paint the rim of the two-tone stoneware jar.

1 Use the same dark brown for the shadow under the lid of the stoneware jar in the background and on the darkest areas of the lid itself, remembering to paint around the highlights. Darken the tone of both stoneware jars, using vertical brushstrokes and reserving the highlights. Add phthalocyanine blue to the brown mixture and paint the shadow of the glass bottle on the large jar. Use the same colour on the left-hand edge of the bottle, which picks up reflected colour from the green jar to its left.

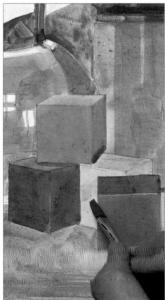

12 Strengthen the colours on the children's play bricks, making the tones slightly darker on the shaded sides. The shape of the brush will help you to keep the edges of the bricks straight.

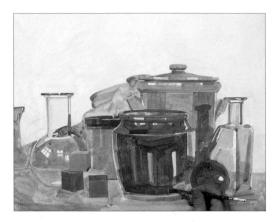

 13° Paint over the green jar again, using the same paint mixture as in Step 7, again reserving the highlights. The jar is now beginning to take on more depth and solidity.

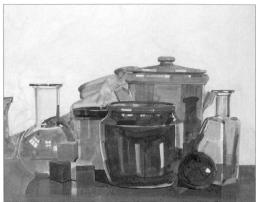

Add burnt umber to the green mixture used in the previous step and, using the edge of the brush, paint a shadow under the base of the green jar, the ball, and the bricks. This has the effect of giving a crisper edge to the objects and helps to define them more clearly. Add alizarin crimson, yellow ochre and a little purple lake to the shadow mixture and paint the deep shadows between the bricks and the jars, and between the ball and the green jar.

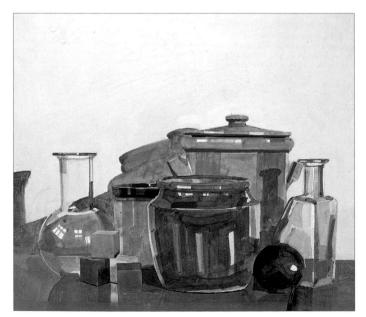

 $15\,\mathrm{Mix}$ a purplish blue from phthalocyanine blue, cadmium red and titanium white and reinforce the shadow colour on the wall. Mix a dark, warm brown from phthalocyanine blue, burnt umber and a little cadmium red and darken the shadow under the lid of the stoneware jar. Add more red to the brown mixture and darken the ball.

16 Add phthalocyanine green to the brown mixture to make a very dark green and paint the very dark shadow cast by the ball on the side of the green jar.

All the surfaces in this still life are very smooth and hard, and so an impasto approach, with lots of textured paint, would be inappropriate. Here the artist has built up the layers gradually, adjusting the tones and colours until he achieved

the correct density. He has also paid close attention to the shadows and the way the light casts highlights on the objects, as these things are critical in making the objects look three-dimensional.

Glass takes its colour from surrounding objects which are either reflected in it or seen through it; here, colour is reflected from the shadows cast on the background.

The highlights, which are mostly left white, reveal the intensity and the direction of the light source and show up the different facets of the iars.

The shadow cast by the bottle is subtly coloured but helps to make the bottle look more three-dimensional.

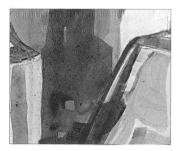

Painting Buildings

Although you can get away with shapes and proportions being slightly wrong in some subjects (landscapes, for example), if buildings in your paintings are askew, it will be very noticeable. If you are painting anything other than a head-on view of a façade, therefore, you must give some consideration to perspective. This sounds a lot scarier than it is: in fact, a combination of careful observation and a little basic theory, which you can get from any good book on drawing, will set you on the right

track. Just remember that all parallel lines on the same plane recede to the same vanishing point.

Unless you are very confident, start by making a light underdrawing and measuring the different parts of the building. Using a pencil to measure things is a classic method that artists have employed for centuries. Hold the pencil out in front of you at arm's length and align the tip with the top of the building. Then run your thumb down the pencil until it aligns with

the base. Transfer this measurement to your canvas, again keeping the pencil at arm's length and holding your arm straight. Look, measure and then check again; in fact, whatever you are painting, you should make a conscious effort to spend more time looking at your subject than you do looking at the canvas.

Buildings are one area where including a lot of detail in your underdrawing can really help you, as establishing the relative sizes and positions of doors, windows, arches and other features is critical. Also remember to count: if there are five arched window on a façade, make sure there are also five in your underdrawing.

It is also important to assess the tones in your subject carefully. The exterior of a building is often comprised of one main material (brick, concrete, stucco, for example) and hence it is largely through differences in tone that we make it look three-dimensional. Remember that both acrylic and gouache paints look slightly darker when dry than when wet; test your mixes on scrap paper, and leave them to dry so that you can judge the real tones before you apply them to your painting. Shadows also play a part in this: even a small shadow cast by a window ledge or a decorative embellishment such as a stone statue or door knocker will contribute to the three-dimensional illusion.

Once you have established the basic form of the building, you can put in decorative details and textures. On worn, weathered buildings and peeling paintwork, scumbling is often a good technique for creating texture. If you are painting in acrylic, you might also consider using one of the many proprietary texture mediums on the market. Drybrush, sgrafitto, spattering and sponging are all useful techniques for creating texture on buildings.

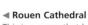

This is a scene that has been painted countless times, most notably by the French Impressionist artist Claude Monet (1840–1926). In this version, the plants and café umbrellas bring a touch of modernity to the scene and hint at the bustling street life that goes on around the cathedral.

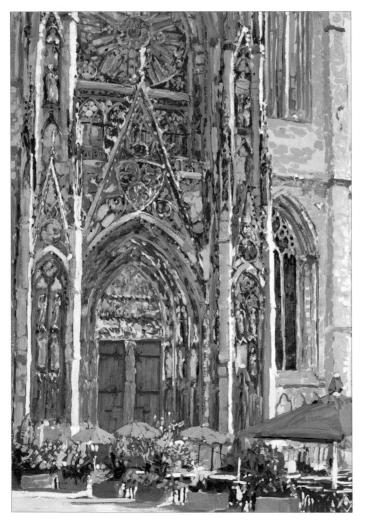

- Tips: Observe the rules of perspective and make a light underdrawing to check that you have got things right; this will ensure that your building does not look as if it is about to fall over.
- Draw and paint your building in the same order that it was built
 inh main structure first, followed by doors and windows, and finally architectural details such as railings and statues.
- If you are painting the façade of a building, pay particular attention to the direction and length of any shadows: they will help you to create a sense of depth in an otherwise flat subject.

The shaded courtyard A

This is a delightful evocation of a shaded courtyard in southern Spain. The shadows cast by the plants and the arches create an intriguing and lively pattern of dappled light on the ground. Note that the shadows are predominantly purple in tone shadows are rarely if ever, black.

Midday, Gnomon ▶

Textures and the strong diagonal midday shadows are what make this somewhat dilapidated building look so interesting. Scumbles of oil paint allow the underlying colours to show through – a classic method of conveying the texture of worn, weathered surfaces.

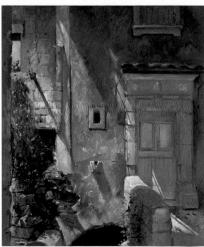

Church in snow

Buildings are an integral part of many landscape paintings. Even when they're not necessarily the prime focus of attention, they add an element of human interest by implying the presence of man, and they also help to give a sense of scale.

In this project, the church in the background brings another dimension to a tranquil rural setting. Its solid form, positioned roughly on the third, contrasts well with the landscape around.

Begin by establishing the basic shape of the building and painting it as a flat area of tone. You can then develop this, creating contrasts of light and shade that reveal the different sides of the building, and finally putting in just enough detailing to tell us about the architectural style and period. The human brain is amazingly adept at interpreting a few generalized indications of shape and texture, and too much information can actually destroy the balance of the painting as a whole – particularly when the building is in the background, as here. The further away something is, the less detail is required.

For this project, the artist began by toning the canvas with dilute olive green oil paint. The cool colour suits the wintry scene and gives a good, neutral mid-tone from which to start painting.

Just like water, snow reflects colour from the sky and objects nearby. Where the sun strikes, the snow may be tinged with warm yellows or even pinks, depending on the time of day, while shadows will contain shades of blue and violet. Resist the temptation to paint everything as a brilliant, monotone white: shadowy areas contrasting with small patches of bright, sunlit snow will have far more impact. The shadows in the snow also reveal the contours of the land beneath.

Materials

- · Stretched and primed canvas
- Oil paints: olive green, permanent mauve, titanium white, cobalt blue, raw sienna, viridian, burnt sienna, Indian yellow, cadmium red, lemon yellow
- Turpentine
- Brushes: selection of small and medium filberts

The scene

Although the church is far away and relatively indistinct, it is still the main focus of the scene. Along with the trees, it provides a strong vertical element on which the viewer's eye can alight, while the curve of the water leads us around the scene.

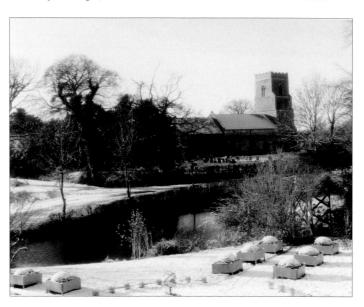

Make an underdrawing of the church, main trees and water area, using a small brush and thin olive green paint. When you paint buildings it is particularly important to get the proportions and angles right, so measure carefully and take your time over this stage. Also indicate the shadows on the snow in the foreground and roughly scumble in the largest reflections in the water.

2 Block in the trees on the far bank, using a mid-toned purple mixed from permanent mauve, titanium white, cobalt blue and raw sienna, and a bluegreen mixed from olive green, viridian and a tiny amount of burnt sienna. Using a small brush, begin putting in the cool shadows on the snow on the far bank, using a blue-grey mixed from cobalt blue, titanium white and permanent mauve.

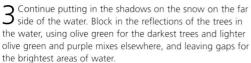

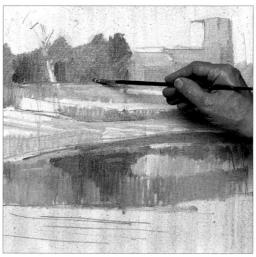

4 Mix a pinkish brown from burnt sienna, titanium white and cobalt blue and paint the walls of the church. Paint the snow-covered roof, which is in shadow, in a cool bluegrey. Overlay some pale blue on the purple trees in the background; this helps to link the trees with the snow.

Assessment time

Lively scumbles are a quick way of establishing basic shapes and tones in the early stages of a painting, and are particularly useful when you are painting outdoors. The underpainting is now virtually complete. For the rest of the painting, concentrate on texture and detailing, checking periodically to ensure that you maintain the tonal balance.

The church, which has been roughly blocked in, adds solidity to the scene.

Lively scumbles establish the basic shapes and tones.

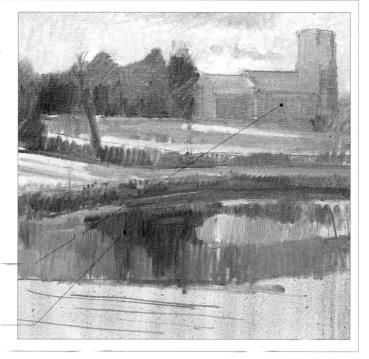

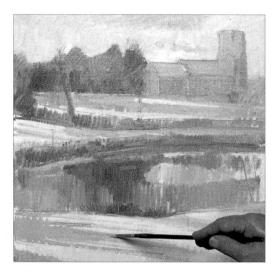

5 Indicate the grasses on the near bank by scumbling on a little of the dark green mixture from the previous step and raw sienna. The warmth of the raw sienna helps to bring them forward in the painting. Brush on more blue for the shadows in the foreground snow, using horizontal strokes that follow the direction of the shadows. For the unshaded areas of snow, use a warm off-white colour mixed from titanium white and a tiny amount of Indian yellow.

6 Using a fine brush and the purplish-grey mixture from Step 2, put in the bare branches that poke up from the ivy-covered trees in the background. Don't try to put in every single detail or the painting will start to look overworked and fussy; you can create a general impression of the shape and texture of these thin branches by means of a series of short parallel lines. Reserve the main detailing and texture for the foreground of the scene.

7 Put in the thin saplings along the bank, as well as their reflections. Darken and strengthen the colours of the reflections: once you've established the general area, you can smooth out the brushstrokes, blending the colours together on the canvas.

Read There is an overly bright and distracting area of water near the centre of the image, which needs to be toned down in order to blend in with the rest of the painting. Leaving the brightest areas untouched, lightly brush a very pale purple over this area.

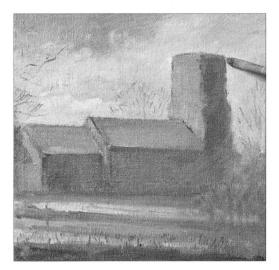

9 Mix a warm but pale yellow from Indian yellow and titanium white. Lightly touch it into the sky, where the winter sun shines through from behind the clouds.

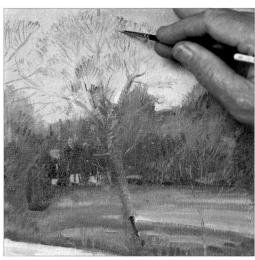

10 Continue with the linear, drybrush detailing on the bare branches of the trees, as in Step 6, again resisting the temptation to put in too much detail.

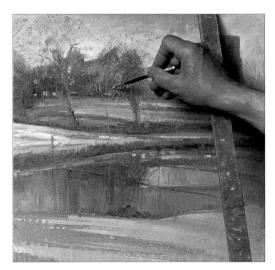

1 Using a fine sable brush and a pale blue-grey mixture, put in the branches of the young supplings on the bank. Adjust the proportions of the colours in your mixture: the shaded branches are bluer in tone, while those branches to which the snow is clinging are whiter.

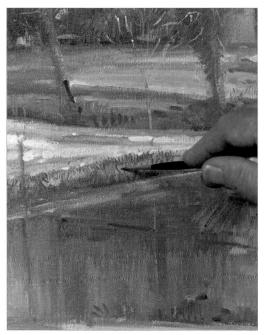

12 Strengthen the colours of the low bushes on the far side of the water, using short vertical strokes of reddish browns and dark olive greens. The warm colours help to bring this area forwards in the painting.

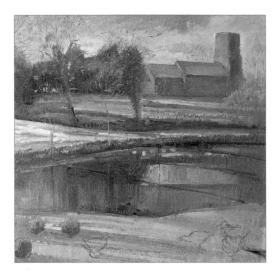

13 Using thin paint, draw the shapes of the box topiary and geese on the near bank. Roughly block in the shapes of the topiary with a pale blue-green mixture, adding more white on the side that catches the light. Using the same colours as before, brush in the shadows cast by the topiary and the geese.

14 Warm up the foreground snow by scumbling the off-white colour from Step 5 over those areas that are not in shadow. Paint the geese in a blue-tinged white, adding more blue to the mixture for the markings on the feathers. Paint their feet, legs and beaks in cadmium red mixed with white and a little lemon yellow.

15 Using a paler version of the stone colour from Step 4, paint the sunlit sides of the church so that the building looks three-dimensional. Paint the lines on the tower in a blue-grey, adding more white where the snow clings to the ridges. Paint the castellations on the turret by overpainting some of the sky colour. Use the brush handle to blend colours around the edge of the church and create a crisp outline.

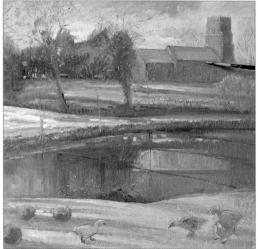

16 Paint the windows of the church in a dark brown, leaving the underlying colour showing through for the stonework.

This is a muted scene that nonetheless captures the feeling of thin, early-morning winter sunlight very well through its use of pale blues and pinks. The church is rendered indistinctly and almost appears to be seen through a haze, but there is enough detail to tell us about the architectural style. The geese in the foreground are painted in more detail and add life to what might otherwise be a rather static scene. Note how many different tones there are within the snow.

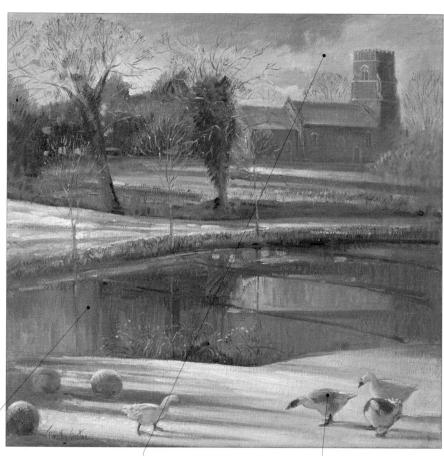

The brushstrokes in the reflections have been softly blended.

Warm but pale yellow in the sky lightens the scene.

The geese and their shadows enliven the foreground.

Arch and balcony

In the eighteenth and early nineteenth centuries, it was common practice for members of the aristocracy to undertake a grand tour of the major cities of Europe in order to complete their education. In those days before the advent of picture postcards and easy-to-use cameras, sketches made *in situ* were, for many, the only means of recording the wonders that they saw. As a consequence, watercolour paintings abound of the sites that they visited: great palaces and chateaux, romantic vistas and ruined follies were all captured on paper to show to admiring friends and relations.

In some respects this project, which relies on careful observation and measuring to record the detail of the building, is very much in the same tradition. However, it also goes beyond that, seeking as it does to capture the spirit of the place and the quality of the light. Attempting to create a sense of atmosphere is one of the things that will lift your work above the level of a technical exercise and turn it into a painting. Moreover, whether you are painting close to home or in a land far away, the very act of consciously examining your subject over an extended period of time somehow seems to imprint the scene in your memory in a way that taking a photograph can never do.

The building that features in this project is the Royal Pavilion, in Brighton, in the south of England, commissioned and closely overseen by the then Prince Regent (later King George IV), who confessed that he cried for joy when he contemplated the Pavilion's splendours.

Often when you are painting buildings – particularly ones such as this, which are rendered in stucco or plaster or constructed from smooth stone – you are dealing with very subtle differences in tone. You need to observe your subject and assess the tonal differences very carefully, as this is what conveys the three-dimensional nature of the building.

Remember, too, that gouache paint always looks slightly darker when it is dry than it does when it is wet. Make sure you test your mixtures on a scrap piece of paper or board and allow them to dry thoroughly before you apply them to your

painting, as this is the only way to judge whether or not you have got the mix right. Although it is possible to paint over areas if you find you've made them too dark, it is far better to get the tone right first time – particularly when you are using the gouache in the form of thin washes, as here – otherwise your painting may start to look heavy and overworked.

Materials

- Watercolour paper
- Acrylic gesso
- HB pencil
- Illustration board
- Gouache paints: raw umber, zinc white, jet black, ultramarine blue, brilliant yellow
- · Brushes: small round

The scene

Many people might have been tempted to select a viewpoint that included the whole of the arch and window, with the arch symmetrically positioned, but this could lead to a very static composition. This viewpoint is much more interesting: it allows us to see the form of the arch, rather than just a flat façade, while the turret on the edge of the balcony is positioned "on the third".

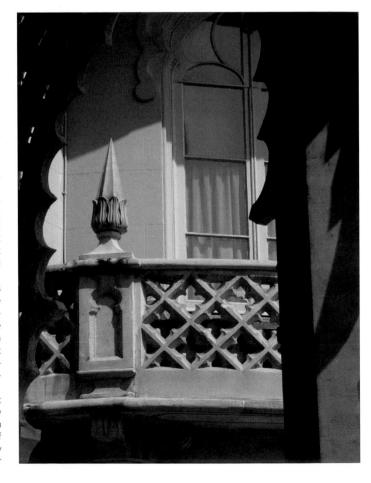

Using a sharp HB pencil, make an underdrawing on watercolour paper primed with acrylic gesso. It is important to measure everything carefully. Pay particular attention to the shape, size and number of the quatrefoil shapes in the tracery of the limestone balcony.

Mix a dark brown from raw umber, zinc white and jet black and, using a small round brush, paint the dark spaces around the quatrefoil shapes on the balcony. In some areas light is reflected back: paint these shapes in a blue-grey mixture of zinc white and ultramarine blue.

3 Using the dark brown mixture from Step 2, paint the shaded side of the foreground arch. Add more white to the mixture and paint the dark cast shadows on the right-hand side of the scene, making sure you paint them with crisp edges

4 Paying careful attention to where the light falls and alternating between the brown and blue-grey mixtures used in the previous steps, paint the scallop shapes will the lott hand side of the foreground arch.

 $5\,$ Mix a warm stone colour from zinc white, brilliant yellow and a litle raw umber and paint the lightest area of wall behind the balcony. Add ultramarine blue to the dark brown mixture and paint the shaded area above the turret and the edge of the stuccowork to the left of the window.

Paint the shaded left-hand side of the foreground arch, using the same dark mixtures as before. Although bright highlights are visible through gaps in the stonework, it is too difficult to try to work around them at this stage: you can reinstate them later using pure white gouache.

7 The blue sky reflected in the window can be seen behind some of the cut-out shapes in the balcony: paint these in a bright blue mixed from ultramarine blue and zinc white. Complete the dark shadows behind the quatrefoil shapes on the balcony; note that the colour changes should not be uniform in tone.

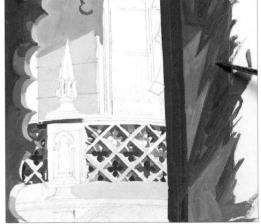

Mix a light brown shadow colour from raw umber and zinc white and paint the unpainted stonework on the right of the foreground arch. Scumble a little ultramarine blue over the cast shadows that you painted in Step 3 to make the colour look less flat and create some variety of tone.

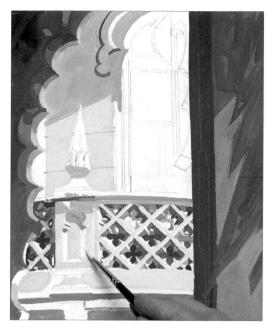

9 Add ultramarine blue to the warm stone colour that you mixed in Step 5 and paint the shadow areas on the balcony. Paint the lightest areas of stone on the balcony in a pale mixture of brilliant yellow and zinc white; you will need to look very carefully to see where the tone changes.

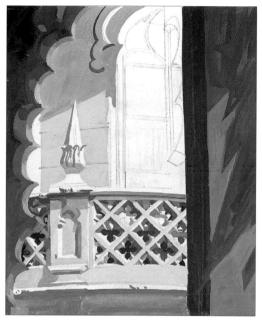

 10° Add raw umber to the stone colour and paint the area under the overhang of the balcony, which is in shadow and therefore darker in tone. Using a mid-tone brown, put in some of the dark detailing and the most deeply shaded side of the turret.

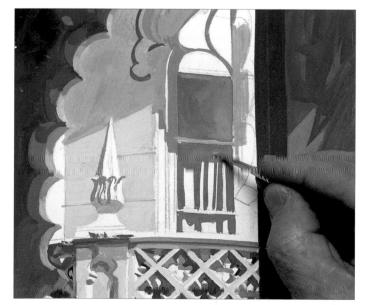

11 Put in the mid-toned areas of the glazing bars on the window, using a slightly paler version of the stone colour used earlier. Mix ultramarine blue, zinc white and a tiny amount of yellow and paint the reflections of the sky in the window, painting around the very lightest areas, where the curtain hangs in folds.

Tip: To avoid dirtying the white on your palette when mixing it with other colours, use a clean brush and add white to the colour you have already mixed rather than vice versa

Assessment time

Now that the painting is almost complete, spend some time assessing the tonal values. Is the difference in tone between the light and dark areas strong enough? Any adjustments that you make in the final stages will be very slight.

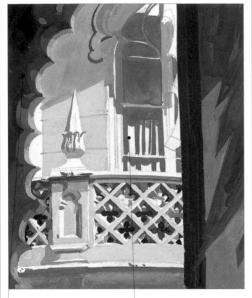

This dark mass tends to overpower the image; the highlights should be reinstated.

The unpainted white areas are too stark; they leap out from the image and demand attention.

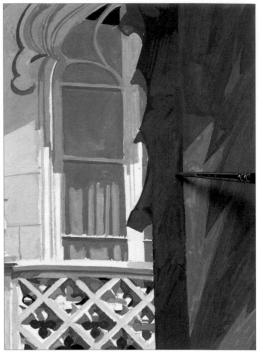

12 Using the stone colour, reinforce the shadows on the underside of the glazing bars. Mix a pale blue from ultramarine blue and lots of zinc white and paint those highlight areas of the curtain that are unpainted. Paint the scalloped edges that jut out from the right-hand side of the arch and scumble a little blue over the darkest part of the arch in order to create some texture and variety of tone in the stonework.

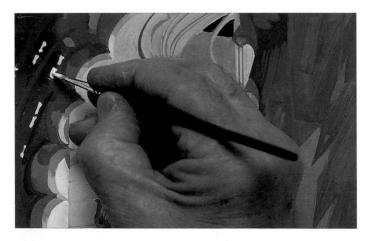

13 Dot in some pure white highlights on the left-hand side of the arch, where light shines through the tracery of the stonework.

Tip: Keep the paint mix quite thick when you are putting in highlights. If you use very watery paint, it is harder to control and may run. Touch the tip of a fine brush into the paint so that there is very little paint on the fibres, and hold the brush almost vertical to the support so that you can make very small, tightly controlled marks.

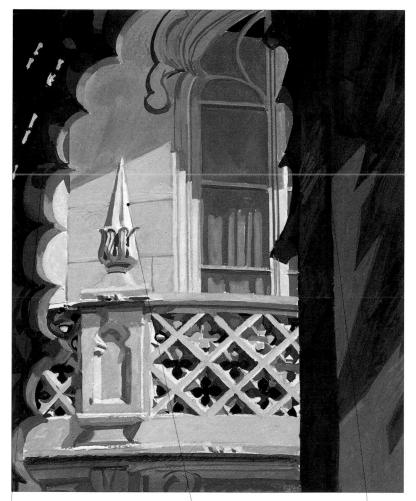

This is a considered painting of an interesting architectural detail. However the bold shadows and sense of light and shade lift it beyond being a mere record of the building. The arch frames the view, but the fact that it is off-centre creates a more dynamic and interesting composition. The colour palette is limited, but the subtle differences in tone have been carefully observed to create a scene that really looks three-dimensional.

Using gouache enables you to paint highlights over dark paint without any of the underlying colour showing through.

Note how the subtle differences in tone convey the feeling of strong sunlight and the form of the turret.

Scumbling different colours over the darkest area prevents it from looking flat and creates texture and variety in the stonework.

Moorish palace

Small details can often sum up the character of a building far more effectively than a view of the building in its entirety – particularly when, as here, there is an abundance of decorative detail in the form of beautifully shaped arches and mosaic tilework.

This scene shows part of a fourteenthcentury Moorish palace in Andalucia, in southern Spain. The view is painted from the central courtyard, which is surrounded by a cool, shaded gallery of the horseshoe-shaped arches that are so typical of this area and period. An arched doorway on one side of the gallery leads into a beautiful walled garden resplendent with splashing fountains.

Try to respect the architect's intentions when you are painting buildings of any kind. Symmetry was an important consideration in Moorish architecture and a symmetrical composition will help you to capture something of the formality of this particular building. Remember, however, that you are making a painting, not an architectural plan: you also have to take into consideration things like the play of light and shade and the contrast between the heat of the garden and the coolness of the gallery.

Materials

- Acrylic paper
- Acrylic paints: phthalocyanine green, phthalocyanine blue, cadmium red, titanium white, lemon yellow, alizarin crimson, ultramarine blue, brilliant yellow green
- Brushes: large round, medium flat, medium round, small flat
- Charcoal pencil

The courtyard and gallery

From this angle, the arch creates a "frame within a frame", leading us through to the garden and fountains. We can also see the gallery surrounding the courtyard, which tells us more about the building as a whole, and there is an interesting and atmospheric contrast between the brightly lit garden and the cool, shaded gallery.

The garden and fountains

Here, you can see the garden and fountains clearly. Architecturally, however, it is not as interesting as the view from the courtyard.

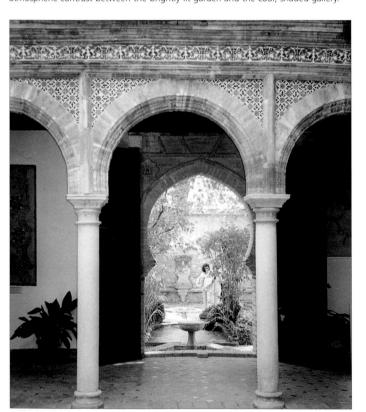

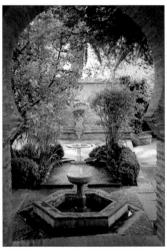

Tip: Always spend time exploring your subject from different viewpoints before you start painting; even a slight adjustment to your position can make a substantial difference. Instead of trying to capture the whole scene, decide what elements appeal to you most — and make quick compositional sketches to decide which viewpoint works best.

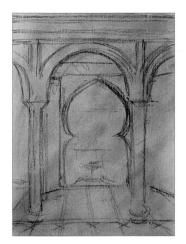

1 Mix a bright blue from phthalocyanine green and phthalocyanine blue. Using a large round brush, lay a flat wash over the paper. Leave to dry. Using a charcoal pencil, sketch the scene, observing the perspective carefully to ensure that all the lines run at the correct angles.

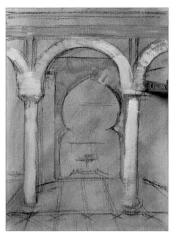

2 Mix a warm, off-white stone colour from cadmium red, titanium white and lemon yellow. Using a medium flat brush, paint the lightest tones of the vertical columns and foreground arch. Add a little more red to the mixture and paint the arch into the garden and the line of bricks above the foreground arch.

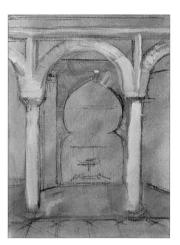

Add more water to the mixture and paint the shaded tiled area of floor beyond the arch. Because the paint is very dilute, it serves as a glaze, allowing some of the colour of the support to show through.

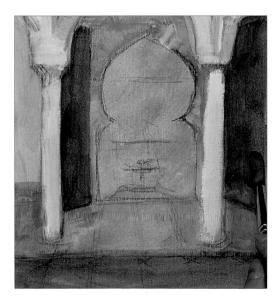

A Mix a purple shadow colour from alizarin crimson, ultramarine blue and a little lemon yellow and, using a medium round brush, paint the huge wooden doors on each slide of the unit usually little statistics of the same colour for the tiled courtyard floor.

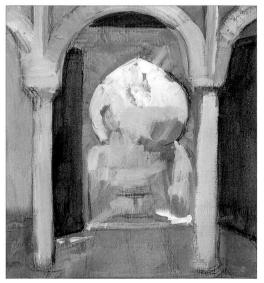

5 Mix a pale, bright green from brilliant yellow green and titanium white and paint the lightest foliage. Add more brilliant yellow green and a little ultramarine blue and dot in the darker foliage. Paint the pool surround in the stone colour from Step 2, adding more white for the side in sunlight.

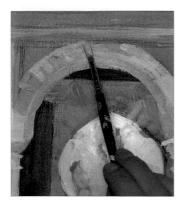

6 Mix a warmer stone colour from cadmium red, lemon yellow and titanium white and, using a small flat brush, paint the darker-toned bricks that run around the top of the arch.

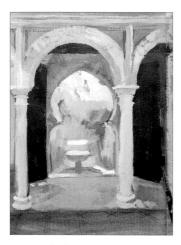

Paint the fountain base in the same colour and the interior of the fountain bowl in the initial pale stone colour. Add more water to the pale stone colour and scumble it loosely over the ground inside the archway. Reinforce the shadows at the top and base of the supporting columns. Brush a little very dilute lemon yellow over the wooden doors.

Assessment time

Although the dark wooden doors give some indication of perspective and distance, the image looks very flat and one-dimensional. There is some detailing on the brickwork of the arches, but the garden in the background consists of little more than a few blocks of colour. The next stage is to reinforce the sense of depth. More foreground details, suggesting the intricacy of the carved arches, would help to bring the arches forwards in the scene. Introducing some reflected light into the glazed tiles of the gallery floor would help to connect this area with the sunlit garden that lies beyond.

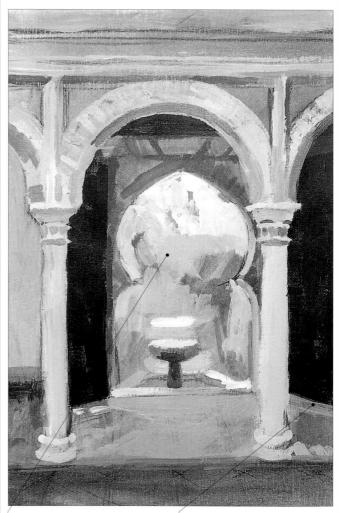

Indistinct masses of green imply the garden beyond, but more definition is needed.

The sloping line of the door gives some indication of depth and perspective.

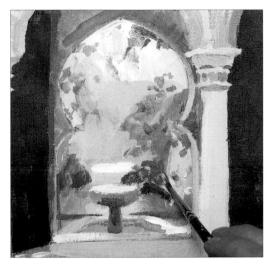

Mix a dark green from phthalocyanine green and brilliant yellow green, and a lighter green from brilliant yellow green and lemon yellow. Using a small round brush, dot these two mixtures over the foliage to give it more form, using the lighter colour higher up, where the sun catches the trees.

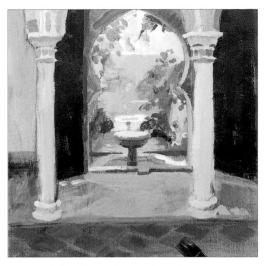

Mix a dull red from cadmium red, titanium white and a little phthalocyanine blue. Using a medium flat brush, put in the terracotta tiles of the courtyard, leaving lines of the blue glaze showing through. Darken the shaded edge of the step leading into the garden with the same colour.

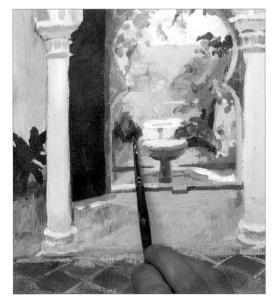

10 Mix a greenish black from phthalocyanine green and a little ultramarine blue. Block in the dark leaves of the potted plant to the left of the foreground arch and dot the same whom into the foliage in the garden; again, this helps to link the inner and outer courtyards.

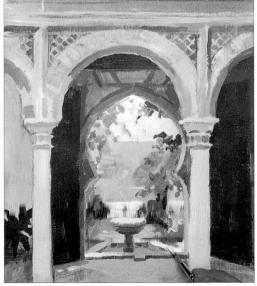

1 1 Add a little cadmium red and some titanium white to the pale stone colour and, using a small flat brush, put in the pink-coloured tiles around the top of the archway. Paint the small blue tiles in this area in a mixture of phthalocyanine blue and titanium white. Darken the shaded edge of the step.

12 Add a little titanium white to the pale stone colour and, using the tip of a small flat brush, paint mortar lines around the top of the arch. Using the same colour, paint the highlit side of the column that separates the central arch from its neighbour.

13 Using a small round brush and the terracotta mixture from Step 9, paint the plaster above the tiles. Paint the decorative tiles above the arch using the same colour and phthalocyanine blue. Interpret the pattern loosely. Add the mortar lines that separate the tiles, as you did in Step 12.

14 Paint the water splashing from the fountain in titanium white. Mix a pale ochre from lemon yellow and brilliant yellow green and paint the back wall of the garden, allowing some of the foliage colour to remain visible.

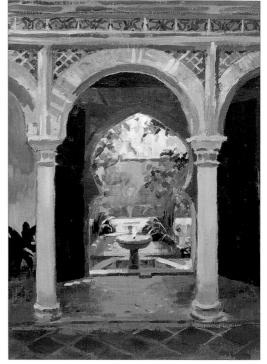

 $15\,$ Mix a very dilute, dull purple from alizarin crimson and phthalocyanine blue and paint the shadows cast by the heavy wooden doors on the tiled floor with smooth, even brush strokes.

This painting is all about contrasts: contrasts of light and shade and of warmth and coolness. The colour palette is beautifully balanced: the colour of the blue-toned ground is picked up in the tilework and the water, while terracotta and ochre complement the blue and bring added warmth to the scene. The arch in the foreground acts as a frame for the arched doorway and the garden beyond — an established compositional device that draws the viewer's eye through the picture.

The soft colours of the tiles, brickwork and plaster look faded, as befits the age of the building.

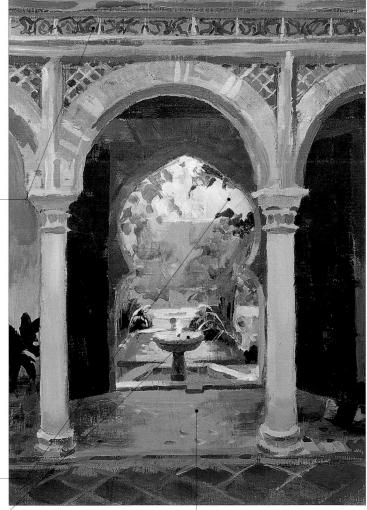

Pale yellows and greens are used to show how strongly the sunlight is hitting the tops of the trees.

The splashing water of the fountain is painted with energetic, curving brushstrokes.

The original blue-toned ground shows through the thin terracotta glaze, creating a feeling of coolness in this shaded area.

Wisteria-covered archway

Using an archway as a frame for a view is a classic compositional device, drawing the viewer's eye through the scene to linger on what lies beyond. Here, however, the view through the arch is little more than a soft, out-of-focus blur: the main interest lies around the arch itself, in the form of the old and somewhat worn brick wall and the violet-coloured wisteria flowers that cascade over it.

In this project, acrylic paint is used both in thin glazes to build up the colour and more thickly, mixed with white, for the mortar lines in the brickwork and the wisteria flowers.

Contrasts of texture are important in building up the image, and a range of techniques is used to achieve this. Spatters of paint in the foreground convey the gravelly texture of the path; fine texture paste on the wall gives a sense of the worn, crumbling brickwork; and different brushstrokes, from flowing curves to short dabs and dashes, capture the textures and shapes of the foreground plants.

Materials

- 300gsm (140lb) NOT watercolour paper
- HB pencil
- Painting knife
- Fine texture paste
- Ruling drawing pen or fine-nibbed steel dip pen
- Masking fluid
- Acrylic paints: light blue violet, vermilion, Hooker's green, yellow ochre, titanium white, violet, burnt sienna, cadmium orange, cadmium yellow, ultramarine blue
- · Brushes: medium chisel or round
- Waterproof sepia ink

The wisteria flowers

By moving around to the right, the artist was able to see more clearly the colours in the petals and how the flowers hang in clusters. Taking reference photographs or making quick sketches of details such as this will prove invaluable.

The scene

Although this viewpoint shows the arch and pathway well, there is no real focus of interest and the detail of the flowers is indistinct

1 Using an HB pencil, lightly sketch the scene. Using the tip of a small painting knife, dab texture paste randomly over the brickwork and the path. Leave to dry. Dip a ruling drawing pen or fine-nibbed steel dip pen in masking fluid (frisket) and mask out the lightest parts of the wisteria and the other foreground flowers, and the mortar lines around the archway and in the brick wall. Leave to dry.

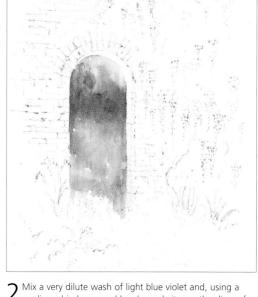

 $2\,$ Mix a very dilute wash of light blue violet and, using a medium chisel or round brush, apply it over the sliver of sky that is visible at the top of the image and through the archway. Brush dilute Hooker's green over the foliage that can be seen through the arch. Mix yellow ochre with a little vermilion and titatnium white and brush this mixture over the path on the far side of the arch.

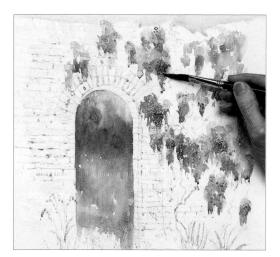

3 Mix separate washes of violet and light blue violet.

Alternating between the mixtures, brush these colours

the flowers from the despent coloured flowers, dress more violet, wet into wet, into the first wash. Leave to dry.

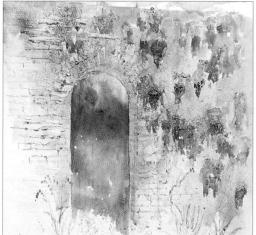

4 Brush a dilute wash of burnt sienna over the brick wall, changing to very pale yellow ochre for the lower part of the wall, and a mixturn of burnt sienna and cadmium orange over the archway.

5 Mix a warm brown from burnt sienna, Hooker's green and vermilion and, while the brickwork is still wet, drop this mixture into it in places to deepen the colour. Brush in the general shapes of the wisteria foliage and the foliage above the wall in Hooker's green. Using various mixtures of Hooker's green and Hooker's green plus cadmium yellow, start painting the spiky foliage of the foreground plants.

Tip: When painting the foliage, match your brushstrokes to the shape of the plant – curving, calligraphic strokes for long-leaved plants, short dots and dashes for round-leaved plants.

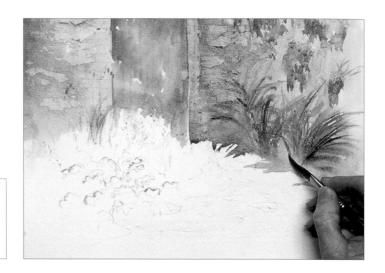

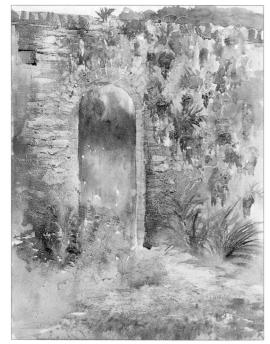

6 Brush the warm brown colour from Step 5 over the foreground and the darkest parts of the wall to build up the colour. While it is still wet, add more burnt sienna to the mixture and spatter it over the first brown. Mix a dark bluegreen from Hooker's green and ultramarine blue and paint the foliage to the left of the arch, adding cadmium yellow to the mixture for the grass at the base of the image. Leave to dry.

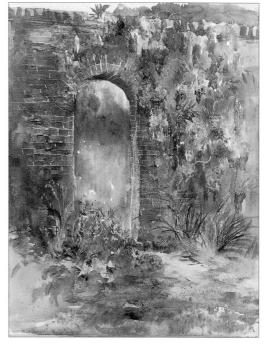

7 Using the blue-green mixture from the previous step, continue painting the foliage to the left of the arch, noting the spiky shapes of the leaves. Mix a dark brown from violet and burnt sienna and brush this mixture over the wall and path, so that the colour is gradually built up in thin glazes. Apply the colour unevenly to create some tonal variation and texture.

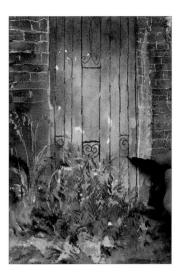

Susing a technical drawing pen or fine-nibbed steel dip pen loaded with waterproof sepia ink, draw the wrought-iron gateway. (Black ink would look too harsh: sepia is a much more gentle colour.)

Tip: The ink must be waterproof, otherwise it will smudge if any paint is applied on top of it.

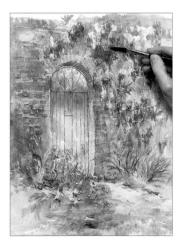

The wisteria flowers look a little flat;

Inilid Himm up by brushing on pure violet in the darkest areas. Leave to dry.

Assessment time

Rub off the masking fluid with your fingertips; sometimes it is hard to see whether or not you have removed all the fluid, so run your fingers over the whole painting to make sure no lumps of fluid are left. Blow or shake off any loose, dried fluid before you continue painting.

Although the painting is nearing completion, it needs a little more "punch" and contrast. Take some time at this stage to assess where more work is needed: by glazing selected areas with thin layers of acrylic paint, you can build up the colours to the required density while at the same time adding much-needed texture on areas such as the path and brickwork. The adjustments that you make in these final stages of the painting will be relatively small, but they make an important contribution to the overall effect.

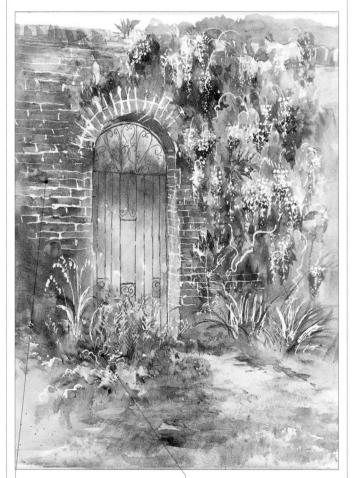

The areas previously covered by the masking fluid are too stark and need to be knocked back

More detail is required in the foreground foliage.

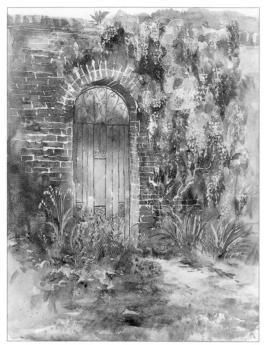

12 Dotting the paint on the tip of the brush, paint the lightest wisteria flowers in a pale, opaque mixture of white and light blue violet. This points up the contrast between the lightest and darkest areas and gives the flowers more depth.

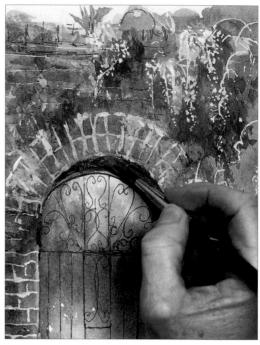

1 1 Mix a pale, yellowish brown from yellow ochre and green and paint some of the exposed mortar lines in the brickwork. Do not worry if you go outside the mortar lines as it will simply serve as a glaze, enhancing the texture of the crumbling brickwork. Dot violet paint into the wisteria flowers to give more contrast between the light and dark flowers. Paint the shaded interior of the arch in the same colour.

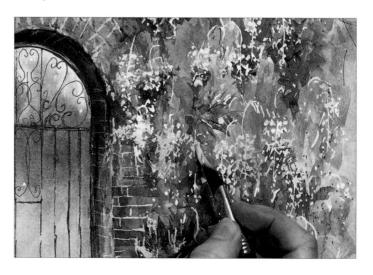

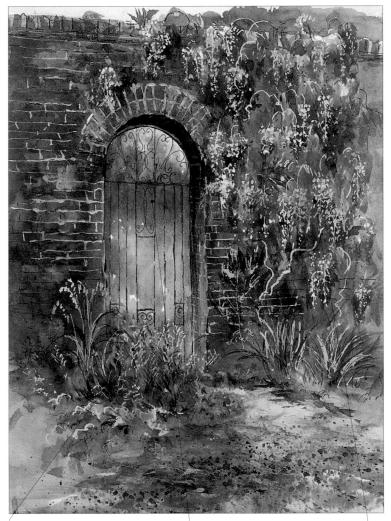

This is a soft, romantic painting of part of an old walled garden. The plants are painted in a fairly loose, impressionistic way rather than as highly resolved botanical studies, but they are nonetheless recognizable from their general shapes and colours. The path draws our eye through the scene to the flower-covered wall and archway; the arch itself is positioned slightly off centre, which adds interest to the composition and prevents it from looking too static.

The blue-green colour of the plants in this area halances the blues and violets of the wisteria.

Although no detail is visible, the garden hevand the archway is implied through the use of soft, muted colours.

The artist has paid careful attention to the different colours within the flowers and to the overall shapes of the flower clusters.

Domestic interior

For this project the artist painted part of his kitchen, with one of his own paintings hanging on the wall. Why not set yourself the challenge of painting a small corner of your own home? It will have relevance and personal associations for you and your family – and you will have the advantage of painting something that you know well already. You can include objects that have special significance for you, such as family heirlooms or holiday souvenirs – but be selective and don't try to include too much, or it will be difficult to establish a centre of interest in the scene.

Choose your viewpoint carefully and remember that it's perfectly all right not to include the whole of an object. Here, for example, the artist decided to include less than half of the table, but did add a tablecloth. This gives an air of informality to the scene, making it seem like a snapshot of family life. The fact that the table is slightly angled, rather than painted square on, also leads the viewer's eye into the scene and makes for a much more dynamic composition.

One of the beauties of working with acrylics is that you can build up several layers of thin glazes. This gives a richness and luminosity to the work, as glazed colours reflect light more readily than opaque colours. This is the approach that is taken in this project and it seems to work particularly well in a scene such as this, which contains many smooth surfaces.

Materials

- Canvas primed with acrylic gesso
- Acrylic paints: cadmium yellow light, raw umber, ultramarine blue, yellow ochre, permanent violet, vermillion, magenta, titanium white, cerulean blue, cadmium red, cadmium yellow deep
- Brushes: medium flat, flat wash, small round
- Rag
- · Painting knife

Dot cadmium yellow light acrylic paint over the canvas and wipe over it with a rag to spread the paint over the support. It's better if the coverage is slightly uneven. Leave to dry.

The scene

Fruit and flowers on the table inject colour into a scene that consists largely of wood and brick. The flowers also provide a visual link with the painting on the wall.

2 Using a medium flat brush, "draw" the frame of the painting on the wall and the fireplace recess in raw umber. Mix a dark green from cadmium yellow light and ultramarine blue and outline the struts of the chair, the panels in the dresser and the flower stems. Leave to dry.

Block in the brick-covered chimney breast and the wood of the dresser in yellow ochre, painting around the green flower stems. While the paint is still wet, wet a rag with water and wipe off circular smudges of colour for the flower heads. Although the paint feels dry, it won't be totally immovable for about 24 hours and the yellow will come off if you rub gently.

Paint the dark recess of the fireplace in permanent violet and the shaded side of the dresser in raw umber. Sketch the outline of the bowl of fruit on the table in yellow ochre and block in the oranges and bananas in the same colour, leaving the highlights untouched. Paint the reddest part of the apples in verminion and begin putting in the red flowers on the curtains.

5 Paint the chair in vermillion. Although you are simply blocking in the underlying colour at this stage, without putting in any detailing, it will act as a glaze and establish the warm colour of the wood. At this point the artist decided to include another chair in his composition. He painted it in permiument violet as a shair in this position would be in chade and hence darker in tone than the other chair.

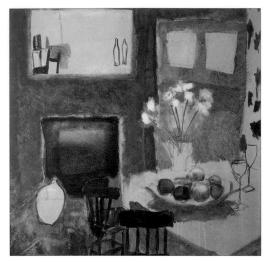

Outline the stone jar on the hearth in the green mixture from Step 2. Begin putting in some of the detail of the painting on the wall. Paint the shadow under the fruit bowl in raw umber. Paint the tiled floor and the shaded sides of the table in magenta. Draw the outlines of two stemmed wine glasses on the table in green.

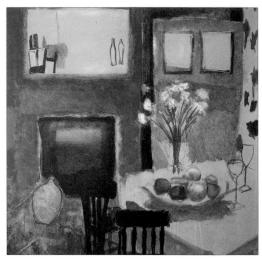

Z Glaze yellow ochre over the stone jar on the hearth. Paint the shaded sides of the chair in a dark, almost black mixture of red and green, leaving the seat red; immediately it begins to look more rounded and three-dimensional.

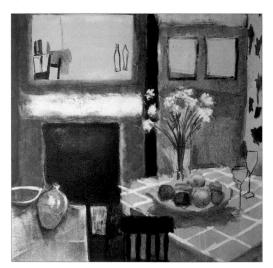

Outline a round bowl on the hearth in titanium white and block it in using yellow ochre. Paint the highlights on the stone jar in titanium white. Brush dilute titanium white over the tiled floor and the fireplace lintel. Use a thicker mix of titanium white to paint the checks on the tablecloth. Brush ultramarine blue over the fireplace recess and the shaded side of the dresser. Leave to dry.

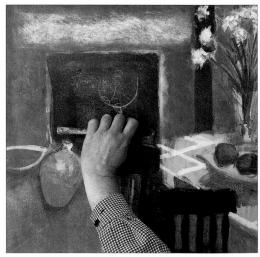

9 Using the tip of your painting knife, scratch off paint in the shape of the outline of the candle sconce in the fireplace. Still using the painting knife, scratch off paint to create highlights on the back of the chair. You could equally well paint these elements in white, but sgraffito imparts a lively quality to the work and is an interesting technique to experiment with.

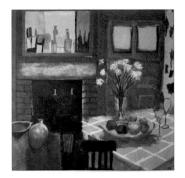

10 Paint the lines of the bricks in vermillion. Mix a dull brown from raw umber and cadmium yellow light and paint the picture frame. Glaze the same colour over the shaded side of the dresser, which you painted blue in Step 8.

Tip: Because the colours in glazes mix optically, rather than physically, the mixes often look more lively.

Assessment time

The overall warm mood of the scene has been set. Although the colours may look unnatural at this stage, they will be modified as the painting progresses. Never be afraid to alter things halfway through if you feel they're not working. At this point the artist decided that the checked tablecloth was overpowering the image and that the chair-back in the immediate foreground blocked the viewer's eye from moving through the picture. Radical changes were needed!

The rich, warm colours look very dominant at this stage, but they provide a warm undertone for the scene.

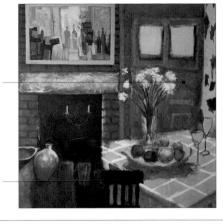

The chair-back interferes with the composition.

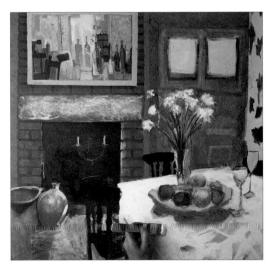

1 1 Using a large flat wash brush, brush titanium white over the tablecloth and the tiled floor, carefully brushing around the stone jar on the hearth and between the struts on the chair. At this point the artist also painted out the chair in the immediate foreground, which he felt had become too intrusive, and at the same time added another chair-hack to the fireplace end of the table.

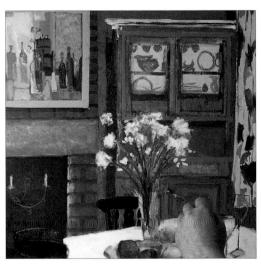

12 Complete the pattern on the curtains using cerulean blue and cadmium red. Using a small round brush, paint the china in the dresser in cerulean blue. Mix a midtoned brown from cadmium yellow light, raw umber and titanium white and brush this mixture over the dresser. The colour now looks more natural, but it ctill rotains the warm glow of the underlying orange.

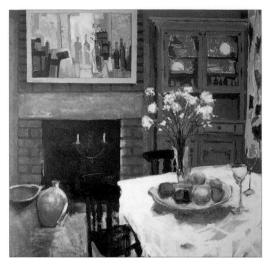

13 Finish painting the china in the dresser. As it is behind glass, which reflects the light, it is hard to see any detail in the china, so a general impression of the shapes will suffice.

14 Using a small brush, brush thin diagonal strokes of dilute titanium white and white mixed with cerulean blue over the glass doors in the dresser to show how the glass reflects light from the window.

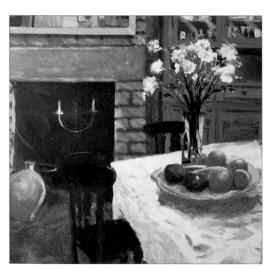

 $15 \ {\small \ Glaze \ the \ floor \ with \ a \ mixture \ of \ vermillion \ and \ }} \ titanium \ white. \ Paint \ white \ highlights \ on \ the \ fruit.}$

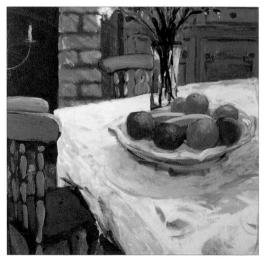

16 Use the mid-toned brown mixture from Step 12 to give the chairs their natural wood colour, leaving the previous purplish tone visible in the most deeply shaded parts. Adjust the tones on the fruits so that they look rounded, using the same colours as before. The bananas, in particular, look too light so paint them again in cadmium yellow deep using permanent violet for the shaded facets.

The finished painting

This is a colourful, contemporary-looking painting. The composition looks informal but has been carefully considered, while the choice of predominantly warm colours creates a

cosy and inviting mood. The flowers and fruit contrast well with the solidity of the furniture and fireplace and provide a homely touch that tells us this is a domestic interior.

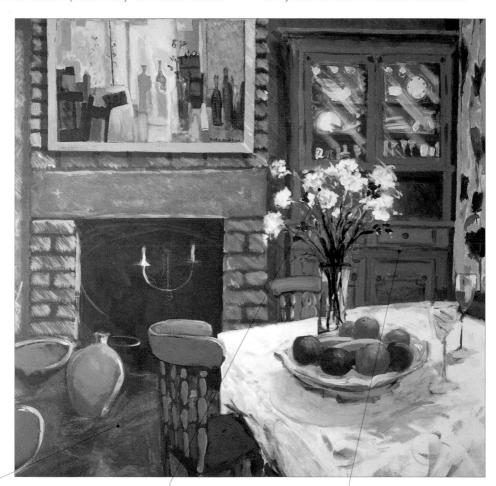

The colour is built up in glazes, creating the effect of light shining on the tiled floor.

The flowers are loosely painted and enliven the composition

The underlying colours modify subsequent

Painting People

People are one of the most challenging and rewarding of all subjects to paint and your aim should be to capture not only a good likeness but also something of the sitter's character and personality.

Whether you're painting a head-andshoulders portrait or a full-length study, it's generally advisable to start by making a reasonably detailed underdrawing. Take careful measurements and concentrate, in particular, on establishing the position of the facial features.

One of the joys of using oils or acrylics for painting people is the ease with which you can blend colours wet into wet on the support, to create almost imperceptible transitions from one tone to another. This is invaluable when painting flesh tones: the contours of the body are generally soft and rounded, which means that differences in tone can be very subtle – but they are critical in achieving a sense of light and shade and making your subject look three-dimensional. The same technique can be used for painting hair.

If you are new to portrait painting, start with a simple set-up – a plain background and perhaps just one light positioned to one side of your model to cast an obvious shadow. A head-on view, with the model looking directly at you, is the best way to begin. With a profile there are other complications to bear in mind, such as how the nose breaks the line of the cheek.

As you gain more experience and confidence, you can begin to introduce more elements – props that tell us something about the sitter's interests, a domestic interior that reveals something of their lifestyle, even a street scene of people going about their everyday business. Take care not to overcomplicate things, however, or the background will begin to detract from the portrait.

Venice grainseller ▼

In the contre-jour scene such as this, with the light coming from behind the subject, detail is subdued. Nonetheless, the shapes and overall proportions must look right.

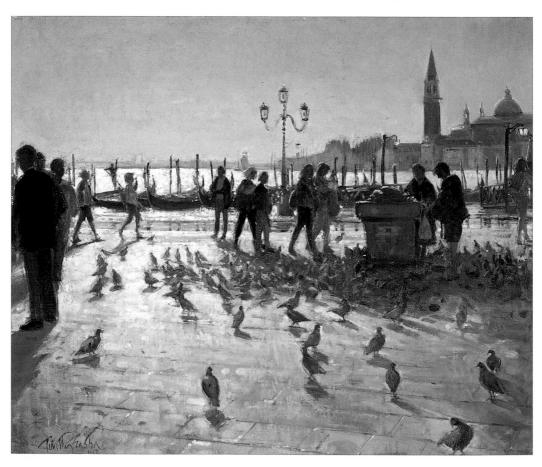

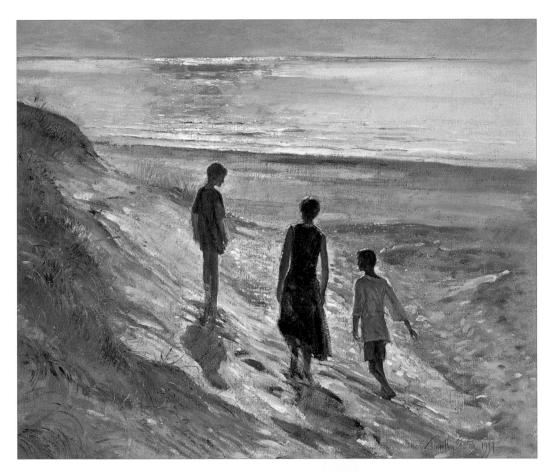

- **Tips**: Whatever medium you are using, begin with thin applications of paint.
- Treat a portrait in the same way as you would any other subject: plot the facial features tystements will follow.
- Pay attention to things like spectacles and clothes that will give a clue as to what the person is like.
- Assess skin tones carefully. The transitions between one tone and another are subtle, but they help to establish the different planes of the heady.

Down to the sea A

We cannot see the faces in this delightful painting of a mother and her children walking towards the sea, which imparts a somewhat enigmatic mood to the scene, inviting ur to make up our UWII stuly about who they are and what they are doing.

Brittany market ▶

The figures are almost incidental to this colourful market scene, as we can see very little of the facial detail, but the stances have been sarefully obcound and they bring life to the scene.

Portrait of a young child

There are several things to remember when you are drawing or painting a portrait of a child. The first is that young children are very active and have a short attention span: you cannot realistically expect them to sit still for hours while you work on your portrait, and for this reason you will probably find it easiest to work from a photograph.

Second, in children the head is much larger in relation to the overall body size than it is in adults. Although the human race is infinitely varied, as a general guideline the head is about one-seventh of the total height of the body in adults – but in babies it may occupy almost as much as one-third of the total. The little girl in this portrait is about two years old: her head represents approximately one-quarter of her total height.

This project starts by toning the support – a classic technique that was much used by some of the great portraitists such as Peter Paul Rubens (1577–1640). This provides the advantage of starting to paint from a mid-tone background, rather than a stark white ground, which makes it easier to judge the subtle flesh tones and the effects of light and shade cast by the sun. It also establishes the overall colour temperature of the portrait from the outset. In this instance, burnt sienna gives the portrait a lovely warm glow, which is particularly appropriate to the dappled sunlight that illuminates the scene.

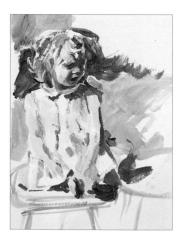

Materials

- · Board primed with acrylic gesso
- Acrylic paints: burnt sienna, ultramarine blue, titanium white, cadmium red, lemon yellow, alizarin crimson, phthalocyanine green
- Brushes: small round, medium flat, small flat
- Rag
- Matt acrylic medium

The pose

Relaxed and informal, this child's attention is occupied by something that we cannot see. Note that she is positioned slightly off centre. If a figure in a portrait is looking off to one side, it is generally better to have more space on that side, as this creates a calmer, more restful mood. Placing a figure close to the edge of the frame creates a feeling of tension.

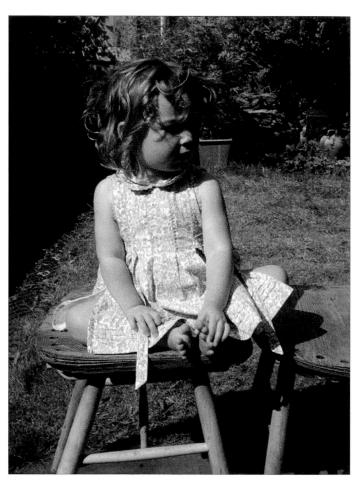

Preliminary sketch

Flesh tones can be tricky, and you may find it useful to make a quick colour sketch experimenting with different mixes, such as the one shown on the left, before you start painting.

Tone the primed board with burnt sienna acrylic paint and leave to dry. Mix a dilute, warm brown from burnt sienna and a little ultramarine blue. Using a small round brush, make a loose underdrawing, concentrating on getting the overall proportions and the angles of the head and limbs correct.

 $2^{\rm Mix}$ a darker, less dilute brown, this time using more ultramarine blue. Using the small round brush, put in the darkest tones of the hair, the shadows on the face and under the collar of the girl's dress, and the main creases in the fabric of the dress. These creases help to convey form.

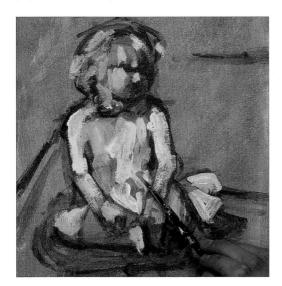

3 Mix a very pale pink from titanium white, cadmium red and a little lemon yellow and paint the palest flesh tones on the face, arms and legs, as well as some highlights in the hair. Add more water and put in the lightest tones of the girl's dress. Note how the colour of the support shows through.

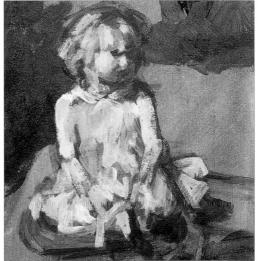

A Mix a warm purple from ultramarine blue and alizarin crimson. Using a medium flat brush, block in the dark foliage area to the left of the girl. Add more water and ultramarine blue to the mixture and paint the darkest foliage areas to the right of the girl and the shadows under the stool.

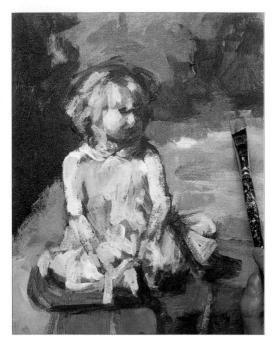

 $5\,$ Mix a bright green from phthalocyanine green, lemon yellow, titanium white and a little cadmium red. Block in the lawn and background foliage. Use less lemon yellow for the shaded grass and more white for the brightest parts.

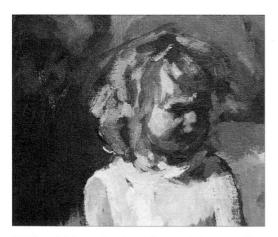

Mix a dark brown from burnt sienna and ultramarine blue and start to put some detailing in the hair and on the shadowed side of the face. Mix a warm shadow tone from alizarin crimson and burnt sienna and build up the shadow tones on the left-hand (sunlit) side of the face, alternating between this mixture and the pale pink used in Step 3.

 $6\,{\rm Mix}$ a very pale green from titanium white and phthalocyanine green and brush it loosely over the child's sun-bleached cotton dress.

Add titanium white to the purple mixture from Step 4 and paint the stool to the right of the child. Paint the stool on which she is sitting in a mixture of brown and titanium white, with brushstrokes that follow the wood grain. Mix a rich brown from burnt sienna and alizarin crimson and, using a small round brush, paint the shadows at the bottom of her dress.

Dab some of the purple mixture (the stool colour) over the background foliage. Using the same colour in this area establishes a visual link between foreground and background; the light colour also creates the impression of dappled light in the foliage. Mix a dark, bluish green from ultramarine blue and phthalocyanine green and paint the shadow under the dress collar and any deep creases and shadows in the fabric of the dress.

10 Using the pale pink mixture from Step 3 and a round brush, go over the arms and legs again, carefully blending the tones wet into wet on the support in order to convey the roundness of the flesh.

Assessment time

The blocks of colour are now taking on some meaning and form: for the rest of the painting, concentrate on building up the form and detailing.

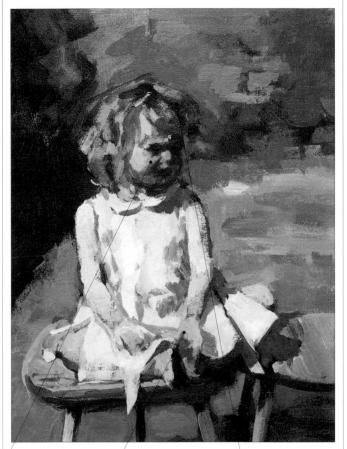

The tonal contrasts on the face are too extreme and need to be blended to make the skin look more life-like.

The hands and feet, in particular, need to be given more definition.

The child is not sufficiently well separated from the background.

Tip: Io make flesh look soft and rounded, you need to blend the tones on the support so that they merge almost imperceptibly; it is rare to see a sharp transition from one tone to another. Working wet into wet is the best way to achieve this, gradually darkening the tone as the limb turns away from the light. With acrylic paints, you may find that adding a few drops of flow improver helps matters: flow improver increases the flow of the paint and its absorption into the support surface.

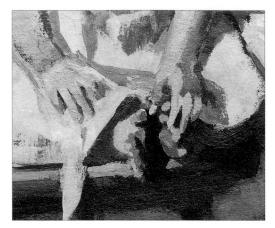

1 1 Mix burnt sienna with a tiny amount of titanium white. Using a small round brush, paint the dark spaces between the fingers and the shadows between the feet and on the toes. Try to see complicated areas such as these as abstract shapes and blocks of colour: if you start thinking of them as individual toes, the chances are that you will make them bigger than they should be.

12 Refine the facial details, using the same mixes as before. Put in the curve of the ear, which is just visible through the hair, using the pale pink skin tone. Mix a reddish brown from alizarin crimson, ultramarine blue and burnt sienna. Build up the volume of the hair, looking at the general direction of the hair growth and painting clumps rather than individual hairs.

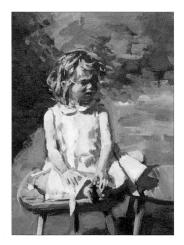

13 Using the purple shadow mixture from Step 4 and a small flat brush, cut in around the head to define the edge and provide better separation between the girl and the background. Mix a dark green from phthalocyanine green and ultramarine blue and loosely dab it over the dark foliage area to provide more texture. Using cool colours here makes this area recede, focusing attention on the little girl.

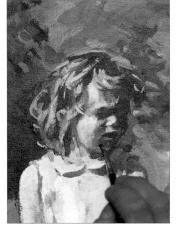

14 Add a little matt acrylic medium to the pale pink flesh tone and go over the light areas of the face, working the paint in with the brush so that it blends well and covers any areas that are too dark in tone. The matt medium makes the paint more translucent, so that it is more like a glaze. Do the same thing on the arms, adding a little burnt sienna for any areas that are slightly warmer in tone.

15 Make any final adjustments that you deem necessary. Here, the artist felt that the girl's hands were too small, making her look slightly doll-like; using the pale flesh colour from previous steps, she carefully painted over them to make them a little broader and bring them up to the right scale.

The finished painting

This is a charming portrait of a toddler with her slightly chubby face and arms, rounded mouth, big eyes, and unselfconscious pose. There is just enough detail in the background to establish the outdoor setting, but by paying very careful attention to the tones of the highlights and shadows, the artist has captured the dappled sunlight that pervades the scene.

Although no detail is visible in the eyes, we are nonetheless invited to follow the child's gaze.

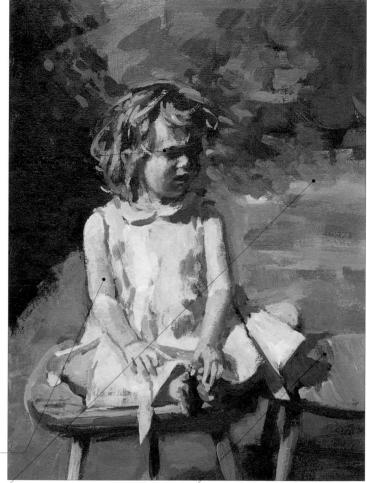

Subtle blending of colour on the child's arms and face makes the flesh look soft and rounded.

There is just enough background to give the scene a context without distracting from the portrait.

Brushstrokes on the stool follow the direction of the woodgrain – an effective way of conveying both pattern and texture.

Head-and-shoulders portrait

The surroundings and clothing in this head-and-shoulders portrait have been kept deliberately simple in order to give you an opportunity to practise painting skin tones.

You might think it would make life very simple for artists if there was a ready-mixed skin colour that could be used in all circumstances. However, although you may come across a so-called "flesh tone" in some paint manufacturers' catalogues, it cannot cope with the sheer variety of skin tones that you are likely to encounter.

Even in models with the most flawless of complexions, the skin will not be a uniform colour in all areas. The actual colour (particularly in fair-skinned individuals) can vary dramatically from one part of the subject to another: the cheeks, for example, often look redder than the forehead or chin simply because the blood vessels are closer to the surface. And, just as with any other subject, you need to use different tones in order to make your subject look three-dimensional. To understand this, look at blackand-white magazine photographs of models with good bone

structure: note how the cheekbones cast a shadow on the lower part of the face. Even though (thanks to make-up) the skin colour may be virtually the same all over the face, in strong lighting there may be big differences in tone.

You also need to think about colour temperature: using cool colours for the shadows and warmer ones for the lit areas is a good way of showing how the light falls on your model. Although cool blues and purples might seem strange colours to use for painting skin, it is surprising how using them with warmer colours can bring a portrait to life.

The same principles of colour temperature also apply to the light that illuminates your subject. Although we are generally unaware of the differences, the colour of sunlight is not as warm as, say, artificial tungsten lighting. It's hard to be precise about the colours you should use for painting skin tones, as the permutations are almost infinite, so the best advice is simply to paint what you can actually observe rather than what you think is the right colour.

Materials

- Board primed with acrylic gesso
- B pencil
- Acrylic paints: Turner's yellow, cadmium red, titanium white, burnt umber, cadmium yellow, lamp black, phthalocyanine blue, alizarin crimson, yellow ochre
- Brushes: large flat, medium flat, small flat

The pose

A three-quarters pose with the light coming from one side, as here, is generally more interesting to paint than a head-on pose, as it allows you to have one side of the face in shadow, thus creating modelling on the facial features. The lighting also creates highlights in the model's dark eyes, which always helps to bring a portrait to life. Although this model was sitting in front of a very busy background, the artist chose to simplify it to a uniform background colour in the finished portrait to avoid drawing attention away from the face.

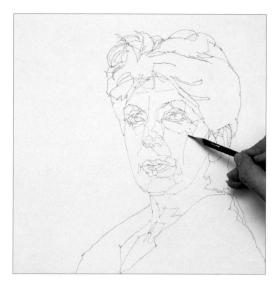

Using a B pencil, lightly sketch your subject, indicating the fall of the hair, the facial features and the areas of shadow. Put in as much detail as you wish; it is particularly important to get the size and position of the facial features right.

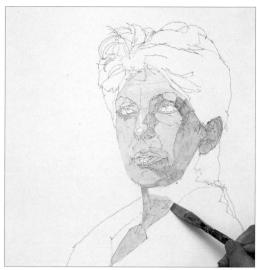

 $2^{\text{Mix a light flesh tone from Turner's yellow, cadmium red} \\ \text{and titanium white. Using a medium flat brush, block} \\ \text{in the face and neck, adding a little burnt umber for the} \\ \text{shadowed side of the face.} \\$

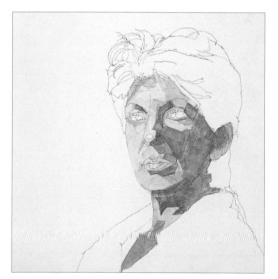

Add a little more cadmium red to the flesh-tone mixture and use it to darken the tones on the shadowed side of the face, under the chin and on the neck. Mix a red-biased orangey mix from cadmium red and cadmium yellow and paint the cheek and the shadowed side of the neck and the shadowed area that lies immediately under the mouth.

Immediately the portrait is taking on a feeling of light and shade.

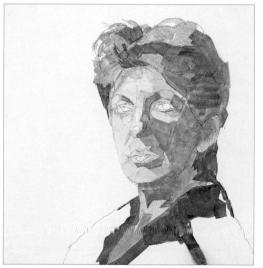

A Mix a pale bluish black from lamp black and phthalocyanine blue and begin putting in the lightest tones of the hair, making sure your brushstrokes follow the direction in which the hair grows. When the first tone is dry, add burnt umber to the mixture and paint the darker areas within the hair mass to give the hair volume. Add more phthalocyanine blue to the mixture and paint the model's shirt.

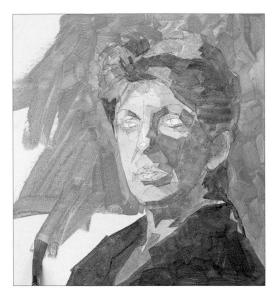

 $5\,$ Mix a pale brown from cadmium red, burnt umber, Turner's yellow and titanium white and loosely block in the background, painting carefully around the face. You may find it easier to switch to a larger brush for this stage, as it will allow you to cover a wide area more quickly.

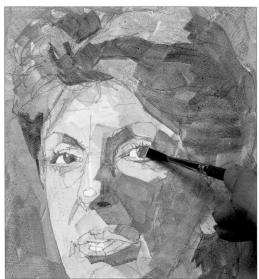

6 Mix a rich, dark brown from lamp black, burnt umber, cadmium red and a little of the blue shirt mixture. Using a small flat brush, paint the dark of the eyes and the lashes, taking care to get the shape of the white of the eye right. Use the same colour for the nostril.

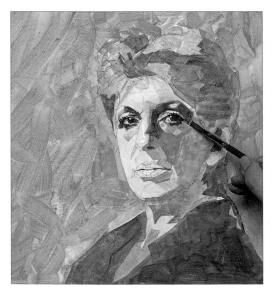

7 Use the same colour to define the line between the upper and lower lips. Mix a reddish brown from burnt umber and phthalocyanine blue and paint the shadows under the eyes and inside the eye sockets.

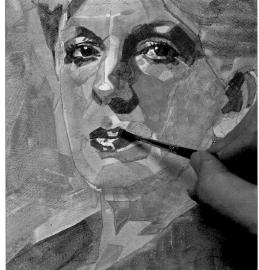

Paint the mouth in varying mixes of alizarin crimson, cadmium red and yellow ochre, leaving the highlights untouched. The highlights will be worked into later, using lighter colours.

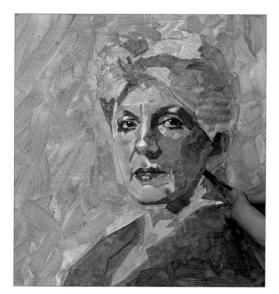

Darken the flesh tones on the shaded side of the face where necessary, using a mixture of alizarin crimson, phthalocyanine blue and a little titanium white, adding more blue to the mixture for the shadow under the chin, which is cooler in tone.

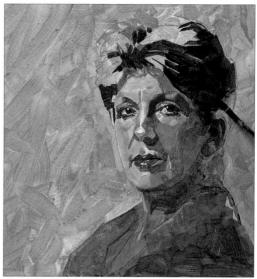

10 Mix a dark but warm black from burnt umber and lamp black and paint the darkest sections of the hair, leaving the lightest colour (applied in Step 4) showing through in places. This gives tonal variety and shows how the light falls on the hair.

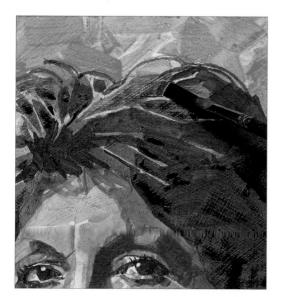

1 Add more water to the mixture to make it more dilute and go over the dark areas of the hair again, this time learning unity a face highlights shoulding through at rolationly fine lines.

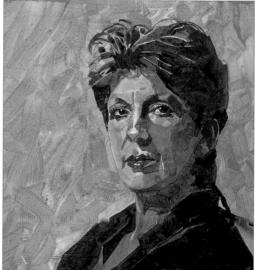

 $12\,$ Mix a dark blue from phthalocyanine blue and lamp black and paint over the shirt again, leaving some of the linhter blue areas annlied in Step 4 showing through. Your brushstrokes should follow the direction and fall of the fabric.

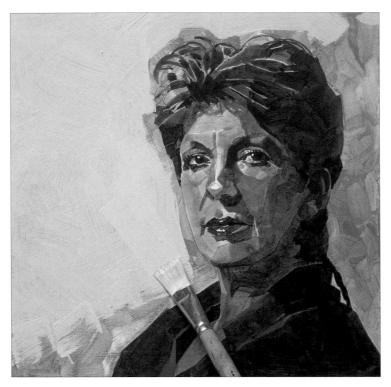

13 The beauty of acrylics is that you can paint a light colour over a dark one, without the first colour being visible. If you think the background is too dark and there is not sufficient differentiation between the model and the background, mix a warm off-white from titanium white, yellow ochre and burnt umber and, using a large flat brush, loosely paint the background again.

14 Using a small flat brush, cut around individual hairs with the background colour, carefully looking at the "negative shapes".

 $15\,$ Using a fine round brush and titanium white straight from the tube, dot the highlights on to the eyes, nose and lower lip.

This is a relatively simple portrait, with nothing to distract from the sitter's direct gaze. Although the colour palette is limited, the artist has achieved an impressive and realistic range of skin and hair tones. Interest comes from the use of semi-transparent paint layers and allowing the directions of the brush marks to show through.

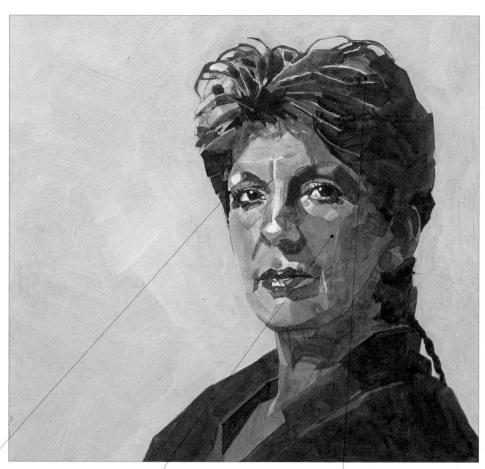

Carefully positioned highlights in the eyes make them sparkle and bring the portrait to life.

Variations in the skin tone, particularly on the shaded side of the face, help to reveal the shape of the face and its underlying bone snucture.

The highlights in the hair are created by putting down the lightest tones first and allowing them to show through subsequent applications of paint

Café scene

At first glance, this café and street scene looks extremely complicated and full of movement, with a complex play of light and shade across the whole scene. You could be forgiven for wondering how on earth you can capture such a wealth of detail in paint.

The trick, at least in the initial stages, is to forget about the detail and to concentrate instead on the overall impression. Look for blocks of colour and tone – and try to see the scene as a series of interconnecting shapes, rather than as individual elements. If you get too caught up in details such as a person's hair or the precise pattern on one of the café umbrellas, the chances are that your painting will become tight and laboured.

Remember, too, that the spaces between objects (which artists describe as "negative" shapes) are as important in a painting as the objects themselves (the "positive" shapes). Although the rational part of your brain may be telling you that a person or a solid object such as a table should take precedence over an apparently empty background, in painting terms the two are equally important: one helps to define the other.

The complex pattern of light and shade requires careful treatment, too. There are many shadows here, both in the open foreground and in the dark, narrow street in the background. Shadows are rarely, if ever, black; instead, they often contain colours that are complementary to the main subject. If buildings are a warm terracotta colour, for example, their shadows may contain a little complementary green.

Sketch

Scenes of people can change quickly, so make a quick preliminary sketch to capture the moment.

Materials

- Board primed with acrylic gesso
- Willow charcoal
- Acrylic paints: cadmium yellow, cadmium red, titanium white, phthalocyanine green, alizarin crimson, lemon yellow, ultramarine blue
- Brushes: large round, medium flat, small round
- Kitchen paper

The scene

This is one type of subject in which painting from photographs really comes into its own. There is so much going on that you could do little more than put down the bare bones of the scene on the spot – but a quick reference photo or two will "freeze" the action and provide you with plenty of information on which to base your image.

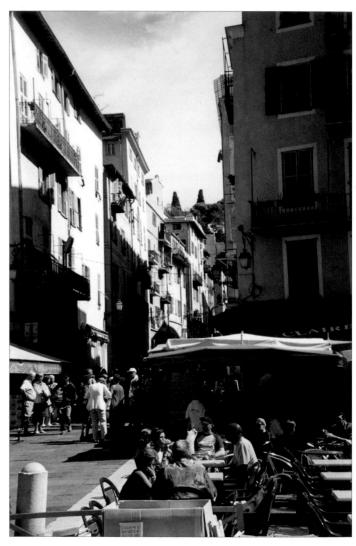

1 Block in the darkest areas of the background buildings and the shadows on the pavement, using the side of a stick of willow charcoal, as this allows you to cover large areas quickly. Although the charcoal will be covered up by subsequent applications of paint, it allows you to establish the structure of the scene at the outset, and makes it easier for you to find your way around the complex mix of colours and tones.

To avoid dirtying your colours when you begin applying the paint, gently dust off any excess charcoal powder using a clean piece of kitchen paper. (Alternatively, you could use a spray fixative.)

Mix a warm orange from cadmium yellow and cadmium red. Using a large round brush, brush in the warm colours of background buildings. Paint the tale unibiellas and usining in mixtures of cadmium red and titanium white, varying the proportions of the two colours to get the right tones. Putting in these strong tones in the early stages helps give the scene some structure. The order in which you apply them is not terribly important, but while you have you one colour on the pulctic try to use it everywhere that it occurs.

A Loosely indicate the café tables in phthalocyanine green. Mix a very dilute green from phthalocyanine green and titanium white and paint the shadow areas in the foreground. (Note that this green is a cool complementary colour to the reds used on the awning and umbrellas.) Add alizarin crimson to the mixture and paint the very dark colours of the buildings in the background. This gives you the necessary darkness of tone without having to resort to using black, which often tends to look flat and lifeless. It also picks up on colours used elsewhere in the painting, greating one of many colour links that will ultimately help to hold the whole image together.

5 Mix a pale yellow from lemon yellow and titanium white and put in the light-coloured buildings in the background. Add more titanium white to the mixtures that you used to paint the umbrellas in Step 3, making the paint fairly thick, and paint the pinkish stripes on the umbrellas.

6 Using the dark mixture from Step 4, begin blocking in the figures sitting at the café tables. Do not try to put in substantial detail at this stage: simply look for the overall shapes. Look at the tilt of people's shoulders and heads and concentrate on getting these angles right, as they will help to make the painting look realistic. Brush more of the dilute phthalocyanine green and white mixture over the street area, particularly at the point just beyond the café where the street narrows and is in deeper shade.

7 Block in the colours of the shirts of the café customers in the foreground, making the colours darker in tone for the creases in the fabric, as this helps to reveal the form of the body and give more of a sense of light and shade.

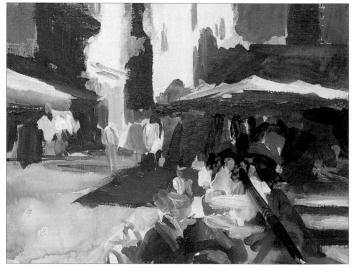

Brush over the highlight areas with titanium white, using the paint thickly in order to create some texture. Deepen the tones of the big foreground umbrella where necessary. Using the same dark mixtures as before, carefully brush around the figures sitting at the café tables; although the figures are little more than blocks of colour at this stage, and very little detail has been put in, defining the negative shapes (the spaces between the figures) in this way helps to separate them from the background so that they stand out more clearly.

Assessment time

Using brilliant blue and alizarin crimson, block in more of the shirt and trouser colours of the passers-by on the left. The main elements are now in place, and the rest of the painting will be a gradual process of refinement: although

they may look like fairly abstract blocks of colour at this stage, the subjects will soon start to emerge more clearly. Training yourself to look for blocks of colour, rather than attempting to define every element, is a useful exercise.

The dark blocks laid down in Step 1 provide the structure for the image.

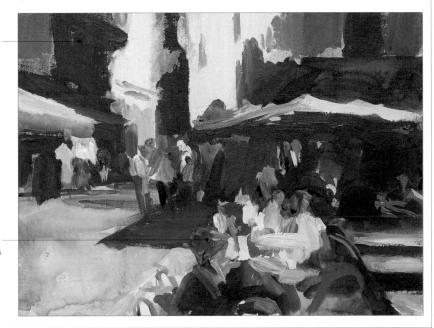

The people are painted as bold blocks of colour; detail can be added later once the basic shapes and colours are in place.

Pick out details using a small round brush. Falm the thirvent half harvs in phthalocyanine green, and the hair of the café customers in various browns mixed from cadmium yellow and cadmium red. Remember to look carefully at the spaces between objects as well as at the objects themselves: going around the figures in a dark tone helps to make them stand out.

10 Continue adding defining details across the painting, again looking at the negative spaces and looking for identifiable blocks of colour on the clothes of the passers-by. Vertical strokes of green on the background buildings are a quick-and-easy way of implying the dark window recesses; the colour also provides a visual link with the green chairs in the foreground.

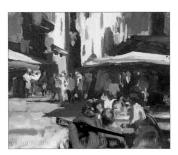

1 Because it is so bright, the eve is drawn to the paved foreground area in the bottom left of the painting, which looks very empty. Using more of the green mixture from Step 6 and a medium flat brush, make broad horizontal strokes across this area. This enhances the feeling of dappled light playing on the ground and creates texture and interest.

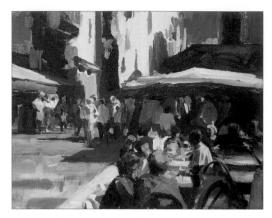

12 Switching to a medium flat brush allows you to shape straight-edged elements, such as the eaves of the roofs (top right) and the table edges (bottom right), more precisely.

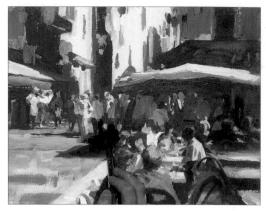

13 Using a pale, blue-grey mixture of titanium white and ultramarine blue, loosely indicate the lettering on the café awning. Continue adjusting tones across the whole scene: adding a pale, but opaque yellow to the background buildings reinforces the sense of light and shade, while the shadows on the ground can be made stronger with a bluish-purple mixture as before.

14 Using the flat brush again, block in rectangles of colour on the roofs to define their edges more clearly. The precise colours that you use are not too important: look for the relative lightness and darkness of different areas, as this is what will make the picture look three-dimensional.

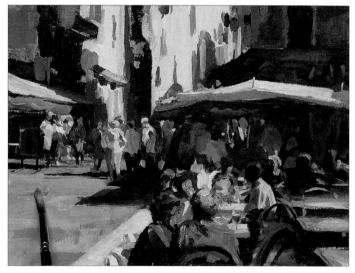

15 Using a fine round brush and the same pale blue-grey mixture that you used for the café awning lettering, "draw" in the vertical posts of the awning and the large foreground umbrellas. Adjust the tones on the shaded sides of both awning and umbrellas, if necessary, to reinforce the different planes of the image. If you decide that the bottom left corner is still too bright in relation to the rest of the painting, brush more of the bluey-green shadow mixture across it. Finally, look for any areas that catch the light, such as the edges of the foreground tables and chairs, and lightly touch in the highlights here with a pale mixture of phthalocyanine green and titanium white.

The finished painting

This is a spontaneous-looking painting that belies its careful planning and the meticulous attention to capturing the effects of light and shade. The composition looks informal, like a snapshot of a moment "frozen" in time; in fact, the large, virtually empty space on the left helps to balance the image, while the receding lines of the café tables lead the viewer's

eye through the picture to the bustling street and buildings in the background.

Creating the right tonal balance is one of the keys to an image like this; resisting the temptation to put in too much detail, with the consequent risk of overworking the painting, is another. Here, the artist has succeeded on both counts.

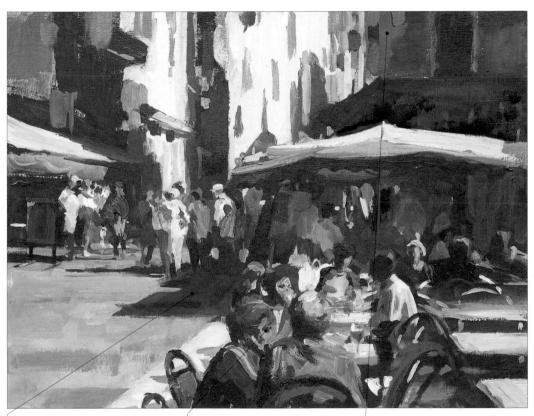

Deep shadows reveal the intensity of the sunlight. They are balanced by the large, brightly lit buildings in the background and help to bring the scene to life

Although there is relatively little detail on the faces, by concentrating on the tilt of the heads and bodies the artist has conveyed a feeling of animation.

The artist has used some artistic licence in choosing the colours for the building in the background, but they complement and balance the foreground colours well.

Reclining nude

The reclining nude – more particularly, the reclining female nude – is a classic subject in Western art.

There are a few practical considerations to take into account – particularly if you are painting from life. First, make sure your model is comfortable: provide a sofa, blanket or other soft surface for her to lie on and make sure that the room is warm and free of draughts.

As far as the pose is concerned, it is often better to allow the model to settle into a position that feels natural to her than to tell her what pose to adopt. Although you can obtain interesting and dynamic paintings by directing the model to tense her muscles, such poses are difficult to hold for any length of time.

This particular pose is easy to hold, even for a relatively long period of time. The model's weight is evenly distributed along the whole length of her body and she is able to rest her head on her right forearm, cupping her hand around her head for extra support.

The differences in flesh tone need to be very carefully assessed in this project. Certain areas, such as the hands, the soles of the feet and the lower body, tend to be warmer in colour than others, because the blood vessels run closer to the surface of the skin. The upper body, on the other hand, is usually cooler in tone. However, one of the joys of painting in oils is that the paint remains soft and workable for a long time, so you can blend colours on the support as you work to create subtle transitions from one tone to another as the body curves towards or away from the light source.

Materials

- Stretched canvas
- · Rag
- Oil paints: cadmium orange, brilliant pink, raw sienna, cadmium red, cadmium yellow, brilliant turquoise, titanium white, ultramarine blue, lamp black, vermilion, cerulean blue
- Turpentine
- Drying linseed oil
- Brushes: selection of small and medium rounds, small or medium flat

The pose

One of the most interesting things about this particular model is the way in which her upper vertebrae and ribs are so clearly defined. The natural curves of her body create clearly defined areas of light and shade, which add interest to the composition. Note the masking tape on the blanket, outlining the model's pose. This enables the model to get back in the same position if she inadvertently moves during the session or has to take a break.

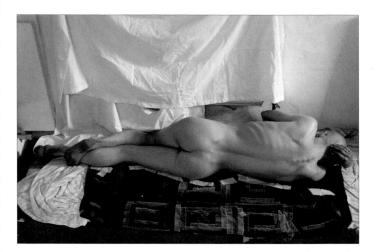

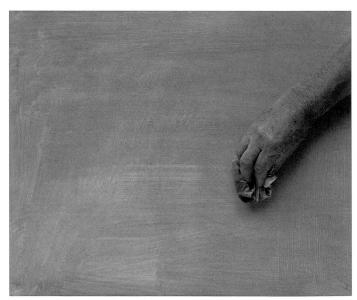

With a rag, spread cadmium orange paint evenly over the canvas, changing to brilliant pink in the top left. Leave to dry.

2 Using a medium round brush and raw sienna, "draw" the edges of the blanket on which the model is lying and the dark shadow under her hips. Delineate the head and upper body and the legs in cadmium red. The actual colours are not too important at this stage, as this is merely the underpainting, but warm colours are appropriate to the subject. Mix a range of warm flesh tones from cadmium yellow and cadmium orange and block in the warmest toned areas – the buttocks, the soles of the feet, and the curve of the spine. Start putting in the main folds of the background cloth using mixtures of brilliant turquoise and titanium white.

Mix titanium white with a little ultramarine blue and block in some of the dark folds in the background cloth. Using a fine brush and cadmium red, loosely "draw" the head and supporting hand, reinforce the line separating the legs and indicate the angle of the hips.

Tip: It is always important to remember the underlying anatomy of the pose, even when you are painting fleshy parts of the body where the shape of the bones is not visible.

Using green (mixed from titanium white, cadmium yellow and ultramarine blue) and a dark grey (mixed from ultramarine blue and raw sienna), start putting in the pattern of the patchwork blanket. Mix a pale blue-green from ultramarine blue and raw sienna and indicate the shadows under the ribs and the shaded part of the back. Note that this inflature is a complementary colour to the first flech tones shadow areas often contain a hint of a complementary colour.

5 Mix a pale orange from cadmium red, cadmium yellow and titanium white and begin putting in some of the paler flesh tones. Alternate between all the various flesh tones on your palette, blending them into one another on the support and continually assessing where the light and dark tones fall and whether the colours are warm or cool in temperature. Almost immediately you will see that the body is starting to look three-dimensional.

Continue working on the flesh tones. The highlights and shadows reveal the curves of the body: the backs of the thighs, for example, are in shadow and are therefore darker in tone than the tops of the buttocks, which are angled towards the light. Note the greenish tones on the upper body: the upper body is often noticeably cooler in tone than the lower body, perhaps because the blood vessels in this area are not so near the surface of the skin.

Block in the most deeply shaded areas of the white background cloth with a blue-biased mixture of ultramarine blue and titanium white. Use a slightly lighter version of this colour to paint the model's shaved head, allowing some of the ground to show through in parts as the colour of her scalp. Loosely "draw" the hand and fingers in cadmium red, indicating the joints in the fingers by means of rough circular or elliptical shapes.

Assessment time

Although the areas of warm and cool tone have been established, the figure still looks somewhat flat and onedimensional. More tonal contrast is needed: spend time working out how you are going to achieve this. Remember to work across the picture as a whole rather than concentrating on one area otherwise you run the risk of over-emphasizing certain areas and making them too detailed in relation to the rest, thus destroying the balance of the painting.

The broad areas of light and shade have been established – now you can refine this area.

There is not enough tonal contrast for the figure to look truly three-dimensional.

The cloth at the model's feet is draped to create interesting folds. Block in its shape loosely in a mixture of ultramarine blue and white, then put dark strokes of a darker grey or brown over the top to indicate the main folds. Begin putting in some of the mid-tones in the background cloth, using mixtures of ultramarine blue and white as before.

Dosely paint the pattern of the patchwork blanket on which the model is lying, using broad strokes of the appropriate colour. Do not try to be too precise with the pattern: a loose interpretation will suffice. You should, however, note how the lines of the pattern change direction where the blanket is not perfectly flat.

10 Continue working on the blanket, gradually building up and strengthening the colours while keeping them fresh and spontaneous.

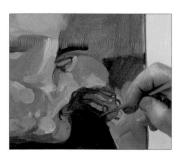

1 1 Nodofino the fingers in cadmium orange and a little brilliant pink.

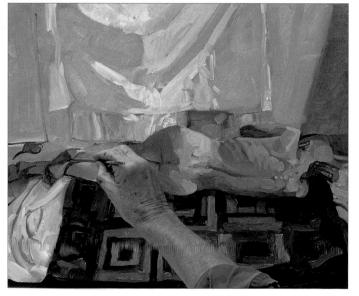

12 Darken the area around the head with a mixture of ultramarine blue, white and a little lamp black, so that the head stands out from the background. Work on the flesh tones, to improve the tonal contrast: the shoulder blade, for example, is lighter than the tones laid down so far, so paint it in a mixture of cadmium orange and white. Use the same colour to define the highlights on the top central vertebrae. The soles of the feet are very warm in colour; paint them in a mixture of cadmium red and vermilion.

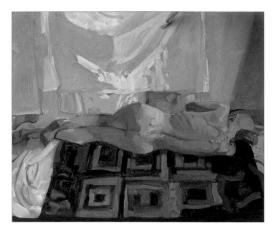

13 Now turn your attention to the background cloth, reinforcing the dark and mid-toned folds with a mixture of ultramarine blue, white and a tiny amount of cerulean blue – all the time assessing the tones of the cloth in relation to the overall scene rather than looking at it in isolation.

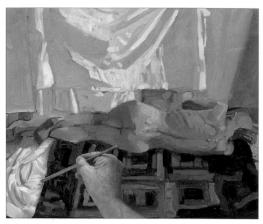

14 Use pure white for the brightest areas of the background cloth, changing to a smaller brush for the finest creases. Note how the folds vary in tone depending on how deep they are: use some mid-tones where necessary to convey this.

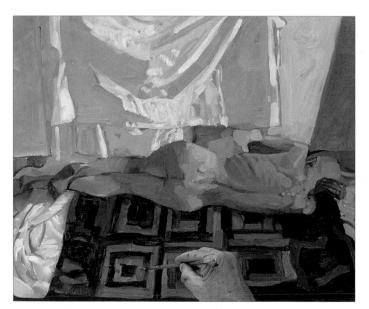

 $15\,$ Mix a dark green from ultramarine blue and cadmium yellow and reinforce the dark colours in the blanket. Use the same colour to strengthen the shadow under the model and give a sharp edge to the curve of her body. Brighten the light greens and pinks in the blanket; as the patchwork pattern is made up of straight strips of fabric, you may find that it helps to switch to a small or medium flat brush so that the lines of the pattern are straight and crisp-edged.

16 The triangular-shaped wedge of cloth on the right, just above the model's head, is too light and leads the viewer's eye out of the picture. Mix a mid-toned green and block it in, directing your brushstrokes upwards to avoid accidentally brushing paint on to the model's head.

The finished painting

The figure is positioned almost exactly across the centre of the picture – something that artists are often advised to avoid, but in this instance it adds to the calm, restful mood of the painting. The dark colours and sloping lines of the blanket

and the folds in the background cloth all help to direct the viewer's eye towards the nude figure. The background cloth is painted slightly darker in tone than it is in reality: overly stark whites would detract from the figure.

The legs are slightly bent: light and dark flesh tones show how some parts are angled into the light while others are shaded.

Careful assessment of tones is required in order to paint the white backcloth convincingly.

Skin is stretched taut over the ribs and upper vertebrae: subtle shading reveals the shape of the underlying bones.

Cupped hands

Hands and gestures are very expressive and can tell you a lot about a person's character and mood. Sadly, many people seem to find it difficult to draw and paint hands – and the reason is usually that they give too much attention to individual elements such as the fingers, rather than trying to see the hand as a whole. You should always try to think of the hand as a complete unit rather than as something made up of four fingers and a thumb. If you paint each finger separately, the chances are that you'll make them too big in relation to the rest of the hand.

This project is a simple pose that gives you the chance to examine the structure of the hand in some detail.

Before you begin the painting, spend time looking your own hands. Some people's fingers are short and stubby, while others have long, elegantly tapering fingers; nonetheless, you will be able to make some general observations that apply to all hands. Look at the number of

joints and see how the fingers widen slightly at these points. Spread your hand out flat: you will see that each finger is a different length and that the joints do not align with one another. Similarly, the knuckles run in a curved line across the back of the hand. Arch your hand, with your fingertips placed on the table top and your wrist elevated, so that you can see the bones and tendons that connect the fingers to the rest of the hand and arm.

Finally, note how the creases in the skin, and subtle changes in tone as each finger turns away from the light, will help you to create a three-dimensional impression.

Materials

- B pencil
- Board primed with acrylic gesso
- Acrylic paints: raw umber, ultramarine blue, cadmium red, cadmium lemon, titanium white, quinacridone red
- · Brushes: medium flat, small flat

The poseIn this project the sitter's hands are clasped loosely around a cup of coffee – a pose that is easy for the sitter to hold, giving you plenty of time to make your study. The structure of the fingers and the way the joints are articulated can be seen clearly. Light comes from the top left of the scene and causes the cup to cast interestingly shaped shadows on the sitter's left hand.

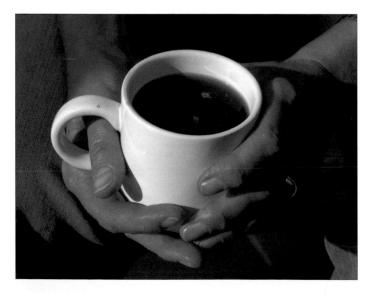

1 Using a B pencil, make a light underdrawing. Mix a dark brown from raw umber and ultramarine blue and, using a flat brush, paint in the shadows above and below the fingers. Add a little cadmium red and block in the shadows on the sitter's left hand.

2 Mix in a little more red. Paint the shadow on the finger undersides.

3 Paint the hands in a mix of cadmium red, raw umber and cadmium lemon, and paint the coffee in a mix of raw umber and cadmium red. Mix grey from ultramarine and raw umber and paint the shaded parts of the mug. Lighten the mix and paint the rest of the mug.

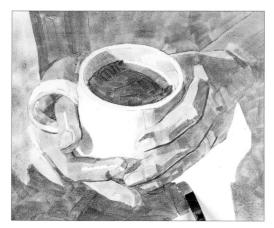

Add a little more ultramarine blue to the mixture used for the coffee mug and paint the sitter's trousers. Paint the reddish brown area between the sitter's legs in a mixture of cadmium red and raw umber.

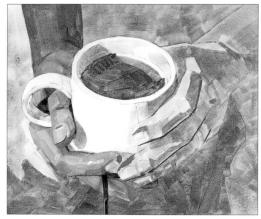

 $5\,$ Mix cadmium red, raw umber, cadmium lemon and a little titanium white and paint the mid-pink tones on the hands. Note how the changes in tone between the different segments of the fingers define their form.

Assessment time

We are beginning to get some sense of the shape of the hands and how the fingers bend, but the tonal differences are not yet sufficient for them to look fully rounded. The background and the hands are, at this stage, too similar in tone; as a result, the hands do not stand out clearly. Overall, the colours are too pale and need to be strengthened.

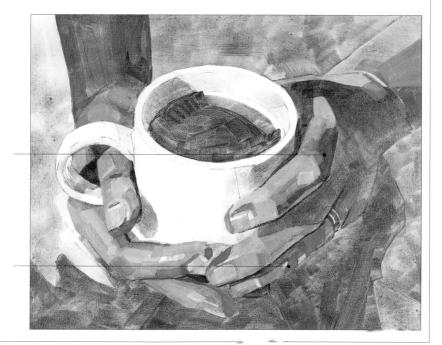

The form of the hands needs to be more fully developed.

The hands merge into the background.

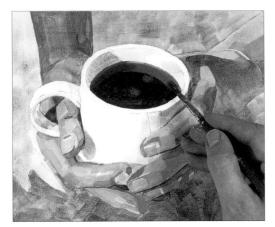

 $6\,$ Mix a dark brown from raw umber and ultramarine blue and paint over the coffee again, adding a little white to the mixture for areas where the light hits the liquid. It is important to realize that the coffee is not a uniform shade of brown throughout.

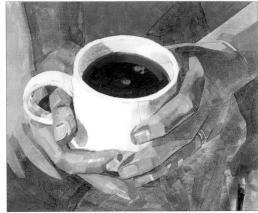

Mix a neutral grey from ultramarine blue, raw umber and titanium white and put in the shadows on the trousers caused by creases and folds in the fabric. Darken the flesh tone overall, leaving little areas of light tone on the nails, which are shiny and catch the light.

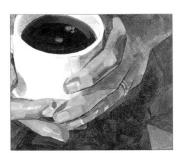

Parken the brown between the legs. Immediately, the hands start to stand out from the background.

9 Use a range of dark neutral greys to paint the shadows cast on the mug by the fingers.

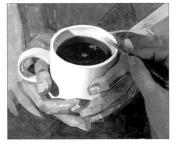

10 Using lighter tones of grey and white, tidy up the tones on the coffee mug.

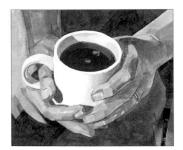

11 Darken the background – the sitter's trousers. This throws the hands forward to become the main focus of the painting.

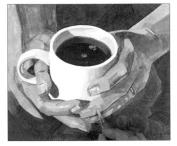

12 Lighten the flesh tones where necessary and refine the tones on the fingers, making use of the same mixtures as before.

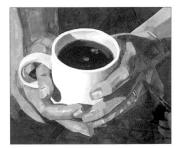

13 Darken the shadows on the left hand using raw umber, quinacridone red and ultramarine blue. This gives depth to the scene.

The finished painting

This is a simple and relaxed pose that has been skilfully painted, with careful attention being paid to the different flesh tones in order to convey the shape of the hands and the

way the fingers curl around the coffee mug. The background is a plain colour, which allows the hands (the focal point of the image) to stand out clearly.

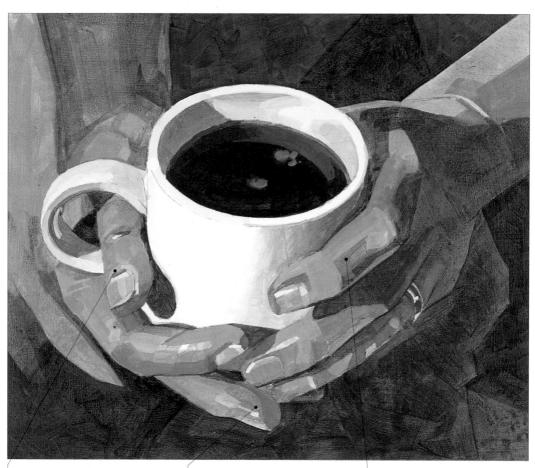

Shadows cast by the fingers reveal both the direction and the intensity of the light.

The dark background allows the hands to stand out clearly.

Changes in tone, delineated with a flat brush, reveal the form of the fingers.

Glossary

Additive

A substance added to paint to alter characteristics such as the paint's drying time and viscosity. Gum arabic is a commonly used additive in watercolour painting.

Alla prima

A term used to describe a work (traditionally an oil painting) that is completed in a single session. *Alla prima* means "at the first" in Italian.

Body colour

Opaque paint, such as gouache, which can obliterate underlying paint colour on the paper.

Colour

Complementary: colours that lie opposite one another on the colour wheel.

Primary: a colour that cannot be produced by mixing other colours, but can only be manufactured. Red, yellow and blue are the three primary colours.

Secondary: a colour produced by mixing equal amounts of two primary colours.

Tertiary: a colour produced by mixing equal amounts of a primary colour and the secondary colour next to it on the colour wheel.

Composition

The way in which the elements of a drawing or painting are arranged within the picture space. The composition does not need to be true to real life.

Closed composition: one in which the eye is held deliberately within the picture area.

Open composition: one that implies that the subject or scene continues beyond the confines of the picture area.

Drybrush

The technique of dragging an almost dry brush, loaded with very little paint, across the surface of the paper to make textured marks.

Fat over lean

A fundamental principle of oil painting. In order to minimize the risk of cracking, oil paints containing a lot of oil ('fat' paints) should never be applied over those that contain less oil ('lean' paints) – although the total oil content of any paint mixture should never exceed 50 per cent.

Format

The shape of a painting. The most usual formats are landscape (a painting that is wider than it is tall) and portrait (a painting that is taller than it is wide), but panoramic (long and thin) and square formats are also common.

Glaze

A transparent layer of paint that is applied over a layer of dry paint. Light passes through the transparent glaze and is reflected back by the support or any underpainting. Glazing is a form of optical colour mixing as each glaze colour is separate from the next, with the mixing taking place within the eye.

Gouache see also Body colour.

Ground

The prepared surface on which an artist works. See also Support.

Highlight

The point on an object where light strikes a reflective surface. In watercolour painting, highlights are often left as white paper.

Hue

A colour in its pure state, unmixed with any other.

Impasto

Impasto techniques involve applying and building oil or acrylic paint into a thick layer. Impasto work retains the mark of any brush or implement used to apply it.

Line and wash

The technique of combining watercolour washes with pen-and-ink work.

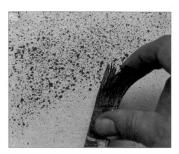

Mahl stick

A piece of equipment used in oil painting, consisting of a light rod of wood (often bamboo) with a soft leather ball secured on one end. The mahl stick is held in one hand and rested on the edge of the work, with the painting hand resting on the rod. This steadles the painting hand and keeps it clear of any wet paint.

Mask

Any substance that is applied to paper to prevent paint from reaching specific areas. Unlike resists, masks can be removed when no longer required. There are three materials used for masking — masking tape, masking fluid and masking film (frisket paper) — although, depending on the techniques you are using and the effect you want to create, you can simply cover up the relevant part of the painting by placing a piece of paper over it.

Overlaying

The technique of applying layers of watercolour paint over washes that have already dried in order to build up colour to the desired strength.

Palette

(1) The container or surface on which paint colours are mixed.

(2) The range of colours used by an artist.

Pan

A small, rectangular container in which watercolour paint is sold.

Paper

The commonly used support for watercolour paintings. HP (hot-pressed): The smoothest type of watercolour paper. HP paper is particularly good for fine brushwork.

NOT: This shortened name stands for

"not hot-pressed". It is a slightly textured paper.

Rough: The most textured type of watercolour paper.

Tinted: Although watercolour paper is normally white, tinted watercolour paper is available in a small range of pale colours. Weight: The weight of a paper s normally given in pounds per ream (a ream being 500 sheets) or grams per square metre. The heavier the watercolour paper, the more water it can absorb. Papers under 140lb (300gsm) need to be stretched before use to prevent them buckling when water is applied.

Perspective

A system whereby artists can create the illusion of three-dimensional space on the two-dimensional surface of the paper. Aerial perspective: the way the atmosphere, combined with distance, influences the appearance of things. This is also known as atmospheric perspective. Linear perspective: linear perspective exploits the fact that objects appear to be smaller the further away they are from the viewer. The system is based on the fact that all parallel lines, when extended from a receding surface, meet at a point in space known as the vanishing point. When such lines are plotted accurately on the paper, the relative sizes of objects will appear correct in the painting.

Primer

A substance that acts as a barrier between the support and the paint, protecting the support from the corrosive agents present in the paint and the solvents. Priming provides a smooth, clean surface on which to work. The traditional primer for use with oil paint is glue size, which is then covered with an oil-based primer such as lead white. Nowadays, acrylic emulsions (often called acrylic gesso) are more commonly used.

Resist

A substance that prevents one medium from touching the paper beneath it. Wax (in the form of candle wax or wax crayons) is the resist most commonly used in watercolour painting; it works on the principle that wax repels water.

Scaling up

A method of transferring an image to a larger format. First, a grid of squares is superimposed on the original image. Then a second grid of larger squares in the same proportion is marked out on the new, larger support. Finally, each square of the original is copied on to the corresponding square on the larger format.

Scumble

A technique that involves applying dry, semi-opaque paint loosely and roughly over a dry underlayer, leaving some of the underlayer visible to create optical colour mixes on the support. The technique also produces interesting surface textures.

Sgraffito

The technique of scratching off paint to reveal either an underlying paint colour or the white of the paper. The word comes from the Italian verb *graffiare*, which means "to scratch".

Shade

A colour that has been darkened by the addition of black or a little of its complementary colour.

Size

A weak solution of glue used to make canvas impervious prior to applying layers of primer or oil paint.

Solvent See Thinner

Spattering

The technique of flicking paint on to the paper to create texture.

Sponging

The technique of applying colour to the paper with a sponge, rather than with a brush, in order to create a textured appearance.

Stippling

The technique of applying dots of colour to the paper, using just the tip of the brush.

Support

The surface on which a painting is made. See also **Ground**.

Thinner

A liquid such as turpentine which is used to dilute oil paint. Also known as Solvent.

Tint

A colour that has been lightened. In pure watercolour, a colour is lightened by by adding water to the paint.

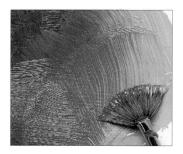

Tone

The relative lightness or darkness of a colour. Also known as **Value**.

Tonking

An technique named after the British artist Henry Tonks (1862–1937), which involves placing a sheet of newspaper over the wet oil or acrylic paint, smoothing it down and peeling it away to remove excess paint.

Underdrawing

A preliminary sketch on the canvas or paper, over which a picture is painted. It allows the artist to set down the lines of the subject, and erase and change them if necessary, before committing irrevocably to paint.

Underpainting

A painting made to work out the composition and tonal structure of a work before applying colour.

Value See Tone.

Wash

A thin layer of transparent paint that usually covers a large area of the painting. Flat wash: an evenly laid wash that exhibits no variation in tone. Gradated wash: a wash that gradually changes in intensity from dark to light or (less commonly) vice versa.

Variegated wash: a wash that changes from one paint colour to another.

Wet into wet

The technique of applying paint on to wet paper or on top of an earlier wash that is still damp.

Wet on dry

The technique of applying paint to dry paper or on top of an earlier wash that has dried completely.

Suppliers

Manufacturers

If you are unable to find what you want in your local art shop, the leading manufacturers of paints, papers and brushes should be able to supply you with details of stockists in your area.

Daler-Rowney UK Ltd PO Box 10 Bracknell Berkshire RG12 8ST United Kingdom Tel: (01344) 424621 Website: www.daler-rowney.com

Winsor & Newton
Whitefriars Avenue
Wealdston, Harrow
Middlesex HA3 5RH
United Kingdom
Tel: (020) 8427 4343
Website: www.winsornewton.com

H. Schmincke & Co.
Otto-Hahn-Strasse 2
D-40699 Erkrath
Germany
Tel: (0211) 2509-0
Fax: (0211) 2509-461
Website: www.schmincke.de

Stockists

UNITED KINGDOM
ABS Brushes
Wetley Abbey, Wetley Rocks
Staffordshire ST9 0AS
Tel: (01782) 551551
Fax: (01782) 551661
Email: abs.brushes@btinternet.com
Website: www.absbrushes.com
(Brushes only)

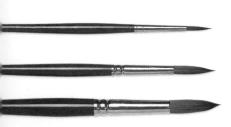

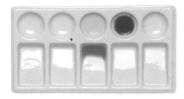

Art Express
Freepost NEA8739, Leeds LS1 1YY
Freephone: (0800) 731 4185
Fax: (0113) 243 6074
Website: www.artexpress.co.uk
(Postal address for overseas customers: Index House, 70 Burley Road,
Leeds LS3 1JX, UK)

Atlantis Art Materials 7–9 Plumbers Row, London E1 1EQ Tel: (020) 7377 8855 Website: www.atlantisart.co.uk

Dodgson Fine Arts Ltd t/a Studio Arts 50 North Road, Lancaster LA1 1LT Tel: (01524) 68014 Fax: (01524) 68013 Email: enquiries@studioarts.co.uk Website: www.studioarts.co.uk or www.studioartshop.com

Falkiner Fine Papers 76 Southampton Row London WC1B 4AR Tel: (020) 7831 1151 Fax: (020) 7430 1248 Email: falkiner@ic24.net

Hobbycraft
Hobbycraft specialize in arts and crafts
materials and own 19 stores around the
UK. For details of stores near you, phone
freephone (0800) 027 2387 or check out
the yellow pages or the company's
website. Website: www.hobbycraft.co.uk

Jacksons Art Supplies PO Box 29568 London N1 4WT Tel: (0870) 241 1849 Fax: (020) 7354 3641 Email: sales@jacksonart.com

Website: www.jacksonart.com

Buy on-line from:

Paintworks 99–101 Kingsland Road London E2 8AG Tel: (020) 7729 7451 E-mail: shop@paintworks.biz

Russell & Chapel Tel: (020) 7836 7521

SAA Home Shopping PO Box 50 Newark Notts NG23 5GY Freephone: (0800) 980 1123

Tel: (01949) 844050 (overseas customers) Email: homeshopping@saa.co.uk

Website: www.saa.co.uk

Stuart Stevenson 68 Clerkenwell Road London EC1M 5QA Tel: (020) 7253 1693

Turnham Arts & Crafts 2 Bedford Park Corner Turnham Green Terrace London W4 1LS Tel: (020) 8995 2872 Fax: (020) 8995 2873

UNITED STATES

Many of the following companies operate retail outlets across the US. For details of stores in your area, check out the yellow pages or the relevant website.

1055 South Tamiami Trail Sarasota FL 34236 Tel: (941) 366-2301 Toll Free: (800) 393-4278 Fax: 941-366-1352 Email: orders@in2art.com Website: www.in2art.com

Art & Frame of Sarasota

Dick Blick Art Materials PO Box 1267 Galesburg IL 61402-1267 Tel: (800) 828-4548 Fax: (800) 621-8293 Website: www.dickblick.com (More than 30 stores in 12 states.) Hobby Lobby Website: www.hobbylobby.com (More than 300 stores in 27 states.)

Michaels Stores Michaels.com 8000 Bent Branch Dr., Irving, TX 75063 Tel: (1-800) 642-4235 Website: www.michaels.com (More than 750 stores in 48 states.)

Mister Art 913 Willard Street, Houston, TX 77006 Tel (toll-free): (866) 672-7811 Fax: (713) 332 0222

Website: www.misterart.com.

The Easel Studio Tel (toll-free): (800) 916-2278 Fax (309) 273-0362

E-mail: bobbielarue@yahoo.com Website: www.easelstudio.com

CANADA

Artists in Canada 803 Brightsand Terrace Saskatoon, Saskatchewan, S7J 4X9 Website: www.artistsincanada.com

D. L. Stevenson & Son Ltd 1420 Warden Avenue Scarborough, Ontario M1R 5A3. Tel: (416) 755-7795 E-mail (Canada): colourco@interlog.com E-mail (US): customer service@

Buy customized paper and canvas stretchers from:
Upper Canada Stretchers Inc.
1750 16th Avenue East
Box 565 Owen Sound
Ontario, N4K 5R4
Tel: (1-800) 561-4944
Fax: (519) 371-7328
Email: donato@ucsart.com
Website: www.ucsart.com

The Paint Spot Tel: (800) 363 0546 Website: www.paintspot.ca

Colours Artist Supplies 414 Graham Avenue Winnipeg Manitoba R3C 0L8 Tel: (204) 956-5364.

Fax: (204) 943-6989 Email: colours@mb.sympatico.ca

AUSTRALIA Art Materials

Website: www.artmaterials.com.au

(6 stores across western Canada)

Dick Blick Art Materials Customer Service: (800) 723-2787 Product Info: (800) 933-2542 International: (309) 343-6181 E-mail: info@dickblick.com Website: www.dickblick.com

Madison Art Shop Tel: (800) 961-1570

Website: www.MadisonArtShop.com

MasterGraphics Inc. 810 West Badger Road Madison WI 53713 Tel: (608) 256-4884

Toll Free: (800) 873-7238 Fax: (608) 210-2810

E-mail: mastergraphics@masterg.com

Website: www.masterg.com

North Shore Art Supplies 10 George Street Hornsby New South Wales Tel: (02) 9476 0202 Fax: (02) 9476 0203

Oxford Art Supplies Pty Ltd CITY 221–223 Oxford Street Darlinghurst NSW 2010 Tel: (02) 9360 4066 Fax: (02) 9360 3461

Email: orders@oxfordart.com.au Website: www.oxfordart.com.au or www.janetsart.com.au

Oxford Art Supplies and Books Pty Ltd Chatswood 145 Victoria Ave Chatswood NSW 2067. Tel: (02) 9417 8572 Fax: (02) 9417 7617

NEW ZEALAND
Draw Art Supplies Ltd.
PO Box 24022
5 Mahunga Drive
Mangere Bridge
Auckland
Tel: (09) 636 4989
Fax: (09) 636 5162
Free Fax: (0800) 506 406
E-mail: enq@draw-art.co.nz
Website: www.draw-art.co.nz

Fine Art Supplies PO Box 58 018, 38 Neil Park Dr. Greenmount Auckland New Zealand Tel: (64-9) 274 8896 Fax: (64-9) 274 1091

Website: www.fineart supplies.co.nz

Index

abstract work 28, 78-9 acetate 298 acrylic paint 264 additives 278-81 blending with water 313 characteristics 264-5 projects café scene 488-93 cupped hands 500-3 domestic interior 468-73 farmyard chickens 382-7 head-and-shoulders portrait 482-7 irises 352-7 Moorish palace 456-61 portrait of a young child 476-81 rolling hills 410-15 still life with glass and ceramics 436-41 still life with gourds 418-23 stormy sky 394-7 wisteria-covered archway 462-7 removing 334, 335 starter palette 266 underdrawing 301 acrylic papers 286 additives 64-5, 222, 254, 264 acrylic paint 278-81 oil paint 276-7 adhesive qualities 264 aerial perspective 88-9, 102, 164, 208, 209, 505 alizarin crimson 261 alkyd oil paints 260 alla prima painting 316-19, anemones painted alla prima 316-19 applying paint 272-3, 290-1 applying varnish 287 arch and balcony 450-5 arched window 222-7 autumn leaves 313-15

back-run 78 bark 60 beaches 56–7, 62 black lava texture gel 281 bleached linseed oil 276 blending 267, 312–15 blending: autumn leaves

auxiliary equipment 288-9

autumn tree 144-7

313-15 blotting up excess oil 328 boards 284 covering with canvas 285 priming 284 body colour 84-7, 152, 254 broad scumble 324 broken colour 43, 138 brushes 18-19 brushstrokes 26-7 brushstrokes 384, 399, 400, 437, 447, 464 applying pressure 292 dots 291 fine marks 292 long strokes 291, 292 rough texture 291, 292 rounded marks 291, 292 short strokes 291, 292 thin strokes 291 uneven texture 291, 292 buildings 208-9 arched window 222-7 church spire 74-81 hillside town in line and wash 210-15 Moroccan kasbah 216-21 burnt sienna 261 burnt umber 266, 269 butterflies 388

cadmium lemon yellow 261, 294 cadmium red 261, 266, 269 cadmium yellow light 266, 269 café scene 488–93 candle wax 340 candles 52, 53 canvas 282

canvas paper and board 286 priming 284 stretching 283 cerulean blue 261 charcoal 20 charcoal underdrawing 300 Chinese brushes 18, 19 chisel brushes 19 church in snow 444-9 church spire in line and wash 68-71 circular objects 93, 182 citrus solvents 277 cleaning brushes 270 cleaning knives 272 clear film (plastic wrap) 78, 290 closed compositions 98, 504 clouds 62, 78, 88, 98, 102, clouds at sunset 104-7 cold-pressed linseed oil 276 collage 265 colour 15, 38-9, 94, 138, 140, 176, 372, 384, 399, 504 alizarin crimson 261 body colour 84-7, 152, 504 burnt sienna 261 burnt umber 266, 269 cadmium lemon vellow 261. cadmium red 261, 266, 269 cadmium yellow light 266, 269 cerulean blue 261 change when dry 263, 266, 268, 380 contrast 41 darkening 294 distance 354 glazes 320, 471 harmony 42 lifting off 62-3, 78 lightening 265, 268, 294 mixing 15, 40, 41, 43, 263, 320, 453 overlaying 44-5 Payne's grey 266, 269 perspective 88, 89

phthalocyanine blue 266,

phthalocyanine green 266,

quinacridone red 266, 269

269, 274

Prussian blue 294

269

boards 285

raw umber 261, 266, 269 skies 102 temperature 40 terre verte 302 titanium white 261, 266, 269 tonal equivalents 295 tone 34-5 ultramarine blue 261, 266, 269 underpainting 302 viridian green 261, 274 yellow ochre 261, 266, 269 coloured pencils 20, 28 combining gouache techniques 342-7 complementary colours 41, 42, 176, 504 composition 94-9, 174, 504 compositional sketches 377, conch shell 82-3 containers 275 cooking foil 79 cool colour 39, 40 cotton duck 282 covering power 265 craft knives 22, 23, 82, 334, 341 craggy mountains 168-73 crashing waves 120-5 crayons 20, 21, 52, 53 cupped hands 500-3 curved objects 29, 93, 182 damar varnish 287 darkening colours 294 dippers 275

damar varnish 287
darkening colours 294
dippers 275
disposable palettes 275
distance 88
distressed wood and metal
325–7
dividing the picture area 96–7

domestic interior 468–73 dots 291, 293 drawing drawing boards 22, 231, 289 oils 260 underdrawing 300–1, 368, 504 drybrush 60–1, 138, 228, 338–9, 341, 504 seashells 338–9 drying times 262 extending 265 speeding up 330

easels 22, 288-9 equipment 12-23 erasers 23 Euclid 94 exercises: anemones painted alla prima 316-19 autumn leaves 313-15 beach with spattered pebbles 56-7 church spire in line and wash 68-71 combining gouache techniques 342-7 conch shell 82-3 distressed wood and metal 325-7 fruits with stippled texture glass jar and chiffon 321-3 graffiti-style abstract 78-81 impasto landscape in oils

60–1 log and axe on toned ground 76–7 masking a white-patterned jar 50–1 monochrome 36–7 monochrome underpainting 302–3 overlaying colours 44–5

Italian landscape 309-11

landscape using flat and

gradated washes 30-1

lily with drybrushed leaves

332-3

peacock feathers in watersoluble pencils 72–5 pumpkins painted impasto using acrylics 329–31

painting light on dark 84-7

scaling up a small sketch

299
seashells 338–9
seeing in tones 295–7
sponging 62–3
still life painted wet into
wet 46–7
sunset using a variegated
wash 32–3
teapot on toned ground
305–7
textured stone and iron
65–7
using resists to create
texture 53–5
watermelons 334–7
eve of the tiger 188–9

fan brushes 19, 60, 271, 338 blending paint 312 farmyard chickens 382-7 fat over lean 262, 504 field boxes 13 filbert brushes 271 fine detail brushes 271 flamingo 202-7 flat brushes 18, 26, 27, 271, 291, 292 flat washes 27, 28, 505 flesh tones 479, 482, 494 floating leaf 358-61 flow-improving mediums 279, flowers 78, 152-3 artificial 352 lilv 60-1 poppy field 148-51 summer flower garden 158-63 sunflower 154-7 foam applicators 273, 290

foam brushes 290 foliage 43, 138 formats 94–5, 158, 504 French vineyard 164–7 frottage 52 fruit 44–5 fruits with stippled texture 58–9 strawberries and cherries in a bowl 176–81 fur 188 otter 196–201 tabby cat 190–5

gel mediums 264, 280, 281 George IV 450 glass beads texture gel 281 glass jar and chiffon 321-3 glass palettes 275 glazing 320-3, 471, 504 acrylics 265 glass jar and chiffon 321-3 oils 262 aloss mediums 278 gloss varnish 287 glycerin 64 golden section 96 good working practice 262 gouache 12, 24, 84, 504 gouache paint 267 characteristics 267-8 combining gouache techniques 342-7 projects arch and balcony 450-5 floating leaf 358-61 rocky landscape 398-403 sleeping cat 376-81 still life with pebbles 424-9 woodland path 368-73 removing 334, 335 starter palette 269 techniques 340-7 gradated washes 28, 29, 505 graffiti-style abstract 78-81 granulation medium 64 grass 60 around 504 log and axe on toned ground 76-7 grounds 304-7, 504 see also supports groupings 174 guidelines 363 gum arabic 12, 23, 64, 78, 228, 242

gum strip 23

hake brushes 27
harbour moorings 132–7
head-and-shoulders portrait
230–5, 482–7
heavily textured scumbling
324
heavy gel medium 280
highlights 12, 82, 84, 112,
188, 193, 267, 323, 401,
454, 472, 504
eye of the tiger 188–9
hillside town in line and wash
210–15
horizon line 90, 98, 99
hues 14, 39, 294, 504

illustration board 286 impasto 328–33, 504 impasto landscape in oils 332–3 pumpkins painted impasto using acrylics 329–31 improvized palettes 275 Indian market scene 248–53 inks 21, 28, 68, 210, 465 iridescent mediums 281 irises 352–7 Italian landscape 309–11 ivory black 261

jars 264

kitchen paper 22, 79
knives 12, 22, 82, 272, 334, 341
broad marks 293
dots 293
impasto 328
long, uneven marks 293
press on and lift off 293
removing paint 334
short marks 293
thin strokes using the knife
edge 293
uneven lines 293

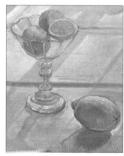

lake with reflections 126-31 landscape 28, 30-1, 98, 102, 138. 140 craggy mountains 168-73 French vineyard 164-7 lavender oil 277 laying a wash 308 leading the eye 98-9 lemons in glass dish 430-5 lichen 62 lifting off colour 78 light 38, 174 light colour scumbled over dark 324 light scumbling with a rag 324 light to dark 24-5, 36, 43, 152, 228 painting light on dark 84-7 lightening colours 294 acrylic 265 gouache 268

church spire 68–71 hillside town 210–15 linear perspective 90–1, 164, 208, 209, 505 linen canvas 282 liner brushes 271 lines, painting 296, 345 linseed oil 274, 276

lily with drybrushed leaves and

line and wash 21, 68-71, 504

buds 60-1

liquid acrylics 264 liquin 277 log and axe on toned ground 76–7

low-odour thinners 277 mahl sticks 289, 504

marks 26–7 masking 23, 48–9, 50–1, 52, 152, 196, 340, 371, 377, 378, 504 matt mediums 278

matt varnish 287 MDF (medium density fibreboard) 284, 440 mediums 264, 276, 278–80 glazes 320

impasto 328 mirrors 231 mixing colours 15, 40, 41, 43, 320, 453

oils 263 mixing tones 35 modelling paste 280 monochrome 36–7 monochrome underpainting

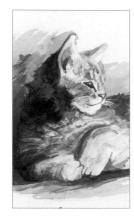

302–3 Moorish palace 456–61 mop brushes 18, 26 Moroccan kasbah 216–21 muddied colours 267 multiple-point perspective 92

natural sand texture gel 281

oil bars 260 oil of spike lavender 277 oil paint 260 additives 276-7 alla prima 316-19, 504 characteristics 262 projects church in snow 444-9 lemons in glass dish 430-5 reclining nude 494-9 sunlit beach 404-9 tropical butterfly 388-91 tulips in glass vase 362-7 removing 334, 335 starter palette 261 usina 262-3 oil papers 286 oil pastels 52, 53, 222 open compositions 98, 99, 504 optical mixes 43, 44 otter 196-201 overlaying 44-5, 504

paint shapers 273, 290 paintbrushes 270–1, 296, 388, 389 acrylics 291 gouache 292 impasto 328

loading with paint 338 oils 291 paints 12, 14-15 palette 15, 504 palette knives 272, 293, 328 palettes 274-5, 504 palettes (equipment) 13, 504 pans 12, 504 paper 16-17, 23, 52, 78, 82, 107, 113, 196, 504-5 paper board 286 pastels 11, 28, 52, 53, 222 Payne's grey 266, 269 peacock feathers 72-5 pearlescent mediums 281 pencil underdrawing 301 pencils 20, 28, 216 water-soluble pencils 72-5,

water-soluble pencils 72–5 158 pens 21, 68 people 228–9

head-and-shoulders portrait 230–5 Indian market scene 248–53 seated figure in interior

242–7 swimmer 236–41 perspective 88–93, 94, 112, 231, 504, 505 phosphorescent mediums 281 photographs 35, 164, 196, 210, 230, 236, 242, 248, 298

phthalocyanine blue 266, 269, 274 phthalocyanine green 266, 269

physical mixes 43 pigments 12, 13, 14, 40 plastic knives 272, 293, 328 Plato 94 Pointillism 58 poppy field 148–51

poppy oil 276 portable box easels 288–9 portrait of a young child

476–81 primary colours 38, 39, 40, 504

priming 504 board and canvas 284 Prussian blue 294 pumpkins painted impasto

using acrylics 329–31 quinacridone red 266, 269

rags 280, 324, 396

rainbow and storm clouds 108–11 raw umber 261, 266, 269 receding landscape 309 reclining nude 494–9 refined linseed oil 276 reflections 112, 182 removing and adding colour with a sponge 62–3,

78 removing paint 268, 334–7, 421

watermelons 334–7
representational work 28
resist techniques 340, 504
resists 52–3, 222, 505
retarding mediums 279
retouching varnish 287
rigger brushes 18, 19
rocky landscape 398–403
rolling hills 410–15
round brushes 18, 26, 60, 271, 291, 292
Royal Pavilion, Brighton 450
Rubens, Peter Paul
(1577–1640) 302, 476

safety considerations 277
safflower oil 276
salt 64, 65
sand 52
sandpaper 82, 335, 341
scale 88–93, 94
scaling up 298–9, 504
scaling up a small sketch
299
scalpels 22, 23, 82
scraping off paint with a knife
334
scumbling 324–7, 504
distressed wood and metal

325–7 seashells 338–9 seated figure in interior 242–7 secondary colours 38, 39, 40,

504 seeing in tones 295-7 Seurat, Georges (1859–91) 58, 388 sgraffito 22, 82-3, 138, 335, 341, 504, 505 shades 39, 505 shadows 209 shape 94 shape-holding ability 265 shingle 52 size 88, 89, 90, 284, 504 sketches 30, 34, 36, 120, 130, 144, 158, 174, 222, 488 compositional sketches 377, 456 scaling up 299 tonal sketches 358, 377 skies 29, 88, 102-3 clouds at sunset 104-7 storm clouds and rainbow 108 - 11sunset using a variegated wash 32-3 slanted-well palettes 274 sleeping cat 376-81 snow 56, 84 solvents see thinners spattering 28, 56-7, 115, 148, 222, 341, 359, 425, 505 spectrum 38 sponge applicators 273, 290 sponges 23 sponging 52-3, 78, 168, 222, 341, 396, 505 spotter brushes 18 stand linseed oil 276 stay-wet palettes 275 steel knives 272, 293, 328 still lifes 44-5, 58, 174-5 conch shell 82-3 peacock feathers 72-5 still life painted wet into wet 46-7 still life with glass and ceramics 436-41 still life with gourds 418-23 still life with pebbles 424-9 still life with stainless steel 182-7 strawberries and cherries in a bowl 176-81 stippling 28, 58-9, 222, 505 stonework 60, 62, 64-7 storm clouds and rainbow 108-11 stormy sky 394-7

strawberries and cherries in a

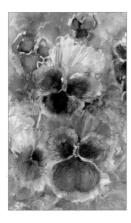

bowl 176–81 stretching paper 17, 23 students' quality paint 260, 264 studio easels 289 summer flower garden 158–63 sunflowers 154–7 sunlit beach 404–9 sunset clouds 104–7 sunset using a variegated wash 32–3 supports 52, 282–6, 505 see also grounds swimmer 236–41

tabby cat 190-5 table easels 288 teapot on toned ground 305-7 terre verte 302 tertiary colours 38, 39, 40, 504 texture 28, 43, 52, 56, 58-9, 62, 94, 144, 291, 292, 324. 335 additives 64 perspective 88 stippling 58-9 stone and iron 65-7 using resists 53-5 wet paint 78 texture gels 264, 281 texture pastes 281 thick and thin oil paint 263 thinners 276-7 thirds 96 tinted papers 16 tints 39, 505 titanium white 261, 266, 269 tone 34-5, 43, 148, 182, 217, 294-7, 504, 505 flesh tones 479, 482, 494 monochrome 36-7 perspective 88, 89 seeing in tones 295-7 tonal sketches 358, 377 using a toned ground 76-7 toned grounds 304 grounds: teapot on toned ground 305-7 tonking 334, 504 Tonks, Henry (1862-1937) 334, 504 tracing 359 translucency 24, 25, 34, 43.84 transparent scumble using acrylics 324 trees 62, 138-9 autumn tree 144-7 painting 310, 368 woodland in spring 140-3 tropical butterfly 388-91 tubes 260, 263, 264 impasto 328 tulips in glass vase 362-7 Turner, J. M. W. 120 turpentine 277 two-point perspective 92

ultramarine blue 261, 266, 269 underdrawing 20, 164, 208, 300–1, 368, 504, 505 underpainting 302–3, 504 monochrome underpainting 302–3

value see tone
vanishing point 90, 91, 92, 93
variegated washes 28, 32–3,
505
varnishes 287
vegetation, painting 310, 332,
372
viridian green 261, 274

warm colour 38, 40 washes 27, 28–33, 43, 76, 78, 84, 308–11, 504, 505 clouds 102 Italian landscape 309–11 line and wash 21, 68–71, 210–15, 504 wash brushes 271 water 43, 112–13 crashing waves 120–5

harbour moorings 132-7 lake with reflections 126-31 woodland waterfall 114-19 water-mixable oil paint 260 water-soluble pencils 20. 72-5, 158 watermelons 334-7 waves 52, 56 crashing waves 120-5 wax 52 wax varnish 287 weather 43 wet into dry 340 wet into wet 46-7, 152, 182, 202, 210, 228, 263, 268, 312-15, 340, 504, 505 autumn leaves 313-15 wet on dry 228, 505 wet paint applied to damp paper 340 wet paint applied to dry paper 340 white palettes 274 white spirit 277 white-patterned jar 50-1 wisteria-covered archway 462 - 7wooden palettes 274 woodland in spring 140-3 woodland path 368-73 woodland waterfall 114-19 working into paint to create texture 335 working into wet paint 78-81

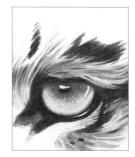

yellow ochre 261, 266, 269

Acknowledgements

WATERCOLOUR

The publishers and authors are grateful to Daler-Rowney UK and Turnham Arts and Crafts for their generous loan of materials for the photography.

In addition, special thanks must go to the following artists for their step-by-step demonstrations:

Ray Balkwill: pages 132–7; Diana Constance: pages 44–5, 216–21; Joe Francis Dowden: pages 114–19, 126–31; Paul Dyson: pages 49, 188–9, 196–201, 202–7; Abigail Edgar: pages 140–13, 168–73, 242–7, 248–53; Wendy Jelbert: pages 120–5, 144–7, 154–7, 158–63, 176–81, 222–7; Melvyn Petterson: pages 62–3, 65–7, 68–71, 72–5, 79(b)–81, 84–7, 108–11, 190–5; Paul Robinson: pages 210–15; lan Sidaway: pages 28–9, 32, 36–7, 48, 50–1, 54–5, 56 (tl, tr, cl, cr), 58 (tl, tr), 60 (tl, tr), 64, 76–7, 78–9 (t), 82–3, 182–7, 236–41; Albany Wiseman: pages 30–1, 33, 46–7, 56–7, 58–9, 60–1, 104–7, 148–51, 164–5, 230–5.

Copyright paintings and photographs are reproduced in this section by kind permission of the following:

Paul Dyson: pages 24, 94, 95 (t); Trudy Friend: pages 25 (t), 103 (b), 139 (b); Jonathon Hibberd: page 148 (t); Sarah Hoggett: pages 62 (bl), 65 (tl), 68 (b); Wendy Jelbert: pages 26 (b), 95 (br), 103 (t), 103 (t), 112, 113 (b), 139 (t), 152; Ian Sidaway: pages 95 (bl), 96–7, 98–9, 102, 113 (t), 138, 153; George Taylor: 32 (b), 104 (t).

OIL, ACRYLIC & GOUACHE

The publishers are grateful to the staff at Paintworks, 99–101 Kingsland Road, London E2 8AG for the generous loan of materials and equipment.

In addition, special thanks must go to the following artists for their step-by-step demonstrations:

Martin Decent: pages 398–403, 410–15, 424–9, 468–73; Paul Dyson: pages 358–61, 376–81; Timothy Easton: pages 362–7, 404–9, 430–5, 444–9; Abigail Edgar: pages 280–1, 298–9, 300–1, 304–5, 309–11, 313 (b), 314–15, 321–3, 325–7, 332–3, 335 (br), 336–7, 338 (br), 339, 394–7, 456–61, 476–81 488–93; Wendy Jelbert: pages 352–7, 382–7, 418–23, 462–7; John Raynes: pages 368–73, 388–91, 450–5, 494–9; lan Sidaway: pages 261–70, 278, 279, 283, 284–5, 287, 290–3, 294–7, 302–3, 304, 308, 312, 313 (t), 316–19, 320, 324, 328–31, 334, 335 (t), 338 (t), 340–7, 436–41, 482–7, 500–3.

Copyright paintings and photographs are reproduced in this section by kind permission of the following:

Keith Adams: page 388 (t); Martin Decent: pages 351 (t), 374, 393 (t), 417 (t), 444, 475 (b); Timothy Easton: pages 350, 351 (b), 375 (both), 392, 393 (b), 416, 417 (b), 445 (both), 474, 475 (t); Jon Hibberd: pages 313 (b)), 335 (b)).

t = top, b = bottom, l = left, r = right, c = centre.

This edition is published by Hermes House

Hermes House is an imprint of Anness Publishing Ltd, Hermes House, 88–89 Blackfriars Road, London SE1 8HA; tel. 020 7401 2077; fax 020 7633 9499

www.hermeshouse.com; www.annesspublishing.com

If you like the images in this book and would like to investigate using them for publishing, promotions or advertising, visit our website www.practicalpictures.com for more information.

© Anness Publishing Ltd 2005, 2008

All rights reserved. No part of this publication may be reproduced, stored in a retrieval system, or transmitted in any way or by any means, electronic, mechanical, photocopying, recording or otherwise, without the prior written permission of the copyright holder.

Previously published as two separate volumes: Mastering the Art of Watercolour and Mastering the Art of Oils, Acrylics and Gouache A CIP catalogue record for this book is available from the British Library.

ETHICAL TRADING POLICY Because of our ongoing ecological investment programme, you, as our customer, can have the pleasure and reassurance of knowing that a tree is being cultivated on your behalf to naturally replace the materials used to make the book you are holding. Our forestry programme is run in accordance with the UK Woodland Assurance Scheme (UKWAS) and will be certified by the internationally recognized Forest Stewardship Council (FSC). Certification ensures forests are managed in an environmentally sustainable and socially responsible way. For further information about this scheme, go to www.annesspublishing.com/trees

Publisher: Joanna Lorenz Editorial Directors: Judith Simons and Helen Sudell Editors: Sarah Ainley and Simona Hill Consultant Editor: Sarah Hoggett Photographers: George Taylor and Nigel Cheffers-Heard

Designer: Nigel Partridge

Illustrator: Ian Sidaway
Project Contributors: Ray Balkwill,
Diana Constance, Martin Decent,
Joe Francis Dowden, Paul Dyson,
Timothy Easton, Abigail Edgar, Wendy
Jelbert, Melvyn Petterson, John Raynes, Paul
Robinson, Ian Sidaway, Albany Wiseman
Editorial Readers: Jay Thundercliffe and
Rosanna Fairhead
Production Controller: Don Campaniello

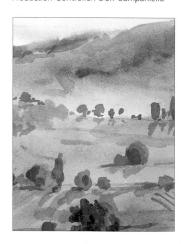